(TGN)
£15 ~
Art
20/6

FRENCH ART

PREHISTORY
TO THE
MIDDLE AGES

This work is dedicated to the thousands of artisans and artists who have built and loved this country. And to the hundreds of scholars who have saved them from being forgotten.

A.C.

ANDRÉ CHASTEL

FRENCH ART

PREHISTORY
TO THE
MIDDLE AGES

Translated from the French by Deke Dusinberre

Flammarion
Paris - New York

Illustration page 8: Fragment of a mosaic from Saint-Roman-en-Gal (Rhône).
The month of January: the baker.
Early third century. Musée des Antiquités Nationale, Saint-Germain-en-Laye.

Illustration page 90: *Image du Monde.* The Liberal Arts: Geometry.
Thirteenth century. Bibliothèque Nationale, Paris (Ms. Fr. 574, fol. 280v).

The original French text was edited by Marie-Geneviève de La Coste-Messelière,
who also established the bibliography.

The English edition was copyedited by Christa Weil

Additional research by Sophy Thompson

DESIGNED BY Martine Mène
PICTURE RESEARCH BY Béatrice Petit
TYPESET BY Octavo Editions, Paris.
COLOR SEPARATION BY Bussière, Paris
PRINTED BY Clerc, S.A., Saint-Amand-Montrond
BOUND BY BRUN, Malesherbes

Flammarion
26, rue Racine
75006 Paris

ISBN: 2-08013-566-X
N° d'édition: 0849
Dépôt Légal: October 1994

Printed in France

CONTENTS

PART I ORIGINS

PREHISTORY: TIME-HALLOWED SITES 11

CELTS AND GALLO-ROMANS 28

MEROVINGIANS 50

CAROLINGIANS 66

A TROUBLED CENTURY 80

PART II THE MIDDLE AGES

THE WEST AT WORK 93

THE ROMANESQUE PERIOD

1. EMERGENCE 987–1059 138
2. DECISIVE ACCOMPLISHMENTS: AROUND 1100 153
3. A DIVERSITY OF CHURCHES 164
4. ARRAYS OF SCULPTURE 172
5. ROMANESQUE COLOR 188
6. CASTLES: COURTLY AND SECULAR LIFE 196
7. THE CISTERCIAN COUNTER-MOVEMENT 200

THE GOTHIC ERA

1. THE ART OF BUILDING 206
2. THE ROYAL BASILICA AT SAINT-DENIS 214
3. NEW ARCHITECTURE, NEW SCULPTURE IN THE TWELFTH CENTURY 220
4. THE YEAR 1200 232
5. THE THIRTEENTH CENTURY: ARCHITECTURAL PLENITUDE 236
6. THE THIRTEENTH CENTURY: SCULPTURAL PLENITUDE 250
7. "ROYAL" ART IN THE DAYS OF SAINT LOUIS 259
8. PRECIOUS OBJECTS IN GOTHIC FRANCE 268
9. CASTLES AND TOWNS 274

ARISTOCRATIC GOTHIC

1. TROUBLED TIMES 278
2. COURT ART: MINIATURES AND CURIOS 284
3. ARCHITECTURE AND STATUARY 299
4. CHARLES V AND "ROYAL ART" 307
5. ARISTOCRATIC OSTENTATION: THE THREE PLEASURES 313
6. THE "INTERNATIONAL" STYLE 323

NOTES 336
INTRODUCTION TO THE HISTORY OF FRENCH ART EXTRACTS 341
BIBLIOGRAPHY 353
INDEX 361
PICTURE CREDITS 367

OPERA INTERRUPTA

The task was indeed interrupted. Fortunately, however, there is no need for the long commentaries, learned or idle, that usually accompany unfinished books—for good reason.

Namely because there is nothing didactic about these final pages written by André Chastel on *French Art.* Nothing could be further from an academic "treatment" of the subject. Rather, this study is rich in associations and confidences. The notes are sometimes as clear and telling as stealthy footprints, sometimes as intense as a spotlight cast across the ages. An incredible flavor of intellectual freedom emerges here, nurtured by alert aesthetic experience based on a long and varied personal itinerary. The work comes across as a personal record of encounters—stumbling upon an old Roman road, deciphering a decorative motif, looking up toward a dome, holding a barbarian torque in the palm of the hand, or gazing, yet again, on a Poussin, a Vuillard, or indeed the Eiffel Tower.

Despite its primary concern for direct contact with artworks rather than a discussion of ideas, the enormous work that went into *French Art* obviously cannot be reduced to a stack of personal impressions, however relevant or irrelevant, however reasonable or incisive. So although readers may enjoy participating in what seems like a challenging hunt—finding more questions than answers in Chastel's Socratic method, which deliberately rejects the framework of event-driven history—it is important to stress that the structure of the argument is still grounded on concrete developments, not one of which is gratuitous.

These volumes represent the "last frontier" of a work which moreover has nothing geographical about it, since it vigorously criticizes banal concepts like national borders.

Obviously, accomplishing this complex undertaking—this close interrogation of multifarious artistic activities across the centuries—constitutes an impressive exploit. It required mountains of texts, from brief notes to long, completely drafted sections, from plans buried in files to precise illustrations, etc. All of which had to be re-grouped, re-ordered, re-arranged.* In short, four thick volumes, each amounting to 368 pages, had to be put together.

A "ROBUST CONTINUITY"

Chastel started by asking why the French were far less interested in their own art than, say, the Italians were in theirs, despite admiration for French art on the part of foreigners. The answer lay in the fact that the history of art was developed in Central Europe in the nineteenth century, based on Italian examples and notions alien to French production. According to Panofsky, this approach, rather than following the natural evolution of issues, concentrated on the codification of specific episodes. Chastel therefore combats three types of assumption—the disastrous concept of "influence," the postulate of "linear evolution," and the hypothesis of "recurring patterns" that argued that any series of artworks inevitably moves through three phases (rise, apogee, decline). French art did not follow these rules of maturation commonly found in textbooks, but rather was marked by a long, profound and almost unconscious current, which Chastel labeled "robust continuity." The often anonymous artists were barely aware of this strong drive which, associated with instinctive artisanal aptitudes, favored exercises in free development not always beholden to higher considerations. The journeymen-builders' art of construction is an excellent example, for their craft, with its ancient roots, is carefully differentiated from more recent "folk art" that brashly copies the fashion set by oustanding examples. Soft-spoken craft skills ultimately produced the practical and almost unchanging arrangement that characterized French houses between 1540 and 1870. Construction, it must be stressed, was considered a privileged domain by André Chastel, for whom French art is first and foremost a question of architecture.

*Our gratitude is extended to everyone who worked on this long and difficult task, in particular Marie-Geneviève de La Coste-Messelière, for whom the works of André Chastel hold no secrets, and Claire Lagarde, whose great competence was amply demonstrated.

It will be noted in the pages devoted to "artisanal culture" that the discredited notion of "influence" has been replaced by "selective assimilation," defined as a process of "self-interested filtering." Significant clarifications concerning architecture are also made, since "construction alone is not architecture"—architecture implies the important concept of "taking the site in charge."

Chastel points to the original contributions of French art with obvious delight: the skillful organization of interior space, an almost unflagging taste for stone vaulting, and the "art of stonecutting." Castles, houses, and churches sometimes spark individual eulogies for the quality of stone or for some intricate gable, and sometimes generate more sweeping reminders that the most handsome kingdom in the West managed to produce—like Greece with its temples in the fifth and fourth centuries B.C.—a set of cathedrals unique in the world, "taking [architectural] exigencies to the limit."

Like Spain and Italy, France was was obliged to "construct its territory," which was established and enhanced as a reflection of the nation's "more gentle and more varied" nature. French artisanal aptitudes were complemented by "intellectual maturity" and epitomized by a certain *joie de vivre*, radiant delight and "an unparalleled sense of formal arrangement."

Every civilization, however, is mortal.

Paule-Marie Grand-Chastel

PUBLISHER'S FOREWORD

Like his book *Italian Art*, André Chastel's *French Art* was initially conceived as a single volume. But it soon assumed exceptional importance within his historical oeuvre. Chastel's interest in the undertaking grew even as the task became increasingly vast. Only illness prevented him from completing this project, whose very ambitiousness spurred his enthusiasm.

As it turned out, however, the thousand or so pages of manuscript gave birth to several volumes, the first of which is now appearing in English under the subtitle *Prehistory to the Middle Ages*. The work was to have been preceded by a long introduction that Chastel left uncompleted at his death in 1990; its various sections, organized according to the precise plan he set out, have been published separately in France in a paperback edition. The publishers decided that it would also be useful to append relevant fragments from this unfinished introduction to each of the volumes of *French Art*.

Following Chastel's death, the editing of the text and the production of this volume would have been impossible without the unstinting help of Mme André Chastel and all those from whom the author himself sought advice, assistance, or criticism, notably Paul-Marie Duval, Michel Laclotte, Marie-Geneviève de La Coste-Messelière, Anne-Marie Lecoq, Pierre Rosenberg, Francis Salet, Antoine Schnapper and, for this first volume in particular, Eliane Vergnolle. They all deserve grateful acknowledgment.

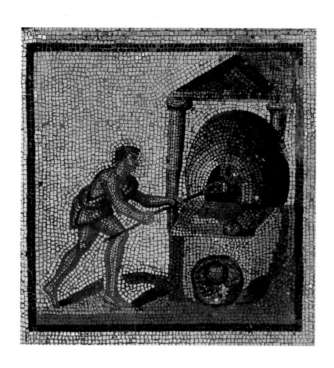

PART I

ORIGINS

PREHISTORY

CELTS AND GALLO-ROMANS

MEROVINGIANS

CAROLINGIANS

A TROUBLED CENTURY

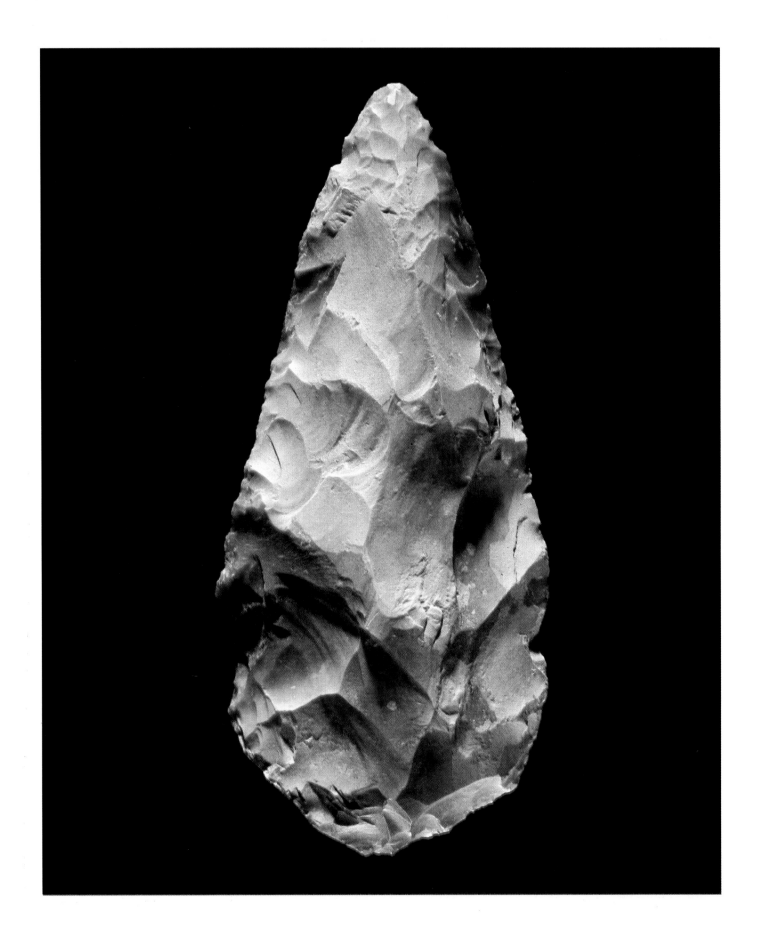

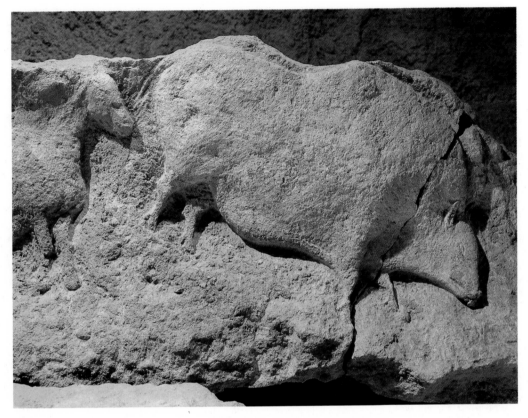

Carving of wild boar and sheep (detail) from Roc-de-Sers (Charente).
Solutrean (c. 20,000–16,000 B.C). Musée des Antiquités Nationales, Saint-Germain-en-Laye.

Left: flint spearhead from La Gravière du Buissonnet (Oise).
Lower Paleolithic (c. 100,000 B.C.). 21 × 9.3 cm. Musée de l'Homme, Paris.

Prehistory: Time-Hallowed Sites

The Universal Exposition held in Paris in 1867 featured a large selection of "prehistoric art." The number of sites yielding hand-fashioned objects and vestiges of all sorts made it apparent that France—or rather the group of highly varied and overlapping regions that make up France today—played a major, indeed privileged, role in terms of the first manifestations of the human race.

The speculative volume published in 1847 by Boucher de Crèvecoeur de Perthes (1788–1868), titled *Antiquités Celtiques et Antédiluviennes*, no longer provoked laughter but still shocked people somewhat, insofar as it proposed an original interpretation of human history (and therefore of Genesis). A new breed of scholar was beginning to coordinate the various, scattered items that strollers had always come across in the provincial countryside, namely all the sharpened and carved bones, the hewn and incised stones that had no explanation or date. Scholars were obliged to abandon two key assumptions that had prevailed up till then—that the mysterious Celts could be credited with everything (following a fashion imported from England in the late seventeenth century) and, naturally, that the Flood recounted in Holy Scripture marked the end of a first race of humans.

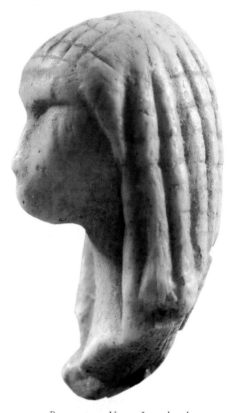

Brassempouy Venus. Ivory head
from La Grotte du Pape, Brassempouy (Landes).
Aurignacian–Perigordian, c. 23,000 B.C.
Height: 3.5 cm. Musée des Antiquités Nationales, Saint-
Germain-en-Laye.

Feline form carved in reindeer antler from Isturiz (Basses-Pyrénées). Magdalenian
(c. 15,000–8,000 B.C.). Musée des Antiquités Nationales, Saint-Germain-en-Laye.

Right: Harpoons, awls, and needle from La Madeleine (Dordogne). Magdalenian (c. 15,000–8,000 B.C.).
Musée des Antiquités Nationales, Saint-Germain-en-Laye.

The idea of an evolution common to all species suggested that human history stretched back to outlandishly remote periods of terrestrial geology.

In 1884, Edouard Lartet and Henry Christy published an article based solely on French findings, describing carved and engraved animal figurines "and other products of art and industry attributable to the primordial period of human history."[1] A crucial and increasingly obvious fact was emerging: there existed an order of concrete realities exterior and anterior to civilization's written tradition, a specific domain that involved objects made by *homo artifex.* These objects offered a glimpse of original and fascinating skills, thanks to an elementary and determining confrontation with form.

As Boucher de Perthes boldly and discerningly asked, "Does not this rough axe prove the existence of a human being as surely as Phidias's *Minerva* or Praxiteles's *Venus* ?" The axe raised a hundred other questions—simply saying it was beautiful was not enough, because it was also once a functional tool. Everything suddenly seemed more complicated than expected. During the enormous lapse of time called the Upper Paleolithic era (35,000–10,000 B.C.), preliterate humans left many concrete traces of their know-how and ideas, to the extent that today they are no longer total strangers to modern experts.

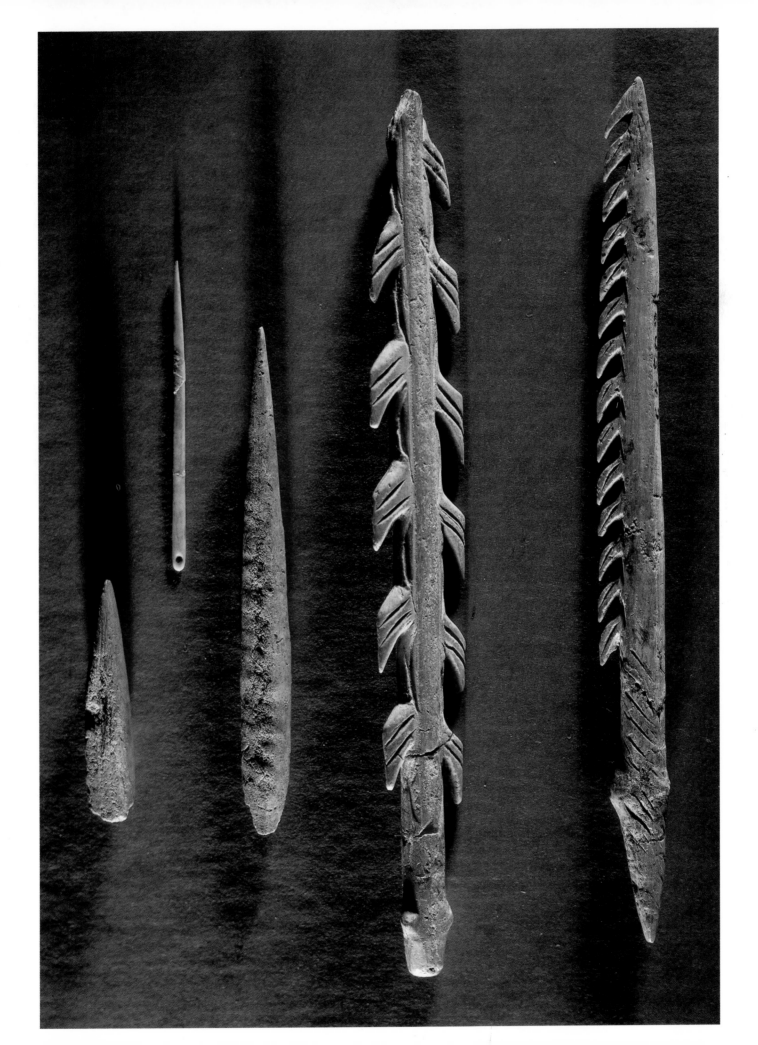

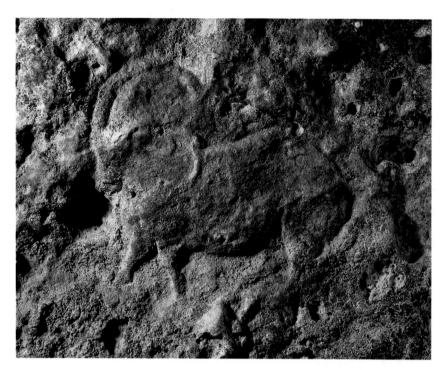

Carving of an ibex on the ceiling of the Pataud cave,
Les Eyzies-de-Tayac (Dordogne). Solutrean (c. 20,000–16,000 B.C.).

Reconstruction of the hearth at Pincevent (Seine-et-Marne).
Magdalenian (c. 15,000–8,000 B.C.).
Musée des Antiquités Nationales, Saint-Germain-en-Laye.

In the past century, "prehistoric" scholars have gathered and classified countless data, erecting a sufficiently coherent chronological framework based on observations made in France (corroborated and extended by a wealth of discoveries in other parts of Europe, Africa, and Asia). Thanks to the stratigraphic and statistical analysis of sites, these mute witnesses have supplied information precise and eloquent enough to offer a reasonable picture of the situation pertaining to the lands that would later become Gaul and France.

The question had long been discussed. Ancient texts by Pliny and tales by travelers (like the sixteenth-century monk André Thevet) abounded with references to huge bones, indeed entire skeletons. Relying on the Bible, people interpreted these finds as vestiges of antediluvian species. Curio cabinets and even churches were full of such objects. In the seventeenth and eighteenth centuries, many academic debates centered on the validity of such data (there were resounding hoaxes, such as "the giant Theutobochus, King of the Teutons" in 1619). Louis Jaucourt's article on giants in Diderot's 1757 *Encylopédie* represented a crucial if not decisive step forward for the discovery of fossils, and the work of Georges Cuvier fueled the issue of "the origins" of these mysterious prehistoric remains right into the mid–nineteenth century.[2]

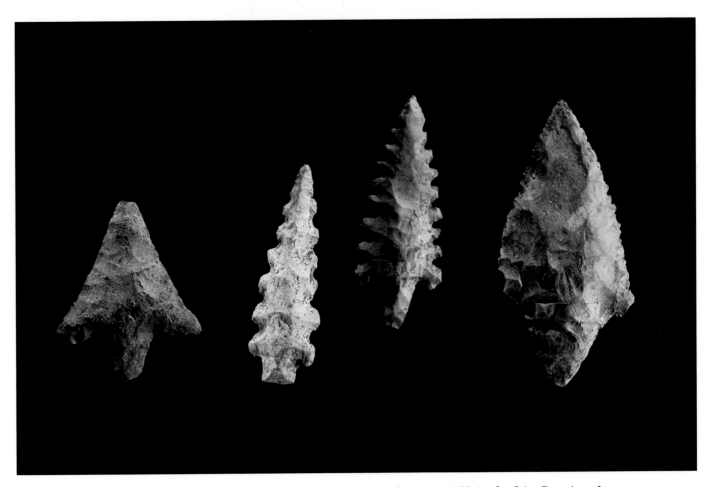

Flint and stone arrowheads. Neolithic (c. 6,000–2,500 B.C.). Musée des Antiquités Nationales, Saint-Germain-en-Laye.

A CERTAIN CONTINUITY OF PLACE

What, exactly, did Boucher de Perthes discern?

Observing traces of human activity such as sharpened stones and carved bones among the remains of animals belonging to extinct species, he was obliged to admit that the traces were far older than any known chronology. The growing number of finds in France and Great Britain began constituting an enormous and somewhat repetitive collection of sharpened stones and bones, located along a large northern arc that stretched from England to the Seine and Meuse regions of France, comprising settlements characterized by their tools. A major modern scholar, André Leroi-Gourhan, has undertaken digs at sites like Pincevent where the ancientness of human habitation is clearly indicated by its material, and at Arcy-sur-Cure, near places occupied through subsequent ages (such as the artfully planned first-century B.C. sanctuary and baths of Fontaine-Salées, the agricultural villages abandoned during tenth-century invasions and, in the heart of this area, the "sacred hill" of Vézelay). At the same time, the methodical exploration of sites south of the Loire and in Spain revealed the existence of a so-called Franco-Cantabrian zone, in which a wealth of artifacts was accompanied by cave paintings of immense interest. The authenticity of these images of deer and oxen was accepted only gradually, and it was a long time

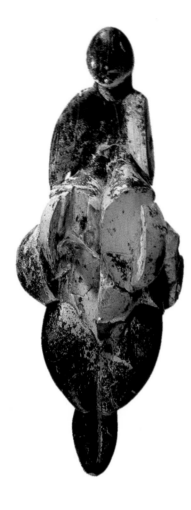

Lespugue Venus.
Statuette sculpted
from a fragment of mammoth tusk
from Lespugue (Haute-Garonne).
Upper Paleolithic (c. 25,000–18,000 B.C.).
Height: 14.7 cm.
Musée de l'Homme, Paris.

before a potential date was attributed (25,000 B.C. at the earliest, 15,000–12,000 B.C. at the latest). The chance discovery in 1940 of a cave at Lascaux (pp. 17–18) in the Dordogne region contributed spectacular parts to a picture that was slowly becoming clearer thanks to the establishment of distinct, structured episodes within what had been the great void of prehistory.

The standard periods within the Upper Paleolithic were named after sites explored in France: Aurignac ("Aurignacian," from 30,000 to 25,000 B.C.), Solutré ("Solutrean," 20,000 to approximately 16,000 B.C.), and La Madeleine ("Magdalenian," covering a period from roughly 15,000–12,000 B.C. to 10,000–8,000 B.C.). Of the four hundred known Magdalenian sites, over three hundred are found in southwestern France, closely linked to Cantabrian Spain. Such striking statistics indicate that the region was frequently and actively inhabited, though little more than that can be said.

A mild climate obviously had much to do with this, as did a harmonious system of rivers. Traffic always being easier along these generally convenient valleys and waterways, it is not surprising to discover that during the millennia following the glacial periods of the Quaternary era, there are numerous sites where the presence of *Homo sapiens* is marked by the characteristic skeleton of Cro-Magnon man (named after the Cro-Magnon cave near

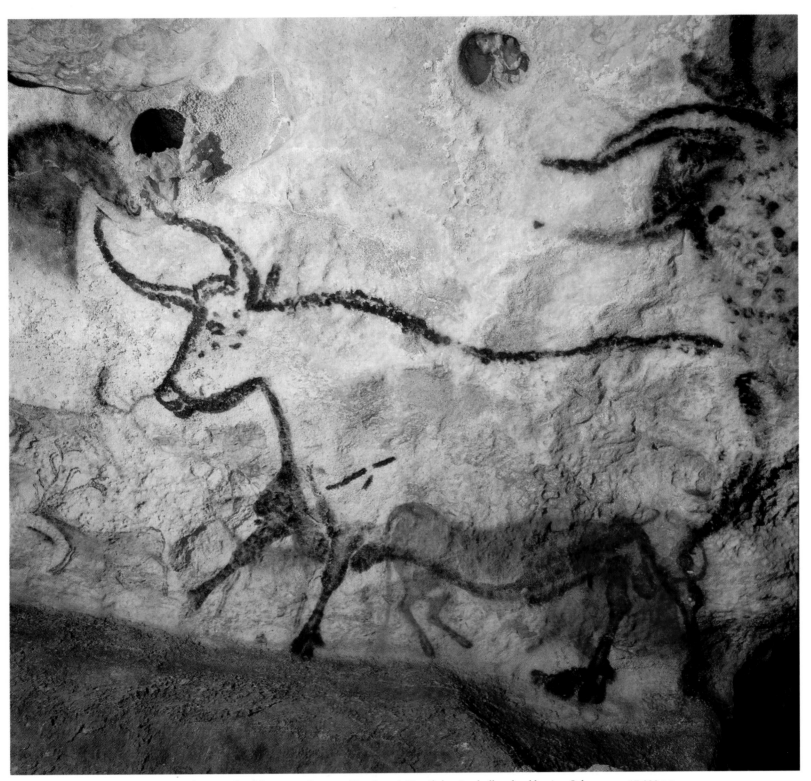

Paintings in the rotunda of the cave at Lascaux (Dordogne). Detail showing bull and red bovine. Solutrean, c. 17,000 B.C.

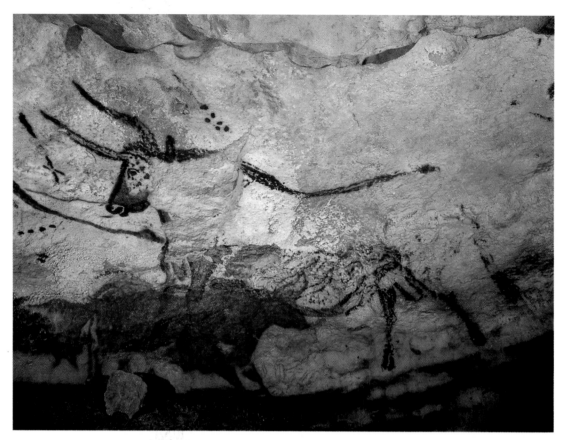

Lascaux (Dordogne), rotunda. Detail showing bull and a red cow followed by her calf.
Solutrean, c. 17,000 B.C.

Les Eyzies in the Dordogne), as well as by tools, surprisingly complete series of which have now been assembled. Furthermore, there are images of animals and human figures engraved or sculpted on soapstone and ivory, often of outstanding artistic quality, like the *Lespugue Venus* (p. 16). And, of course, there are the wonderful animal paintings that reached a pinnacle during the Middle Magdalenian period (Leroi-Gourhan's "Style IV," 14,000–12,000 B.C.).

Major changes in climate, including the advance of glaciers around 10,000 B.C., led to changes in the animal population, to human migration, and to the extinction of entire groups. But in addition to sites formed by centuries of habitation, these strangers left behind a mass of tools, weapons, and decorated artifacts of amazing quality. But we are not the first or only people to unearth such objects. Periodically, the chance discovery of a cave or the finding of a fine tool in previous times would spur people to forge, as best they could, an idea of "the mystery of human origins." Unusual finds fueled superstition and legends. So many prehistoric sites were used by the Celts or by medieval society that topographic continuity was established. Sometimes the awareness of something else even emerged—in 1575, François de Belleforest's *Cosmographie Universelle* reported "great marvels" found in a vale near Miramont, consisting of "fine halls and chambers . . . several altars and paintings" in a

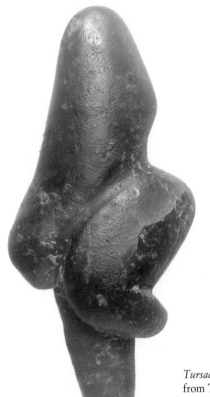

Bison carved in reindeer antler, from the cave of La Madeleine (Dordogne).
Magdalenian, c. 13,000 B.C. Length: 8.8 cm.
Musée des Antiquités Nationales, Saint-Germain-en-Laye.

Tursac Venus. Fragment of statuette
from Tursac (Dordogne). Translucent calcite.
Aurignacian–Perigordian, c. 23,000 B.C. Height: 7.15 cm.
Musée des Antiquités Nationales, Saint-Germain-en-Laye.

subterranean spot "where our idolatrous fathers of yore went to sacrifice either to Venus or to infernal gods" (Vol. I, col. 198.9). There are good reasons for thinking that Belleforest was referring to a cave at Rouffignac in the Dordogne, featuring long branch galleries where, since 1956, increasingly large crowds of visitors have gone "to see prehistoric art." Yet the cave has always been visited as a fascinating site. It should be added that close examination of Paleolithic art, with its hundreds of images now classified into groups and precise classes of animals that are never positioned arbitrarily, suggests that the visibly overlapping images are not just random—rather, it is a question of decoding veritable "mythograms."[3]

THE AGE OF MEGALITHS
"This land, in the forefront of the history of civilization during the Paleolithic Age, lost its leading role in the Neolithic."[4] It was no longer a center of expansion, but a territory to be traversed, a space unevenly occupied, difficult to characterize. Toward the fourth millennium B.C., what Gordon Childe called the "Neolithic revolution"[5] transformed methods of production and social organization, as well as rites and apparel. Everything changed at that stage, and humanity as we know it got under way. The transformation, although varying with

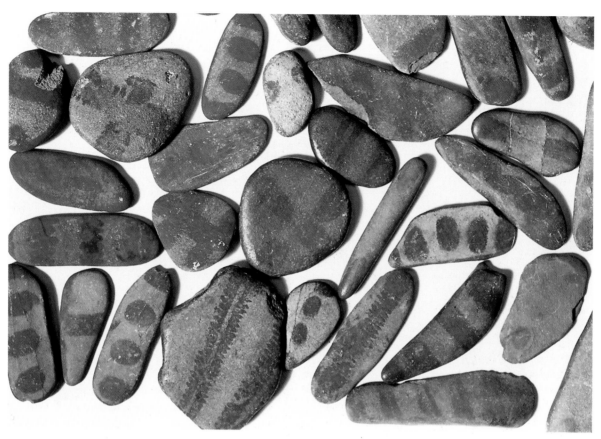

Painted stones from Mas d'Azil (Ariège). c. 9,000 B.C. Musée des Antiquités Nationales, Saint-Germain-en-Laye.

region and moving in diverse directions, entailed the introduction of agriculture, livestock, and pottery. It took place in Provence (the Mediterranean trend), in the east (the Danube trend, with original developments in Peu-Richard in the Charente area during the third and second millennia B.C.), in Brittany with its vertical megaliths or "menhirs," and in the south.

More than fourteen hundred dolmens (megalithic structures with capstones) have been counted in these regions, with perhaps four thousand found throughout all of France. The phenomenon is worth stressing. Erecting these huge blocks required labor and planning that supposes a populous and hierarchical society—hundreds, perhaps thousands, of men were needed to prepare ditches and move megaliths. Such monuments imply a notion of preferential "public works," and they always have been viewed with astonishment. Even after the anonymous tribes vanished, certain funeral practices intimately linked to social structure survived (as happened at the same time with Egypt's magnificent dynasties, such as Tutankhamen's). These tombs—small buried buildings filled with treasure—have provided European countries with a major archaeological resource.

Brittany, with its original variant of stone monuments solidly planted in the countryside, was no remote hinterland at that time. It was one of the centers of a civilization spanning the British Isles and the Atlantic coast.

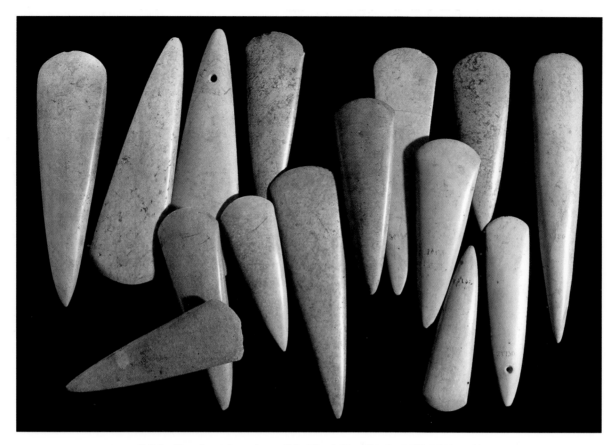

Polished hand axes from Arzon (Morbihan). Neolithic (c. 6,000–2,500 B.C.).
Musée des Antiquités Nationales, Saint-Germain-en-Laye.

The era of megaliths lasted, according to estimates based on carbon-14 dating techniques, from the fifth to the second millennia B.C., with special periods marked by contact with Britain and Spain—the surprising megalithic alignments at Carnac and the famous dolmen at Gavrinis are part of a family of monuments labeled "Druid," found all across the region. The number and location of such sites point to the existence, by the early third millennium B.C., of powerful building techniques linked to worship of the dead. These enormous and unexplained vestiges were long contemplated by peasant farmers and shepherds. They were thought to be signals or symbols that, whatever the case, lent prestige to the site. On the plateau where Le Mans Cathedral was built, there was once a dolmen (which disappeared in 1778) and a menhir "with the ochre and yellow colors of sandstone."[6] The menhir was built into the wall of the cathedral by late eleventh-century builders. It is no coincidence that local fables, like that of Melusina told in the Poitou region, provided a marvelous explanation for the "planted stones" that seemed to have fallen from the sky. Architecture began with these monoliths.

Perhaps, at certain times, they served as inspiration. The "monuments" could be compared to the graveyard lanterns that were "infinitely more numerous in the Limoges, Poitou, and Saintonge regions than elsewhere. . . . Almost all of them date from the eleventh and twelfth centuries."[7] Such lanterns, placed at the edge of a Christian

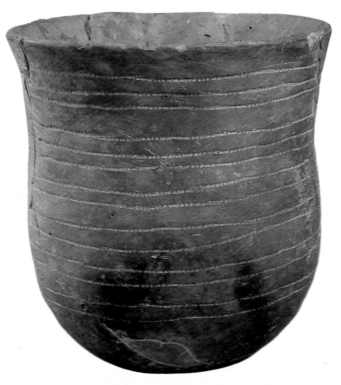

Terra-cotta bowl decorated with carved horizontal bands.
Neolithic (c. 6,000–2,500 B.C.).
Musée des Antiquités Nationales, Saint-Germain-en-Laye.

Terra-cotta bowl with carved decoration,
from Grand-Pressigny (Indre-et-Loire). Neolithic.
Musée des Antiquités Nationales, Saint-Germain-en-Laye.

necropolis in respect of forgotten rites, were not cemetery crosses; instead, they were cylinders, or a cluster of columns, such as the magnificent examples at Fenioux bearing a light "in homage to the faithful laid to rest in this consecrated ground." Folklore attributes these strange structures to the worship of the dead in the remote past, indeed to the Druids. Although these intriguing features may be after all the result of amazing coincidence, they are accompanied by a fact as impossible to ignore as it is difficult to pinpoint chronologically: every one of the decorative motifs found on upright stones, tools, and other objects has remained in subsequent repertoires (spirals, rosettes, rings, knotwork, "solar" crosses, etc.).

In a land covered with vast forests punctuated by valleys of generally easy access, a great number of sites or focal points were defined (and, to a certain extent, socialized) by the habits and habitat of the human groups that settled there more or less durably. Without wanting to exaggerate the significance of the amazing Commarque castle in the Dordogne, whose ruins sit above a Neolithic cave, many fortresses or strongholds were built on ancient sites that archaeological excavations have dated back thousands of years, for instance in Burgundy and the Loire Valley. Many nineteenth-century finds were guided by local oral traditions, by folklore, indeed by place-names. There have always been obscure legends, superstitions, and fantastic tales concerning

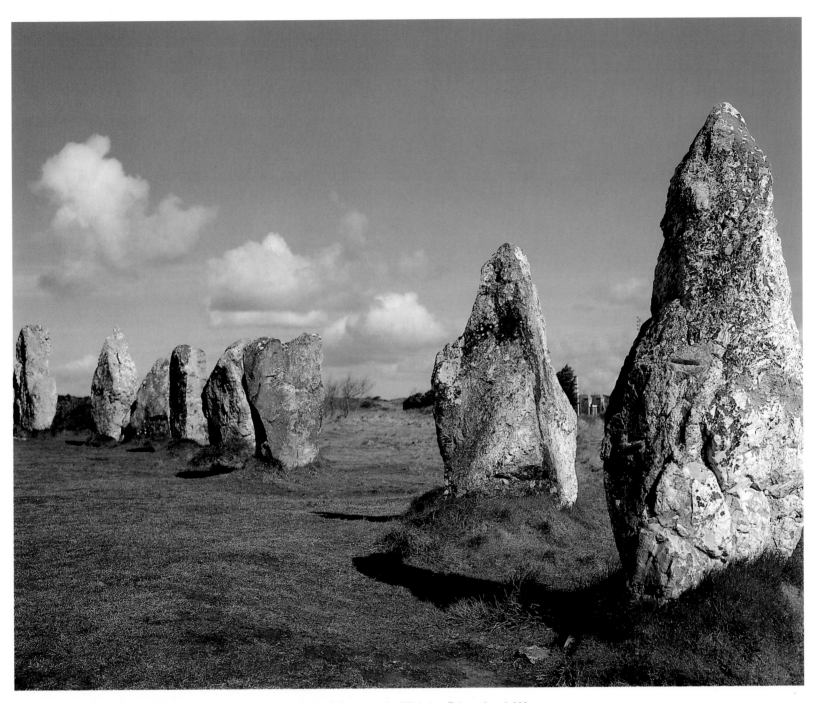

Row of megaliths. Lagat-Jar (Finistère, Brittany). c. 3,000 B.C.

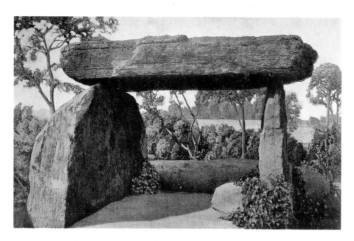

Dolmen in a public garden in Saint-Nazaire (Loire-Atlantique).
After an engraving by Gillot.
Bibliothèque des Arts Décoratifs, Paris.

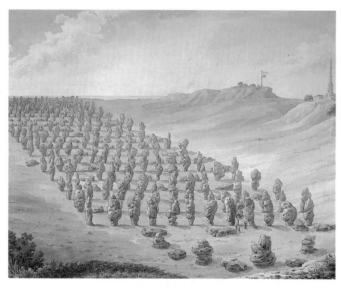

F. Debret. *Surveying and Measuring the Rows of Neolithic
Megaliths at Carnac* (Morbihan). India ink and wash,
nineteenth century. 30 × 38 cm.
Bibliothèque des Arts Décoratifs, Paris.

Megaliths forming a covered passageway.
La Roche-aux-Fées (Ille-et-Vilaine, Brittany).

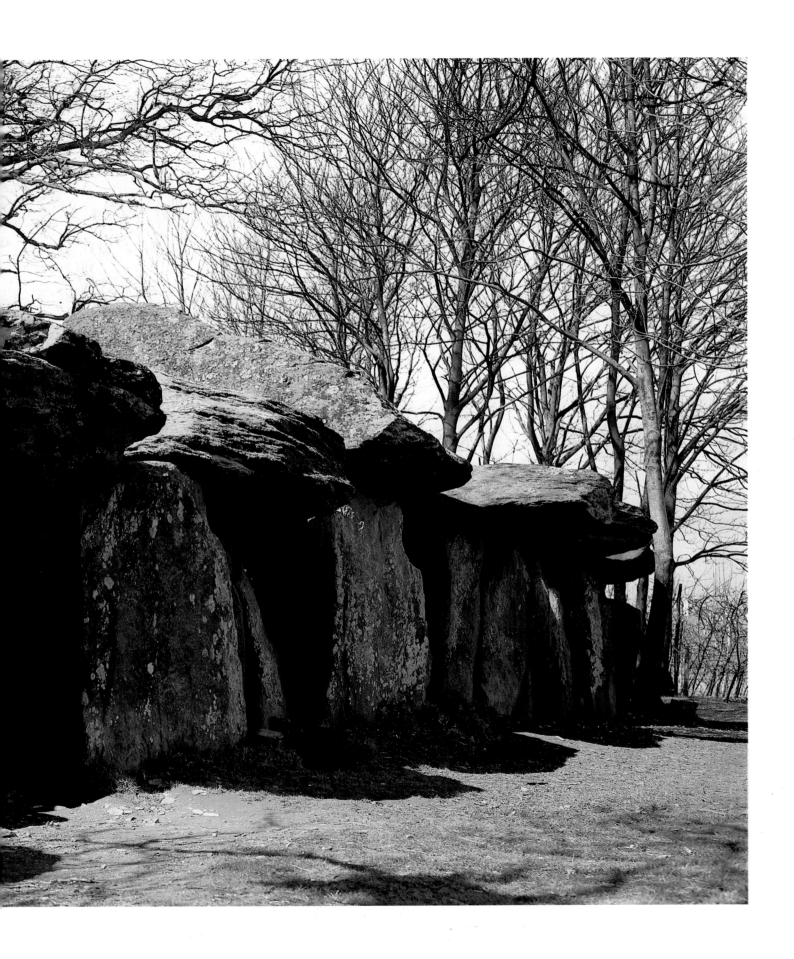

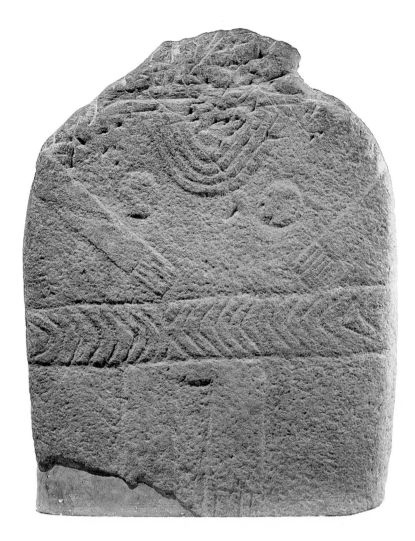

Inscribed sandstone menhir
from Mas d'Azaïs (Aveyron).
Second half of the third millennium.
Musée des Antiquités Nationales,
Saint-Germain-en-Laye.

Right:
Inscribed sandstone menhir
from Serre-Grand (Aveyron).
Second half of the third millennium.
Musée des Antiquités Nationales,
Saint-Germain-en-Laye.

the cliffs, peaks, and caves that ultimately produced revealing archaeological sites. In nineteenth-century Brittany, polished hand axes were apparently worn like amulets and called "thunder stones."[8] But this practice is not only true in Brittany—many things survive in the subconscious region of human societies, only to emerge as folklore.

Another factor is the continuity of habitation, as verified by deep archaeological excavations in the oldest "time-hallowed" places in France. Stratigraphic analysis reveals the permanence of a great number of sites. It is almost as though the country's "nerve centers" were established in the Neolithic age. Abundantly populated and a crossroads of human development, France would seem to have anticipated its lasting configurations right from the darkest ages.

Curiosity about such matters is not new. The comte de Caylus, in the fourth volume of his anthology of Egyptian, Etruscan, Greek, Roman, and Gallic antiquities (1794), noted with interest the dolmen at Avrillé in Poitou and the covered alley of La Roche-aux-Fées in Brittany (pp. 24–25). The marquis de Girardin built a garden folly in the form of a dolmen at his park in Ermenonville (near the Temple of Philosophy so dear to Jean-Jacques Rousseau), in homage to a tradition distinct from classical antiquity. Girardin observed that "for a long time men have been in the habit of attributing to Giants, Fairies, and Divinities, in short to supernatural beings, works that seem to be beyond their own power."[9]

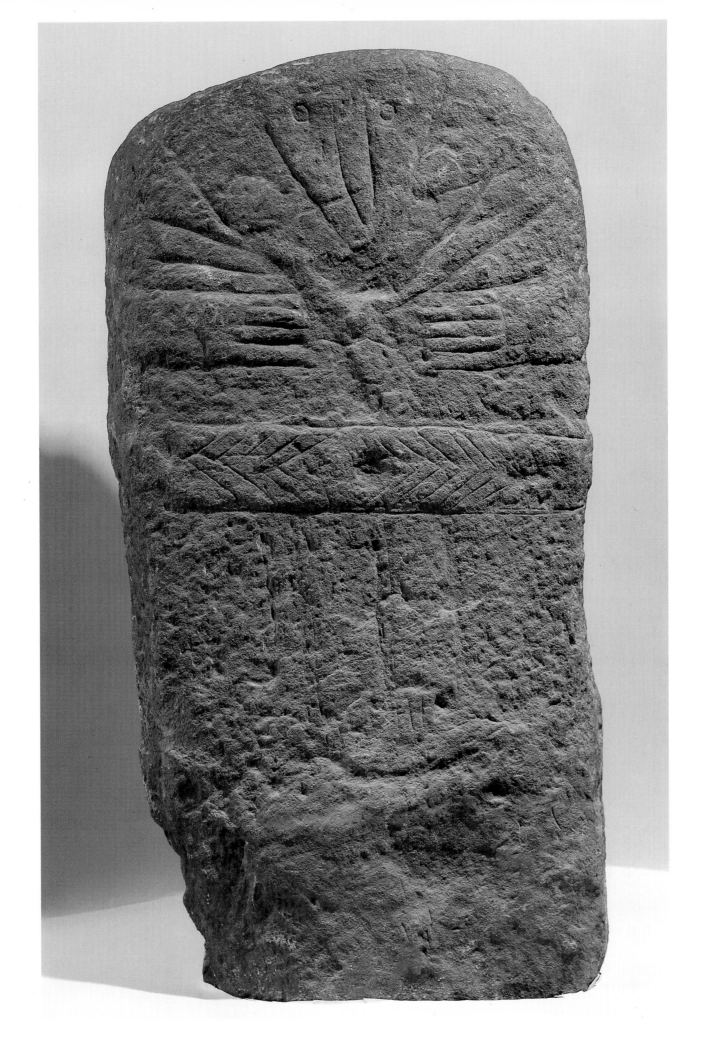

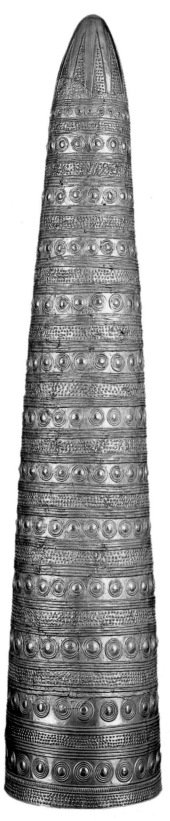

Golden cone from Avanton (Vienne).
1,500–1,250 B.C. Height: 53 cm.
Musée des Antiquités Nationales,
Saint-Germain-en-Laye.

I CELTS AND GALLO-ROMANS
MASTER ARTISANS

The founding of the Musée des Antiquités Nationales at the château of Saint-Germain-en-Laye in 1869 marked an advance in the state of historical knowledge. The origins of France itself were now the focus of study, based on a knowledge of objects, weapons, and tools that were distinct from prehistoric items. This entailed regrouping and interpreting objects, whether indigenous or not, and it helped to identify the role of the Celts, forerunners of the Gauls.

Certain details about the Bronze Age are known thanks to weapons and pottery. Rivers were still the main highways, but there also must have been many roads, judging by the scope of exchange and therefore by the extent of traffic during millennia too often considered impoverished. Starting around 750 B.C., central Europe was the source of new population movements, as indicated by the Hallstatt site in Austria. This represented the early Iron Age, whose most remarkable feature was without doubt "chariot tombs." These mounds enclosed sepulchral chambers containing not only a princely chariot but also jewels and costly garments, often of great beauty. Approximately fifteen such tombs, similar to the ones found in central Europe, have been discovered in eastern France. But these ties to societies in Switzerland and the Rhine region did not preclude special imports from elsewhere. A tomb at Vix in Burgundy yielded a two hundred-kilogram *krater* for mixing wine (p. 29) that is purely Mediterranean in technique and was produced by Greek workshops in southern Italy around the sixth century B.C. Thus two civilizations would henceforth continually encounter one another, in an oscillating fashion, in the region between the Alps and the Atlantic.

INVENTING FORMS
The presence of Celts in France can be clearly discerned starting around the middle of the fifth century B.C. They belonged to the barbarian world that the classical Greeks, then at the height of their civilization, viewed with astonishment. These people living to the west of the Rhine helped forge a decorative art that stretched from the Russian steppes to insular Britain, characterized by elegant, ornamental, and carefully executed animal motifs. The Celts could be located along an arc of a circle with its center at the Danube (where Herodotus noted their

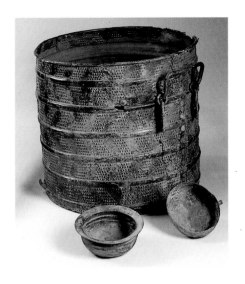

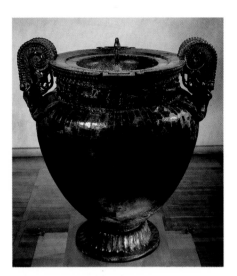

Left:
Bronze cist (height: 32 cm) and bowls from the burial mound at Magny Lambert (Côte d'Or). Late seventh–early sixth centuries B.C. Musée des Antiquités Nationales, Saint-Germain-en-Laye.

Right:
Bronze *krater* from the burial mound at Vix (Côte d'Or). Grecian, sixth century B.C. Height: 164 cm. Musée des Antiquités Nationales, Saint-Germain-en-Laye.

Below:
Reconstruction of the chariot tomb from Gorge-Meillet, Somme-Tourbe (Marne). c. 450–300 B.C. Musée des Antiquités Nationales, Saint-Germain-en-Laye.

presence). The remarkable find at La Tène, near Lake Neuchâtel in Switzerland—a hoard of weapons and fibulae (garment clasps)—provides an idea of what was happening in Gaul.

Unlike Germanic peoples, the Celts in Gaul occasionally built strongholds (stone or wood stockades), probably in imitation of the Greek colonies in the western Mediterranean, as witnessed by the nineteenth-century excavation of an *oppidum* (fortress) at Bibracte near Autun. The sites of future French cities were already inhabited, such as Bourges (Avaricum), Orléans (Genabum), and Le Mans (Vindinum, the capital of the Aulerci tribe). The southern Tectosages tribe was headquartered at Rodez (Segodunum). Powerful clans equipped themselves with glamorous tools and objects, often acquired through exchange or pillaging of southern cities, or commissioned from well-known workshops. Although *oppida* existed, there were no grand buildings, in contrast to the preceding age. Dwellings were often drystone huts (like those at Ensérune) or, more commonly, wooden cabins. Urbanization did not arrive until the first century A.D., along with the Romans. Celtic crafts nevertheless transmitted an attractive reper-

toire throughout the Western world, which would not be swiftly forgotten by artisans. Noteworthy examples display virtuoso filigree work, such as the torque (neck ornament) found at Fenouillet, and elaborate tracery like the swirls on a gold and bronze helmet found at Amfreville (Musée des Antiquités Nationales, Saint-Germain-en-Laye).

Possible links to Greek and Etruscan models do not preclude the identification of certain Celtic decorative traits. First comes scroll-like foliage, the curvilinear form par excellence. It was used on openwork pieces for chariots, like a bronze piece found at La Bouvandeau (fourth century B.C., Musée des Antiquités Nationales) and on scabbards, numerous examples of which exist. Careful study of the hundreds of interesting items now assembled suggests certain revealing patterns. "Open torques, then bracelets of the

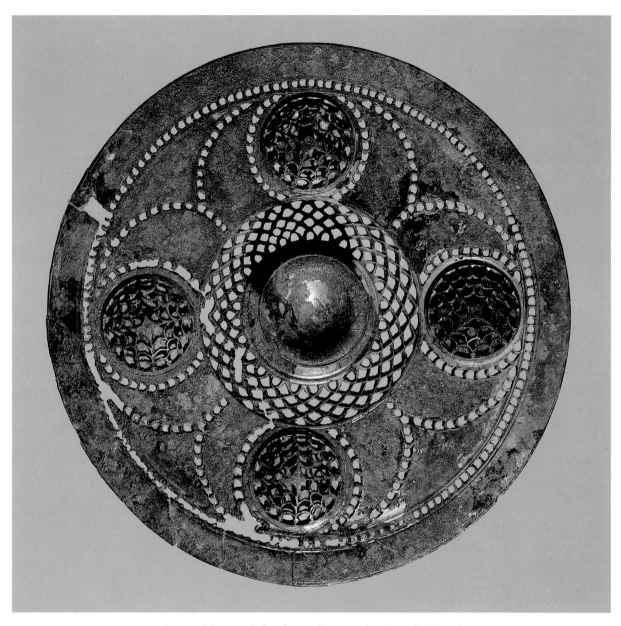

Openwork bronze phalera from a chariot tomb at Cuperly (Marne).
450–300 B.C. Diameter: 11 cm. Musée des Antiquités Nationales, Saint-Germain-en-Laye.

same type with triple decoration, [featured] masks and face-palmettes, spirals, S-shapes, loops, and palmettes." Only rarely, however, "at least in the central and western regions," was there the knotwork so favored by other cultures—Celtic art "owes some of its elegance to this rejection."[10]

The amazing combinations that resulted from this fusion of hard-won forms yielded a carving technique worth stressing, because it would long remain—insofar as continuity can be postulated—a highly intriguing approach: a play of solids and voids that permitted the mixing of two or more motifs with a view to combining several facets or "readings." A pelta (small shield) contained a mask, for instance, or a form folded back on itself could contain (yet not contain) the profile of an animal. Especially in Gaul, this trend found its finest expression in the art of minting coins during the second and first centuries B.C., inspired by Greek coins such as Philip of Macedonia's gold stater. Gallic goldsmiths and designers had enormous fun—it is hard to use any other term—playing with the visual metamorphosis of numismatic imagery.

A Macedonian model, brought back by some mercenary or merchant, bears

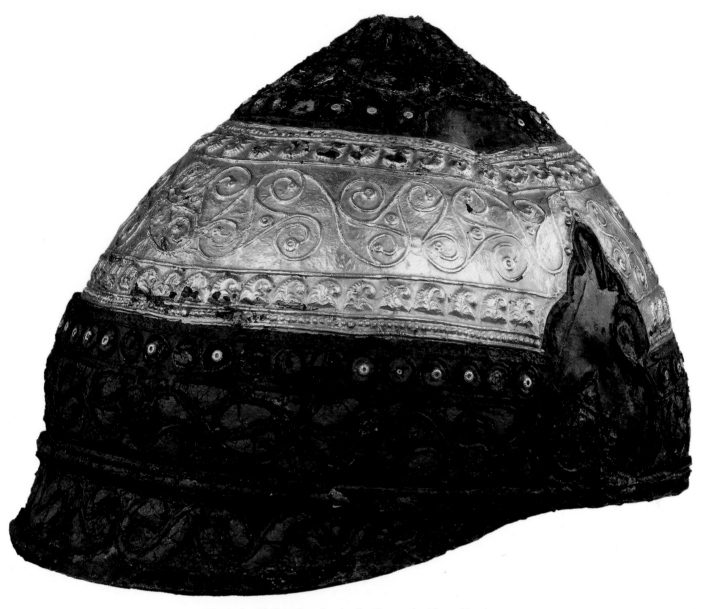

Ceremonial helmet found at Amfreville-sous-les-Monts (Eure).
275–225 B.C. Bronze, iron, gold and enamel. Height: 17.5 cm. Musée des Antiquités Nationales, Saint-Germain-en-Laye.

Apollo's head on the obverse, with a biga (two-horse chariot) on the reverse. The former soon became a sketchy profile, the latter a wheel and an attenuated being with a human head. No other aesthetic transformation has been so complete, inventive, and dazzling in its results: the Parisii minted a coin with a sort of curled dragon whose point of departure is no longer apparent, while the Osimii dis-

sected some goddess's profile to arrive at a coin with a decorative arrangement of lines and dots. Never since has there been such an unself-conscious demonstration of freedom on the part of goldsmiths. Because these coins were made of gold, the governing authorities must have sanctioned this display of artistic originality and independence from Mediterranean monetary models.

The clear aesthetic preferences exhibited by Celtic objects have led to the establishment of a sort of repertoire or "grammar" of decorative motifs, all the more remarkable for the fact that the Celts had no writing. The classification of formal combinations, somewhat similar to what has been done with Romanesque stylistics, inevitably links the delight generated by these abstract variations to two

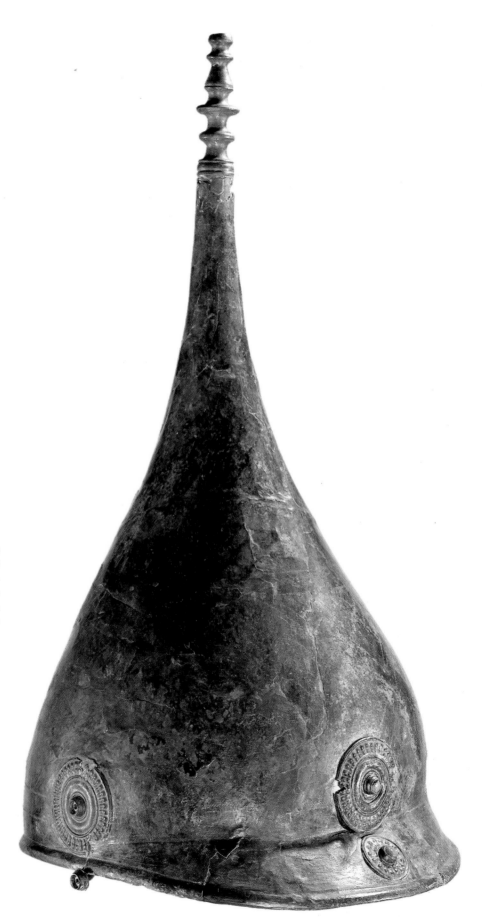

Bronze helmet
from the chariot tomb
at Gorge-Meillet (Marne).
450–300 B.C. Height: 37.7 cm.
Musée des Antiquités Nationales,
Saint-Germain-en-Laye.

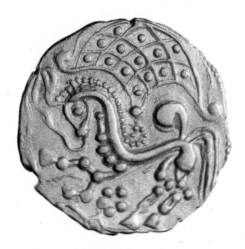

Gold coin of the Parisii (reverse).
Provenance unknown. 150–100 B.C. Diameter:
2 cm. Cabinet des Medailles, Bibliothèque
Nationale, Paris.

considerations. The first concerns the origins—the historical starting point, the place of invention or propagation. This question involves following a trail through time and space in the direction of the steppes and "protohistoric spaces" (to use an expression combining time and space). Ultimately, it produces a long chain of "formal" consistency and reality for societies—perhaps entire civilizations—about which almost nothing else is known. This is similar to the hypothesis of a proto–Indo–European language that explains shared linguistic structures and analogous notions across distant societies whose mutual contacts and derivations remain unclear.

The second consideration, spurred by the first, springs from a desire to understand why such configurations emerged. In the absence of explanatory texts, historians are obliged to behave like ethnologists and to reconstruct or infer "rites and customs" that may in turn, if confirmed by archaeological and material data, provide explanations for the formal choices made by these peoples. Just as the existence of writing immediately points to civilized man, so the *opus artisticum* indicates *homo faber* (and therefore attention to form).

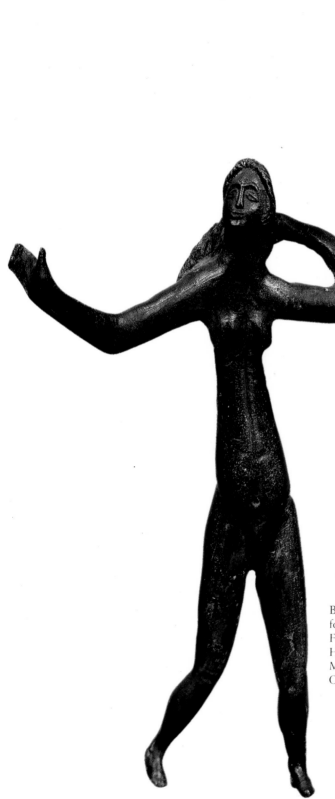

Bronze statuette of a woman,
found at Neuvy-en-Sullias (Loiret).
First century A.D.
Height: 14 cm.
Musée Historique de l'Orléanais,
Orléans.

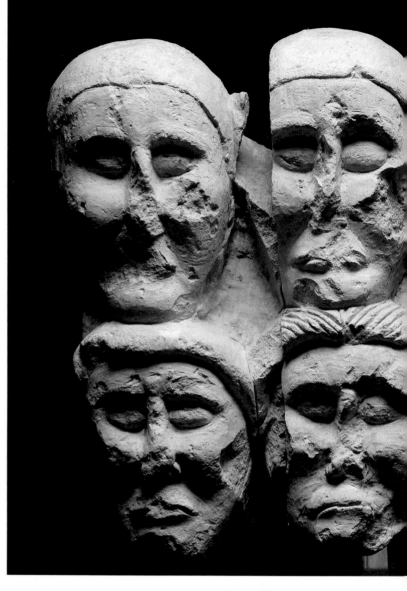

Group of five heads
from the sanctuary at Entremont
(Bouches-du-Rhône). Limestone.
Second century B.C. 43 × 52 cm.
Musée Granet, Aix-en-Provence.

Right:
Sculpted heads,
known as the *Two-Headed Hermes*,
from the sanctuary at Roquepertuse
(Bouches-du-Rhône). Limestone.
Third–second centuries B.C.
19.5 cm × 29 cm. Musée
d'Archéologie Méditerranéenne,
Centre de la Vieille Charité, Marseille.

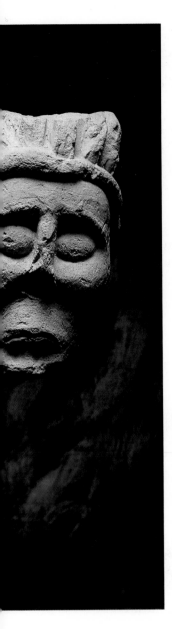

The little carved and enameled arrangement of an earring may thus testify to an initiative taken centuries earlier. In somewhat the same fashion, folk tales and oral literature, without the benefit of writing, sometimes give the impression of conveying vestiges of remote, archaic situations as crucial as they are undecipherable.

Sculpture apparently made a far less noteworthy contribution. It is nevertheless worth singling out the statuary found at Entremont (left and p. 36), which predated the arrival of the Romans in 120 B.C. and is notable for the strange heads with hand on top (Musée Granet, Aix-en-Provence). Also worth noting are the sculptures from the Celto-Ligurian *oppidum* of Roquepertuse (below) where heads were exposed on the pillars of a little portico (Musée d'Archéologie Méditerranéenne, Marseille). These sculptures, linked to some cruel, protohistoric rite, are hard to connect with the rest of Celtic art, like the strange limestone warriors wearing enormous helmets, found in the Gard region (Musée de Nîmes). The function of such statues is unknown. The pillar-man of Euffigneix (p. 49) bearing an engraved boar on his torso and a giant eye on his side interestingly suggests a magic emblem, as do the long wooden pillars that served as ex-votos in a sanctuary erected at the source of the Seine (Musée

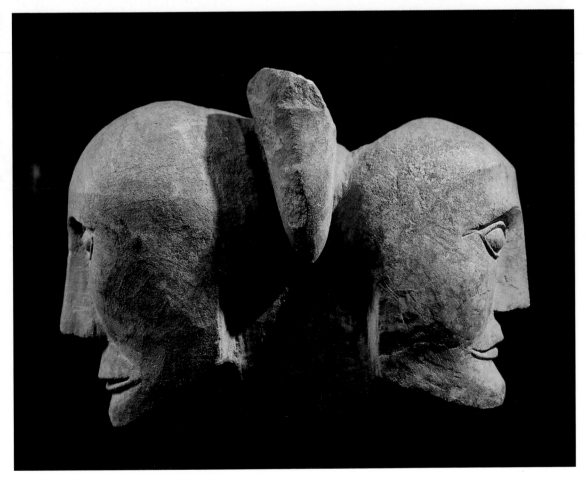

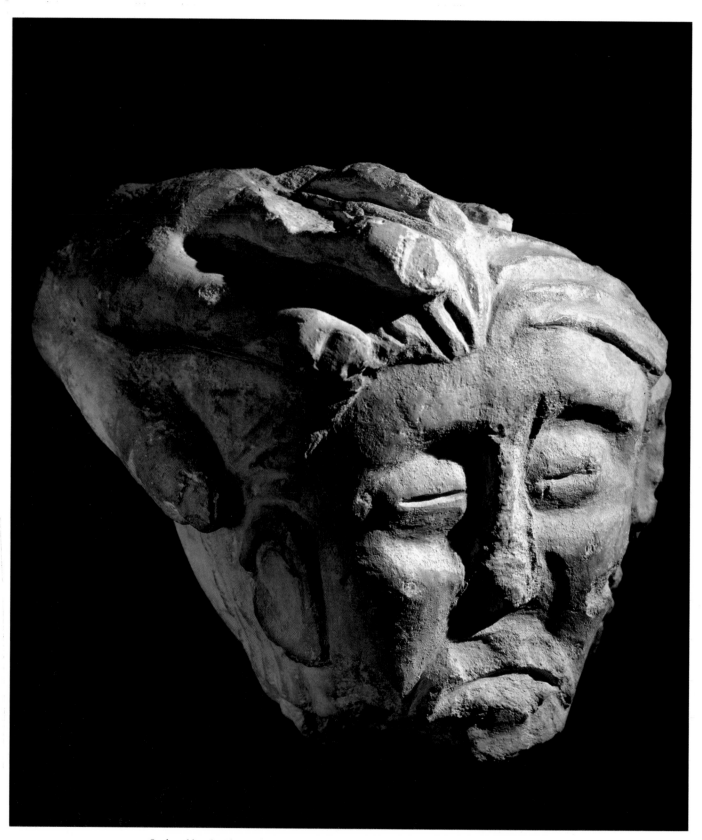

Sculpted head with attached hand from the sanctuary at Entremont (Bouches-du-Rhône).
Limestone. Second century B.C. Height: 23 cm. Musée Granet, Aix-en-Provence.

Archéologique, Dijon). This society imposed no artistic canon on human forms. Thin bronze statues of women, like the one from Neuvy-en-Sullias (p. 34), are handled in free arabesques. A general impression of stubborn non-conformism emerges. A bronze compass (formerly at the Musée d'Autun) bears the inscription *utere felix*, a way of saying "work well and be happy."

THE WORLD OF FINERY

The Gauls crafted luxury items. Livy, describing a victory over Celtic tribes in 191 B.C., noted that gold torques and silver vases were *non infabre factu*, "not without artfulness" (XXXVI, 40). The Biturige tribe was known for tin-plating copper objects, while western Celts developed a type of champlevé enamel technique (Philostratus, *Eikones*, I.27.3).

In describing the Gauls, classical historians like Strabo, Caesar, and Diodorus were all stuck by the importance placed on finery by these blond giants with their fine heads of hair. They wore gold torques as necklaces (right), and were also said to use gold breastplates, bronze helmets with horns, headpieces, gilded belts, engraved shields, and so on. All of this implies highly active and often refined craft activity. The Gauls sacrificed domestic luxury in favor of external finery, and their gleaming warriors astonished the Romans. It is tempting to see this as a characteristic feature of the land.

After all, if these primitive clans handed anything down, it only could have encouraged pleasurable ostentation, which would have led to a taste for fashion. The Gauls were rightly considered to be experts in weaponry—swords and scabbards, pikes and spears, helmets and breastplates, trumpets, and above all harnesses (they were renowned riders and had superb equestrian equipment). Their rich decorative repertoire did not die with the Roman conquest, and Gallic craft skills constitute an ancient component of French art.

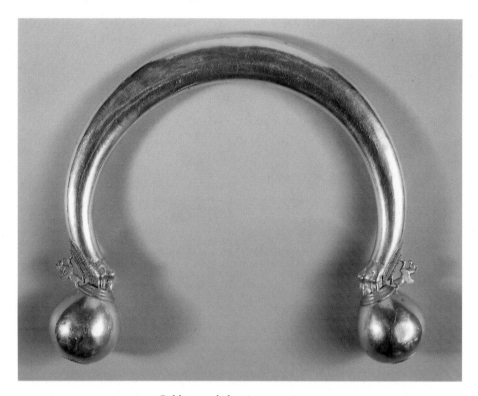

Gold torque belonging to a princess, from the burial mound at Vix (Côte d'Or). Greco-Scythian, sixth century B.C. Diameter: 27.4 cm. Musée Archéologique, Châtillon-sur-Seine.

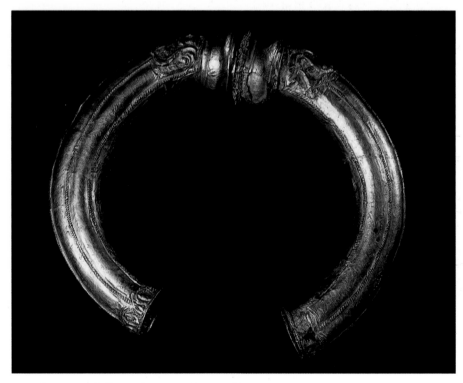

Gold torque with filigree decoration, from Mailly-le-Camp (Aube). Second–first centuries B.C. Diameter: 19.8 cm. Musée des Antiquités Nationales, Saint-Germain-en-Laye.

Section of the *Pillar of the Nautes* representing the Gallic deity Esus. Limestone. A.D. 14–37. 110 × 80 × 80 cm. Musée de Cluny, Paris.

Stele representing a cobbler. Stone. Second century A.D. 105 × 76 × 36 cm. Musée Saint-Remi, Reims.

MONUMENTS OF ROMAN GAUL

Cisalpine Gaul fell under Roman domination by the early second century B.C., followed by the Rhone corridor. Caesar's campaign of 58–51 B.C. finally subdued all of Gaul, divided into four provinces—Narbonensis, Aquitana, Lugdunensis (or Celtica), and Belgica. Waterways were complemented by a major network of *viae ferratae* (literally, "iron" roads, because they were tamped with iron dross), providing swift routes to the Mediterranean basin. Posts and relays were set up at critical crossroads, even in difficult geographic locations. Traces of a complete garrison, with riverside docks and a statue of Bacchus, have been discovered at an altitude of 3,000 feet on the Margeride plateau where the Clermont–Nîmes road crossed the Lyon–Toulouse road, on the site of the present-day town of Javols.

Roman and Gallic societies merged thoroughly and peacefully. A perfect expression of this association can be seen in the *Pillar of the Nautes* (above) confidently dated to the reign of Emperor Tiberius (A.D. 14–37). Although historians have concluded that the imposition of Roman government, the establishment of a capital at present-day Lyon, and the division of Gaul into three main regions led to the systematic elimination (or at least, disappearance) of the native ruling class, this was not the case for the many highly appreciated craftsmen such as blacksmiths, goldsmiths, and potters. This fact is of major importance—everyone required the services of these artisans, and all conquerors would eventually turn to them.

Caesar offered a key insight in his analysis of Gallic fortifications at Avaricum (Bourges). He said that the Gauls were "extremely ingenious and had singular aptitude to imitate efficiently what is seen here or there" ("*summae genus sollertiae atque a.d. omnia imitanda et efficienda quae ab quoque traduntur aptissimum,*" *De Bello Gallico,* VII, 22). This assertion is confirmed by numerous descriptions and accounts as well as by objects and structures that demonstrate a skill for assimilation which fully exploits models, rather than merely copies them. This raises a question of great importance—where do the original features begin, which traits are unique to this

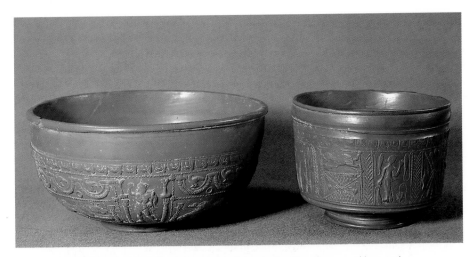

Sigillated ceramic bowls from a workshop at La Graufesenque (Aveyron).
Late first century A.D. Musée des Antiquités Nationales, Saint-Germain-en-Laye.

population? How many of them are due to the *interpretatio gallica*?

In contrast to the Romans' somewhat deprecating attitude toward manual work, the Gauls maintained traditions particularly favorable to craft production. Their god Lug, a Gallic Mercury, was the patron of all crafts based on the three forward-looking technologies of ceramics, brick and stone construction, and ironwork.

The Gauls were above all masters at woodworking, an ancestral craft dating back to prehistoric times. The importance placed on such work is demonstrated by

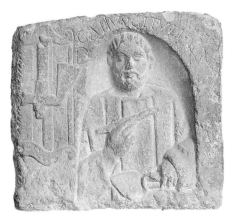

Stele of an architect found near
Saint-Symphorien church, Autun. Limestone.

the many tools such as chisels, axes, and adzes pictured on funeral steles and reliefs.[11] Gallic craftsmen were as attached to their tools as warriors were to their weapons. Coopers held a place of honor, but there were also cloth fullers, basket-makers, potters. A fine genre scene in Reims shows a cobbler at work (p. 38). It evokes an ingenious and dexterous people, appreciated as such in these western lands. Moreover, all techniques were adopted and developed—glassmaking, for instance, in which Gallic virtuosity led to the invention of fancy bottles, rainbow colors, and an intriguing little cask probably designed for funerary use.

This probably explains the growth of industrial activity in which the natives, spurred by trade, demonstrated new skills. One example is the simple and probably inexpensive pottery called sigillated (i.e. with stamped decorations), produced at the La Graufesenque ceramics works near Millau (above), which enjoyed enormous export success. It must have been about that time that all Gallo-Roman professional trades acquired a certain reputation, which survived for a long time—several centuries later, masons were sought in Gaul to build churches in England.

Roman Gaul, in fact, was covered with buildings. Roman construction techniques were thoroughly assimilated by a population that had previously known only wood structures. The traditional carpenter's trade with its perfected tools was not abandoned, however. For nearly two hundred years, from the end of the first century to the end of the third, Gaul was the site of "numerous buildings to which Roman architecture contributed only its techniques [as opposed to its materials]."[12] This crucial phenomenon could be seen as the harbinger of a long tradition of borrowing and adapting. Temples, for example, were no longer oblong, but were based on a central, square, or polygonal plan. They were often accompanied by another edifice or two, built alongside—a common if poorly explained feature—and would have a peripheral gallery with a colonnade.[13] The development of stone construction was a determining event, not only because it stimulated quarrying activity in the Narbonne and Seine regions, but

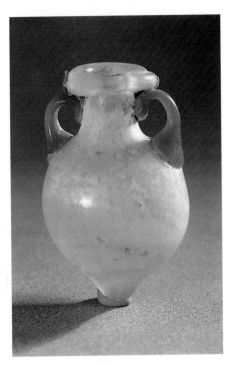

Glass vessel. Second century A.D.
Musée d'Art et d'Archéologie, Apt.

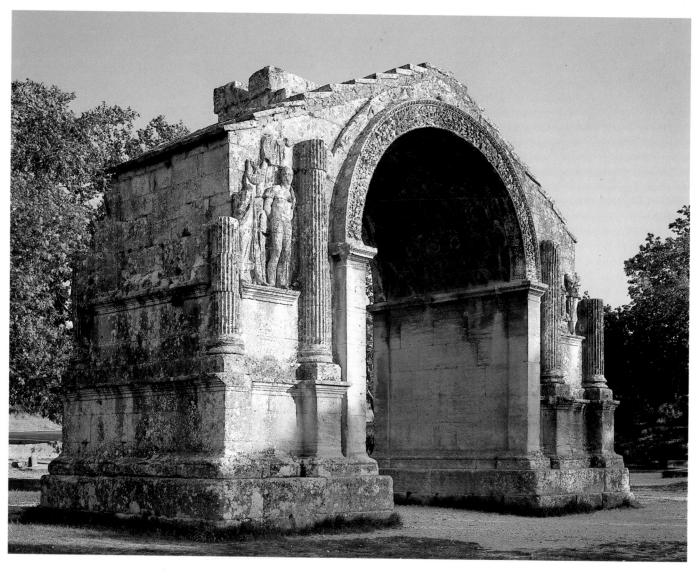

Triumphal arch at Glanum, Saint-Rémy-de-Provence (Bouches-du-Rhône). 20 B.C.
Right: The ancient amphitheater at Orange (Vaucluse). Early first century B.C.

also because it was associated with brick-work piers covered with stucco, which met with considerable success in Gaul. "It was only after the Roman period, in the early Middle Ages, probably in imitation of buildings that had already lost their facing, that brick was given a decorative role by being laid in geometric patterns."[14]

Towns were traditionally endowed with amphitheaters and temples. Famous examples like the amphitheaters at Sanxay, Orange (right), Vaison, and Lutetia (130 meters long) remained stand-ing for centuries, visible to all. At Saint-Rémy-de-Provence, near the ruined city of Glanum, the Jules family mausoleum (circa 25 B.C.) could hardly pass unob-served, being 18 meters high and boasting a rotunda on a four-sided arch (above). This Roman structure would be profitably adapted centuries later when Christian churches were built, if Venantius Fortunatus is to be believed—a passage in his sixth-century *Carmina* described Nantes cathedral with a tower over the intersection of nave and transept "whose round summit lightens the square con-struction at its base."

The arch built at Orange around A.D. 25 presents a thoroughly classical struc-ture decorated with relief carving that fea-tures indigenous elements—weapons, dress, and probably the composition itself. This was not the case with the Maison Carrée in Nîmes (p. 42) or the bridge over the Gard River (p. 43), models of classic forms whose prestige was never far from the minds of builders. The connétable de Montmorency, as governor of Languedoc,

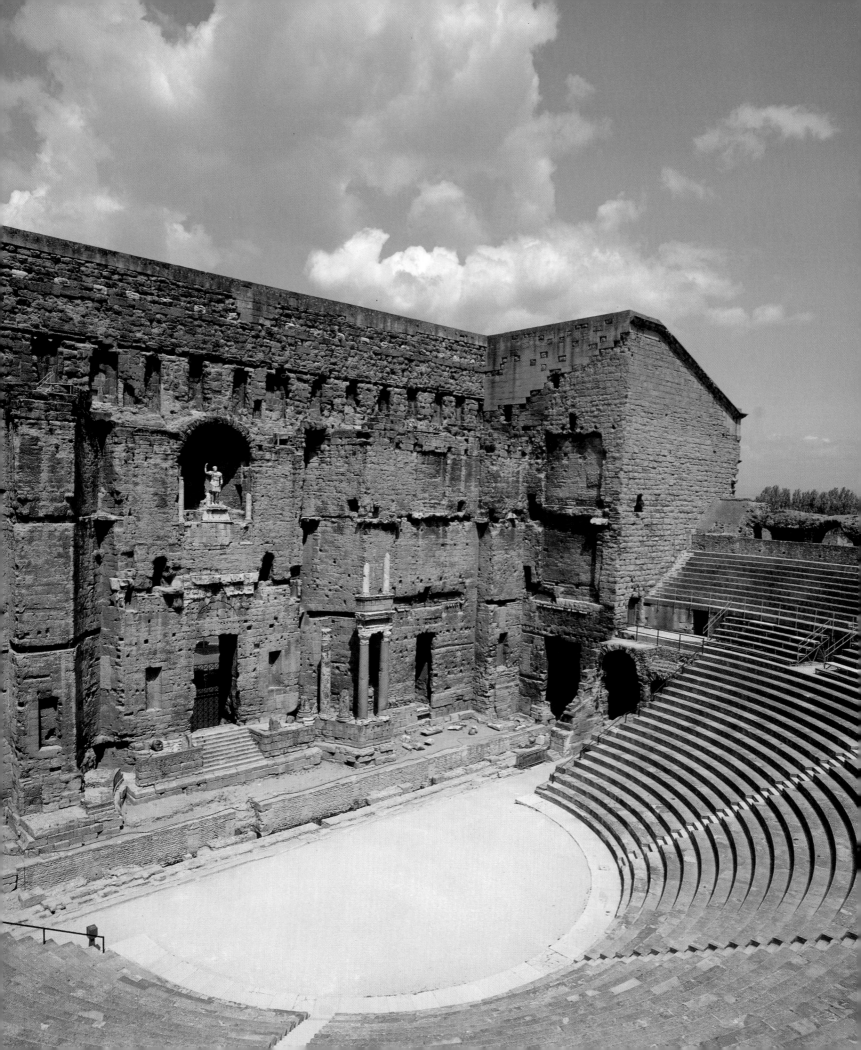

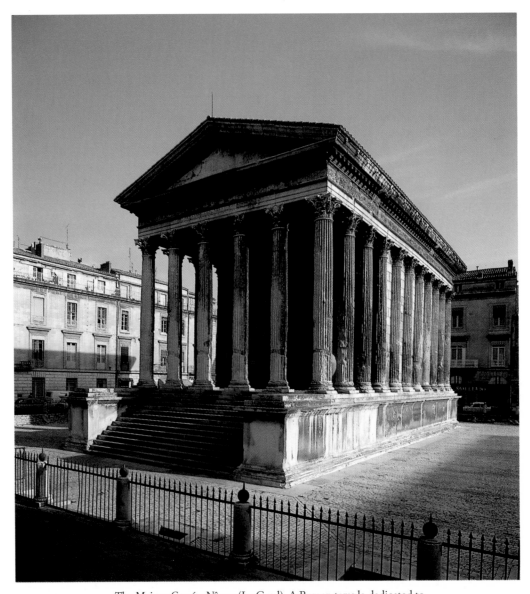

The Maison Carrée, Nîmes (Le Gard). A Roman temple dedicated to
Gaïus and Lucius Caesar, the adopted sons of Emperor Augustus. First century A.D.
Right: the Pont du Gard. Roman bridge–aqueduct crossing the Gard River. Second half of the first century A.D.

later manifested an already venerable attitude by issuing letters patent to preserve ancient buildings that were a source "not only of pleasure but of much profit for the art of architecture."

These typically Mediterranean edifices were found in the southern provinces. Elsewhere, sanctuaries of a more original type were built, based on a central building surrounded by a gallery, within a large peribolus (enclosing wall), such as the superb small-stoned tower in Périgueux, today stripped of its marble facing. There is also the thoroughly Roman-style square temple, called the Janus temple, at Autun. These buildings, always part of the urban landscape, still exist. They probably represent vestiges of local cults and therefore of burial-ground sanctuaries—this echo of wooden temples dedicated to heroes or gods of the underworld might explain the particularities of the square or circular stone and brick temples that inevitably left their mark on early builders of Christian churches.

The Gauls were also able blacksmiths and cartwrights who could work sheet iron. Many workshops also produced statuettes and fibulae. The silver plate found in tombs was usually imported, but funerary relief sculpture, statues of gods (whether Gallic or not), and votive altars represent a local version of original Roman

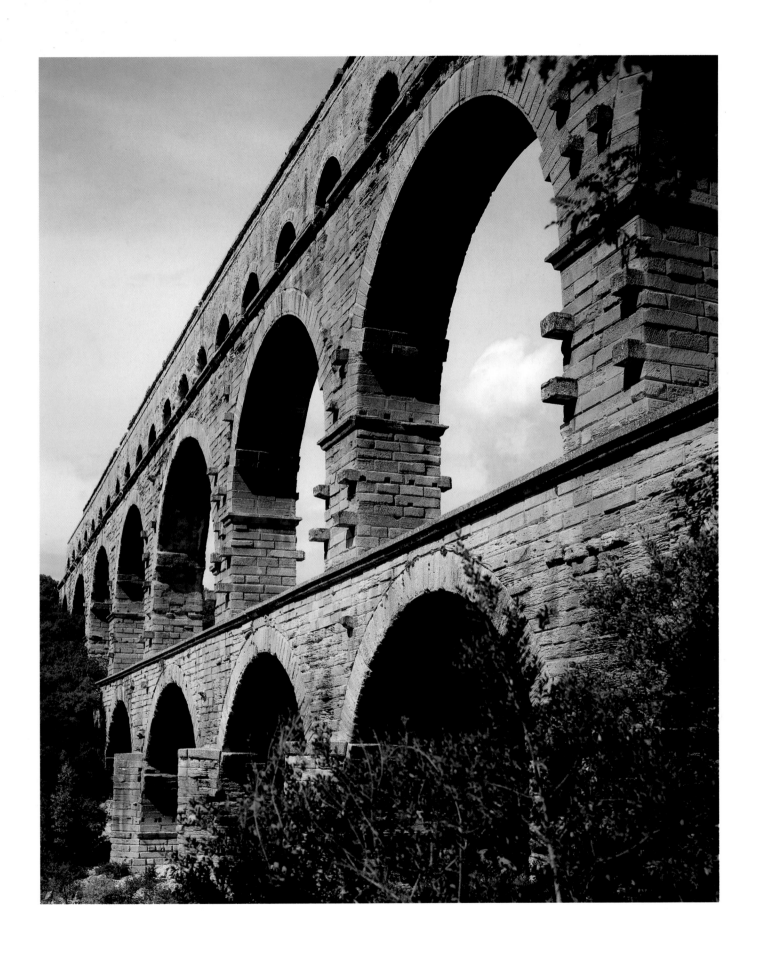

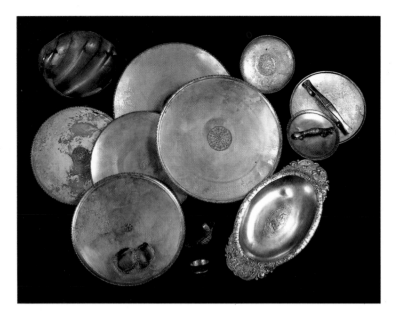

Plates, dishes, and jewelry from the Rethel hoard (Ardennes).
Third century A.D. Musée des Antiquités Nationales, Saint-Germain-en-Laye.

forms, usually simplified and rigidified as at the Cernunnos altar (Reims). Sometimes Roman models were translated into local materials, like the white terracotta Venus from Nièvre (Musée des Antiquités Nationales, Saint-Germain-en-Laye). Or Mercury might be dressed in Gallic clothing, like the one from Lezoux (also at Saint-Germain), or even seated cross-legged like typical native gods, notably Cernunnos. A statue of an earth-mother goddess found at Saint-Aubin-sur-Mer in 1943 affords a particularly interesting idea of second-century clothing and finery (notably a Gallic torque). It was probably thrown into a well for religious reasons.

The authorities would sometimes import statues and bas-reliefs, like the two heavily carved white marble sarcophagi found in the Gironde region in the nineteenth century; dating back to the third century, both were produced by the same Roman workshop and are of remarkable quality. One depicts the history of Endymion and Selene with a great profusion of figures, while the other shows Dionysus and Ariadne. There were many others—a marble sarcophagus with a bas-relief of a lion hunt was perhaps sculpted before a certain Jovin was buried in it in 370. At any rate, it was famous in Reims throughout the Middle Ages.[15] Not imported, however, were the sarcophagi that were later grouped together in spectacular fashion at Les Alyscamps (pp. 46–47) —they quite certainly came from a local, if highly Romanized, workshop. In the Languedoc region to the south, imported models were understood and imitated, like the *Labors of Hercules* found at Martres-Tolosane[16] and the statues of Venus from Montmaurin, sculpted from Pyrenees marble. Tools, sarcophagi, and capitals were exported, even to a Byzantium that did not disdain "the black marble of the Celtic mountains" (Paul the Silentiary, *Descriptio S. Sophiae*). But in many places, local industry handled these same models fancifully (those produced in the Comminges area, for example),[17] adding curves, spirals, and rings drawn from the old protohistoric repertoire. Thus two styles, or two approaches, began to emerge: one polished and "official," the other rough and "popular."

This marked the birth of a highly significant phenomenon. It was minor sculpture that perpetuated the forms and, thanks to superstition, the beliefs of the peasants (or pagans, both words deriving from the Latin *paganus*). These forms and beliefs insinuated themselves into the Christian repertoire via hagiographic legends that the new religion

Fertility goddesses from Vertault (Côte-d'Or). Limestone.
Gallo-Roman. 38 × 42 × 14 cm.
Musée Archéologique, Châtillon-sur-Seine.

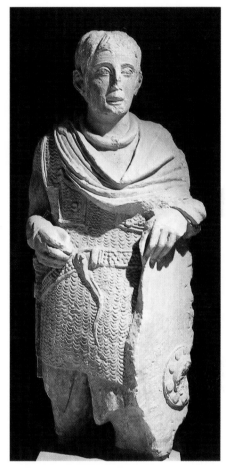

Statue of Gallic soldier from Avignon.
First–second centuries A.D.
Museo della Civiltà Romana, Rome.

absorbed during the fourth century. This might explain the cult of the mother goddesses, the most memorable vestige of which is the *Virgo Paritura* or Black Virgin venerated in the crypt at Chartres (unless, of course, it actually stems from a fourteenth-century legend, taken up in the sixteenth century by an anonymous chronicler who attributed it to the Druids—a highly revealing assumption in itself).

Caesar counted roughly thirty towns when he arrived in Gaul. Three centuries later, there were many more complete and duly organized cities. One of the most brilliant was certainly Lutetia (now Paris), which rose on the southern hill above the Seine; around a main artery which would become Rue Saint-Jacques, there was a forum (Rue Soufflot) and other usual features like baths (Cluny) and an amphithe-

ater (Rue Monge). Local vineyards and terraces made Lutetia an attractive spot for the Emperor Julian to tarry, sometime around 360. And, to judge by objects found there during excavations, it can be supposed that local artisans excelled in making fabrics, plates and dishes, and jewelry.[18]

So many scattered, ruined, and re-employed monuments could not survive in

INTEGERADQVEPIVSVITAETCORPOREPVRVS
AETERNOHICPOSITVSVIVITCONCORDIVSAEVO
QVITENERISPRIMVMMINISTERMIVLSITINANNIS
POSTETIAMLECTVSCAELESTILEGESACERDOS
TRIGINTAETGEMINOSDICIMVSPERSTILITANNOS
HVNCTOSIDEREAMRAPTVMOMNIPOTENTISINVIAM
ETMATERBLANDAETPATRISMIFVNEREQVAERVNT

place for centuries, as indeed they did, without generating legends, without sparking the imagination, without providing decorative motifs, and without reminding people that a glorious art of building once existed. It is hard to believe that the Gallo-Roman cultural landscape was totally obliterated and immediately forgotten once the disruptive invasions began. Although traditions were shattered, certain works of art traversed the ages, losing then regaining relevance in a series of cycles. This is particularly clear in southern France. It is not difficult to establish analogies between antique or Gallo-Roman steles and statues in the Narbonne area and works produced six or seven hundred years later, in the eleventh and twelfth centuries. One need only look at the toga-wearing archangels by master Bernard Gilduin and his companions at Saint-Sernin in Toulouse, or the large, thoughtful figures at Saint-Just-de Valca-brère near Saint-Bertrand-de-Comminges, or the draped apostles at Saint-Gilles-de-Gard. In this whole region, relatively untouched by "Carolingian neoclassicism" in the eighth and ninth centuries, all the mute testimony to antique art must have sustained a certain presence that fostered what might be called "elective affinities."[19]

GALLIA CHRISTIANA
A strange and complex welcome was given to Christianity—henceforth the official Roman religion—by a population familiar with Gallo-Roman syncretism. The major preoccupation of evangelical authorities was the elimination of idols and their worship. In the Brittany countryside where Christianity penetrated deeply, rural churches rose on the foundations of late empire buildings. That at least is what is recounted in the lives of Samson, Gildas, Paul Aurelian, and other saints who rooted out false gods. Similar events must have occurred more or less everywhere. The way in which civic and religious life in pagan Gaul was simultaneously eliminated and assimilated by the establishment of the Christian church was surely a key phenomenon, one of the profound factors that paved the way for medieval France and its art.

Sarcophagus of Bishop Concordius
from the cemetery at Les Alyscamps. Marble.
c. 390. 84 × 220 × 80 cm.
Musée Réattu, Arles.

After the edict of religious tolerance (A.D. 313), Christianity steadily gained a foothold in Gaul (from twenty-four bishoprics in 346 to fifty-four by 376), along with a religious architecture about which little is known but which must have been based on models borrowed from Roman and eastern Christianity (basilical and central plans, respectively). Above all, the organization of the country into religious precincts (that is to say, dioceses) had begun by the fourth century, and had a major impact on the future. The *Notitia provinciarum et civitatium Galliae* (circa A.D. 500) established ecclesiastical boundaries once and for all, except for a few modifications such as the subdivision of dioceses like Périgueux and Sarlat, or

Paris and Sens in 1622. This Gallo-Roman map still existed practically unchanged at the time of the French Revolution in 1789.

It was a period of great bishops. The "clerical" culture that developed was also an aristocratic culture, insofar as the upper clergy established it. This culture, with its Latin heritage of great authors, maintained intellectual criteria that distinguished it from common, emotional instincts. The *Life of Saint Martin* by Fortunatus mentions peasants who wanted to protect their temples; rather than indicating an attachment to paganism, it might be seen as an act of resistance by the "folk culture" that the church would have to combat throughout the Middle Ages.[20] A Gallo-Roman bas-relief of a hunting scene

placed in a wall near Le Puy cathedral may, for all we know, be a vestige of a cult devoted to Diana.

But the great disruptive invasions had already begun, leading to an initial destruction of this wonderful organization. And the invasions further muddied the historical picture since, as is well known, the major incursion by the Franks and the Alemans in A.D. 276, affecting some sixty towns, meant that the late third century was devoted to erecting fortifications around all urban settlements. Stones were taken from older buildings, which dramatically altered the urban physiognomy. Furthermore, everywhere the barbarians appeared, the reaction was to bury valuable items, many of which

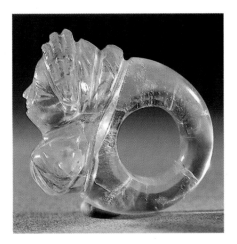

Rock crystal ring
decorated with the bust of a
woman, from the Rue des Thermes,
Glanum (Bouches-du-Rhône).
First–second centuries A.D.
Musée Archéologique,
Saint-Rémy-de-Provence.

have since been rediscovered. A recently discovered "treasure," for instance, buried circa 270–280 near Rethel in the Ardennes when a Germanic tribe invaded, comprised a large bronze cauldron containing sixteen pieces of plate and jewelry.

In the fourth century, Romanized Gaul, like Italy, still held a fatal attraction for Germanic tribes. Illiterate and unmoved by faith in Christ, they simultaneously admired and despised vestiges of the notorious empire. Barbarian raids, pillaging, and potential settlement obliged the shaken Gallo-Roman social order to regroup in a way that would have far-reaching consequences.

The era of the "fortress town" thus dawned. Cities withdrew behind fortifications that entailed substantial construction work—sometimes resulting in extensive surrounding walls (Orléans, Reims, Bordeaux), sometimes in a square or oval of smaller dimensions (Tours, Périgueux)—that employed pre-existing structures (baths or arenas) either as a linchpin for the fortification or as a quarry for building walls. Gregory of Tours mentioned roughly thirty towns that reacted thus, triggering the irreparable disintegration of Gaul's "stock" of ancient edifices. The ruined remnants can still be seen today.

It is important to appreciate the emotional and intellectual excitement engendered when heavily rural populations, living in all those provinces under the threat of barbarian invasion, heard evangelizing preachers. Victims of repeated destruction and disorder were being asked to make the terrific conceptual revolution required by Christianity, that is to say to adopt a tragic view of history along with the expectation that the "good news" would be regularly updated through miracles. Collective movements of this type occurred more or less everywhere, thanks to the enormous prestige of certain miracle workers like Saint Hilary of Poitiers and Saint Martin of Tours, founders of sanctuaries who within a generation were the object of cults that induced abbeys to wrangle over their relics. Place-names, so full of poetic and eloquent designations, leave a revealing record of how the religious network intimately penetrated the French countryside through the erection of churches with their "artistic" appurtenances. The importance of the phenomenon was all the greater for being accompanied by new requirements in terms of sacred architecture and decoration that kept generations of workers employed. Every diocesan city came to have a group of three religious buildings: a baptistery and two episcopal churches. Furthermore, outside the city walls, near cemeteries (Christianity being linked to worship of the dead), there were other churches of the basilical type. Such, at least, are the current conclusions of archaeological research.

The urban landscape changed a second time, more extensively, when invasion turned into more or less extended settlement by barbarians on the sites of their choice. In 418, for example, the Visigoths (who, though Christianized, were Arian heretics) occupied the Narbonne province for a good century, with Toulouse as their capital. Frankish, Alemannic, and Burgundian tribes overran other regions, sometimes elbowing one another out. They were once credited with rejuvenating an old, weary civilization—a naive, romantic view. What matters, apart from the ravages and impoverishment they caused, is the way in which they settled down and adapted. The Visigoths to the south remain a special case, whereas the other tribes were merely the most recent bearers of an old art from the steppes—barbarian tombs from the fifth century contain only poor-quality objects and jewelry. Things would change, however, in the following century as the Merovingians entered the picture by embracing Rome's religion, while the Visigoths and Ostrogoths clung to their Arian heresy. The sixth century in many respects represented the culmination of an era. Moreover, when the barbarian tribes did settle down, they instinctively

preferred the countryside. They distrusted towns, which they left to the Romans, preferring to keep closer to food supplies.[21]

Once the Franks converted, the city–countryside relationship tended to change. Their predatory rides through agricultural areas threatened the strongholds constituted by Gallo-Roman *villae*, farming centers that slowly developed into villages, where clan chiefs could settle. In many regions, however, this spacious residential and productive system was abandoned in favor of clustered resettlement along roads, by sources of water, or on heights. Aerial photographs of the Somme region[22] betray the shift in habitation patterns that occurred when comfortable, "classic" residences were abandoned for simpler housing. Except in areas like Provence, where there was a different approach to the re-use of the classical heritage,[23] it could be said that the structure of Gaul was thoroughly dismembered during the fourth and fifth centuries.

But the fourth century not only represented the ruin of Gallo-Roman civilization, it also gave birth to two developments that would, in subsequent generations, produce a new landscape, a new mental climate: the destruction–assimilation of traditional paganism, and the emergence of a Christian "collective imagination" of immense attraction and scope.

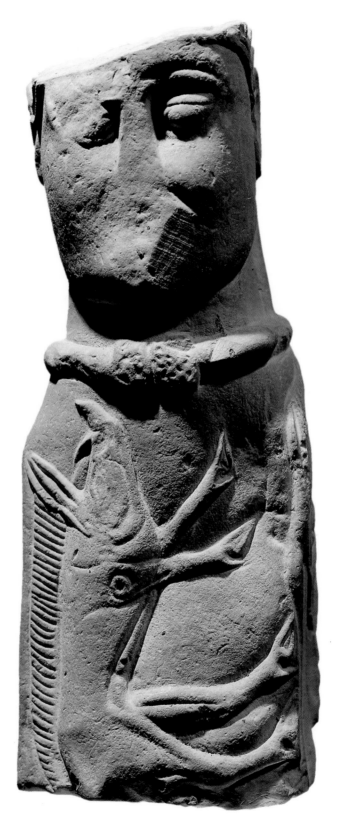

Fragment of a pillar–statue representing a Gallic god,
from Euffigneix (Haute-Marne).
Limestone. First century B.C. or A.D. Height: 30 cm.
Musée des Antiquités Nationales, Saint-Germain-en-Laye.

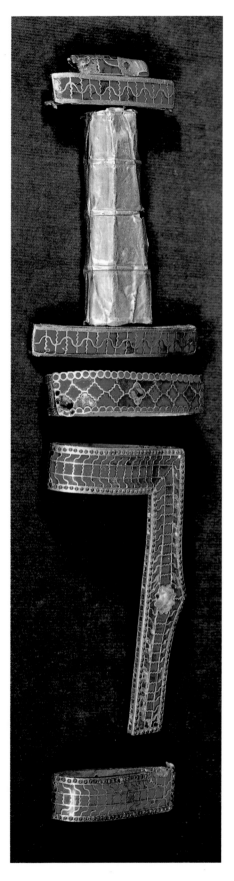

Elements of a long sword and a short broadsword found in the tomb of Childeric I (died A.D. 481) at Tournai. Gold, iron, and cloisonné garnet enameling. Cabinet des Médailles, Bibliothèque Nationale, Paris.

II
MEROVINGIANS
(500–750)
THE FRANKS BUILD CHURCHES

When the tomb of Childeric I, king of the Franks (died 481), son of Merovech (or Meroveus), was discovered at Tournai in 1653, the funerary artifacts were absorbed into the royal collection. The French monarchy still placed great store in "relics" from the father of the great Clovis. Vestiges (left) included a long sword, a short sword (or scramasax), and ornaments such as the locust-shaped fibulae that reportedly later served as models for the ones worn by Napoleon. This set of objects in gold-and-garnet cloisonné enamel displayed "a degree of perfection guaranteeing that they were produced by the royal workshops in Tournai."[24]

While Childeric's role in establishing the "first race of kings" was duly recorded by the chronicles, it is also important to acknowledge the dynasty's action in the realm of artistic commissions and foundations. The advent of Merovech and his descendents ("Merovingians"), who abandoned the Germanic forests in order to establish a veritable realm in "Francia," represented above all a sudden and lasting change in behavior that merits examination.

The fact that the first capital was a northern town is a good indication that the center of gravity had shifted north and that "Francia" extended as far the Meuse and the Rhine rivers. Things evolved quickly. A group of Franks led by Clovis, residing between the Seine and Loire rivers, eliminated their rivals one by one, so that by the time of his death in 511 this descendent of the obscure Merovech had guaranteed his tribe two good centuries of

Les Grandes Chroniques de France:
Clovis is baptised by Saint Remi.
Northern School, 1380.
Bibliothèque Municipale, Castres
(fol. 11r.).

domination over the former Gaul. Clovis had converted to Roman Christianity prior to the year 500, and the zeal of his queen, Clotilda, generated remarkable initiatives. These simple facts not only indicate the initial shift from Roman Gaul to the land of the Franks, they also shed light on the vast operation to enhance prestige by building a wealth of edifices of a new type, which would have incalculable consequences.

The Roman organization of Gallic provinces enabled the barbarians, though relatively few in numbers (perhaps five percent of the total population), to remain masters over a subject people. A series of dukes and counts, who adopted Latinate titles, imposed themselves at the cost of horrible clashes recounted in monotonously bloody chronicles. All social mores were marked by violence—the only potential brake on violence was religious authority, which had great difficulty in cooling passions (and often inflamed them). Through the force of circumstances, churches became the place where people gathered and where certain acts were made public. In 585, the Council of Aux-

erre had to firmly prohibit the dancing that habitually took place there. For over two centuries, churches were the focus of critical developments.

This strange period might be initially described as a meeting of two "cultures." The Germanic tribes brought primitive tools and decorative arts to Gaul, where they encountered the whole repertoire of forms and materials common to the Mediterranean world. Arriving in Gaul must have given them the impression of discovering a magnificent past. The conquerors apparently felt they could stake their own claim to it, because they demonstrated a naive desire to equal, indeed to surpass, everything they had just discovered. In a poem written in honor of a duke named Launebolde, who erected a basilica to Saint Saturnine in Toulouse around 570, Venantius Fortunatus praised "that man of barbarian race" for having accomplished what no "Roman" before him had dreamed of undertaking.

In the realm of religious architecture, the scope and wealth of the foundations laid during the sixth century can be reconstituted from traditions and texts, especially the *Historia Francorum* by Bishop Gregory of Tours (538–594).[25] It is enormously difficult to identify original structures beneath all the renovations,[26] especially those dating from the Romanesque period, and a good deal of historical imagination is required. Two features, however, have been brought to light by recent scholarship. First, all major towns eventually adopted a fourth-century arrangement of buildings called the "episcopal group," comprising two side-by-side churches—one dedicated to the Virgin and the other to a martyred saint—plus a baptistery. "It was only in the fifth century, in the East as well as in the West, that the cult of the Virgin and martyrs became widespread." Second, sanctuaries designed to commemorate a saint were built around a tomb where that saint's relics

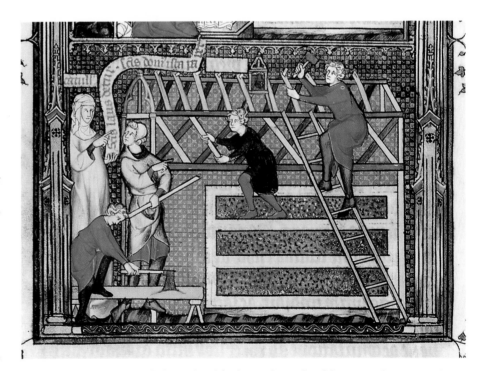

La Vie de saint Denis. Catulla has a church built over the tombs of the martyrs Saint Denis, Saint Rusticus and Saint Eleutherius (detail). 1317. Bibliothèque Nationale, Paris (Ms. Fr. 2092, fol. 75v).

The Charlemagne reliquary chest. Drawing by Etienne-Eloi Labarre (1764–1833). Bibliothèque Nationale, Paris (Est. Le 38c.).

were venerated. Thus, "in the sixth century, the former Roman town of Arles became a holy city, a diocesan holy city par excellence, possessing cathedral, baptistery, martyriums and holy cemeteries. . . ."[27] Once a town was no longer the residence of a bishop, it declined or disappeared. It was through religious institutions, via the network of dioceses, that a certain civic order was established and stubbornly maintained. Religious institutions were the site of new relationships between Gallo-Roman descendents (whom the preachers were trying to save from paganism) and the warlords (who were attracted by antique pomp and vestiges of the past).

That was the period when what would become the religion of the entire land took shape. Subsequent history was heavily colored by the collective memory of a few outstanding individuals who were immediately sanctified, becoming legendary figures for the people. It is impossible to grasp fully the pivotal period of the fifth and sixth centuries without appreciating the ability of anonymous but certainly evangelized masses, and of passionate religious leaders, to perceive and venerate the singular phenomenon of sainthood. A precarious existence was buttressed by a network of protectors and mediators, with devotion focusing on saints like Geneviève (circa A.D. 450), a daughter of Lute-

tia; Remi, apostle of the Franks (circa A.D. 500); and two particularly famous names—Denis and Martin. An extraordinary series of misconceptions would make Denis, a third-century martyr, one of the major patron saints of the kingdom. Dionysius (or "Denis") the Areopagite, converted by Saint Paul, became confused with Denis, the first bishop of Paris, who was decapitated on Montmartre along with two companions. Subsequently, yet another Denis, a great fifth-century theologian and author of mystical treatises of considerable importance, was in turn assimilated with the first two. And that was only the first stage—more confusion would come in the Carolingian period.

Saint Martin, meanwhile, was apostle to the Gauls and bishop of Tours in 371, and became something of a French national saint. His worship spread with unbelievable fervor throughout the land, inspiring numerous religious establishments and assuring lasting prestige for the mother abbey in Tours, especially after its somewhat swashbuckling acquisition of religious relics.

Denis was a martyr, then, whereas Martin was a confessor, that is to say a non-martyred saint, an apostle who set an example. It was apparently with Martin's veneration that the cult of confessors first assumed its full scope.[28] In both cases, it goes without saying that the saint's cult required a sanctuary in grand style, with exceptional decoration. The appeal of sainthood and of the church's often powerful and inventive art mutually reinforced one another. Just as place-names indicate the spread of local cults (a saint's name always indicating a sanctuary), so new forms of religion became intimately linked with new art and architecture throughout the land during the fifth and sixth centuries. This might be formulated as a theorem that holds true for the entire Middle Ages: worship was based on relics, whose location was marked by architecture and whose presentation to the Christian people required noble and luxurious settings. The will to make art was implicit in the religious exaltation associated with sainthood, which in a way stood for everything. Given the liturgy of the mass, this creative tension quite naturally focused on the altar—originally a table, *mensa*, yet also a transformed classical *cippus* (funerary stele), as confirmed by numerous fifth- and sixth-century examples in the south of France.

The close association of altar and relics was established by the sixth century and assumed its full scope in subsequent centuries, thereby shaping many religious features of the pre–Middle Ages.[29] Accounts, and sometimes vestiges, give an idea of the

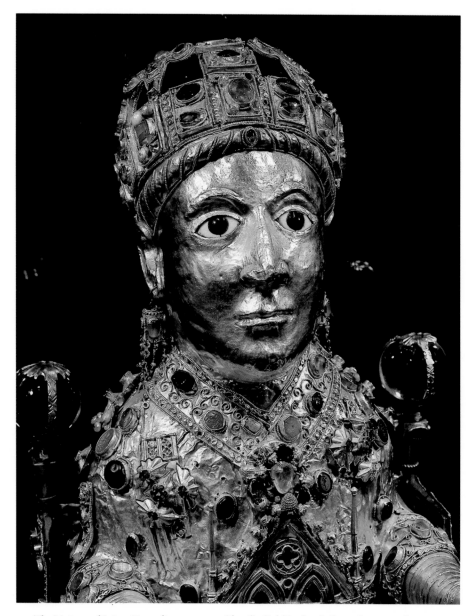

The Majesty of Sainte Foy, reliquary statue (detail). Gold leaf and silver gilt on wooden core, filigree, cloisonné enamel, precious and semi-precious stones, pearls, glass beads, and rock crystal. Fifth–tenth centuries (one arm dates from the sixteenth century). Height: 85 cm. Church of Sainte-Foy, Conques.

magnificent reliquaries placed on altars on solemn feast days, such as the so-called Charlemagne chest at Saint-Denis (more correctly ascribed to Charles the Bald) and the even better-known statue of Sainte Foy (Faith) at Conques (above). The late seventh-century appearance of what was called, in imitation of Roman churches, a *confessio* (i.e. a small crypt permitting circulation around a holy relic), resulted in the ninth-century development of two-level sanctuaries in major monastic churches such as Saint-Germain in Auxerre, Saint-Médard in Soissons, Saint-Philibert in Grandlieu, etc. Furthermore, in cathedral churches, where the institution of priestly chapters in the eighth century created a body subject to defined rules, the chancel was transformed little by little into a "holy of holies" which in a way

partitioned the sanctity of the site within the overall space of the church. This helps explain how the rest of the building could serve as a meeting place where people circulated freely. A final consequence of this arrangement was the establishment of chancel gates by the eleventh century (distant ancestors of Gothic rood screens).

SPECTACULAR SETTINGS

Sometime around 475, a church was built on a site several leagues outside of Paris (the location of the future Abbey of Saint-Denis). One hundred and fifty years later, Dagobert I, king of the Franks, had himself buried there. The circumstances surrounding this decision are not entirely clear, but it would have weighty consequences. The abbey underwent two noteworthy transformations—in 700–775 and then under Louis VII (1137–1180)—slowly becoming a center of learning, a sort of archives of government, simultaneously commemorative and documentary. This all took place in the heart of the vast fertile plain comprising the Ile-de-France region, a major commercial crossroads of the day.

Martin, meanwhile, died in 397, and by 400 a biography had been written, the *Vita Beati Martini*. Less than a century later, Bishop Perpetuus (458–488) built a large basilica over the saint's tomb, as required by the worship of miracle workers. Just as the *Vita Beati Martini* (revised and augmented by Paulin of Périgueux around 463) became a model for hagiographic literature, so Perpetuus's basilica inaugurated hagiographic imagery in Gaul, notable for the importance given to depictions of Christ (including the theme of Christ walking on the water, eight centuries before Giotto), as well as those of the eponymous saint.[30] Visual models obviously existed in Rome and Ravenna, but not in Gaul. This initiative on behalf of an already immensely popular figure assumed even greater impact in the following century, when the old episcopal church of

Folk image of Christ. Molded terra-cotta plaque, Grézin (Puy-de-Dôme). Fifth–sixth centuries. Musée des Antiquités Nationales, Saint-Germain-en-Laye.

Tours was redecorated. First erected in the fourth century, the church was rebuilt between 573 and 590 by Gregory, and endowed with a large painted cycle showing Saint Martin's miracles. The subject is known thanks to a poem by Martin's friend Venantius Fortunatus (530–609). In the cycle were scenes showing the destruction of an idol, the miracle of the pine (a sacred tree for pagans), and the denunciation of a phony tomb where the crowd thought it was venerating a martyr. These "facts," including the unmasking of a false martyr, were obviously relevant during Martin's lifetime in the fourth century, and were probably still so in the sixth.

Nothing remains of this cycle, although certain episodes were imitated elsewhere, such as at Vézelay (miracle of the pine tree) and Chartres (a stained-glass window of the false martyr). Furthermore, a somewhat severe style can be inferred

from later manuscript paintings and from contemporary compositions in Italy and the Orient. Yet it is plausible to assume that great sanctuaries in Merovingian "Francia," a confused land subject to incoherent powers, boasted painted cycles like the one at Tours that combined the attraction of the miraculous, the haven of a holy place, and education through images.

There is interesting evidence for this. Bishop Namatius erected a basilica to Saint Stephen outside Clermont. His wife Ceraunis "wanted it to be decorated with colored frescoes. She used to hold in her lap a book from which she would read stories of events which happened long ago, and tell the workmen what she wanted painted on the walls" (Gregory of Tours, *Historia Francorum*, II, 17). This incident, recounted as a simple human interest story, merits attention, for the taste for narrative hagiographic cycles of paintings or mosaics supposes a staff of practitioners able to depict them. The above anecdote took place in the mid–fifth century; when Namatius died in 460, a still-extant letter from the bishop of Limoges announced to Ceraunis that he was sending her a good painter.

Unlike the Byzantine East, the Latin West never elaborated a "theology" of sacred images. The doctrine that governed the validity of the depiction of divine figures in churches for centuries was formulated by Pope Gregory the Great (circa 540–604) in a letter addressed to Serenus, the iconoclast bishop of Marseille. Serenus was troubled on seeing how many pagan practices survived in Gaul; Gregory, aware of the development of mural decoration in Gaul, was keen to justify it. Paintings were designed, he argued, to instruct the ignorant who could not read (*homines illiterati*), bringing them to the true faith and helping to banish idols. In this respect, the use of such imagery was as legitimate as the transformation of temples into churches. These recommendations were all the more timely in that cycles of

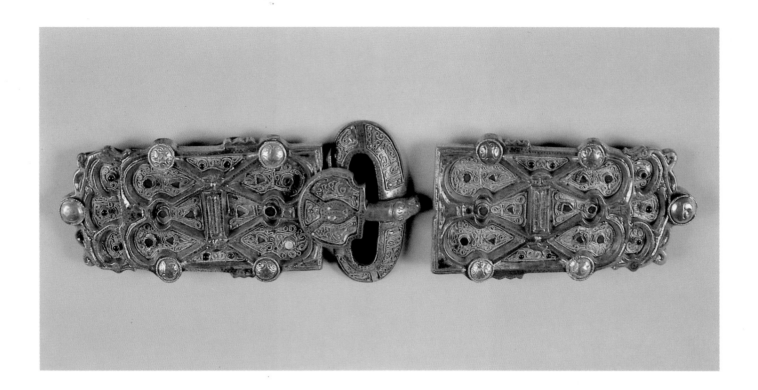

Buckle, ring, earrings, and pins once belonging to Queen Arnegunde,
from the abbey church of Saint-Denis. Gold, silver, niello, garnets, and glass beads. c. A.D. 565–570. Musée du Louvre, Paris.

Fragment of the "Saint Eloi" (Eligius) cross,
made for the Abbey of Saint-Denis, destroyed in 1794. Gold, precious stones (the almandite has
been removed). c. 600. 10 × 10 cm. Cabinet des Médailles, Bibliothèque Nationale, Paris.

hagiographic paintings and mosaics were multiplying in episcopal centers; some, like the church of Notre-Dame-La-Daurade in Toulouse and the Holy Apostles in Paris, acquired swift fame.

Thanks to Gregory of Tours, the scope and wealth of Merovingian religious institutions are known today.[31] Modern examination of 46 town plans reveals the lasting impact left by religious establishments—although burned, ruined or transformed, these churches continue to leave their mark on local and national heritage.

Paris was little more than the continuation of the Roman settlement of Lutetia up until the time of Philip II Augustus (1165–1223). The sixth century, however, was critical to the city. Clovis had made it his capital ("*Parisi, cathedram regni consti-*

tuit," wrote Gregory of Tours). Clovis was buried in the basilica of the Holy Apostles, later named after Saint Genevieve, on whose tomb it was built. Outside the city walls, Childebert erected the church of Saint-Vincent-et-Sainte-Croix (which in circa 1000 became Saint-Germain-des-Prés), a church in the form of a Latin cross, said to have been magnificently decorated with mosaics (of Roman or Byzantine origin) and capitals carved in marble from the Pyrenees.

As Paris grew in importance, so did the church-cum-royal mausoleum at Saint-Denis; the chain of Merovingian churches that would later constitute so many stations between Paris and Saint-Denis already seemed to be emerging. Towns (*vici*) were springing up around Paris, as were

estates (*villae*) of members of the ruling elite, both having their local churches. Excavations conducted in the past thirty years have produced an accurate and reliable map that in many cases confirms oral tradition—the archaeological picture of Paris is increasingly complete, thanks to a slew of small suburban churches that have yielded trapezoidal sarcophagi in plaster with stereotyped decoration, whose production is firmly dated.[32]

In major churches, marble and gold were to a certain extent mandatory, in order to give the relics of wonder-workers all the necessary glamour. Mosaics were also often required, as at Autun (the church of the legendary Queen Brunehilda), Reims (Saint-Nicaise), Marseille (Saint-Victor), Poitiers (Saint-Hilaire),

and Toulouse, whose La Daurade remains one of archaeology's knottiest problems. This "golden" edifice, destroyed in the eighteenth century, was built on a central, twelve-sided plan, and was perhaps a classical temple re-dedicated to the Virgin; it boasted three levels of imagery against a gold ground—the Old Testament, Christ, and the Evangelists.[33]

A new architecture was developing simultaneously in the East and West. The former Gaul displayed concerns similar to those of Theodoric in Ravenna (Sant'-Apollinare Nuovo, circa 520, for example). New approaches were being tested. One arrangement, mentioned above, called for twin churches—one for the bishop, one for the people.[34] In the sixth century, a second church was added to the cathedrals in Tours and Bordeaux. In the seventh century, more churches were added. The second church, dedicated to the Virgin, was used as a public church in Paris, Sens, Senlis, Amiens, and elsewhere—nearly forty cities in all.[35] When this practice went out of fashion, space was freed for extensions and more ambitious building programs, as occurred notably in Paris.

The building plan referred to here as basilical was used for monumental undertakings (or at least what appear as such today)—it has been estimated that Saint-Martin in Tours was 53 meters long by 20 wide and 15 high. The roof beams could span a nave and two aisles. The apse was set over the saint's tomb. The architectural masses must have been rather simple, but

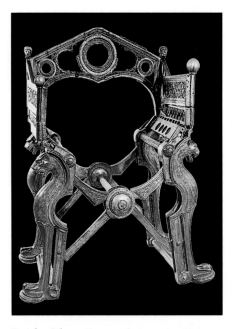

Dagobert Throne. Bronze gilt. Seventh–eighth (?) centuries (restored in the twelfth and nineteenth centuries). Height: 135 cm. The abbey church of Saint-Denis until 1791; Cabinet des Médailles, Bibliothèque Nationale, Paris.

already there was a bell tower—a porch-bell tower at Saint-Martin; a central tower at Saint-Julien in Brioude, in Nantes, and in Clermont; while Saint-Martin in Autun probably had a facade with two towers prior to A.D. 600.

METALWORKING

Precious metalwork still held pride of place. In 1959, a previously unexamined tomb in the crypt at Saint-Denis turned out to contain the finery of a certain princess named Arnegunde (p. 55), probably Arégonde, the mother of Chilperic I (539–584), mentioned by Gregory of Tours. Round cloisonné fibulae, clasps for a cross-belt, earrings, and embroidery provide an excellent idea of queenly luxury.[36]

Tradition associates the reign of Dagobert (629–639) and the initiatives of his minister Eloi, master of the royal mint, with several masterpieces that played a significant role throughout the *ancien régime*. These valuable ecclesiastical items include the remarkably elegant Chelles

The Master of Saint Giles, *The Saint Giles Mass* (detail): seen above the altar is the cross of Saint Eloi. c. 1500. Oil on canvas. 61.6 × 45.7 cm. National Gallery, London.

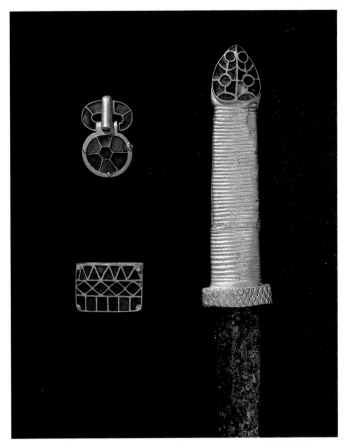

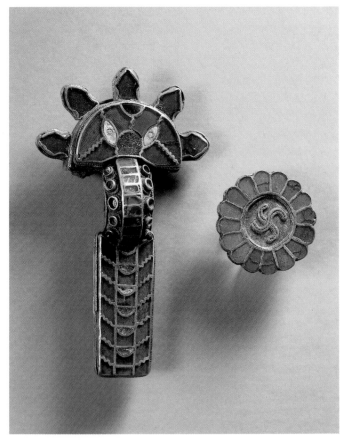

Buckle and detail of pommel and hilt of a sword
from the Pouan treasure (Aube). Gold and cloisonné enamel.
Fifth century. Musée des Beaux-Arts et d'Archéologie, Troyes.

Buckle and fibula from Picquigny, Somme.
Silver gilt and cloisonné enamel. Frankish, first half of the sixth century.
8.3 cm and 2.7 cm. Museo Nazionale del Bargello, Florence.

chalice made of gold and colored gems (vanished after 1790, known from a drawing of 1653), and more especially the large gold cross over the altar at Saint-Denis in cloisonné gold with garnets and cabochons (unfaceted stones), of which a putative fragment still exists (Bibliothèque Nationale, p. 56). The cross was depicted on a panel by the master of Saint Giles (circa 1480, National Gallery, London, p. 57), but there is still a great deal of uncertainty over dates and original form, given the constant reworking of spectacular items. The jewel-studded cross topped a gold, triple-arched retable with an enormous gem in the center—there are reasons for thinking that the cross was offered to the church by Charles the Bald two cen-

turies later. What is certain is that Eloi organized a goldsmiths' school and workshop on the Ile de la Cité in Paris. Centuries later, the brilliant and highly esteemed lay goldsmiths' guild became a famous Paris institution, the "Culture of Saint-Eloi [Eligius]."

No less famous is the so-called *Dagobert Throne* (Cabinet des Médailles, Bibliothèque Nationale, p. 57), which is a folding, curule-type chair of gilded bronze. The top, back, and arms were restored by Abbot Suger in the twelfth century for the abbey church of Saint-Denis, but the lion-head legs date back at least to the eighth century, indeed perhaps back to Eloi's day.

The legend surrounding Dagobert and his minister conveys in its own way the

activity devoted to crafting precious metal and stones. Misfortune would have it that the sparkle of enameled reliquaries and tombs, described in the *Life of Saint Eloi,* has been lost forever. "On a marble table, adorned with magnificent gold and gem work, he placed a border of a leafy pattern of admirable composition." Scattered pieces have turned up in church collections, for example at Gourdon. But a small reliquary like the one at Saint-Benoît-sur-Loire, in chased copper with a ring pattern and a gallery of six simple figures, merely demonstrates that craftwork was much weaker outside the major artistic centers.

The prestige of goldsmiths in the Merovingian world can be explained by royal monetary requirements and the pro-

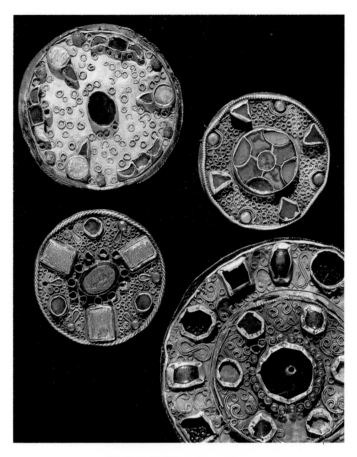

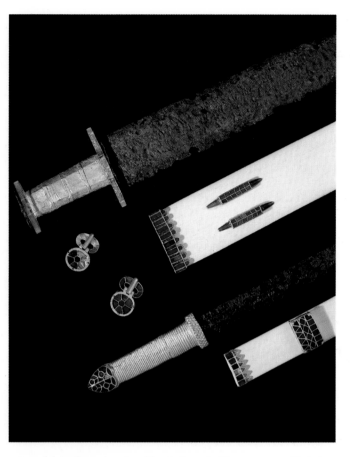

Fibulae with filigree decoration.
Silver gilt and almandite. Seventh century.
Musée Archéologique, Strasbourg.

Sword, broadsword, and scabbards from the Pouan treasure (Aube).
Gold, cloisonné enamel, and ivory. Fifth century.
Musée des Beaux-Arts et d'Archéologie, Troyes.

duction of ecclesiastical furnishings, notably reliquaries. This raises an interesting question concerning the attitude of the conquerors who now set themselves up as the lords of Gaul. As seen with the tomb of Childeric, the chief's personal "treasure" accompanied him to the grave—either it was considered indispensable to his survival in the afterlife (as was the case with the funerary chariots placed in Celtic tombs a few centuries earlier), or else it was simply expected to disappear along with the lord and master. In the latter case such burial meant that the lord's successors renounced valuable material as a way of paying homage to the majesty of a king.

Funeral practices did not retain this profligate nature indefinitely. Of course

there have always been a certain number of personal or symbolic objects placed in a princely tomb along with ceremonial dress. But it has been suggested that the purple shrouds of Childeric and Arnegunde may have been specially designed for the tomb, in which case this would indicate a new approach to funeral rites.[37]

In any event, it has been noted that the last Merovingians abandoned the archaic practice of burying the chief's treasures with the body. It is probable that church efforts had much to do with this, insofar as religious authorities encouraged the donation of precious items to sanctuaries in memory of saints; this ultimate destination not only justified the production of such

treasures, but also led to a certain shift in the very notion of "treasure" toward the increasingly demanding sphere of the church.

The Abbey of Saint-Denis received, probably from Dagobert and certainly from the Carolingians, precious items that bear scrutiny because they often—perhaps always—consisted of "assemblies" of ancient pieces. At the very least, they were studded with gems or Roman and Gallo-Roman jewels endowed with special glamour. In this respect, it might be said that church "hoards" played a role in conserving art objects broadly similar to the one played by monastic libraries in preserving manuscripts. The consequences of both types of hoarding were enormous for

medieval art and culture, as well as for the very authority of the church.

During this long period there also existed a more modest, primitive art that might be labeled "popular." Once again, it was to be found in graveyards. Nothing is more revealing than an inventory of funeral monuments carved during the early Middle Ages, as slowly and minutely reconstituted by scholars.[38] Funeral steles and bas-reliefs carved in modest materials display attempts to adapt decorative motifs borrowed from precious metal-work. For example, over half of the towns in the Vexin area (to the northwest of Paris), have yielded steles and sarcophagi from the Merovingian period (sixth to eighth centuries) carved in locally abundant limestone or in plaster, with modest designs of rings and ecclesiastical symbols.[39] This impoverished, limited repertoire is indicative of at least minimal adornment in homage to the deceased. Here, even more than with the dazzling items produced for royalty by court goldsmiths, it could be said that "henceforth objects meant more than buildings, and symbols were more interesting than human figures."[40]

Despite a probable halt in marble quarrying, Pyrenees marble continued to provide material for sculptural elements thanks to re-use. Throughout the south of France—in Toulouse, in Nîmes, in Saint-Guilhem-le-Désert—panels decorated with small columns or garlands or incised covers have been unearthed. Some items were exported further north, so that "Pyrenees" capitals must have embellished the interiors of vanished basilicas.

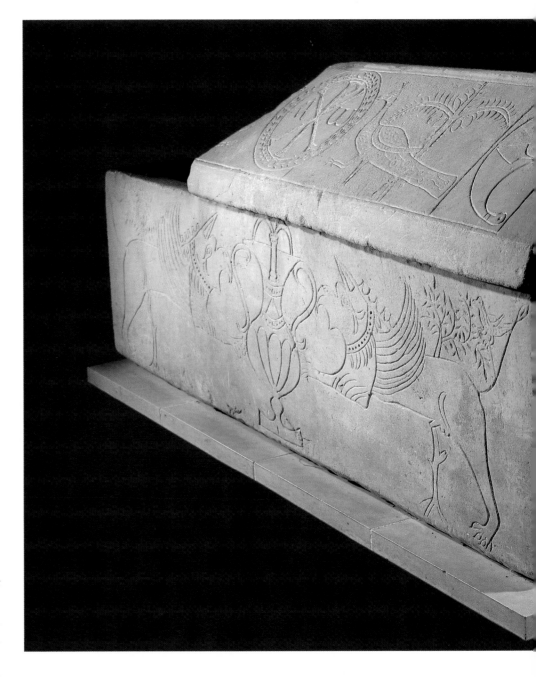

AN AGE OF MONKS
The chronicles are full of thefts, abductions, and crimes by powerful, brutal, lordly figures with barbaric, guttural names. Yet sometimes there is also mention of the deference they show to religious authorities, as well as acts of devotion such as Brunehilda's founding of the Saint-Maur monastery in Autun. How could these inelegant potentates, with their uncertain grasp of Latin, impose their laws and sometimes their protection on the peasant masses whose Romanized language was slowly changing tonality? Latin was the idiom in architecture as well as in language. But housing continued to evolve away from the Gallo-Roman *villa* with its auxiliary buildings, which had long served as both a center of agricultural production and a small village-like unit. Toward the seventh century, there was a trend toward regrouping, clearly detected by archaeological evidence on the plain to the north of Paris for example, yielding the artifacts of rather poor quality mentioned above. A sort of "cellular enclo-

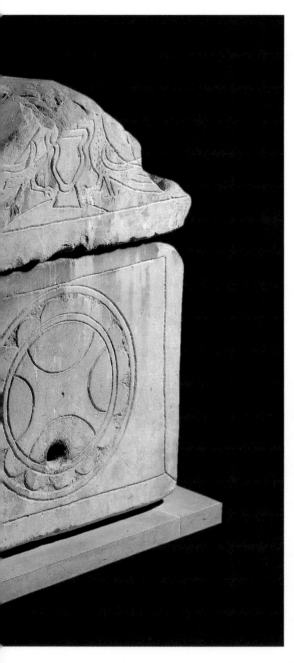

Sarcophagus of Saint Chalan
from Charenton-sur-Cher Abbey. Limestone.
Seventh century. 98 × 214 × 77 cm.
Musée du Berry, Bourges.

Plaster panel from a sarcophagus.
Musée Alfred-Bonno, Chelles.

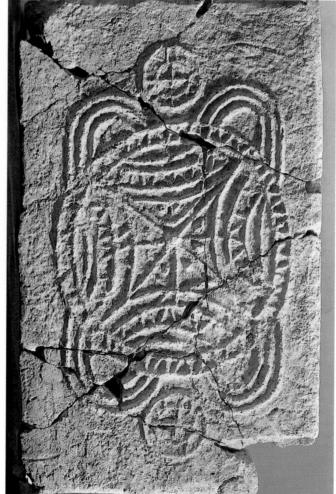

sure" (to use Robert Fossier's term) took place in many cases, with a cemetery next to the church and merchants next to the seignorial tower. The two authorities provoked a sort of crystallization of groups around two generally modest but useful edifices.

After great efforts at development and construction during the fifth and sixth

centuries, times became tougher. It is not too clear what occurred during the seventh century and the first half of the eighth, but it seems as though everything suffered from a sort of lassitude or ageing, as inferred from the rapid and sudden spread of monasticism. In 529, Saint Benedict of Nursia proposed a rule of monastic life that found particularly fertile terrain in Gaul. In the north and east of the country, two hundred monasteries were founded in the late sixth and seventh centuries. These included Jumièges with its wall and towers, and Jouarre with its crypt of highly interesting sarcophagi (the only surviving feature, right). The tomb of Theodechilde, for instance, has an abstract pattern based on an antique model, while Agilbert's sarcophagus shows the Last Judgment featuring the four apocalyptic beasts and a frieze of praying figures who represent the souls of the departed.

These monasteries drew many followers and gave a new dimension to religious life. Their success meant that the traditional episcopal organization was paralleled by a completely different network of institutions obeying a new model. Monks participated in rural life through clearing and planting. With the introduction of plainsong and vigorous decorative projects, they altered the modalities of religious life. In fact, the two networks often intersected as abbots became bishops; nor was there a lack of conflicts (which fortunately now provide information on the internal problems of abbeys and their possessions). Just as civilian authority was weakening almost everywhere, something more basic was replacing it. Urban schools were less active, but monasteries housed scriptoria and became the repositories of the old culture. This would have enormous consequences, given the general decline in written culture. Traditional knowledge, with its array of texts and images, became concentrated in a highly limited number of places. Everywhere else, trade skills were handed down with a

The north crypt of the old abbey
at Jouarre (Seine-et-Marne).
Seventh century.
On the left is the tomb of Bishop
Agilbert; on the right, the tomb of
Theodechilde.

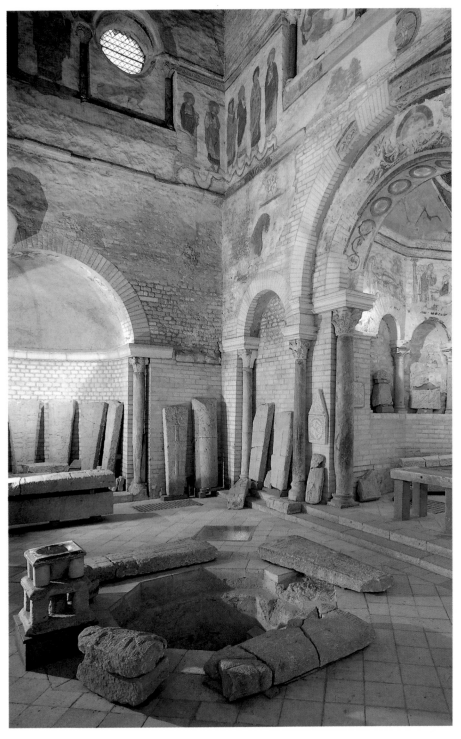

Interior of the Saint-Jean baptistery, Poitiers. Seventh–eighth centuries.

uncertainty in identifying and dating interesting buildings. For example, there is a remarkable group of provincial baptisteries in Fréjus, Aix, and Venasque. These were of course subsequently altered but the basic type and arrangement—an octagon set in a square, probably with a small cupola—belong to the sixth century. The Saint-Jean baptistery in Poitiers (left), with its fine design and faithfulness to Roman models in its use of brick and small stone, plus its rich, careful decoration around the bays, basically dates from the seventh century.

Archaeological study has yielded two crucial observations: in the fifth and sixth centuries, Romanized Gaul became dotted with churches and villages (the two going hand in hand), and these small centers favored the cross-fertilization of more or less pure Mediterranean traditions (columns, figured scenes) with decorative techniques of a different origin (the grand Celtic and Germanic repertoires of yore). Most of these buildings, however, were subsequently modified or fell to ruin, first during the Carolingian period and later during the general recovery of the eleventh century. Vestiges often range across a period of five centuries, and archaeologists must try to ascertain the role of successive generations from among superimposed foundations, altered walls, and rebuilt roofs.

The lasting change in Gaul's fortunes calls for further clarification and in-depth analysis, because the questions it raises concern the social mores, traditions, aptitudes, indeed the very vitality and sensibility of a population that had been so gifted. What remained of a culture when its political and economic foundations were shattered? What happened to shared cultural tendencies when the associations that fostered them were threatened by unheard-of disruption, and what was the fate of related objects? What became of habits, customs, and behavior concerning buildings and their symbolic organization?

certain fidelity, while folklore mixed legend with tradition. The absence, vagueness, or partial nature of information, plus the lack of confident artworks, gives the unsettling impression that six or eight generations lived in the anxiety and inertia symbolized by the late Merovingian kings, whose legendary passivity earned them the title *les rois fainéants*—the "do-nothing kings." That might explain archaeologists'

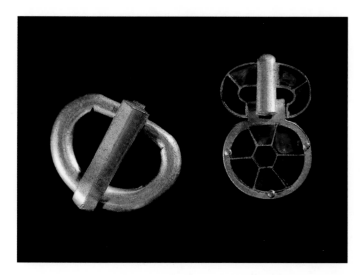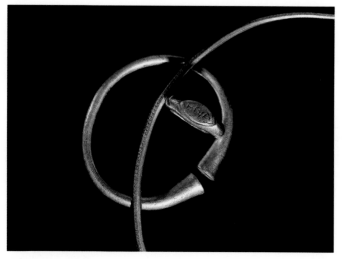

Left: buckle and belt buckle. Gold, cloisonné enamel.
Right: gold bracelet and ring. Fifth century. Musée des Beaux-Arts et d'Archéologie, Troyes.

How did collective memory, shaken by the brutal arrival of new rulers, continue to survive, slowly evolving into a sort of collective unconscious? Will a little enlightenment come at last from all the objects that museums have collected, all the buildings that archeology is trying to reconstitute?

The true low point of the pre–Middle Ages came sometime during the sixth and seventh centuries. Around 590, there was even an outbreak of that demoralizing epidemic called the plague. Gregory of Tours deplored the disappearance of too many schools and the end of written culture. His own book (580) and the poems by his friend Fortunatus indicate that literary sources and examples still existed, despite the general slide toward illiteracy that accompanied the neglect of religious buildings. A chain of scholars, or at least of writers, nevertheless provided a certain continuity up to the Carolingian revival, a renaissance that assumes its full meaning when it is realized that the choice was between antiquity and the church doctors, or nothing.

But despite this rather inglorious end, Merovingian kings became a part of local tradition and, better still, picturesque characters like Clovis and Clotilda, Dago-

bert and Eloi were subsequently the object of a strange intellectual misconception. "Seventeenth-century archaeologists, unfamiliar with the genius of the Middle Ages, helped to validate the idea that the images of former kings adorned the portals of twelfth-century churches. Montfaucon, in *Monuments de la Monarchie Française*, was convinced that the eight large statues on the portal of Saint-Germain-des-Prés (now destroyed) represented seven princes and princesses from the Merovingian period, accompanied by the bishop–saint Remi. Montfaucon even named them, affirming that they represented Clovis, Clotilda, Chlodomer, Theodoric, Childebert, Queen Ultrogoth and Chlotar."[41] This "Benedictine misconception"[42] was so widespread that the royal portals of churches in Saint-Denis, Chartres, and Le Mans were interpreted in terms of the history of France rather than from the standpoint of the Old Testament Book of Kings. The result is well-known: the pure and simple destruction of statues purportedly symbolizing detested oppression and monarchy during the French Revolution. In 1793, the members of the radical Jacobin club and their followers struck down the figures of the first "race

of kings" that incarnated the fateful union of Throne and Altar.

Yet what was the cause of this misconception? There are reasons for thinking that it went way back, that it had its roots in popular wisdom. In fact, reference to Merovingians was used to authenticate the founding of early monastic edifices. In the refectory of Saint-Germain-des-Prés, there was a statue of Childebert on the pier of the portal, placed there during the time of Abbot Simon (1239–1244); this work, noble if somewhat conventional, is now in the Louvre. Another example was the abbey of Moutiers-Saint-Jean in Burgundy, which flattered itself on its ancient origins. Clovis and Chlotar were supposedly its founders, and their statues were placed on either side of the portal erected in the late thirteenth century (now in The Cloisters, New York). This is not the only example of the commemoration of Merovingians during the Gothic period, as witnessed by the tombs Louis IX (Saint Louis) had built in Saint-Denis. Given the metaphorical parallel, it was quite natural that the medieval imagination should conflate the sons of Merovech, ancestors to the Christian monarchy, with the gallery of Biblical kings, ancestors to the Savior.

III
CAROLINGIANS

(750–850)
ASPIRING TO GREAT ART

The gold scepter that Charles V had made for his coronation at Reims in 1364 was specially designed. It showed Charlemagne holding the long rod and globe, his throne set on an enormous gold lily. The knob of the scepter, studded with pearls and garnets, also depicted two scenes from Carolingian legend. The king of France was thereby staking visual claim to descent from Charlemagne, in the face of Emperor Charles IV, king of Bohemia, who was no less attached to it. This was neither the first nor the last time that this distinguished ancestry was disputed. Two centuries earlier, the veneration of Charlemagne's relics at Aachen and his canonization (1166) had served the cause of the Hohenstaufens, while the portal depicting the Coronation of the Virgin at Notre Dame in Paris (circa 1220) also showed Charlemagne and Pope Leo III.

Such reminders are necessary because scholarship has had to pick its way through a dense forest of legends and tendentious interpretations which, from the tenth to fifteenth centuries, have masked historical reality. The Carolingians themselves belonged to the realm of collective

Psalter of Charles the Bald. Back panel of cover.
School of Charles the Bald's Court, 843–869.
Bibliothèque Nationale, Paris (Ms Lat. 1152).

Equestrian statue known as the "Charlemagne" statue from the cathedral at Metz. Cast and gilded bronze. Ninth century (the horse perhaps dates from the late Roman Empire). Height: 23.8 cm. Musée du Louvre, Paris.

imagination as well as to the world of fact; this was perhaps because they, too, were propelled by a utopian idea—an intellectual, artistic, and cultural mirage whose exact consequences have always been hard to assess.

During the century that ran from Charles Martel's victory over the Saracens (735) through the reign of Pepin (751–768) to the death of Louis I the Pious (840), there was an apparent attempt to fashion a powerful amalgam. An energetic dynasty shook a somnolent society awake. It still projected a "barbaric" image through traditional jewels and finery, yet it made its own cultural mark with books,

especially illustrated books, that rendered the dynasty more visible and identifiable.

The great migrations came to a temporary halt with the Carolingian empire. The coronation of Charlemagne in Rome in 800 struck the people's imagination, guaranteeing the Franks the power they had long envisioned. With greater assurance than the first "race of kings," the new lords took classical Rome as their model—interpreting it in their own way, of course. Royal architecture was defined at Aachen, and well-designed churches were erected in centers where schools flourished. In a singularly powerful allusion to Rome and imperial ideology, equestrian statues were

once again given a place of honor. An equestrian statue of Theodoric, a royal precursor, was transported to Aachen; the small bronze statue of Charlemagne or one of his sons (Louvre, above) attests to the appeal of this monumental expression of authority. No less important were the superb ivory bindings that constituted small bas-reliefs. Worth special attention are the *Drogo Sacramentary* (p. 68), with its nine compartments relating the story of Christ in a solidly paleochristian style, and the circa 850 *Psalter of Charles the Bald* (left and p. 69) with its singularly lively juxtaposition of divine images (both at the Bibliothèque Nationale, Lat. 9428 and

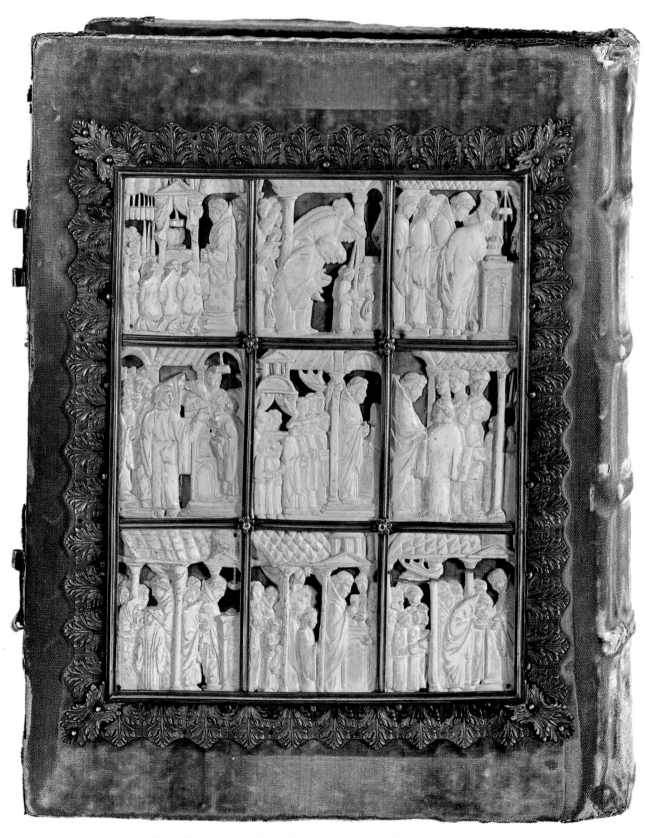

Drogo Sacramentary. Back panel of cover: the bishop of Metz celebrating a mass.
Ivory with silver mount. Metz, 850–855. Bibliothèque Nationale, Paris (Ms. Lat. 9428).

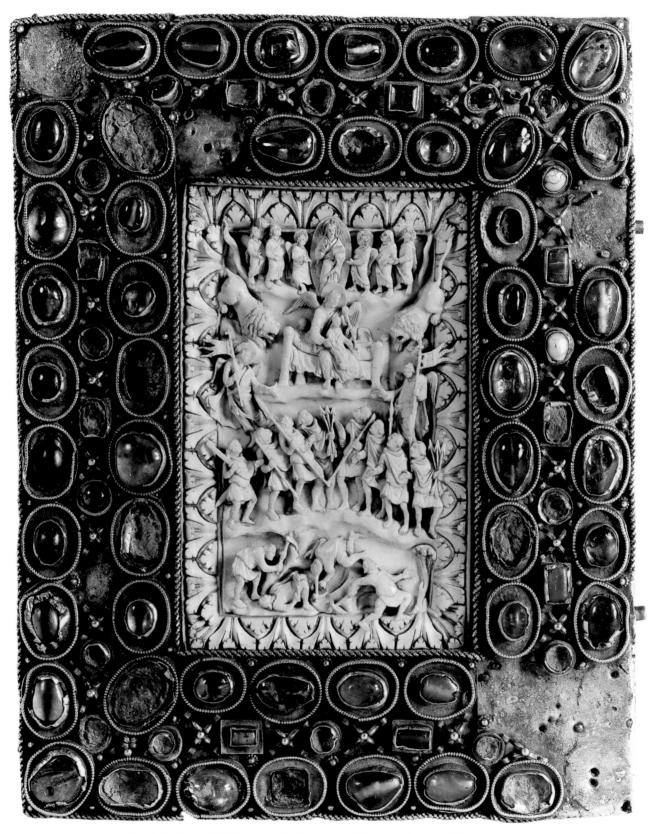

Psalter of Charles the Bald. Front panel of book cover illustrating Psalm 57, "Among the Lions."
Ivory with gem-studded filigree mount. School of Charles the Bald's Court, 843–869. Bibliothèque Nationale, Paris (Ms Lat. 1152).

Carolingian crypt of the abbey church of Saint-Germain, Auxerre.
Scenes from the life of Saint Stephen. Fresco. 841–859.

cal settings. It is the work of modern scholars to explain fully how all these elements constituted a whole. The advent and activities of the Carolingians, in deliberate and regular communication with Lombardy, the Rhineland, Saxony, and Spain, should underscore the fact that what happened in Gaul—which had become Francia—was merely one episode (if a crucial one, for the French) in the interrelated history of the West.

In certain respects, religious architecture did little more than confirm prior designs by imitating and amplifying them when rebuilding was required. The key event was the reorganization of the regular clergy of cathedral churches, which finally took place. Canons had to conform to what was rightly called the *vita canonica* in a setting similar to a monastery (chapter house, refectory, etc.). In Metz, Lyon, and Vienne, the founding of a chapter led to the erection of a new church near the cathedral group. In old town centers such as Chartres, a coherent group of buildings sprang up around the bishop's seat—the bishop's palace, hospital, and cathedral group with baptistery. A construction system thus took shape which, if it can be rightly dated to the eighth and ninth centuries (as now seems possible after many minute analyses), constituted a capital development insofar as it permanently bound together a number of disparate structural features such as the arrangement of arches and segmented piers, bell towers, and an ambulatory ringing the apse. Episcopal churches in poor condition were renovated along these lines (which presupposes competent labor). In cities like Le Mans and Reims, churches arose with surface areas roughly equal to those of thirteenth-century cathedrals. The so-called Basse-Oeuvre Church in Beauvais was built in basilical form (nave and two aisles) with courses of small stones.

A more affirmative use of stone led to a relatively new type of church with crypt and tombs, designed for pilgrimages and

Lat. 1152 respectively). These carvings represent a synthesis of contemporary sources of sculpture. Several scenes are remarkable in the way they group figures and in the narrative quality of their composition. Faithful to the frieze-style organization of classical models, reliefs of this type sufficed to sustain interest in sculpture, to the great benefit of the Romanesque age.[43]

Artistic "reappropriation" was based on borrowings from late classical models, often from Ravenna, and represented above all a grand recycling of "treasures" in which gold and gems played a key role. Precious metals and fabrics were major signs of wealth. Everything that came from Byzantium or the Sassanid world was appreciated, strangely inserted into classi-

relic worship. Carolingian crypts, located below the east end of the chancel, encouraged meditation near sacred remains. A number of major examples were built, especially in northern France—Saint-Médard in Soissons (underway by 841), Saint-Philibert in Grandlieu (836–854), Saint-Germain in Auxerre (after 841–859, left), and Flavigny (after 860). The same approach was also used in the Rhineland, at places like Saint-Gall (which set the example) and Cologne.

Other designs were explored. Since a stone vault was the normal way to honor either the body of a saint or an altar with reliquary, many churches in the ninth to eleventh centuries were built with a vaulted chancel but a wood-beamed nave. Crypt altars, non-existent in the previous period, became common during the Carolingian age. This trend, inspired by an ever-growing devotion to relics, should probably be linked to the appearance of Eastern-style rotundas over the choirs of certain churches. Byzantium, in fact, had established the great *martyrium* model of Christian commemoration by adapting the plan and vaulting of classical mausoleums to the worship of martyred saints. This powerful architectural model effectively symbolized the hereafter.[44] Such architectural "appurtenances" were frequently found in Burgundy: Saint-Germain in Auxerre, Saint-Pierre in Flavigny, etc. Additional architectural spaces of this sort appeared in the ninth and tenth centuries, raising questions as to their use. In several specific cases, at least, they seem to have harbored not a holy body but a sort of secondary reliquary, becoming oratories designed to facilitate the veneration of relics by separating them and making circulation easier, in a prefiguration of the ambulatory with radiating chapels that would soon come to the fore.[45]

CENTULA ABBEY
Founded by Angilbert, a close associate of Charlemagne, Centula Abbey in Saint-Riquier (below) was a key project. Completed in 788, the highly active monastery originally boasted a large church and housed three hundred monks (destroyed in 881 by the Norsemen, it was rebuilt in the eleventh and twelfth centuries). It contained four imposing chapels, including one that "sparkled with gold, incrusted gems and precious colors" (*Life of Angilbert*). That is to say, spectacular mosaics extensively covered the walls, especially in the apse. Did a specialized industry exist on the site, or was it expressly imported? Whatever the case, Carolingian undertakings required excellent labor.

In places like Verdun, Cologne, and Fulda, experiments were even made in constructing churches with two opposing apses at each end of a long nave.[46] This bold design had been adopted in the Rhine region for the grand sanctuaries built for the rulers of the Ottonian dynasty (tenth and eleventh centuries) but had little subsequent impact in the western part of the empire.

Centula Abbey (Saint-Riquier, Somme) during the Carolingian era. Seventeenth-century engraving. Bibliothèque Nationale, Paris (Est. Va. 80).

Suger's Eagle, from the abbey church of Saint-Denis.
Antique porphyry vase with twelfth-century silver gilt mounting.
Height: 43 cm. Musée du Louvre, Paris.

SAINT-DENIS

And then there was the new Saint-Denis. In the old basilica made famous by Dagobert, Fulrad (acting on behalf of Pope Stephen II) conducted a royal anointing of Pepin and his two sons in 754. This was a major initiative that linked a new rite to the basilica in Saint-Denis (as distinct from Reims, where the coronation took place). Saint-Denis therefore required a new extension—a chancel with angled corners and a transept that recent excavations have brought to light. Painted stucco decoration and major furnishings were added. The result was that henceforth the *regalia*, that is to say the emblems and instruments used in the sacred coronation rite (to which was added the famous pennant starting with Louis VI), were deposited at Saint-Denis when they were not kept with the royal treasure. Once again, a luxury craft was revived or instituted, for some local workshop delivered not only a gilded lectern but also the bronze doors (which thus became part of the imposing series of monumental doors found in Rome, Verona, and Hildesheim). These were of course exceptional pieces, precisely because it was essential to mark the grandiose nature of the sanctuary. The church already owned rare and ancient items such as an agate cameo from the cross of Saint Eloi, a two-handled agate cup transformed into a chalice, and an extraordinary porphyry vase from late antiquity (that Abbot Suger would transform into an eagle in the twelfth century, above).

Everything was henceforth in place. It might be recalled that the Irish theologian Johannes Scotus Erigena, who lived in France between 840 and 847, had produced a Latin translation of and commen-

tary on the mystical writings of Dionysus (or "Denis") the Areopagite. This influential text enhanced the prestige subsequently enjoyed by the Abbey of Saint-Denis, for it presented the universe as theophany (the divine manifestation), and it taught that divine illumination necessarily evolved toward total splendor by degrees—a lesson which would not be forgotten by Abbot Suger when he decided to renovate the church. Three centuries earlier, however, the Carolingian sanctuary was already magnificent.

THEODULF'S VILLA

Another important building or vestige is Theodulf's *villa* at Germigny-des-Prés on the Loire River. The chapel, appallingly restored in 1889, was in the form of a Greek cross endowed with four apses and topped by a squinched dome. Uncoincidentally, correlations have been established between this church and others from Catalonia (San Miguel at Terrassa) all the way to Armenia (Etschmiadzin Cathedral)—similar structures could be found literally from one end

of the Mediterranean Sea to the other.

The *villa* itself at Germigny-des-Prés was decorated with paintings described by Theodulf: "antique" cycles like the liberal arts and the four seasons, whose nature can be more or less inferred, though nothing of them has survived. In the chapel, the apse mosaic (below) depicts a theophanic vision of the Ark of the Covenant guarded by cherubim (though without the divine face, in accordance with the Carolingian court's unfavorable attitude toward images of the Lord).

The Ark of the Covenant, Cherubim, and the Hand of God. Apse mosaic in the former chapel
of the *villa* belonging to Theodulf, bishop of Orléans. c. 800. Parish church, Germigny-des-Prés (Loiret).

Godescalc Evangelistary. The Fountain of Life.
Illumination on parchment. School of Charlemagne's Court, 781–783.
Bibliothèque Nationale, Paris (Ms. Nv. Acq. Lat. 1203, fol. 3v).

Right: the first *Bible of Charles the Bald*, also known as the *Vivian Bible*.
Frontispiece from the Book of Psalms: David surrounded by his guards and musicians.
Illumination on parchment. Tours, 845–846. Bibliothèque Nationale, Paris (Ms. Lat. 1, fol. 215v).

Another vestige of ninth-century painting can be found in the crypts at Saint-Germain in Auxerre. A chapel dedicated to Saint Stephen boasts three frescoes depicting the life of the saint, including a stoning scene with a large, lively figure of the martyr vigorously painted in greens and browns, plus two portraits of bishops reminiscent of classical funerary portraits. There is every reason to believe that a great number of other painted cycles also existed.

PAINTED BOOKS

Books have already been mentioned. One of Charlemagne's claims to celebrity, according to his biographer Einhard, was that he advocated education, a return to "letters," and the production of books. It is true that the scriptoria, by copying ancient texts in so-called Carolingian writing, constituted a critical link in the chain of Western culture.

The production of "fine books" became widespread. A Frank named Godescalc was commissioned to prepare an evangelistary (completed in 783) based on a late classical model (Bibliothèque Nationale, Nv. Acq. Lat. 1203, p. 74). His successors also drew on late classical

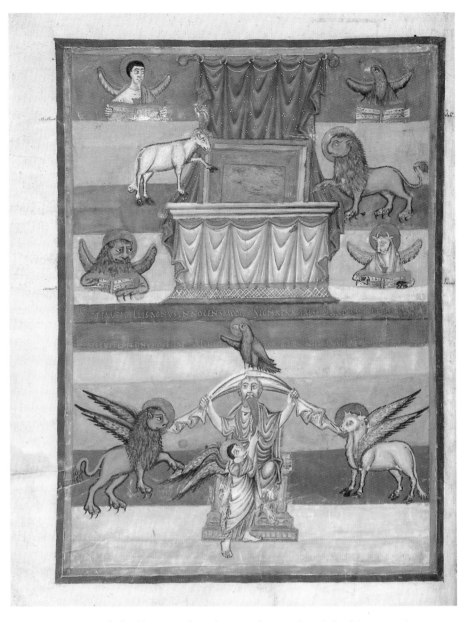

Moutier-Grandval Bible. Scenes from the Apocalypse and symbols of the Evangelists. Tours, 825–850. British Library, London (Add. 10546, fol. 449).

Drogo Sacramentary, illuminated capital letter: the Ascension. Illumination on parchment. Metz, 850–855. Bibliothèque Nationale, Paris (Ms. Lat. 9428, fol. 71v).

models, though in a different style. The frontispiece would usually present synoptic tableaus in an architectural framework, employing an unmistakably elegant style typified by animals running across pediments, fluid outlines, fluttering togas, rounded clouds, crenelated edges, etc. This style is obviously important to the history of painting for what it retained of the antique manner, namely animated, vigorous forms rather than solemnity.

Alcuin (735–804), the English theologian and teacher recruited by Charlemagne, set up a center for biblical studies in Tours, where there was a steady and prolific production of manuscripts, often characterized by "antique style" narrative friezes (*Moutier-Grandval Bible*, British Library, London, Add. 10546, above).

Above and right: *The Ebbo Gospels*: Saint Mark
and details from the Canons of the Gospels.
Hautvilliers Abbey, 820–830. Bibliothèque Municipale, Epernay.

Figures of Roman warriors surround the psalmist (p. 75) in the first *Bible of Charles the Bald* (Bibliothèque Nationale, Lat. 1). On the *Drogo Sacramentary* mentioned above, figurative motifs (left) are inscribed with amazing skill in the foliage of illuminated capitals (Bibliothèque Nationale, Lat. 9428).

Scholarship has also established the importance of Reims as a center of painting and visual expressiveness during the Carolingian period. Archbishop Ebbo (816–835) played a key role. He was responsible for the *Ebbo Gospels* (820–830, Epernay, Bibliothèque Municipale, above), as well as the masterpiece of the new

"ancient style" culture: the Hautvilliers psalter (between 820 and 830), now known as the *Utrecht Psalter* after its final location (Utrecht University Library, Ms. 32). With its 166 illustrations drawn from second- and third-century models, it constitutes a veritable repertoire of Roman painting. It was recopied and imitated for two hundred years all across northern Europe as well as in the Tours and Meuse regions. Its success within scriptoria, its wide distribution, and its influence on all other arts were exceptional.[47] There were three successive English "remakes" right up to the early thirteenth century, that is to say the moment when the vigorous, lively, "impul-

sive" aspect of the figures hardened, and the fluid space was enclosed in disfiguring linear frames.

Thus, in the ultimately limited Carolingian process of *renovatio* or "acculturation," what is now called art inevitably played a highly visible, almost privileged, role—one that would not be forgotten.

Pursuant to the artistic and social importance of Reims, one example will

illustrate how complex problems often arise. The fame of Saint Remi was well established, and during the sixth century the chapel where he was buried outside the city walls became a large basilica. The basilica itself later became a veritable royal necropolis once the Benedictines moved in during the Carolingian period (late eighth century)—several members of the dynasty were buried there, including the last Carolingian kings, Louis IV *d'Outremer*, Lothair, and Louis V (died 987). Despite the ravages of wars and the French Revolution, fragments of the tombs were found after 1920, notably including a superb head of Lothair, identified thanks to Montfaucon's early eighteenth-century drawings. Yet, as the head's accomplished style demonstrates, Carolingian tombs were redone and royal figures reworked by pious hands sometime around 1130. Meanwhile, the tomb of Archbishop Hincmar (c. 806–882), renovated during the twelfth century, may have been one of the very first examples of a tomb recessed into the wall, if the renovation was faithful to the original design.[48] All this means that Saint-Remi in Reims played a complementary role to Saint-Denis in consecrating the Carolingian heritage. Saint-Denis was the site of the *regalia*, or monarchic emblems, part of a treasure that the Capets would preserve with the same ardor as the Carolingians. Yet it was Saint-Remi that, starting in the ninth century, housed the Holy Vial miraculously brought from heaven by the saint himself to baptize Clovis, according to Hincmar's account. So coronation took place at Reims, burial at Saint-Denis. The monarchy's ritual apparatus was thus installed in France's two great "places of national commemoration."[49]

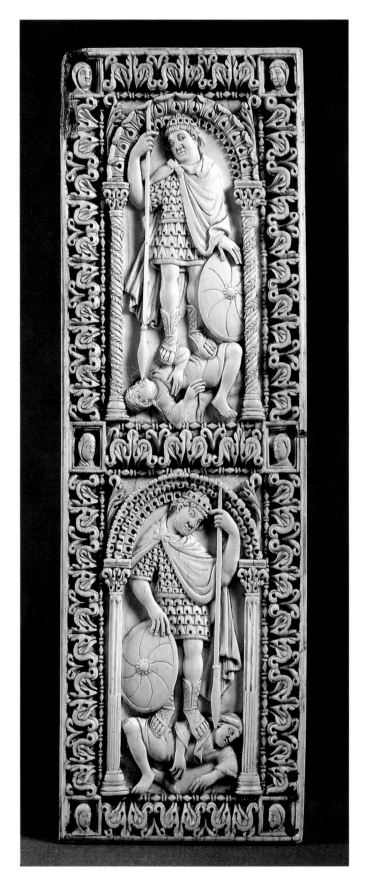

Section of an ivory diptych
from Ambronay Abbey (Ain).
School of Charlemagne's Court. Ninth century.
Museo Nazionale del Bargello, Florence.

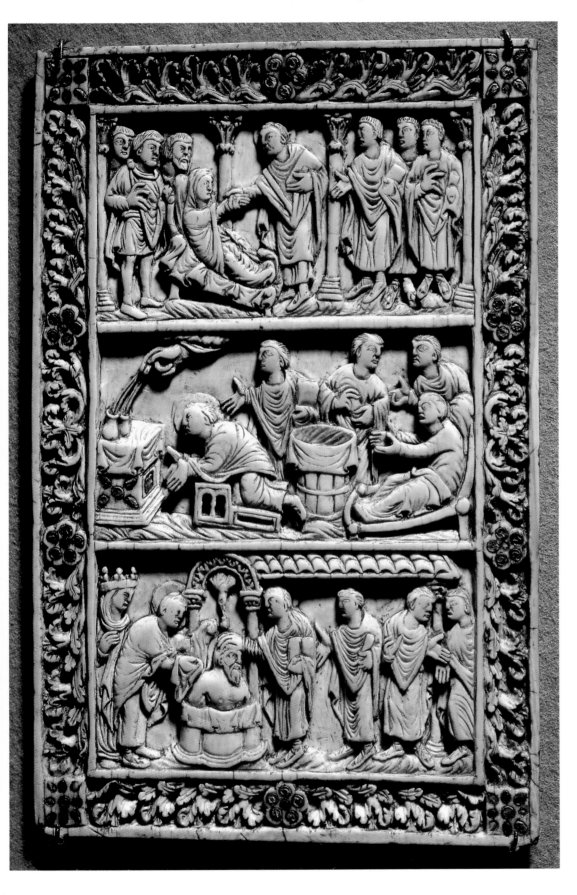

Book cover:
Miracle de Saint Remi.
Ivory inlaid with bronze.
Reims, c. 880. Height: 18.3 cm.
Musée de Picardie, Amiens.

IV A TROUBLED CENTURY

(850–987)
OF TREASURES
AND SCRIPTORIA

In the mid–ninth century, the Carolingian empire began to collapse under its own weight. It was divided into three enormous pieces at the partition of Verdun in 843.

East Francia, bequeathed to Louis II the German (804–876), had a brighter future than might have first appeared. In the following century, Otto I, known as Otto the Great (912–973) would supersede the last Carolingian and become Holy Roman Emperor in 962. The dynasty he founded almost represented a new phase of the Carolingian Renaissance—this time purely Germanic, Saxon, and Rhenish, producing major religious art that had no equivalent in the West.

Meanwhile, the kingdom given to the turbulent Lothair I (795–855), brother of Louis II, largely wound up falling into the hands of the powerful Ottonians (925).

As to West Francia, it fell to Louis's half-brother, Charles the Bald (823–877), at

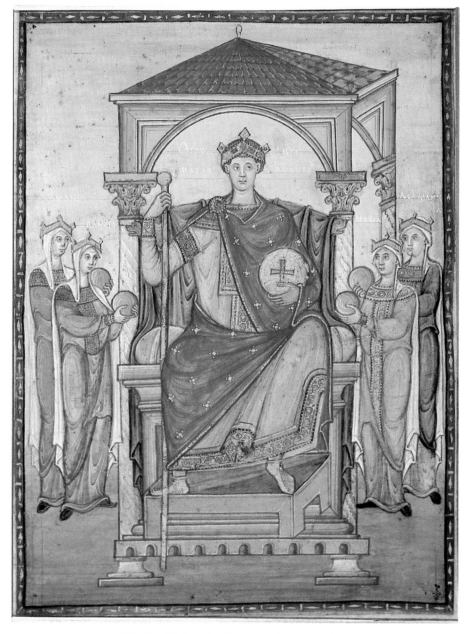

The Otto III Gospels: Nations pay homage to Otto. Germany, tenth century. Musée Condé, Chantilly.

a time when the Atlantic seaboard (which he inherited, so to speak) was undergoing the worst assaults the renascent Christian world had ever known. Overwhelmed rulers clung to appearances of authority, as had the last Merovingians, for nearly a century. But like their predecessors, they were eclipsed by energetic warlords better able to withstand the invaders' onslaughts. The family of Robert the Strong finally won out when it had Hugh Capet proclaimed king in 987—the precocious designation of Hugh Capet's son, Robert the Pious, as heir to the throne ten years later confirmed the advent of France's third dynasty, one that would last until 1792.

Although it is important to cite these facts, they often create a fallacious image of those remote times. Everything since the third century appears as one long struggle between natives and invaders, constant conflict between rival masters, endless attempts to eliminate the Visigoths, roll back the Saracens, halt the Huns. Gaul was dominated and, in a sense, protected by Germanic conquerors. But this reading of facts too glibly masks the slow passing of time for the Gallo-Roman population with its vintners, its farmers, and above all—from the standpoint of this book—its artisans, who survived events that did not directly concern

them. For such people, the enormous institution of the church provided work or, more often, a preferable form of submission. Francia was highly populated, active and dotted with interesting buildings in towns and even villages. The north was already quite different from the south, probably in terms of language and certainly in terms of customs and worship.

In the middle of the ninth century, however, the more or less satisfactory stability of everyday life was shattered. This time, Western Christianity was subjected to pillaging, brutality, burnings, abductions—in short, an apparently irreversible rupture. Each generation that might have repaired

the damage and recovered its strength suffered, in turn, a discouraging blow. The invaders were primitive, unscrupulous, well-equipped Norsemen who arrived from Jutland in swift ships. In 843, the year the kingdoms were divided, Viking raids began at the mouth of the Loire—swift, determined, devastating, interested only in booty. In 843–845, fifty or a hundred Viking ships laden with hefty warriors sailed up the Loire, Garonne, and Seine rivers. The worst moment came toward the end of the century, 879–891, when the list of disasters was long and straightforward. By 845, the exemplary Centula complex and the poor Saint-Germain-des-Prés

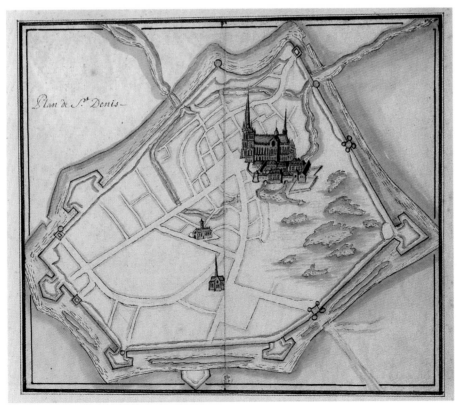

The Abbey of Saint-Denis within a walled enclosure.
Watercolor. Bibliothèque Nationale, Paris (Est. Va. 93).

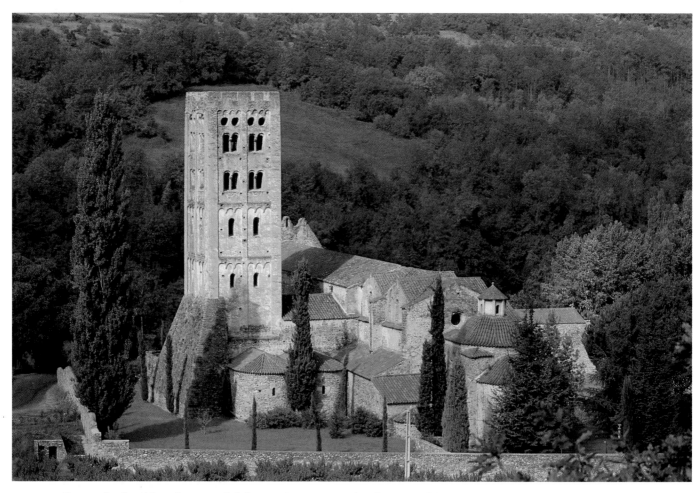

Above and right: Abbey of Saint-Michel-de-Cuxa (Pyrénées-Occidentales), view of the southeast flank and of the interior. 960–970.

monastery had already been destroyed; in 863, the Norsemen swept down as far as Clermont in Auvergne. Aquitaine to the south, however, like Burgundy, was in theory less vulnerable.

The invaders could sometimes be bought off, as when Eudes saved Paris in 884 or when Emperor Charles the Fat gave them gold so that they would pillage Lothair's Burgundy instead. A single fact suffices to convey the climate—in 869, Charles the Bald protected the Abbey of Saint-Denis and its outbuildings with a *castellum*, or surrounding wall and garrison (p. 81). Everywhere it was a question of defensive measures, just as five centuries earlier when Gallo-Roman towns had been obliged to withdraw into themselves. The

situation was, in a sense, more serious—fires were burning everywhere. The basilica of Saint-Philibert in Grandlieu, south of Nantes, which dated back to the early ninth century (as established by recent excavations), was totally devastated (the nave and some of the chapels would be rebuilt in the eleventh century).

What actually happened? As soon as the sinister, dragon-prowed ships appeared, monks fled with their relics and treasures, the invaders' favorite prey. Benedictine abbeys were sufficiently numerous to provide shelter for the population long enough to let the storm—which did not necessarily reach every monastery and town—pass. In a typical example of successive retreats, the monks

of Saint-Philibert fled Grandlieu in 836, taking their relics to Burgundy, where they found refuge at Tournus on the Saône River. But this town on the edge of the empire was threatened by the Hungarians. After another retreat toward the Auvergne region, it was only in 949 that the community settled permanently in Tournus.[50]

This created a strange and disastrous situation, which must be assessed as lucidly as possible in order to appreciate the "miracle" that followed, the major sign of which was the reconstruction of churches. First, there was a concentration of farms and houses around strongholds or less-vulnerable zones; second, abbeys assumed a more active role once reserved for the long-established clergy, even

becoming, in the southwest for example, auxiliary administrative centers.

The Saracens, meanwhile, were solidly entrenched in Spain and were masters of the Mediterranean, periodically threatening cities on the coast and even inland, reaching as far as the Valais region. In 940 they destroyed the large, late eighth-century abbey of Saint-Maurice at Agaune. Only central provinces like Burgundy were spared such invasions. This may explain the establishment of a large Benedictine center at Cluny in Burgundy, where Abbot Odon built the first church dedicated to Saints Peter and Paul in 915, followed fifty years later by a second church during the time of Abbot Mayeul. A remarkable development occurred here—since the order's authority was constantly growing, the fifth abbot, Odilo (994–1048), acquired unprecedented influence and power over a network of monasteries oriented notably toward Spain. Carolingian influence had previously extended in that direction, and links were forged once again through the pilgrimage to Compostela. In 987, the church of Santiago (Saint James) was destroyed by an Arab raid, a reminder that Compostela constituted the frontier of Christianity. But worship began again immediately, and the sanctuary at "land's end" exercised its powerful attraction over Christian crowds for another two centuries.

The circulation of architectural models that naturally resulted from such contact is not easy to retrace, however. Dates remain uncertain, though perhaps less vague than they might seem. Buildings from the period circa 1000 or shortly after established designs proper to the new Romanesque movement, even if renovated subsequently. At Saint-Michel-de-Cuxa in the eastern Pyrenees (above), a Benedictine abbey was built circa 960–970 whose horseshoe arches suggest the builders were Mozarab (Christians under Moorish influence). But fifty or sixty years later, the edifice was completed by two large, Lombard-style bell towers (of which only one survives) with progressively large openings toward the top. In the twelfth century, it received its famous pink cloister (now preserved in part at The Cloisters in New York).

The big surprise, however, occurred in northern France, when the terrible Norsemen finally reached an agreement in 911 with one of the last Carolingians, who granted them an entire province, one of the richest in Francia. This would become Normandy. For two hundred years, it served as the conquerors' base for bold and usually successful expeditions to England and Sicily. Norman dynamism was such that the province granted to the obscure Rollo became one of the most active in Francia in terms of new building. Right from the tenth century, then, major labor resources were drawn to and retained in the new duchy.

FEUDALISM AND CASTLES

More or less everywhere, fragmented power passed to local lords or determined chiefs (sometimes simple adventurers who led a band of men), who dominated an area by warding off pillaging invaders every now and then. This was the origin of control over exploitable land by many small lords who, by constantly battling one another, gave birth to what is called feudalism. The relationship and rivalry between liege lord and vassal concerned above all the right of fortification: a *castellum* (fortress) or *firmitas* (fortified house) with a ditch and, in general, a stockade. When Charles the Bald in 864 announced his intention of erecting a series of fortresses to dissuade pillaging Vikings, such fortifications were still a royal prerogative. Like everything else, however, this right became diluted. In certain western and central regions, fortresses had become veritable entrenched camps, often mentioned in chronicles, with a central courtyard and outer stockades. By the late tenth century (or perhaps earlier) the *castellum* emerged, a strong wood dwelling (that evolved into the *donjon*, or keep) perched on an artificial mound. People thus protected themselves against neighboring lords and suzerains who indulged in banditry. Hence during the tenth century over

Loches Castle (Indre-et-Loire).
View of the keep.
Late eleventh century.

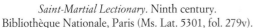
Saint-Martial Lectionary. Ninth century. Bibliothèque Nationale, Paris (Ms. Lat. 5301, fol. 279v).

The Gospels: the lion of Saint Mark. Manuscript from Saint-Amand Abbey. Ninth century. Bibliothèque Municipale, Valenciennes (Ms. 69).

ten thousand fortified residences, more or less meriting the name of "castles," appeared all over the land. These remarkable structures sometimes coincided with earlier habitations, thereby transforming a great number of previously established sites. Building materials were taken from France's abundant forests—oak rather than chestnut—using waterways as means of transportation. All this required a significant labor force in many instances prior to the year 1000, without which 150 *castella* in the Charente region alone could not have existed by the eleventh century.

Yet a question on the nature of these constructions remains open. "If it is acknowledged that the large stone towers in the eleventh century derived from the stone *domicilium* of a prior *castrum* rather

than from the wooden *turris* of terraced fortresses, there is no longer any reason to presuppose a revolution in the art of building castles in the eleventh century, but rather a natural evolution spurred by advances in siege techniques."[51] In short, it is important to distinguish military structures—mound and wooden tower—from the ancient concept of fortified residence, which ultimately produced the keep. This evolution has been detected at Montbazon and Loches (p. 85). The large, regular mass of the keep, which in itself sums up the feudal system, was in gestation prior to the year 1000.

MIRACULOUS "IDOLS"
Something more serious and perhaps more profound was occurring among iso-

lated populations that had difficulty communicating with one another. Suffice it to say that for one hundred and fifty years or so the only communication was oral. Writing was practiced only in monastic centers, where chronicles were compiled. So it was a great period of fables and legends, indeed fabrications. The so-called *Gesta Dagoberti* (ninth century) attributed the founding of the Abbey of Saint-Denis to the Merovingian king Dagobert, complete with fictitious documents. Almost everything written down transfigured—even falsified—history.

Since piety called for miracles, which were associated with the possession of relics, numerous tales (initially oral, then recorded) accompanied venerated remains. Each major sanctuary tended to

constitute its own collection by acquiring or even stealing *memorabilia*. Every "treasure" became fertile ground for fantastic tales reflecting the joys and terrors of humble people. These stories were recounted to the only available chroniclers, the monks, who had their own preoccupations, notably focused during a certain period on the reading and illustration of Saint John's apocalyptic Book of Revelations. This "dark age" should not be imagined therefore as a time of mental emptiness or despair, but rather one of feverish imagination that attached exceptional importance to prestigious figures, objects, and sites. As might be expected, books favored a somewhat rote mental activity (if sometimes highly cultivated), whereas the predominantly oral culture lent folklore an unprecedented scope.

In short, this created a situation in which monks—guardians of the Scripture that they copied, glossed, and illuminated—focused their piety on books, plus the chanting of psalms. The Christianized masses, meanwhile, with no access to these instruments, tended to worship fascinating, benevolent relics that were lavishly presented, offered as a reward at the end of an itinerary they traced. An entire society was built around this situation.

The famous statue of Sainte Foy at Conques is the main vestige of what was then a common practice.[52] A mask taken from a statue, perhaps dating from the Late Empire, was placed on a wooden frame (in this case probably when the relic was appropriated during the third quarter of the ninth century). It was then endowed with a prodigious covering of gold and gems (here, sometime before 1000). Thus, in 1010, Bernard d'Angers, coming from the north and initially scandalized by southern veneration of statues other than those showing Christ on the cross, ultimately praised it as "the richest piece in the [church's] treasure." That, at least, is how the story goes in the

Apocalypse. Latin manuscript from Saint-Amand Abbey.
Ninth century. Bibliothèque Municipale, Valenciennes (Ms. 99).

Miracles de Sainte Foy. Bernard's somewhat inquisitorial visit can be explained by the statue's far-flung fame, and by the fact that the abbey at Conques lay on one of Western Christianity's new pilgrimage routes. On this score, as on almost every other, the uncertain and difficult days of the ninth and tenth centuries paved the way for eleventh-century advances more than is generally believed.

Special Situations
Limoges
Occupying a pivotal location between north and south, Limoges was implicated in conflicting political trends. It nevertheless constituted a creative center due to its school of music. The upper town, erected on the site of the Roman *civitas,* had the usual set of episcopal buildings. Saint-Etienne Cathedral, built on the site of a

Bible of Saint Martial: canon of the Gospels. c. 950.
Bibliothèque Nationale, Paris (Ms. Lat. 5, II, fol. 134).

and copies of contemporary Byzantine ivories that undoubtedly arrived via Germanic routes. Located on the border between north and south, the large abbey in Limoges would soon turn toward Aquitaine [southward]."[53] Artisanal eclecticism welcomed various sources, but what was lacking was a determined, explicit style. It would not be long in coming, however. The Limoges example also underscores the fact that medieval people sang a great deal, and not only in church.

Especially revealing is a page from the first *Bible of Saint Martial* (circa 950, Bibliothèque Nationale, Lat. 5, II. fol. 134), in which the pilasters are decorated with a dense cluster of animals (left). The miniaturist remained faithful to Carolingian canons, but took liberties with the norm by introducing a brutal note into his crowd of animals; once again, two traditions are mingled.[54] Such forms had become common, probably reflecting the harshness of existence. But it may be that the scribe was exorcising his own obsessions through imagery, just as Romanesque sculptors would do later with their terrible and lifelike bestiaries. The connection is all the more legitimate in that other tenth-century illuminations from Limoges show ornamental combinations, such as two animal bodies curved toward a single head adorned with foliage, that exactly prefigure Romanesque motifs.[55]

Mont-Saint-Michel

Mont-Saint-Michel, which became a sort of "national" symbol in the fifteenth century, represented another special situation. It was in 708, during a time of great confusion, that Aubert, bishop of Avranches, had a vision in which heaven instructed him to found a sanctuary similar to the one on Monte Gargano in Apulia, where worship of the archangel Michael had been drawing crowds for over a century. Aubert did as instructed. The Norman legend precisely copied that of Italy. It had a remarkable impact, and

temple of Jupiter (fueling the legend of hallowed sites), would be replaced by a new edifice shortly after the year 1000. In addition, the third-century tomb of the region's evangelizing preacher, Saint Martial (credited with being the thirteenth apostle), inspired the founding of an abbey near the burial crypt (brought to light during recent excavations). This served as the nucleus for a second architectural ensemble that included the castle of the counts of Limoges. All of this is typical of pre-medieval development in France. Yet Limoges also had a special feature, for in the ninth century it became a remarkable center for the study of liturgical chant

based on the Gregorian principles established at Rome.

This resulted in the production of books containing antiphons, tropes, and lectionaries, that is to say musical manuscripts with noteworthy illustrations. One lectionary from Limoges (Bibliothèque Nationale, Lat. 5301) has been described as follows: "Carolingian traditions, generally diffuse, were maintained with singular fidelity at Saint-Martial in Limoges until the end of the tenth century: broadly drawn foliated scrolls, palmettes, leaves, animals . . . ; one lectionary from the abbey combines this Carolingian repertoire with even older Merovingian animal-like initials

the strange and beautiful figure of the archangel—the celestial protector who lived on high—was fervently adopted. Christianized Normans became attached to Mont-Saint-Michel; in 933 William Longsword made donations to the canons serving the church, and in 966 it was taken in hand by twelve Benedictine monks from Saint-Wandrille. There then began a series of bold construction projects with a system of crypts below the upper floor—the so-called "Church of Our Lady Underground"—that would serve as the base of a new church in 1060. Once again there was the combined effect of a revered site, the influence of southern Christianity, an attractive goal of pilgrimage, and extraordinary efforts at building.[56]

These remarkable examples demonstrate that bold initiatives could be taken in active centers even though misery and terror gripped certain regions, even though dread of doomsday troubled certain feverish minds in the cloisters. These centers were widely dispersed and Francia was not an organic entity, but the void was not total. The state of villages and towns is hard to describe—what did the urban landscape resemble in places like Reims, Paris, Poitiers, and Toulouse? Life clung to more or less ruined buildings and to the "cultural" refuges of abbeys. A comparison with Rome, whose situation is better known and whose case is much more spectacular, may help provide a picture of things in the former Gaul. In Rome, defense towers, houses, and taverns rose on the site of the forum and over temples and patrician residences. Rome lost its classical appearance and became a sort of rural town. Yet amid this wretched chaos there were not only churches famous throughout Christendom, but also monuments that sustained, far and wide, the image of Rome as *caput mundi*. As one major historian, Richard Krautheimer, put it: "Indeed, the image of Rome as determined by her past was to medieval man a reality no less powerful than politics and

Manuscript of musical tropes and prose, Abbey of Saint-Martial, Limoges. 988–996. Bibliothèque Nationale, Paris (Ms. Lat. 1118, fol. 104).

economics."[57] When Abbot Gauzlin from Fleury-sur-Loire went to Rome in 1012, it was the decline of the *caput mundi* that was the subject of his *oratorio* on the Capitol—for Gauzlin, the misfortunes of the day had nothing to do with impending apocalypse and everything to do with the decline of the ancient heritage. The obsession with antiquity during those centuries had a strange consequence. Imaginative writers of chronicles who busied themselves in recomposing the past during the seventh and eighth centuries spawned the fanciful idea that the history of the Franks was linked to the Trojans via Homeric heroes and the descendants of Hector (*Liber Historiae Francorum*). The idea spread in the ninth century (Francis of Ado's *Chronicon*) and the tenth century (*De Gestis Rerum Francorum* by a monk from Fleury). This was just one "founding" legend among others, but it shortly entered the repertoire and would acquire a sort of fabulous authority when a monk from Tours, Benoît de Sainte Maure, offered Eleanor of Aquitaine in 1165 the singular *Roman de Troie,* soon adopted by Parisian miniaturists.

PART II

THE MIDDLE AGES

The West at Work

The Romanesque Period
The Gothic Era
Aristocratic Gothic

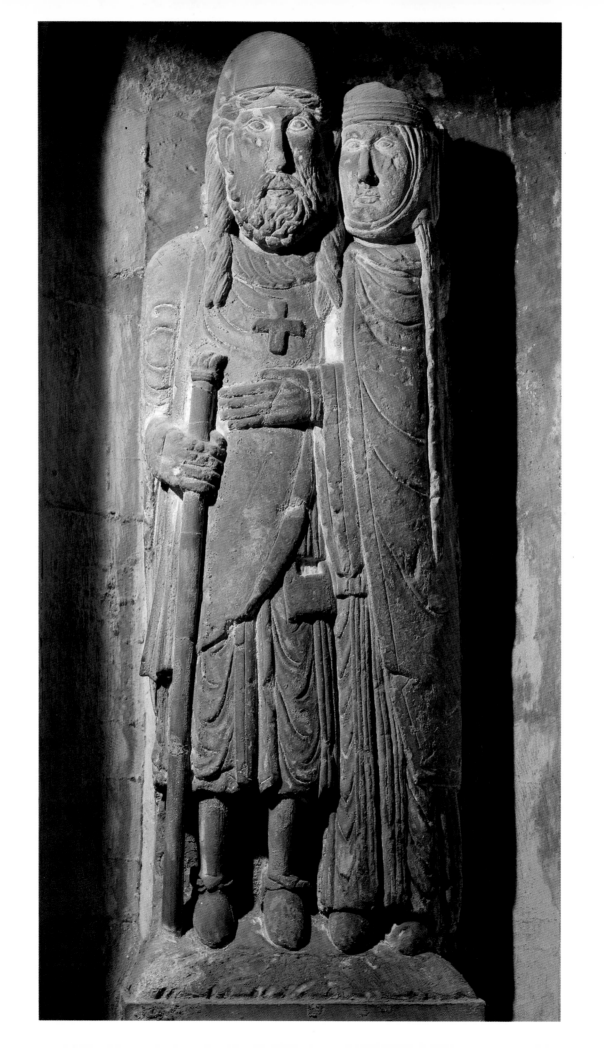

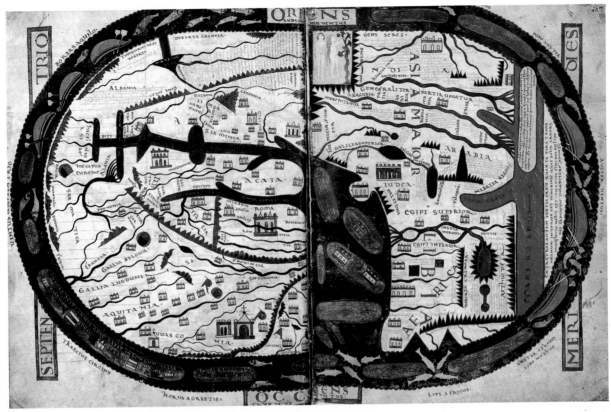

Map of the world from the Saint-Sever *Apocalypse*, an eleventh-century reworking of Beatus of Liebana's *Commentary on the Apocalypse* (776). Bibliothèque Nationale, Paris (Ms. Lat. 8878, fols. 45*bis*v–45*ter*).

Left: *Return from the Crusades* (Hugues de Vaudemont [d. 1165] and his wife, the daughter of the duke of Lorraine). Sculpture from the Belval priory. Twelfth century. Franciscan Church, Nancy.

THE WEST AT WORK

The term "Middle Ages" is unfortunate. Henri Focillon had the courage to reject it when he titled his book on the period *The Art of the West*,[1] coming to terms with the enormous production of the Christian world during five or six dense centuries by identifying major watersheds in space and time. The concern here, however, is to try to describe the role played in that imposing development by what would later be called France.

The term Middle Ages is unfortunate because such a long period can be labeled "intermediate" only through contempt, only by regretting—as doctrinaires of the classical age boldly did—that so many centuries dominated by barbarians came between ancient civilization and the "moderns" who reclaimed antiquity as their own. This viewpoint is doubly mistaken because, as pointed out repeatedly in the preceding pages, the buildings, sculpture, forms, and practices of Romanized Gaul did not magically vanish when the first Burgundian and Frank horsemen crossed the Rhine and drove their chariots to the banks of the Saône and the Loire. Furthermore, even though customs changed and *civitates* shrank as the Roman Empire went through its

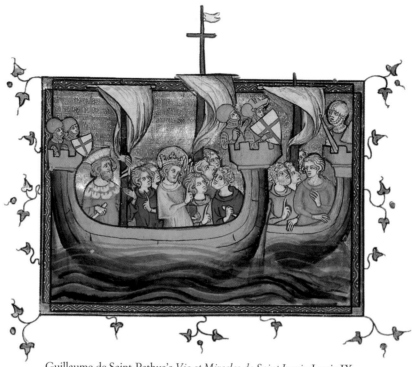

Guillaume de Saint-Pathus's *Vie et Miracles de Saint Louis*: Louis IX
setting sail from Aigues-Mortes, the Languedoc port
founded during the Crusades, 25 August 1248. c. 1330–1340.
Bibliothèque Nationale, Paris (Ms. Fr. 5716, fol. 40).

long death throes, the empire's prestige paradoxically continued to grow as it appeared increasingly remote.

This explains the strange series of scholarly "renaissances" attempted in the eighth and ninth centuries by the Carolingians, and again in the twelfth century by an intellectual movement in Chartres and Paris that has been described as being "closer to the fifteenth and sixteenth centuries than was the spirit of the following century."[2] Yet it was not merely a question of "intellectual" activities. To account for a crucial and poorly interpreted phenomenon—the birth of Gothic art—modern scholarship has had to present "the year 1200" as a pivotal period that assumed the features of a "proto-Renaissance."

A new human society, complete with the underlying coherence and ramifications of a civilization in all its plenitude, emerged in the thirteenth century under the aegis of what was henceforth France. This colossal phenomenon was almost without precedent (except in Byzantium and under the great Umayyad caliphates), and naturally constitutes the first major focus of study here. It was via artistic activity, especially architecture (which had become the envelope for all other arts), that the new plenitude took lasting shape; this volume will adopt a traditional approach to that activity, with one major exception to be explained below.

All this supposes a demographic, economic, and psychological revival of Western vitality, accompanied by a certain tempering of violence and brutality that was long in coming (if, indeed, it ever came for good). Noting the commercial revival of Baltic cities after the Norse expeditions, and a certain trade activity with newly

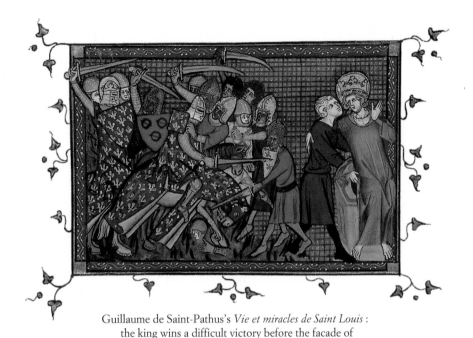

Guillaume de Saint-Pathus's *Vie et miracles de Saint Louis* :
the king wins a difficult victory before the facade of
the Egyptian citadel of El Mansura. c. 1330–1340.
Bibliothèque Nationale, Paris (Ms. Fr. 5716, fol. 199).

stabilized Muslim kingdoms, some historians like Jacques Le Goff have described the tenth century as "a period of decisive innovations, notably in the realm of crops and foodstuffs, where the massive introduction of plants . . . of high energetic value gave Western humanity the strength that enabled it to build cathedrals and clear vast fields."[3]

Domestic growth was spurred by advances in agricultural tools (such as plows with mold-boards) and more efficient use of animals (harnessing techniques), to the benefit of landowners and the religious communities that had become major landlords alongside (or in competition with) feudal masters. This development was not accompanied by any coherent political organization—almost nonexistent in the eleventh century—which makes things so difficult to explain. In fact, it was thanks to a mosaic of feudal holdings, plus agitation begun in the preceding century, that the house of Capet rallied northern France around it, whereas the south remained master of its own political organization and culture until the thirteenth century, when the momentum of unification carried the day there as well.

The major difficulty lies not in tracing this fascinating evolution—it has been done, and well, a hundred times since Michelet's pioneering history of France in the mid–nineteenth century—but in freeing oneself from the political obsession that guides most historians, understandably fascinated by the precocious birth of a fully populated and dominating nation. In the thirteenth century, France had such influence throughout the West,

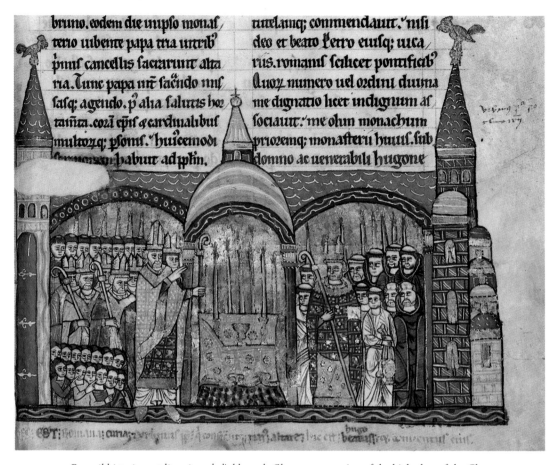

Recueil historique et liturgique de l'abbaye de Cluny: consecration of the high altar of the Cluny
abbey church by Pope Urban II, 25 October 1095. c. 1190. Bibliothèque Nationale, Paris (Ms. Lat. 17716, fol. 91).

including Naples and Cyprus, that it is tempting to focus all attention on this brilliant dynastic and historical situation. Yet it seems crucial to approach things from the angle of two concomitant factors that explain this newfound influence as much as it explains them—the Church and artistic activity.

During the eleventh century, the papacy effected—or tried to effect—an internal reform of the clergy by introducing the discipline associated with the name of Gregory VII (pope from 1073 to 1085). Once the vivid conflict of the Investitures was resolved (a struggle in which the pope opposed Emperor Henry IV, king of the Germans), the power exercised by religious institutions in France became manifest. Already the French cleric Gerbert, elected pope under the name of Sylvester II (999–1003) had talked of curbing "excesses." Odilo, fifth abbot of Cluny (994–1048) had acquired so much power that he intervened in every sphere. And it was the French pope Urban II (1088–1099) who, during a long voyage in which he consecrated nine new churches in France, broached the idea of a crusade at the council of Clermont (1095). From these events onward, the history of the Church was intimately linked to France—the Capets' relationship with the Holy See was so close that after the edifying reign of a model king, Louis IX (canonized in 1297), it was hardly surprising to see a French pope, Clement VI, transfer the seat of the Church to Avignon in 1348 in order to benefit from the (theoretical) protection of the king of France.

Scenes from *La vie de Saint Martin*. c. 1100. Bibliothèque Municipale, Tours (Ms. 1018, fols. 37 and 36v).

SAINTHOOD AND CONSECRATION

Yet the essence of the period was to be found neither in these political relationships nor the extension of projects and initiatives they allowed, but rather in a more serious and profound phenomenon—sainthood. The term is used here to refer to the spiritual dimension of existence which, in all its disconcerting manifestations (whether private or ostentatious), represented the highest value of Christian faith during this whole era. In the third and fourth centuries there had been martyrs such as Saint Denis, whose names and relics were venerated in constantly refurbished and embellished sanctuaries. Then came the age of confessors and doctors, notably Saint Martin and Saint Hilary, in whose honor inspiring churches were built. Subsequently, founders of religious orders, all issued from the Benedictine movement, became the great figures of the eleventh century— Saint Bruno, Saint Bernard, and so on. Finally, later, came theologians who taught at Paris, Saint Thomas Aquinas foremost among them.

What is the significance of this stream of individuals promoted by the church to the rank of Blessed? What did the theory of ideal models, constantly invoked and admired, really mean? Simply that Christian philosophy—Christian lifestyle—adopted a conquering attitude (though expressed differently in different centuries) toward a human world that resisted its teachings, its authority, its spectacular deployment.

Sébastien Mamerot's *Passages faits outremer . . .*
Saint Bernard preaching the Second Crusade in the
presence of Louis VII, king of France,
at Vézelay in 1146. c. 1490.
Bibliothèque Nationale, Paris (Ms. Fr. 5594, fol. 138).

Saintly individuals should not be envisaged as civil servants whose promotion was a reward for loyal service. They were people of uncommon vigor on the level of action or contemplation, often both. The extraordinary Saint Bernard, who conceived of his order as a knighthood of Christ, called for a crusade, castigated worldly clerics, and formulated rules of mystical elevation for the pure of heart. It is this tension—the focused fervor for human salvation and love of Christ—that must be fully restored to the period. Otherwise, events appear as little more than strange incidents and hollow episodes of feverish spirituality. It has to be realized that the veneration accorded to these saintly individuals throughout their lives, along with the climate of miracles that chronicles endlessly sustained, had an impact impossible to assess accurately today. A true feeling for the period must therefore be intuited through the images and edifices that it inspired.

In a sense, everything was miraculous or easily could be conceived as such. It was important, for example, that in the year 1100 admirers of the third abbey church at Cluny (known as Cluny III) be told that the design of the imposing edifice was revealed in a dream to the architect, Gauzon, by none other than Saint Peter himself. This legend was part of the monastery's supernatural "case history." The presence or evocation of "saints" encouraged people to live in the expectation (or recollection) of a miracle. All events were interpreted in this light. The third book of a chronicle by Ademar of Chabannes (988–1039), which recounted the major lines of dynastic and religious history since Clovis, included passages like "In those days, Guillaume, called Dirty-Beard, count of Mâcon in Burgundy, built a castle near the monastery of Cluny, in order to best Count

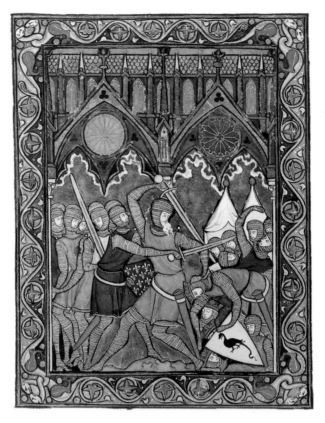

Saint Louis Psalter: Abraham, conqueror of kings. c. 1260–1270.
Bibliothèque Nationale, Paris (Ms. Lat. 10525, fol. 5v).

Hugues. This act drew divine vengeance: from that moment, he could neither stand nor walk. A few days later, Count Hugues suddenly seized the castle and razed it to the ground." Whatever the exact causes of illness, attack, and retribution, it was all assimilated to the divine protection the illustrious monastery enjoyed—indeed, could not possibly not enjoy.

Such texts, far more numerous than once believed and now well-studied by recent historians, are characterized by two features. On the one hand, they establish a simple framework of notions like that of the "three orders" (nobility, clergy, commoners) that render society comprehensible and stable,[4] and on the other hand they contain dramatic anecdotes recounting raids on castles, battles in churches, broken oaths, sudden accidents, divine threats, Moorish invasions, treason, eye-dislodging blows to the head, magnificent presents of gold, and so on.

The violence practically never ceased, despite efforts to calm stormy conflicts between big and little feudal masters—such as Odilo's "heavenly truce"—and despite the public intervention of "saints." If the chronicles are to be believed, daily life was hard, bitter, and often ghastly. These more or less "sensational" accounts should perhaps not be exaggerated, but they indicate that the primary image of existence was struggle. In this clash between rival energies, it was often necessary to identify the cruel role of the enemy. It then becomes less surprising if, at least during the so-called Romanesque period, sculptors put so much energy into depicting scenes of violence, of battles with monsters, of angels wrestling with demons.

Church of Saint-Pierre, Chauvigny (Vienne), figured capital: Satan. c. 1080–1120.

The Basilica of Sainte-Madeleine, Vézelay (Yonne). Nave capital:
profane music and the demon of lewdness. Mid–twelfth century.

The "Sainte-Chapelle" reliquary:
Saint Maximilian, Saint Lucian, and Saint Julian. Silver gilt.
Ile-de-France, 1261. Musée de Cluny, Paris.

Portable altar known as the "Sainte Foy" altar.
Alabaster, silver gilt and filigree, cloisonné enamel on copper and gold.
Late eleventh century. Church of Sainte-Foy, Conques.

Right: *The Soissons Diptych*. Ivory. c. 1300. 32.5 × 23 cm. Victoria and Albert Museum, London.

ART AND THE SACRED

The real problem stems from a simple fact. The vast artistic activity defined and described here as well as possible had only one avowed goal—to pursue, maintain, and defend the Christian message in its totality and permanence. Artists evolved within an immense tradition (*consuetudo*), which each generation sought to imitate in its own fashion. Today's modern concepts, through which the artistic activity of those days is often interpreted, are of an entirely different order—initiative, originality, imagination. It is far from certain that a contemporary of Abbot Suger or Saint Louis would have understood such language. Not only did sculptors and miniaturists not refuse to imitate, they tended to pile artistic allusions on top of one another, combining them in a effort to add that much more "authenticity" to the work.

The question, then, is the following: how did Romanesque and Gothic artists (at least until the middle of the thirteenth century) manage to be so inventive and original without ever claiming to be so? A signature was the expression of a victory or successful solution, not a gesture of arrogant personal pride. Later, however, despite the law of fidelity, tradition, and modesty that was initially manifest, signatures did come to convey that personal pride. The evolution that slowly allowed the personality of the artist to assert itself will be discussed below.

Large reliquary of Saint Fauste from
Sergy Church (Indre):
the Martyrdom of Saint Fauste.
Champlevé enamel on copper
gilt on blue ground.
Limoges, c. 1220–1230. 45 × 52 × 18 cm.
Musée de Cluny, Paris.

Right: reliquary of Saint Taurin.
Silver, copper gilt, and enamel plate.
1240–1255. Church of Saint-Taurin,
Evreux.

Small reliquary of Thomas Becket:
the murder and burial of Thomas
Becket. Champlevé enamel on
copper gilt. Limoges,
thirteenth century. 13 × 13 × 6 cm.
Musée de Cluny, Paris.

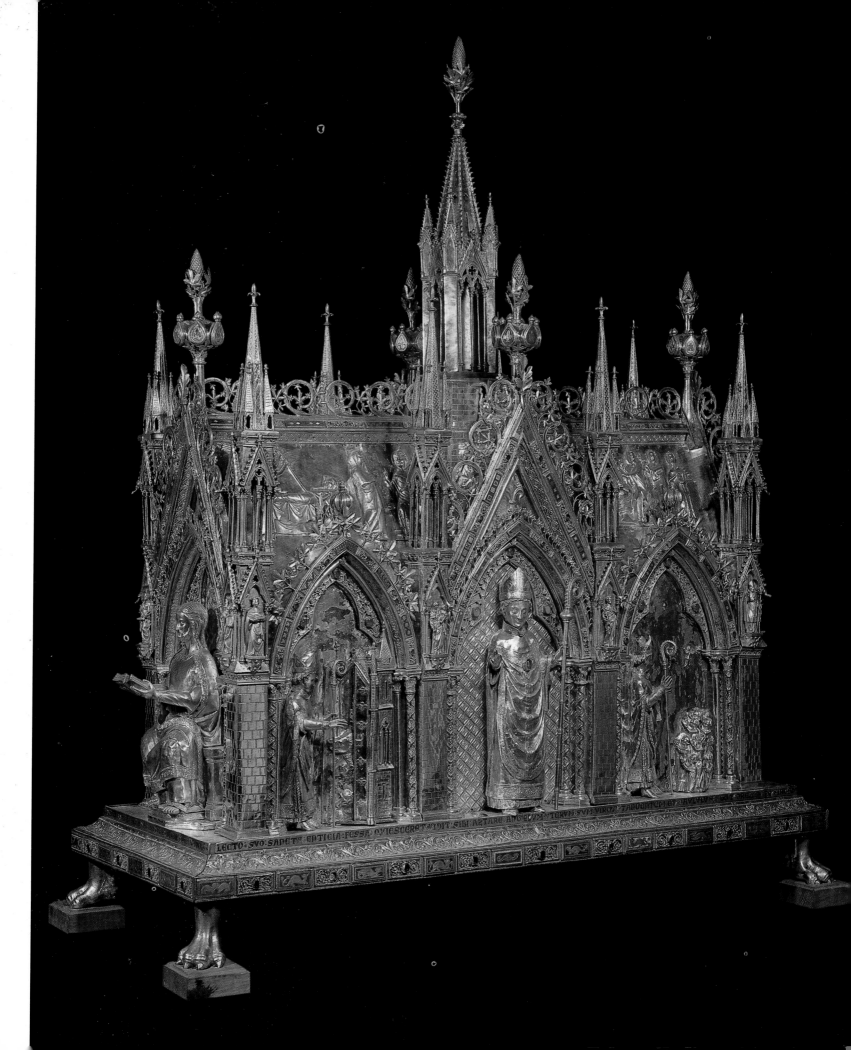

Angel of the Annunciation. Ivory. Paris.
Third quarter of the thirteenth century.
Height: 31 cm. Musée du Louvre, Paris.

Virgin of the Annunciation. Ivory. Paris.
Third quarter of the thirteenth century.
Height: 29 cm. Musée du Louvre, Paris.

Many texts of the day attest to the power of art, which has not always received the attention it merits. Why was it so essential that a relic, contact with which sanctified the end of a pilgrimage, be presented in a dazzling coffer that sparkled with gems and gleamed of solid gold (or, more often, of equally dazzling gilded copper)? Why did each sacred repository have to be magnified by an architectural setting that transformed it into a receptacle of the invisible, a space that folded in on itself, providing a safe haven and place of confidence for all?

The secret of medieval art (which ultimately loses none of its fascination) may well be that, after having forthrightly identified formal beauty with the sacred, it continues to convey a trace or feeling of sacredness today thanks to its formal beauty.

Two constant features of medieval art—the use of precious materials and highly wrought execution—can naturally be explained from this angle. By universal consensus, rarity and sparkle were the expression of wealth, and therefore had to be offered to the Lord. The concept of worldly "treasure" was transferred to the church, whose collection of valuable relics is still called *trésor* in French. But precious materials only attained pious distillation when thoroughly wrought. A dictum from Ovid, "*opus superabat materium,*" was vaunted by religious authorities to underscore the spiritual value of artistic work. They were not averse to the idea that an object, made doubly sacred by its material value and the perfection of its execution, acquired a somewhat

Coronation of the Virgin. Painted ivory with gold leaf. Late thirteenth century. Height: 28 cm. Musée du Louvre, Paris.

Moralia in Job, initial letter Q: monk harvesting.
Cîteaux Abbey. Second quarter of the twelfth century.
Bibliothèque Municipale, Dijon (Ms. 170, fol. 75v).

Letters of Saint Jerome: frontispiece.
Cîteaux Abbey. First half of the twelfth century.
Bibliothèque Municipale, Dijon (Ms. 135, fol. 2v).

"magical" quality. The consequence of these premises was not only impeccable detail, but also a tendency to multiply symbolic forms and allusions to the point of confusion. The genius of great artists or their advisers often consisted in regulating or moderating this instinctive inclination. Otherwise, attempts to pay pious homage led to the confused repetition sometimes seen in liturgical items and carved decorations. So the true sign of authenticity henceforth became the quality of execution. There finally arose a certain concern to put things in order, to eliminate extravagance and heaviness. It was this new requirement that spurred the emergence of another phase—Gothic art.

In theory, Holy Scripture governed the universe of symbolic signs that constituted sacred art. Just as exegesis was restricted to the text itself, so the figurative world was limited to a well-defined frame of reference. Indeed, Romanesque art gives the impression of unfolding violently within a narrow frame. It was only allowed to address history and nature through the prescribed grid of signs laid upon visible reality, leading to the intense manipulation of a relatively limited number of elements.

A shift of major import occurred during the twelfth century. It can be detected first among great theologians, who opened new horizons with the idea that the world of experience could participate in the permanent redefinition of faith, once it was admitted that "the sensible universe is a sort of book written by the hand of God" (*liber scriptus digito Dei*). This would translate simultaneously into mathematical exploration

Image du monde: solar eclipse. Thirteenth century.
Bibliothèque Nationale, Paris (Ms. Fr. 574, fol.101v).

whose unique merits were demonstrated by Robert Grosseteste (1175–1253), and into an investigation of individual beings as bearers of meaning (a concept henceforth authorized thanks to knowledge of ancient philosophy). This considerable innovation was notably proposed by Hugues, a theologian at Saint-Victor (1096–1141), the famous monastic school in Paris. It is no coincidence that this new view of nature coincided with "Gothic" emancipation.[5]

SECULAR LIFE

"Courtesy"—like "preciosity," a French invention—conveyed the ruling class's aspiration to elegance and moral rectitude. Since courtesy first appeared in Provençal literature with the rise of epic poetry that cultivated an atmosphere of religious struggle and perilous adventure, it is important to award the courtly code a major place in the overall picture of the culture that emerged so quickly and distinctly from the twelfth century onward. Courtesy represented an ideal of exquisite gentility and refinement, in contrast to manifestly harsh anxiety and danger. It may have been largely a question of aristocratic escapism, but it generated a contagious attitude that would have considerable impact on the figurative arts of sculpture and manuscript illumination, in both a sacred and secular context. This non-religious influence, then, should be incorporated into the general picture of the society then emerging.

Mirror case: Cupid and two couples. Ivory.
First half of the fourteenth century.
Height: 9 cm. Musée de Cluny, Paris.

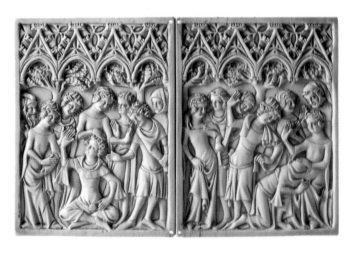

Writing tablets:
playing games known as "hot
cockles" and "the frog." Ivory.
Second half of the fourteenth
century. 9.5 × 7 cm.
Musée du Louvre, Paris.

Yet it is important to go a little further. The framework skillfully elaborated by the church attributed roles to society's three "orders," but that framework should not be taken at face value. It was theoretical, and sought to organize ideally a confused situation marked by much social mobility and ambivalence. Above all, the framework cannot account for a shared energy that it took for granted, without ever examining too closely—namely, the vitality of the Western world. Songs, for instance, existed in both north and south, and bear witness to the swift spread of traits and behavior that, like all manifestations of joy and graciousness, obeyed no status. Nor should dancing, or the penchant for wit, be overlooked, for they quickly became an important facet of manners. Neglecting such features would mean losing sight of one of the most authentic influences on artistic production, in which marginal, tangential, and comic elements were allowed to be so delightfully burlesque. Medieval humor developed alongside great art, which the Romantics realized even though they formulated it as the somewhat facile contrast of the sublime and the grotesque. Gothic cathedrals are fascinating not only for their powerful structure and noble facade, but also for the hundreds of gnomic, grimacing, apparently gratuitous and in any case bizarre figures. This Romanesque heritage is detectable everywhere on cathedral exteriors, as illustrated by the notorious gargoyles so appreciated by Victor Hugo in his "atmospheric" novel, *Notre-Dame de Paris* (1831), by Viollet-le-Duc during his nineteenth-century restorations, and by Charles Méryon when he produced a typically "picturesque" print of *The Gargoyle of Notre-Dame.*

Le Chansonnier de Paris. Playing blind man's buff. c. 1280–1315.
Musée Atger, Montpellier (Ms. 196, fol. 88r).

Le Chansonnier de Paris. Playing lawn bowls. c. 1280–1315.
Musée Atger, Montpellier (Ms. 196, 231r.).

It is therefore not sufficient to picture a society stimulated and regulated by the Christian faith alone—as was done in the nineteenth century and is still sometimes done today—when accounting for the extraordinary artistic energy that surfaced with such force in France in the twelfth and thirteenth centuries. There have long been doubts about how thoroughly the masses were Christianized, for a certain natural "paganism" was always present. One might also wonder whether all the efforts by preachers and "saints" were not mainly designed to tame violent passions, which never completely bowed to Christian morality. Far from imagining that the church had permanently won minds through ingenuity and zeal, it is probably better to picture a constant resurgence of pagan mores, instincts (or, at least, tendencies), curiosity, and interests that could not be completely contained by Christian norms. Something of the sort must have occurred to prod theologians (of which there was a magnificent series in the twelfth and thirteenth centuries), to integrate progressively a little more nature and secular thinking into their analyses. Indeed, the very development of art underscores the need to consider traces of paganism.

Nor is it any more sufficient to examine the constantly overlapping interests of ecclesiastical and secular authorities when trying to comprehend highly industrious medieval building activity. The issue arises when trying to assess the economic aspect of the terribly expensive task of erecting big abbeys and cathedrals. What were the real ambitions and interests behind such "public works"? It is not easy to grapple with this long-

Mask from the cornice of a tabernacle, from Reims Cathedral.
Thirteenth century. Palais du Tau, Reims.

overlooked question. Strong personalities were almost always involved, although sometimes a weaker personality was the key, as with Robert II the Pious who, in founding numerous churches, was a somewhat simple tool of religious authorities. It could be supposed, however, that Robert, at the very least, liked architecture. When it came to Abbot Gauzlin at Fleury-sur-Loire, who at about the same time was convinced of the need to build, the impression is one of a determined and decisive man, full of ideas. Given so many abbots and prelates who, all over the land, launched new construction projects or rebuilt their churches, it is inevitable that there was an element of competition in which personal glory was imperceptibly mixed with the desire for sanctification.

COLOSSAL UNDERTAKINGS

Available information indicates that people thronged to these immense enterprises, each person bringing his or her contribution and labor, in a touching and truly popular spirit. A chronicle by Robert de Torigny, concerning Chartres in the year 1144, recounts that "one saw that year in Chartres the faithful harness themselves to carts laden with stone, with wood and wheat and with all that might serve in building the cathedral, whose bell towers were rising as if by magic." At Chalons-sur-Marne there was collective collaboration that Gui de Bazoches, in a letter written between 1162 and 1171, described as one big celebration: "Nobles of both sexes,

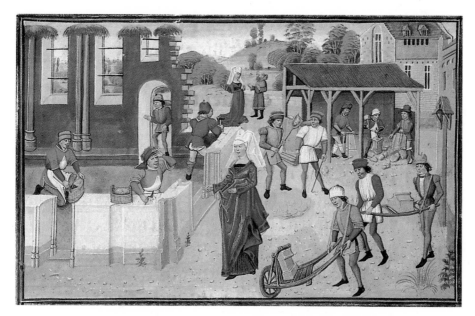

Histoire de Charles Martel et de ses successeurs: building the Basilica of Sainte-Madeleine at
Vézelay under the supervision of Berthe, wife of Girart de Roussillon.
Fifteenth century. Bibliothèque Royale Albert Ier, Brussels (Ms. 6, fol. 554v).

cables attached to their shoulders to drag the enormous block, heaved with ardor. . . . There were brave soldiers, solid matrons, young boys and girls, old men and adolescents, barefoot, streaming in with merry heart from every street and square."[6] The idea of an exceptional event or miracle still had to underpin the launching of any project, and the finest miracle of all was the ardor of the Christian people.

Things were not always thus, however. There were reports—somewhat later, to be sure—of scheming between feudal lords and prelates, and even of popular revolts like the one that brought a momentary halt to the construction of Reims Cathedral.

How did this activity—whose scope and mobilizing effect are hard to overstate—correspond to what is known of medieval society itself? Historians explicitly affirm that the struggle against natural disasters, especially famine, was complicated by the absence of precautionary measures and organization. Furthermore, theologians' strict attitudes toward money and, more simply, credit, paralyzed growth. Growth could only occur indirectly, via compromises strangely linked to deep-rooted moral prejudices. That said, it would seem that the economy functioned backwards, in a sense. Instead of favoring the accumulation of money, it was only interested in "treasures." Ecclesiastical authorities favored "sterile" investment in the construction and decoration of churches, while the nobility felt honor-bound to indulge in ostentatious expenditure (the vanity of which was condemned by the church). The extraordinary artistic development of the period took place within an economy in which

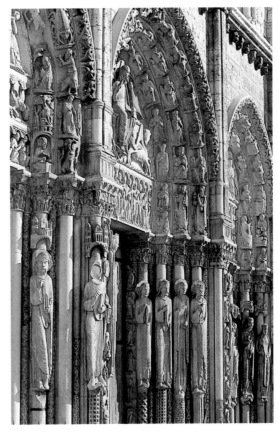

Chartres Cathedral (Notre-Dame).
West facade. Royal Portal. 1145–1155.

monetary problems were poorly addressed, in which two social orders out of three were not subject to the law of productive labor (one being dedicated to the glorification of God, the other to earthly glory).

This overall picture of medieval art appears to reveal, in an extraordinary way, an acceleration of artistic activity so rapid (once the way was open) that an entire society was transformed by it. The observation rests on a simple, incontrovertible fact: the astonishing increase in churches, which elevated, marked, and exalted the urban and rural landscape in the space of just a few generations. The increase is difficult to justify on functional grounds, because it hardly seems reasonable. There is the impression of a race between towns and cathedral cities, with everyone—simple priest or prelate—determined to demonstrate his "modernity." This raises a problem for which today's concepts provide no solution. Sanctuaries were initially conceived as oversized containers—a city like Chartres, with four or five thousand inhabitants, built a cathedral that could hold twenty thousand people. It might be argued that this represented the Christian equivalent of ancient amphitheaters, designed to receive occasional crowds. Perhaps, but building an amphitheater required the effort of only two or three generations. The number of churches whose construction spanned several centuries inevitably raises questions about the initiators' ability to "program" construction and about the imperatives faced by their successors. There is only one possible solution to this complex issue: the Augustinian concept of the "City of God" must have been projected onto popular imaginations and everyday spaces. An enormous sanctuary was

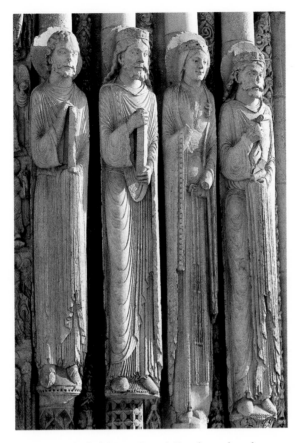

Chartres Cathedral (Notre-Dame). Royal portal on the west facade; detail of central bay, right-hand splay: figures from the Old Testament. 1145–1155.

Next page:
Carcassonne Cathedral (Saint-Nazaire). View of the upper choir. c. 1270–1330.

Coutances, Cathedral (Notre-Dame) in Normandy. The octagonal lantern at the crossing. 1218–1250.

both the symbol and the guarantee of the fulfillment promised to Christian souls, and a powerful structure could physically incorporate the total deployment of current knowledge and forms.

The construction fervor was linked to an increasingly spectacular "artistic" boom. It is hardly surprising that, even within the movement, certain stern monastic circles expressed reservations, criticisms, and ultimately accusations that were not without effect (as will be discussed later). In short, this incitement or explosion—it is impossible to know whether it was planned or not, controlled or not—produced throughout the land work that no longer responded to precise needs but rather to collective exaltation, procuring satisfactions that all levels of society apparently found worthwhile. There came a moment when the wealth of discoveries was so dense and their implications so varied that, during one or two relatively peaceful reigns in the thirteenth century, the technical superiority and exceptional experience of French builders triggered a sort of cultural crystallization— the new art (now called "Gothic") became *opus francigenum*, the expression of the domination of the Capet dynasty. It all happened as though the enormous artistic development of two centuries had been shaped into a hegemonic tool. This idea may seem hard to accept, for history only yields this sort of simplification thanks to the hindsight of historians seeking elusive intelligibility. And yet something like that did occur, and it is important to try to grasp it.

Although architectural restorer Viollet-le-Duc exaggerated the "anti-feudal" and secular nature of the great

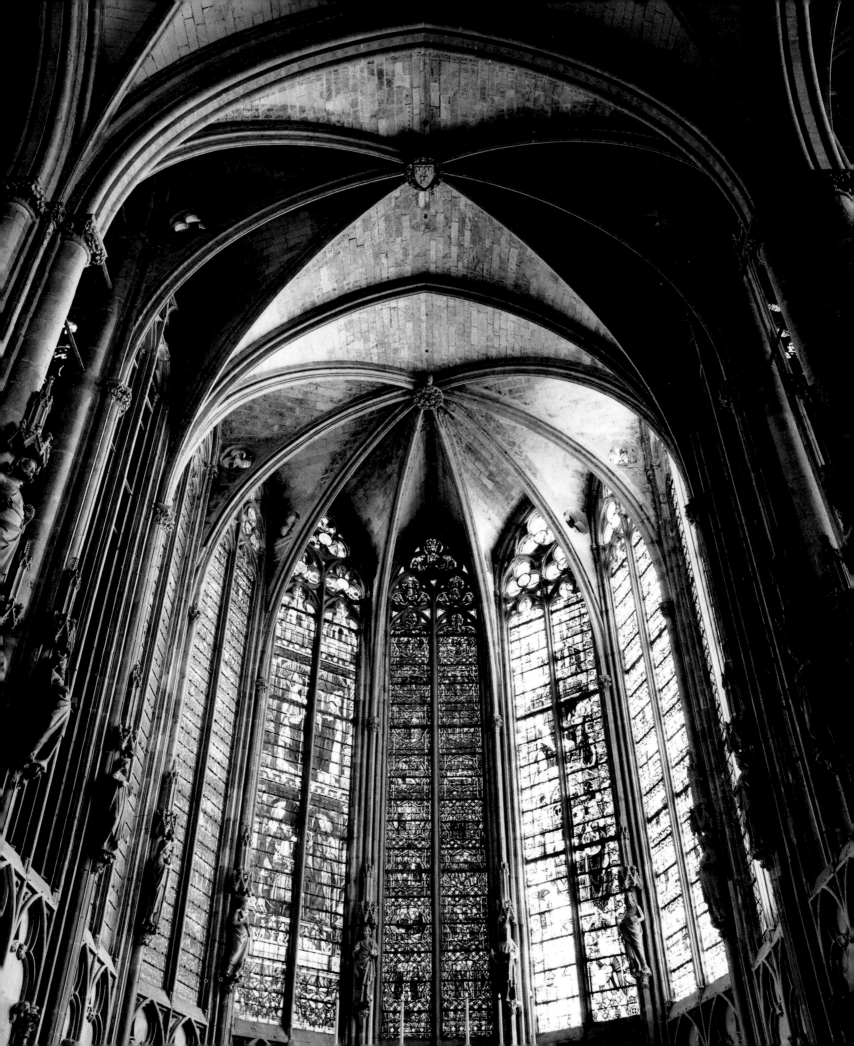

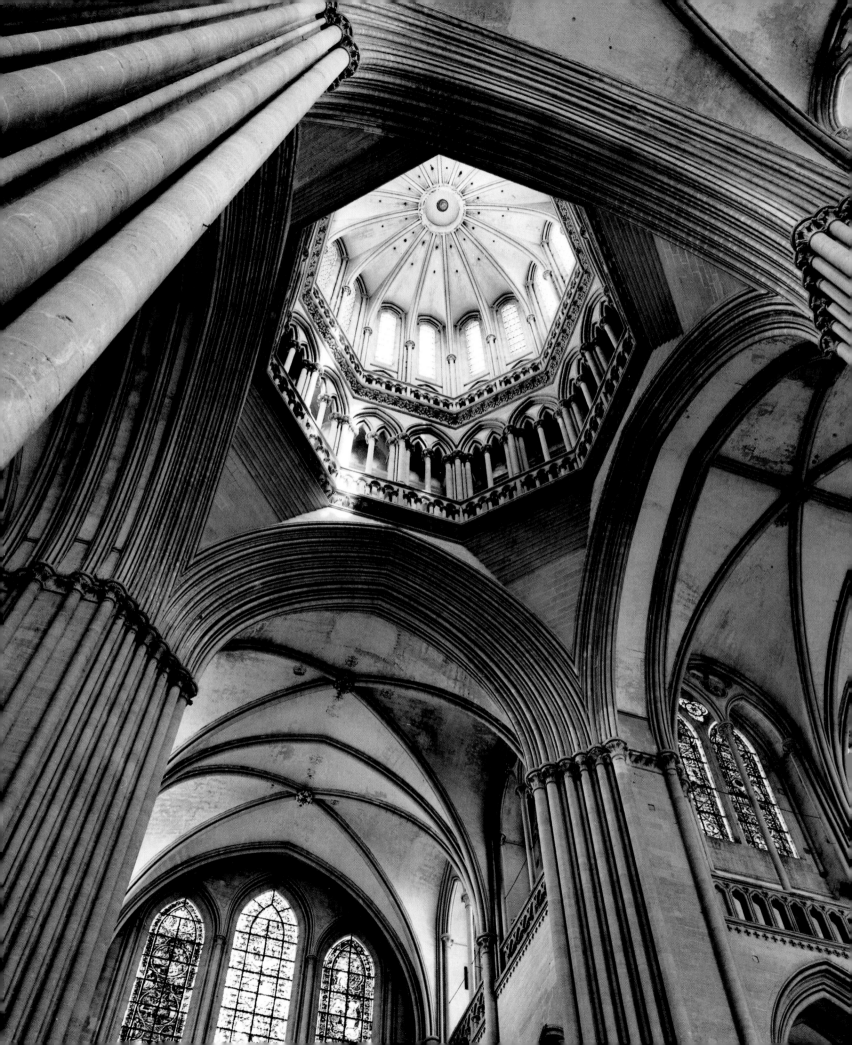

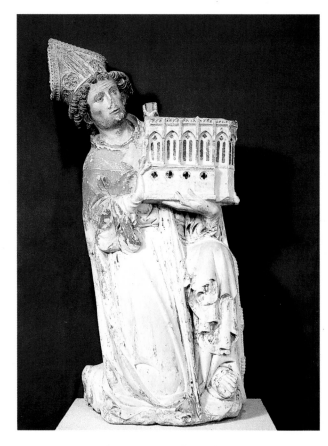

Bishop Jean Tissandier as donor,
from Rieux Chapel at the Franciscan monastery of Toulouse.
Sandstone, traces of polychromy. 1333–1334. Height: 132 cm.
Musée des Augustins, Toulouse.

cathedrals, he clearly discerned the close link between these creations and the urban condition. Solidly organized aristocratic bishops and prebendal canons took charge of the enterprise. A good number of cases, meanwhile, attest to the correlation between the building of churches and economic prosperity, indeed expansion. Although hardly surprising, this points to conflicts of interest and rivalries that could even lead to violence.

Diocese and chapter owed their strength to the fact that they administered sacred territory dating back to venerable times, reinforced by relics to which the people were strongly attached. Archaeology generally confirms this assessment. Sanctuaries had age-old roots, as did the guardian figures of local saints who had been worshipped uninterruptedly. The idea of giving modern form to a town's traditional church therefore encountered general acceptance. But it represented a leap into the unknown insofar as initial funding was insufficient. This in turn meant that the completion of grand cathedrals constantly depended on appeals to the generosity of Christian folk, on municipal pride, on good fortune, and even on miracles. It is even possible that marvelous accounts of popular enthusiasm by Torigny and others were a response to protest movements or even revolts provoked by the cathedral clergy's exactions and requests for money. In Reims, Beauvais and Chartres, as noted above, more or less serious incidents had an impact on the pace of work. Each of the grand cathedrals was thus affected. Their history was far from smooth and peaceful.[7]

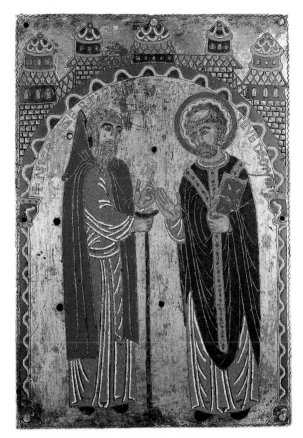

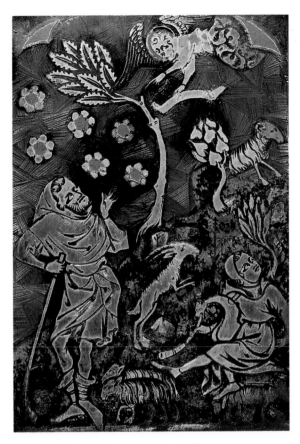

Plaque from the high altar, Grandmont Abbey:
Saint Stephen of Muret speaking with his disciple,
Hugo Lacerta. Champlevé enamel on copper gilt.
Limoges, c. 1189. 26 × 18 cm. Musée de Cluny, Paris.

Virgin and Child, detail of base:
the Annunciation to the Shepherds. Gift of Jeanne d'Evreux
to the Abbey of Saint Denis. Opaque and translucid enamel
on basse-taille. 1324–1339. Musée du Louvre, Paris.

The idea of a united, fervent Christian population in which every individual contributed stone, cart, or coin is largely the product of a Middle Ages as dreamed up by the likes of Hugo, Ruskin, and Proust. It was not born of an awareness of a major political development, nor of knowledge of original theological principles and the spirituality behind them, nor of any particular sympathy for popular piety, but was above all promoted by admiration for the power and quality of medieval art.

This "obvious fact" has become increasingly evident in the final decades of the twentieth century, thanks to "rediscoveries" that have placed decisive emphasis on what were long considered marginal or minor arts. The perception of medieval art has been profoundly modified by a more serious approach to the use of color and form in stained glass, enamels, and manuscript illumination.

In 1948, an exhibition of twelfth-, thirteenth- and, fourteenth-century enamels from the Limoges area, curated by Marie-Madeleine Gauthier in Limoges, was the starting point for a vast investigation into the semi-industrial production of precious enamels. The results are to be published in a scholarly, five-volume international catalogue, the first volume of which has already appeared.[8] In 1952, *Corpus Vitrearum Medii Aevi*, another magnificent exhibition, organized by Jean Verrier and Louis Grodecki, introduced the public to the key domain of extraordinarily rich and varied stained-glass windows in France, representing ambitious research of a

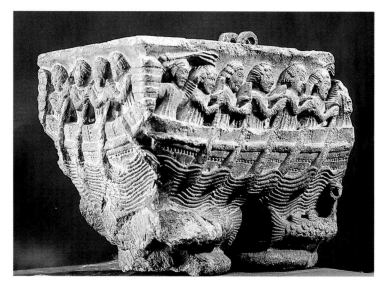

Capital from the church of Notre-Dame de la Daurade, Toulouse.
Twelfth century. Musée des Augustins, Toulouse.

new type at the time. Finally, manuscripts received the same treatment during an exhibition on illumination from the seventh to the twelfth centuries, curated by Jean Porcher at the Bibliothèque Nationale in Paris in 1954. Numerous publications followed, and these neglected fields provided fresh insight into medieval imagination and embellishment. This impressive mass of now-accessible data only confirms the need for a more attentive approach to the quality of forms and the wealth of effects—in short, to art.

THE ROLE OF THE *ARTIFEX*

How has this pertinent research been reincorporated into the dense web of social life, into the syncopated flow of events? The remarkable development of the study of medieval art in France, as well as in the United States and Germany, has established certain lines of investigation that will be respected here. Medieval art appeared to be a constituent element of society every bit as much as it was what is naively called a product of society (as though that society could be apprehended and defined separately from its art). Art was a veritable social motor, for the appearance of new architectural and representational forms triggered and sustained a general dynamism that imposed itself on the very authorities who tried to bend art to their advantage. In a context where, as discussed above, strong emotions and drives were immediately translated into concepts evoking the miraculous,

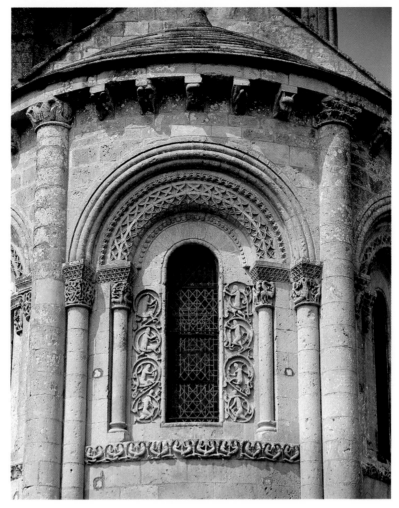

Church of Saint-Pierre, Aulnay-de-Saintonge (Charente-Maritime).
Central window of apse. c. 1130.

it is feasible to think that an encounter with admirably precise and enthralling constructions, like the nave of Chartres Cathedral or Sainte-Chapelle in Paris, would be expressed in terms of prodigy or miracle.

"The creation of medieval art did not require deeply religious artists, but rather artists who had been formed within a stable religious milieu, and whose craft had been developed in tasks set by the church."[9] In other words, everything found in the sanctuary, whether didactic imagery or free decoration, was obviously an offering to the Lord, but this did not completely explain all motivation. Specific problems related to each aspect of the building are worth identifying. The vaulting of a church, for instance, had to obey construction logic, yet it triggered dazzling experimentation; decorated capitals and illuminated letters were found only in ecclesiastical settings and theological treatises, yet they still pursued a purely decorative logic that they developed at an extraordinary pace.

But it would be mistaken to assert—as was often done in the nineteenth century by Viollet-le-Duc, Pugin, and others—that art was therefore a secular, lay activity lodged within a Christian society. No. Builders performed their activity and dialectic in accordance with an unambiguous goal; what they required, however, was freedom in the scope of execution. Similarly, the *artifex* (or craftsman), when criticized for an excess of

Autun Cathedral (Saint-Lazare). Fragment of tympanum from the north portal: Eve.
Attributed to Gislebertus. c. 1130. 72 × 131 × 32 cm. Musée Rolin, Autun.

fancifulness, claimed the right to do the job as he saw fit, *quidlibet audendi potestas*. The deployment of pictorial and sculptural activity obeyed its own logic within the development of forms. It is impossible to understand anything about medieval art unless the degree of freedom granted to the *artifex* or builder is appreciated. Lack of such appreciation can also lead to a modern misinterpretation of the aggressiveness with which the Cistercians reacted against a sphere that had nothing to do with useful tasks or prayer.

Animated ornament and decorative fantasy ultimately became legitimized through widespread practice, but only in the late twelfth century when fantastic art was already in decline, just as the purer Gothic order was emerging. Purism triumphed only in sculpture, however, since miniatures, then in full development, offered an increasingly fertile field of action to scribes and illuminators. The difference in scale was clearly significant, for many of these miniatures were done in workshops or scriptoria no longer attached to monasteries. After a period of exquisite elegance during the reign of Louis IX, capital letters and margins became, as in the past, the site of fantastic ornamental follies.

But that was not all. A phrase commonly used by clerics was the one accidentaly quoted by the most famous and widely read liturgist, Guillaume Durand de Mende. In his famous guide to ritual ceremonies, *Rationale Divinorum Officiorum*, written circa 1280, Durand de Mende lists the various types of work involving the

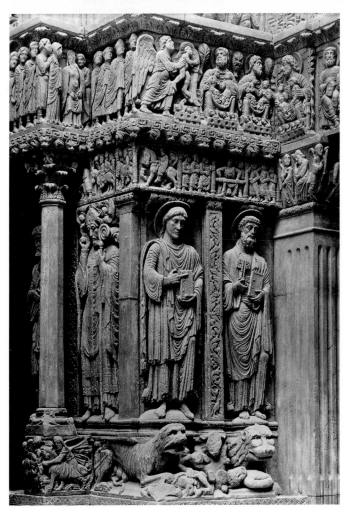

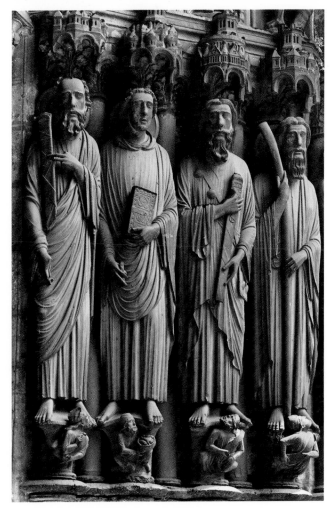

Arles Cathedral (Saint-Trophime). West portal (detail):
Saint Trophime, Saint John, and Saint Peter. Mid–twelfth century.

Chartres Cathedral (Notre-Dame). South transept, central portal;
right-hand splay, detail: Saint Paul, Saint John, Saint James the
Greater, and Saint James the Less. 1210–1215.

representation of saints. He concludes with an encouraging comment: "Scenes of both New and Old Testaments are painted to the painter's liking; for painters and priests always have the same power of initiative [*quaelibet audendi potestas*]." This maxim, which in fact came from Horace, was apparently widely known. It in no way indicates total artistic freedom, but rather the fact that within the agreed program it was up to the artist to organize the composition; one thinks immediately of the testament cycles done at about that time in the stained glass in Sainte-Chapelle in Paris. Once again, it is clear that between the idea of the total submissiveness of the *artifex* to religious authorities and the idea of a totally secular approach, a simpler and more likely notion is required—the awareness that, given the vast and powerful extension of highly admired artwork, artists forged their own original role.

It is thus essential to appreciate interconnected factors. Religious authorities knew that a vast modern sanctuary would draw crowds to their saint and their relics. But imitation of old models was not enough. Master builders, whose identities remain unknown to us, sought powerful formulas. Thus, after a century of various types of experimentation, technicians perfected the "system" of Gothic vaulting, which was a source of endless inspiration and problems. The question explored later in this volume is why the system was so successful, why it seemed so magical.

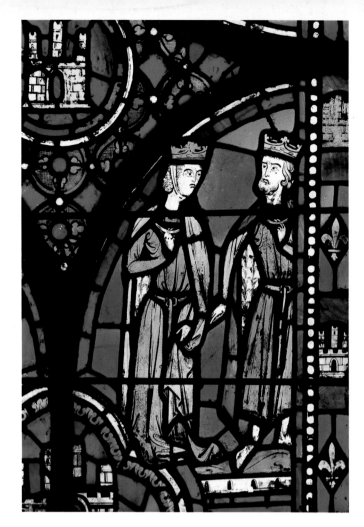

Sainte-Chapelle, Paris. Stained-glass windows in the upper chapel.
Left: the Story of Esther, detail (bay C); right: Book of Judges, detail (bay K). 1242–1248.

Right: Sainte-Chapelle, Paris. The upper chapel. 1242–1248.

Turning now to sculpture, wonderful carving provides evidence of obvious delight in craftsmanship, in the "pleasure of forms" shared by *artifices* and their public (including monks). Too many texts mention the satisfaction given by these beautiful works for there to be any doubt on this matter. One of the most common mistakes made by previous historians and pious admirers was to overlook this simple fact. The West could not fully come into its own without this attachment to artistic accomplishment, to the power of visual imagination, to a delight in forms. The amazing proliferation of statues, with all the variations of which the southern and northern schools were capable, makes no sense if artists and public did not share this attachment (not to be confused with religious inspiration, which required less diversity). Right from the Romanesque period, marvelous carved borders and fantastic figures directly appealed to the delights of the visual imagination (which is just what the censorious Cistercian order accused them of doing). This perhaps became clearer in following generations, even as motives became increasingly complex. The increase in the number of statues of saints offered for contemplation never leveled off, as though noble buildings always required more. Every feudal lord, every chapter house, every guild wanted to have its saint in a sanctuary, in a combined gesture of devotion and ostentation. But this emulation clearly created a certain momentum, attracting the populace, more or less inflecting pious attitudes, in short coloring behavior. Society was transforming itself through these instruments of devotion. It is equally clear that this evolution suited the *artifices*, sculptors who increasingly

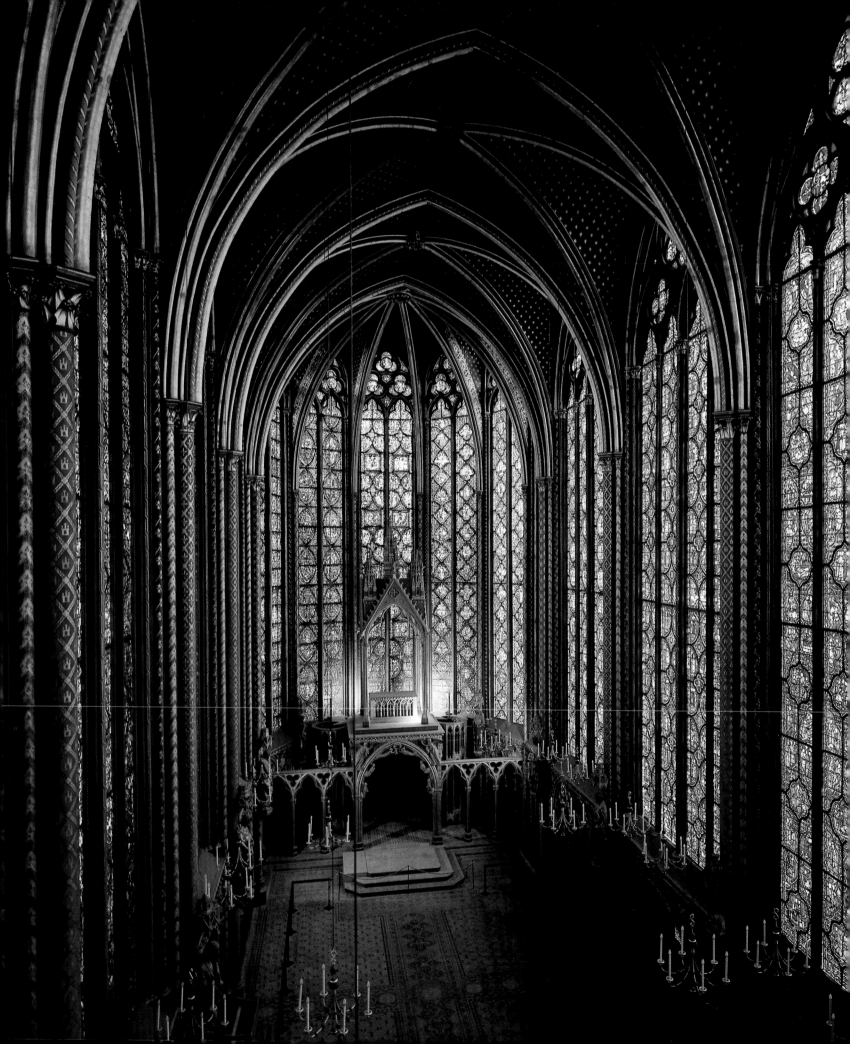

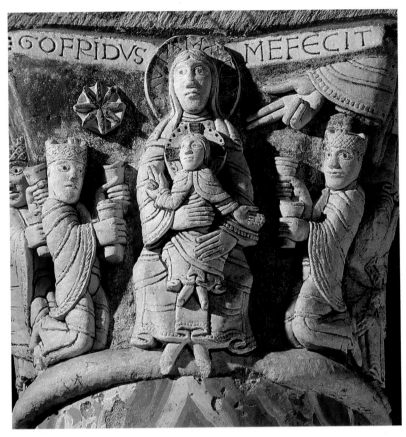

Church of Saint-Pierre, Chauvigny (Vienne). Figured capital in the choir:
the Epiphany; above: Godfridus's signature. 1080–1120.

aspired to prove their artistic qualities in the light of general demand. And it will be argued here that the same thing occurred in two grand arts employing color—stained glass and miniatures—whose five-hundred-year development is so impressive and so worthy of attention.

SIGNATURES AND THE AFFIRMATION OF MASTERS

This interpretation can be confirmed by a well-known fact—the increase in artists' "signatures," that is to say the names of sculptors and architects so often seen etched on their work. This affirmation by artisans of the role they played is one of the key phenomena of the Middle Ages, though it is not always clear how roles were divided (around the year 1000, Helgaud, author of the "standard" biography of Robert the Pious, and therefore patently a scholar, was also a builder and occasionally a goldsmith).[10] In general, though, churches remained silent about authorship. Only chronicles or archives reveal the identity of a founder, inevitably a bishop, lord, or abbot, which supposes the assistance of a qualified technician. In the case of Abbot Suger, it has been suggested that he was both founder and master builder. Nothing could be less certain.

As French etymologist Emile Benveniste pointed out, "*Ego* is he who says *ego*." Putting a name in stone does not have quite the same meaning, however, when done on a grave as opposed to a carved lintel. Of course,

Reims Cathedral (Notre-Dame).
Tombstone of the architect Libergier, master builder of
the cathedral. Thirteenth century.

countless carvings on portals and capitals will remain anonymous forever. The Romantic period naively thought church sculpture was the work of monks in monasteries and cloisters or in urban environments, and that it represented a religious duty executed under the direction of the chapter house. It is not impossible, of course, that special merit was associated with ecclesiastical commissions and statues of Christ and the saints—many legends reinforced the idea of a special link between sculptor and sacred image. But this should not obscure the fact that the general development of the arts produced a social group—or even class—of artisans, to the extent that this group was organized and highly visible by the twelfth century.

Although some monasteries were decorated by monks, especially Cistercians, it was common practice to pay for the services of lay experts, sometimes lay brothers, known as *artifices conducti*. They were heirs to the classical tradition of artisanry, and worked with a clear and complete awareness of their role and skills, to judge by the considerable number of signatures noted on tables, lintels, capitals, and tympanums. Starting in the eleventh century, signatures appeared by the dozens.[11]

Thus Gislebertus, who carved the *Last Judgment* at Autun, has become famous. Similarly, the priory of Saint-Pierre in Carennac (p. 128) boasts an inscription which reads: GIRBERTUS CEMENTARIUS FECIT ISTUM PORTANUM, BENEDICTUS SIT ANIMA EJUS. The inscription prompts a number of comments. First of all, the *artifex*

Saint-Pierre Priory, Carennac (Lot). Capitals bearing Girbertus's signature.
First half of the twelfth century.

spoke Latin, like a scholar. Second, he called himself a *cementarium*, or mason, which is the generic term as opposed to stone-carver, *latomus*. Finally, he wrote his name over the work without the least modesty, asking due reward from heaven. In other words, if the inscription is properly interpreted, the sculptor was proud of his work from the artistic standpoint as much as from the religious one.

But it should not be assumed that this constituted a lasting tradition. Although there are many signatures dating from the twelfth century, the same is not true for the high Gothic period. By the thirteenth century, everything was being executed on the worksite by teams working more or less in concert, and a single signature no longer made any sense. It was not the names of sculptors, but rather of master builders that were henceforth recorded. The strange "labyrinths" that existed in Amiens, Sens, Bayeux, and Chartres constituted a symbolic representation of the Holy Land, and not a masonic symbol as Viollet-le-Duc surmised, and it is most unusual for them to record, as at Reims, the names of architects.[12] Master builders are identifiable above all by tombstones that display their tools of ruler and compass.

Thus Pierre de Montreuil, master builder of Notre-Dame in Paris in 1265, buried in Saint-Germain-des-Prés in 1267, was depicted with the tools appropriate to a *doctor latomorum*. The most famous figure is probably that of Hugues Libergier, at Reims Cathedral, holding a model of the church in his right hand (p. 127). All

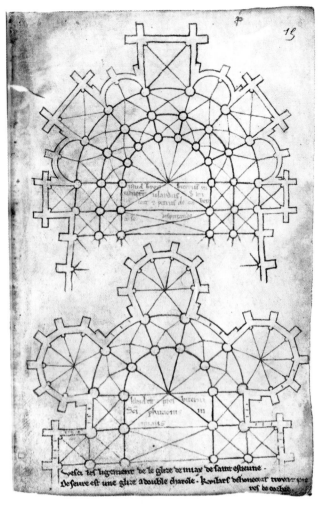

Villard de Honnecourt's notebook: "Here is the apse
designed by Villard de Honnecourt and Pierre de Corbie."
Mid–thirteenth century. Bibliothèque Nationale, Paris
(Ms. Fr. 19093, fol. 15).

known master builders appear to have been rich and esteemed because, as a sermon dated circa 1261 declared, "in these great edifices, it is customary to have a principal master who executes them with words only, rarely or never lending a hand, nevertheless he receives wages more considerable than the others."[13]

Contrary to popular belief, the title of *architectus* had no precise meaning in the thirteenth century and did not designate the master builder who worked without using his hands.[14] Rather, if anyone were named it was the "master" of the lapidaries and masons. The term *magister* itself constituted an intellectual distinction, as exemplified by the social success of Pierre d'Agincourt, thirteenth-century architect to Charles of Anjou in Naples. Furthermore, as Erwin Panofsky pointed out, the note that accompanied Villard de Honnecourt's sketch of the plan of an apse, circa 1235, is revealing: "Here is the chancel that Villard de Honnecourt and Pierre de Corbie designed, discussing it between themselves [*inter se disputando*]." This phrase evokes the academic term for scholastic debates, *disputationes*.

As time passed, portraits of master builders were increasingly found in sanctuaries and in miniatures depicting construction sites, especially in Germany and England. In France, it was not until 1400 that painting and stained-glass work adopted such portraits as a favorite subject. By then one had entered, at least it would seem, a period of artistic activity for which the term "late Middle Ages" is singularly unsuitable.

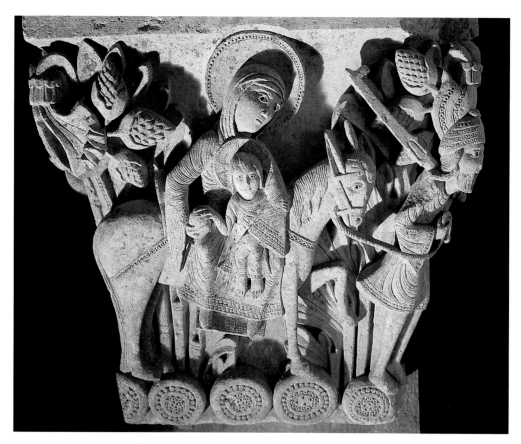

Autun Cathedral (Saint-Lazare). Chapter house. Capital from the chancel (detail):
the Flight into Egypt. Second quarter of the twelfth century.

ROMANESQUE ART, GOTHIC ART, FINAL PERIOD

Romanesque art represented a glorious period for the provinces, whereas Gothic was a centralized art—bold, intelligent, and hegemonic—associated with the Ile-de-France region. This dialectical definition is designed to convey the prodigious artistic vitality of the day by stressing the teeming diversity of regional production during an initial period, followed by the sudden rigor of decisive, innovative development. There are few historical examples of such strong and fertile relationships within so dense an activity, but Greece in the sixth and fifth centuries B.C. has been invoked to find an analogy for the fascinating transition from archaic smiles and frowns to an accomplished and imperious classic order.

Fate was bizarrely unfair to medieval architecture. The two key edifices of architectural history in France during the so-called Romanesque period—the basilica of Saint Martin of Tours, consecrated in 1004, and the abbey church at Cluny, which reached its zenith around 1100—were stupidly destroyed, leaving only stumps. It is hardly surprising that despite the diligence and ingenuity of eminent archaeologists, all sorts of problems still remain in reconstituting the order of things. In contrast, the major projects of the so-called Gothic age, before and after 1200, have miraculously survived—damaged, altered, or manipulated perhaps, partially ruined like

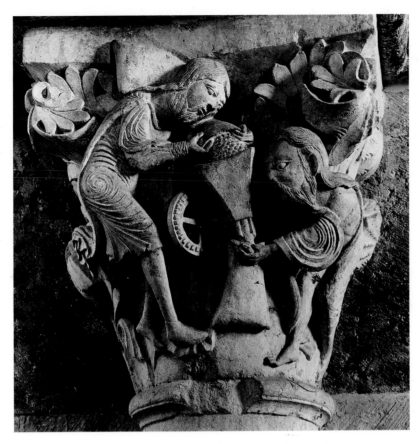

Basilica of Sainte-Madeleine, Vézelay. Capital in the nave (detail):
the Mystic Mill. c. 1132.

Reims, yet continuously maintained—allowing them to be actively "restored" today. The list of existing Gothic cathedrals is impressive, and they continue to dominate the French landscape. It all happened as though destructive malice symbolically limited itself to portal statues and tombs, as though, even in the sphere of ravages, Fate itself had a certain predilection for the Gothic—France's "national" art. This unequal treatment of the two facets of medieval art is striking.

Contrary to common belief, there is no reason to place these two grand periods back-to-back as though Romanesque art was merely a groping search for the Gothic style, thus making Gothic art the culmination of a steady, continuous evolution. Jean Bony, a connoisseur of the Middle Ages, felt it necessary to raise the issue by asking the unusual question of whether Gothic art might have been the product of an accident.[15] Later sections of this book will present technical arguments to support the affirmation that Gothic construction design was the result of a series of unforeseen gambles whose success hinged on a favorable conjuncture. This now-accepted historical perspective rejects the affirmation that Gothic art was born of the desire to resolve difficulties inherent in Romanesque structures. Initially, it was merely another episode in dynamic twelfth-century activity.

Working with limited resources and rather simple combinatory formulas, builders finally produced a model

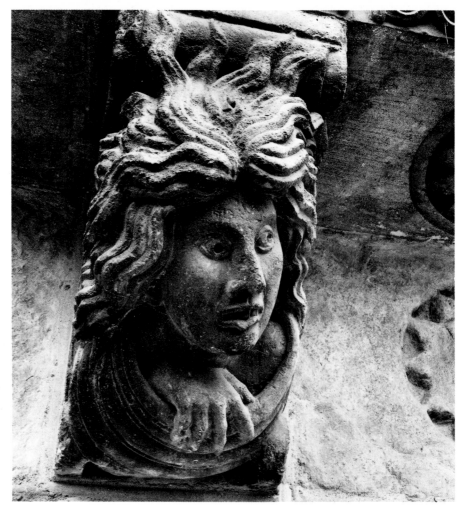

Basilica of Saint-Sernin, Toulouse. Miégeville door (detail). c. 1118.

structure that was conveniently elegant and supple, although it had hardly been foreseeable in the mid–twelfth century. However, once the new model proved its success and became accepted, a new order was established with such conviction that most Romanesque churches were decked out with the new system—the old basilica of Saint Martin of Tours, for instance, was given ogival vaulting in the late twelfth century. There was a general *aggiornamento*, or modernization, to which everyone conformed. But not all provinces followed the model developed in the Ile-de-France region. There were many compromises, especially in the western part of the country. Then the historical conjuncture came into play. A decisive factor, this time political, intervened during the reign of Louis IX—the modernism of "Gothic" art became associated with the "national" aspirations of the French monarchy. This explains the extraordinary tour of southern France made by architect Jean Deschamps in the third quarter of the thirteenth century.

If the history of the Gothic "mutation" is thus presented as a series of inventions and leaps forward, it becomes clearer why, even after it crystallized into a system, its terms could continue to be modified and shifted. New trends were emerging and, by the mid–thirteenth century, a sort of capriciousness stressed vertical and diagonal effects, leading to what is called "rayonnant" Gothic.

Notre-Dame Cathedral, Paris. West facade, left-hand portal.
Detail of spandrel in the right-hand splay. 1210–1220.

But that is not the whole story. In architecture, as everywhere else, Romanesque art and practices did not disappear overnight, and diverse provinces did not totally succumb to "royal French" fashion. It is another of art history's illusions to reduce thirteenth- and fourteenth-century development to the unifying definition of "French classicism." True enough, it is wonderful to see how the so-called minor arts of metalwork and miniatures were in turn reformed and reorganized in the spirit of the new style. The Gothic phenomenon assumed unforgettable coherence and authority that impressed the entire West. But the many accomplishments of the previous age were maintained in peripheral areas, as can be seen in the less closely monitored zones of the decorative arts and manuscript illumination, sectors favorable to fanciful imagination. This means that the complete story on medieval art cannot be told as a linear tale from the Romanesque to the Gothic—terms, for that matter, retained mostly for convenience—but rather as a long confrontation between the trend that blossomed during an initial period and the plenitude of a second period that momentarily and incompletely overshadowed the first.

The evolution of medieval art should be understood as the alternation and complementarity of brilliant inventions subjected to phenomena of survival and revival, creating cycles within medieval development. Such

Head of an Old Testament queen from the west portal
of the abbey church of Saint-Denis.
Limestone. c. 1140. 32 × 20 cm. Musée de Cluny, Paris.

Right: head of a prophet from the west facade of the abbey church of
Saint-Denis. Stone. c. 1140. 41 × 23 × 24 cm. Musée de Cluny, Paris.

recurrences make the surprising singularity of forms all the more obvious. One merely has to look at what sprang from vault bosses, for instance, or the way the Romanesque masks, shields, and strange creatures invaded previously anodyne parts of buildings. This ultimately meant that the total edifice, while impressive in its very plenitude, lost some of its stability. The "flamboyance" of ornamental forms was nothing next to flamboyant imaginations. Paradoxes multiplied during the fourteenth century, and the old heritage was subsumed by an unfettered Gothic style that might be labeled imaginative and paradoxical as much as "precious." By 1400 it evolved into the rich "international" style that stimulated and swept across the entire West. And that is when the French Middle Ages, strictly speaking, came to a close.

There seems little point in taking the traditional if impoverished concept of the "late Middle Ages" up to the sixteenth century. The term is not only an admission of impotence but also relegates some of the finest products of French art in the spheres of stained glass, miniatures, painting and sculpture to the status of one long, dying gasp. True, it is worth pointing out once again that the political and military vagaries of the Hundred Years' War created a climate of crisis. But those vagaries engendered one of the strongest outbursts of nationalism

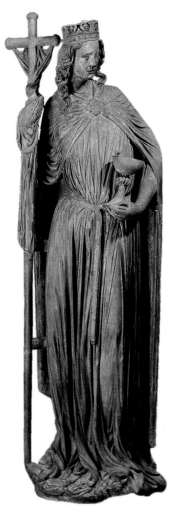

The Synagogue and *The Church*. Statues from the Bishop's Portal,
Strasbourg Cathedral (Notre-Dame). Vosges sandstone. c. 1225–40.
Height: 197 cm and 200 cm. Musée de l'Oeuvre Notre-Dame, Strasbourg.

Right: Reims Cathedral (Notre-Dame).
Detail of the inner wall of the west facade: a knight takes communion. 1250–1260.

France has ever known, which distinctly separates the fifteenth century from medieval ecumenism. True, the crumbling of hierarchies and the dispersal of authority to great provincial powers signaled the end of Capet centralization, but it also permitted the emergence of remarkable, forward-looking "regional" productions in Burgundy, Touraine, and Provence. The general mood seemed governed by the routine, monotonous maintenance of "Gothic" construction in the fifteenth century and beyond, yet this very continuity should be reinterpreted so that it does not mask the fundamental nature of the period, which this book unhesitatingly detaches from the great body of the Middle Ages. That nature entailed an unprecedented exacerbation of forms linked to a largely "secular" outlook. The form may look the same, but the content had changed. Art was shifting gear. Another world was emerging.

I THE ROMANESQUE PERIOD

1. EMERGENCE: 987–1059

Abbey of Saint-Savin-sur-Gartempe (Vienne). Fresco on the porch vaulting, detail: scene from the Apocalypse. c. 1100.

Dread and dereliction did not prevail everywhere in the West in the year 1000. One need only consider, as did art historian Henri Focillon, the stature of major figures who emerged on the eve of the millennium, such as William of Volpiano (abbot of Saint-Bénigne in Dijon), Saint Abbo of Fleury, Emperor Otto III, and Gerbert of Auvergne (Pope Sylvester II).

The general picture of the Christian world that successive historians have painted, based on bountiful documentation, shows a continent full of dark holes and bright spots, yet endowed with enough energy to resist Saracen pressures and reduce the remaining barbarian threat (the conversion of the Hungarians being a key event).

But what of Francia itself? Historian Henri Pirenne suggested that it was primarily characterized by the revival of trade after a nightmarish paralysis. Although this is true, increased commercial activity also reflected a more general affirmation expressed above all by the

almost unbelievable extent of construction work—building projects are not the product of improvisation, nor are they even directly linked to trade. This raises the possibility that the millennial terror and dread of doomsday, stressed by some later writers like the prolix Raoul Glaber, may have been due to their simple and almost instinctive blackening of the earlier picture, that is to say a typically exaggerated rejection of the past at a moment when the general pace of history has shifted (the same thing would occur in the sixteenth century when "Gothic" mores were challenged, and again when the French Revolution denounced the ancien régime). "Apocalyptic terror" was probably only a retrospective explanation of the difficult and problematic situation that characterized the preceding century (at least until 950). A vacuum must have

indeed existed in several regions, but the total discontinuity sometimes depicted is illusory. The true picture behind Glaber's rhetoric is not hard to discern: "Although most [churches] were well-built and had no need of [further building], veritable competitiveness drove each Christian community to have a more magnificent one than its neighbors."[1] It was really a question of surplus building, not a fresh start.

The case of William of Volpiano (961 or 962–1031) is enlightening. An Italian related to people in high places, he became a monk at Cluny in 985 and was made abbot of Saint-Bénigne in Dijon in 989. If his biographer, the notorious Raoul Glaber, is to be believed, William ran his monastery energetically. From there, he went on to Fécamp, Mont-Saint-Michel, and Bernay. But the point worth

138

discussing here is William's accomplishment in Dijon, the capital of Burgundy. He built a church with a multilevel rotunda at its eastern end, of which only the lower level remains (largely restored in the nineteenth century). This design is less unusual than it might appear, because there were the aforementioned precedents for a church rotunda in provincial towns like Flavigny and Auxerre. According to Louis Grodecki, "the structure of this crypt, dating from around 1000, is highly artful, with bonded walls and blocked vaulting. Large, single monocylindrical columns were matched by half-columns against the walls. It was a Romanesque building not only in its architectural forms, but also in its sculpted decoration."[2]

The rotunda, begun in 1001, points to a whole series of developments. An architectural culture was emerging that took into account designs current in Italy and along the Rhine. Unsurprisingly, King Robert the Pious (reigned circa 996–1031) undertook the founding of new churches at Orléans, Etampes, Melun, Senlis, and Paris, all the while promoting abbeys with which he had links, such as Fleury-sur-Loire. This desire to build and rebuild constantly, in a sort of competitive spirit, presupposes that there were masons and laborers able to carry out such work. As mentioned above, ideas were circulating throughout the West, but each region had its own resources, traditions, and habits; the problem faced by historians of Romanesque art ever since this notion was accepted (in the early nineteenth century), has been to distinguish local initiatives from transversal currents propagated in particular by monastic orders like the one based at Cluny.

One should not be misled by the fact that in 987 Hugh Capet replaced the last Carolingian at the head of what was not yet a nation, for he enjoyed only a vague sovereignty in the north of modern-day France. Four major regions, with no

View of the lower level of the rotunda built by William of Volpiano at Saint-Bénigne, Dijon. Eleventh century. Ink wash. Bibliothèque Nationale, Paris (Est. Ve 26p, fol. III).

organic unity, were still evolving toward uncertain fates. These regions were the royal domain around Paris (called the Ile-de-France), Burgundy (which stretched to the east as far as the Rhone), Aquitaine (where the Provençal dialect known as *Langue d'Oc* was spoken, and which constituted an original repository of forms), and Normandy (the new duchy that sparked all sorts of initiatives).

The unstable and conflict-based society called "feudal" could not have existed without the architectural development of castles which, alongside churches, represented the other major medieval feat. Various studies have slowly brought to light the ninth-century genesis of castle architecture, providing a progressive definition of the form as a function of site, residence, service, defense, and jurisdiction. Defensive systems of stockades and

hillocks were combined with aspects of construction in stone. This socio-political edifice slowly reached maturity in the west, along the Loire.

The development of keeps within castles is a tricky question that remains unresolved. They were initially, and perhaps somewhat hastily, thought to have constituted the primary defensive element. Recent research, however, suggests that the impressive tower at Langeais, dated slightly after 1000, was originally designed as a residence.[3] "When the functions of seignorial residence and main defensive strongpoint were combined in a single edifice—as early as the first half of the eleventh century at Montbazon and Nogent-le-Rotrou—the keep was obliged to stack vertically what had previously been spread out in the closed space of a *castrum*."[4]

Scriptoria Persevere: Illumination

Manuscript illumination provides unmatched testimony on this period. The importance of the commentary on the Apocalypse by the Catalan monk Beatus of Liebana, produced in Asturia in 775, is well-known; many copies of it exist, typified by flat washes of color in the Mozarabic style. On the other side of the Pyrenees, an illuminator named Garsia, working at the abbey of Saint-Sever-sur-Adour during the time of Abbot Gregory of Montaner (1028–1072), was obviously familiar with the Beatus manuscript. As has been widely noted, Garsia re-employed much of the composition's broad areas of dense color, yet added motifs and inflections that immediately paved the way for Romanesque sculpture like that seen at Moissac (Bibliothèque Nationale, Lat. 8878, p. 93 and right).

The choice of the Apocalypse was not necessarily a response to universal terror, since a predilection for the great visionary text was only natural in monastic circles. It utilized magnificent symbols to remind all Christians of the end of life and the universe, known as doomsday. The apocalyptic scene, which became a canonical motif on the tympanums of Romanesque portals, was painted sometime around 1000 at Saint-Benoît-sur-Loire by a monk from Saint-Julien of Tours, whose name, Odolricus, has been recorded in chronicles. A century later, it was painted at Saint-Savin-sur-Gartempe (p. 138). Depictions of this subject were not limited to this period, but would in fact traverse the entire history of Christianity.

Manuscript miniatures, meanwhile, favored dynamic forms and, in particular, fantastic monsters. In a manuscript of Saint Clement's *Recognitiones* (Avranche Bibliothèque Municipale, Ms. 50), the scribe depicted himself presenting his book to Saint Michael (p. 142). The two elongated bodies stand out against a reddish-purple ground, and are framed by

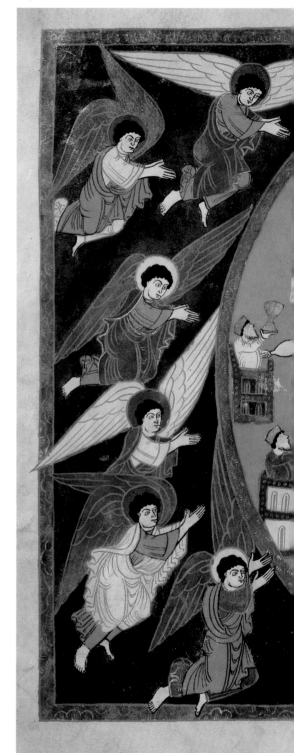

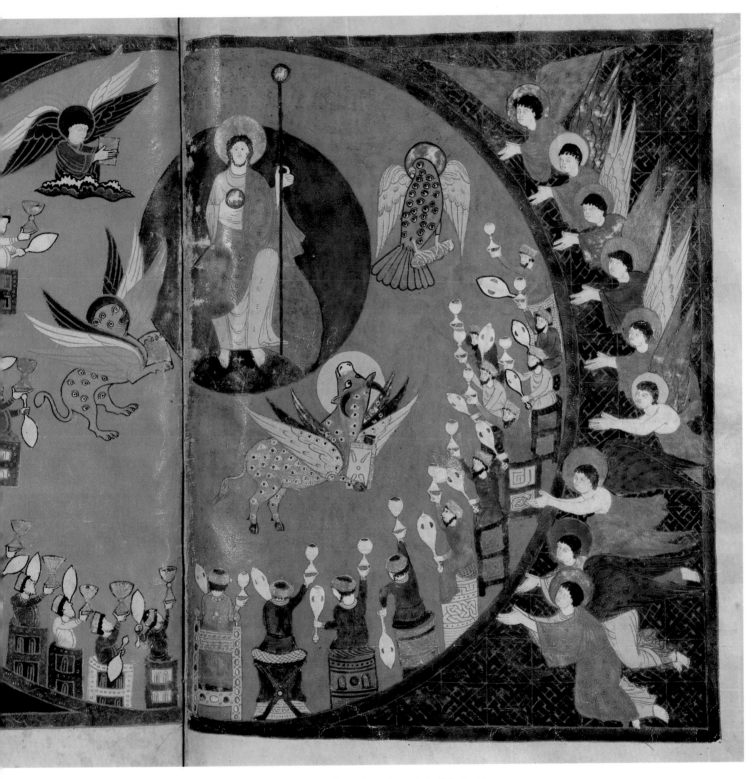

Saint-Sever *Apocalypse.* Saint John's vision.
Mid–eleventh century. Bibliothèque Nationale, Paris (Ms. Lat. 8878, fols. 121v–122).

Saint Clement, *Recognitiones*: the scribe presents his book to Saint Michael. Mont-Saint-Michel, late tenth–early eleventh centuries. 17.5 × 25 cm. Bibliothèque Municipale, Avranches (Ms. 50, fol. 1).

Bibliothèque Nationale (Lat. 1126). It represents a rare but highly significant adaptation of rich Ottonian miniatures. There are reasons for thinking that this manuscript, called the *Evangelistary of Gaignières* (after its seventeenth-century owner), was produced at Fleury in the days of Abbot Gauzlin, Robert's half-brother, and may have been executed by an itinerant painter from Lombardy.

Carolingian tradition had not completely disappeared at Saint-Bertin in Picardy and other northern schools which, though diminished, were still active.[5] The production from Saint-Bertin also testifies, however, to obvious contact with Anglo-Saxon art, especially in the days of Abbot Odbert (986–circa 1007). A number of lively manuscripts produced there include important "recastings" of Carolingian manuscripts, as well as a superb *Psalter* with highly imaginative initial letters (Boulogne Bibliothèque Municipale, Ms. 20).

Gaignières Evangelistary. Tenth–eleventh centuries. Bibliothèque Nationale, Paris (Ms. Lat. 1126, fol. 2v).

twin arches. Saint Michael is shown slaying a skeletal devil. The idea of placing a combat with monsters in an interior setting was part of the repertoire handed down by the Carolingian school at Tours. Thus an evangelistary canon from Limoges (ninth or tenth century, Bibliothèque Nationale, Lat. 260) already displays the simultaneously architectural and dramatic composition that would later be deployed in Romanesque sculpture.

The abbey at Fleury-sur-Loire copied a collection of *Homilies on Ezekiel* (Bibliothèque Municipale, Orléans, Ms. 175) that was decorated with large drawings probably executed by an English hand, because the skills of British brethren from highly advanced manuscript workshops were often solicited. Another noteworthy manuscript is an outstanding evangelistary with letters of gold and silver on reddish-purple (above right), commissioned by "Robertus Devotus" (Robert the Pious), now at the

Mont-Saint-Michel Sacramentary:
Christ slaying the basilisk and asp.
Mid–eleventh century. The Pierpont Morgan
Library, New York (Ms. 641, fol. 66v).

Another scriptorium at Saint-Vaast, still in the early eleventh century, sustained a similarly eclectic tradition. But it was the monastery at Mont-Saint-Michel that produced a great *Sacramentary* toward the middle of the century (left), in which the Carolingian repertoire was enriched and amplified by elements borrowed from English models (Pierpont Morgan Library, New York, Ms. 641).

Attention has recently focused on fragments of a book of models from Fleury-sur-Loire, bringing to light the "artistic culture" that prevailed at the abbey on the eve of the year 1000.[6] Anthologies of designs that combined ancient art with Carolingian art—draped figures, acanthus leaves, foliated scrolls, and plans of towers—obviously existed and were circulating two centuries before the famous book of drawings by Villard de Honnecourt. The vitality of centers in the Loire region was therefore not sapped by the misfor-

tunes of the dark century, providing a smooth transition toward the "ancient-style" decoration of the porch tower with its superb Corinthian capitals, erected by Gauzlin in front of the abbey in the second quarter of the century.

ECCLESIASTICAL ARCHITECTURE: GENERAL INITIATIVES

It would be wrong to picture the world as tranquil. Given the geographic, human, and architectural landscape of the year 1000, efforts by dynamic individuals and powerful monastic institutions like Cluny to impose a certain order can only be understood in the context of confusing situations, overlapping and artificial jurisdictions of power, and poorly controlled religious beliefs.

Everything tended to be expressed in fantastic terms, for those were the only terms able to move crowds, the only ones likely to be used by monks educated by reading the Scriptures. In addition to the apocalyptic themes mentioned above, it is interesting to note other texts that reveal the visionary tendency of the day, such as the count of Lomello's account of the exhumation of Charlemagne's body. The emperor apparently appeared seated on his throne, wearing a crown of gold, scepter in hand. This gave birth to a legend that proliferated in Ottonian Germany and resurged with Frederick Barbarossa, but which also had great appeal for western Francia.[7] The *Chanson de Roland* and epic cycles then made their appearance before the end of the century, giving legendary scope to everything Carolingian. The founding of an institution was often attributed to some hero or other. The name of Girart de Roussillon was often cited in connection with the basilica of Sainte-Madeleine in Vézelay, and a *chanson de geste* (an epic poem) was composed when pilgrimages to the basilica became so popular that this tradition needed to be made more explicit. Legendary foundings and epic literature thus went hand in hand.

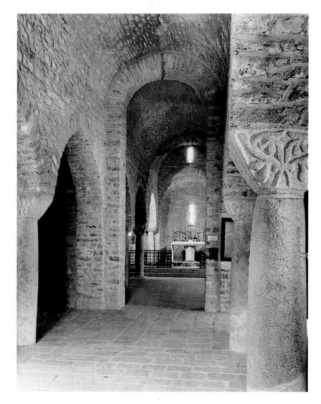

Abbey of Saint-Martin-du-Canigou (Casteil, Pyrénées-Orientales). The nave and the chancel of the upper church. Early eleventh century.

In this context it might be recalled that Catalonia bordered on the Carolingian realm, and that Navarre, at the other end of the Pyrenees, was in contact with Languedoc and Aquitaine. Yet it is hard to incorporate into the "French" tradition offshoots of innovations directly linked to the powerful Abbey of Ripoll, even when those echoes are found north of the Pyrenees. Saint-Michel-de-Cuxa (970), for instance, has a square apse, a transept with chapels, and two aisles with so-called "Cordoban" stone facing. At Saint-Martin-du-Canigou (1009), vaulting runs along the entire nave (above).[8]

In the Loire region, where the Carolingians were well-implanted, completely different building designs were common. The best example is that of the abbey of Saint-Benoît-sur-Loire (p. 144). In the days of Abbo (who was abbot from 988 to 1004) and his successor, Abbot Gauzlin (from 1004 to 1030), this active center built various chapels and copied numerous manuscripts. A fire in 1026 led to the reconstruction or renovation of the Carolingian church, which contained a crypt with the relics of Saint Benedict. It is not certain, however, that the fire was related to Gauzlin's decision to build the massive porch, with bell tower and open arcades on three sides, sometimes called a *galilea* (that is to say, a shelter for outcasts) or *porticus*. With its monumental feel and classical-style capitals, this porch was in reality an "antechurch," a sanctuary grafted onto the church itself, as was done in the Rhine region. The edifice, which Gauzlin allegedly said was "designed to be an example to Gaul," had and still has an ambitious and authoritative air. The apse and transept of the church were rebuilt by

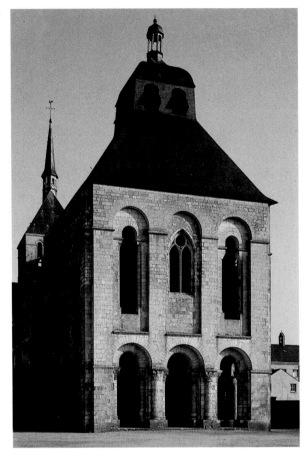

Abbey of Saint-Benoît-sur-Loire (Loiret).
The porch tower. Second quarter of the eleventh century.

Far right: Church of Sainte-Foy, Conques (Aveyron).
The apse. Second half of the eleventh century.

usually motivated by a specific analogy with the rotunda in Jerusalem. There are many indications that a central design existed in the eleventh century, only to be gutted by the later addition of a nave, as was case with the church of Saint-Julien at Villeneuve d'Aveyron (eleventh century), transformed in the fourteenth century. The structure of the multilevel rotunda at Charroux (eleventh century) was similarly readapted to a longitudinal plan.

The chronology necessary for truly assessing not only general imitation but also specific borrowings and divergences is unfortunately still plagued by a great deal of uncertainty. But it was no longer ravaging pillagers that led to ruin and therefore reconstruction, it was decrepitude and, above all, fire—the scourge of ancient architecture. At Saint-Martin in Tours, after an initial renovation around 1000, there was a vast reconstruction in the mid or late eleventh century, although the exact date has been the subject of much discussion.[10] Recent excavations suggest that the big apse was erected from 1070 to 1080, then the nave and the facade.[11] It would be instructive to know

Gauzlin's successor, starting in 1070, with two types of capitals. One type is figured, illustrating tales from the Bible (Samson, right) or scenes from the life of Saint Benedict, in an animated yet somewhat chaotic style. The other type, more ornamental in spirit, would be taken up at Charité-sur-Loire and in the Berry region in the center of France.[9]

A completely different development occurred in southern regions near Spain, where intense building activity took place. Closely tied to local traditions and resources, it directly reflected the preferences of each area, which is precisely the great interest of this "early Romanesque

art." In a geographic arc extending from Catalonia to Lombardy and Burgundy, a certain type of modest, solid, squat building appeared during the tenth century, surviving into the middle of the eleventh. Notable features included the use of small stones, vaulted ceilings over chancel and crypts (often extended over the entire church when the dimensions were modest enough), and decoration characterized by lesenes (pilaster strips without capitals or bases) and dentils (small square blocks under the cornices). It was perhaps a minimal art designed for poor country regions.

Then there is a separate group of original structures, like those on a central plan

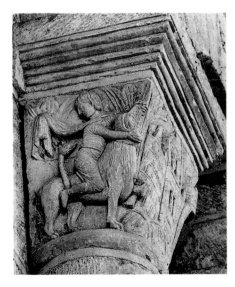

Abbey of Saint-Benoît-sur-Loire (Loiret).
Capital in the sanctuary. Samson
Slaying the Lion. c. 1100.

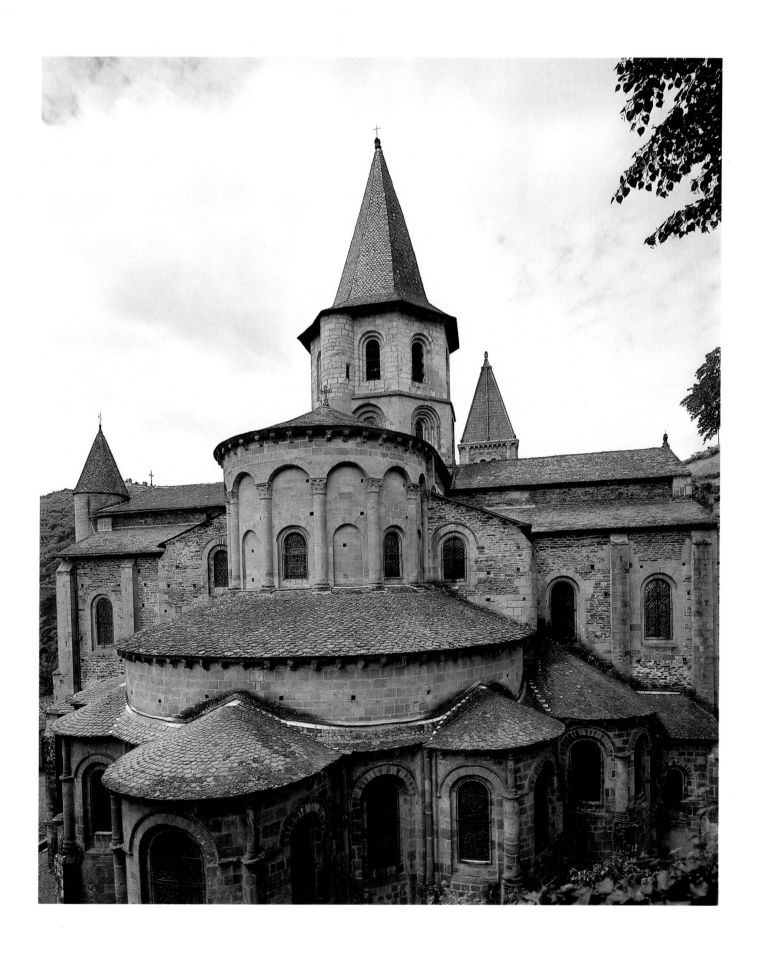

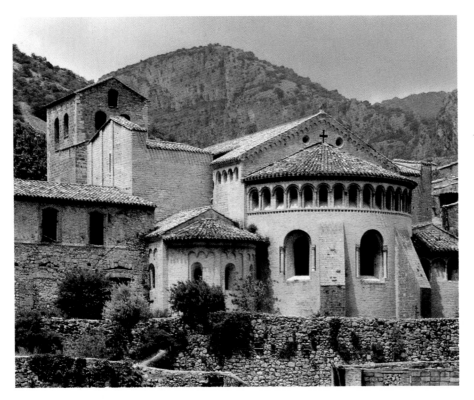

Abbey of Saint-Guilhem-le-Désert (Hérault).
The apse. Second half of the eleventh century.

the exact date of this key structure—an apse with radiating chapels—for the same system was employed at Conques during Odolric's abbacy (1039–1065, right) and at Saint-Philibert in Tournus as early as the beginning of the eleventh century.[12]

Monastic authorities, who were bringing monastic life back into line with liturgical functions, sought appropriate ways to organize interior space. Since the monks attended simultaneous masses, a number of chapels were required; furthermore, chapels with relics had to be placed in convenient locations for the faithful. In addition, the layout of the community's utilitarian spaces—chapter house, dormitory, refectory, cloister, etc.—offered each order further organizational possibilities. Such arrangements even appear at abbeys in hard-to-reach places like Saint-Guilhem-le-Désert (above). Located in the

so-called "Gellone wilderness" of the Hérault region, the abbey was founded in the ninth century, allegedly by William of Orange, hero of southern *chansons de geste*. At a date hard to determine (but prior to consecration in 1076), the church received an aisled nave followed by a superb apse adorned with eighteen arched niches and a two-storey cloister (unfortunately dismantled in the early twentieth century, one storey being shipped to The Cloisters in New York).

In Burgundy, meanwhile, the above-mentioned abbey church of Saint-Bénigne remained an isolated masterpiece. Other original Burgundian projects date from the eleventh century, however, like the nave of Saint-Philibert at Tournus (right), built toward the middle of the century, with transversal barrel vaulting and a two-storey vaulted narthex distinct from a

porch with bell tower. The second church at Cluny also fell under the law of reconstruction and was thus endowed with a narthex that boasted impressive rib-vaulting on the ground-floor level.

The most dynamic and ambitious province, though, was Normandy. It produced an uninterrupted generation of major churches like the one at Avranches, begun in 1015, and Rouen Cathedral, prior to 1037. Several Norman churches were completed rapidly, such as Bernay (circa 1013–1050), Mont-Saint-Michel (1023–1034), Coutances (nave, 1056), and Bayeux (1077). Division into bays and three-level elevation (arcade, gallery, and clerestory above groin-vaulted aisles) was already being practiced, in various versions that do not necessarily appear to be experiments. The abbey at Jumièges must have been begun around 1040, for it was consecrated in the presence of William the Conqueror in 1067. Jumièges (p. 148) is a tall structure with compound piers and, along the transept, a gallery-level passage was built into "thick walls." These features testify to the builders' mastery, as the spectacular ruins of the abbey still confirm today. Mastery is no less evident at the Abbaye-aux-Hommes (or Saint-Etienne, in Caen), with its equally remarkable adoption of a porch as facade between two towers—at Jumièges, the two flanking towers were linked by a gallery.

The import of these accomplishments is readily evident. They represent the culmination of experiments that date back to the Carolingian period, and their real point of departure can be found in so-called "Ottonian" churches. The marked verticality of these tall, pointed structures profoundly altered the urban landscape in both France and England (where similar experiments were conducted prior to the conquest in 1066).

The absence of unity observed in sculptural work, in which archaic elements coexisted with brilliant innovation, counsels against speaking too quickly of

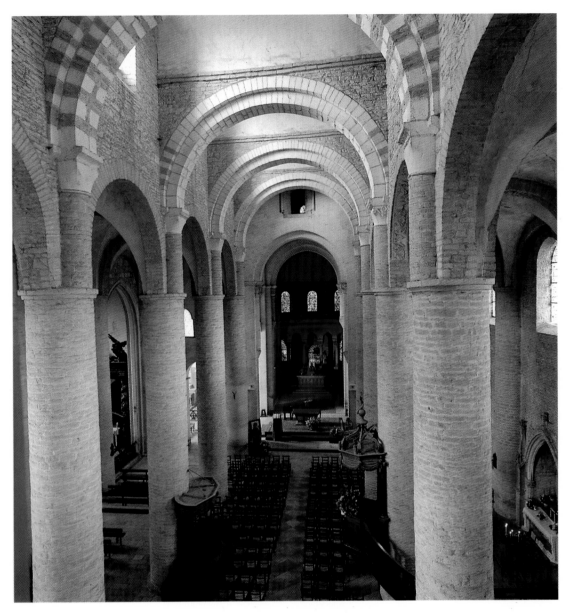

Church of Saint-Philibert, Tournus (Saône-et-Loire).
The nave. Mid–eleventh century.

"French" art. Eleventh-century figurative reliefs combine styles of varying origin, vocation, and scope. Everywhere there was what Henri Focillon called "appliqué art" right next to rather faithful imitations of classical forms (especially Corinthian capitals). Diverse influences led to inventiveness that could either shatter the usual architectural framework of the capital, or produce calm, richly decorated composi-tions conforming to the clearly established volumes of tympanum or capital.

A series of richly illustrated books has largely documented the repertoire of Romanesque sculpture.[13] The very diversity of that repertoire is proof of a vitality able to assimilate and transform everything. Vain attempts have been made to systematize this development by defining, for instance, two main poles: one Spanish (Compostela, Silos), the other Lombard. Between these two, the Languedoc and Burgundy regions of France theoretically developed their own innovations starting around 1050–1060. The highly "Western" nature of Romanesque phenomena can hardly be doubted—north and south also indulged in exuberant decoration, but always in very specific places, namely on portals and capitals. Whatever the rela-

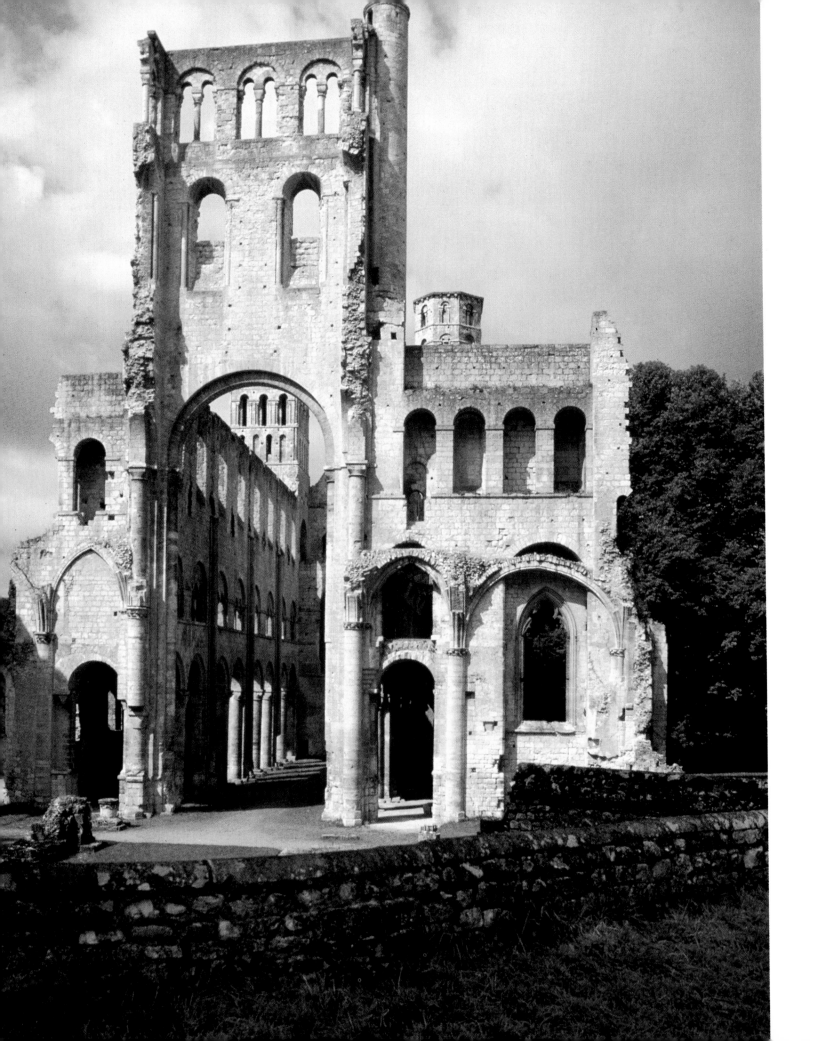

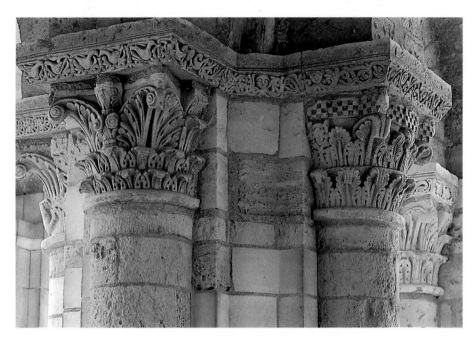

Abbey of Saint-Benoît-sur-Loire (Loiret).
Acanthus-leaf capitals on the ground floor of the porch tower. 1067–1218.

Left: Abbey of Jumièges (Seine-Maritime).
Ruins of the transept and the nave. c. 1040–1067.

tionship with Mozarabic decoration or with certain geometric patterns that might be labeled "barbarian," designs supplied by classical tradition, although fragmented and simplified, were always present and they easily found an echo in Ottonian art so enamored of acanthus-leaf decoration.

The church of Saint-Etienne at Vignory in the Marne region has a wood-roofed nave that boasts a powerful arcade with square piers on the ground floor, above which is a gallery of double bays separated by columns with enormous capitals (p. 150). The church, which evokes the solid world of the Rhine region, is dated circa 1000 by Focillon, mid–eleventh century by others. Nowhere else is the rich, sumptuous potential of capital decoration displayed to such fine effect.

On one capital, the sculptor placed two symmetrical four-footed animals under a rounded palm leaf—a design borrowed directly from Byzantine fabrics.

Nearby, a panel cut into the side of a block shows birds around the tree of life. And so on. It would seem that designs borrowed from fabrics and metalwork circulated a great deal. As pointed out by Louis Bréhier, sculpture was initially nourished by the so-called minor arts, in what was a widespread phenomenon.

This may have been the case at Saint-Remi in Reims, where the abundant imagery had already produced, by the first half of the eleventh century, an elegant fusion of figures (such as open-armed atlantes) with decorative elements like foliated scrolls and palm leaves. The phenomenon may also have been at work at Saint-Bénigne in Dijon where, in a more brutal fashion, fantastic masks and figures adorn tormented capitals (pp. 150–51). These precocious examples seem to point to a "culture" which drew inspiration from ancient models that could be transformed at will.

The same issue arises with the chancel at Bernay (circa 1025), which can be linked to Dijon insofar as William of Volpiano spent time there. The sculptor obviously enjoyed executing a whole series of variations on scrolls and palms, even pushing aside acanthus leaves in order to insert round masks or "cut heads" among them. The same approach can also be found at the Trinité church in Caen, indeed is typical of Romanesque sculpture in Normandy.

Shortly after 1000, the abbey of Saint-Germain-des-Prés in Paris was endowed by Abbot Morard with a facade tower and a choir that underwent, as was often the case, modification in the twelfth, seventeenth and nineteenth centuries. The capitals in the eleventh-century nave (now displayed at the Musée de Cluny in Paris), are disconcerting in their diversity. They include purely decorative motifs and elaborate scenes from the Bible (perhaps including an Apocalypse) on all four sides of a capital with, above the corbel, rows of animals constituting a frieze. Direct sources are hard to establish, since the date is uncertain. But at the very least the capitals convey a strong determination to "illustrate" the inside of a sanctuary without resorting to the noble and abstract idiom of Corinthian foliage which the porch at Saint-Benoît-sur-Loire (p. 151), faithful to Carolingian models, was reinvigorating at that very moment.

Dozens of buildings would have to be discussed, with the usual reservations about dates and relative precociousness, to cover the wealth of eleventh-century carved decoration in churches both urban and rural, noble and modest, all across the land. To take just one, often overlooked, example, the rustic capitals in the nave of the priory at Saint-Pierre-le-Moutier develop a surprising repertoire that includes wrestlers, musicians, bear-baiters, and owls appearing among monsters, gryphons, and palms. It is impossible to establish a serious iconographic cycle; rather, it is the impression of

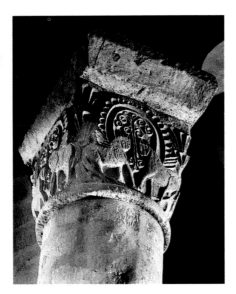

Church of Saint-Etienne, Vignory (Haute-Marne). Capital in the ambulatory. Mid–eleventh century.

King Robert the Pious, patron of monasteries and issuer of charters of immunity, went on a pilgrimage toward the end of his days, in 1030, which took him across central and southern France—Brioude, Saint-Gilles, Conques, and so on. Sacred relics and souvenirs were what reputedly drew him, but for a king who had never attempted the trip to Rome, Jerusalem, or Compostela, the pilgrimage represented above all an opportunity to take to the road, perhaps with largely political ulterior motives.

As Georges Duby aptly pointed out, "one of the most obvious signs of economic and social détente around the year 1000 was the sudden wave of major pilgrimages."[14] They were an unmistakable sign of mobility and confidence, representing the spread of a practice already highly esteemed due to the glamour associated with sacred places and miraculous sanctuaries. The case of Mont-Saint-Michel in the tenth century, described above, was manifestly inspired by the desire to offer western pilgrims an Atlantic equivalent of the prestigious Monte Gargano on the Adriatic.

Why did crowds travel along highways, sometimes with armed knights, animated by an enthusiasm that would benefit from (or at least would soon engender) comfortable roadside services and hostelries that divided the journey into manageable legs? Why were there so many people on the road to Santiago de Compostela, with staff and shell? Throughout the Middle Ages and particularly in the tenth, eleventh, and twelfth centuries, Spain was in a permanent state of Crusade. Santiago (Saint James), who converted Spain just as Saint Martin converted Gaul, permanently entered Christianity's collective imagination with the incident at Clavijo (844), where he reportedly appeared above a flowering white bush to announce a Christian victory over the Saracens. Compostela symbolized Christianity's mis-

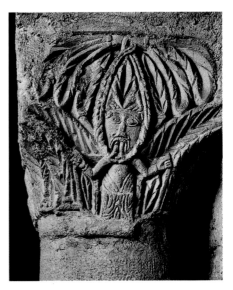

Church of Saint-Bénigne, Dijon (Côte-d'Or). Capital in the east apsidiole of the crypt. Early eleventh century.

sion in the West just as Jerusalem, that other pole of attraction, did in the East. They reflected the irresistible pull toward the two ends of the world.

As early as the tenth century, people went to Compostela to venerate a battling saint, to provide moral support and, potentially, to lend the Asturian principalities an active hand in resisting the Saracens. El Mansur's raids turned the pious act into a hot issue but never managed, it would seem, completely to strangle the flow of pilgrims. Godescalc, bishop of Puy, made his pilgrimage in 950 and brought back a major Visigoth manuscript. It is essential to appreciate the sense of solidarity toward Spanish Christians in order to understand why William, duke of Aquitaine, crossed the Pyrenees into Spain in the early eleventh century, and why King Sancho III "the Great" of Navarre solicited help from Cluny around 1032, to which the monks vigorously responded.

The consequences of this solidarity (at once popular and religious, political and dynastic, economic and swashbuckling) have often been assessed, for they pro-

freedom and amusement that requires explanation.

Given this situation, it is understandable why systematic study of Romanesque styles and techniques has been preferred to highly risky research into direct influences and borrowings. A stylistic, technical approach is above all suited to the reliably dated major productions after 1100, when portals became as important as the capitals discussed here. The main point that emerges from scattered eleventh-century examples is the widespread use of stone for its expressive possibilities as well as its constructive value. All of the examples cited, plus many others, employed sculpture in the strict sense as a decorative touch designed briefly to enliven a massive stone structure; sculpture operated by inflecting or winding forms into the block reserved for it. Differences stemmed primarily from the nature of the stone used, whether sandstone or pure limestone—the marble so beloved by the Carolingians had practically disappeared.

duced an impressive picture of princely intermarriage, shared institutions, common building projects, and exchange of ranking officials (in 1085, the first archbishop of Toledo and primate of Spain was a Frenchman, Bernard de Sédirac). The extension of roads to and from Compostela and the French provinces, not to mention the amazing convergence of traffic at "ports" or Pyreneen passages along footpaths running from church to church, functioned as the drive belt of exchange for nearly two centuries.

It was naive of archaeology to try to interpret this twin movement in a unilateral way, arguing either the priority of Spanish models over French accomplishments[15] or, inversely, the subjugation of Navarre to French influence. In the cathedral at Le Puy, which has a famous wooden door bearing inscriptions to the Virgin in "kufic" script, frescoes from the *Chanson de Roland* —of later date, true enough—decorate a room above the cloister. At La Sauve-Majeure, a cornerstone is decorated with a medallion of Saint James; at Saint-Lazare in Autun, pilgrims with their sacks are shown among the Elect on the lintel; on the wall of Tavant, a bearded pilgrim holds a palm frond, etc.

Naturally, there was a flow of the faithful to the Holy Land, a long and grand adventure full of promise and reward for the soul. Raoul Glaber claimed that vast crowds went to see the Tomb of Christ in 1033. Here again, the consolidation of ecclesiastical and political authority made organized travel feasible—in 1095, the circular tour by Pope Urban II and the Council of Clermont set the stage for one of the most extraordinary escapades in Western history: the First Crusade. The Crusades represented a revival of Christian consciousness among lay people. According to a recent historian, J. Riley Smith, the slogan *Gesta Dei per Francos* efficiently rallied the knighthood, but meant, according to chroniclers themselves, the intention to infuse secular life

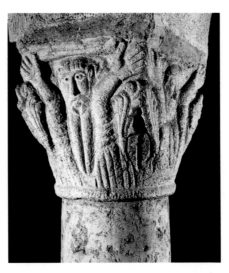

Church of Saint-Bénigne, Dijon (Côte-d'Or). Capital in the rotunda. Early eleventh century.

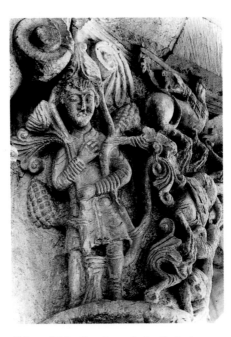

Abbey of Saint-Benoît-sur-Loire (Loiret). Detail of capital on the upper level of the porch tower. c. 1067–1218.

with the nobility, organization, and sacrifice proper to monastic life.[16] It would remain to be seen what became of the initial ardor several generations later. The concrete idea of the Crusades lasted for two hundred years, from victory to defeat, persisting for yet another two centuries as a chimerical ideology. It was probably one of the most notable features of Western— especially French—mentality, given the people who backed it, from Louis VII to Saint Louis, and given the role that it continued to play in political discourse during the Valois period.

Most relevant here is the hard to overlook fact that the precarious kingdoms founded in the Holy Land, along with related territories such as Cyprus, allowed Western architectural practices to be exported, tested and, as far as military architecture goes, perfected in the field by contact with Byzantine and Umayyad fortresses. As with Compostela, the question of whether French builders were "influenced" or "influencing" has inspired theories in both directions. A sort of back-and-forth movement obviously existed in that sphere as well. The inner fortress of the Krak des Chevaliers (a stronghold begun in 1170 to protect Tripoli), was developed in successive layers that make it possible today to see how the defenders conceived its progressive adaptation.

ARCHITECTURE ALONG PILGRIMAGE ROUTES: AN OBSOLETE ISSUE

One issue which historians once hotly debated was whether the "dynamic" of pilgrimages, especially to Compostela, perhaps explained new architectural designs, the grand "Romanesque" designs. A guide for Compostela pilgrims (circa 1140) cites four churches that constituted the start of routes converging toward Spain—Saint-Martin of Tours, Saint-Martial of Limoges, Sainte-Foy of Conques, and Saint-Sernin of Toulouse (p. 152).

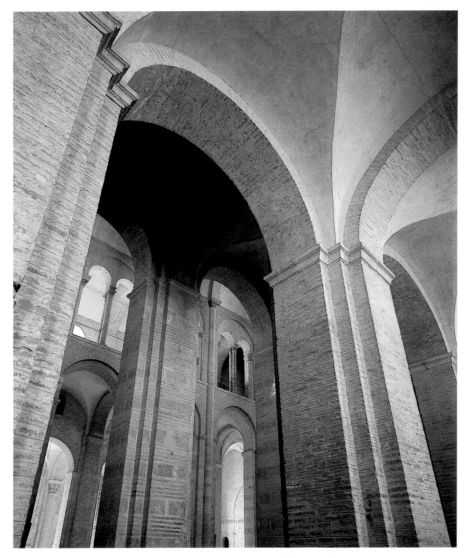

Basilica of Saint-Sernin, Toulouse. Interior view showing side aisles.
Second half of the eleventh century.

nated in Spain with the magnificent Romanesque masterpiece of Santiago de Compostela (itself closely related to Saint-Martial in Limoges and Saint-Sernin in Toulouse), and culminated in France, via Chartres and Laon, in the outstanding accomplishment of great Gothic cathedrals characterized by a wide ambulatory ringed by chapels, a transversal development of the transept, extension of the nave toward the west, and the lofty crowning of every tower."[18] Thus Gothic masterpieces allegedly capped the development of sanctuaries which were spurred by pilgrimage routes.

This historical simplification is no longer accredited, even though it still apparently survives in the way the issue is presented. The geographic grid it proposes must be re-interpreted in light of a comparative study of the conditions specific to each church, the examination of special features, and the constant transformations that new needs imposed on each edifice. Seen in this light, features common to the above-mentioned churches are limited to an abstract plan favoring the internal circulation of large crowds. All the other features cited, notably the superbly stacked composition of the apses found at Saint-Sernin, at Cluny, and so many lesser sanctuaries, had been under development, so to speak, for a long time. The oft-mentioned ambulatory with radiating chapels, for instance, appeared in embryonic form in the crypt of Clermont Cathedral (tenth century) and it was incorporated into the apse at Saint-Martin of Tours at a time when the Compostela pilgrimage was not at its height. Purely liturgical requirements could have dictated the redesign of chancels in many monastic churches, occasionally resulting in a conflict between the needs of the religious community and those of pilgrims, as happened at Saint-Benoît-sur-Loire, for instance. This issue underscores the need to look at multiple causes, especially for developments so hard to circumscribe.

There were marked analogies between these edifices: they were all very large, had completely vaulted ceilings, and their interior spaces were well arranged for the circulation of large crowds. It was commonly thought, then, that these sanctuaries (to which could be added others like Saint-Etienne of Nevers) constituted a single family of "pilgrimage churches" related to the western destination of these organized trips, Santiago de Compostela.

The phenomenon seemed to provide a necessary and sufficient explanation for the rise of sculpture, implying the absolute priority of Spanish construction and therefore re-datings with which it is difficult to agree.[17] In terms of architecture, an "extreme" attitude was expressed by Elie Lambert in a synthesis that bears quoting: "The model for large sanctuaries with relics found along pilgrimage routes, established at least in part by the first half of the eleventh century at Saint-Martin in Tours and Saint-Remi in Reims, culmi-

2. DECISIVE ACCOMPLISHMENTS: AROUND 1100

Pope Urban II's circular tour of 1095, with multiple consecrations of more-or-less finished churches, illustrated the important role acquired by Capetian France not only in the eyes of the papacy but in those of all of Christianity. At a time when the Capet dynasty was not yet solidly rooted, French ecclesiastics were increasingly found at the head of Church affairs, and new religious foundations multiplied. In 1082, Bruno founded the hermitage at Grand Chartreuse. In 1098, Robert de Molsme founded a reformed branch of the Benedictine order at Cîteaux. Bernard, a young noble with exceptional energy and conviction, entered the new order in 1112 and founded the Clairvaux monastery in 1115; in 1146 he advocated the Second Crusade before the assembly at the basilica of Sainte-Madeleine in Vézelay. In 1120, Norbert, also later canonized, founded the Premonstratensian order. In 1113, William of Champeaux drew up the rules of the canons of Saint Victor. Each of these initiatives would prove crucial to

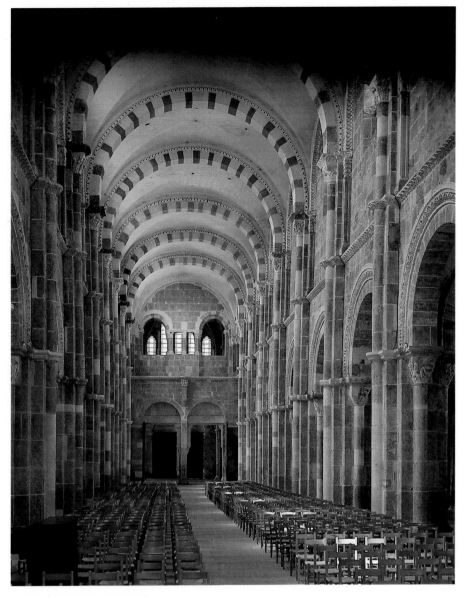

Basilica of Sainte-Madeleine, Vézelay (Yonne).
View of the nave looking west. First half of the twelfth century.

liturgy, to monastic practices, and to the design of sanctuaries.

And they all reflect the French response to major reformist measures taken by two popes, Gregory VII (1073–1085) and Urban II (1088–1099), who wanted to purify ecclesiastical mores by denying secular authorities the right to name bishops and by asserting the superiority of pope over emperor. To combat

the imperial party, or Ghibellines, the pope backed the Guelphs and sought support from the kings of France, which contributed to the pre-eminence of the French dynasty a century later. The notion of *reformatio ecclesiae* is crucial to the Romanesque period,[19] involving new liturgical practices that included performing the mass facing the altar rather than facing the congregation.

In monasteries, an abbot elected by the community (depending on the rules of the order) might be joined by an administrative abbot appointed by the feudal lord, especially when that lord had contributed to construction costs. Bishops also might seek to impose their control. Cluny's strength therefore resided in the order's ability to obtain papal bulls enabling it to resist domination by secular authorities. Its success led to a vast, multicelled organism, the *corpus cluniacensus ecclesiae*.[20] The second version of the monastic church at Cluny was already famous for liturgical ostentation when, around 1100, Robert d'Arbrissel referred to "Cluny, where there are such fine processions." Moreover, the order had also begun building its third sanctuary, the one that became the largest church in Christendom, bigger even than Saint-Martial of Limoges, consecrated in 1095, or Saint-Sernin of Toulouse with its grandiose chancel in brick (p. 152). This was the moment when various architectural elements arranged in varying ways began to form a sort of complex model. Both chancel and nave were henceforth almost always given vaulted ceilings, which spurred builders to study technical issues, notably the role of columns and piers in supporting vaults. Numerous mechanical devices were developed, and stonecutting methods achieved a certain standardization.

The institution of regular canons led to the addition of a cloister, and cloisters led to the spread of figured decoration everywhere. Facades were henceforth strongly marked by twin bell towers and sometimes had several portals reflecting the interior layout. Sculpture became a permanent feature; it seems as though churches decided to present a more explicit exterior, and a more decorative and lively interior. This accords with the extensive deployment of wall paintings, statues, and precious metalwork, creating a setting almost impossible to reconstitute today.

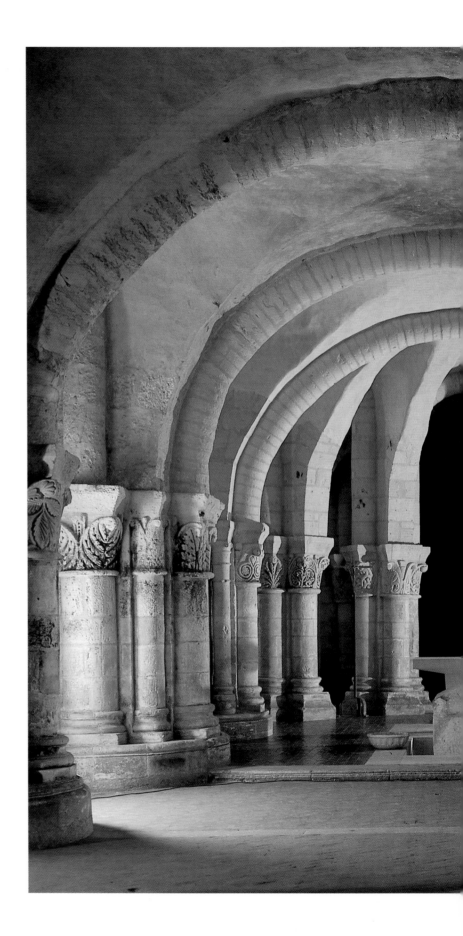

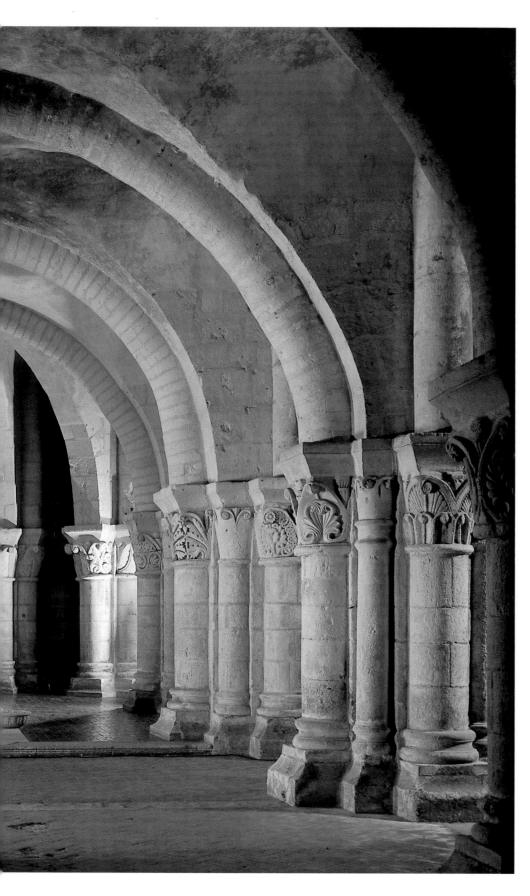

Church of Saint-Eutrope,
Saintes (Charente-Maritime).
View of the lower church.
Late eleventh century.

Two sides of a Romanesque capital illustrating the "tones" of music, from the ambulatory of the former Cluny abbey church (destroyed 1798–1823). 1095. Granary of the former abbey, Cluny.

DIDACTIC ART

In western France, where local stone was of the right quality, facade–frontispieces abounded, like the one on Notre-Dame-la-Grande at Poitiers (second quarter of the twelfth century). The facade boasts several registers of sculpture articulating a rich doctrinal thesis—this theological "discourse" unfolds amid a rich collection of decorative elements that add sparkle to a facade set between two small bell towers and below a pediment shaped like a giant reliquary. The same could be said of Angoulême Cathedral which, although completely different in interior layout, received a sort of figured frontispiece of enormous interest (unfortunately massacred by Abadie's restoration) during the days of Bishop Girard (elevated in 1101). At Saintes (pp. 154–55 and right), Pope Urban II and Bishop Ramnulphe consecrated the altars of the upper and lower churches of Saint-Eutrope in 1096—the old capital of Roman Aquitaine was at the center of a diocese of seven hundred parishes. During the twelfth century over two hundred and fifty churches or modern facades were built,

yielding magnificent exterior sculpture.

Turning to Burgundy, similar didactic concerns emerged around 1100. First there was Cluny, whose high altar was consecrated in 1095 (the church's magistral structure will be discussed later). Eight apse capitals saved from nineteenth-century destruction feature elegant, gentle figures inside mandorlas edged with inscriptions, organized in groups of four elements such as the "tones" of music (above), the rivers of Paradise and, probably, the liberal arts.[21] This type of imagery "explained" the physical and mental universe. It is hard to be precise about dating—the capitals must have been carved on blocks hewn within twenty years of the consecration of the altar.

The abbey church of La Madeleine at Vézelay (p. 153) is another major initiative of the year 1100. In the mid–eleventh century, the sudden appearance of a relic of the sinning saint unleashed a popular pilgrimage that called for renovation of the old Carolingian basilica. The consecration—precocious as usual—took place in 1104, and this date is ascribed to several

Christ in Majesty. Cloisonné enamel on copper, taken from an altar plaque. Second half of the eleventh century. 12.4 × 7.9 cm. The Metropolitan Museum of Art, New York.

capitals re-used in the south aisle of the nave, the rest of the work having been delayed by violent and intractable clashes of authority (which only came to an end in the mid–twelfth century).

This list of contemporary achievements could be considerably lengthened and nuanced, but it already points to the approach generally followed by authorities during the height of the Romanesque period. They realized that artistic methods had to be further extended in order to "teach through images" the lessons that Christendom needed. They adhered to the maxim formulated by the monk Gratian : *Quod est clerico litera, hoc est laica pictura* ("Pictures are to lay people what texts are to the clergy"). It was no longer merely a question of impressing the ignorant with representational images, but of completely teaching books, including sacred texts, through a display that made them more perceptible to all. Paintings and stained glass were for general edification.

Strangely, this was the moment when exegetes began complicating the Christian message. A monk named Honorius of Autun, about whom it would be interesting to know more, conceived *De Imagine Mundi,* an encyclopedia full of extraordinary etymologies. Enthusiastic compilations were designed to convey the fact that, by *translatio studii*, the center of culture that had once shifted from Greece to Rome was henceforth located in France. Cosmological and historical information contained in such books were part of shared culture, and therefore resurfaced in the decorative arts. In another book (circa 1100), *Speculum Ecclesiae,* the mysterious Honorius used sermons to develop a comparative method that would have considerable impact: every incident in the Savior's life corresponded to something in the Old Testament that prefigured it, or even to fantastic creatures that illustrated it. The Nativity was thereby linked to Isaiah's prophecy, to Gideon's fleece, and to the unicorn (all depicted on a stained-

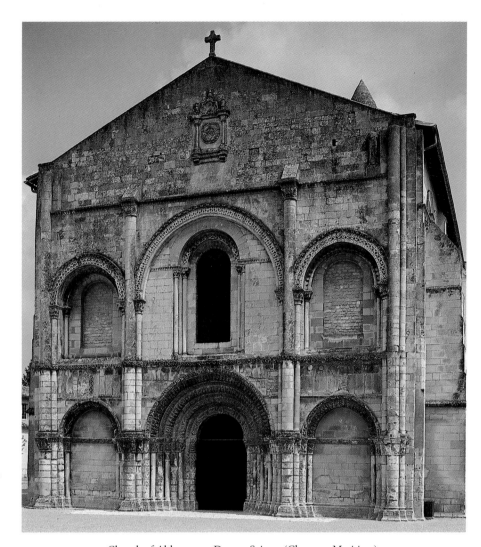

Church of Abbaye-aux-Dames, Saintes (Charente-Maritime).
West facade. Second quarter of the twelfth century.

glass window in Laon), and so on. Christian imagery thus developed a coded discourse, with complications all the more surprising and delectable for being, in theory, designed to edify the people. In fact, this concern manifested itself above all in the numerous references to the life of the saint associated with each sanctuary.

Artistic undertakings became ever more complex, as the total organization of a church became increasingly tied to its specific vocation. An equally strong devel-

opment could be observed in church furnishings of precious metalwork, in wall paintings, and in stained-glass windows. The importance of relics, noted above, explains why the production of decorated coffers was so amazingly extensive. There were also plaques to be placed on the altar, often illustrating Christ in Majesty, such as a small enamel with lively cloisonné folds, dating from the second half of the eleventh century, now in the Metropolitan Museum, New York (left).

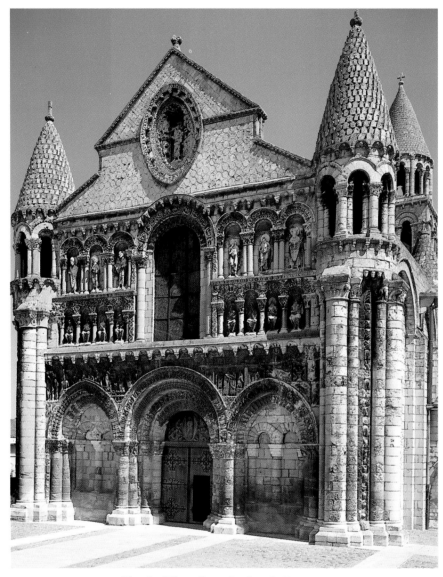

Church of Notre-Dame-La-Grande, Poitiers.
West facade. Second quarter of the twelfth century.

The embellishment of the statue of Sainte Foy by the abbey of Conques, discussed above, also fits into this context; the portable altar of Sainte Foy (part of the basilical treasure, p. 102) shows that this work, somewhat simplified, continued into the eleventh century, along with the reliquary of Abbot Bégon (circa 1100) and a strange "lantern" in the form of an octagon capped by a cupola, which must be based on some Byzantine model.

Southwestern France played an early role in the semi-industrial production of precious enamels, because it sent all sorts of compositions to all four corners of Christendom. Some ten thousand pieces or fragments have now been inventoried. Unfortunately, a great deal has also been lost, like the decoration for the tomb of Saint Front at Périgueux, reportedly designed by a monk named Guinamundus, specially summoned from La Chaise-Dieux around 1080. But it was in Limoges during the heyday of the Plantagenet kings that enamels acquired the authority and success which perhaps made them the linchpin of southern industry; they would accompany and sometimes trigger stylistic development, as would the miniatures to be discussed later.

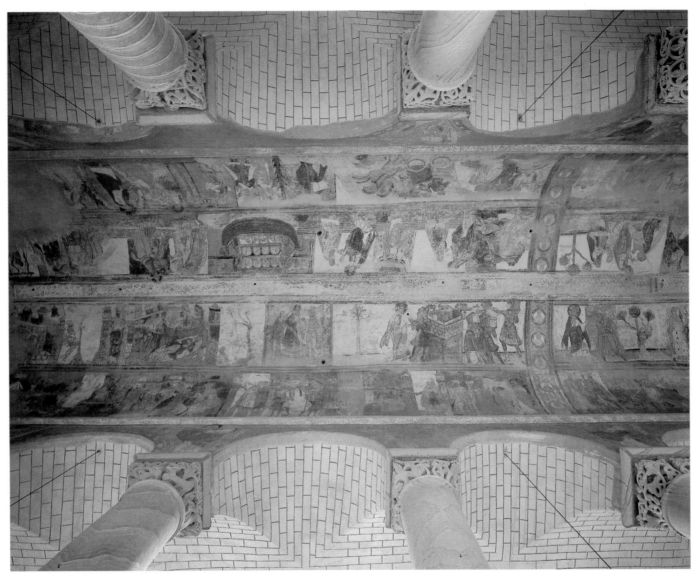

Abbey of Saint-Savin-sur-Gartempe (Vienne). View of biblical scenes decorating the nave vaulting. Late eleventh century.

MURAL PAINTING

Painting played a major role. The abbey church of Saint-Savin-sur-Gartempe, for instance, boasts a long, late eleventh-century nave with two aisles. The nave ceiling is a long barrel vault devoid of transverse ribs, while the aisles have groin vaulting. It is obvious that the surface of the barrel vault was designed to receive decoration in the form of a painting, which turns out to be the strongest and most ingeniously composed example of its type in all of Romanesque art (above). Nowhere else was the Biblical story of creation so well arranged into lively, eloquent episodes, animated by ochre and brown tones. Scenes of the Creation itself, the Tower of Babel, and Exodus were executed with admirable ease and authority characterized by a rigorous economy of forms.

Stylized elements (mushroom-like trees, wavy ground, a miniature city) were conceived with the same decisiveness as the main elements of pictorial discourse (meaningful gestures, poses, clothing). That is what gives this cycle such exceptional impact, along with its delightful equilibrium of color and draftsmanship.

In comparison, the less well-preserved paintings in the porch, depicting images from the Apocalypse, initially seem more conventional. But the scenes of Saint Michael and the Angels Battling

with the Enemy, in the east bay, are notable for their harmonious arrangement of gestures and movement, especially concerning the angels.

The tribune formed by the upper level of the porch bell tower shows a Passion cycle, centered on a Descent from the Cross on the tympanum and featuring evangelical scenes of the Angel at the Tomb, the Apparition to Mary Magdalene, and other scenes harder to identify. The artful grouping and the subtle use of ochre and earth colors—in short, the overall stylistic quality—are what so impressed Prosper Merimée, the writer who was then inspector of historic monuments, when he first saw them, as related in his 1845 account. In the crypts dedicated to Saints Savin and Savinian, another painter—identifiable by a harsher, more summary style—depicted the two martyrs' suffering. It is hard to imagine a more complete set or more varied registers of painting.

This thoroughly mature masterpiece begs for precise documentation which, unfortunately, does not exist. Other paintings in western France that extended or paralleled this tradition will be discussed

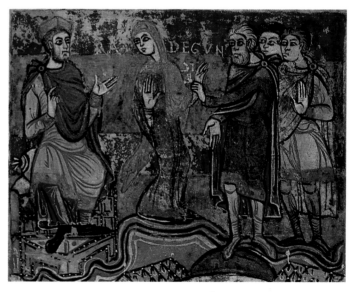

Vie de sainte Radegonde: Radegund is led before King Clotaire I. Eleventh century. Bibliothèque Municipale, Poitiers (Ms. 250, fol. 22v).

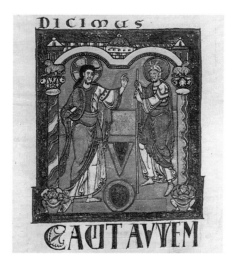

Second Bible of Saint Martial of Limoges: Moses before the Lord. c. 1100. Bibliothèque Nationale, Paris (Ms. Lat. 8¹, fol. 41).

later. What needs to be stressed here is the disconcerting appearance of an artwork as masterful as that seen on the ceiling, with no way of being able to account for it. There were frescoes and stained-glass windows at the church of Sainte-Radegonde (Radegund) in Poitiers, recorded on twenty-two pages of an illuminated manuscript (Poitiers, Bibliothèque Municipale, Ms. 250). In Tours, the church of Saint-Julien had frescoes (also lost), and what is known of the abbey of Saint Martin suggests the extent to which Tours preserved the art of fresco and narrative skills for centuries.[22] In our ignorance, however, the masterpiece at Saint-Savin remains an isolated artifact, a *unicum*.[23]

What must have been a major cycle was discovered after 1940 in the church of Saint-Jean-Baptiste in Château-Gontier. It shows scenes from Genesis with rich decorative features employing all the resources of geometric and animal forms. This damaged cycle can be stylistically and chronologically related to Saint-Savin, confirming links between the latter and the Loire Valley. Other vestiges are still

coming to light, adding to our picture of the period. One of the most interesting is the image of Saint Peter in *cathedra*, being enthroned by Christ, discovered in the chapter room of La Trinité in Vendôme.[24] The lively yet refined ochre hues are those used in the area around Saint-Savin, but under the authority of Abbot Gregory of Vendôme (1093–1132), painting reflected contemporary political and religious developments, so that "Gregorian" ideas of reform and papal authority were clearly illustrated here. Finally, the more common theme of *traditio legis,* the Lord handing the keys of the church to Saint Peter (and the power they represent), was probably depicted in mosaics on the left portal of Saint-Denis.

Around 1100, then, major mural paintings existed in churches, and the technique would be practiced throughout the century (the remarkable examples at Vicq and Tavant will be discussed later). Furthermore, stained-glass windows also existed already. A description of Saint-Remi in Reims around 995 mentions win-

dows with scenes (*historiae*), though there are no eleventh-century vestiges. It is possible to conceive, however, of a relationship between stained-glass compositions and the forms and framing used in miniatures. The *Second Bible of Saint Martial of Limoges* (p. 160), which dates from the late eleventh century, retains the vitality of tenth-century examples already cited; it is a large work that energetically deploys figures, the whole work being animated by surprising contrasts of reds and greens, plus the insertion of burdened figures (atlantes) at the bases of the arches (Bibliothèque Nationale, Lat 8).

Another manuscript center that emerged at that time was Cîteaux in Burgundy, where an Englishman named Harding became abbot in 1109. A four-volume bible was directed and probably drawn by the abbot himself. It constitutes an extraordinary repertoire of narrative inventiveness and fancy (e.g. the story of David in seventeen tableaus). The coloring is light, and the miniatures' charm resides in the often ironic drawing (ascribable to the abbot's British roots?). In any event, it is hardly surprising that this masterpiece was solely intended for the delight of monks (Dijon, Bibliothèque Municipale, Ms. 12–15).

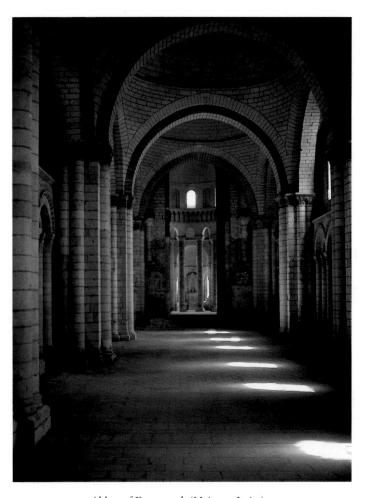

Abbey of Fontevrault (Maine-et-Loire).
View of the nave looking east. First half of the twelfth century.

The Secular World

A certain number of notable political and cultural developments around 1100 help illustrate the artistic vitality of what would become France. As already mentioned, this was the period when northern French troubadours, poets, and wandering musicians launched into epic compositions—the *Chanson de Roland* was immensely appreciated by feudal aristocracy, spurring major poetic development in the north (the version known today was not written down until 1140). Meanwhile, southern—or Languedoc—culture with its songs and courtly poetry was blossoming under William IX, duke of Aquitaine (1071–1127), a noble whose praise of courtly pleasures did not go unnoticed. Languedoc literature influenced northern poetry—less refined, less free in tone—in a general cultural revival that also affected dress and manners. The Norman chronicler Orderic Vital accused Duke Robert Curthose of having made southern dress fashionable by wearing a *chainse* (shirt) that was long rather than short, and a *bliaud* (jacket) with elaborate pleats and armholes. Secular culture—courtly tales, poetry, and romances of love and adventure—would soon reach its heyday with Duke William's granddaughter, Eleanor. On her marriage to Louis VII in 1137, Eleanor took this culture north to courts in Champagne and Ile-de-France. And when she was divorced by Louis in 1152, her immediate remarriage to Henry Plantagenet, future king of England, had more than political repercussions—it was a major event in the history of culture.

The 1066 invasion of England by the Normans under William the Conqueror had been depicted in an extraordinary "comic strip" that was probably embroidered in England, though intended for the cathedral of Bayeux. The Bayeux Tapestry (p. 162) is immensely interesting in its translation of an event into images marked by a dynamic arrangement of scenes in which emblematic figures, gestures,

The Bayeux Tapestry. Details of two panels. Embroidered linen. Height: 50 cm. Length overall: 69.5 meters. c. 1095.
Centre Guillaume le Conquérant, Bayeux.

equipment, and architectural symbols are always employed in a clear, lively, and efficient manner. The Bayeux Tapestry illustrates the fact that by the late eleventh century the West possessed a capacity for narrative imagery, an instinctive need for which would soon be felt everywhere.

The famous tapestry also invites reflection on the evolution in Anglo-Norman power in the twelfth century, which a rare but efficient convergence of circumstances amplified when Henry Plantagenet, count of Anjou, became King Henry II of England in 1154. His marriage to Eleanor

lent exorbitant dimensions to English domains. The resulting rivalry between the French and English kings was disastrous in the conflicts it sparked, yet fertile in the competitive art and architecture it spurred. This period was defined by two century-long wars between Plantagenets and Capets. The first, an essentially territorial conflict (1150–circa 1250), was followed by a dynastic struggle between the last Capets and their English rivals for the French throne after the coronation of King Philip VI of Valois (1328) that continued through the middle of the fifteenth

century. But during the first phase, at the time of the grand Plantagenet domain, the movement back and forth between western France and England so accelerated the development of architecture on both sides of the channel that it is no longer possible to consider them separately. Plantagenet political power was symbolized by the Abbey of Fontevrault (p. 161), where Robert d'Arbrissel had gathered his disciples in 1099. The church was consecrated (though not necessarily finished) in 1119, and the order established itself with such success on Plantagenet territory that

Fontevrault became the dynasty's mausoleum starting with Henry II of England (died 1189) and his queen Eleanor (died 1204). The abbey was moreover organized like a veritable town, with remarkable facilities like an octagonal kitchen with eight alcoves and pyramidal ceiling, the most sophisticated of its kind in the Middle Ages.

This rapid sketch of the year 1100 would not be complete without a reference to the "proto-humanist" current that surfaced during the reign of Philip I (1060–1108). It was just about the year 1100 that Hildebert de Lavardin (1056–1133), the worldly bishop of Le Mans, composed his works in Latin. His famous elegy on Rome—*par tibi, Roma, nihil, cum sis prope tota ruina*—was the first to adopt a tone of historical nostalgia. Lavardin was familiar with Virgil and Ovid, cultivating a poetic knowledge that would survive throughout the century, influencing fictional poetry. Suddenly it no longer seems so surprising to discover images of Pyramus and Thisbe depicted on capitals. Many Ovidian romantic scenes would undoubtedly be found on ivory mirrors and boxes from the twelfth century, had more of them survived.

Southern France valued its classical heritage, and knowledge of Roman law was apparent in the twelfth century. On a noble residence in Saint-Antonin-Noble-Val, which pre-dates 1155 and which Viollet-le-Duc mistook for a town hall but which in fact was a viscount's palace, a famous statue shows Emperor Justinian holding Moses-like tablets bearing a painted inscription, long indecipherable, that was nothing other than the beginning of the *Incipit* from Justinian's *Institutions*.[25]

3. A DIVERSITY OF CHURCHES

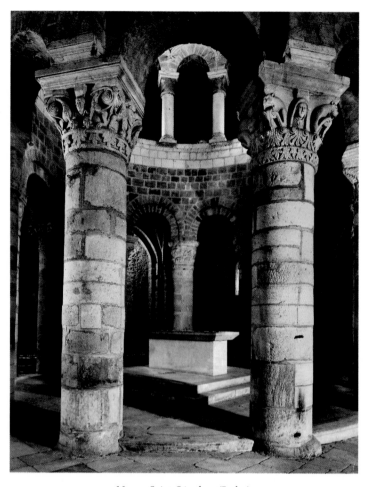

Neuvy-Saint-Sépulcre (Indre).
The lower level of the rotunda. Early twelfth century.

The order of the Knights Templar—born of the Crusades, endorsed by the Council of Troyes (1128), with statutes drawn up by Saint Bernard—built centrally planned chapels in their commanderies, several examples of which still exist (in Laon, for instance). It was in Jerusalem that the Crusaders had discovered the Anastasis rotunda dating back to the days of Constantine (early fourth century). The Arab conquest under Omar in 638 had altered it, but this centrally planned structure capped by a high cupola more than ever constituted a monumental, universally valid symbol of the resurrection of Christ. It figured as such on coins and reliefs. William of Volpiano, as discussed above, built a rotunda at Saint-Bénigne. Another rotunda, at Neuvy-Saint-Sépulcre (above right), was placed under papal protection in 1079—it was reportedly founded by the local feudal lord on his return from the Holy Land, in order to enable pilgrims to anticipate or symbolically repeat their distant voyage. The glamour of a rotunda structure endured in Western art, though only as an exception and, as was the case at Neuvy, with the more or less successful addition of a nave.

Another church design—that began with the outline of a cross marked on the ground—was equally explicit in its simplicity. The general plan nevertheless tolerated variants in the nave (single or multi-aisled) and, above all, in the arrangement of the apse. Countless experiments in the twelfth century attest to the absence of shared norms. Regional habits counted more heavily than ever, all the while vigorously responding to information that might come from a visit or voyage, yielding increasingly brilliant alternatives. The flavor of Romanesque art owes much to the fact that, although dependent on formulas, it seems relatively open to local influences. Emulation and competitiveness clearly

existed, but each element of the edifice could only incorporate them in a groping fashion. The result was that the handling of transept chapels, or a lantern tower, or crossing, required a sort of on-going reflection on constituent elements and their particularities. Certain innovations must have appeared more pious than others, and monks steadily developed a taste for the symbolic interpretation of every aspect of a church. This attitude, however, would only be completely formulated in works by liturgists like Durand de Mende in the thirteenth century. It is therefore often difficult to interpret the intentions of twelfth-century builders, even though their technical reasoning is relatively clear.

Churches built during the high Romanesque period—the twelfth century—could be presented as the outcome of extensive architectural play on potential combinations of a set of constant features and variable volumes, depending on the local site and materials. Wooden roofs had become nearly obsolete; technical considerations henceforth focused on the requirements of stone facings and roofs. The interior appearance of the church depended largely on the solutions adopted in response to inevitable questions over the nature of the walls (thick or thin) and nave supports (whether the transversal arches of the vault were sprung from piers or columns, etc.).

VAULTING

An unbroken barrel vault was rare—the one at Saint-Savin was logical since it was designed to receive the painting of the Genesis cycle. Elsewhere, however, longitudinal depth was orchestrated by transversal arches connected to the piers of the nave by slim columns that literally divided the edifice into rhythmic units (or bays). At Vézelay, the transversal arches were built with stones of alternating colors, considerably enhancing the effect of perspective. The basic model could be employed in a variety of ways, as exemplified by the round and pointed barrel vaulting at Cluny III, the broad nave at Saint-Sernin in Toulouse, or the narrow nave at Conques.

At Fontenay (above right), the barrel vault evolved into an equilateral pointed arch, and the space reads differently insofar as the nave was deliberately left blind—no window pierces the walls, and light arrives only through openings at the level of the aisles. As with a Cistercian church, the glass has neither color nor image; everything is in grisaille, perhaps to allow more light to penetrate into the dark nave.

Such was the range of choices in Romanesque architecture—the final adjustment of various structural and decorative factors was not automatic, and in each

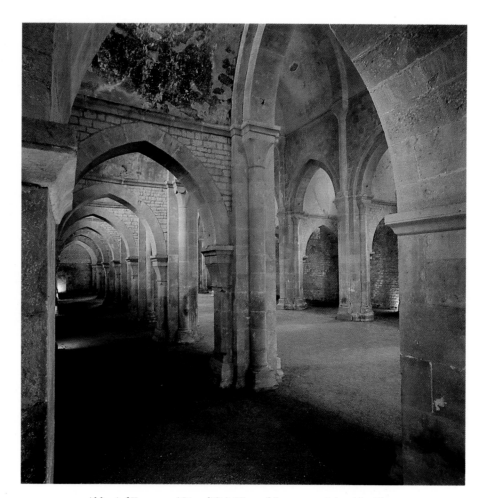

Abbey of Fontenay (Côte-d'Or). View of the nave and the side aisles.
Mid–twelfth century.

region there was the possibility of following a given design or not. A single nave with pointed barrel vaulting was appreciated in Provence (sometimes with aisles of half-barrel vaults), as can be seen at Saint-Trophime in Arles and Saint-Gilles-du-Gard (to cite only those examples exalted by sculpture), and at Notre-Dame-des-Doms in Avignon. Saint-Paul-Trois-Châteaux has a nave and two aisles but no ambulatory, for its apse was polygonal in shape.

Major experimentation took place farther north. In a single region such as Poitou, aisle vaulting could take diverse forms such as groin (Notre-Dame-la-Grande, Poitiers) or quarter circle (Saint-Eutrope, Saintes).

Side aisles might also be cut by transversal barrel vaults, creating a strange undulating effect. In certain rare cases, the main nave of a church would be completely organized around these transversal barrel vaults, as at Saint-Philibert in Tournus (p. 166). The result is amazing: the bays become repeated cylindrical vaults set on extradosed arches, whose external curves are dramatically underscored. The windows fit easily into the wall since the entire horizontal roof is at the same level. Here juxtaposition is the basis of all structural support. It is hard to imagine a design more different from the supple articulation of ribs that would yield Gothic art.

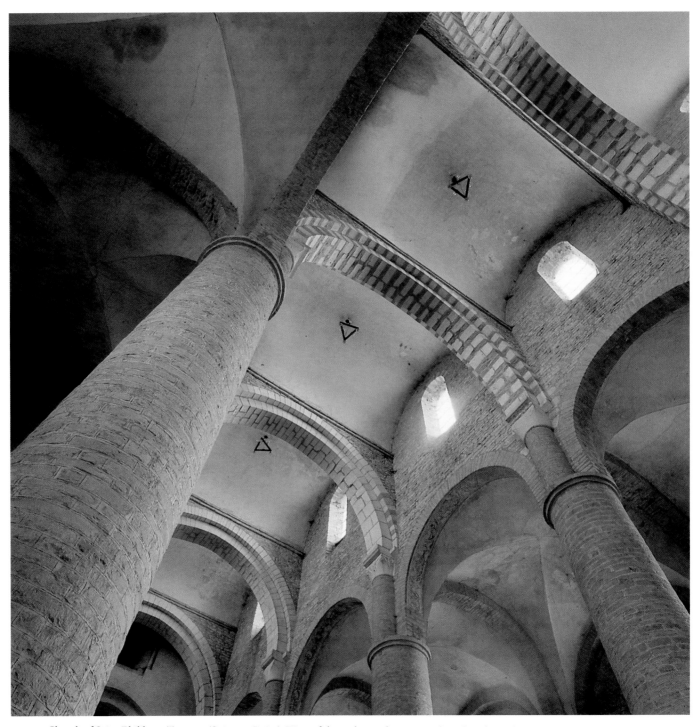

Church of Saint-Philibert, Tournus (Saône-et-Loire). View of the arches and transverse barrel vaults in the nave. Mid–eleventh century.

Decisions had to be made not only about vaults, but also about the general pattern of elevation. By and large, churches in the first half of the eleventh century did not bother with upper floors, except for ambitious edifices in Normandy such as Jumièges (where a gallery giving onto the nave was set on the haunches of the aisle vaulting) and Saint-Etienne in Caen, this latter being more supple and assertive (taking into account subsidence and the changes in proportions resulting from the ogival vaulting added fifty years later).

The main attraction of galleries was to increase the area available to the faithful when they crowded in. Thus this type of elevation was found along the pilgrimage routes cutting diagonally across France on "the road to Compostela," such as at Saint-Paul in Issoire and Saint-Sernin in Toulouse (chancel consecrated in 1095). The question of upper levels was fundamental for large structures—it determined the distribution of supporting and buttressing features, and above all required a rigorous interpretation of solids and voids stacked on top of one another. The nave became a sort of street between opposing facades.

Turning to the Auvergne region near Clermont-Ferrand, there is a wide variety of twelfth-century churches that nevertheless share a family of features: the use of local sandstone, apses of regularly stepped volumes, squat appearance, and a large polygonal bell tower set on an oblong base. Saint-Nectaire (above right) and Orcival provide good examples of these hill-country churches. There might be three or four apsidal chapels or, exceptionally, a single square one as at Issoire, or even, at Saint-Saturnin, no chapel at all (for that matter, this church has no figured capitals either). At the center of this system, so to speak, was the basilica of Notre-Dame-du-Port, where the half-barrel vaults of the galleries support the high vaulting of the nave, over which sits a dome on pendentives. Like its

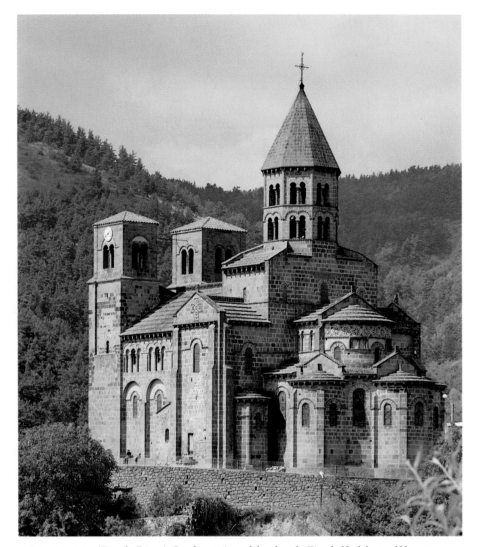

Saint-Nectaire (Puy-de-Dôme). Southeast view of the church. First half of the twelfth century.

sister churches, this edifice gives an impression of rustic calm enlivened by simple yet robust decoration. In such sanctuaries, ever-present wooden reliquaries of the Virgin constitute a local version of the Virgins in Majesty popular during the Carolingian period.

DOMES
Wooden roofing still existed in the north, but farther south, along rivers flowing toward the sea, an attachment to dome vaults emerged, this structure being possible only in regions with good quarries. A

somewhat isolated area between Cahors and Angoulême particularly favored this type of vaulting.

If any trend constitutes a "school" within the general Romanesque movement, then it must be the domed churches in southwestern France. This group is found not just in Périgord, but also in Aquitaine and Gascony. Modest village churches of moving simplicity have a little cluster of half-spheres in fine stone, side by side (such as Agonac in the Dordogne). There are also several poignant designs, like Saint-Etienne-de-la-Cité in Périgueux,

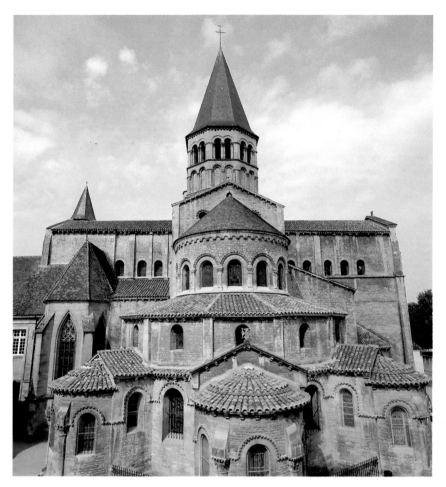

Priory of Paray-le-Monial (Saône-et-Loire). Apse.
First half of the twelfth century.

where a "telescoped" arrangement of bays of increasing size supported a row of blocks topped by squinched domes with galleries where people could circulate. The first two, smaller domes were destroyed by the Huguenots; the last was rebuilt in the seventeenth century with a care that betrays obvious admiration for the conception of volumes. The church belonged to the village called La Cité, built on the ruins of Vesone.

On the nearby hill where the cathedral city rose, the basilica of Saint-Front was built over a previous edifice of which only the porch bell tower, dated 1047, survives. Saint-Front represents a unique example of a Greek cross design topped by five large domes, the prime concern being the stonework and lofty volumes (unfortunately rendered bland by Abadie's radical 1855 restoration, the worst of the excesses committed by nineteenth-century "diocesan" architects). The interior boasted appropriate furnishings, tapestries, and wall decorations. But even reduced to the status of a giant maquette, the church retains great solemnity, and the exterior domes trace a silhouette matched only by San Marco in Venice and Santa Giustina in Padua, their common prototype probably being the no longer extant Church of the Holy Apostles in Constantinople.

Although Saint-Front was not innovative, it constitutes the triumphant expression of Aquitaine's penchant for domed roofing (p. 170). In the diocese of Sarlat (which was slightly larger than present-day Dordogne), there were nearly six hundred churches by the eleventh and twelfth centuries, of which two hundred and fifty were covered with domes. An entire architectural province opted for domes. At the cathedral of Cahors in 1112, Bishop Giraud de Cardaillac decided to place two domes over the nave, independent of the semicircular design of the chancel. At Souillac, the two-bay nave ended in a transept bearing a central dome.

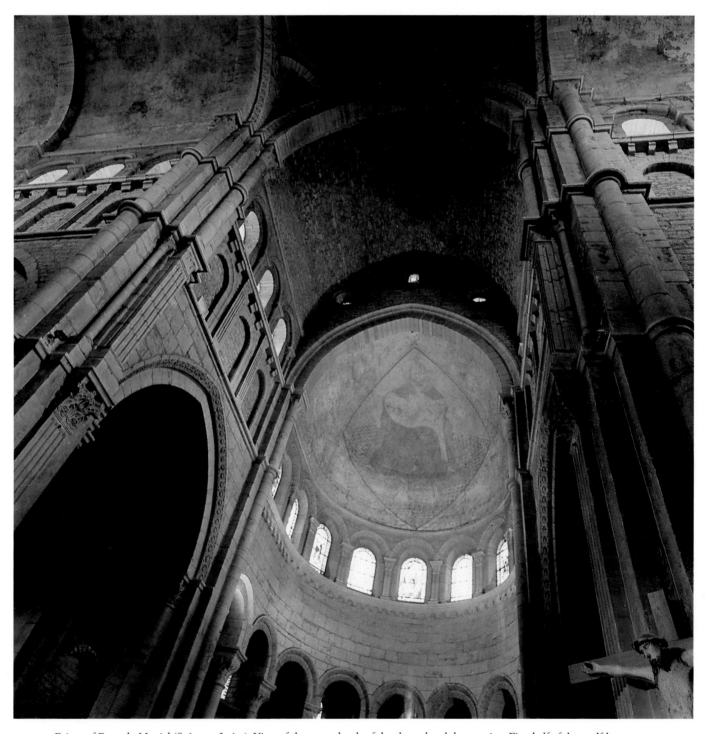

Priory of Paray-le-Monial (Saône-et-Loire). View of the upper levels of the chancel and the crossing. First half of the twelfth century.

A key feature of this Aquitaine group is the absence of sculpture. It is the impeccable cutting and shaping of stone that creates impact, resulting in a family of buildings of exceptional interest. The early system of block vaults evolved into the fine stonework seen at Saint-Avit-Senieur, Trémolat, and Saint-Etienne-de-la-Cité. This does not mean that portals were undecorated, but that decoration remained simple or was derived from Limoges or Languedoc models (Cahors, Souillac).

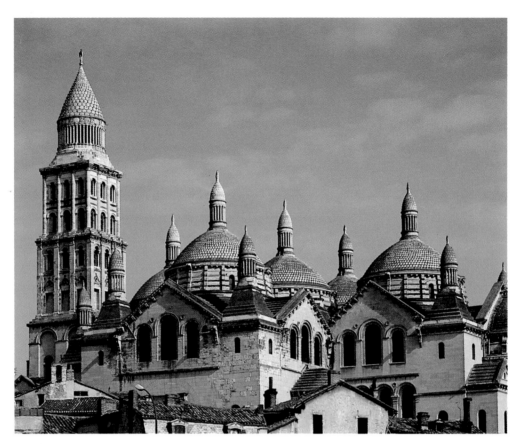

Church of Saint-Front, Périgueux (Dordogne). View of the domes and the bell tower.
First half of the twelfth century.

Saint-Pierre Cathedral in Angoulême remains a case apart insofar as Bishop Girard II decided that a grandiose frontispiece should be erected (later disfigured by Abadie). The cathedral has four domes with enormous pendentives that dilate, in a sense, the interior volume. It also has a lantern-tower over the transept. Saint-Pierre did much in the West to promote the concept—ultimately neither Romanesque nor Gothic—of a nave composed of large unitary cells of space, as found in the Loire region. The juxtaposition of curved, or "domed," vaults and ogival ribbing represented an interesting development employed during the twelfth century at Angers (at both the cathedral and the Church of Saint-Serge), Saint-Malo, and Laval.

CLUNY III

The phenomenon associated with Cluny, as mentioned above, spread throughout the Western world as an unprecedented organizing and dominating force. Cluny grew, starting in the year 910, from a small estate in Mâcon, which already raises historical issues given the economic wealth and power accumulated by the order thanks to great administrators who ran the estate with serf labor. In the eleventh century, an abbot originally from Auvergne, Odilo of Mercoeur, undertook to renovate the tenth-century church by adding the stone vaulting that had become indispensable to the acoustic quality of the liturgical plainsong (Cluny II).

With the long abbacy of Saint Hugh, from 1049 to 1109, it seemed important to elaborate a grand architectural project that would assert the order's preeminence in Christendom; it was long thought that this project was swiftly and masterfully executed between 1088 and 1109. Whatever the case, the most sensational, famous, and vast church in western Christendom lost its importance by the end of the twelfth century. After surviving for a long time, and undergoing a fine renovation of the abbey buildings in the seventeenth century, the enormous complex was gutted and hacked apart, disappearing in the early nineteenth century and leaving only a southern wall of the transept. Cluny is now the most fascinating of ruins.

The church's dimensions are well known: 138 meters long, or 187 meters if the narthex is included. The architectural

layout is also known. It featured a double transept that created a breathtaking interior perspective, double side aisles, a ring of radiating chapels, a vaulted ceiling thirty meters high, four bell towers and—worthy of special note—"ancient-style" blind arches slipped in between the tall arcade and high windows, intelligently alluding to a certain classical heritage. Finally, the placement of sculpted elements was clear and precise—on portals and capitals. The sculpture that survives, from columns of the hemicycle, suffices to demonstrate the quality of workmanship and inspiration of universal resonance.[26]

Problems arise, however, with interpretations of the pace of work and methods of construction for this huge organism. How far had things proceeded when Pope Urban II, a Cluniac monk, came to consecrate the high altar of the abbey church in 1095? It is tempting to think that a work so vast and harmonious, based on a strict play of proportions, was already complete at this, its greatest moment of glory. But it is hard to be sure, and a severe revision has been proposed.[27] It was not by vertical bays but rather by horizontal layers that the church was erected; starting with a general layout, everything rose simultaneously. The pointed barrel vaulting of the nave (or of the big transept) collapsed in 1125, but was rebuilt in record time, which presupposes an exceptional level of organization at the worksite. The final dedication took place in 1130.

The harmony of the interior gives the impression not only of uninterrupted construction but also of a design established right from the start, prior to 1100. Yet there were changes in the scheme. The building came into being as it went along, so to speak, like many Gothic churches. It was only in the last design that the vaulted ceiling was raised to a height of thirty meters. The apse was apparently not completed until 1118. The narthex was added toward the middle of the twelfth century. Such details become important when con-

Jean-Baptiste Lallemand (1710–1805), *View of Cluny Abbey.*
Watercolor. Bibliothèque Nationale, Paris (Est. Ve 26p).

sidering the highly original and elegant sculpture in the chancel.

It is nevertheless the extraordinary size of the edifice that strikes first and foremost. But two problems immediately arise. Can the development of the mother institution be considered in isolation, or should links with Spain be taken into the account, given Cluny's leading role in the great pilgrimage ever since the early tenth century? In other words, perhaps there were specific recollections of the grand church in Compostela, at the other end of the Christian world, when Cluny was being built. Nor should it be forgotten that the abbey authorities would surely have kept abreast of construction work completed by daughter establishments in Lombardy and even in Rome. As will be seen later in the Gothic period with Saint-Denis, a design's aesthetic power of attraction had a lot to do with the fact that it successfully assimilated all peripheral

input. The idea was always to try and cap all ancient and recent developments.

On the other hand, it would be misleading to proclaim the existence of a single Cluny "school" too hastily. The influence of Saint Hugh's effort in Burgundy and beyond is obvious, as seen at Paray-le-Monial (pp. 168–69), Autun, Semur-en-Brionnais, and Langres. Sculpture in Saulieu and Vézelay belongs to the same family. But can the Cluny model be extended to all the daughter establishments in Europe? This over-simplification does not stand up to local archaeological evidence. To the west, around Poitiers for example, or in the south, the idea that local priories and abbeys submitted to the mother house's architectonic model obviously needs to be tempered. Cluny III was the culmination of a huge undertaking—a masterpiece rather than a prototype. The same could not be said of the Cistercian architectural reform.

4. ARRAYS OF SCULPTURE

The quantity of works carved in stone around 1100 and throughout the twelfth century is as surprising as their quality and diversity. This artistic output is so authentic and vital that it acquires universal value. Archaeological analysis offers glimpses of a network of influences or perhaps exchanges, without fully revealing the extent to which they go beyond a regional framework. Ever present in the background were the three artistic poles generally located in northern France (especially Burgundy), the south (Languedoc) and the west. Everything occurred more or less within this triangular formation.

BURGUNDY: AUTUN AND VÉZELAY
Initially, carved reliefs were characterized by an emotive intensity that became somewhat rare twenty years later. This is clear in Burgundy. The tympanum of Anzy-le-Duc deploys contrasts—wise men versus Christ and, on the lintel, heaven versus hell—with a brutality accentuated by the twisted figures of the victims of evil and the double-curl of an enormous dragon straddling the damned. Even more astonishing is a portal at Neuilly-en-Donjon,[28] where the lintel is bizarrely and brilliantly adorned with a depiction of Simon's Banquet that aligns twelve figures (like the Last Supper), with Mary Magdalene squatting on the left, as well as Adam and Eve. Above it is a rather high relief carving

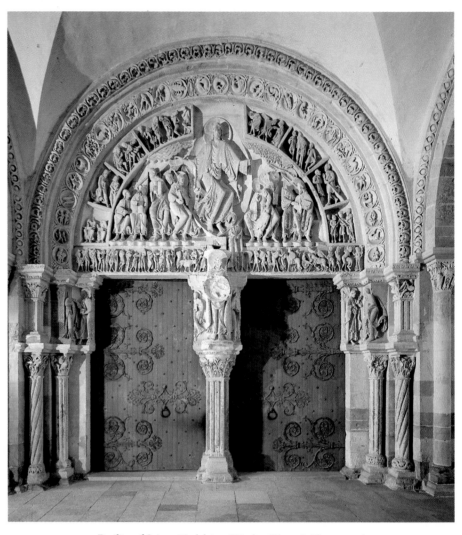

Basilica of Sainte-Madeleine, Vézelay (Yonne). Nave portal.
Tympanum: Christ and the Apostles. c. 1120.

of The Adoration of the Magi, one of the most tumultuous imaginable—full of curves, of unstable figures in motion, the Virgin and her throne resting on the rumps of two outsize monsters bent under the feet of saintly figures. The potentially threatening meanings of this strange vision are not entirely clear.

In comparison, the Last Judgment at Autun (p. 173), patently signed by Gislebertus, displays a general determination (somewhat contradicted by specific details) to put things in order, a desire to

dominate the tumult of forms, if only through the proportions of figures set on either side of the large mandorla framing the Lord. It dates from 1130–1140. The abbey of Saint-Fortunat in Charlieu (in the Loire region) was razed during the Revolution, yet—heaven only knows why —the narthex survived. Its large portal with abundant Cluny-style sculpture was executed with admirable authority, and includes a Vision of the Judgment and an Ascension. The Wedding at Cana seen on the tympanum of the northern bay repre-

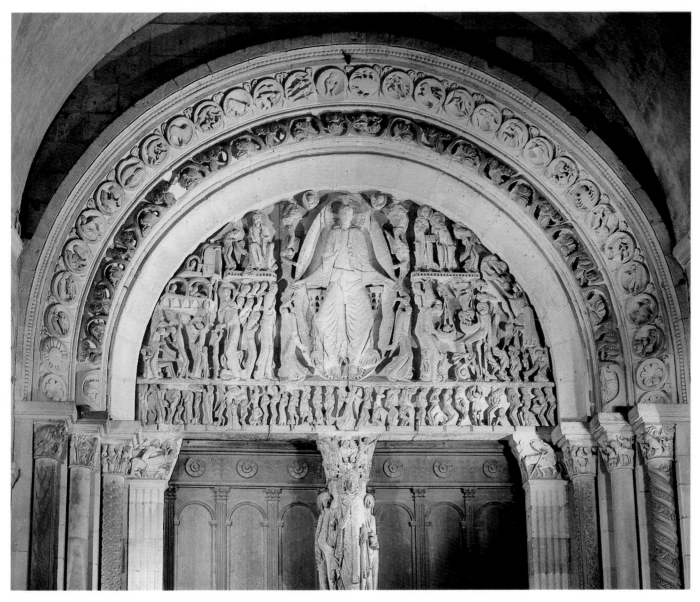

Church of Saint-Lazare, Autun (Saône-et-Loire). Tympanum over the west portal, signed Gislebertus: the Last Judgment. c. 1130–1140.

sents a veritable piece of bravura, with its refined and engaging verve. They were probably executed circa 1130, during the abbacy of Peter the Venerable.

The large porch at Vézelay (left) conveys a concern to allow all forms to resonate—an electric charge can almost be seen running through the group of apostles surrounding Christ. His robe, falling in spiral folds, not only adds to the vibrant effect but also constitutes an ingenious device for lending coherence to a daring and difficult composition. The key feature of this properly ecumenical piece has been deliberately placed very high, in the form of small picturesque scenes marking the presence, despite everything, of strange, sinning humanity. All of this was executed in a masterful system of relatively flat relief characterized by delicate borders and elegant, confident incisions.

LANGUEDOC: MOISSAC

There is no better way to demonstrate sculptors' ability to assert their personalities than to leave Burgundy for the Languedoc region in the south. At

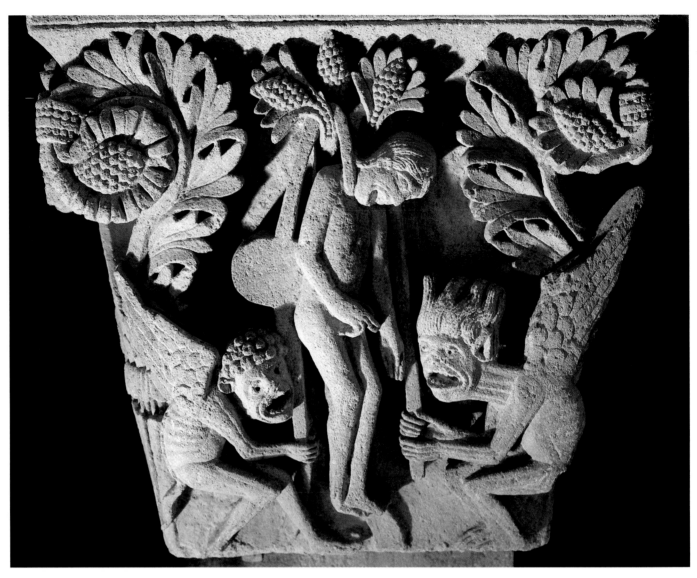

Capitals at the church of Saint-Lazare, Autun. Above: Judas Hanged.
Opposite: an angel and the sleeping Magi (attributed to Gislebertus). Second quarter of the twelfth century.

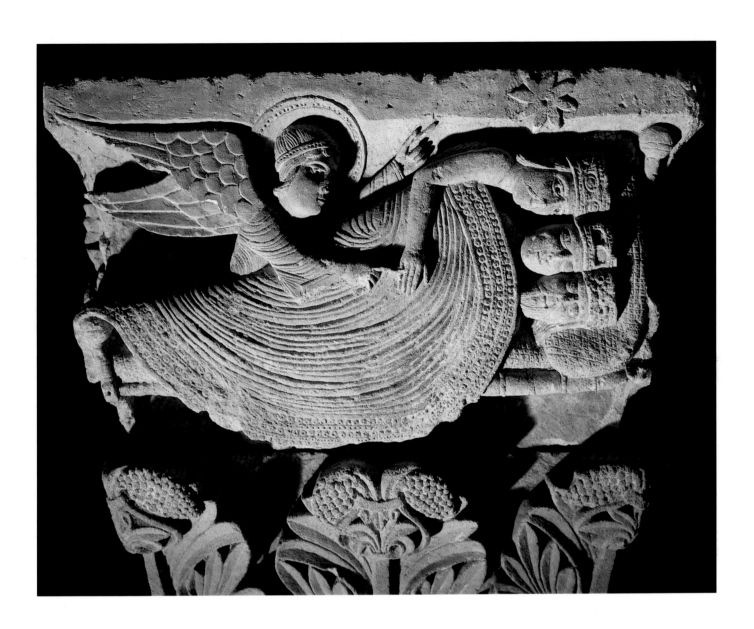

Moissac, one is confronted with the wonderful sculptural authority of the master of the Moissac portal (right). The abbey there became affiliated with Cluny in 1047. After numerous vicissitudes and difficulties—as so often occurred—with feudal lords or bishops, the cloister was built and decorated circa 1100, during the time of Abbot Ansquitilius (1085–1115), a friend of Saint Hugh of Cluny. A frieze of tracery and tiny figures runs along the top of the capitals, and the tight space of each side of the capitals is exploited to the maximum (p. 179). There was also a concern to identify figures via inscriptions on the surmounting abacus or within the ground—GOLIAS for Satan, MARTINUS for the scene of Saint Martin dividing his cloak, DANIELE for the prophet surrounded by two upright lions identified, as though it were necessary, by the inscription LEO. Wonderful decorative devices can be found in the floral capitals, giving the impression that the sculptor was working with one eye on a rich sample of patterns from oriental carpets and fabrics.

The tympanum and piers of the portal must have been carved in subsequent years, but they were perhaps taken down around 1130 and placed in the shelter of a porch on the southern side, leading to a new arrangement of elements. An impressive marble lintel underscores the composition, with a substantial trumeau (central pier) supporting the ensemble. There are also narrative reliefs, perhaps of somewhat later date, under the arcades on the sides of the porch. It is important to point out these details because Moissac was not the work of a single master, but covers thirty or forty years of activity.[29]

The tympanum provides what is probably the finest, most complete, and skillful example of this sculpture, displaying a full range of modeling techniques and refined ornamental carving. Furthermore, the overall arrangement required many intelligent decisions on the part of the artist. The crowned Elders described in

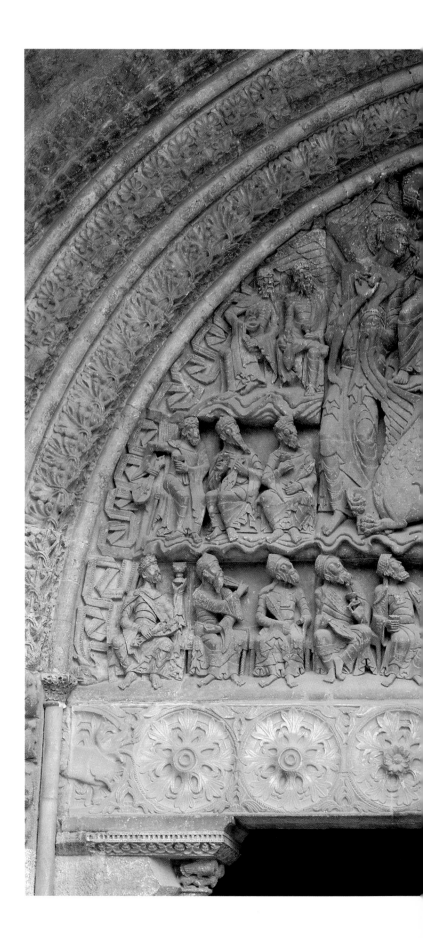

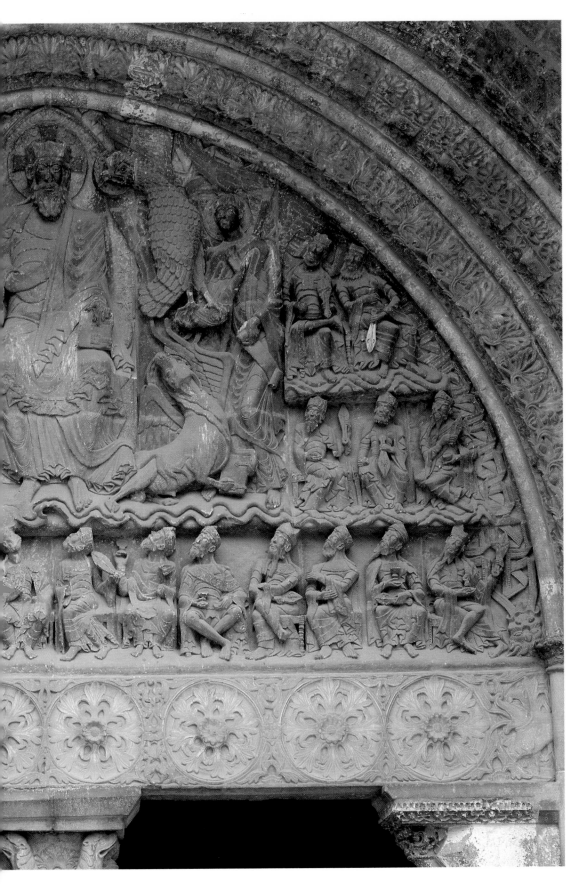

Church of Saint-Pierre,
Moissac (Tarn-et-Garonne).
Tympanum over the south door:
the Vision of the Apocalypse.
1125–1150.

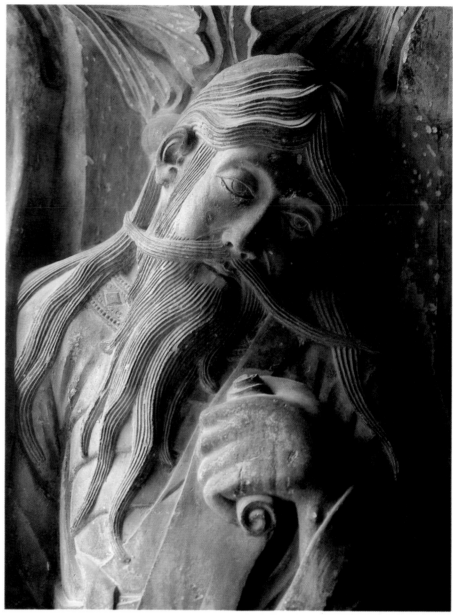

Church of Saint-Pierre, Moissac (Tarn-et-Garonne). South portal.

Top left: detail of tympanum: the Elders of the Apocalypse.

Above and left: detail of trumeau: the prophet Jeremiah and animal figure.

the Apocalypse (top) turn attentively toward the tetramorph (four evangelical symbols), forthrightly asserted though a square layout yet somewhat animated by elegantly curving poses. Only the figure of Christ remains at rest.

The clever re-use of the lintel nobly concludes the ensemble with a series of eight large leafy rosettes. The arch moldings are free of figures, and instead are decorated with palmettes that generate a slight shimmer without distracting from the central motif. Despite the apocalyptic theme, no feeling of terror or threat survives, since every element is subordinated to an overall effect so confident and strong. What reigns instead is a great attentiveness to mystery—an enormous step toward serenity had been taken.

That is not the whole story, however. The trumeau (over three meters high), segmented into three toothed scallops, features tall figures of Saint Paul and the prophet Jeremiah (above), their limbs

bent to suggest movement. But behind their backs, on another side of the pier, are interlaced figures of cruel and threatening animals, constituting a monstrous trophy that can be linked to the rest only with difficulty. It does not appear to be some marginal accompaniment, but rather a presentation on the same scale, pointing in the opposite direction. Perhaps nowhere else is the play of antagonisms—the torment that Romanesque art sought to express and transcend—deployed with such figurative force. This tympanum and trumeau are more eloquent than the lateral sculpture of the porch, with scenes from the gospel and allegories of the vices (somewhat forced, as always).

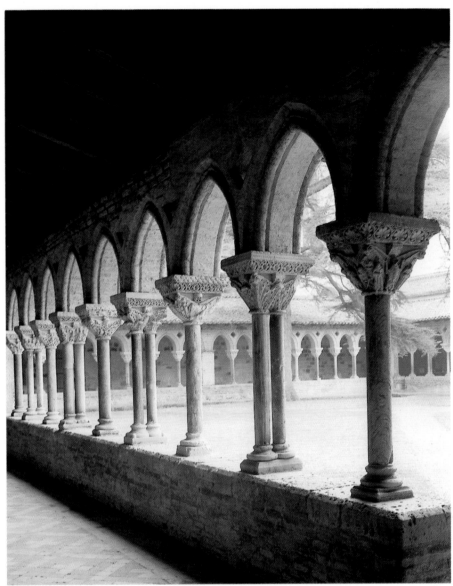

Church of Saint-Pierre, Moissac (Tarn-et-Garonne). The cloister. c. 1100

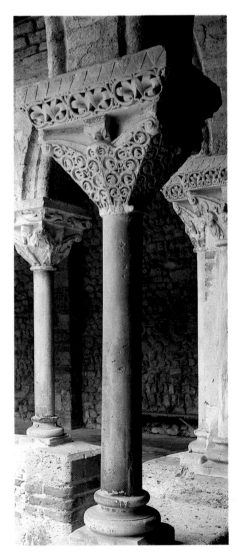

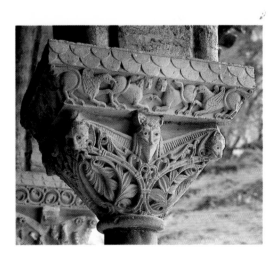

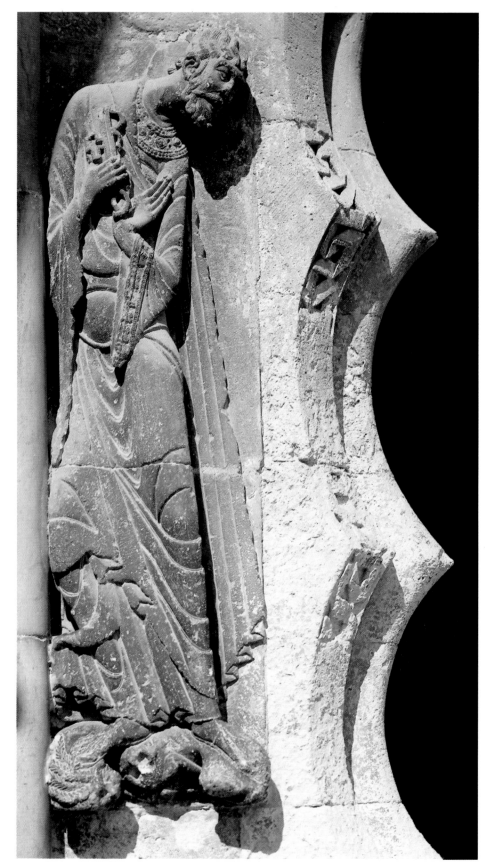

Church of Saint-Pierre, Moissac.
(Tarn-et-Garonne).
South portal, detail of the west jamb:
Saint Peter.

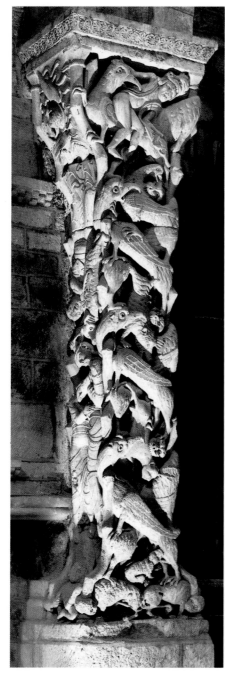

The only sculpture that bears comparison to Moissac is the tympanum at Beaulieu in the Corrèze region (1130–1140), depicting the Last Judgment (with devouring monsters of hell that undulate horizontally across the lintel), and above all, the carving at Souillac (this page). Unfortunately, all that remains for study on the inner west wall is a re-assemblage of figures that escaped Huguenot destruction in 1562. The relief showing the Story of Theophilus is more popular but less eloquent than the two sculptures related to Moissac, namely the figure of Isaiah (angled as though triangulating space) and the fantastic trumeau with its zigzag of self-devouring monsters interspersed with little human figures. Never in the West had stone been so deeply carved with such sinister ingeniousness. Naturally here, as at Moissac, comparison is inevitable with the "animated" pilasters found in tenth-century miniatures—the motif of the "infernal column" reached a paroxysm at Souillac. In Gothic art, it would be employed differently.

THE WEST

A tympanum was not a structural feature of construction. The proof lies in the fact that in western France it could be omitted, as at Aulnay. But where a tympanum was employed to block the upper part of a portal, it was composed of slabs cut in such a way that they almost never corresponded to the division of sculpted scenes—the subordination of a sculptural composition to architecture was therefore only relative. It must be supposed that sculptors and stone-hewers reached a working agreement on a case-by-case basis, since at Autun the figure of Christ was carved from several slabs, at Vézelay from two, and at Conques from only one.[30]

Soft limestone enabled the sculptors of Aulnay-de-Saintonge (p. 182) to carve embroidery-like patterns of stunning liveliness. Monsters and foliated scrolls intertwine on capitals in smooth and

Above and right: Church of Sainte-Marie, Souillac (Lot). Inner wall of the west facade, trumeau and sculpture from a former portal: the prophet Isaiah. Second quarter of the twelfth century.

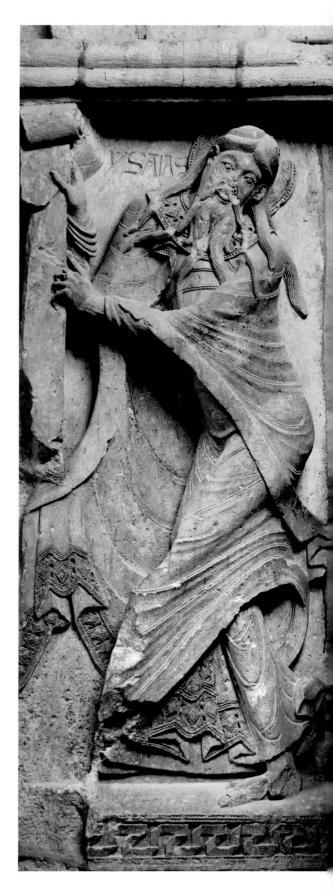

ings (arches here are rounded, not pointed), with their markedly soothing effect of well-orchestrated ornamental forms. The most brilliant examples of this effect are precisely Abbaye-aux-Dames and the gem-like church at Aulnay, which took up the falsely naive idea of lodging those inevitable little elders in the arch-stones. This approach appealed to sculptors' sense of verve, and it was employed again on the western portal of Sainte-Croix in Bordeaux.

Sculptural virtuosity in the Saintonge area has left interesting clues to technique: sometimes empty capitals testify to mysterious discouragement or abandonment of the worksite (as at Abbaye–aux–Dames), sometimes incomplete elements reveal that sculptors worked after the stone was set in place (at Aulnay and Pérignac, for example), whereas at other times it appears that carving was done at the workshop and not on site (at Saint-Quantin-de-Rançannes, for example, horse heads were ultimately stuck on to a wall for which they had not been designed).[31] In short, there was no standard rule.

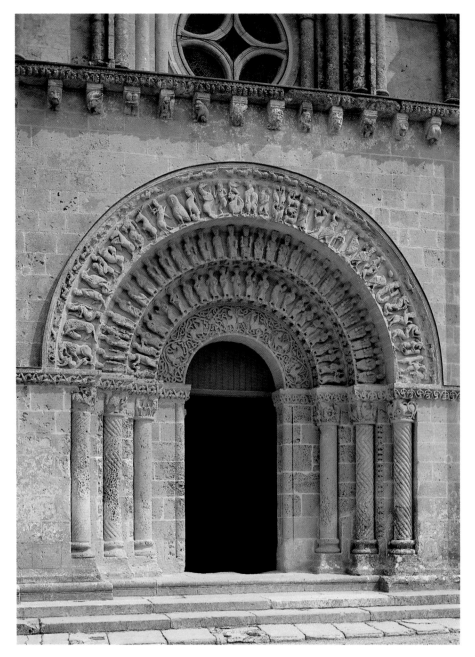

Church of Saint-Pierre, Aulnay-de-Saintonge (Charente-Maritime).
South portal and detail of arch molding. Second quarter of the twelfth century.

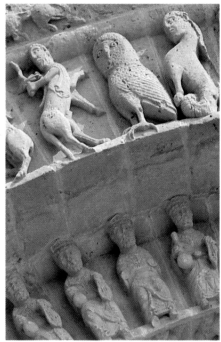

harmonious continuity. At Saintes, meanwhile, on the central portal of Abbaye-aux-Dames, the Massacre of the Innocents is depicted in the arch moldings in the form of a three-figure motif repeated like some decorative pattern, giving the impression that the artists handled the subject in a light-handed way. Even more striking, each elder of the Apocalypse (here numbering fifty-four) is nestled calmly in his arch-stone, with nary a threatening, judgmental God in sight.

The overall impact is created by the concentric-circle pattern of the arch mold-

PROVENCE

Provence, in the south, developed architectural forms the most removed from those found in Auvergne, Burgundy, Poitiers, and the Saintonge region. Particularly favorable historical circumstances and specific links to Roman orthodoxy enabled large churches—Saint-Trophime at Arles and the abbey of Saint-Gilles—to erect facades with spectacular iconographic programs. The standard idea of the facade was suddenly transformed by the incorporation of a powerful monumental feature familiar to the south—the triumphal arch. Elsewhere, portals might be modest and almost timid, whereas here they provide a powerful demonstration of art and doctrine.

At Saint-Trophime (mid–twelfth century, right), the porch is recessed to give the tympanum (showing Christ in Majesty) a frame of bare arch moldings. Apostles arrayed across the lintel, and on the jambs to each side of the doors, provide vertical thrust. They were designed to accord with the pilasters of the portal itself and with the light-colored, detached columns on right and left, framing the figures of saints. A small frieze, displaying episodes from the gospel clustered together to maintain continuity, runs along and behind the capitals. Something dense, intelligent and organized is thus offered to the gaze—the placing of reliefs and ornamental courses obviously invokes the spirit of Roman monumental arches.

The skill of the workshop master is perhaps even more marked at Saint-Gilles. Two columns stand out from the portal, each crowned with an enormous capital and projecting abacus, like those seen in Ravenna and Lombardy. A continuous frieze rich in narrative detail runs along the projections, sectioning the facade. Fluted pilasters, like the one on the trumeau, accentuate the main features. The decorative repertoire is rigorously classical. On the little side wall serving as a sort of foundation, a relief showing two

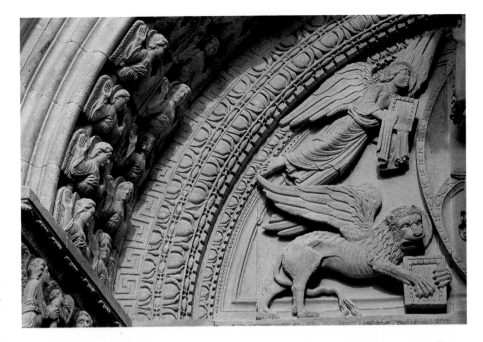

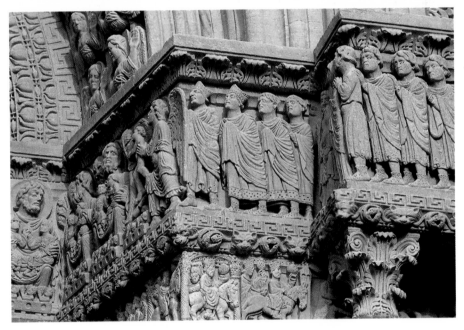

Arles Cathedral (Saint-Trophime). West portal,
details of tympanum and lintel. Mid–twelfth century.

scenes from the Cain and Abel story would appear to be drawn from a Carolingian model of the type seen in the *Utrecht Psalter*, its figures frozen in motion. In short, this monumental and artfully composed edifice, indisputably Romanesque, presents an ensemble of striking originality. Unfortunately, it is hard to elucidate every aspect of this ensemble, notably an iconography apparently inspired by the struggle against heretics who ignored Rome's authority, to judge by the prominence granted Saints Peter and Paul.

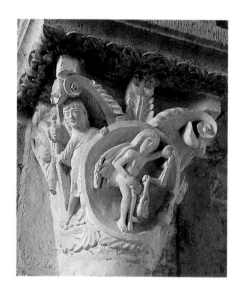

The complementarity—or polarity—between northern centers and southern workshops was never sharper than in the second quarter of the twelfth century, when these buildings were rising in the south just as (and this is the difficult, indeed mysterious, point) the facades of Saint-Denis and Chartres were being erected in the north. Historians were formerly tempted to explain the innovations noted in Ile-de-France as an eruption of southern vitality and "classicism" into new construction sites up north. This hypothesis had brilliant defenders but lacks a reliable chronology, which would require year-by-year accuracy since the royal portal at Chartres dates from the 1140s. Above all, however, stylistic analysis has now attained a degree of sophistication permitting the conjecture that Charlieu and Autun may have first influenced Provence. Nor does that exclude the possibility that sculptors on the huge Chartres site were aware of southern accomplishments (at Saint-Gilles and elsewhere) and Burgundian experiments. Overly simple answers to such historical questions no longer exist.[32]

A UNIQUE PHENOMENON

All sorts of classifications have been proposed to help interpret the Romanesque formal system, including a distinction between the "long canon" typical in Aquitaine (for example the elongated figures at Moissac and Souillac) and the "short canon" (found in Auvergne). It has been conjectured that the carvings of squat, stocky figures with large heads might represent a vestige of the Gallo-Roman repertoire that remained locally popular; thus a capital at Mozac is suggestive of third- and fourth-century models. Given regional predilections, however, it would be safer to say that the human figure was a variable element, that is to say a flexible, malleable feature of a sculptural art that so delighted in metamorphosis.

Left:
Basilica of Sainte-Madeleine, Vézelay.
Capitals in the nave.
From top: the Abduction of Ganymede (?);
the Scales; Moses and the Golden Calf.
Second quarter of the twelfth century.

Top right:
Church of Saint-Pierre, Mozac
(or Mozat, Puy-de-Dôme).
Capital illustrating the Resurrection.
Second quarter of the twelfth century.

Bottom right:
Church of Saint-Pierre, Moissac (Tarn-et-Garonne). South porch, inner west wall:
Saint John (detail) and Lazarus in Abraham's arms. Second quarter of the twelfth century.

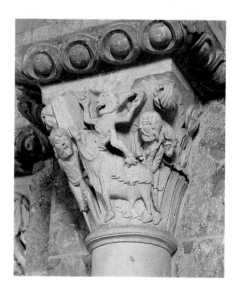

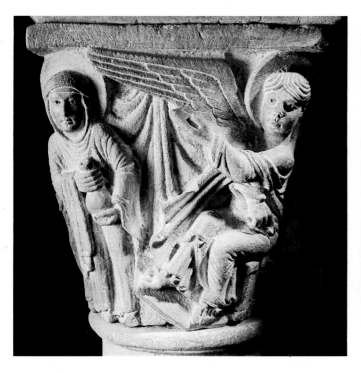

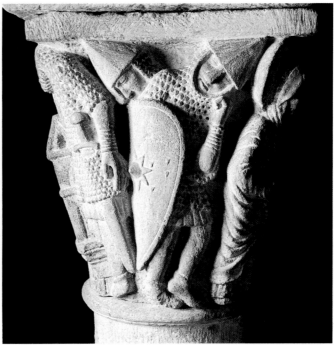

Although the passage from a violent register to one more serene can be detected in the major tympanums, the same is not true of capitals where, throughout the eleventh century and into the first half of the twelfth, a wonderful absence of discipline reigned. It might be said that in this somewhat subordinate realm, artisans behaved as though anything were possible. The juxtaposition of diverse approaches was the rule in every region. Once again, what is striking is the determination to lend effervescence to architectural structure through a play of pure ornamentation and bizarre forms.

Around 1120–1130, the desire to dramatize scenes led to a tendency to elongate forms and accentuate brusque movements. A Stoning of Saint Stephen at Saint-Lazare in Autun, for example, features wiry, twisted executioners. The cathedral also presents both a grotesque scene illustrating the fall of Simon the Magician, and an exquisite idyll of the three Magi asleep under a tablecloth-like blanket, gently awakened by an angelic finger (p. 174). At Vézelay, an enormous bird carries a body in its beak—surprisingly resembling Ganymede and the eagle, probably borrowed from some relief or gem. In a small carved frieze on the facade of Angoulême Cathedral there is the very rare motif of winged horses;

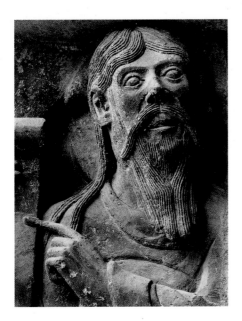

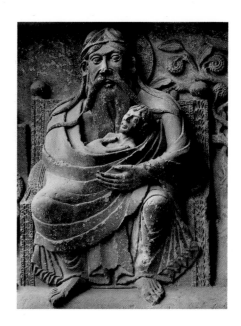

Church of Saint-Sulpice, Marignac (Charente-Maritime). Frieze and capitals in the transept. First third of the twelfth century.

this has nothing to do with Pegasus, but was a direct and enthusiastic borrowing from Sassanid fabrics. The Middle Ages assimilated everything.

Yet it should not be forgotten that repeated destruction in the more or less distant past has left terrible gaps in the extraordinary picture presented by this sculpture. It is impossible to trace the development of the statue–columns now associated with Gothic portals—they were

probably a Romanesque invention that emerged from Languedoc sculptural ensembles. Statue–columns represented a pivotal form between Romanesque art and Gothic art. They lent Gothic art an unforgettable physiognomy, but misfortune has destroyed almost all the cloisters where this astonishing and richly meaningful form appeared. The overall picture is shamefully blank on this point.

The secret of such art is nevertheless clear. Ornamental elements—foliated scrolls, palmettes, dentils, beading—are never inert nor pushed definitively to the edge of the frame. Figurative elements—heads, busts, bodies—are not governed by rules of proportion or strict canons. On the contrary, human and animal figures can be molded or adapted to the surface to be treated, just like decorative elements.

A masterful study by Jurgis Baltrusaitis describes the stunning wealth of ornamental and figurative combinations used by Romanesque sculptors.[33] Two more or less constraining principles governed form: the "law of the frame," that is to say the con-

cern to fill and embellish the half-moon of a tympanum or the corners and sides of capitals, and "faithfulness to compositional patterns" such as tracery, palmettes, symmetry, opposition, and repetition that lend charm to the fantastic and assurance to the geometric.

Pure ornamentation of free scrollwork was not prohibited, but was usually accompanied by small freakish or bizarre details; large, whole figures in tympanums were surrounded by rosettes and palmettes, invaded by spiraling folds or lines that were simultaneously imperious and refined. The authority of decorative devices leaps to the eye when forms are compared. This does not, however, exclude an expressive aspect, or more exactly an emotional (rather than didactic) tension, which remains to be discussed.

Behind this impeccable play of forms lay a concern to manifest the wonderful and exorcise the horrible, which was everpresent if not always explicit. Violence abounds in Romanesque imagery in various ways—there is much trampling

(of Vices by Virtues, for example), tearing, grimacing, smothering. Sometimes antagonists are armed equally (with helmet and shield), sometimes the battle is unequal (giants versus distorted hybrid beings). There are countless forms of human combat, not always devoid of a certain humor, as when beards are pulled, a gesture also seen in the Saint-Sever *Beatus* manuscript, bearing the commentary, "Two bald men can seize each other by the beard."[34]

Romanesque sculpture could be defined, without contradiction, as a huge formal exercise, a combinative art endowed with an exceptional emotional charge. That, in a sense, also sums up the Middle Ages. Yet the Romanesque period was so dense, so authentic and so explicit that within the universe of art it constitutes a phenomenon as impressive as Khmer masterpieces or archaic Greek art.

Perhaps it could be said that sculptors slowly became convinced of their own power. Their images initially fulfilled the protective function of warding off evil. But this invocatory role was soon surpassed. By carving devouring figures into a block of stone, by permanently fixing them, by taking pleasure in drawing them onto a surface (like the miniaturist on vellum), the *artifex* produced a pious work insofar as the basic commission was fulfilled. Yet by representing so effectively the tensions of psychic torment that inspired their task, artists ultimately wound up emptying evil symbols of their virulence. Symbols of evil were not vanquished so much as dominated and sublimated—that, perhaps, is the eternal function of art. It would be truly surprising if none of the hundreds of bold and able sculptors of the day made this connection. Perhaps it was even made by the "Girbertus Cementarius" who, sometime around 1130–1140, carved his inscription into the tympanum at Carennac. Girbertus's sculpture was clearly based on a piece of precious metalwork, but his

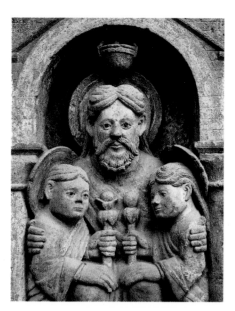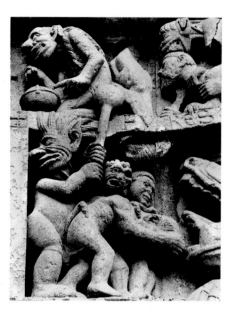

Church of Sainte-Foy, Conques (Aveyron). West portal, details of tympanum: Abraham and the Damned. Second quarter of the twelfth century.

own artistic satisfaction shines through. And this somewhat triumphant attitude—faith in the overriding power of art—must have truly existed, for in the midst of Romanesque development there arose the sternest denunciation of artistic means ever expressed in Western Christendom prior to the Reformation. This counter-movement will be discussed in Section 7 below.

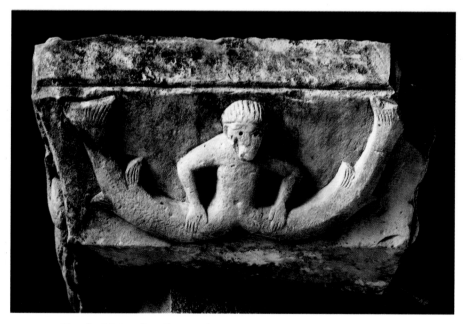

Church of Sainte-Foy, Conques (Aveyron). Abacus of a capital in the cloister decorated with a two-tailed figure. Second quarter of the twelfth century.

5. Romanesque Color

Romanesque art embodied a certain determination to unite architectural structure with sculpture, proudly ensuring the joint reign of carved stone and setting. But it would be wrong to overlook the appeal of color and sparkle that was evident throughout Europe, thanks to the circulation of illuminated manuscripts and precious enamels. Murals and stained-glass windows represented a natural extension of color within churches, and France was in the forefront of those fields. The problem arises from the fact that it is impossible to reconstruct the interaction and/or conflict between these activities, and so their mutual development cannot be fully grasped. Their interrelationship can only be discussed with prudence and regret.

The influence of precious objects on carved reliefs has been rightly argued, and often proven by the presence of the guilloche (twisted scroll) decorative patterning used in fine metalwork. But how can the precise object used as the model for a tympanum be positively identified? It has been suggested that the Vision of Saint John from the Saint-Sever *Apocalypse* (Bibliothèque Nationale, Lat. 8878), with its regular distribution of small figures, was the model used by the Moissac sculptor. Yet even though the general convergence is interesting, the sculptor who tightened the composition and individualized each of the figures very probably referred to other works which, as Meyer

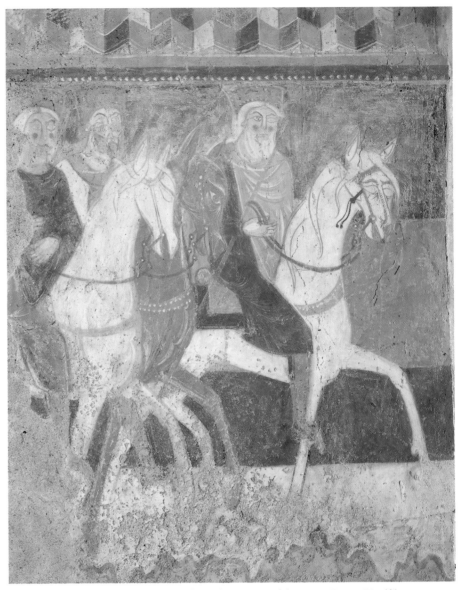

Church of Sant-Aignan, Brinay-sur-Cher. The Journey of the Magi. Fresco. Twelfth century.

Schapiro suggested, may have had a common source. In other instances, carved borders used the Greek key pattern so often adopted—in imitation of Byzantine Italy—in frescoes and manuscript illumination. Color, in such cases, was ignored in favor of design alone. Miniatures and precious artifacts with their rich, tried-and-tested formal systems were behind architectural sculpture and wall paintings during the Romanesque period. But differences in scale changed the outcome,

and, in addition to any liberties taken in the execution of the large-scale formats, it is always possible that a multiplicity of sources was involved, as suggested at Saint-Savin.

And, as usual, once a major work appeared, it triggered and influenced other initiatives. Thus a dominant "school" of color (typified by light backgrounds and matte finishes) emerged in western France. The style already had roots in the Loire region—in this context,

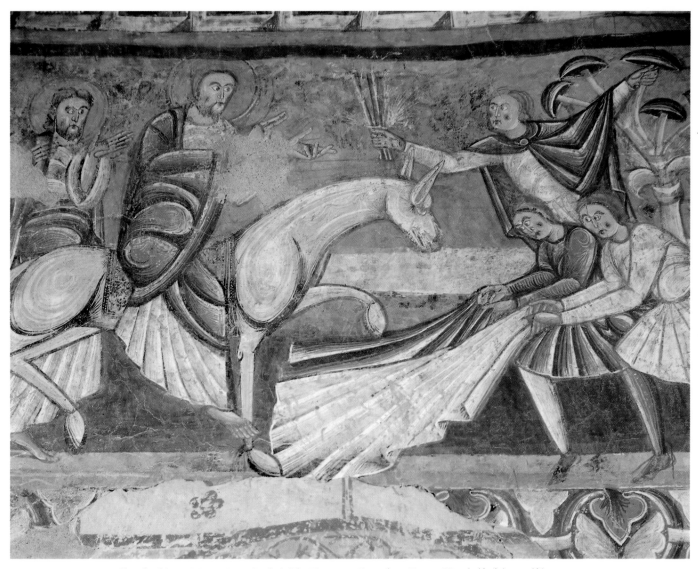

Church of Saint-Martin, Vicq (Indre). The Entry into Jerusalem. Fresco. First half of the twelfth century.

closer study of the role of the Tours scriptorium circa 1100 might be profitable. In any event, the hard-to-date productions of the twelfth century were followed by bold works at Vicq and Tavant. At the church of Saint-Martin in Vicq, a series of paintings that must slightly post-date Saint-Savin luckily survives in the chancel—large scenes of the Adoration of the Magi and the Entry into Jerusalem are painted with extraordinary transport that can only be fully appreciated after examination of contemporary manuscripts

exhibiting the same turbulent style. In contrast, calm reigns in a nearby church at Brinay-sur-Cher (left), where scenes from the Life of Christ ring the choir like a two-level frieze. Careful drawing distinguishes figures painted in fine red and ochre hues. Greek key patterns or angular forms accompany scenes of the Last Supper and the Baptism with an authority that perhaps owes something to tradition. The painting reconstitutes, in its own way, the diversity of the portal sculpture, where ornamental patterns alternate with representational

figures. Under the entrance arch there are even images of the twelve months borne by squatting atlantes.

The somewhat skewed and cramped space of the crypt in Tavant displays the work of one of the most original painters of the twelfth century. Enormous red-ochre clouds in the form of a saw-toothed arc are deployed around scenes of the Descent from the Cross, the Resurrection, and assorted biblical figures. No coherent iconographical program emerges; rather, the scenes appear to be a

series of samples from some ideal cycle. Figures such as a centaur and a dancer display striking draftsmanship, while an allegory of Lust—a tortured figure in green and yellow ochre stabbing herself—evokes similar images carved in stone (at Charlieu, for example). There is an Infant cycle in the less well-preserved chancel, and a Christ in Majesty can still be seen in the apse, surrounded by "exquisite and lively figures of small angelic figures with butterfly wings"[35] executed in a range of hues. Vestiges of Carolingian dynamism can be detected in the brisk handling and lively silhouettes. These paintings, discovered in 1844, immediately interested Prosper Mérimée, but their conservation has not been easy. Thus there are regular discoveries, underneath more recent daubings, of vestiges of the vast fresco on a pale ground with accents of ochre all the more expressive in that the artist avoided use of the rich blues and tones favored in eastern France.

In general, the distinct approaches of two regions can be identified—a glossy finish on dark ground was typical of Burgundy and central France, whereas a matte finish on light ground was used in western France. This polarity was the general rule.

Cluny III, in Burgundy, boasted substantial decorative painting—the refectory had cycles on the two testaments, and texts also refer to portraits of the "founding" saints (circa 1090). Such hagiographic portraiture was the function of painting—the large, no longer extant Christ on gold ground, mentioned above, clearly provided the model. And the Cluny-affiliated priory at Berzé-la-Ville proves that this model entailed "Greek" techniques with certain "Italian" traits, in accordance with the "Roman" theme of the *traditio legis*. For the frescoes in the apse—the only ones still in good condition—illustrate a theme rare in France but not in Rome; Christ, four meters high, surrounded by the apostles, hands Peter (wielding a giant key) the

Cluny Lectionary: the Pentecost. Cluny, c. 1100. Bibliothèque Nationale, Paris (Ms. Nv. Acq. Lat. 2246, fol. 79).

scroll of the new Law. Below are two scenes of the martyrdom of Saints Blaise and Vincent, flanked by columns over busts of female saints (assimilated into the Wise Virgins) then nine busts of male saints, only two of which (Denis and Quentin) are French. In style and content, then, the Berzé decoration, discovered in 1887, adapts a Roman decor, though its exact date remains undetermined. In the apse of Paray-le-Monial, the Lord is dressed in royal purple to evoke a triumphal effect. This is also echoed at Brioude, where the Byzantine manner is even more pronounced. Thus eastern France, on the edge of the Holy Roman Empire, maintained contact with Oriental Christianity, a contact that would intensify toward the end of the twelfth century.[36]

MANUSCRIPT ILLUMINATION

These sketchy details would acquire added interest if the mural style and technique could be more closely related to

manuscript work. For instance, although only six miniatures survive from the Cluny *Lectionary* (Bibliothèque Nationale, Nv. Acq. Lat. 2246), they show that Cluny illumination aspired to great art by assimilating Rhenish and Byzantine models right from the time of Abbot Hugh (above). But in Bibles produced in the second half of the twelfth century (right), which are difficult to group stylistically, there appears to be an increasingly marked taste for narration and movement of Latin inspiration, as seen in a Bible donated in 1795 to the Clermont-Ferrand Library (Ms. 1) and in the so-called Souvigny Bible (Moulins, Bibliothèque Municipale, Ms. 1). The miniaturists used muted blues and bright reds, and conveyed a sense of dynamism through gesture and composition; feet and arms would extend beyond the frame of a decorative letter, for example, or when convention required a more traditional composition for a Biblical scene, an enormous dragon might coil

Souvigny Bible: scenes from Genesis. Souvigny, late twelfth century. Bibliothèque Municipale, Moulins (Ms. 1, fol. 4v).

Clermont-Ferrand Bible: Judith and Holofernes. Central France, c. 1170–1180. Bibliothèque Municipale et Interuniversitaire, Clermont-Ferrand (Ms.1, fol. 211v).

Souvigny Bible: scenes from the life of David. Souvigny, late twelfth century. Bibliothèque Municipale, Moulins (Ms.1, fol. 93).

around everything, spewing multicolored ornamentation (Bibliothèque Nationale, Lat. 116, fol. 63).

Miniatures favored a much more rapid and broad proliferation of initiatives and new models than did sculpture. It is practically impossible to present a clear picture of these developments, but an intensification of entwined forms can be noted, along with a growing predilection for images of animal and human figures tearing one another to pieces. These prodigious arabesques became the telling symbols of Romanesque tension and cruelty. On an initial letter in the *Works* of Saint Augustine (first half of the twelfth century, Cambrai, Bibliothèque Municipale, Ms. 559), figures in mortal embrace betray a marked taste for horror, even though color somewhat softens these atrocious yet elegantly drawn frays. Graphic delirium did not preclude an artful layout, which makes these images all the more disconcerting. When depict-

ing a carpet in the Saint-Amand Bible (Valenciennes, Bibliothèque Municipale, Ms. 1–5), the artists, probably inspired by some oriental rug, could not resist giving the floral pattern a bizarrely teeming air. This effect constitutes a striking equivalent to the fantastic element in sculpture, even though the current state of research cannot provide an explicit description of the precise relationship between the two. Such analogies nevertheless make it clear that amazing visual experiments were taking place generally. "Artists" gave form to practically all registers of expression by improvising freely and adding countless narrative scenes to an initial repertoire that entailed above all the solemn and hieratic "presentation" of sacred figures. This gave birth to a broad development encompassing various trends, innovations, and occasional conflicts.

Not all scriptoria regularly produced illuminated Bibles—those at Limoges and Clairvaux did produce them,

although a given manuscript's exact workshop of origin can be difficult to identify. It is even thought that during the twelfth century a sort of mixed style developed, stemming from the dominance of the English school. The prodigious inventiveness of the heirs to the Winchester school, as seen for example in the *Psalter of Henry of Blois* (circa 1150, British Library, Cotton Nero C. IV), would certainly have struck painters who came across it. The relatively late Souvigny Bible (1180–1200) is even more interesting. Its large format (56 × 39 cm) contains veritable paintings that, as was customary, condense scenes in a closed, tight style similar to Byzantine manuscripts. Whereas its robust forms belong to the tradition of Romanesque bibles (of which it is one of the last), the manuscript's affinities with the Greek canon already points to the "1200 A.D." phenomenon, to be discussed in the pages to come.

Abbey of Saint-Benoît-sur-Loire (Loiret).
Church flooring (detail).
Early eleventh century.

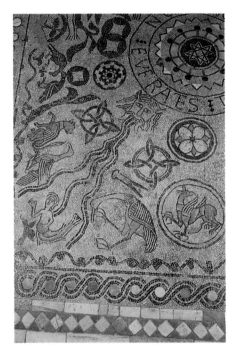

Chapel of Saint-Nicolas, Die (Drôme).
Detail of floor: The Euphrates.
Mid–twelfth century.

MOSAIC FLOORING

An element of French and Italian architecture recently placed in the limelight is the figurative mosaic flooring in churches. The *Vie de l'Abbé Gauzlin* recounts that the abbot "decorated the cantors' choir [of Saint-Benoît-sur-Loire, above] with a very fine marble decor that he had brought from the land of *Romania* [i.e. Byzantium]"—the flooring still exists today. Meanwhile, the Alpine church of Ganagobie, one of Cluny's daughter monasteries, boasts an extraordinary set of floor mosaics including a knight charging a chimera (north wing), fantastic animals interwoven with tracery (transept), and signs of the zodiac (apse). The stunningly animated zodiac is edged with an inscription that bears the name of the monk responsible for this work—the *operarius* Pierre Trutbert. The carpet of tesserae (playing on the three colors of black, white, and red-ochre) covers an area of seventy square meters, and dates from the first quarter of the twelfth century.[37] At Die in the Drome region (above), a rectan-gular floor mosaic featuring medallions and heads (from which rivers flow diagonally) recalls antique mosaics, as does a mosaic at Saint-Paul-Trois-Châteaux. Finally, at Saint-Denis, a medallion shows the kneeling figure of the monk who directed the work (*hoc nobile fecit opus*). Similar floor mosaics exist in Venice, Otranto, and Reggio Emilia. This twelfth-century practice was fairly common throughout the West[38]—it was yet another spectacular decorative element, inherited from the Roman world, that paradoxically enlivened churches in the "modern" spirit that so aroused the contempt of Saint Bernard and the Cistercian counter-movement.

PRECIOUS METALWORK AND ENAMELS

Enameled plaques and reliquaries began to circulate in the late eleventh century, and were clearly widespread by the mid-twelfth century. The most famous and most impressive piece of Romanesque enameling was the funerary plaque (far right) depicting Geoffroy Plantagenet, called the Fair (1113–1151), who was count of Anjou and Maine, and, as the father of Henry II, ancestor of the English dynasty. This large plaque (63 × 33 cm, Musée Tessé, Le Mans) was placed upright in the young noble's mausoleum in the cathedral of Saint-Julien in Le Mans (destroyed in 1562). The skillful execution combines enamel, engraving, and incrustation techniques, playing on cobalt and turquoise blues, with gold and brown highlights. The effigy pays homage to Geoffroy as a *princeps* of peace within the church (an allusion to some problem plaguing the clergy). Above all, however, it represents "the earliest example of a shield bearing a

Champagnat Reliquary. Copper gilt and champlevé enamel.
Limoges, mid–twelfth century. 12.4 × 19.1 × 7.9 cm.
The Metropolitan Museum of Art, New York.

Book binding: Christ in Majesty. Copper gilt and champlevé enamel. 1165–1175. Height: 23.6 cm. Musée de Cluny, Paris.

Right:
Funerary plaque of Geoffroy Plantagenet (1113–1151). From his tomb in Le Mans Cathedral. c. 1158. Copper gilt and champlevé enamel. Height: 63 cm. Musée Tessé, Le Mans.

personal emblem."[39] With his conical cap and yellow-lined shield featuring four gold lions, Geoffroy perhaps represents another Joshua. Western miniatures provide models for the decorative floral pattern and the city set between arch and frame, but this enamel also has, in addition, that special "gaiety of sparkling substances [that] would remain the hallmark of Limoges workshops."[40]

As part of Aquitaine, Limoges was closely linked to Spain, and it is not unreasonable to use the term Hispano-Limousin art in referring to the Champagnat reliquary chest (The Metropolitan Museum of Art, New York, left), or to an enamel binding that employs a superb green and yellow palette to depict Christ in Majesty

(circa 1170, Musée de Cluny, Paris, p. 193). The term applies above all to an enormous altar front of the Virgin and Three Kings (1 × 1.8 m, circa 1175–1180), comprising twelve plaques of exceptional richness, reworked several times. This princely commission was long sheltered in the mountains of Navarre, and is now at the Pamplona Museum. The gold-incrusted folds of the garments play on green and blue enamel surfaces, shimmering with an intensity that underscores the confidence of the design and the dignity of the sections in relief.

An original scene on one of the pre-1190 enameled plaques on the altar of Grandmont Abbey (now in Paris, Musée de Cluny) bears an inscription in the Limoges-area dialect that identifies a monk in the hooded blue cloak typical of the order as a certain Hugo Lacerta—he is shown speaking with his haloed master, Saint Stephen of Muret (died 1124), who holds a book. The scene is given a typical Limoges-style setting that features the colorful domes of an ideal city, and is a wonderful illustration of the development of what might be called "Plantagenet art." It also demonstrates the fact that the sanctification of the founder of an order was practically the rule. The church of the Virgin was built in Limoges around 1160 and, even before the local hermit Stephen was canonized in 1189, it boasted seven large reliquaries in addition to the high altar. This triumphal set of precious enamels was dispersed, the altar itself having been sold in 1791 to a local coppersmith.

The large gold cross on the tomb of Saint Denis that so preoccupied Abbot Suger around 1140 came from an entirely different source. Having restored, re-gilded and completed a gold altarpiece dating from the time of Charles the Bald, the abbot wanted to enrich further the basilica's high altar with a monumental crucifix. As Suger noted in his description of the cross, he had to gather pearls and gems from all over, even from monks at Cîteaux and Fontevrault, as well as a large quantity of gold. "In less than two years we had goldsmiths from Lorraine, sometimes five, sometimes seven, compose the pedestal with the four Evangelists, and the shaft that bore the holy image was adorned with enamels [*smaltitam colomnan*] showing the story of the Savior and allegories corresponding to the Old Law" (*De Administratione,* chap. 32).

Suger, then, called on enamel specialists from the Meuse region, notably Godefroid de Huy, whose disciple, Nicolas of Verdun, went on to great fame. The shaft of the cross contained seventeen enamels illustrating the correspondence between the two Testaments (a theme found again in Nicolas's masterpiece in Klosterneuburg). This remarkable object, studded with precious stones, shimmered at the entrance to the chancel. It was destroyed during the French Revolution but an idea of it can be had from a small-scale copy which was found at Saint-Bertin in the nineteenth century (Musée de Saint-Omer). Worth noting is Suger's defense of this unparalleled artwork in the face of certain detractors. Praising the Lord, argued Suger, required purity of heart, but could also be facilitated by external ornamentation of the instruments of the holy sacrifice. In short, gold and beauty had their own purity, too. This reasoning helps explain the widespread use of artifacts that, directly or indirectly, imitated precious substances and employed enameling to provide the required imagery.

STAINED GLASS

The earliest stained-glass windows from the mid–twelfth century are so impressively sublime that the massive disappearance of Romanesque stained glass can only be bitterly regretted. Yet as Louis Grodecki stressed, the totality should not be reduced to the admittedly important and prestigious collection of stained glass installed in the abbey of Saint-Denis around 1145. At Le Mans (right), for

Trinité Church, Vendôme. Stained-glass window: Virgin and Child. c. 1160–1165.

example, roughly fifty early panels are still scattered among the windows of the nave, including an outstanding Ascension (circa 1145) in which the apostles, clustered in twos and threes, invite comparison with the figures in the crypt at Saint-Savin and with certain miniatures from the Limoges region. They follow the western decorative style, their most remarkable aspect being the way figures stand out against a background that alternates between red and blue of exceptional conviction (the lunette and lower register are modern additions). Fragments found at Mont-Saint-Michel would seem to be of the same type.

Other examples worth citing can be found at Poitiers, where a large window showing the Crucifixion (circa 1160–1165) also used red and blue grounds to underscore the figures, and at Vendôme (left) where a hieratic, serene *Virgin and Child* are presented in an elongated mandorla that would not have an equivalent until some thirty years later at Chartres.

The windows in the ambulatory at Saint-Denis were one of the initiatives of which Abbot Suger (who left a commentary on them) was most proud. He was aware of having brought the art of his day to a grandiose culmination through the symbolic organization of the medallions and their presentation in a new light. The original stained glass has suffered terribly and undergone drastic restoration, so it is only recently that the windows have been correctly interpreted. There were six figurative windows in the original 1144 series: "Of these six windows . . . sixteen panels have been preserved; but the original compositions are known thanks to drawings executed in 1794–1795 by the architect Percier."[41] The medallions have attractively dotted borders and depict scenes of martyrdom or Biblical themes (such as the Burning Bush) that display affinities with the "picturesque" idiom of the Carolingian tradition in northern France. Here again, items of precious metalwork had a major influence. Whatever

Le Mans Cathedral (Saint-Julien). Stained-glass window, southern side aisle: the Ascension. Second quarter of the twelfth century.

the case, these compositions, like so many others, remain on the borderline between Romanesque and Gothic.

Champagne is another region noted for its stained glass. At Châlons-sur-Marne, the analogy with precious metalwork (more specifically Mosan enamels, from the Meuse region) is once again suggested by the size of the medallions, their framing, simple outlines, and robust effects. Among the vestiges of early glass there is notably a large quatrefoil window showing the Crucifixion against a red and blue ground, surrounded by images of the Church (above), the Synagogue (below), Isaac and Moses (left and right), all set

against light grounds. This composition constitutes an original interpretation, circa 1150, of the correspondence between the Old and New Testaments, which confirms the impression that stained glass was becoming a choice medium for the elaboration of learned imagery. The Champagne region was obviously adopting this new idiom, as demonstrated further by the stained-glass Crucifixion at Saint-Remi in Reims. The region thereby participated in the stylistic upheaval that occured around 1200, only to succumb, like everywhere else, to Gothic stained glass. At the end of the eleventh century, France was one huge stained-glass workshop.

6. Castles: Courtly and Secular Life

Earth and wood were the basis of the *motte*, a defensive unit comprising a fortress on a natural or artificial hillock. The fortress might serve as a temporary or permanent residence, and was often called a *castellum* in the tenth century. The Bayeux Tapestry (circa 1075) shows William the Conqueror's army building a fort, accompanied by the explanation that "*Hic fussit castellum edificari.*" But these strongholds were not built under the aegis of a central authority—"the very implantation of fortresses in most regions of France show that they were erected as a function of private interests, associated with limited territories."[42] The residence often included a farmyard (or *bayle*) so that, little by little, castle and village sprang up together.

Construction in stone had never completely disappeared from southern France since the days of the Gallo-Romans. Not only was material from ancient ruins long re-used, but town walls were built and, where resources permitted, noble residences rose in the form of towers at places like Langeais and Doué-la-Fontaine. It was later, at the turn of the eleventh century, that these stone towers were fortified and became keeps with a military function inside a *castrum* still ringed, in many cases, by a stockade. Around 1100, keeps evolved into castles, that is to say a combined residence and military fortress. Many still survive, especially in western France, from the late eleventh century (Loches) or twelfth century (Montbazon). These tall structures

"Caesar's Tower," Provins. Twelfth century.

were quadrangular, with moderately thick walls and multiple floors. They were progressively improved by polygonal or circular plans and, inside, by spiral staircases (late twelfth century) and vaulted ceilings on upper floors.

During the twelfth century, all of France became dotted with seignorial residences dominated by the keep, which became the most finished and ostentatious feature. The keep at Houdan (1110–1125) is twenty meters high and has four abutting towers, while the one at Châteaudun is thirty-one meters high and seventeen meters in diameter, with a wall

that thins progressively in sloping stages. At Provins, a perspectival effect accentuating the impression of domination was obtained with "Caesar's tower," an octagonal keep surrounded by four turrets on a hillock, with a rampart walk halfway up and turret roofing. The role of the keep in the castle's defensive structure would remain unchanged until the days of Philip Augustus in the late twelfth century.

How were these enormous construction projects carried out? Our knowledge is only fragmentary. Forced labor, obviously, was part of it. But where did military engineers and technicians come

Château-Gaillard, Les Andelys. 1197.

from? When this type of building spread throughout the land, there must have been a rivalry of skills. An intriguing, overlooked text from 1151 provides information on Montreuil-Bellay, near Saumur: to fortify his castle, Geoffroy the Fair, count of Anjou, began poring over a Roman treatise by Vegetius and "placed full hope" in his study of masonry and roofing techniques.[43] That, however, did not prevent Geoffroy's fortress from falling into enemy hands.

The Plantagenets had a highly evolved policy on fortresses—twin keeps at Niort with cylindrical turrets, large buttresses,

and machicolations (circa 1160); an octagonal keep at Gisors, adhering to the fortress revetment (the retaining wall); a sixteen-walled polyhedron on a circular foundation at Châtillon-Coligny, with vaulted rooms, circling hallways, passages within the walls, and tight buttresses. To this day it remains one of the most impressive and most studied of round keeps. It was erected by a member of the Blois-Champagne family, which refused to acknowledge the sovereignty of Philip Augustus and intended to affirm its own nobility and authority. Thus Henri I, count of Champagne, built Provins between

1152 and 1180, Thibaud V of Blois erected Châteaudun between 1170 and 1190, and Etienne of Sancerre built Châtillon between 1180 and 1190. The feature common to Provins and Châtillon is an "oriel" or curved balcony projecting from the upper storey (called "Caesar's Room" at Châtillon).[44] The final edifice in this series was the spectacular construction at Château-Gaillard (above), the linchpin to Normandy, laid out by Richard the Lionheart in 1197. It boasted a round keep with a counterfort at the base, inside two protective rings of fortress walls. This enormous undertak-

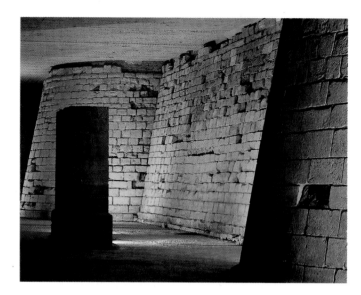

Foundations of the original Louvre, Paris.
Built by Philip Augustus, late twelfth century.

ing provokes questions about the military experience that inspired it, and a comparison with the famous Krak des Chevaliers fortress in the Holy Land would seem to supply the answer. There was a lot of travel to and from the East in the twelfth century, and the bartizans (entryway turrets), curtain walls, and machicolations that became so typical of French castles were discovered on contact with Byzantine and Muslim fortresses.

The first part of the reign of Philip Augustus (1180–1223) was marked by a war of fortresses with his Plantagenet rivals, Henry II (1154–1189) and Richard I (1189–1199). The Plantagenets organized a corps that specialized in the art of sieges, soon imitated by the French king. This led to memorable military episodes like the capture of the castle at Boves by the royal French "sappers" (engineer units), as well as to further refinements in fortress architecture, thanks to experience gained in the Holy Land (without, however, imitating the gigantic fortresses in Lebanon).

In general, Philip Augustus's engineers adopted a circular design for keeps—the standard formula involved a sloping base, walls three or four meters thick, and rib-vaulted ceilings. Placement of the keeps varied, from one corner of the fortification (as at Dourdan), to an off-center (Chinon) or center (Louvre) position. The Louvre castle overlooked the new wall of Paris, guarding the western gate; it was square in design, had side walls seventy-five meters long, with the standard, large round towers at each corner. On the eastern side facing the city, two semicircular towers flanked the rear entrance. Nineteenth-century excavations provided a precise outline of Philip Augustus's Louvre, while those conducted in 1985 (above) totally unearthed superb stone courses that give a good idea of state-of-the-art construction in the year 1200.

It was within such edifices that secular culture developed into the "courtly" life typified by gallant behavior, musical and literary pastimes, dancing, recitals, and polite rituals that centered on noblewomen. The period's glorification of womanhood has long been noted, the origins and consequences of this phenomenon having been analyzed more recently. The exaltation was stimulated on the one hand by Saint Bernard's cult of the Virgin and on the other hand by the rites of "courtesy." Here again, the twelfth century was at the heart of a vast cultural experiment.

Epic poetry has already been mentioned briefly. The *Chanson de Roland*, composed by Turold around 1100—the time of the Crusades—was swiftly adapted into German and Italian (*I Reali di Francia* would continue to influence Italian writers up to Pulci and Ariosto). This Europe-wide literary success paralleled the spread of architectural forms; the stereotype of the knight or hero was used to illustrate, for instance, the spiritual combat of the soul, and often played a role in narrative Biblical scenes. But it should not be forgotten that the emergence of epic poetry marked an interesting turning point in a culture which seemed exclusively dominated by the demands of religious figures and themes. The increasingly restive class of knights called for suitable literature—the markedly secular inspiration of the *Chanson de Roland* generated new imagery,[45] of which the Bayeux Tapestry was not the only manifestation. In short, it would be prudent to include a strong secular or lay aspect, open to all sorts of traditions, as a constituent element of "Romanesque civilization."

For it was no coincidence that the nobility responded enthusiastically to the "tales of Britons" which uncovered a Celtic substrate that had been buried for so long. The *Historia Regnum Britanniae* by Geoffrey of Monmouth (1137–1148) brought back to life a Celtic chief, Arthur, mentioned in the *Historia Britonum* (eighth or ninth century). But Monmouth linked Arthur to Troy. A connection can thus be established between the *Roman de Brut*, a verse adaptation of this legend by the Norman poet Robert Wace (circa 1155), and the allusion to Hellenistic origins made by Benoît de Sainte Maure's *Roman de Troie* (right) and by the anonymous *Roman d'Eneas*. The two major literary themes of Arthur

and Troy obviously reflected concerns for dynastic legitimacy (the latter would continue to have implications in the fifteenth century), but they also served as a medium for purely poetic and literary developments, the scope of which it is hard to exaggerate, given that they promoted and enlivened a "Gothic" mentality by lending it great charm. All these cultural registers coexisted—Béroul was writing *Tristan et Iseult* just when Notre-Dame Cathedral was being built in Paris.

So although it was not the great Chrétien de Troyes (1135–1180) who introduced courtly romance and marvelous deeds into French literature, his *Lancelot* (circa 1168) and *Yvain* (circa 1170) endowed them with them a lasting, infinitely attractive form. Meanwhile, the delightful short verse tales, or lays, by Marie de France (circa 1170) further transformed French letters. The main points to retain include the general fascination with Celtic legends dating six or seven centuries earlier, and the fact that these themes were once again assimilated into official culture in somewhat the same way that silhouettes and medallions were incorporated into miniatures and sculpture to enhance their significance.

The new courtly literature differed sharply from the direct and heroic tone of epic tales, and this comparison points to a new era in culture in which love, enchantment and the marvelous would henceforth play a considerable role, to the delight of an aristocracy enamored of the novelistic. This shift in sensibility helps to illustrate, in a sense, the passage from a solemn, serious art to a more pleasure-seeking output, and it reveals a lively taste for opulence, as demonstrated by frequent allusions to objects made of precious metals and rare gems. Chrétien de Troyes made a clear distinction between the matter, ideas, and craft that all went into an artwork.

In a romance of adventure, prodigious acts are inevitably associated with

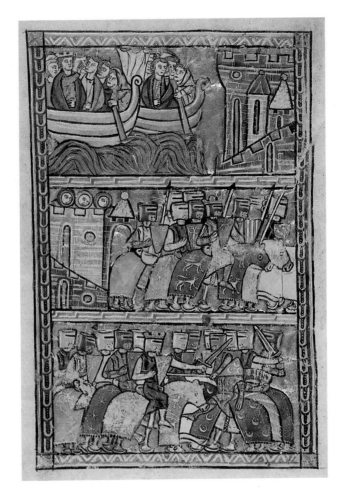

Benoît de Sainte Maure, *Roman de Troie*. 1264.
Bibliothèque Nationale, Paris (Ms. Fr. 1610, fol. 17v).

marble fountains or glamorous objects like swords with gold handles and scabbards of orphrey (richly embroidered fabric). This penchant reflects a fundamental and undying feature of Western civilization: a sense of the mysterious and marvelous associated with the purity of materials and gems. In *Percival*, the Grail incarnates all the beauty of every known object. There has been much discussion about what it was in the Grail legend that so fascinated the French and, later, Germans: the purely Celtic tale, the resonance with mysterious discoveries made in Byzantium and the Orient, or more simply the heroic adventure story that transposed the familiar objects, processions,

and rituals of Christian symbolism into an exotic and almost "pagan" mode.[46]

The wave of aestheticism and dilettantism that marked the entire period should not be overlooked. Church archives in Le Mans contain a description of the episcopal manor commissioned around 1158 by Bishop William of Passavant—it included a wonderfully lit room with windows "in which the workmanship surpassed the quality of the materials," a chapel with paintings that so fascinated visitors "that in their delight with the images they forgot their own business," another chamber more beautiful still, and an exquisite garden.[47] Secular, aristocratic taste could even be found among ranking clergymen.

7. The Cistercian Counter-movement

Cistercian churches might initially appear to be nothing more than a lighter, more modest version of Burgundian architecture. Cluny had not yet been completed and consecrated when Clairvaux proposed a counter-model that spread remarkably swiftly (there were already three hundred and forty three monasteries affiliated with the reformed order at Saint Bernard's death in 1153). The simple, bare design of this new model employed relatively straightforward construction techniques that could be executed by lay brothers, avoiding the ever-suspect participation of outside teams. That, at least, is the hypothesis.

Fine examples in Burgundy itself, such as Cîteaux (erected between 1125 and 1130) and Fontenay (founded in 1119, with a nine-bay church built from 1139 onwards), with their pure lines of pointed barrel vaulting, were swiftly imitated by daughter houses in places as far away as Italy (Chiaravalle in Lombardy, 1135–1137, and Fossanova, consecrated in 1208).

By linking contemplative life to an active life via the "chaste labor of the earth," the Cistercian order could choose isolated sites where it would clear the land for cultivation. This explained its expansion as far as Sweden and Germany, where it was looked upon favorably by Emperor Frederick II of Hohenstaufen. Individual establishments, limited to twelve brothers and an abbot, kept in close touch with one another, constituting an original network throughout Europe and, of course, the Holy Land. The Cistercians' competence in agricultural economy was matched by a "modern" approach to architecture that featured functional buildings, churches without imposing bell towers, simplified construction techniques (especially after

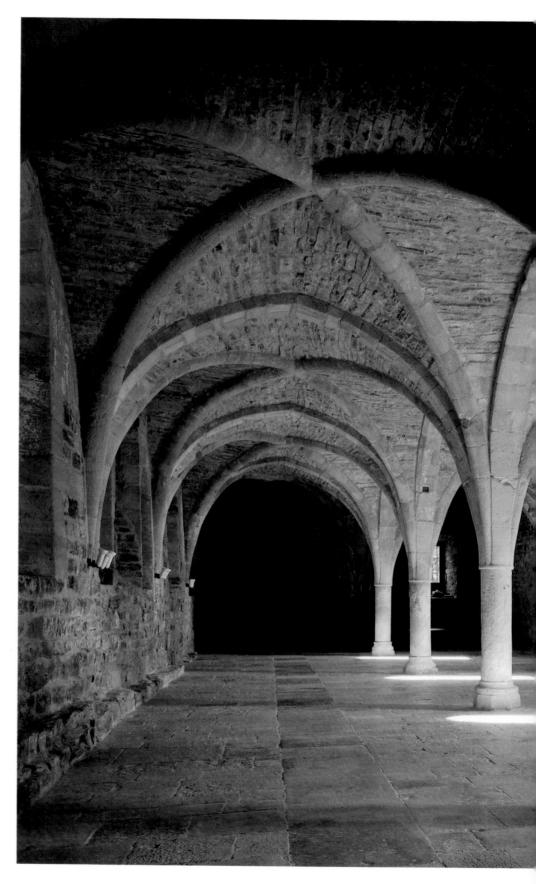

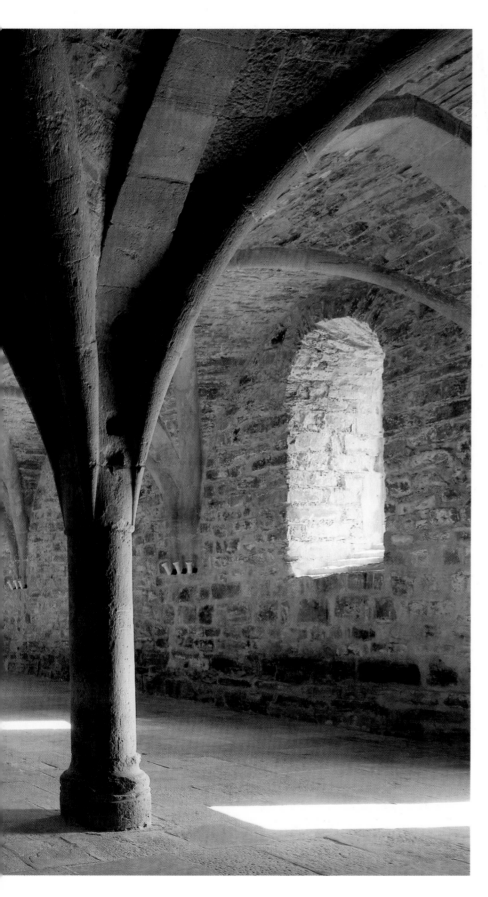

Sylvanès (Aveyron),
chapter house of the former
Cistercian abbey.
Late twelfth century.

adoption of the "minimal" Gothic style), and a contempt for ornamentation. Their skills were paradoxically solicited even for construction projects that had little to do with sanctification—in Apulia and the Capitanate, so many monks and lay brothers were lent to Frederick II that the pope finally complained.

This swift success perfectly illustrates the almost electrifying impact of the eloquent figure, Saint Bernard, who brought new life to the Christian message for the regular clergy. Less than a century later another preacher would arrive, this time bringing the message to all the faithful—Saint Francis of Assisi. He denounced the sclerotic "establishment" and facile piety in an effort to re-awaken the Christian people. Advocates of renewal thus emerged periodically, each time proposing new models for churches and for art.

Saint Bernard's reform movement therefore assumed considerable importance, in response to a malaise within Benedictine monasteries that might be described as the torment of purity. It was accompanied by a series of vigorous manifestations that associated the movement with a desire to reform the Church's very attitude toward art and architecture. Benedictine texts on the subject were so important and had such long-lasting impact that they were still being cited by reverend fathers at the Council of Trent during the Counter-Reformation.

Benedictine criticisms of contemporary imagery had the acerbic tone of Pascal denouncing superstitious vanities—one of the criticisms addressed to monasteries was that when "a statue of a saint is displayed, it is thought to be that much more holy if it is laden with color." This comment, moreover, is confirmed by the spread of painted statues.

All artistic practices of the Romanesque era were unhesitatingly challenged. But above all, it is hard to look at sculpture from that period without thinking of the famous passage describing the partic-

Moralia in Job, letter M: monks folding laundry. Cîteaux Abbey. Second quarter of the twelfth century. Bibliothèque Municipale, Dijon (Ms. 170, fol. 20).

ularities and extravagances of cloister decoration, a passage that still merits quoting: "In the cloister, under the eyes of the brethren who read there, what profit is there in those ridiculous monsters, in that marvelous and deformed beauty, in that beautiful deformity [*deformis formositas ac formosa deformitas*]? To what purpose are those unclean apes, those fierce lions, those monstrous centaurs, those half-men, those striped tigers, those fighting knights, those hunters winding their horns? Many bodies are there seen under one head, or again, many heads to a single body, Here

Moralia in Job, letter Q: monks chopping wood. Cîteaux Abbey. Second quarter of the twelfth century. Bibliothèque Municipale, Dijon (Ms. 170, fol. 59).

is a four-footed beast with a serpent's tail; there, a fish with a beast's head. Here again the forepart of a horse trails half a goat behind it, or a horned beast bears the hind-quarters of a horse. In short, so many and so marvelous are the varieties of shapes on every hand, that we are more tempted to read in the marble than in our books, and to spend the whole day wondering at these things rather than in meditating the law of God."[48] The extraordinary author of this accurate and learned description was none other than Saint Bernard of Clairvaux, a Cluniac monk who, after writing this letter to Abbot William of Saint Thierry, went on to found the Cistercian order.

This key attack, which merits commentary, followed an equally ferocious denunciation of the architecture even of Cluny. "Among the most serious points, which seem all the less so for being so common, we will pass over the enormous height of churches, their extraordinary length, their excessive width, their sumptuous sculpture, and their strange paintings [*curiositas*] whose *aspect* turns the heads of the faithful, who thereby lose *affect*."[49]

None of those things was really valid, according to Bernard, who asked why churches needed so much gold and riches. Give the money to the poor, he argued. His severe stance stemmed from a prevailing attitude that intended not only to make monastic life conform to the moral discipline of chivalry (which spurred the founding of the order of Knights Templar), but also and above all disapproved of the magnificence of the Church. The criticisms against Cluny can be explained and, in a sense, justified by the extravagant scandals that rocked the great monastic headquarters under Abbot Pons de Melgueil (who wound up in prison in 1126). The next abbot, Peter the Venerable, tried to defend Cluny in the wake of that crisis, but Bernard apparently granted him no time to do so, if the

famous letter's date of 1124 is accurate. Cluny's failings, however, occasioned a double attack—on the opulence of the Church as well as the absurdity of the decoration in cloisters. Bernard was thus the earliest and most penetrating analyst of what had been and would continue to be the backbone of ecclesiastical art—a taste for splendor and its corollary, the play of *curiositas*. Bernard's negative reaction helps to pinpoint the very essence of medieval creativity.

In conclusion, Bernard declared that it all reminded him of "the ancient rites of the Jews," a nasty allusion to those who thought they could justify ecclesiastical opulence by pointing to the riches of the Temple in Jerusalem as built by Solomon and described in Holy Scripture. His attitude clearly poses the issue and ambivalence of artistic activity with the Christian Church.

When he described the strangeness of Romanesque "monsters" with such striking verve, Bernard put his finger on a principle that would continue to function during the Gothic period, soon attaining the summit of intensity. He thought that such "absurdities" were not only useless, but morally dangerous because based on distraction. Monks, who were supposed to be men of the Word rather than men of the Image, were foolishly distracted. In large churches, meanwhile, imagery that was supposed to be a visual tool of education for illiterate believers became just another distraction through the draw of *curiositas*.

The same polemic against excesses and perversion of holy imagery resurged in the fourteenth and fifteenth centuries, which suggests the existence of an internal contradiction between the Church and artistic activity, or at the very least an issue of appropriateness and legitimacy that Saint Bernard should be credited with raising but which, for reasons that will be made clearer later on, remained suppressed until the Reformation.

Saint Bernard, *Oeuvres*: illustration from a treatise on the twelve degrees of humility. Benedictine Abbey at Anchin (Nord). Second half of the twelfth century. Bibliothèque Municipale, Douai (Ms. 372¹, fol. 100).

On reading his strongly negative letter, it is tempting to compare Bernard to Tolstoy, who condemned art and music for being guilty of uselessly stimulating the passions. The issue is similar, though expressed here in the context of Christian

and monastic philosophy. What had been the pride not only of Cluniac monks but also of builders for the past three or four hundred years was being condemned—murals, stained glass, mosaic floorings and, of course, everything made of gold, everything that glittered, like *coronae gemmatae* (chandeliers). The scope of Bernard's comments and of the Cistercian reform can only be grasped in the context of a general criticism of religious practice in France. Bernard was fully aware of this when he asked his disciples to reject the entire century by turning it on its head "like those jugglers and dancers who, with head down and feet up, in an inhuman fashion, stand or walk on their hands." Bernard thereby borrowed an image from the repertoire of Romanesque sculpture in order to challenge its spirit. The strength of his affirmation did not go unnoticed—the Cistercian penchant for plain simplicity was often considered to be a mark of pride, like the white habits that distinguished them from black-robed Benedictine monks.

The spread of the Cistercian reform was marked by categorical recommendations and injunctions, of which only scattered examples have survived.[50] They condemned gold crosses, images on floors, and showy decoration, advocating changes fatal to local tradition. Yet, faster than the founding saint would have liked, compromises were made with traditional practices. So the desire for reform continued to be expressed through polemical documents, one of the most interesting being the "Dialogue between a Cluniac and a Cistercian," written circa 1155 by a former Cluniac monk. The condemnation of opulence is explicit: "Beautiful pictures, varied sculptures, both adorned with gold, beautiful and precious cloths, beautiful weavings of varied color, beautiful and precious windows, sapphire glass, gold-embroidered copes and chasubles, golden and jeweled chalices, gold letters in books: all these are not required for

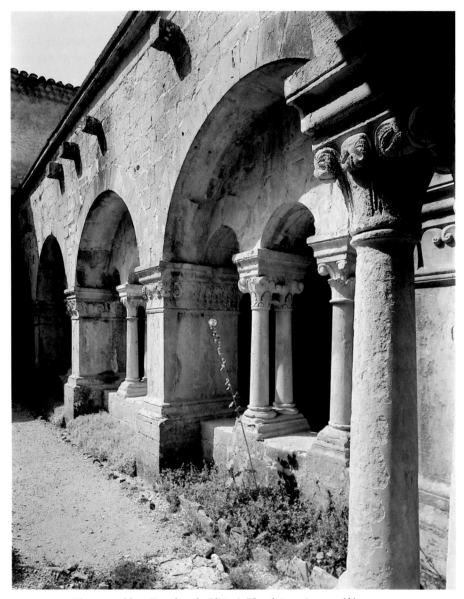

Silvacane Abbey (Bouches-du-Rhône). The cloister. Late twelfth century.

often convey a musical charm that functions as the secret defense of such architecture (although architects of other orders may well have relied on it also). In Burgundy and Provence to the south, namely at Sénanque and at Silvacane, Cistercians provided wonderful demonstrations of the clean lines and forms that Bernard thought indispensable to the edification of his brethren.

Cistercian criticism had a particularly radical effect in two spheres—sculpture and stained glass. The order's buildings were totally devoid of representational sculpture (the dreaded site of indulgent *curiositas*); the penchant for monotonous, simple foliate decoration led one historian to complain that "the only boring capitals in Romanesque art are Cistercian capitals." As to windows, if Bernard's ascetic recommendation for the exclusive use of plain grisaille glass had been followed, some of the most stunning creations of medieval French art would have been stillborn.[52]

The second quarter of the twelfth century therefore represents a period of intense spirituality and intellectual rigor exceptional in the history of the Christian Middle Ages. By advocating a simplified architecture that was easy to implement and, as they say, "functional" (at least from the monks' elitist point of view), Bernard's successors perhaps unwittingly paved the way for the schematization required by another approach to construction—Gothic. But that is not really the issue, for the two developments were contemporary; whereas the Cistercian reform defined itself in terms of Cluniac art, the same could not be said of Abbot Suger's undertaking at Saint-Denis, the cradle of Gothic art. The two trends are separated merely for convenience of argument. Suger (circa 1081–1151) was slightly older than Bernard (1090–1153), and the two men knew one another. Suger even suffered criticism from his junior. Just as the "reformed" churches were

practical needs, but for the concupiscence of the eyes."[51] This passage gives a good idea of the way some people in the twelfth century perceived the very things that lent churches charm, and which therefore had to be rejected.

Thirty years after Bernard's harsh injunctions, his followers were fully aware that it would never be possible to abolish completely what they saw as the Church's "worldliness," and that the struggle would last forever. The author of the "Dialogue"

admitted as much when he evoked the contrast of Martha and Mary. Yet there was an intimate link—perceived by the Cistercians with horror—between the superb spectacle of religious art and a specific form of concupiscence, a dangerous *libido*, namely a certain love of beauty. That was the real problem. How, in that case, could a "Cistercian art" be developed? The answer was to reduce everything to minimal forms, bare walls, simple proportions—spare Cistercian buildings

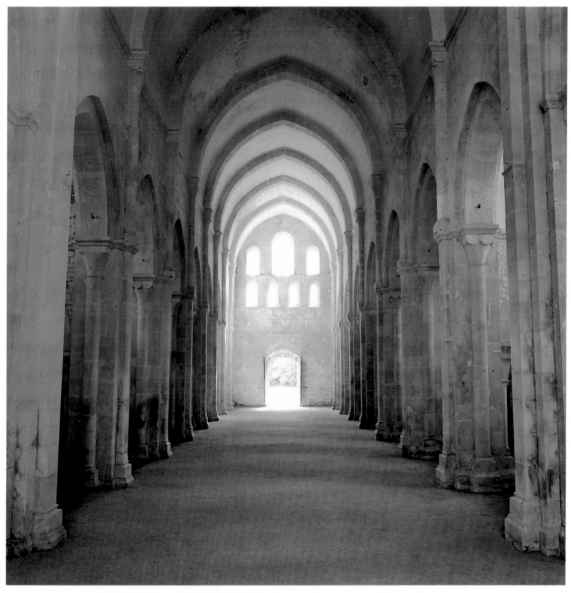

Fontenay Abbey (Côte-d'Or). View of the nave looking west. Mid–twelfth century.

being built in Burgundy, Saint-Denis was becoming the decisive center of an art of spectacular magnificence and modernity. Suger, moreover, was present at the final consecration in 1130 of the grand abbey in Cluny.

Although there was no direct clash between the saint who "renounced everything except the art of writing" and the abbot who was also a powerful minister to the French king, a more striking antagonism can hardly be imagined. In terms of art and its use, the confrontation even assumes the nature of a paradigm which, after having emerged during a period of great vitality within medieval culture, could apply to the French mentality as a whole, beyond specifically religious examples and the conception of the Christian church. At the heart of Bernard's message is a total rejection of the world, a turning inward that eschewed external vision (according to his biographer, Bernard reportedly rode along Lake Geneva for a whole night long without noticing it). There was a dread of spiritual dispersion induced by *curiositas*, which became the supreme temptation.

Suger's activity was entirely devoted to the opposite approach, which involved reinforcing traditions, glorifying heritage, amplifying the spread of precious objects as instruments of spiritual life. Suger's Gothic represented the order of the marvelous, whereas that of the Cistercians constituted the order of purity.

II THE GOTHIC ERA

1. THE ART OF BUILDING

In Nicolas François Blondel's famous architectural treatise, published in 1675, Gothic architecture was presented as a powerful but aberrant phenomenon, a sort of technical enigma. The adjective "Gothic" (as used by literary figures like Rabelais and La Bruyère) generally referred to coarse, barbaric manners of the past, as well as to edifices that diverged from good classical taste yet were nevertheless admirable from a technical standpoint. The art of building in stone had always been highly appreciated in France, and by the late sixteenth century, historian Etienne Pasquier was already praising the "admirable architecture" of Sainte-Chapelle. "National" considerations obviously influenced his judgment, but that is precisely the point to be stressed (as it will be stressed again as regards the Renaissance)—the "stonecutting artistry" displayed in monumental buildings was thought to be the prerogative of French artisans, a source of professional pride which led them either to resist imported fashions or to demonstrate their ability to adapt such fashions. It is highly possible that this attitude fully emerged as early as the twelfth century with the appearance of Gothic art.

France, like southern England and the entire Plantagenet realm, had been the site of an amazing variety of churches since the eleventh century. What happened then? In the second quarter of the twelfth cen-

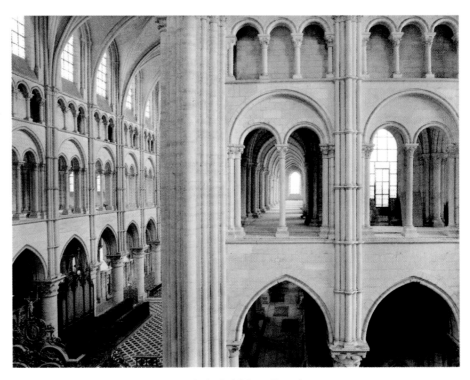

Laon Cathedral (Notre-Dame).
South elevation of the nave and the north galleries. 1150–1200.

tury, two new construction techniques—pointed arches and ribbing—appeared more or less everywhere without, however, generating anything radically different. They were employed at Durham in England as early as 1100, and at Lessay in Normandy where, although used precociously, pointed arches were still combined with thick walls. In Burgundy, the use of these new techniques remained hesitant, and in the famous ambulatory at Morienval, north of Paris, they were used merely to create an enormous interlocking support. This means that innovation did not occur all at once, contrary to the structuralist interpretation implied by Viollet-le-Duc's superb analyses. Instead, the new movement coalesced from a series of unpremeditated solutions to specific design problems—like the enlargement of the chancel of Saint-Martin-des-Champs or employment of thin walls and supports for the chancel of Saint-Denis. The decisive moment came when it appeared pos-

sible to interconnect counter-arches solidly through the effect of "reciprocal compression," which subsequently suggested a totally new architectural equilibrium. Gothic architecture should be seen as "the product of a series of accidents" relying partly on the luck of historical conjuncture, and partly on the ambitiousness and vitality of the Ile-de-France region, which successfully exploited technical ideas that were surfacing almost everywhere.

Around 1140, however, the game was far from over. The results of major Romanesque experiments were yet to be fully incorporated. Increased elevation—rising to four levels—meant that gallery, triforium and clerestory had to be stacked above the arcade. This was successively accomplished at Tournai, based on the example of the cathedral at Cambrai (no longer extant), and on the imitation of Norman and English precedents at Laon (above) and Noyon.[1] But the new architecture was not the inevitable product of

Romanesque inventions; rather, at each phase of its development it exploited prior discoveries that suddenly appeared attractive. There were at least three phases—the definition of a new structural system (ribbing, flying buttresses, etc.), the elaboration of a new design at Chartres (based on previous experiments), and the arrangement of internal elevation in terms of linear networks (the nave of Saint-Denis, circa 1230).[2]

The passage from "Romanesque" to "Gothic," then, was a zigzag affair. The main action took place in the northern part of the country when, around 1140, the Ile-de-France region (which had been dormant till then, compared with Normandy and Burgundy) assumed the lead of a surprising and innovative construction movement that ultimately prevailed. The driving element was a technical development perfected by master masons—who had always represented the leading wing of French art—when they achieved the engineering feat of the proper intersection of ribs in a vault, a problem which occupied almost everyone at the time. Construction scaffolding could then be simplified, because a preliminary structure of six arches sufficed: four for the frame plus the two intersecting rib arches. This skeleton not only gave decisive scope to lovers of huge designs and vast naves, but also led to a systematization of adjoining spaces and an ever-stricter definition of buttressing elements. This, as will be discussed later, led to a complete redistribution of sculpture on the inside and outside of churches.

Yet it was no simple affair. In fact, the new structure relied not only on pointed arches and ribbed vaults, but also on advanced techniques in drafting and cutting stone, on France's "stonecutting artistry." Starting in 1140, construction projects in Ile-de-France were the site of many technical developments in this sphere. For example, the drafting of compound piers as practiced at Amiens in the

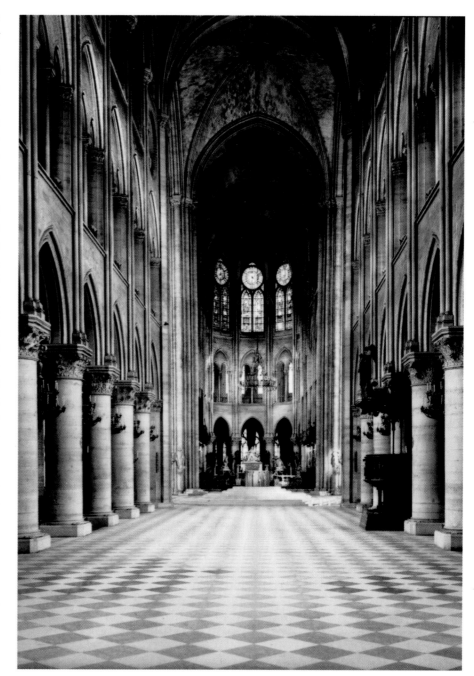

Notre-Dame Cathedral, Paris. View of the nave looking east. Late twelfth century.

thirteenth century constituted a remarkable technical advance based on a type of prefabrication method.[3] And it was only by stages that the main mechanism was perfected, that key to the system's stability, namely the proper adjustment of forces and weight-bearing supports.

Things had to be conceived in three dimensions, in a complementary play of clustered piers that bore the weight, ribbed arches that distributed it, and flying buttresses that anchored the whole system from the outside by providing support at a very specific point on the wall—one

Builders went not only from initiative to initiative, but also from accident to accident. Some accidents were due to fire as in the earlier days (despite the added protection afforded by stone vaulting), others to storms and hurricanes, and still others to faulty construction calculations. There are countless examples of such catastrophes. When a 1218 fire meant that Amiens Cathedral had to be rebuilt, this misfortune was turned to advantage by the adoption of a new design. In 1227, the upper storeys of Troyes Cathedral were destroyed by a hurricane, and were rebuilt even more boldly. The typical and most famous case of problems directly linked to Gothic structure is Beauvais Cathedral (right), which collapsed in 1284—due not, in fact, to the extreme height of the vaulting but to the excessive overhang of intermediate piers.[4]

In many cases, accidents were due to more or less felicitous aesthetic compromise solutions. Thus Saint-André in Bordeaux was endowed in the early thirteenth century with six rib vaults that constantly threatened to collapse; but they covered a single, over-wide nave probably initially designed to be topped by a line of domes.

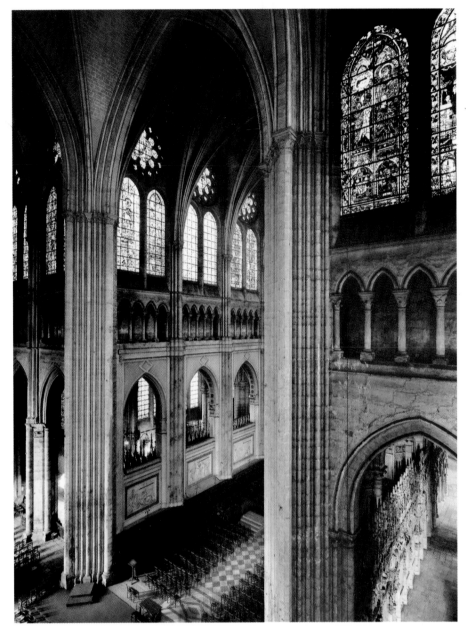

Chartres Cathedral (Notre-Dame).
View of the chancel and the crossing. c. 1200–1220.

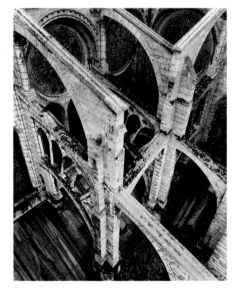

Chartres Cathedral (Notre-Dame). View of flying buttresses. Early thirteenth century.

that was hard to calculate with precision.

"Reasoned empiricism" might be the best term to describe the approach of the builders who developed, using a variety of solutions, the new architectural devices employed at Sens, Saint-Denis, Laon, and elsewhere in the twelfth century. Then, in a marked spirit of competition, major construction projects were launched at Chartres, Paris, Amiens, and Reims. All of these major undertakings presupposed faith in the future and an often unrealistic optimism concerning financing, not to mention technical and professional confidence in an architectural logic that later required serious analysis to explain fully. Collectively, they constitute an admirable chapter in human history.

The tower over the crossing of Troyes Cathedral fell in 1365, but construction of the edifice was still underway, and perhaps not all the supports were fully in place. Ultimately, given the number of projects in progress for so long (with open work-sites and incomplete walls), it is rather remarkable that catastrophes were not more numerous.

Thirteenth-century builders were perfectly aware of the complexity of the balance of forces at work in Gothic structures, yet did not have the mathematics to assess them accurately. When looking at the admirable sections drawn by Viollet-le-Duc, it is impossible to analyze the structure of cathedrals like Bourges or Reims without being struck by the anonymous designers' intellectual audacity. Debate over the true significance of intersecting ribs—whether technological framework (as argued by Viollet-le-Duc and Auguste Choisy) or decorative trompe l'oeil (according to Pol Abraham)—has been fueled mainly by current ignorance about the exact calculating and construction methods used by the brains behind these masterpieces.[5] As more documents come to light, it is beginning to look as though master builders succeeded one another on a given site much more rapidly than had been thought. That would explain the many minor modifications that have often been noted; as will be discussed later, the Gallery of Kings that now lends so much character to the facade of Notre-Dame in Paris was probably not part of the initial plan. Stone-by-stone analysis sometimes produces unsettling results: some forty construction teams apparently succeeded one another at Chartres, each composed of two to three hundred craftsmen who moved on to other worksites after a year or two of work. Given these changing conditions, it is hard to understand how buildings ultimately managed to display a sense of unity—it almost seems as though the final result emerged all by itself. It is unfortunately impossible, at the time of writing,

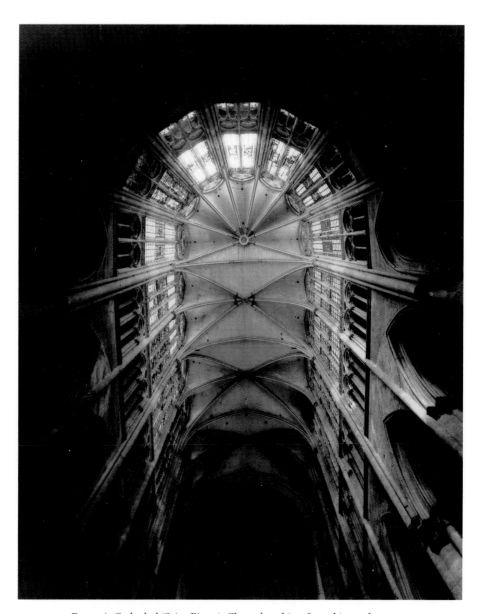

Beauvais Cathedral (Saint-Pierre). Chancel vaulting. Late thirteenth century.

to explain how this "implicit doctrine," or shared vision of ultimate outcome, guided these huge projects; in any case, they must have been directed somewhat less anonymously than supposed. The problem is that Villard de Honnecourt's album of drawings, the main document on these gigantic projects, provides no information on the essential intellectual component.

Various factors explain the interminable duration of certain construction projects, which inevitably led to many incongruities. The well-studied case of Troyes Cathedral, where there were no fewer than seven campaigns (this is to say seven halts and seven new starts, from the thirteenth to the sixteenth century), is only too obvious.[6] Political complications (at a time when Champagne was being annexed to the royal domain) and the mid-century's misfortunes were less important than poor organization of the worksite and the incompetence of successive master builders. The tower over the crossing

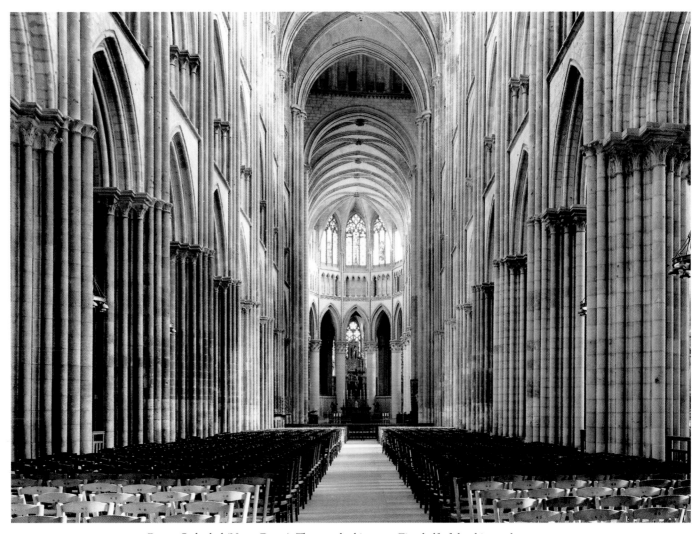

Rouen Cathedral (Notre-Dame). The nave looking east. First half of the thirteenth century.

collapsed in 1365, as did the wall of the north transept in 1389. Conflicts between local laborers and outside specialists also delayed work in the the fifteenth century. Things were only sorted out when the Chambiges dynasty of master builders arrived in Troyes in the early sixteenth century.

VILLARD DE HONNECOURT

A notebook (or album of drawings) of the architect Villard de Honnecourt came into the possession of the seventeenth-century historian André Félibien, who bequeathed it to the Benedictine monastery of Saint-

Germain-des-Prés, whence it passed to France's Bibliothèque Nationale. It contains notes taken by the architect on voyages throughout Europe between 1220 and 1235, and comprises three types of drawing: a great number of sketches of figures and ornamental details, a few architectural plans and elevations, and a final group illustrating technical devices (right). In order to assert his authority and inspire confidence, the author (or rather authors, since the notebook has additions in another hand) refers to the *art de jométrie* ("art of geometry"). This affirmation has led several scholars to assume that

they were dealing with the fragments of a treatise, a more or less scientific manual, without which Gothic construction would not have developed. In short, they feel it contained "secret" masonic teachings. It is natural to attribute a theoretical backbone to such substantial accomplishments, but hypotheses must be based on reliable notions of the necessary mental baggage subtending them. And that is a sphere in which the Middle Ages are often quite disconcerting. Monks, for instance, knew of the (unillustrated) architectural treatise by that old Roman, Vitruvius,[7] yet they drew little of use from it, except per-

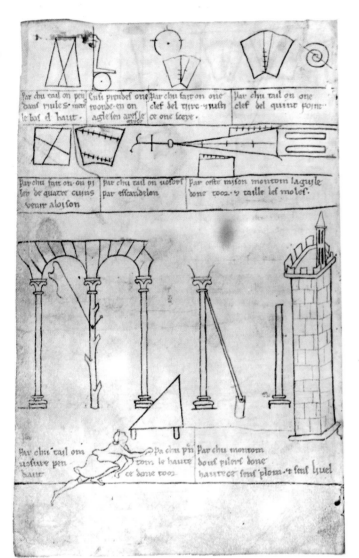
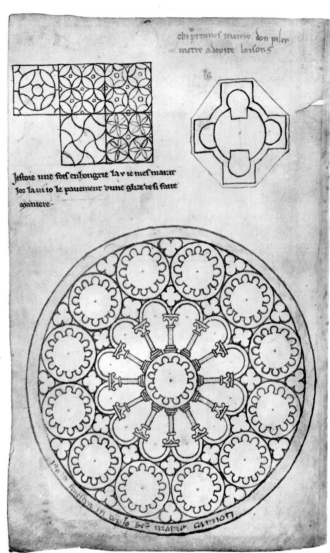

Villard de Honnecourt 's notebook: system of assessing height, and diagram of a rose window.
c. 1220–1235. Bibliothèque Nationale, Paris (Ms. Fr. 19093, fols. 20v and 15v).

haps the design of "ancient-style" capitals.

The idea that Villard's drawings constituted part of a treatise is mere fiction, for things functioned differently. The *art de jométrie*, also called *practica geometriae*, comprised elementary knowledge taken from Euclid and the modest compilations then in use. It guaranteed a certain rigor in the computation, measurements, and diagrams necessary for calculating both volume and height. But none of this was taught in schools. Rather, it was a case of applied knowledge, of practice, in which craft traditions and professional techniques were passed on, discussed, and potentially improved at the worksite.[8] The elevation of Reims Cathedral as drawn by Villard is very close to a present-day analysis of supporting structures, but Villard's drawing carries no comments and moreover corresponds to an initial state (circa 1230) that was later modified. The very sketchy plan of an apse—a study for the church at Vaucelles, but never built—indicates ribbing and piers in a clear if schematic way, yet nothing more. Nor is it certain that Villard was himself an architect, even though he was formerly assumed to have played that role at the collegiate church of Saint-Quentin.[9] Ultimately, his notebook contains the observations of a connoisseur who wanted to provide practitioners with working material. His drawing technique is very similar to the one used by goldsmiths and decorators, and his 163 sketches of men and animals are enormously interesting for their "ideogrammatic" clarity.[10] But to whom could they be useful other than decorators?

Rouen Cathedral (Notre-Dame). The crossing. First half of the thirteenth century.

soning, and it is true that scholasticism and its "logical modes" were exactly contemporaneous with the cathedral-building era. But perhaps it is also necessary to refer to the realm of music. After all, Paris was the leading center in the development of polyphony, thanks to the famous composer Perotinus at Notre-Dame—the brand new cathedral resounded with his music composed for several voices.

Although a certain unity underlies all these developments, it does not appear in treatises. An inventory has been made of anthologies or books of "models" (in manuscript form, obviously, followed in the fifteenth century by printed books) that might constitute the architectural treatises so notoriously lacking in the Middle Ages.[12] Most of them are German, however, and all of them are late (M. Roriczer, 1486; L. Lechler, 1516), thereby documenting a state of theory considerably posterior to the grand cathedrals. Their publication moreover contributed to the legend that Gothic art was primarily Germanic, which scholarship took a long time to debunk.

Plans were drawn up at the start of a construction project, although not all the details were specified. The texts speak of mental representation—*in mente concepture rei opus*, "the work conceived mentally"—with the purely intellectual elaboration of an *exemplar*, or "model." Attention was paid to details as things went along, as Villard's notebook suggests. Drawings of complete or partial structures such as arch moldings, gables, and flying buttresses have been found traced on walls and high platforms (Limoges, Clermont-Ferrand, and elsewhere), which suggests that things proceeded from sketches made on the spot. Around 1230–1240, however, plans on parchment were being used, during the period when Gothic construction followed highly coherent standards. But, as with treatises, surviving plans date only from the fourteenth and fifteenth cen-

Villard's most interesting drawing is probably the one that shows how to take vertical sightings and measurements. String and scriber were the basis for calculations, and construction measurements could be reduced to several rather simple rules—a graduated string playing on three points reconstituted the Pythagorean triangle, and was used to trace arcs and execute required plotting.[11] That said, however, the efficient and convincing proportions elaborated with the aid of this tool need to be interpreted. And here it proves impossible to elucidate the intellectual and tangible operations indispensable to such grand designs. Erwin Panofsky has suggested that they were analogous to the dialectical process used in scholastic rea-

turies. Scale models in wood or terra cotta may have existed (as perhaps recorded by the small replicas often depicted in the hands of benefactors).[13]

From the standpoint of construction techniques themselves, the drafting of entire courses of stone led to an increasing standardization of work. Viollet-le-Duc pointed to an important development around 1200—larger stones were used, making it easier to raise walls. But this in turn presupposes that more reliable equipment existed. In fact, the "enlargement" of blocks began around 1170, notably at Laon. The swift evolution of construction can only be understood in terms of a sort of "industrial revolution" in the middle of the twelfth century. William of Sens, for example, was admired as a builder of devices for loading and unloading materials.

Little is known of the vocabulary employed, except for the Latin terms (which are not always explicit) used to record groundbreaking or consecration ceremonies. Certain words sprang from technical innovations. Thus the use of slender detached columns as auxiliary braces appeared in the nave of Notre-Dame in Paris somewhat prior to 1178; this was once thought to be a way to strengthen supports, yet was also a new way of underscoring the effect of height. Since they were made of monolithic shafts cut horizontally from the quarry, these detached columns were called *délit*, which indicated that they were bedded against the grain.

There is another example of a word that emerged to describe a new architectural element, the "triforium." It was Gervase of Canterbury who first used the term around 1180 in reference to his Canterbury Cathedral, which was closely related to French cathedrals. The term probably comes from the Latin *transforatum*, "perforated," indicating a transparent passageway. Originally, in Normandy, small, open passageways were built high in the walls, usually above the gallery, to make it easy to reach the roof. This feature became increasingly interesting from a decorative standpoint, imitating a lacy arcade, and its history closely followed that of classic Gothic architecture. One advantage of this horizontal grille was to push the walls back—as evident at Cambrai (circa 1150, now destroyed), Saint-Germer-de-Fly, Noyon, and Laon—while awaiting the ultimate development, namely the fusion of wall and window that occurred at the second Saint-Denis in around 1235–1240.

British archaeologists working on Plantagenet sites have established the existence of a skilled, itinerant labor force that traveled from site to site. It is thought that the same situation pertained in France, and the idea of a master mason who could be beckoned in an emergency may be accurate but, as time went by, families of specialists tended to settle down—by the end of the fourteenth century, local labor had to be taken into account.

Ultimately, we possess more information in the sphere of vernacular architecture—fortresses and castles—which underwent remarkable development in the thirteenth and fourteenth centuries. The ruling family of Anjou, for instance, held land in at least three regions—Anjou, Bar, and Provence—and their numerous worksites always called on local artisans, as can be seen at Saumur, Tarascon, and Aix. It can be assumed, then, that by 1400 there were specialized laborers more or less everywhere, though this situation probably existed much earlier.

As to masonry itself—the choice of stone, drafting, and cutting techniques—developments applied equally to castles and cathedrals alike. "Gothic" fortresses in Coucy (above), Najac, and elsewhere reveal increasingly thin layers of mortar (one centimeter by the thirteenth century), and a system of vaulted niches linked to the main vaults that created a "sort of stone strutting as sturdy as if the wall were solid."[14] These increasingly

Coucy Castle (Aisne).
Interior of a corner tower.
First half of the thirteenth century.

sophisticated techniques required professional experts for castles as well as cathedrals, namely master Nicolas de Beaumont-le-Roger for the Dannemarche castle at Dreux (1224) and Pierre d'Agincourt for Castelnuovo in Naples (1292), built on the model of Angers Castle. This growing "professionalization" is hardly surprising in a field viewed over a span of centuries. Yet it helps to explain the rather swift secularization of the profession; master builders were no longer exclusively monastic or clerical by the thirteenth century, even less so by the fourteenth. Little is known about how the profession functioned, how principles and problems were conveyed and discussed. But it is probable that a guild of master builders played a considerable role across the land. And it then becomes understandable how, once new knowledge and techniques had been tried and tested, the most brilliant among the masters yielded to the temptation to indulge in virtuoso effects.

2. THE ROYAL BASILICA AT SAINT-DENIS

Around 1140, in the middle of the "Romanesque era," the basilica of Saint-Denis was erected according to a new set of propositions that would have enormous significance. The man behind the project was Abbot Suger, who not only headed the monastery but was also King Louis VII's political minister. Saint-Denis is a crucial case insofar as it intimately links a technical approach to a more global one concerned with meaning. Nowhere else were political and even "national" motives so inextricably bound to religious motives.

It was formerly taught that Jules Quicherat led French archaeologists in pinpointing Ile-de-France as the place where intersecting ribs were first used in an edifice, namely at Saint-Denis, where the facade (right) and initial bay were built in 1140, the chancel in 1140–1144. This key observation, confirmed by Viollet-le-Duc's analyses, endowed the French school with the main doctrine enabling it to counter the "Germanic" explanation of Gothic art that had held sway for so long. Although this historical rectification was valid, the idea that everything began at Saint-Denis was not. The basilica momentarily appeared to be sensationally original. But a closer look must be taken at the initial synthesis that emerged there, in order to appreciate complementary, contradictory, or simply different initiatives, whether contemporary with or later than Saint-Denis.

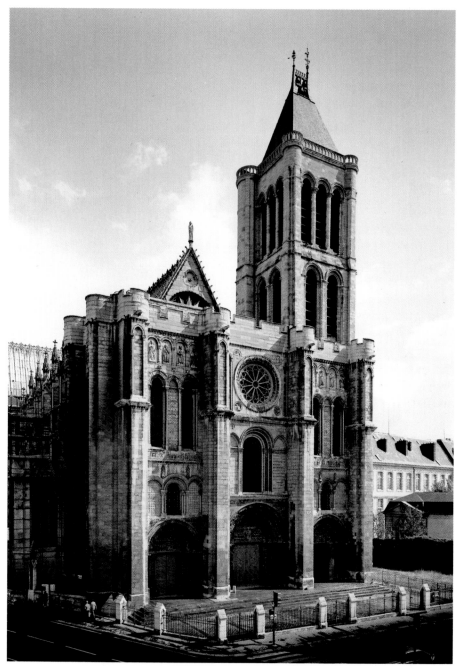

Abbey Church of Saint-Denis. West facade. 1135–1140.
The northwest tower was destroyed in the nineteenth century.

By an extraordinary convergence, for the first time in this history an explicit connection can be made between a new architectural monument (designed to replace the old Carolingian abbey at Saint-Denis), an outstanding Benedictine supervisor who directed the project (Abbot Suger), and a series of texts in which that supervisor explains the conditions and stages of construction—*De Consecratione* concerning the ceremony in June 1144 and *De Administratione* to justify the splendor of

the building. Finally, there is the fact that the supervisor was none other than a close counselor to the king, one who even governed the country when Louis went on crusade from 1147 to 1149.

The political motives behind the project are clear. It was designed to confirm permanently, in the name of the Capet dynasty, the sacred value of an abbey that dated back to the Merovingian king Dagobert and was associated with Carolingian grandeur. Thus it was difficult for historians, both old and new, to avoid making Suger the "creator" of the new Saint-Denis and therefore the inventor of Gothic art.

Suger, renowned for his administrative competence, twice explicitly mentioned having received help from Heaven. Marble columns were required for construction, and going to Rome to acquire columns rivaling those of the Carolingian church would have meant major delays; miraculously, a quarry of excellent limestone was discovered nearby, in Pontoise. Oak beams of unusual size were also required; they were nowhere to be found until, by chance, oak of the right size was discovered in the Yvelines forest not far away.

On the walls of the Carolingian nave, which were in poor condition, Suger had frescoes painted by the finest artists from "different regions," sparing no expense "for gold as well as for precious colors" (*De Consecratione*). He was greatly concerned to endow the entire edifice with exceptional qualities by preserving rather than effacing its glamorous history. Thus the new wall of the basilica contains a vestige of old masonry dating from Dagobert's days, invoking the strange story of a leper locked in the nave who was healed by the Lord (*De Consecratione*).

Suger's detailed account underscores the fact that any new sanctuary was basically designed to glorify relics associated with its founding—this act of commemoration, this memorial, was organized around the most precious of objects, such

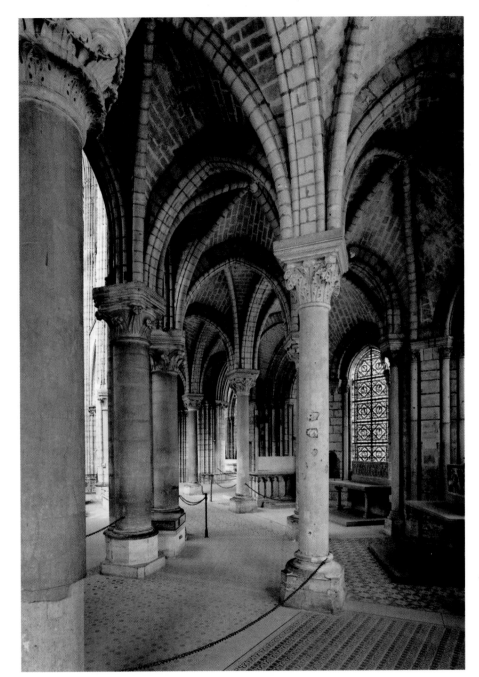

Abbey Church of Saint-Denis. Double ambulatory. 1140–1144.

as the gold altar front honoring martyred saints, the "admirable" cross of Saint Eloi on the high altar, and other prestigious possessions of Saint-Denis. The relics were presented in such a beautiful, stunning setting that visitors from Constantinople found them superior to those in Saint Sophia, according to Suger, who then went on, in a sudden and remarkable shift, to reveal his innermost thoughts. His comments should not be interpreted as promotional hyperbole, for Suger's two accounts

were destined for the abbey's internal use. He quoted a passage from Ezekiel (28: 4) on the heady effect of precious stones, and added, "thus, when—out of my delight in the beauty of the house of God—the loveliness of the many-colored gems has called me away from external cares, and worthy meditation has induced me to reflect, transferring that which is material to that which is immaterial, on the diversity of the sacred virtues: then it seems to me that I see myself dwelling, as it were, in some strange region of the universe which neither exists entirely in the slime of the earth nor entirely in the purity of Heaven; and that, by the grace of God, I can be transported from this inferior to that higher world in an anagogical manner [*more anagogico*]" (*De Administratione*, XXXIII).[15] The interpretation given to this eloquent text will weigh heavily on the way Gothic art is approached. Contrary to certain opinions, this passage is obviously not an emotional reaction to architecture; rather, it is a meditation on liturgical objects made of gold and gems, kept in the sanctuary. And it is worth stressing Suger's careful attention to these precious objects, including the famous cross with its artful arrangement of symbolic enamels (now known only through a reduced-scale copy preserved at Saint-Omer). These enamels clearly derived from the work of Godefroid de Huy (died 1174) and other great Mosan goldsmiths.

Suger's escape from the lower world by virtue of the mysterious effect of shining forms has been compared to the mysticism of "light" as exemplified by the writings of Dionysius the Areopagite. The effect of illumination produced by rare and beautiful objects suddenly elevates the soul to a higher state; Suger shed light on this specific emotion by borrowing the term "anagogical method" (*anagogicus mos*) from Scriptural exegetes. Suger's "confession" has been interpreted as an explicit espousal of the Neoplatonic doctrine of the "ascension of the soul." A

Christianized version of this concept was common among monastic circles, though it encountered some opposition from the hierarchy.[16] In fact, nothing in Suger's comments, inscriptions, or poems goes beyond the basic doctrine of the day. He was not and did not pretend to be a theologian, but rather a spiritual engineer who was particularly attentive to the power of aesthetic form.

It is hard to remain unmoved by the abbot's avowed passion for dazzling light; especially since, in the same text, he claims to have had the idea of installing a set of stained-glass windows (*vitreanum novarum praeclaram, varietatem*) running from the apse (where they would depict the Tree of Jesse, pp. 218, 219) to the facade. He had great difficulty in finding the right artisans and once again had to call on "masters from different regions." And, since their masterful efforts produced a dazzling gallery of glass and sapphire, Suger instituted the post of keeper to maintain the windows in good condition (*ministerialem magistrum*). Furthermore, as a poet, Suger quoted the verses that inspired these "anagogical" windows, repeating the phrase *"de materialibus ad immaterialia exitans"* ("urging us onward from the material to the immaterial").[17] This passage in *De Administratione* (XXXIV) has been duly discussed by recent historians of stained glass, notably in Grodecki's exhaustive and critical publication covering the Saint-Denis windows, a good many of which have fortunately survived.[18]

Suger's reconstruction began with the facade and two adjoining bays that comprise the narthex, with its extremely sturdy piers designed to support the towers (1135–1140). Innovatory efforts then focused on the apse (1140–1144). Suger's key project had three remarkable features that still spark admiration: the unified sense of space from the curved end of the choir to the bays of the exterior wall (thanks to a double ambulatory, p. 215),

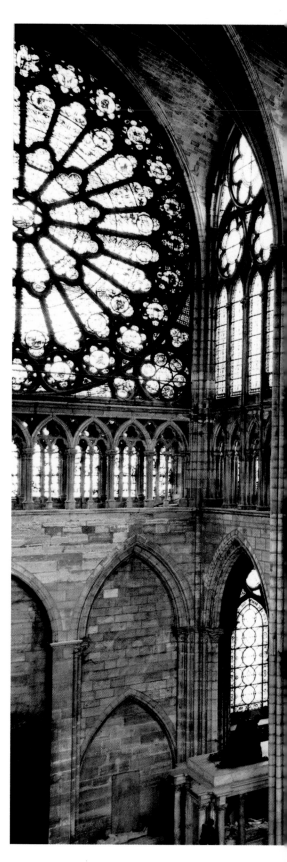

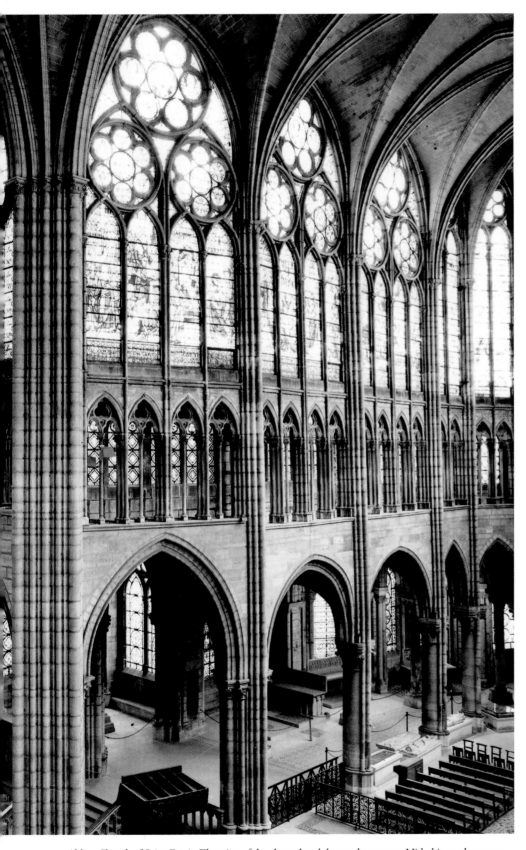

Abbey Church of Saint-Denis. Elevation of the chancel and the north transept. Mid–thirteenth century.

the sense of light, and the grand effect of transparency obtained by an extremely skillful use of ribbing in the interlocking trapezoids of the vaulting. It is probable that the use of simple columns rather than Romanesque piers is a reference to antiquity associated with the Carolingian era. It produced a new impression of breadth. For, as Jean Bony has noted, it is not an effect of verticality or soaring height that was sought in this early expression of the Gothic. Rather, the ample space, fusion of elements, and lightened walls created above all a sense architectural order. The superbly luminous apse of Saint-Martin-des-Champs (1130–1145) was moving in exactly this same direction, at the same moment.

Suger did not have the time to complete his plans by connecting chancel to facade with a long nave that, because of the original Carolingian floor plan, would have featured extremely narrow bays. But a striking detail is that the overall design, as reconstituted during excavations in the 1940s, prefigures the uniform, oblong shape of Notre-Dame in Paris. All that was executed was the apse with its wrapping of stained-glass windows. It would seem as though the full expression of Suger's interior space was designed to allow a filtered, colored light to traverse it from one end to the other. Only tall bays between attenuated supports could create this intense effect, which Suger claimed was the essential thing for him. In many respects, these stained-glass windows are still Romanesque in conception, in terms of their strong colors and the rather abstruse theological framework to which their designer was so attached; they depict the meaning of Redemption across six windows with medallions of narrative or symbolic import (such as the four-horse chariot of Amminadab with the ark topped by the Cross, and "the triumphal chariot of the Song of Solomon that the evangelists would drive to the four corners of the world"). In a way, the windows go further

than the facade sculpture in celebrating the Christian mystery. Their survival is therefore a great stroke of luck, even though they are not complete. Only forty-two of the panels can be considered authentic, the others being rather faithful renovations from the nineteenth century (to which should be added roughly thirty fragments in storage and another thirty or so pieces that strangely found their way onto the market and hence into other collections, including five in France).

The western facade and its no longer extant sculpture will be discussed later in terms of the general evolution of facades as a major medium for sculpted forms. It is worth pointing out here, however, that the portal in the center illustrated, in traditional fashion, the Last Judgment, the one on the right showed scenes from the life of Saint Denis, and the one on the left—a unique case—contained a mosaic of unknown subject matter.[19] These portals' great innovation, however, was the array of statue–columns along the jambs to each side of the doors.

Suger's oeuvre defined the emerging Gothic aesthetic so rigorously that it offers insight into the ultimate consequences of ribbed structures and stained glass. They implied, among other things, the end of Romanesque frescoes, for it was no longer feasible to cover walls and vaults with paintings. The soft, unusual, enchanting light modified the sanctuary's allure—altars and other main features had to be burnished with gold, made more sparkling than ever in order to be perceived in the stained-glass glow. The somewhat subdued, rainbow-hued light favored the perception of statues, preferably polychrome. It is hardly surprising to note that this development coincided with the affirmation and success of enamel-work—crucifixes and reliquaries in gold and rich tones complemented the new light. Thus Gothic architecture led to a general revision of the interior economy of an edifice. All twelfth-century innovations had to

Abbey Church of Saint-Denis. Central chapel of the ambulatory, Abbot Suger presenting a stained-glass window, a detail designed by Viollet-le-Duc when the rest of this window, depicting the Tree of Jesse, was restored in the nineteenth century.

take these factors into account—the question is how, and in what order. The answer, which seemed simple enough a century ago, now appears more complex in the light of recent research; the fifty years of construction that followed the elaboration of the chancel at Saint-Denis were rich in ingenious, innovative, highly varied projects. So although Saint-Denis itself was certainly a stimulating example, it was not necessarily a rigid model. The cathedral at Sens, for instance, was built at the same time (circa 1145) but differs in its insistence on dividing the nave into "grand spatial units." Saint-Denis, then, occurred in the midst of an effervescence that will be discussed in the next chapter.

Suger's renovation of Saint-Denis was never completed, leaving many problems unresolved. In the basilica itself, the Carolingian nave threatened to collapse. It was not until 1231 that one of Suger's successors, Abbot Eudes Clément, attacked the problem. Clément not only buttressed the nave, he endowed it with a new, three-level elevation (arcade, gallery, clerestory, pp. 216–17) that maximized window

space and reduced the structure to a play of vertical lines, to a skeleton of narrow columns rising from the floor, similar to what was being undertaken at Amiens (1270) and would soon be strictly followed at Troyes. Work in fact proceeded apace (1231–1241), including an amazing effort to underpin the ambulatory while it was transformed above in order to raise the total height of the chancel from eighteen to twenty-seven meters.[20] Saint-Denis was thus a construction site for a second span of years, precisely during the high Gothic period. The work was formerly ascribed to Pierre de Montreuil, but this attribution has been challenged.

The point to retain here is that Saint-Denis represents the two poles of the great invention of Gothic architecture, from its beginnings in 1130–1140 to its second, revised version after 1231. To what extent were Suger's contemporaries conscious of the innovation then underway? Chronology provides fairly precise information on the spread of "Gothic" design to the north (Senlis, Soissons) and west (Chartres). Every decade or so, the situation evolved and builders adopted the new design, sometimes too hastily. But was this merely because it provided a more rapid and economical—if not safer—approach, the repetition of units or bays simultaneously offering an interesting play of perspective? The appearance of Chartres provides an explicit response to the question. But the literature and chronicles of the time offer almost no commentary.

A look at contemporary literature, however, such as Benoît de Sainte Maure's *Roman de Troie* and the verse tales of Chrétien de Troyes (circa 1135–1183), reveals, in addition to descriptions of glamorous objects, accounts of residences made of translucent alabaster, or fairy castles that glittered with precious gems. So the type of metaphor that Suger applied to sacred art could also be found in secular poetry, where pure yet passionate heroes resided in palaces of wondrous architecture.

The terrible doomsday vision of the eleventh century was henceforth countered by a vision of heavenly Jerusalem, yet another image drawn from the Book of Revelations (21: 10–23). The abode of the Elect could only be designated by the sparkle of gems, jasper, and garnet. This supernatural edifice was a constantly recurring metaphor in the liturgy, and it fueled the image of an evangelizing Church as a place of pure, gleaming colors and perfect proportions. It would seem reasonable to suppose that these distinct phenomena were spurred by a shared imaginative ardor.

It sometimes seems as though the medieval world allowed metaphors to exercise a certain dominion over minds. Perhaps this was the case with the "rose" as literary symbol which, like the architectural "rose window," played such a remarkable role in the thirteenth century—it is probably no coincidence that the same word referred to a new version of the oculus (or round window) and to the Marian flower that was also the symbol of courtly love. But the architectural gestation of rose windows was somewhat slow and coincides with "classic" Gothic. At Saint-Denis and Senlis, a small circular opening was placed high on the facade. The first rose window of major dimensions can be found in the southern transept of Saint-Etienne in Beauvais (circa 1150); then came dynamic, wheel-like windows such as the one in the center of the facade of Notre-Dame. Rose windows became an almost obligatory part of ambitious designs, with the network of small mullions forming the petals of the flower. On the south portal of Notre-Dame, Pierre de Montreuil transformed such a window into the dominant element thanks to its size and rich, multicolored glass (circa 1260). This grandiose effect led to the adoption of the adjective "rayonnant" in describing high Gothic architecture in France. Although the term does not mean a great deal, it is a fitting echo of Suger's radiant vision.

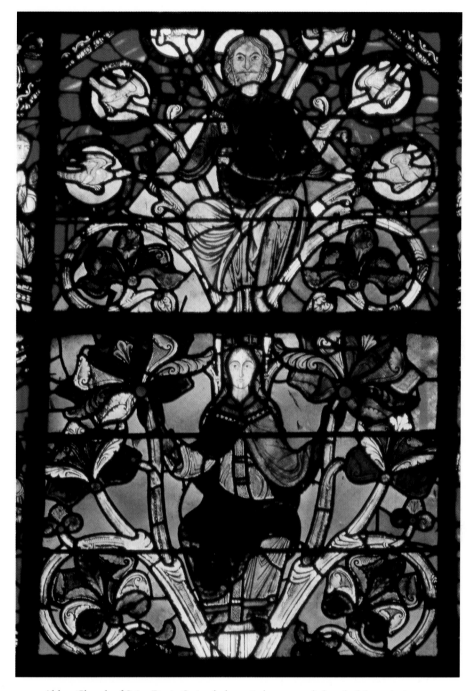

Abbey Church of Saint-Denis. Stained-glass window, central chapel of the ambulatory, *The Tree of Jesse* (detail). c. 1145 (restored in the nineteenth century).

3. New Architecture, New Sculpture in the Twelfth Century

At a certain moment in the twelfth century, the general impulse was the extensive enlargement of interior space, which gave the "Gothic" movement its thrust. An entire set of buildings emerged from this operation during the years 1150–1160. Another imperative was added a little later, spurring the development of large churches skyward—as early as 1170–1180, verticality became almost an obsession in the broad experimental regions, namely Ile-de-France and its surroundings.

In the first set of churches that opted for the new design (Sens, Noyon, Laon), the passage from a Romanesque to a Gothic structure was done with an obvious concern for ample space and luminosity. Sens Cathedral (1145–1160) inaugurated sex-partite vaulting combined with a solidly orchestrated elevation. The vaulting was not taken terribly high, and the six ribs spread out comfortably with the middle rib acting as sort of transverse ridge-rib falling on a shaft that descends to the capital of the twin piers, while the main transverse ribs are taken down to the ground via a cluster of vertical columns. This produces a series of six well-balanced bays, like large spatial cells within which are twin openings made somewhat heavy by similarly arcaded openings below the roof.

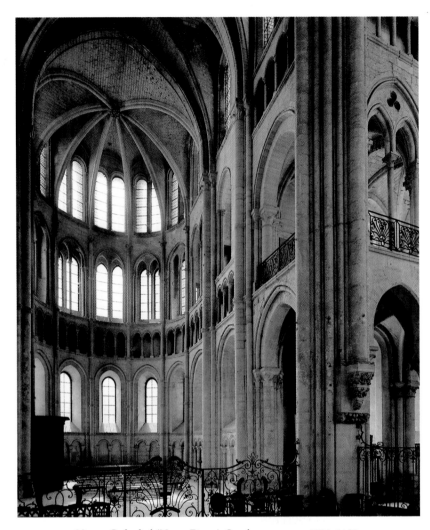

Noyon Cathedral (Notre-Dame). South transept. c. 1170–1185.

At Saint-Germer-de-Fly, the chancel was begun some time before 1140 and the nave immediately afterward,[21] revealing two or three features typical of this first group: a four-level elevation, quadripartite vaulting employing identical supports, and a quarter-circle arch below the roof that plays the role of flying buttress. The southern transepts of Noyon (1170–1185, above and right) and Soissons (1177–circa 1185) represent a taller version of the Saint-Denis model, yielding a space traversed by rays of light. The effect is more successful at Noyon, where a triforium separates the ground-level arcade from the two upper levels; at Soissons, the triforium runs like an opaque strip between the two upper floors. In both instances, the thickness of the walls was reduced and the upper levels and triforium featured double walls that pushed the opaque wall outward and allowed for a play of arcading along the inner wall. This design had been tested at Saint-Etienne in Caen, Normandy, and would play a major role in the Gothic experiment of transforming a hollow wall into a type of double shell.

All of these construction projects were obviously begun enthusiastically, but could not be completed in a single

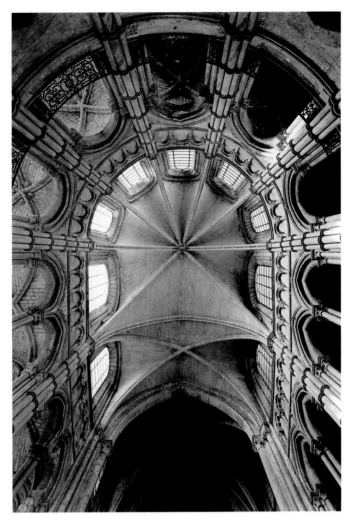

Noyon Cathedral (Notre-Dame). Chancel vaulting.
Second half of the twelfth century.

campaign. The nave of Noyon was not finished until the early thirteenth century, Soissons after 1212. Many twelfth-century churches, whether Romanesque or already Gothic, in fact became stylistic composites (by being capped with rib vaulting in the former case, or subject to successive additions in the latter). A uniform construction style was rarely respected—indeed, the concept barely existed. This is what gives so much charm to edifices in which the initial spirit was faithfully preserved.

One of the best examples of this is Laon Cathedral (circa 1165–1175). In order to take nave vaulting higher than usual, the aisles had to be raised to two levels in order to provide the necessary buttressing. This led to the four-level design that works so well at Laon, producing a vertical arrangement borrowed from Normandy or England (whose style amounted to more or less the same thing): a tall arcade, twin-bay gallery, triforium, and clerestory windows delimited by the wall-ribs of the vaulting. These upper openings echoed the arcade below, and the ribs ran down to round columns rather than piers. Quite striking is the coherence of this interior design, in which all the

technical resources of the new system were fully brought to bear.

According to the original design (circa 1150), the chancel was to have had radiating chapels and the two facades of the transept (like the western facade) were to be flanked by sturdy square towers, complemented by a seventh vertical feature, namely a tower over the crossing. The model for such massive loftiness was the Romanesque cathedral at Tournai, which neared completion around 1160. But the volumes at Laon were handled more broadly, and the architect demonstrated an outstanding sense of plastic values in

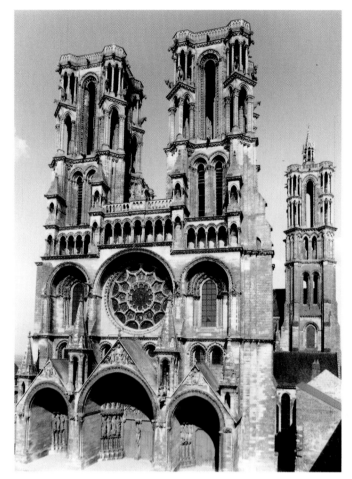

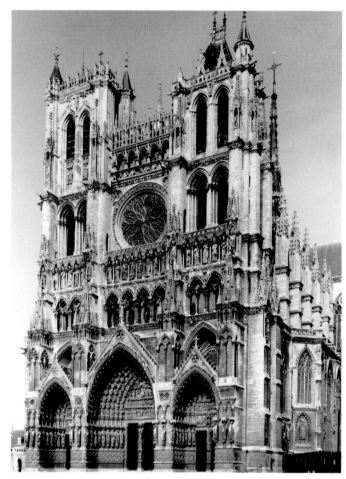

Laon Cathedral (Notre-Dame). West facade. 1200–1215.

Amiens Cathedral. West facade. c. 1243.

FACADES

Facades with two towers had been appreciated since Merovingian days, and again more surely in the ninth and tenth centuries, probably inspired by the so-called "city-gate" model. Such facades represented not only a screen-wall, but an emblematic frontispiece that never completely lost its connotation of triumphal entry. The organization of the facade posed serious problems, however. During the twelfth century, various approaches were tested, with a tendency to endow the facade with solid buttresses but few openings, as can be seen in Normandy.[22] Designs like Notre-Dame-la-Grande in Poitiers and, less imaginatively, Angoulême, remained faithful to the idea of an amply decorated, eloquent frontispiece, but lacked a sufficiently clear articulation of the various registers of sculpture.

Saint-Denis offered little that was radically different from the Norman model except that, to counteract its dryness, Suger proposed a truly sensational innovation—a gallery of statue–columns fronting the portals (these were destroyed during the Revolution).

The same design was adopted at Chartres, where by 1145 the facade between the towers was being built (one of which was later topped by Jean de Beauce's steeple). It was then that a new team got down to work on the royal portal. It has been speculated that this composition was originally planned for a more easterly position, that is to say somewhat recessed, and only later was adjusted to sit between the two towers (the fit with the two lateral masses being imperfect). The magnificently orchestrated theme of the statue–columns depicts the kings of Judah, in imitation of the Saint-Denis facade (completed 1140). The implementation of this amazing device at Chartres guaranteed its long-term success, even though the overall facade does not display the same unity of design.

The arrangement of the main facade. Main facades, indeed, merit consideration.

At Laon, on the other hand, following the apse begun circa 1160 and the transept around 1180, a new type of facade was added to the nave about 1200 (far left). The date is important because Laon represents the first major demonstration of a monumental, grandiose facade that was simultaneously rich and well ordered. The deeply recessed porches with their semi-circular arches are topped by triangular pediments flanked by pointed aedicules. Above all, Laon represents what might be called the definitive implementation of a crucial element prefigured at Saint-Denis, present at Senlis, but ignored at Chartres (until the post-1194 rebuilding campaign): the rose window, that giant oculus whose shape, wheel-like spokes and colored transparency would provide future facades with a wonderful sense of movement, right up until the extinction of "Gothism." It was a vestige of Romanesque design inserted into the new art.

Above the rose window at Laon was placed a series of arcades that inspired the builders of future churches, and above the arcades rise two massive bell towers without steeples. The skillful openwork, the tabernacle–aedicules on the corners that pivot like prisms under the sky, and even the famous cattle perched on the ledges lend this robust composition a charming, almost rustic fullness that perhaps constitutes the last expression of Romanesque solidity, never to be seen again.

The facades of all the large thirteenth-century churches would be variations on this striking statement, marked by a growing concern to lighten the structure and allow it to vibrate. The facade of Saint-Nicaise in Reims (destroyed, but known from engravings) was begun in 1231, after a design by architect Hugues Libergier that made a compete break with the canonic model. The building was pierced through and through by a series of long openings that flanked an enormous rose window itself set over two large windows. Thanks to the stained glass, there must have been

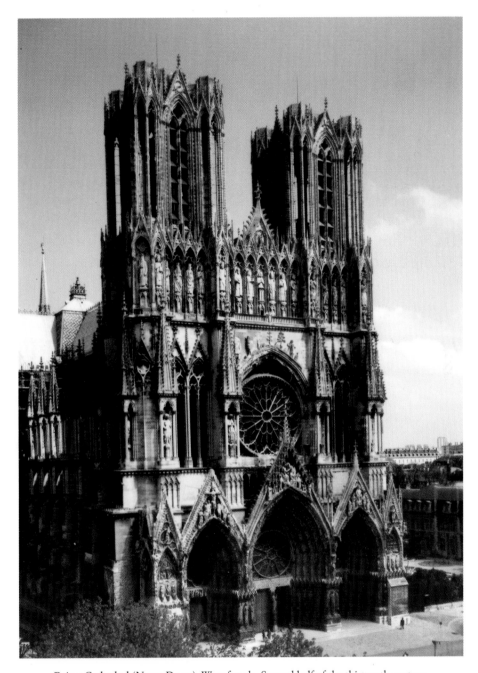

Reims Cathedral (Notre-Dame). West facade. Second half of the thirteenth century.

an extraordinary effect of transparency in this central portion, mimicking a reliquary. No less surprising is the arrangement of the ground level into several little porches topped by gables that suggest a rood screen more than a series of portals.

The cathedral in Reims (above) was of a quite different design.[23] The west facade, which took a long time to complete, looks like a vast display of sculpture of almost unsettling variety. Amiens, completed around 1247, artfully and with admirable

assurance developed a screen–facade that no longer exactly reflected the interior— becoming thicker at the bottom, it looks like one huge carved relief (p. 222). In contrast to that development, Notre-Dame in Paris, circa 1210–1220, maintained (with a certain flexibility) the idea of a geometric mass of stone as had been employed at Saint-Denis and Chartres. All these cathedrals made sculpture an imposing and original feature of the facade, thanks to the new concept of statuary in the form of the more or less appropriately-named "statue–columns."

THE TRIUMPH
OF STATUE–COLUMNS

The three portals on Saint-Denis' west facade originally had a total of twenty statue–columns. They are known today only from the archeologist Montfaucon's book (1729) and a few mutilated fragments. An idea can be gleaned of this impressive gallery of tall, serious, nobly draped figures by looking at the royal portal at Chartres (right and far right), which followed only a few years later, in 1145. It is even possible that the same workshop produced both series. These tall temple guardians are one of the most striking innovations of the entire Middle Ages. They invoke the Old Testament (Moses is regularly included, recognizable by his tablets) on the threshold of a sanctuary that, thus marked with the stamp of Holy Scripture, represented the fulfillment of the New.

The origin of this extraordinary innovation remains unknown. Could it have been Suger's invention? He would surely have commented on it, he who knew so well how to stress the symbolic intention behind his own iconography. Instead, it was probably the definitive development of a technique that had incubated, so to speak, in Burgundy and northern Italy. The statues of the apostles at Saint-Etienne in Toulouse (now at the Musée des Augustins) have also been mentioned

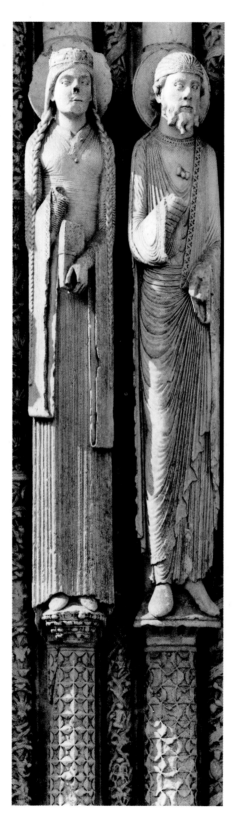

Chartres Cathedral (Notre-Dame). West facade, central portal, left-hand splay (detail): figures from the Old Testament. c. 1145–1155.

as precursors, but the latter were set against a blind arcade, and the way their legs are crossed in an X under the sheet-like folds of their gowns is reminiscent of Carolingian ivories and manuscripts, unlike the perfectly rigid figures at Chartres. Sculpture in the Languedoc region of southern France gives the impression of being closer to the Saint-Denis and Chartres model than does work from the west or even from Artois and Vézelay, as witnessed by the gallery of standing apostles on the portals of Saint-Trophime in Arles and Saint-Gilles-du-Gard, leading to the suggestion that southern artisans were recruited for the Ile-de-France portals.

Perhaps, but how could the simultaneously monotonous and subtly varied design of the twenty statues on the three doors of the royal portal have emerged so suddenly and imposingly? Hiding their extremely long legs under the finely fluted folds of women's skirts or deeply hatched drape of men's gowns, they seem to present visitors with a sort of preliminary, inescapable declaration of the church's role, with a gravity underscored by their verticality. They are almost like a choir softly intoning some sublime biblical cantata.

Each figure at Chartres is crowned by a small architectural element representing a fortified wall, a visible symbol of an invisible city. Each of them, with a vacant gaze yet a face amazingly marked by age, experience, and wisdom, is sheathed in tight folds that that run the length of the body, modulating the parts in an exquisite variety of ways. Finely carved features and layers lend the figures a precious air, as though they were embalmed in some rare substance. The excessive attenuation of some of them never seems shocking or surprising. Each biblical figure, whether crowned or not, makes an admonishing gesture and holds a phylactery or book. Nineteen of the original twenty-four statues have survived.

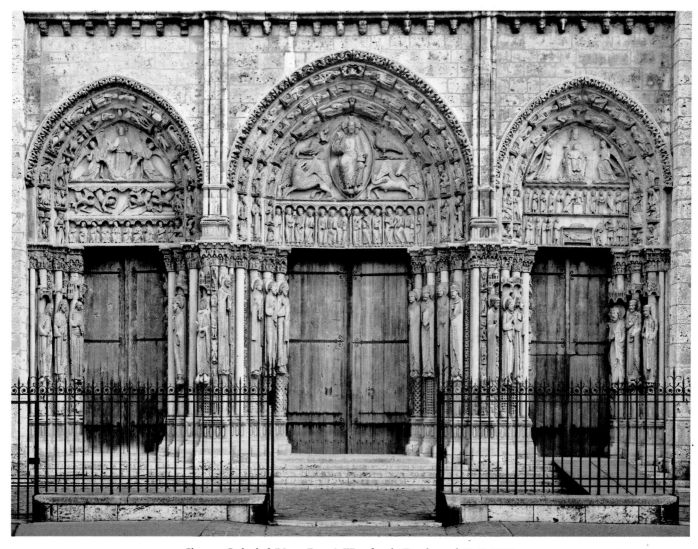

Chartres Cathedral (Notre-Dame). West facade, Royal portal. 1145–1155.

The success of the technique at Saint-Denis and Chartres was immediately co-opted at Etampes, Le Mans, Saint-Loup-de-Naud, Angers, and elsewhere, with even greater decorative virtuosity on the side portals at Bourges, circa 1160. The formula became widespread in only ten or fifteen years. This does not mean that the same sculptors went from one portal to the other, only that the model was copied and each time arranged somewhat differently (which in turn does not exclude the possibility of work by the same hands). The phenome-non demonstrates an almost moving fidelity to the guiding principle, which was to manifest the idea, shared by all theologians, of the general concordance between Old Testament and New: the kings of Judah guarded the gates of the City of Christ.

The same system was used around 1170 in Senlis (p. 227), on the west portal of Saint-Germain-des-Prés in Paris, perhaps somewhat earlier on Saint-Bénigne in Dijon (circa 1160), and on the abbey church of Nesle-la-Reposte, not to mention Vermonton (circa 1170), Saint-Ayoul in Provins, and Château-Chalon in the Jura Mountains. Very soon it was employed for unexpected ends—at Saint-Faron in Meaux around 1160, an enormous recessed tomb (known to monastic scholar Jean Mabillon) was erected and decorated for Ogier the Dane and his squire Benoît (destroyed in 1793), once again featuring stiff stone figures as on the royal portal at Chartres, though the meaning is harder to grasp here.

It is not at all certain that the system of applying statues to columns was limited to

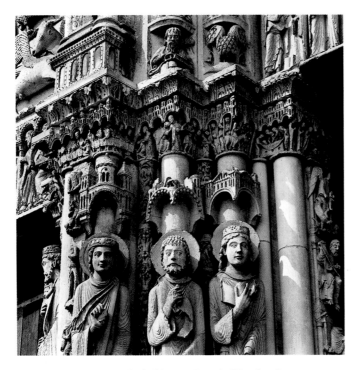

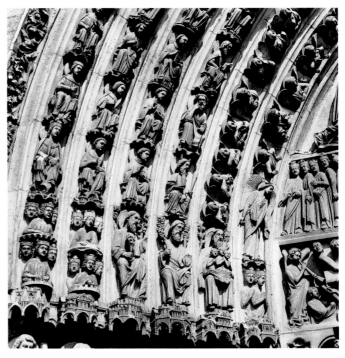

Chartres Cathedral (Notre-Dame). West facade,
right-hand portal, left-hand splay (detail):
scenes from the Life of Christ and
figures from the Old Testament. c. 1145–1155.

Notre-Dame Cathedral, Paris. West facade, central portal,
arch moldings (detail): the Elect are shown along the bottom;
above them (moving from the center outward) are: angels,
patriarchs and prophets, monks, martyrs and virgins. 1220–1230.

cathedrals. Many statues that were once part of no longer extant cloisters have come to light. The discovery of a series of statues originally on Notre-Dame-en-Vaux at Châlons-sur-Marne, destroyed around 1765–1770 and re-used in fragments on a wall, has provided valuable information on a highly interesting ensemble from the late twelfth century (circa 1180), comprising some fifty statues on the shafts of the piers.[24] These included figures from the Old and New Testaments—kings, prophets, apostles—as well as hagiographic groups (a capital featuring the martyr Saint Margaret of Antioch matched a statue–column of her executioner, Governor Olybrius, identified by a scroll). Moral themes were also depicted, as indicated by a pier (deposited in the Louvre in 1956 but since returned to Châlons) that has been reconstituted to show four figures of knights in helmets,

coats of mail and shields bearing a cross or emblem, in an allegory of Virtues triumphing over monsters trampled underfoot or pinned by swords.[25] This was a variation on the capitals showing the psychic struggle between the Wise and Foolish Virgins among the foliage. In short, the very diversity of this vast ensemble is significant, and relied heavily on statue–columns.

Monumental portals as orchestrated at Saint-Denis and developed at Chartres (p. 225) were designed to be almost encyclopedic in scope. All aspects of the faith were depicted in various manners, constituting a sort of anthology of categories of sculpture. Above the statues, the arch moldings (bell-shaped at Saint-Denis, bluntly pointed at Chartres) were decorated with figurines including the Elders from the Apocalypse, as dictated by the central theme of the tympanum, Christ and the Last Judgment. This theme was already a

time-honored choice, but at Chartres it was enriched and inflected by the twelve apostles arrayed among the slender columns on the lintel. Furthermore, beneath the ornamental decoration on the capitals there is a series of little scenes which undulate like a frieze sandwiched between the statue–columns and the overpopulated arch moldings.

Every tympanum had to have its theme. Looking just at Chartres, the tympanum on the left shows the Ascension of the Lord with arch moldings featuring the signs of the zodiac and the monthly labors. To the right was the Virgin in Majesty, which naturally led to a new selection of small motifs for the molding, namely figures representing the Liberal Arts (probably alluding to the famous school of philosophy at Chartres) and Sages from antiquity—one famous statue is supposed to be a portrait of Aristotle.

Themes related to Marian piety abounded. The cathedral at Senlis (right) was innovative with a Coronation of the Virgin, showing Christ and his mother above a lintel depicting a double scene of the Death and Assumption of Mary (circa 1170). Twelfth-century interest in evangelical scenes—and, shortly later, hagiographic scenes—swelled the narrative repertoire. Furthermore, the low section of wall beneath the jamb statues offered descriptive possibilities. This was exploited as early as the Sens portal, for example, with its tiny images of the calendar and—borrowing a "Romanesque" idea—exotic monsters (circa 1200).

The inexhaustible royal portal at Chartres also provided noteworthy examples of minor exercises, so to speak, of little compositions slipped vertically between the columns, as well as small evangelical scenes on capitals. Tympanums, with their double register, evinced less inventiveness, and the arch moldings were not clearly linked to the new system of jamb sculpture. That meant that a general development of those elements would be pursued elsewhere in the years to come. It was as though the designers of Chartres—and Saint-Denis—had decided to provide French sculptors with enough work to last a century.

There is no space here for a detailed discussion of the borrowings, rejections, and counterproposals generated by the vital period in which Paris, Senlis, Le Mans, and other sites reacted to the innovations at Chartres. Eminent historians struggled to reconstitute the dialogue that took place from Normandy to Champagne, between workshops that were all vying to have the last word. A sufficiently clear picture emerged to enable art historian Emile Mâle, aided by the writings of a thirteenth-century Dominican, Vincent de Beauvais, to decode the magnificent organization of the grand iconographic system: statues were set under a canopy, and each had a small emblematic figure at its feet; narra-

tive episodes were placed in the arch moldings, while nature was depicted in the medallions of the wall beneath the jamb statuary. All elements were thus wonderfully orchestrated, the finest partition perhaps being the one played out on the facade of Reims Cathedral.

NOTRE-DAME OF PARIS

By the twelfth century, only the westernmost of the twin Merovingian cathedrals in Paris—Saint-Etienne—still survived. Probably founded by Childebert I in the mid–sixth century, it was a substantial edifice, to judge by the nave, four aisles, and thirty-meter-wide facade revealed by excavations begun in the nineteenth century and taken up again in 1965. But in the twelfth century a new, highly original edifice—which

would become Notre-Dame (p. 228)—was promoted by the powerful figure of Maurice de Sully (circa 1120–1196), backed by the king. The new plan had no broad transepts nor radiating chapels in the apse, but developed an interior space forming a sort of continuous envelope, with upper-storey galleries that created a great deal of animation at the crossing, as at Laon.[26]

A visit by Pope Alexander III in 1163 proves that construction was underway by that date; the high altar was consecrated in 1182 by the legate, which indicates that the chancel had been completed in less than twenty years. All the while (as has been suggested recently), the system of flying buttresses designed to support the vaulting was being perfected. The six-bay

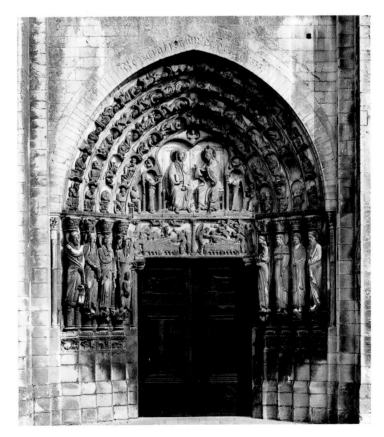

Senlis Cathedral (Notre-Dame). West portal. Lintel: the Death and
Assumption of the Virgin. Tympanum: the Coronation of the Virgin.
Arch moldings: the Tree of Jesse and prophets.
Splays: figures typifying the Old Testament and the calendar. c. 1170.

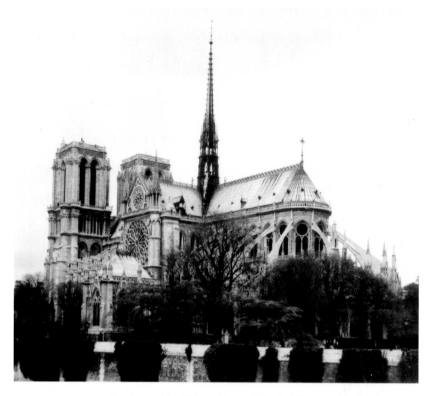

Southeast side of Notre-Dame Cathedral, Paris.
Right: Notre-Dame Cathedral, Paris; west facade. 1210–1230.

nave was then erected under the direction of a different master builder, for—unlike the chancel—the nave does not employ decorative string courses or arcades to produce a relief effect.

Finally, a third master builder had a hand in the three first bays linking the nave to the facade begun prior to 1200. This architect notably took into account the grand novelty introduced at the post-1194 Chartres—a pier comprising a column flanked by four slimmer shafts.

The tendency today is to attribute Notre-Dame to a series of architects—five between 1160 and 1250—which is hardly surprising. Above all, as construction progressed there were changes, occasional breaks, and frequent innovations: the use of stone columns bedded against the grain (which allowed for thinner supports), and the introduction of flying buttresses for the chancel, are accredited to the second master, who worked from roughly 1170 to 1190. Work was carried out more or less simultaneously at the east and west ends, without waiting to terminate the chancel, where construction began.[27]

A notably "Romanesque" feature of the nave was the handling of the triforium with its large oculi. But it had the unfortunate effect of putting too much stress on the wall, and was therefore eliminated in the early thirteenth century by lowering the clerestory windows. Viollet-le-Duc, during his notorious restoration, decided to retain one bay near the crossing as witness to the original arrangement. A fine replica of the initial four-level interior elevation can nevertheless be seen in the chancel of the church at Chars (1190–1200), one of many edifices in the Ile-de France region that echoed the development occuring at the Paris cathedral.

A brief description will suffice to illustrate the originality of a design that would become known as "Parisian," still copied in the sixteenth century at Saint-Eustache in Paris. It should nevertheless be remembered that design was still a question of "ongoing innovation," since changes could always be incorporated into the work, as inevitably happened in the thirteenth century. Thus a spire—the only vertical element, given that the towers were never taken as high as originally planned—was added to the crossing of Notre-Dame. Slender flying buttresses were erected around the chancel, giving the cathedral its famous profile. And the two lateral facades evolved in the mid-thirteenth century to reflect the new, light, and transparent style associated with Saint Louis, a spectacular move that

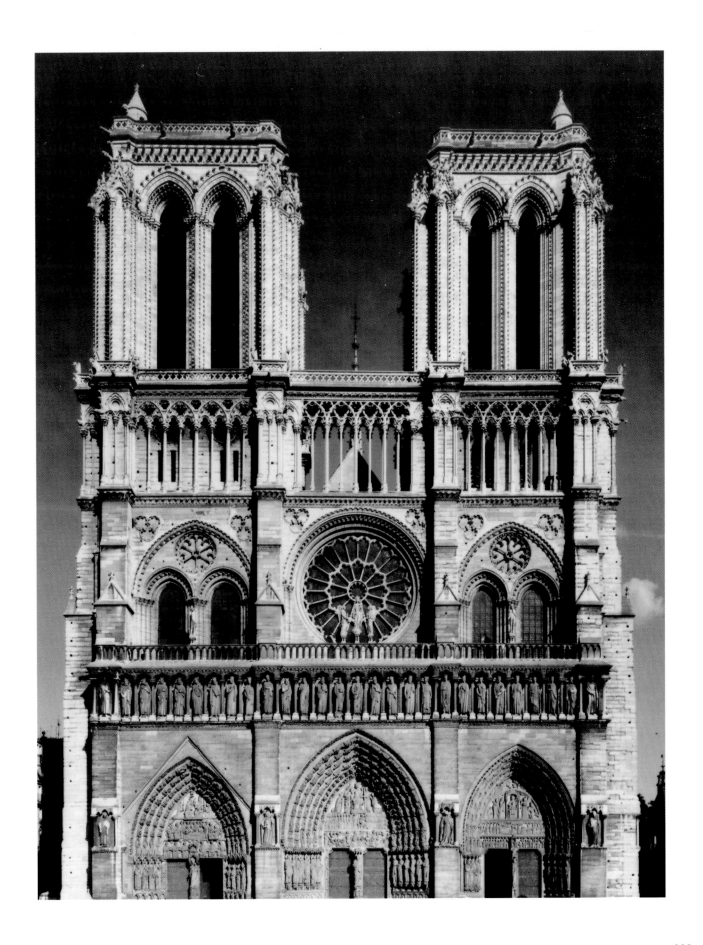

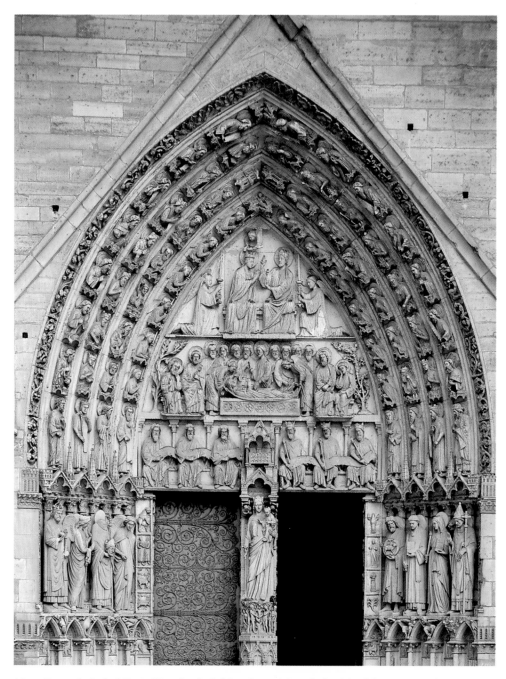

Notre-Dame Cathedral, Paris. West facade, left-hand portal. Lintel: the Ark of the Covenant flanked by the kings and prophets. Tympanum: the Dormition and the Coronation of the Virgin. Arch moldings: angels, prophets, and kings. Trumeau: the Virgin. Splays: an emperor (Charlemagne?), Saint Denis between two angels, Saint John the Baptist, Saint Stephen, Saint Geneviève. and Pope Leo III (the original statues have been restored). c. 1210–1220.

complemented the stained glass already in place. The lively sense of design and movement displayed by the windows (circa 1220) can be seen in the surviving examples like the west rose window (poorly preserved, alas), with the Glorious Virgin surrounded by prophets and an entire range of medallions depicting cosmic and moral subjects (the zodiac, months, vices and virtues).

When work on the cathedral began about 1160, the planned facade was to have portals with an iconographic program and statue–columns like those at Chartres and Saint-Denis. But the facade was not built until half a century later

Notre-Dame Cathedral, Paris.

Left:
detail of arch moldings: angels.
Right and below:
west facade, central portal.
Details of arch moldings: a prophet
and Hell. 1220–1240.

(p. 229), when ideas had changed—the central portal with its Last Judgment and the left portal with its Coronation of the Virgin (left) were redone, and it was the right-hand portal, called the Saint Anne portal, that received the sculpture prepared during the days of Sully: the Virgin and Child enthroned in the tabernacle are flanked by statues of a bishop and a king (Childebert or Louis VII), with a scribe on the left who carefully records the donation (p. 229).

The enormous dimensions of the cathedral corresponded to the grandiose affirmation of Paris as capital city, and its location at the tip of Ile de la Cité in the middle of the Seine gave it an distinctive place in the Paris landscape, as would later be recorded by miniatures and paintings. Until its completion around 1240, however, several generations of Parisians saw only an unfinished hulk of stone, temporary coverings, and a rather uncomfortable interior. The capital's construction projects were nevertheless conducted with ardor and decisiveness—on the western edge of town, King Philip Augustus was building the Louvre at the same time as Notre-Dame; just as the cathedral was being finished, the Palais-Royal, on

the same island, was renovated and its Sainte-Chapelle built.

For the first time on a major scale, then, the idea of an "artistic environment" or "developed environment" became a concrete reality, constituting what some people have suggested is the true field of investigation of French skills. Around cathedrals, as

around castles and even municipal buildings, there was a crystallization of free spaces and constructed volumes. This configuration clearly established a hierarchy and dependency that glorified a certain social order, yet it also offered independent zones and useful sectors where bourgeois activity could prosper.

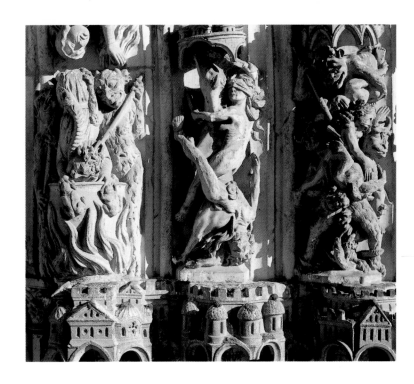

4. THE YEAR 1200

Historians now perceive the pivotal year of 1200 as having true significance for French society. France's old feudal structure was being undermined by economic growth and successful European trade, since feudal lords henceforth had to deal with rich commoners whom they increasingly needed and to whom they were obliged to sell land more and more frequently. Furthermore, the Capet monarchy had finally begun to dominate the landed aristocracy—after Philip Augustus's decisive victory at Bouvines, wrote a chronicler, "no one dares rise up against the King." Literature not only favored long epic tales, but the idea of writing in prose—considered less refined than poetry—was becoming accepted. Official literature displayed a certain evolution from Latin toward the vernacular, which would become more marked in the thirteenth century, when chronicles covering the kings of France (produced at Chantilly, circa 1210–1230) and French history (Saint-Denis, 1274) were written in French. Thus in every respect the period represents an interesting turning point.[28] The "secularization" of professions previously exercised by monks had become apparent. French society could breathe more easily, people were less wary, and there was a general increase in learning along with the communication skills required by emerging artistic development.

Sens Cathedral (Sainte-Etienne). West facade, central portal.
Trumeau: Saint Stephen, detail. c. 1200.

ELEMENTS OF A "PROTO-RENAISSANCE"

Around 1200, an enormous round limestone basin over twelve feet in diameter was set up in the cloister of the abbey of Saint-Denis. It has posed knotty problems for archaeologists insofar as it was decorated with carved medallions bearing names that betray an encyclopedic or scholarly inspiration: Aqua, Ignis Silvanus, Flora. Everything points to the use of antique models taken from jewelry and reliefs, as well as transcriptions from precious metalwork. This impression is convincingly reinforced by examination of the uprights of a recessed tomb at Saint-Père in Chartres, preserved by chance, which clearly imitates cabochons and medals. By degrees, a number of pieces or fragments of sculpture taken collectively has led to the realization that art in Ile-de-France looked back to antiquity at a specific moment that might be called a "proto-Renaissance."[29] Artifacts whose existence has long been known have suddenly received new attention by modern scholars. To judge by the output of its workshops, Sens gives the impression of having been a production center that was highly sensitive to this trend. The example was initially set by goldsmiths from the Meuse region, and it has been rightly pointed out that the years 1190 and after were profoundly marked by works such as the altar frontal that Nicolas of Verdun made for Klosterneuburg in Austria, which was widely imitated. In light of these parallels the serene, heavily draped figures on the Laon portal showing the Coronation of the Virgin suddenly take on new coherence. But it is above all at Sens that sculptures like Saint Stephen on the central portal (left), or the figures on the arch molding, seem to possess a rather new sense of tranquil organization, found also on the lateral portals at Chartres. The tense, moving expressiveness noted a few years earlier in the figures on the Senlis lintel, for example,

Reims Cathedral (Notre-Dame). North transept, Judgment portal. West splay: Saint Peter. c. 1230.

has vanished, as has the hieratic stiffness of the early statue–columns.

Growing attention to antique models around 1200 helps to explain not only the shift from a still-harsh style to the somewhat cool tone occasionally detected on worksites around 1220, but also the oft-observed and surprising relationship between certain figures at Reims (left) and classical Greek sculpture and its Roman copies. "The head of Saint Peter at Reims has been compared to a portrait of Antonius Pius. Technical details like the use of a trepan to hollow the curls of hair reveal a study of Roman statues."[30] It is impossible to look at the Visitation scene on the right-hand side of the central portal in Reims (circa 1230, p. 235) without being struck by the analogies. Through various sources—collections of fragments, pieces brought back from the East, Byzantine coins and objects— something of the Mediterranean repertoire found its way into the powerful sculpture produced in Ile-de-France. But these features were integrated into a different aesthetic project, and so the strong artistic stimulus was exploited in a direction ultimately opposed to that of the classic world.

The major accomplishments of French art nevertheless stemmed from a certain international background. What was already evident at Saint-Denis would become even more widespread in the years 1180–1190. A manuscript with masterful miniatures, the *Queen Ingeborg Psalter* (circa 1190–1200, Chantilly), testifies to what has been called the international Byzantine trend in Western Europe at the end of the twelfth century, probably via English and Sicilian relay points (Canterbury and Palermo). This trend was characterized by a certain stereotypical yet expressive range of gestures, and a henceforth standard palette of blue, brown, and green. The compositional principle of arranging small scenes over two levels was not new, but the vivid draftsmanship and taste for "soft" folds—also found on the portal of the Virgin at Laon, circa 1200— belong to the "proto-Renaissance" trend, echoed term for term in the stained-glass windows in the apse of the same cathedral (circa 1205?).[31]

 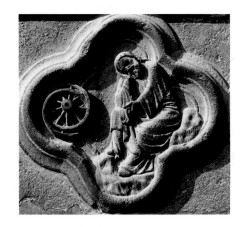 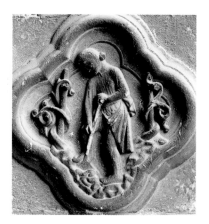

Amiens Cathedral (Notre-Dame). West facade. Detail of socle: the Monthly Labors. After 1236.

Right: Reims Cathedral (Notre-Dame), west facade, central portal.
Right-hand splay: the Visitation (c. 1230); buttress: David (?) and Solomon (1265–1300).

It is even possible to give this observation a more general turn. Partisans of the Gothic style exhibited a taste for formal organization that led them to seize upon anything circumscribed by a distinct frame or medallion or well-defined ornamentation that might serve as framework. And since throughout the Mediterranean world there was growing circulation, indeed trade, of oriental fabrics, decorated boxes, and ivory caskets, there was no lack of models available for use. Villard de Honnecourt's notebooks include over a dozen figures or drawings based on antique statues or ivories, such as a figure fighting a lion with a pike (a common motif on classical sarcophagi), or an ancient tomb with the strange description "tomb of a Saracen."

Gothic artisans were able to make use of everything that came to hand, but they were craftier than their Romanesque forebears in bending diverse imagery to their own design and context. That helps to explain why floor mosaics, carved portal reliefs, and stained glass include all sorts of elements—octagons and squares, diamonds and semicircles—that have an unmistakably classical heritage. These combinations increased with the "cultural" stimulation of the years after 1200,

evident in architectural sculpture as well as in stained glass and miniatures. While Paris was still decorating the base walls of portals with round medallions, Amiens was triumphantly producing, by 1225, a quatrefoil shape in a repeated pattern that formed a long and distinctly "modern" band along the facade (above). This original framing technique would continue to be used throughout the Gothic period, with a strange consequence in the late thirteenth century that will be recounted in pages to come.

It is impossible to assert with certainty that this pattern was the upshot of the scholarly curios that began appearing around 1200—the trajectory of decorative motifs can never be retraced with sufficient precision. But it was indeed just at that time that contact multiplied in all directions. The Crusaders sacked Constantinople in 1204, and the European workshops set up in the Latin kingdom of Jerusalem helped to nourish a sort of Gothic-Byzantine syncretism on every level.[32] Gothic culture was henceforth proud of being able to confront and incorporate contributions from all other civilizations.

The "1200 trend" went beyond France and concerned a northern zone running

from England to the Rhine in a curve that passed through Ile-de-France.[33] But it did not affect southern France, and in that respect it could be said that the center of gravity had shifted away from the Mediterranean, where Provence had excelled (and was still excelling) with a Romanesque-style "proto-Renaissance." In the subsequent stage, northern Gothic would get the upper hand by suggesting that Romanesque stylization could be dropped in favor of suppleness and expressivity, as happened at Sens and would weigh heavily on Reims. This stage constituted an important episode in the interrelationship between the arts. Throughout the Romanesque era, sculpture had constantly evolved within the context of precious metalwork, small reliefs, and fabrics. A reinvigorated repertoire replete with "antique" motifs and other ambitious allusions obviously influenced dynamic sculptural projects early in the thirteenth century. Yet once statuary and relief carving fully asserted themselves, the relationship was inverted. Decorative artists—goldsmiths, ivory carvers, embroiderers—henceforth had to play by the rules established by the "grand art."

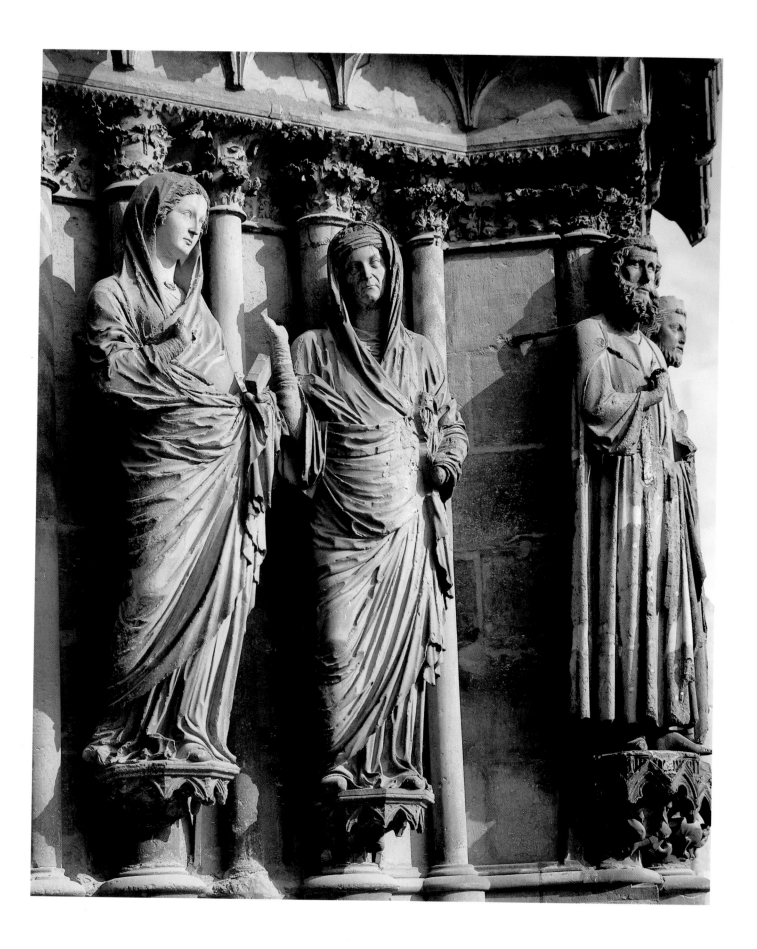

5. THE THIRTEENTH CENTURY: ARCHITECTURAL PLENITUDE

The historian Emile Mâle sketched a classic picture of Gothic architecture in the early thirteenth century: "Never had large churches presented such variety. No two cathedrals resembled one another. Laon had single aisles, Paris double aisles; Sens had no transept, Noyon had a transept with two semi-circular ends, whereas the ends were rectangular at Laon; Senlis had an ambulatory with radiating chapels, Paris an ambulatory without chapels. These churches nevertheless had a few shared features—all had sexpartite vaulting which led to an alternation of strong and weak piers in the nave, an alternation that was sometimes understated. All, except Sens, had galleries."[34]

Yet these features, born of a great desire for monumentality, would be modified even further. The reform came from Chartres—the sexpartite vault was replaced by a simple quadripartite vault of oblong rectangular shape that created a tighter, more regular pacing of piers; the galleries disappeared; and vertical thrust became dominant. Yet there was a competing design that represented another synthesis of the Gothic ideal—at Bourges, begun around 1195, the nave with its four aisles extends from the facade to the apse in a single sweep, with no intervening transept, yielding an artfully hierarchized main space.

PLAN DE L'ÉGLISE DE CHARTRES

Bernard de Montfaucon, plan of Chartres Cathedral. Ink and wash. Thirteenth century. Bibliothèque Nationale, Paris (Ms. Lat. 11907, fol. 182).

CHARTRES

The 1194 fire that ravaged Bishop Fulbert's old cathedral in Chartres meant that everything had to be rebuilt except the facade. But in what order did reconstruction take place—from the chancel westward (where it was decided to retain the Romanesque facade), or from the provisionally restored Romanesque choir to the eastern part of the nave and the transept, and only then toward the old portals and toward the apse? Whatever the case, the new chancel was ready by 1221 (below). With impressive confidence, construction advanced in such a way as to lead to the building of two lateral facades (right) with triple portals completely decorated with sculpture (and therefore more complete than the royal portal). Around 1235–1240, the edifice therefore presented the most coherent and complete exterior volume ever seen (the archaic twelfth-century facade excepted), generating a sense of plenitude reinforced

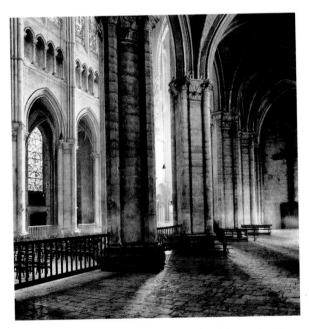

Chartres Cathedral (Notre-Dame). View of the north aisle.
First quarter of the thirteenth century.

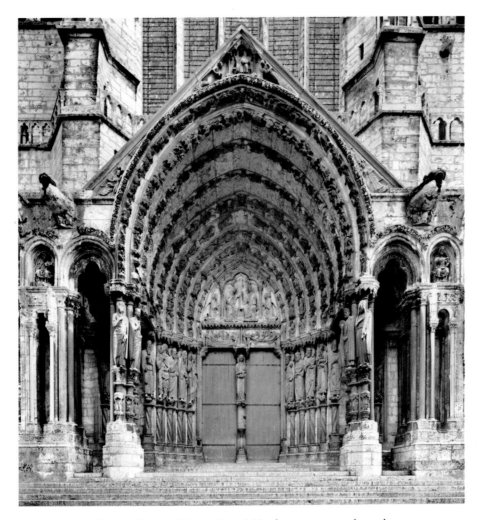

Chartres Cathedral (Notre-Dame). North transept, central portal.
Tympanum: the Coronation of the Virgin. Lintel: Death and the Assumption of the Virgin.
Arch moldings: angels, the Tree of Jesse, prophets. Trumeau: Saint Anne.
Splays: figures typical of the Old Testament. 1205–1210.

by the elegant and measured arrangement of flying buttresses along the outer wall.

By 1200 or so, it was no longer possible to avoid vigorously stressing verticality. The use of oblong vaults and the clear division of the elevation into three distinct storeys produced this effect by compressing the bays. Interior space was divided into rising cells whose perspective accentuated the play of ascending lines, matched outside by a similar stacking of the flying buttresses. It was as though the edifice was cut into giant sections from one end to the other, allowing it to breathe fully and strongly. As Jean Bony has pointed out, the key concept at Chartres was power—power in the construction design, power in the sectioning of space, power in the vocabulary of forms.[35]

At Saint-Gervais-Saint-Protais Cathedral in Soissons, whose south transept represented a fine adaptation of the Saint-Denis model circa 1177–1200, the work on the choir and nave that began in 1212 was inspired by Chartres with a similar concern to clarify the arrangement of the interior elevation. The "Chartres family" also included Longpont (circa 1210, now ruined), the Benedictine abbey of Orbais (circa 1210–1215) with ambulatory, and the two majors cathedrals at Reims and Amiens, which brought the series to a close by combining faithful imitation of design with independence and vitality of execution. Beyond the Ile-de-France region, Chartres also influenced builders in Strasbourg and Cologne.

BOURGES

Chartres represented a limpid example and tranquil affirmation of method. Bourges, built in two parts—the eastern end with choir (1195–1214) and the western end with facade (1225–1255, or perhaps earlier, according to Robert Branner[36])—employed similar elements in a completely different way (right and overleaf). No transept interrupts the unity of a nave that is even more uniform and sweeping in its perspective than Notre-Dame's in Paris. The nave and four aisles produce a wonderful fragmentation of light thanks to various types of openings in the aisles. When viewed straight on, each bay presents five clearly stacked levels governed by the tall arcades that themselves convey monumental verticality. There is magnificent stained glass everywhere, the highly colored row of the clerestory windows being separated from the rest by the darker band of the triforium. Although this unique and striking masterpiece brooked no imitators, Bourges did have an influence on Saint-Martin in Tours (circa 1210), on Coutances (circa 1235) and, further afield, on Toledo (circa 1222)—where the architect fully appreciated the design of long, inverted-V buttresses that align and orchestrate the external mass of the edifice.

The lesson to be drawn from Bourges was as different as could be from that of Chartres. A hybrid of the two types occurred at Le Mans—the chancel (after 1217) boasts a stunning hoard of flying buttresses on the outside, as at Bourges, while the interior (with its play on a double ambulatory and its strong, simple arrangement of bays) echoes Chartres (p. 241). It is also worth mentioning Coutances, whose chancel is limited to two levels in an unusual segue from a nave with galleries.

Right and page 240: Bourges Cathedral (Saint-Etienne). Elevated view of the nave and the aisles. 1195–1250.

Page 241: Le Mans Cathedral (Saint-Julien). The choir. 1217–1254.

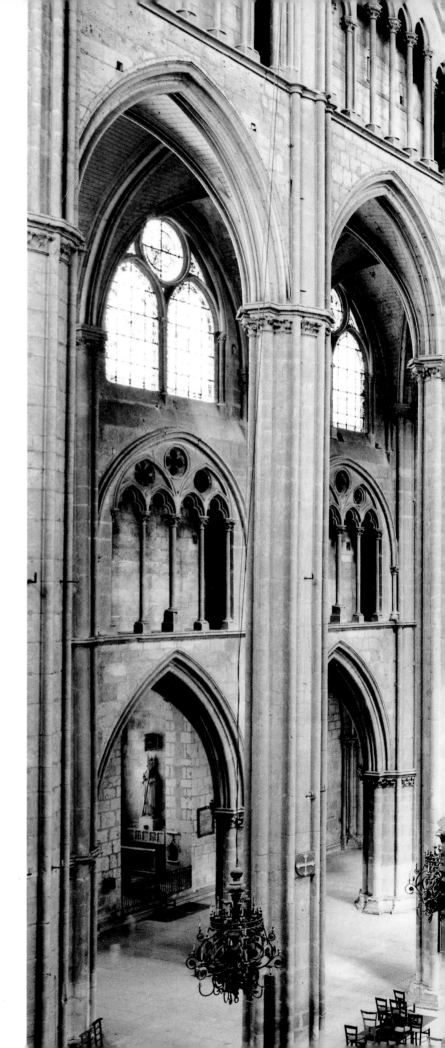

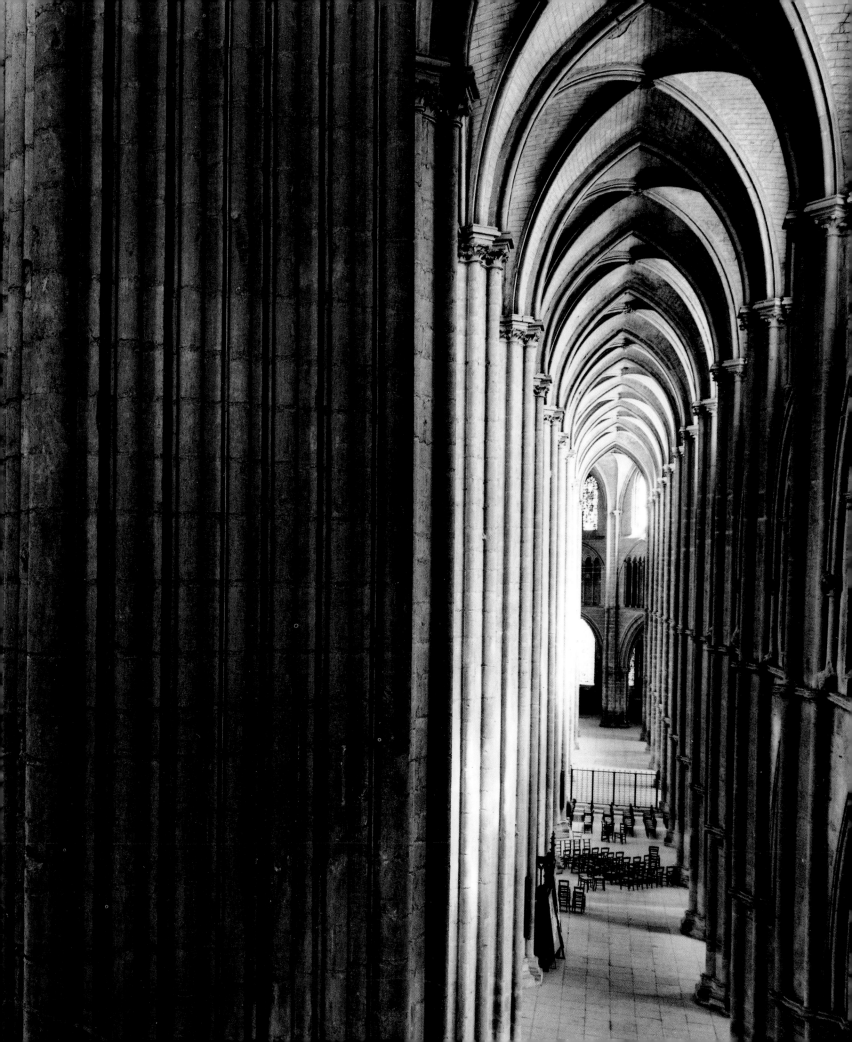

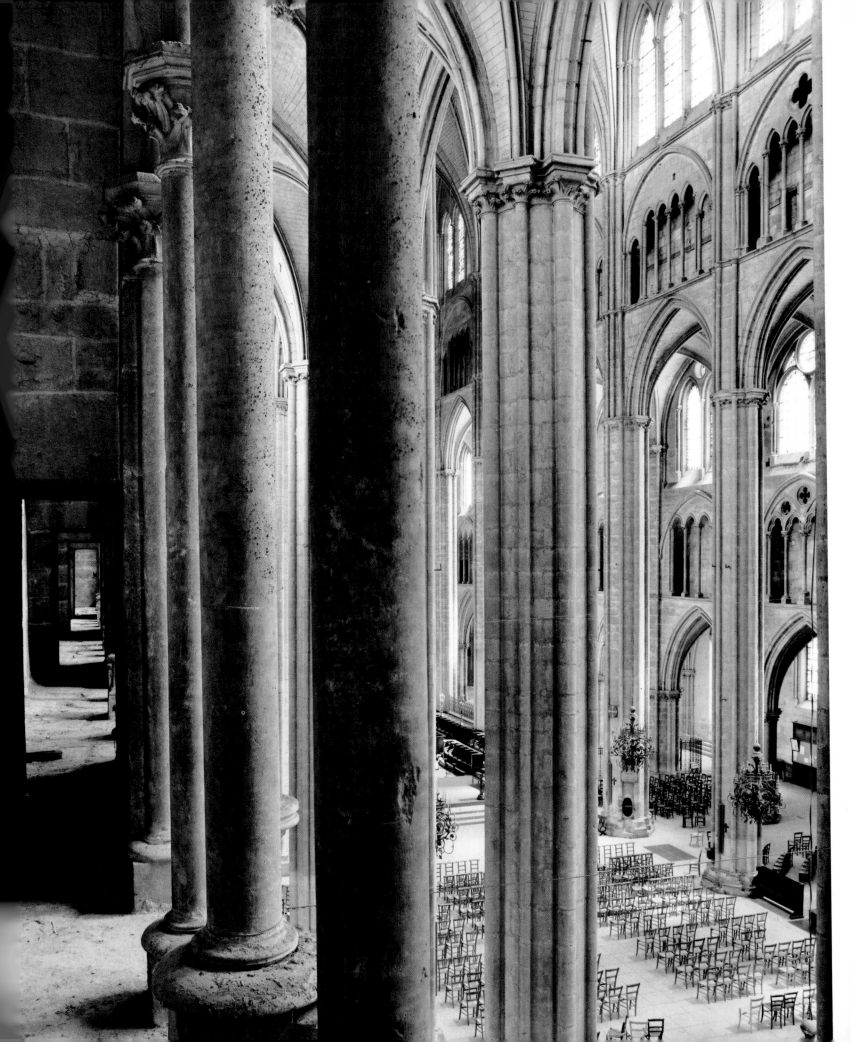

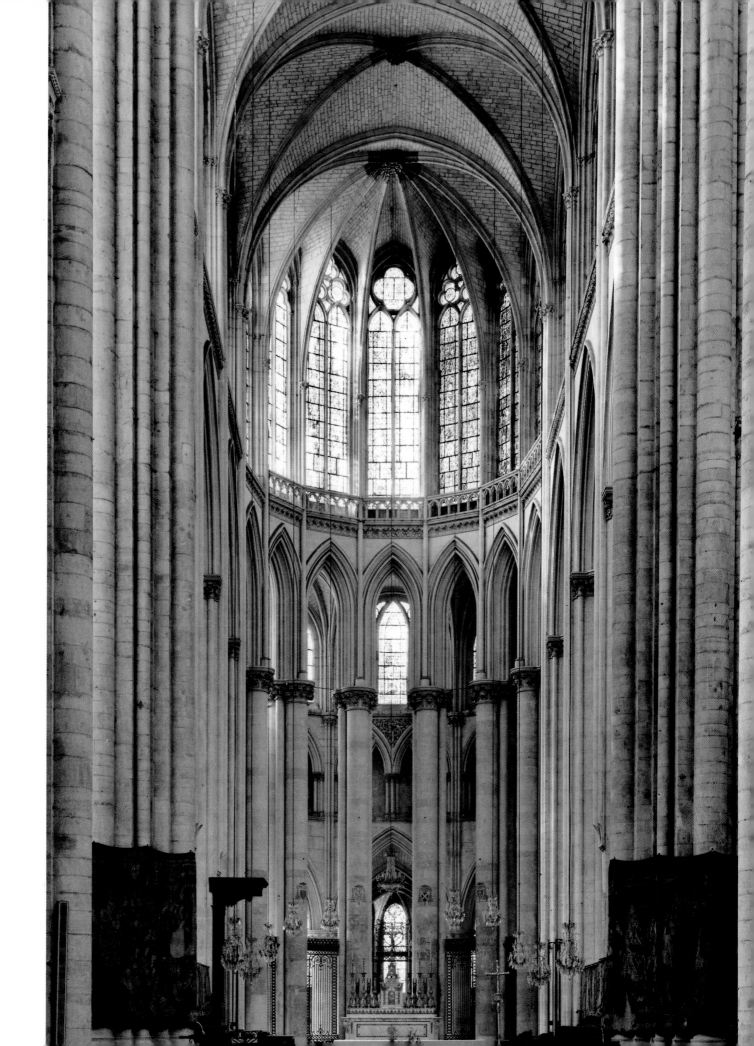

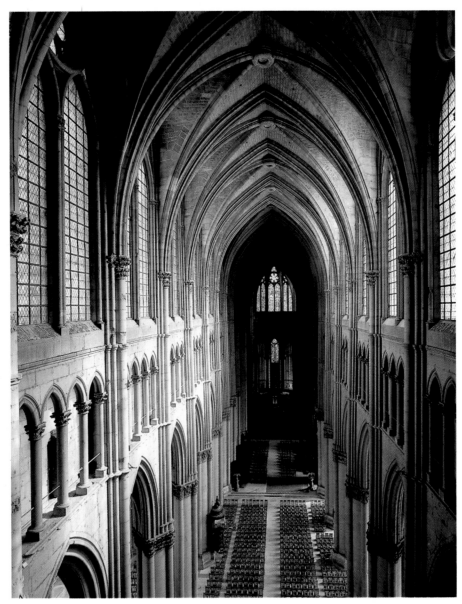

Reims Cathedral (Notre-Dame). View of the nave looking east.
First half of the thirteenth century.

It is hardly surprising that "resistance to Chartres" appeared as of 1220–1230 in Champagne and Burgundy, where other frames of reference held sway.[37] In certain cases, as in the apse at Auxerre that was so crucial for the development of Burgundian Gothic, the shift in orientation that occurred during construction requires a nuanced explanation—it represented a precocious change rather than resis-

tance.[38] Notre-Dame in Dijon maintained the interior passageways cut into the walls at window level, slender profiles and less solemn (or perhaps, less noble) motifs than those of the grand school of Chartres.

REIMS

A providential fire destroyed the Carolingian cathedral in Reims in 1210. A new chancel was erected relatively swiftly

(prior to 1220) thanks to several simplifications in the design—a single ambulatory, five radiating chapels, the two bays of the choir directly adjoining the transept. The nave, flanked by only one aisle on each side, is narrower than the broad harmonious space of the apse (above). The interior elevation is similar to that of the cathedral at Chartres, with a more elaborate system of projecting piers. The great

accomplishment at Reims was the dense yet grandiose western facade with its inexhaustible wealth of sculpture (p. 233). It was begun around 1254 but took a long time to complete. Bernard de Soissons, one of the four masters whose names are inscribed in the labyrinth, probably designed this unique ensemble.

AMIENS

In 1218, Amiens was also ravaged by fire, and work on a new cathedral began in 1220, clearly in competition with Reims. As with Reims, the names of the master builders are known—Robert de Luzarches for the nave, until 1233; then Thomas de Cormont for the ground level of the chancel until roughly 1230; and finally Regnault, who completed the whole thing around 1260. That suggests unusual progress and continuity. By beginning with the nave, the architect wanted to show that he could raise the vault far higher than his predecessors—forty-three meters high, with a fine effect of spaciousness in each bay thanks to a tall arcade twenty meters high (right). Spatial arrangements of this type give the impression of a building intended for giants, for some invisible population of prodigious size. The cathedral is immense—one hundred and forty-five meters long and seventy meters wide at the transept. The adroit layout of the apse—with a harmonious ambulatory and radiating chapels that pleasantly and smoothly join the bays of the chancel—makes Amiens an even more attractive and better-arranged model than Chartres. But this section of the church took so long to build that it was not necessarily used, as has been suggested, as a model for other edifices.

The western facade is a sort of giant lace screen (p. 222) that strangely reflects the ultimate development of the apse. There was in fact a second building campaign launched after 1254–1255 which, in fifteen years, endowed the upper outside parts of the apse with a cluster of gables

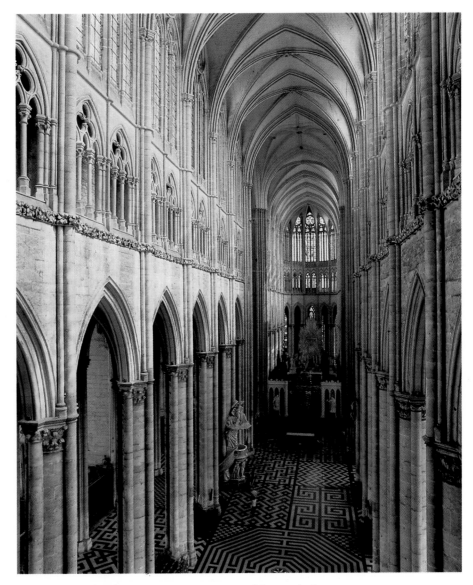

Amiens Cathedral (Notre-Dame). View of the nave looking east. 1220–1240.

and pinnacles (which would be repeated several years later in Cologne). Inside, note was taken of the trend in the 1250s to fuse triforium and clerestory windows, which represented one of the last vagaries of Gothic history. Like all the cathedrals in this grand series, Amiens influenced subsequent construction. Beauvais Cathedral comes immediately to mind, its soaring height being prefigured by Amiens.

But in addition to Amiens, Beauvais was influenced by another mid-century development which had a decisive impact—the Sainte-Chapelle in Paris.

THE ROLE OF STAINED GLASS

Architectural structures were so complex, the role of sculpture so great, and the part played by stained glass so subtle that it is impossible to analyze all these factors

simultaneously. Yet the attempt must be made, for the inevitable division of Gothic art into its constituent components of architecture, sculpture, and stained glass can ultimately lead to misunderstanding. True enough, architects' virtuosity, which increased from generation to generation, began to appear like a pure case of engineering research and development; this is precisely what so charmed Viollet-le-Duc and Gustave Eiffel. But their professional admiration totally overlooked religious goals. Admirable devices and the dazzling play of forms seemed to leave no room for the sacred, paying it only highly conventional lip-service. The purely aesthetic development of statuary, meanwhile, usually prompted a similar conclusion, namely that morality weakened as the propagation of piety began to matter less than the delightful artistic exercise of creating beautiful, curvilinear madonnas.

This commonly adopted critical stance should not go unchallenged. It corresponds to a half-truth, art having become a privileged site of the henceforth relentless invasion of professional and secular attitudes. Assessing intention is obviously impossible, but a different idea of things can be had by encompassing the entire scope of developments. Globally speaking, the prodigious sanctuaries that embodied all sorts of purely technical feats were primarily aimed to exalt religious feeling. That, more than ever, was the goal, and if the fascinating attraction of multicolored glass is added to the seductiveness of countless statues populating such a well-defined, organized, and effective space, there can be no doubt that a highly specific environment was deliberately created. Its power can be sensed today only dimly and distantly, even when the heat of the liturgy, the chant of choirs, and the bustle of the crowd is successfully conjured up.

That said, Gothic art's success represented a major evolution in collective sensibility and triggered enormous advances

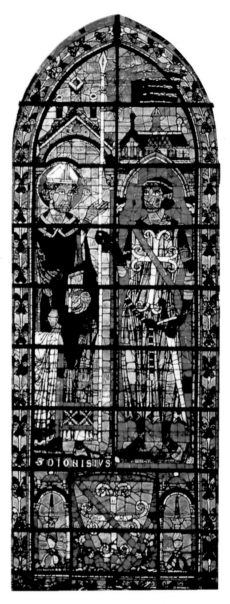

Chartres Cathedral (Notre-Dame). South transept, stained-glass window on the east wall: Saint Denis hands the pennant to the knight Jean Clément. 1228–1231.

Right: Reims Cathedral (Notre-Dame). View of the interior of the west facade and the nave vaulting (detail). Second half of the thirteenth century.

in artistic capabilities. As new workshops were spawned, there was a new attentiveness to the resources of each craft. It was still a pious universe, but one that was increasingly governed by new feelings like public admiration for "beautiful" work

and the pride of individual artists. Texts confirm the existence, as might be expected, of aesthetic reactions on the part of all social groups. A distinction inevitably emerged between ends and means; the former were in no way challenged, but they were less present when the execution itself became so demanding and so satisfying. The situation remained stable during the days of Saint Louis, but when secular inspiration gained the upper hand in the fourteenth century, an imbalance was created that might well be qualified as "the end of the Middle Ages."

The stained glass at Chartres—one hundred and sixty-four windows covering two thousand six hundred square meters—provides a vast, miraculously preserved (and restored) realm that alone outweighs all the known production of the day. Numerous well-organized workshops must have collectively produced this enormous repertoire of glass, a veritable encyclopedia of Christian imagery. The windows in the nave were done starting around 1200, those in the chancel from 1215 to 1236. There were little scenes in the lower level, large figures on the upper level, a rose window on each of the three facades and, in the south transept where they could not be missed, incredibly inventive lancet windows (circa 1220) showing the Evangelists perched on the shoulders of Old Testament prophets—John on Ezekiel, Mark on Daniel, etc. (p. 247). Two are depicted against blue grounds, two against red, with strong accents of black that proclaim a great painter. It is impossible to delve here, even briefly, into an analysis of this immense art gallery. The organization of iconographic themes is far from coherent, and it is easy to see why Emile Mâle had to refer to encyclopedic texts of the day like Vincent de Beauvais's *Speculum Historiae* in order to make methodical sense of it. Within this teeming, somewhat confused setting, a few groups stand out in their purity, such as a window depicting Saint Denis and another in the south

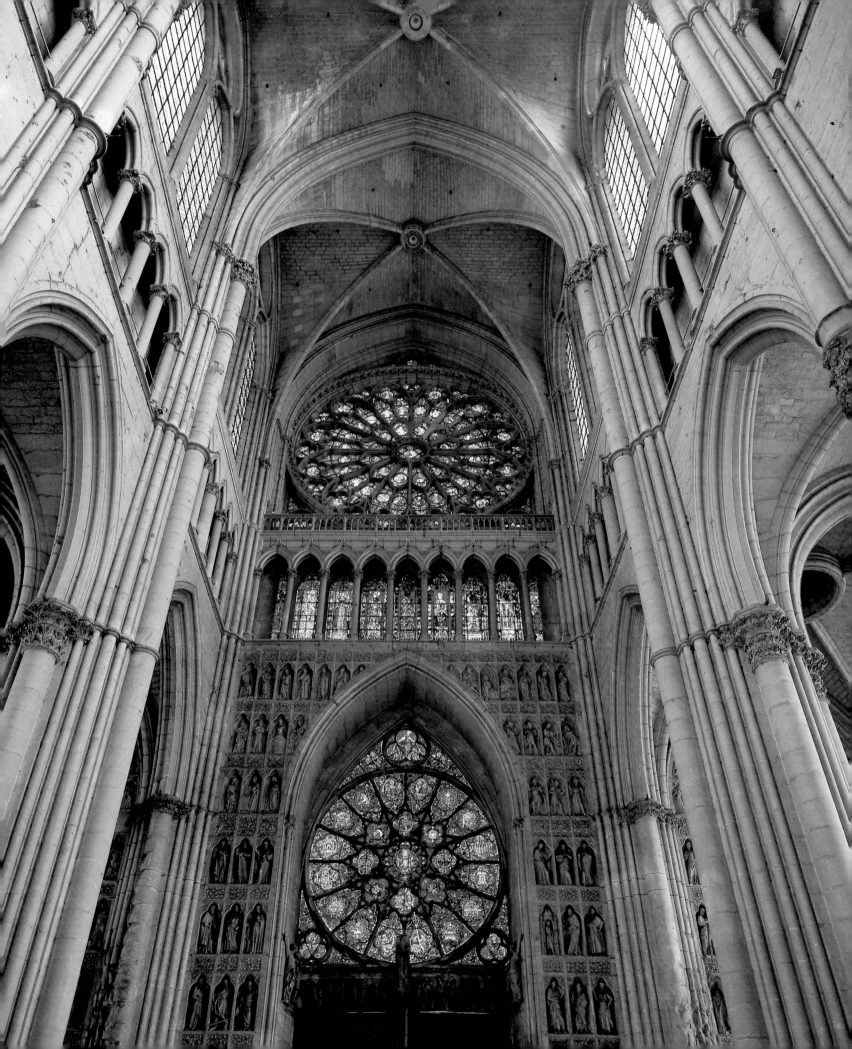

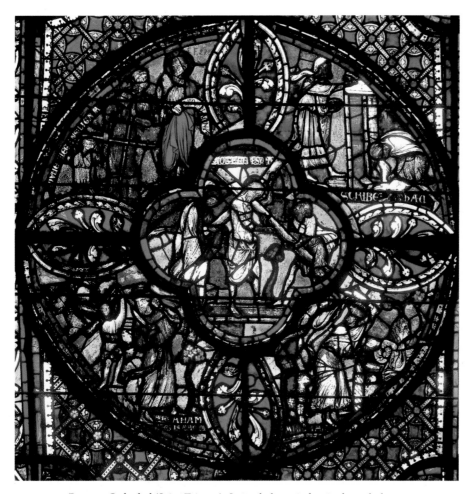

Bourges Cathedral (Saint-Etienne). Stained-glass window in the ambulatory:
the New Covenant (detail). c. 1210–1215.

Reims Cathedral (Notre-Dame). Detail of
stained-glass window, west facade: a king.
Mid–thirteenth century.

Right: Chartres Cathedral (Notre-Dame).
The south rose window: Christ in Majesty,
angels and elders of the Apocalypse. The five
lancet windows underneath depict the Virgin
and Child (center), flanked by the four
evangelists carved on the shoulders of Old
Testament prophets Jeremiah, Isaiah, Ezekiel,
and Daniel. 1221–1230.

transept showing the Clément family. The
calm and noble composition of these works
bears comparison with the contemporane-
ous statues flanking the portal.

Although stained-glass windows, given
their origin and function as a source of
light, were above all a symbolic form, they
nonetheless had to be endowed with
appropriate imagery. That required, first
of all, structuring the opening with the
horizontal saddle bars that secured the
whole frame, plus sturdy ironwork to hold
the multiform lead network. Decorative

elements like bands of flowers, rings of
beads, patterns of foliated scrolls, or tiling
(more or less discreet, depending on the
workshop) are of enormous importance in
determining overall effect. One need only
compare, for example, a composition in
Orbais (circa 1210–1215) where ten
scenes of the Passion are arranged in a
right-angle grid around a central core,
with numerous windows at Chartres from
around 1225, like the ones showing Charle-
magne and Saint Pantaleon, in which
everything is tightly woven like a vertical

carpet, with medallions and half-medal-
lions rhythmically arrayed across a red and
blue background that simultaneously sets
them off and subsumes them. Once this
kind of dense arrangement (where all indi-
vidual elements were successfully subordi-
nated to the powerful effect of the
ensemble) triumphed at Sainte-Chapelle
(circa 1245), there occurred an emancipa-
tion of stained glass that characterized the
second half of the century.

The general dimming of light caused
by extensive use of red and blue (which

was hardly alleviated by the insertion of white or green fillets) was balanced by the use of colorless grisaille glass. This gray glass had already been employed at Bourges, but its role in liberating a figure by setting it against a light background can be best observed in the Churches of Sainte-Radegonde (Poitiers, circa 1270), and Saint-Pierre in Chartres (circa 1300), where wide grisaille bands, neutral and transparent, frame Christ on the cross, Saint Louis, the Virgin and others, allotting each figure an independent ground beneath the tall canopies that pull the ensemble upwards.

The antique and Byzantine influence of the "1200 style" is clearly detectable in three lancet windows in the chancel at Laon (circa 1210) and in the stained glass formerly at Saint-Gervais-Saint-Protais Cathedral in Soissons (circa 1210–1215, dispersed during the nineteenth century and now in various American collections). All the features of the new style are evident in the broadly drawn figures, drapery, and faces.

The most accomplished stained glass of the fresh and inventive early years of the thirteenth century is probably the ensemble found in Bourges Cathedral, notably in the ambulatory with its New Covenant, an artful elaboration of biblical typology (far left), and remarkably dense Last Judgment (1210–1215). The chancel at Bourges Cathedral constitutes one of the high points of the art. Unfortunately, the original arrangement of colored glass and grisaille in the nave, executed slightly later, is no longer known.

The apse at Le Mans, completed after 1254 and similar to Bourges, has upper ambulatory windows that are exceptional both for the minimal amount of restoration undertaken and the extensive atmospheric pollution that has darkened the evangelical and hagiographic images and scenes that are depicted, such as the Childhood of Christ and the Life of Saint Julian (1235–1255).

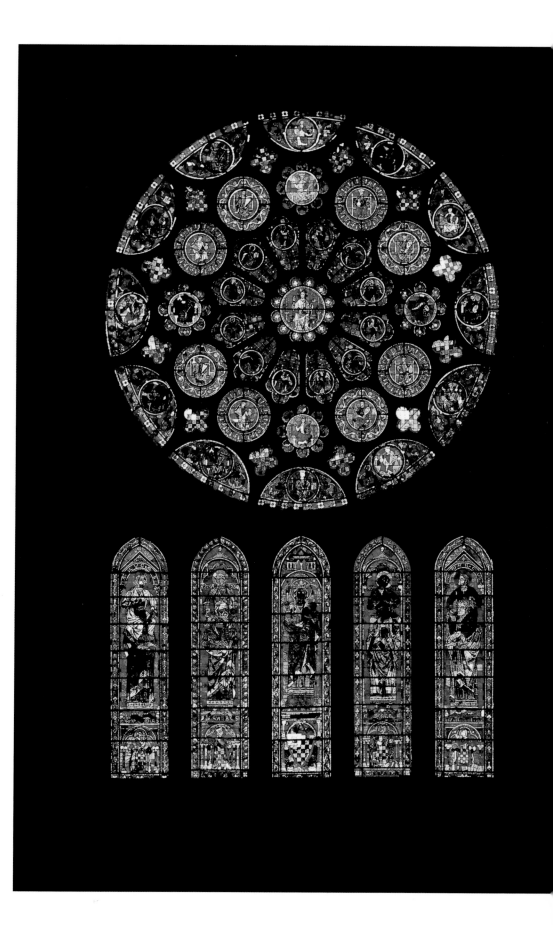

Mont-Saint-Michel, the refectory of "La Merveille," looking west.
First quarter of the thirteenth century.

Musée Lapidaire, Narbonne (Church of Notre-Dame-de-Lamourguier).
View of the timber roof of the nave. c. 1250–1270.

GOTHIC EXPANSION

Work was underway everywhere. From 1204 to 1228, profiting from Philip Augustus's reconquest of Normandy, the determined monks at Mont-Saint-Michel obtained major subsidies from the king for the installation of permanent quarters, henceforth known as "La Merveille" comprising a Guests and Knights Hall on the first floor, plus refectory and cloister on the north side of the second floor (above).

The Gothic architecture practiced by Jean Deschamps, official envoy to central and southern France in the middle of the thirteenth century, has sometimes been called a "synthesis"—it was based on a standard plan, Parisian-type windows, and Saint-Denis II piers. But the approach advocated by that official envoy was above all influenced by the simplified Gothic of mendicant orders and monastic builders. Deschamps had a hand in construction at Clermont-Ferrand (once thought to have been begun as early as 1248, but probably undertaken later), Limoges (1273), Rodez (1277), and Narbonne (1286). An archive document confirms that Deschamps was

indeed the designer of such cathedrals without, of course, having built them from start to finish. The similarity of the chancels does not preclude distinctive features largely due to the use of different materials—igneous stone at Clermont, granite at Limoges, pink stone at Rodez. Floor plans might also be quite original—for instance, there is no nave at Narbonne, and no western entrance at Rodez, which straddled the city wall with astonishing poise. The church of Saint-Nazaire in Carcassonne, built inside the lord's residence, followed the trend by adopting tall windows and large rose windows of the type found at Saint-Denis II, known as the "rayonnant" style. The contrast, then, was all the greater with churches (notably those affiliated to mendicant orders) that stuck to the southern tradition by refusing to fall for Gothic charms. The reactionary nature of such architecture is underscored by the return to archaic solutions such as a diaphragm arch supporting a timber roof, used in 1240 at the church of Saint-Dominique in Perpignan. This example was followed at the priory of Notre-Dame-

de-Lamourguier in Narbonne (circa 1250–1270, above). The Franciscans in Toulouse built a large single nave of great height with long thin openings (begun 1268, demolished in the late nineteenth century), whereas the Dominicans pro-

Strasbourg Cathedral (Notre-Dame).
View of the upper levels of the chancel.
Mid–thirteenth century.

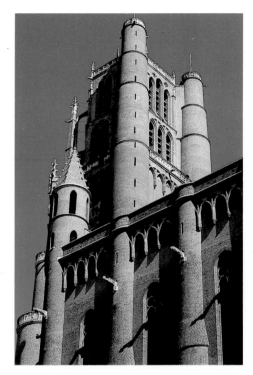

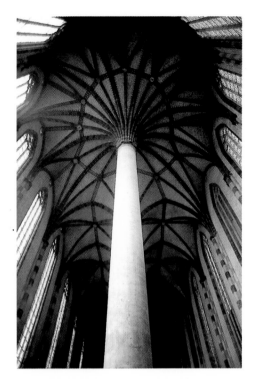

Albi Cathedral (Sainte-Cecile).
Side view of the nave and the bell tower.
Last quarter of the thirteenth century.

Dominican Church, Toulouse.
View of the vaulting in the double nave.
Late thirteenth century.

duced a more ambitious and equally spacious building featuring a double nave borne by a series of slender, unornamented columns twenty meters high (circa 1275–1282, above right). This vast, bare volume was conducive to preaching, probably very economical, and inevitably impressive.

Resistance to the northern Gothic style can also be detected in the early twelfth-century replacement of the nave of Toulouse Cathedral. The newly constructed nave was a strange compromise: it was broad (twenty meters), of rectangular plan though with no side chapels, and of modest height despite ribbed vaults. In fact, this solution echoed what was happening in Barcelona, where the Dominican church of Santa Catalina was begun around 1247, constituting what might be called "Catalan Gothic."

A sense of space differing from that in the north also inspired the southern cathedrals of Saint-Bertrand-de-Comminges (1304) and, especially, Albi (begun in 1282 by Bishop Castanet, the energetic heretic hunter). Albi is unique first of all for its aggressive, fortress-like proportions (above), underscored by the sloping bases of the rounded buttresses, by the spectacular use of brick and, inside, by the absence of aisles and the placing of the chapels between the buttresses (subsequently raised). Intensifying the contradictions, the cathedral was endowed with a fine rood screen (in the days of George of Amboise) and extensive decorative paintings (late fifteenth century) that had nothing whatsoever to do with Gothic.

At the same moment, in Strasbourg (then part of the Holy Roman Empire), a cathedral begun around 1240 featured a nave planned in the spirit of Saint-Denis II and Troyes, with special Rhine characteristics (left); a few years later, under the direction of Master Erwin (died 1318), it was endowed with a facade whose initial design, known from a parchment drawing that has survived, was purely "Parisian." The expansion of late Gothic in the direction of Germany had already occurred; a document reveals that the church of Saint Peter in Wimpfen am Necker, begun in 1269, called on "a mason very expert in architecture who has just arrived from Paris and the regions of France, and Richard raised the basilica in French style [More Francigeno]."[39] Even if no such documents exist for the naves at Bamberg (completed 1237) and Limbourg am Lahn (1275), or for the church of Saint Elizabeth at Marburg (1235–1283) where the margraves of Hesse are buried, these churches' ancestry is apparent. But they betray a frank, robust accent that is also present in their sculpture—the two famous allegorical statues of the Church and the Synagogue at Strasbourg (1220–1225), proud and elongated, like Adam and the Rider of Bamberg (circa 1230), have a character all their own.

6. The thirteenth century: Sculptural plenitude

All the arts joined architecture's inspiriting movement, from stained glass (which, directly linked to architecture, often posed architectural problems) to manuscript painting and precious metalwork (whose role became that of presenting and, in a way, helping to explain the ideas of builders through scale models or painted images, thereby eliciting further refinement, suppleness, and elegance). Imagery, in short, underwent a shift in tone that might be described as follows: "In Romanesque sculpture God appears as the stern judge, the Lord and Ruler of the Last Judgment, the Crucified One, unmarked by suffering, who actively wills His lot. In Gothic sculpture He appears as the mild, all-pitying, and all-loving One, the God suffering on the Cross. . . . On Romanesque crucifixes, Jesus stands upright and alive; nailed to his cross, he is independent. On Gothic crosses he droops in weakness or death; he is dependent."[40]

If things occurred thus, then the change was of immense import—the tone of the sacred was profoundly transformed by a specific reference to the world and to nature, as though both benefited from a more favorable presence. The crucifix, which had formerly been a symbol, now became an example. And everything else followed; parallels are not hard to find in scholastic philosophy, poetry, and fiction. The work

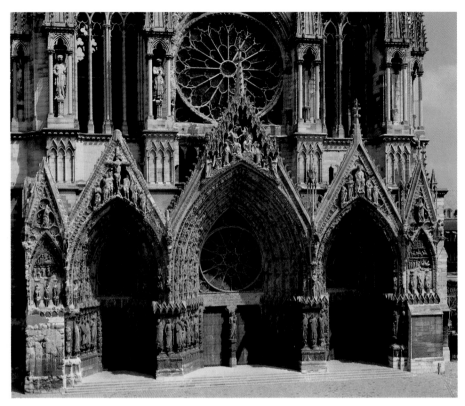

Reims Cathedral (Notre-Dame). Western portals. Mid–thirteenth century.

Right: Reims Cathedral, west facade, left-hand portal, right splay:
Saint Denis [?] (c. 1230) between two angels (third quarter of the thirteenth century).

accomplished in the architectural sphere triggered and imposed a new model of civilization, powerfully reorganizing a French society that remained more hierarchical than ever, yet was completely receptive to new modalities.

Half a Century of Sculpture

A fantastic—if disconcerting—collection of sculpture, done during a fifty-year period and unique in the world, could be obtained by culling the north and south portals of Chartres (1205–1210 and 1220–1235 respectively), the western facades of Notre-Dame in Paris (1220–1230), Amiens (1220–1235, along with its later south portal showing the Golden Virgin), and Reims (1220 to after 1255, plus its earlier north transept), not forgetting the facades of Bourges (1240–1260)

and Poitiers (circa 1250) but leaving aside dozens of lesser churches. As pointed out in the discussion of Chartres, the extensive variety of types of carving—statues, figurines on arch moldings, mezzo-reliefs on bases, decorative friezes along capitals, frames endowed with crooks, decorative garlands in interstices, etc.—meant that a full range of expressive possibilities could be exploited. Figurative discourse in stone here reached a sort of plenitude. Whereas the arch moldings of the north portal at Chartres feature droll little figures (circa 1220), elsewhere there are rows of serious and touching figures conveying saintliness, while the medallions on the base wall evoke a mischievous humor. It was possible to express everything.

Yet perhaps it should be pointed out that this wealth of sculptural art has

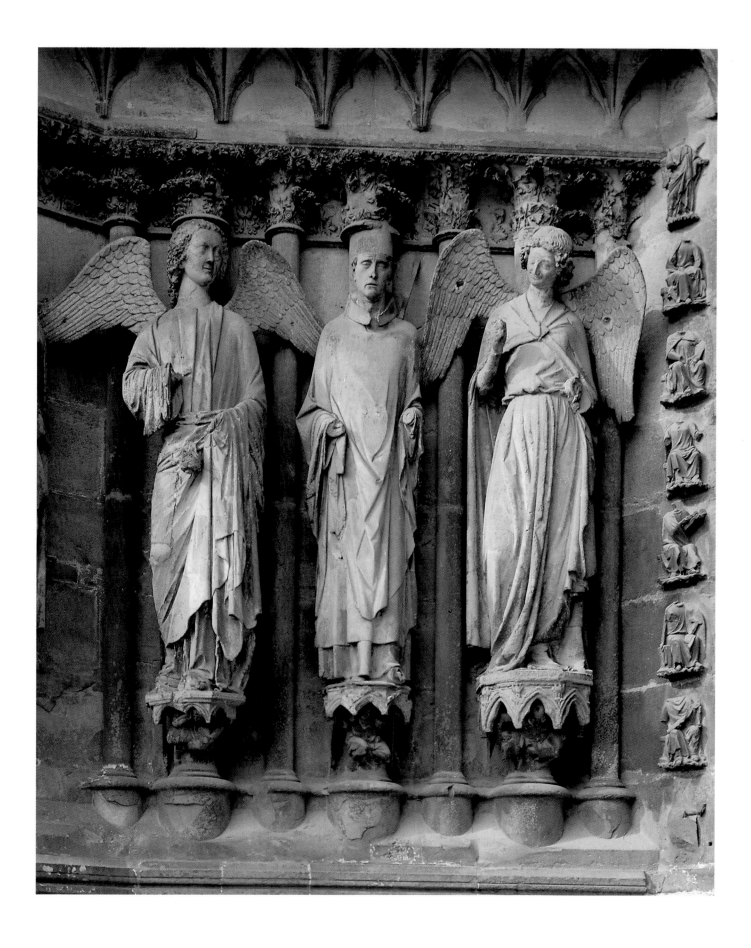

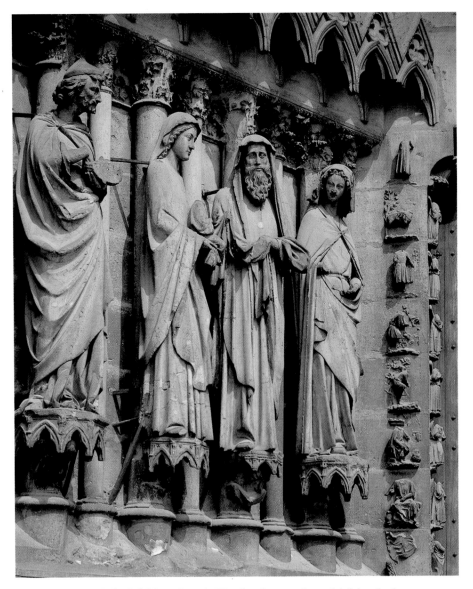

Reims Cathedral (Notre-Dame). West facade, central portal, left-hand splay:
the Presentation at the Temple. Third quarter of the thirteenth century.

archaeological research. In the absence of such information, the relationships (whether competitive or cooperative) that must have existed between the clearly numerous workshops can only be reconstituted today via an analysis of analogous forms and programs, taking into account parallels with the art of stained glass, since all artisans worked together spiritedly (or so it would be nice to think) on huge construction sites. Organizational details, however, remain obscure. Viollet-le-Duc suggested somewhat hastily that all dressing and sculpting was done before the stones were set in place.[41] This is plausible, though far from certain.

The authority and inventive capacities of sculptors were amazing. Around 1200, a radical decision led to the abandonment of all traditional capital ornamentation, which was suddenly replaced by natural foliage from the Ile-de-France region. It was as though someone had decided to start over from scratch, insisting that capital decoration henceforth be based on local flora. Other trends and countertrends can also be identified during this extraordinary half century. Around 1230, for example, the supple, antique style found ultimate expression on the right side of the central portal in Reims in the form of the Visitation of Mary and Elizabeth (above right)—the fluid folds of the two women's garments have always evoked Greek statuary. This is a rather exceptional group in which the nobility of the figures and the diversity of facial expressions and gestures are almost unsettling in their liveliness. Far from projecting the mysterious air of the statues at Chartres, the figures on this central portal at Reims all seem terribly busy—Mary converses with Elizabeth, a smiling angel leans toward Saint Denis (p. 251). Some of them bask in eternal glory, and manage to convey that feeling.

Yet it was at just about that time (circa 1225–1230) that an interesting reaction took place in Ile-de-France and Champ-

undergone multiple restorations, beginning for example in the sixteenth century in Reims, the city of royal coronations. Significant restoration began above all in the nineteenth century when it was necessary to repair damage done by time and by Revolutionary destruction, and again in the twentieth century when wars and pollution took their toll. Paris and Reims suffered particularly badly, and every portal contains its share of more or less felicitous

repairs (not to mention the sculpture that has disappeared forever, like the statues at Saint-Denis).

If the work of French masters had been followed with the same interest shown by contemporaries of, say, Tuscan artists like Nicola Pisano (circa 1220–1283) and his son Giovanni (circa 1250–1314), French historians today would benefit from a wealth of anecdotes and information providing a useful human complement to

tense—the angels have even begun to smile. A delicate touch carried the day; sculpture seemed to be seeking inner gentleness. At the level of the rose window, decorated around 1260, a Christ of the Resurrection wears an amazingly mild and serene expression—a detail that would have interested the Italian masters.

Not all sculptors attained this level. Some work was weaker and repetitive, some was pure padding. That is why possessing a history of specific workshops and key figures would be so fascinating. It is up to historians, who must remain prudent (due to restorations) and patient (due to the multiple correlations required), slowly to fill in some of these gaps.

Above and right: Reims Cathedral (Notre-Dame). Central portal, right-hand splay: the Visitation. c. 1230.

agne against the suppleness and charm promoted by the "1200" generation. This reaction was manifested through miniatures, stained glass, and statuary. It was prefigured by the somewhat dry manner of the Master of the Coronation of the Virgin—on the left portal of Notre-Dame in Paris (p. 230) and the north porch of Chartres (p. 237)—as well as in the stained-glass windows of the anonymous but identifiable Master of Saint-Chéron at Chartres. The new style was marked by broad, calm folds and flat surfaces with no strong accent. Its almost ice-cold power can be felt in the Last Judgment portal at Reims, carved around 1230. "This transformation appears all the more impressive when carried out on the statues of the kings, and the arch moldings of the rose windows in the transept."[42]

Fifteen or twenty years later, everything had changed again. Looking only at Reims, where comparisons are easiest, the saints on the left portal may have serious or painful expressions, but are in no way

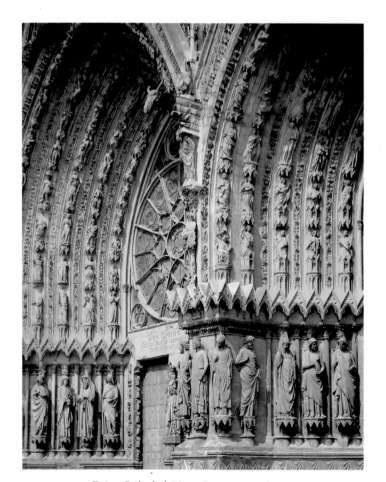

Reims Cathedral (Notre-Dame). West facade.
Central and right-hand doorways. Mid–thirteenth century.

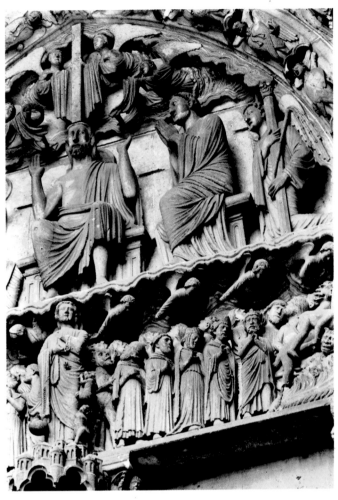

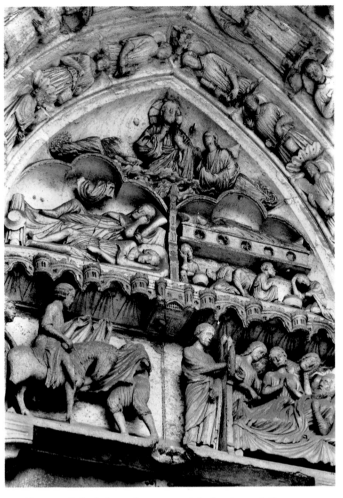

Chartres Cathedral (Notre-Dame). South transept, central portal. Tympanum (detail): Christ, judges, and angels carry instruments of the Passion. Lintel (detail): Separation of the Elect and the Damned. 1210–1215.

Chartres Cathedral, south transept, right-hand portal. Tympanum and lintel. Left: Saint Martin dividing his cloak; above: Saint Martin's Dream. Right: the charity of Saint Nicholas. Above: the infirm before his tomb. Top: Christ. c. 1220.

MAJOR THEMES

The Last Judgment was still to be found on tympanums, but new nuances could be detected everywhere. On the central portal of Notre-Dame (circa 1220–1230), for instance, the official style was somewhat softened by arch moldings that depicted little angels with shell-like wings (p. 231), rather than the royal Elders of the Apocalypse. On the central portal at Amiens (1220–1230), what really counts is not the heavily charged and confusing tympanum, but the image of Christ as teacher on the trumeau below.

From one church to another, what truly differs and lends character—or rather *lent* character, when devoutness was still alive—are the depictions of saints. All were appropriate to the specific site or town with its relics, legends, and traditions, and the typology of saints was obviously nourished on folk practices related to their cult. Thus Saint Honorius was placed on the portal at Amiens above the Golden Virgin, Saint Sixtus on the north transept of Reims. Every saint had a home.

Above all, there were also new, recurring themes that appeared only during this specific period. Two in particular merit discussion—the Coronation of the Virgin and the Gallery of Kings.

Coronation of the Virgin

In the twelfth century, the Coronation of the Virgin became a major theme of tympanum sculpture. The subject conveyed multiple concepts, such as the glorification of the figure of Mary as the embodiment of the Church (a way of denouncing the infidelity of heresies), and the eternal union of Christ with his Church (*Sponsa/Sponsus*, based on interpretations of the Song of Solomon). In addition, the theme very probably repre-

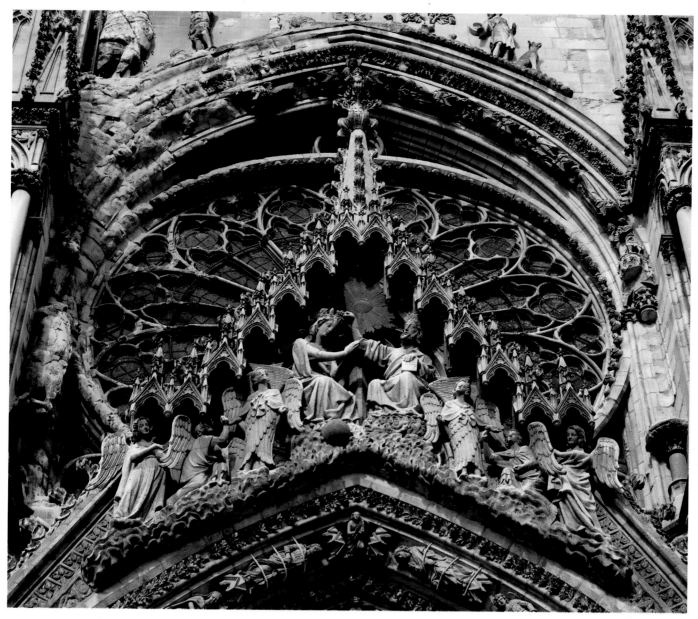

Reims Cathedral (Notre-Dame). West facade, gable over the central portal:
Coronation of the Virgin. Mid–thirteenth century.

sented a transposition of the royal coronation, to the extent that it is not clear whether depiction of the heavenly rite is the source or rather the imitation of the earthly rite to which Abbot Suger attached such importance.[43] The primacy of the Senlis portal (p. 227), as asserted by Emile Mâle and accepted by French archaeologists, is perhaps not absolute. The Coronation of the Virgin at Laon presents the same general design but with a more sober handling typical of the "1200 style" influenced by Mosan enamels and already apparent at Saint-Remi in Reims. The interest of rectifying the chronology lies in the fact that Laon should then be related to the central portal of the north transept of Chartres (circa 1205–1210).

The Marian theme, which was also employed at Chartres (north portal) and Paris (left portal, 1110–1120), generally required the addition of a narrative scene, namely the Death of the Virgin familiar to Byzantine imagery (*koimesis*). At the priory of Longpont (circa 1230) and the north transept of Saint-Thibault-en-Auxois (1240–1250), two narrative tableaus depicting the Death and the Assumption of the Virgin were placed together on the lintel.

By mid-century, things changed. Reims staged a coup by eliminating the tympanum: its central portal has a rose window and the lateral portals have lancet windows with a quatrefoil pattern (p. 250). Brilliantly playing on the potential of "transparent" sculpture, traditional themes were transferred to the lacy carving above the portals—the Coronation of

be set, an unforeseen decision was made for which no known inspiration has been discovered: a gallery of thirty royal figures was placed in a horizontal line all across the facade, lending it a somewhat strangely didactic and programmatic air (p. 229, below and right). The upper zone contains no other sculpture except the gargoyles on the towers. The gallery also constitutes an

than the reactions of Reims, Amiens, and Chartres (south transept) to this innovation. Although no explicit statements of intent have survived, it is clear that the royal gallery glorified the institution of the monarchy through the use of biblical figures from the Book of Kings. It placed a type of monumental seal on edifices that, like Notre-Dame, solicited royal favor. So the

 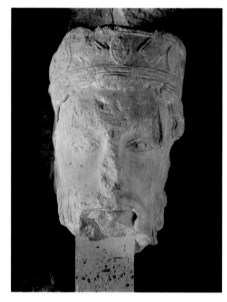

Above and right: heads from the Gallery of the Kings on the west facade of Notre-Dame Cathedral, Paris. Stone, traces of polychromy. 1220–1230. Musée de Cluny, Paris.

the Virgin over the central portal rose window rises to the level of the large rose window in the main facade (p. 255). This solution frees the theme from narrative constraints and gives an almost fairy-like feel to the sculpture. But the limit had been reached. After that date, in fact, the Marian theme rarely recurred. At the end of the century it was given a place of honor at Saint-Jean in Lyon, in the axial stained glass, in what would be its final, somewhat unexpected, appearance.

Gallery of Kings

Around 1220–1225, when the three portals of Notre-Dame in Paris had finally been organized and the facade was reaching the level where the rose window was to

affirmation of horizontality that is repeated in a lighter and more transparent fashion by the blind arcade and "open-work" gallery above the rose window, linking the two towers. The four massive buttresses that vertically orchestrate the facade are therefore cut by two strong horizontals, producing a regular geometric grid that measures some forty meters high by forty meters wide. This rectilinear design gives the facade a serious, rational air, and it is easy to understand why, once the towers were in place, the builders decided not to add steeples that would have altered this arrangement.

Nothing provides a better illustration of the constant communication between workshops, and their different approaches,

other great churches were obliged to follow suit. The chlamys, or Greek-style costume that was part of the stereotypical figure established at Chartres, was abandoned in the early thirteenth century in favor of contemporary dress: full, straight gown, belt that falls vertically, mantle held by a strap. This can be seen not only at Notre-Dame in Paris but also on the upper parts of the transepts in Chartres and Reims.

In Amiens, where there were certain difficulties in placing the rose window and coordinating the facade with the interior nave and aisles, the gallery has fewer statues and runs above a lattice-like arcade and beneath the rose window (p. 222). At Reims, whose west facade was built around 1250–1255, a different solution

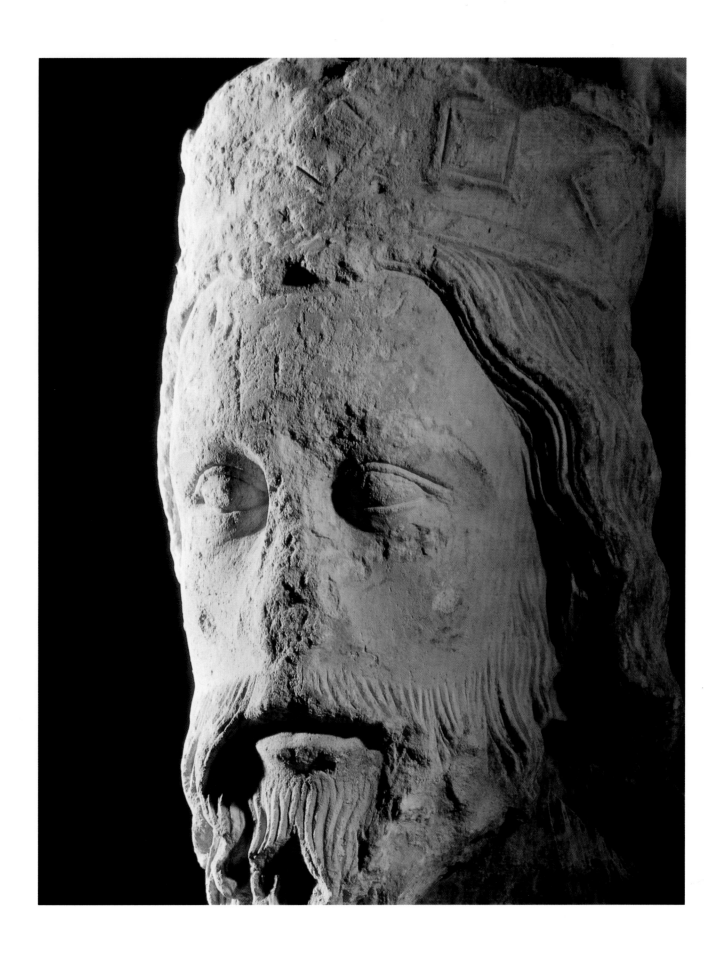

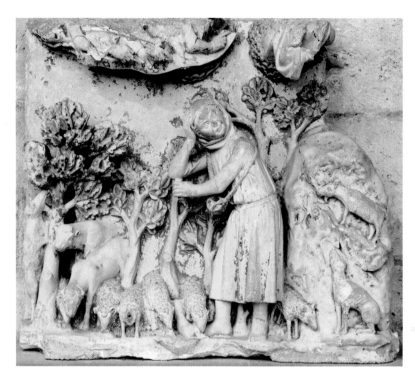

Saint Piat Chapel, Chartres Cathedral (Notre-Dame). Bas-relief from rood screen
(destroyed): Annunciation to the Shepherds. c. 1230–1240.

was adopted—the gallery was accommodated on the south transept, circa 1230. Fourteen figures are placed on high pedestals, under tall canopies, giving this original cycle impressive impact. The statues were probably executed more or less simultaneously despite differences in style, providing an important indication of diversity and tensions within this great period.[44] As to the main facade at Reims, a royal gallery was eventually incorporated—probably at a much later date—creating a strange lattice effect along the base of the towers (p. 223), that is to say in the same position as the "openwork" gallery in Paris. But here it functions as only one element among many in a highly animated, vibrating facade not unlike the church-shaped reliquaries produced by goldsmiths. No royal gallery was included at Laon, Sens, Senlis, Bourges or Strasbourg. The chapter had ended.

Contrary to what today's visitors may think, sculpture was also plentiful inside churches. In western France, where facades deploying a great deal of statuary are rare, statues were placed in the chancel. Many altars boasted carved retables. Starting in the eleventh century, the restricted part of the sanctuary, around the altar, was often protected by a sort of wall or screen. At the end of the twelfth century and certainly by the second quarter of the thirteenth, most large churches installed rood screens—it was felt necessary to organize church space by providing a convenient enclosure for the clergy. Two of the most famous rood screens, those at Chartres and Bourges, no longer exist. The rood screen at Chartres, erected around 1240, was demolished in 1763 due to decrepitude. All that remains are fragments demonstrating great diversity (animals, scenes from the life of Christ, symbols of the evangelists) and sophisticated technique, notably in the capitals (which have been compared to work at Sainte-Chapelle).[45] The Bourges rood screen, dated 1260, was demolished in the eighteenth century—its reputed vitality is another sign of the plenitude of sculpture in Ile-de-France and its influence throughout the West.[46] The abundantly carved screens were ornamented with remarkable care, for they served to attract the gaze of the faithful who might be wandering through the building, perhaps somewhat distracted; major historical and doctrinal themes were developed by stressing the narrative, anecdotal, and picturesque aspects of the Gospel, in an attempt to hold the viewer's attention more effectively. This led to sculpture that was freer than that found on monumental facades, and which might be compared to certain Italian ensembles. In the fifteenth and sixteenth centuries, rood screens provided an opportunity for compositions that were especially scholarly and sophisticated, since they constituted the only possible field for decorative additions to a building completed two centuries earlier.

7. "ROYAL" ART IN THE DAYS OF SAINT LOUIS

It would be hard to overstate the dynastic, political, religious, artistic, and cultural importance of the reign of Louis IX (1214–1270). "With all the chivalrous pride of a western Frank, he radiated the fine, authentic brilliance of royal dignity that, right up to the Sun-King, marked France in a more exemplary way than any other country."[47] Crowned in 1226 at the age of twelve, guided by his mother Blanche of Castile as regent, Louis was a king whose every move was immediately recorded in chronicles. It is therefore easier to assess the inner man—the king's intentions were explicitly stated—as well as the public one identified with his spectacular actions. His hallmarks were piety and authority, wisdom and boldness, asceticism and a sense of grandeur.

On the international level, relations between France and the Holy See were closer than ever, and the Crusades brought Europe into contact with Muslim civilizations that were henceforth able to resist, and later beat back, Christendom. On the national level, two accomplishments of major scope were effected—the power of the Plantagenets was diminished, bringing a large part of western France under royal control, and a difficult but lasting union was forged with Languedoc

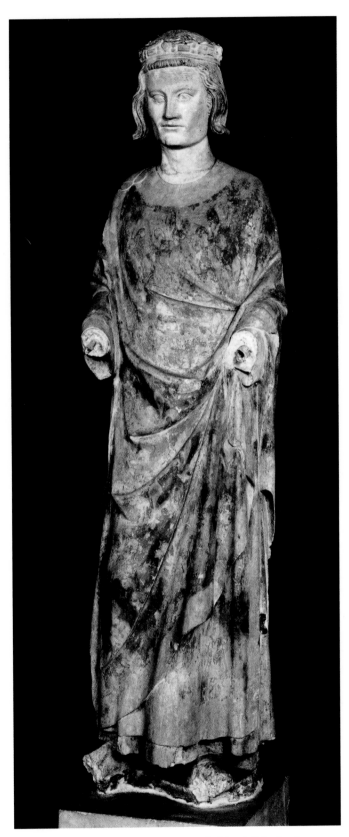

Church of Saint-Pierre, Mainneville (Eure). Saint Louis.
Stone, traces of polychromy. Early fourteenth century.

to the south. The 1259 treaty of Paris with Henry III of England, who was also duke of Aquitaine, exemplifies the first accomplishment; the second entailed the relinquishing of rights by the counts of Toulouse (1129, ultimately finalized in 1271), the resistance of Carcassonne to assault by the rebel Trencavel (1240), the destruction of Cathar fortresses like Montségur (1244), and the founding of the Dominican university of Toulouse (a harsh tool of the Inquisition, although it taught Aristotelian methods).

France, which still considered the Meuse-Saône-Rhone line to be its eastern border, reached its full configuration. But this was also the period when France exported its political and cultural activities in all directions. The most remarkable example concerns southern Italy. With the agreement of Pope Urban IV, Charles of Anjou (Louis IX's brother) was given the mission of destroying the Ghibelline faction in southern Italy and Sicily (1265), where he defeated the last Hohenstaufens. But the French made themselves unwelcome and were in turn driven out during the so-called Sicilian Vespers of 1282. The Anjou family held on to Naples, however, turning it into an active center of French Gothic culture for over a century.

Louis IX was a contemporary of Thomas Aquinas (1225–1274), who taught in the royal college founded by Robert de Sorbon, chaplain to the king. Louis's reign therefore coincided with the rise of scholasticism, in which the force of pure logic attained extraordinary expression and control over all known concepts. In Paris, minds were won over to an encyclopedic approach that featured the same precision and schematization of reality seen on figurative church facades after Chartres. All aspects of nature, and all episodes in history, had to be accounted for within the universal system, which was ultimately designed to confirm the Christian faith. It is not surprising to learn that Vincent de Beauvais dedicated his encyclopedic *Speculum* to the king (circa 1250); the three branches of his book—*naturale, doctrinale, historiale*—covered all possible knowledge. Representational art, too, attained plenitude when it became a mirror (*speculum*) of reality.

Louis IX was an itinerant king, and the long list of sojourns in his own residences or those of his vassals helps to explain the spread of royal tastes. According to Guillaume de Saint-Pathus, biographer of the king, Louis personally intervened at the site of the future abbey at Royaumont, spending more time with the masons than was strictly necessary to lay the first stone. Another chronicler claims that the same thing occurred at Châlons-sur-Marne. These signs of interest in construction, which fully accord with Louis's royal and professional style, raise the possibility that he perhaps founded, like his English counterparts, a sort of building inspectorate that Guillaume de Saint-Pathus perhaps headed sometime around 1254. This remains to be proven, but the scope of the king's projects was such that some sort of organization was required, especially given the group of effective administrators and jurists cultivated by the court of France. Furthermore, the title of *doctor lathomorum* was conferred on Pierre de Montreuil (an architect at Notre-Dame) which might allude to a specific course of instruction.

The medieval historian Jean de Joinville described the king's building activity thus: "Like the scribe who has finished his book and illuminates it in blue and gold, so the King illuminated his kingdom with a host of hospitals and monasteries for Dominicans, Franciscans and other orders. . . ."[48] From 1248 to 1254, most construction had come to a halt due to Louis's leading the Seventh Crusade. It is possible that in the Holy Land the king came to a better understanding of the role of mendicant orders and the importance of a message addressed to the common people.[49] Whatever the case, charitable

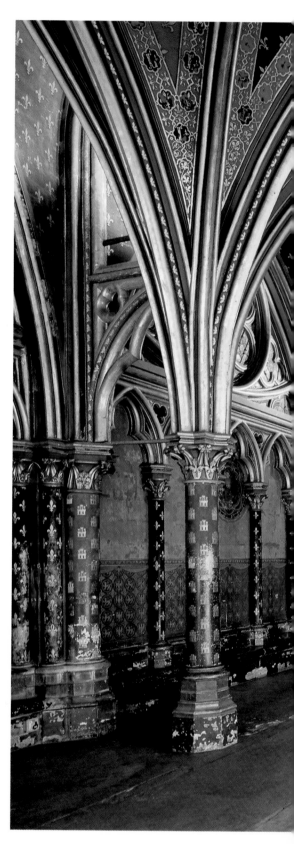

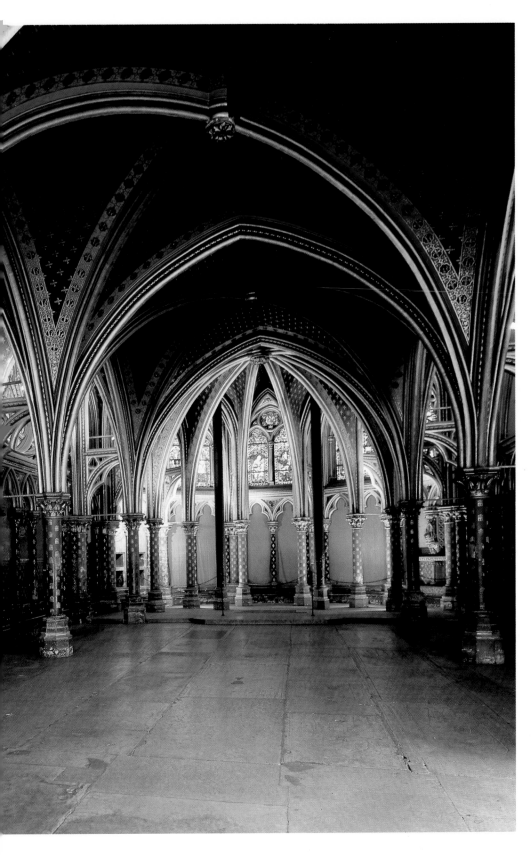

Sainte-Chapelle, Paris. The lower chapel looking west. 1241–1245.

institutions proliferated after his return: the Quinze-Vingts hospital in Paris was extended; others were founded in Compiègne and Pontoise. Then there were monasteries and colleges, which would certainly have been well-organized and functional, like everything initiated by the court. During his trips to the provinces, Louis IX saw to it that a number of buildings were completed, such as Tours Cathedral, which finally received its upper storeys.

In addition to Sainte-Chapelle—the chapel added to the royal palace, marking the reign's supreme moment in 1248—it is important to mention the transformation of Saint-Denis (starting in 1231) and, again, construction at the abbey of Royaumont (1229–1236). The king had specific designs there; he intended it to be another site of dynastic tombs to add to the prestige and solidity of the monarchy.

This range of initiatives could perhaps be discussed in terms of "Louisian art" rather than "court style" (as has been suggested)[50] or "Parisian art" (the label commonly used). The two latter terms seem more appropriate in referring to new forms of manuscript illustration, ivory, and precious metalwork, that is to say arts whose development depended much less on the taste and desires of the king than did the construction projects that truly bore the stamp of the reign.

SAINT-DENIS II AND SAINTE-CHAPELLE

The construction work on Suger's basilica, rapidly carried out between 1231 and 1241 by Abbot Eudes Clément, provided one of the first examples of a new architectural design (or, more simply, the concrete culmination of a new trend) that would have substantial influence.[51] Two typical features are the now-classic pattern of three levels (although the triforium was henceforth little more than an elegant lattice placed in front of windows) and the linear accentuation of supports, notably in the substantially raised chancel. Since the

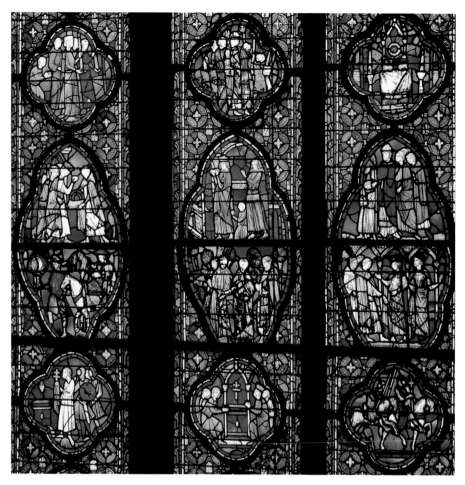

Sainte-Chapelle, Paris. Upper chapel, stained-glass window in nave:
story of the relics of the Passion (detail). 1242–1248.

eighteenth century, it has been thought that this crucial transformation was the work of Pierre de Montreuil, who was later responsible for the Virgin Chapel at Saint-Germain-des-Prés (1245) and the south transept of Notre-Dame (where he succeeded Jean de Chelles). This attitude was later challenged, on the grounds that it implied that Montreuil's style would have changed too radically. Meanwhile, the name of another architect, Thomas de Cormont (who succeeded Robert de Luzarches at Amiens) has been proposed due to his association with one specific aspect—the dado, or low wall, along each bay—which was originally a feature typi-

cal of the Champagne region and more precisely of Troyes. Another detail, the gables over the windows, tends to confirm this hypothesis.

Sainte-Chapelle, begun around 1241, must have been completed in January 1246 (when a corps of guardians was instituted), and was consecrated in 1248. The chapel was built at the express request of Louis, and was by definition one big reliquary. The idea of a devotional receptacle had grown from scale model to monumental edifice, ten meters wide and thirty-three meters high, the upper chapel alone having vaulting twenty meters high. The two levels corresponded to a liturgy estab-

lished around the chapel's remarkable relics (bought in Constantinople for the unheard-of sum of 135,000 livres) notably featuring the crown of thorns. It is hard to imagine a more telling analogy. The upper chapel (p. 125), reserved for the monarch and his retinue, was at the heart of the royal palace near the "Charter Treasure" where legal acts marked with the royal seal were recorded and preserved. Thus the "reliquary," so to speak, of the Capet crown, was next door to the reliquary of Christ's crown.[52] The iconography of the stained glass was conceived in this same spirit.

The crown itself was displayed in a shrine that cost a colossal sum. Destroyed in 1793, it featured a large reliquary chest set behind the altar in a tabernacle some two meters wide. This rather sketchy idea of the reliquary comes from a copy in a Paris miniature from 1430. Reliquary and relic were the objects of such veneration that they were still examined with unusual respect by a ranking visitor, Cardinal Louis of Aragon, in the summer of 1517: "The crown of thorns of Our Lord is in a crystal tabernacle decorated with gold from which shines like the sun a garnet the size of an egg, of inestimable value if it is as fine as has been stated; the crown is whole but without the thorns which can be seen to have been removed; it is round and large, made of thin branches of wicker the origin of which, even though Monseigneur and all of us examined it closely, could not be identified."[53] The Renaissance man dared to ask questions unthinkable to thirteenth-century piety.

The chapel has four oblong bays and a seven-sided apse. Above the low walls on which the statues of the apostles are set, lancet windows rise like veritable glass arrows. The nave windows have four lights (sections) and terminate in quatrefoils (above), while the apse windows have two lights and terminate in trefoils. This strict pattern, counterpointed by the columns of the piers, gives the mullions (the posts that divide a window into lights) an impor-

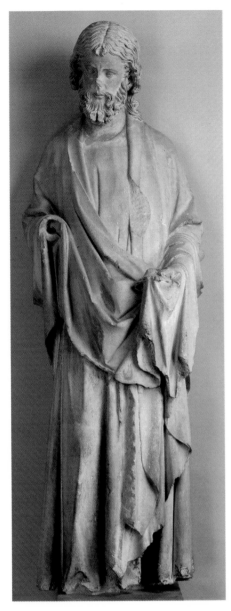

Apostle from Sainte-Chapelle, Paris. Stone.
1243–1248. Height: 165 cm.
Musée de Cluny, Paris.

tance underscored by the vertical column of stained-glass medallions.[54]

Never has the union of architectural structure and stained-glass windows been so obvious or impressive. In this respect, Sainte-Chapelle provides convincing evidence of the effect sought by Gothic art. The fifteen windows took six years to produce and mount, from 1242 to 1248,

which supposes twenty to thirty workshops working simultaneously on a clearly defined program. The iconographic coherence, that is to say the choice of themes allocated to hundreds of small medallions, is matched by the formal coherence of the arrangement of so many small frames. Figurative scenes were artfully flanked by wide or narrow strips of decorative patterning that featured gold fleurs-de-lys and castles. The vibrant colors work against perfect legibility, yet close examination (wherever possible, since a certain number of medallions are now in private collections) reveals thoroughly convincing qualities of finesse and clarity.

There was, indeed, an iconographical program, an abridged universal history based on the Passion of Christ and its relics. Nine windows depict the Old Testament, especially after the Book of Kings; then there is a cycle on the life of Christ, plus windows devoted to the prophets, to Saint John the Baptist, and to John the Evangelist who announced the end of time (the original west rose window evoked the Apocalypse). Finally, the history of relics and their transfer is depicted. The windows in the upper chapel suffered less through the ages than might be imagined—recent investigation suggests that two-thirds of the small pieces are authentic. None of the stained glass on the lower floor (pp. 260–61), however, is original.[55]

Everything conspired to turn the building of the palace chapel into an event—from the bold, brilliant conception and swift execution of a building organized around walls of glass, to the charm and quality of the stained glass itself, to the refinement of decorative details. The saintly king's prestige was significantly enhanced. The instantly famous chapel also had an almost incalculable impact on the art of construction. Whatever its religious inspiration, it represented an extreme example of the possibilities of the new system, as manifested by transparent architecture. This echoed an aspiration

clearly evident in the great cathedrals, an aspiration that would assume enough power to become one of the most frequent goals of French art.

To a certain extent, the story of later Gothic architecture is merely a chronicle of the repercussions of Sainte-Chapelle, where royal—or Louisian—art found its fullest expression. The influence on private chapels was immediate, and nary a palace chapel could afford to ignore the model. At the Benedictine abbey of Saint-Germer-de-Fly, a reliquary chapel (p. 264) repeated the basic features of Sainte-Chapelle—extensive stained glass, windows with canopy, a continuous cornice on the outside. It even displays a certain incipient affectation in the play of mullions that descend right to the floor to accentuate the effect of linear frame. The chancel at Sées (1270–1280) pursued this direction, as did Saint-Urbain in Troyes (home town to Pope Urban IV), completed in record time (1262–1270). Saint-Urbain even eliminated the triforium by completely extending the windows; on the outside, intricate gables form a sort of lacy ruff.

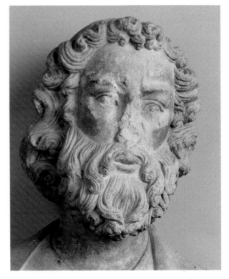

Apostle from Sainte-Chapelle, Paris (detail).
Stone. 1243–1248. Dimensions overall:
91 × 30 × 22 cm. Musée de Cluny, Paris.

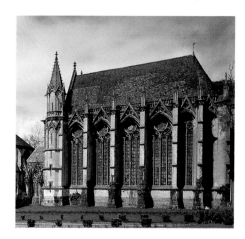

Abbey of Saint-Germer-de-Fly (Oise):
Chapel of the Virgin, southern side.
c. 1260–1267.

The links between this type of architectural structure and stained glass are so close that it is hard to disassociate the two. Such is the case at Saint-Sulpice-de-Favières, rebuilt circa 1245–1250 with a chancel very similar to the fine, airy architecture of Sainte-Chapelle; this church, a place of pilgrimage, boasted fine stained glass, of which three windows on the Life of the Virgin survive—three lancets tipped by a polyfoil rose with the Virgin and Child surrounded by angels. These pieces are noteworthy for their confident draftsmanship, free brushwork, and light palette in which yellow is interposed between blue and red; they constitute a fine example of the poetic handling of stained glass around 1260.

Major edifices still under construction were obliged to take the role of stained glass into account. In 1268, Jean de Chelles began the facade of the south transept of Notre-Dame, which was finished several years later by Pierre de Montreuil. Obviously influenced by Saint-Denis, it constituted a spectacular deployment of the new approach: a giant rose window set in a square section of wall opens across the entire surface between the buttresses, above a translucent gallery. Stained glass is accorded a triumphant role, and the entire central part of the church is bathed in multicolored sunlight.

In a sense, Saint-Denis was partly responsible for the Beauvais venture. Work on the new chancel of Beauvais Cathedral had begun around 1228, in the same spirit as the collegiate church of Saint-Quentin (circa 1220–1257) but with less pronounced radiating chapels and a layout closer to the Chartres model in terms of its planned lateral facades (only completed in the sixteenth century). Seen from the outside, the apse was hidden within a forest of high buttresses, forsaking the balanced masses of Reims and Amiens. The anonymous architect was an experimenter, or rather a conjecturer, and decided to take the standard system to its limits.[56] It should be remembered that work recommenced around 1250, that is to say after the completion of Sainte-Chapelle, which must have acted as a stimulant even though the latter was executed on a completely different scale. The bays of the apses that survived the collapse of part of the Beauvais chancel in 1284 confirm the adroit arrangement of the building and, in a sense, the validity of the system. The extraordinary upward thrust of the interior was slightly altered by doubling the supports, rendered necessary in order to carry the vault to a height of forty-eight meters. The "colos-sal" effects of 1220 were wedded to the "insubstantial" air of 1240 in a masterpiece that, it should be recognized, represented an unsurpassable limit. And the end of a cycle.

For a countertrend already existed. North of Paris, the chancel of the Augustinian church at Saint-Martin-aux-Bois, begun in 1245, took its tall bays between buttresses from Sainte-Chapelle, but the nave was built with a stretch of blank wall—strangely endowed with rose oculi—between arcade and clerestory. It almost seems like a critical comment on the fashion for transparency. By the end of the century, especially in monastic institutions, there was a return to bare interior walls (Mussy-sur-Seine, circa 1295) or to simple verticals (Saint-Thibault-en-Auxois, circa 1290–1320) that inevitably evoke the "perpendicular style" about to emerge in England. The resistance manifested by Languedoc in the south has already been discussed; even in northern France, not all architecture was willing to obey the dictates of "royal art."

FUNERARY ART

Louis decreed that the royal tombs at Saint-Denis be put in order. In 1263–1264, six tombs were built for Carolingian and Capet kings. Everything was later ravaged during the Revolution, though a few recumbent figures survive, like those of Robert the Pious and Constance of Arles. The funerary monuments of Dagobert and Charles the Bald had been placed opposite those of Philip Augustus and Louis VIII. The king wanted to be laid alongside them, but asked that his own tomb comprise nothing more than a plain stone slab; given the subsequent press of pilgrims, another slab of gilded silver was ultimately made. Once Louis was canonized, his relics had to be shared out—the head went to a main reliquary in Sainte-Chapelle (1356) and the bones were placed in a casket (restored several times). The tomb slab itself was

melted down in the fifteenth century, so Louis himself never had a tomb effigy. The royal children buried at Royaumont, however, had effigies of gilded and enameled copper. This double tomb still exists, as do reliefs (now divided between the Musée du Louvre and Saint-Denis) from the tomb of Philip Dagobert, brother of the king, also buried at Royaumont, showing a line of monks under arcades punctuated with castelets (the arms of their mother, Blanche of Castile) in lively hues of red and blue.

Louis was born at Poissy and baptized at the local collegiate church. When a papal bull confirmed his canonization on 11 August 1297, construction immediately began on a Dominican priory there, with a royal residence planned nearby. The design of the church is known from a drawing made by Jules Hardouin-Mansart, which indicates his patron Louis XIV's interest in the building. On the instructions of Philip IV the Fair, the abbey church at Royaumont, founded by

Louis VIII and dear to Louis IX, was to be used as a model. The priory at Poissy assumed a magnificent air, with a large ambulatory featuring seven chapels, a triple nave (where the nuns' stalls were placed) and facades with large portals. Such efforts were justified by the tombs of six royal children placed at the end of the transept and the statues of the saintly king and his wife, Marguerite of Provence, set over the rood screen in the rather unlikely company of their son Robert of Clermont,

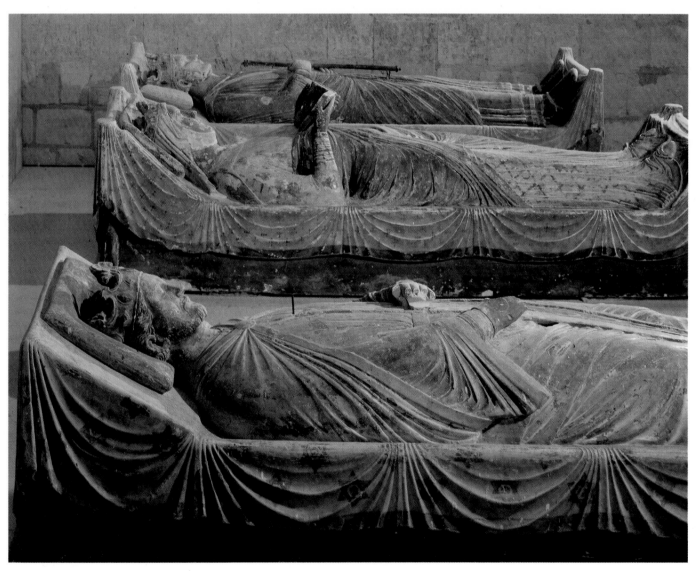

Abbey of Fontevrault. Tombs of the Plantagenets:
Richard I of England (the Lionheart), Eleanor of Aquitaine, and Henry II of England. c. 1220–1230.

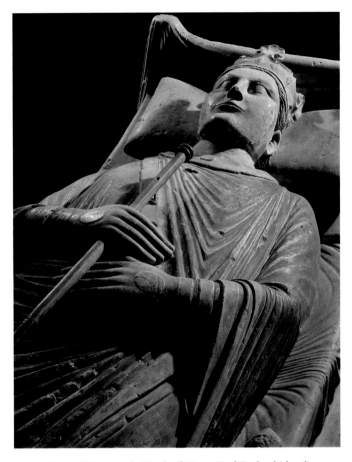

Abbey of Fontevrault. Tomb of Henry II of England (detail).
c. 1220–1230.

his relatives, assumed importance. A stereotyped appearance was swiftly established of a thin king with long hair and fine, clean-shaven features, dressed in the vertical folds of a gown, just as he was depicted on the trumeau at the Cordeliers monastery in Paris (destroyed in 1793) and perhaps also in a polychrome stone statue at Mainneville (p. 259).

There were many images of Saint Louis, from the panels on the altar of the lower chapel of Sainte-Chapelle (only known from copies) to the walls of the Franciscan convent at Lourcine (no longer extant) and stained-glass windows in the sacristy at Saint-Denis (no longer extant). One of the finest series of images is at the chapel of the Virgin of the Trinity at Fécamp, done circa 1310, comprising twenty more or less well grouped panels illustrating popular scenes like Louis's greeting the lepers, gathering the bones of the dead, and so on. This cycle presents an element of additional interest—above each scene is an extremely rich architectural canopy decorated with sharp spires, suggesting that a decorative element from Sainte-Chapelle should accompany an invocation of the saintly king.

who was still alive at the time. Everything was designed to further the cult of Saint Louis. This major ensemble was demolished in 1802, and only two statues and two squat angels survive (Musée du Louvre). It is possible that the reorganization of Saint-Denis into a royal necropolis represented a response to the Plantagenet tombs at Fontevrault, where Henry II, Eleanor, and their family were given funerary monuments (1220–1230, p. 265 and above) in the form of beds of state, on which the recumbent figures lie draped in gowns derived from effigies at Angers and Saint-Germain-des-Prés.

The extension of the Capet family to the kingdom of Naples via its Anjou branch would have important artistic implications, for the house of Anjou marked its long presence there by erecting major funerary monuments. Among the numerous daughters of Raymond-Beranger IV, count of Provence, Marguerite married Louis IX and gave birth to his eleven children while Beatrice married Charles of Anjou (in 1246) and followed him to Naples. Major building projects—the Franciscan church of San Lorenzo (1270–circa 1285) and a Dominican church with nave and two aisles plus transept—provided space for tombs in royal style, a tradition that continued into the next century with Robert of Anjou.

The influence of Saint Louis was so strong that everything concerning his personal image, legend, and—step by step—

Head of angel from the Priory
of Saint-Louis, Poissy. c. 1300.
Height: 20 cm. Musée de Cluny, Paris.

PARISIAN ART: MINIATURES

Things become more straightforward at a certain level of patronage and coherence—the *Psalter of Saint Louis*, for instance, a manuscript of two hundred and sixty pages (21 × 14 cm) produced for the king himself between 1255 and 1270, was precisely designed to accord with the liturgy used at Sainte-Chapelle (Bibliothèque Nationale, Lat. 10525). The manuscript is a lavish production whose exceptional charm and attractiveness stem from masterful illumination relying on the two most precious colors: gold (for backgrounds and architectural details) and blue (garments and decorative settings). One is immediately struck by the level of refinement. The borders, composed of alternating bars of pink and blue with stylized garlands and foliage, avoid fanciful excess because the dominant note is given by the arcades that deliberately recall the rhythm of Sainte-Chapelle, arranged in a frieze of double bays. All scenes unfold in a universe wonderfully structured by miniature gables, pinnacles, and rose windows, which has prompted the somewhat gratuitous supposition that Pierre de Montreuil himself had a hand in producing it.

The seventy-eight full-page paintings that precede the text of the prayers establish the style used for the figurines—skillfully grouped figures with crisp, lively outlines—turn Old Testament stories into delightful contemporary theater thanks to updated dress and gestures. A certain Romanesque stylization is still present in these ordered compositions, Gothic vitality reins itself in, and invention is subordinated to elegance. But the manuscript nevertheless constituted an unforgettable model or prototype. The "Parisian manner" would imitate, then endlessly repeat and dilute these marvelous models, in which the biblical tale itself lost all substance.

Chronicles would also be based on this model. Among the best known are the *Life and Miracles of Saint Louis* by Guillaume de Saint-Pathus (circa 1330–1340, Biblio-

A scene from the *Vie de Saint Louis* by Jean de Joinville: the Storming of Damietta. Paris, c. 1330–1340. Bibliothèque Nationale, Paris (Ms. Fr. 13568, fol. 83).

thèque Nationale, Fr. 5716) and the *Life of Saint Louis* by Jean de Joinville (above), presented to the future Louis X in 1309 but known via a later manuscript (circa 1330–1340) in which fanciful borders in the style of Jean Pucelle have invaded the margins (Bibliothèque Nationale, Fr. 13568).

As already mentioned, the stained-glass windows at Fécamp constitute a superb document from the standpoint of hagiography (the relationship to the biography by Saint-Pathus is clear) as well as from the standpoint of the history of stained glass. As in manuscript miniatures, scenes are crowned by foliate gables, figures are grouped in a similar way, and the transparency of glass wonderfully translates the brilliance of red and blue pigment.

This convergence brings to light a critical phenomenon, namely a sort of osmo-

sis, or mutual influence, between monumental and miniaturized versions of what are known as "rayonnant" architectural forms. Borders and frames of foliate gables or canopies represent a thoroughly typical example. They spread everywhere, from enameled reliquaries and tomb sculpture to miniatures and stained glass; thanks to this general diffusion, the motif returned to buildings—a structure like the Red Door at Notre-Dame in Paris (circa 1270) is a direct echo of this. Henceforth, in both large and small format, gables and pinnacles proliferated on upper storeys (Saint-Urbain in Troyes, 1262–1270) and in the gigantic yet transparent form of an entire portal (the "Portail des Libraires" in Rouen, after 1281). In association with miniatures, stained glass was henceforth in the vanguard, absorbing, magnifying, and dematerializing architectural forms.

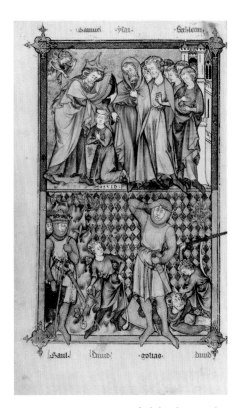

8. Precious Objects in Gothic France

In 1268, Etienne Boileau, the provost of the merchants (i.e. mayor) of Paris, produced the *Livre des Métiers* or "Book of Trades." The book constitutes a remarkable sign of the general determination of France under Saint Louis to regulate things. Attention is paid to every detail, including a title in gold and silver for goldsmiths. Sub-groups of each guild are identified, so that "image painters and carvers" are distinguished from "paternosters" (i.e. ornamental carvers). Most noteworthy, however, is the general secularization of crafts that had previously been brilliantly practiced in the monasteries. The artistic trades had become a lay affair.

Miniaturists

In the early years of the fourteenth century, Dante wrote the *Divine Comedy* which, among other things, was a long broadside against the Capet clan in general (as destroyers of the Hohenstaufen Empire) and Philip IV the Fair in particular (the odious "Judas" who had captured the Holy See). But there was also a famous allusion to "*quell'arte / che alluminare chiamata è in Parisi*" [that art which in Paris is called 'illuminating'].[57] Dante was referring to a miniaturist named Oderisi da Gubbio, known to have worked in Paris in 1269. The fame of Parisian miniatures was indisputable: in 1292, the city boasted thirteen workshops of illuminators, spearheaded by one on Rue Boutebrie run by Master Honoré, who paid the most taxes and was clearly an entrepreneur, for he produced illuminated manuscripts that were not entirely done in his hand. Along with his son-in-law and successor, Richard de Verdun, Master Honoré did put his hand to the vignettes (above left) in the *Decretals of Gratian* (circa 1288, Tours, Bibliothèque Municipale, Ms. 558), and is accredited with the *Breviary of*

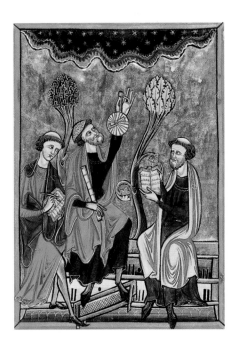

Paris Psalter: astronomer, scribe, and mathematician. Second quarter of the thirteenth century. Bibliothèque de l'Arsenal, Paris (Ms. 1186, fol. 1v).

Master Honoré, *Decretals of Gratian:* a king dictates the law to a secretary in the presence of a knight, a cleric, and a civic judge. Before 1288. Bibliothèque Municipale, Tours (Ms. 558, fol. 1).

Master Honoré, *Breviary of Philip the Fair:* the Anointing of David and David Slaying Goliath. Before 1296. Bibliothèque Nationale, Paris (Ms. Lat. 1023, fol. 7v).

Bible Moralisée. c. 1240–1250. Bibliothèque Nationale, Paris (Ms. Lat. 11560, fol. 52).

Philip the Fair (prior to 1296, left) that includes a large, full-page painting of David remarkable for its supple handling.

Producing books was therefore no longer a monastic affair, but had become a trade. Illuminators were going into business. A retrospective overview of the major examples of the Parisian manner reveals that it tended to follow in the footsteps of stained glass. This can be seen in the colors used for the large, full-page paintings in the *Paris Psalter* (kept at Sainte-Chapelle from 1335 onwards, now at the Bibliothèque de l'Arsenal, Paris, Ms. 1186). The stylized shape of the trees, the draping cloaks, and the expressive eyes and figures somewhat recall the repertoire of Romanesque frescoes (far left, below). But with the building of Sainte-Chapelle and the installation of its stained-glass windows, a decisive movement was triggered and affinities converged. Clarity of layout, dense brilliance of color, and finely drawn figures constituted a style the prototype of which was furnished by the *Psalter of Saint Louis* mentioned above.[58]

The other major production of the 1250s was an ambitious *Bible Moralisée* (left), parts of which are now divided between the Bibliothèque Nationale in Paris (Lat. 11560), the Bodleian Library in Oxford (Auct. B. IV. 6) and the British Library in London (Har. 1526 and 1527). Of very large size (43 × 31 cm), each page has two columns of four medallions each, against a gold ground, accompanied by short texts. The medallions present, in synthesized form, scenes from the Bible: Jesus preaching, miracles, the story of Moses, etc. As Emile Mâle pointed out, the idea was to play on the correspondence of the two testaments as elaborated by a gloss written by a ninth-century commentator, Raban Maur. Putting every aspect of Christian doctrine into images constituted a veritable "literary event," and the importance of the *Bible Moralisée* lay in the fact that it accorded so much importance to illustration, presenting five

La Noble Chevalerie de Judas Maccabée. 1285. Bibliothèque Nationale, Paris (Ms. Fr. 15104, fol. 50v).

thousand little scenarios in a single book. The analogy with the vertical series of medallions in stained-glass windows is obvious, and the representational style is identical. There was clearly mutual influence between all the crafts.

In the already abundant production of the late thirteenth century, crisp drawings were sometimes, so to speak, set in

Martyrology c. 1270. Bibliothèque Nationale, Paris (Ms. Lat. 12834, fol. 64v).

lead (e.g. *La Noble Chevalerie de Judas Maccabée*, 1285, Bibliothèque Nationale, Fr. 15104). From these attractive yet modest vignettes the somewhat dry clarity typical of the French manner emerged (left). In the calendar of a *Martyrology* (circa 1270, Bibliothèque Nationale, Lat. 12834), little genre scenes such as the labors of the months are enclosed in quatrefoils like stained glass and carved reliefs on cathedrals (below left). This manner ultimately unified all the arts.

GOLDSMITHS

Precious metalwork, like illumination, was no longer practiced exclusively in monasteries. A secular guild in Paris had taken up the lead. It had, of course, its own chapel, devotions, and feast-days. The 1292 Book of Trades credits the guild with 120 members, which supposes fairly dynamic activity in the boutiques on the Pont-au-Change. Because goldsmiths worked with precious metals, they were veritable holders of wealth and were often in direct contact with royalty. Enameled copper tomb monuments were still being produced, as evidenced by ones for the tombs of Saint Louis's children at Royaumont, not to mention many other effigies such as the plaque made by Jean Chastelon for Thibaut III and Thibaut IV in Champagne in 1267, or the elegant plaque of Guy de Meijos (1306, Musée du Louvre) showing the nobleman kneeling before the Virgin, cloak dotted with fleurs-de-lys, all set against an enamel ground of quatrefoils.

Liturgical objects were being made in such numbers that the term industrial art is appropriate for Paris and for a still-active Limoges. Among extant reliquaries, there is the exceptional casket of Saint Taurin made from 1240 to 1255 for Evreux, in imitation of Sainte-Chapelle, similar to the no longer extant grand reliquary. Saint Taurin is shown under the porch with his crook, clearly a reduced copy of a statue. Gone, alas, is the gold

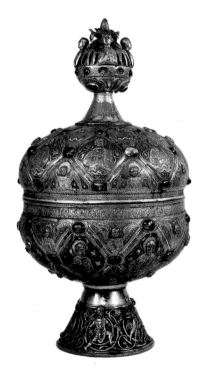

Ciborium signed G. Alpais.
Champlevé enamel on gilt brass.
Height: 34 cm, diameter: 16.8 cm.
Limoges, late twelfth century.
Musée du Louvre, Paris.

reliquary of Saint Genevieve made by a goldsmith named Bonnart in 1242, showing the twelve apostles. Gone, too, is that pride of goldsmiths, the reliquary of Saint Marcel that was once behind the high altar of Notre-Dame.

The somewhat monotonous form of reliquaries was occasionally given a fancy twist. In the early thirteenth century, a workshop in Ile-de-France produced a four-wheeled carriage/monstrance/reliquary that strangely recalled certain Celtic objects; the gilded copper was studded with big cabochons and a fine piece of rock crystal (Church of Saint-Aignan, Orléans).

Nearly a thousand reliquaries containing a piece of the Cross have been identified, and France was full of them in the thirteenth century. Limoges dominated the production of these reliquaries. Examples include a cross, designed as a multiple reliquary, featuring double cross-bar and finials, filigree work, and gems, but without figures (circa 1220, Eymou-

tiers). More successful than that somewhat heavy piece was a casket made for Toulouse (below), along the sides of which are figures depicting the Discovery of the Cross, interspersed with decorative turquoise, and rosettes of white and red enamel. On the roof-shaped lid there are scenes of the Ascension and of the Women at the Tomb (a tomb disconcertingly striped in yellow and green), all artfully arranged (Saint-Sernin, Toulouse). This already venerable type of casket was not always executed with so much care. Yet however common they may have become through their popularity, Limoges reliquaries often display a special charm, with copper figurines against an inimitable ground of turquoise blue and green.

Just as few secular objects in precious materials have survived, whether enameled or not, so ecclesiastical items, however refined, have also tended to disappear. An exception is a ciborium (left) by Master

Alpais (Musée du Louvre); a diamond-pattern covers the globe, framing busts of the Virgin and saints, with a gem at each point of intersection. Another category of liturgical object that has been profitably studied is the bishop's crook. Nothing displays the resources of Gothic inventiveness better than the decoration on these spiral-curved staffs, symbolizing the role of shepherd. They could be given simple majesty through a patchwork of warm, enamel colors, but goldsmiths—as though irresistibly attracted by the teasing curl—almost always placed a dragon's head of some sort on the end, thereby following the logic of miniaturists who animated a curlicue in the margin of a manuscript. Extremely delicate figures might be inserted into the gaps in the spiral, sometimes engaged in small battles in which saints, always in filigree, confront some resurrected Romanesque monster.

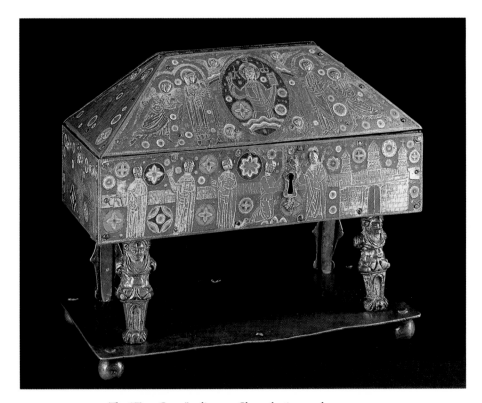

The "True Cross" reliquary. Champlevé enamel on copper.
Limoges, late twelfth century. 13 × 29 cm. Basilica of Saint-Sernin, Toulouse.

Several crooks in ivory display the same virtuosity of design. A charming example from Provence, that serves as transition to the next section, boasts an exquisite scene of the entombment, in which all the carved elements are as fine as thread (circa 1260, Musée Réattu, Arles).

IVORY CARVERS

The minor arts have never really deserved their name. They followed the same rules as monumental art, itself fascinated by the infinite repetition of wonderful detail. The thirteenth century was a period when everything was moving toward the refinement of a shared style, enabling ivory objects to play an unexpectedly prominent role. It was during this period that carved ivory became another Parisian speciality. Although the production of secular vanity objects is well-documented only from the fourteenth century onwards, a series of major religious pieces were produced earlier. People obviously delighted in the polished, gleaming finish of these little sculptures sometimes enhanced with paint or gold leaf.

Three types have been identified. Diptychs, which stood easily on an oratory or table, presented veritable architectural settings around the carved figures (such as the *Soissons Diptych*, circa 1300, Victoria and Albert Museum, London, p. 103). Then there were large groups of figures, some twelve inches high, constituting a tableau like the Coronation of the Virgin or the Descent from the Cross (circa 1260, Musée du Louvre, right). Finally, there were statuettes, notably of the Virgin, that became the speciality of Gothic ivory. The material itself conveys softness and grace, and the vogue for ivory reflects the taste for a delicate mannerism that found its finest expression in this medium. Statues like the Golden Virgin in Amiens or the Virgin on Notre-Dame were produced in reduced-scale, ivory versions. Classical Greece, which immediately comes to mind, also produced commercial figurines

Descent from the Cross. Ivory with gold leaf. c. 1260. Height: 29 cm.
Musée du Louvre, Paris.

that copied illustrious statues. Famous originals have always been made widely known through such copies. It is nevertheless inaccurate to suggest that Gothic production of "beautiful madonnas" was limited to this somewhat simplified role, since workshops rivaled one another in elegance and quality (at least in certain cases) to the point of supplying new ideas to designers and sculptors themselves. The issue of influence, however, would only become acute in the fourteenth century.

HUMOR AND EXOTICISM

The practice of setting decorative tiles into the floor extended largely beyond France; it came from Tuscany, and was popular in England (London, Canterbury). Around 1260, at Saint-Omer, it resulted in a cycle remarkable for the arrangement of medallions and the imaginativeness of figures curled in small regular frames in which the exotic alternates with the geometric.[59]

It was mainly in Normandy that glazed terra-cotta tiles, perhaps of Spanish or Eastern origin, were used—examples have been found at Sainte-Catherine-du-Mont in Rouen (Musée des Antiquités, Rouen) and the chapter house in Coutances. They were also used in England. These handsome, shiny tiles were relatively easy to manufacture and appealed to certain Cistercian monasteries such as the one in Beaubec which were, moreover, reprimanded by their superiors on that score.

The appeal of geometric compositions enlivened by small, more or less fantastic configurations is highly revealing. At Saint-Pierre-sur-Dives in the Calvados region of Normandy, a rosette three meters across, forming a veritable tiled carpet, displays concentric circles with eagles and griffons. Decoration served as the medium for imaginative exuberance that might include Kufic characters or signs of the zodiac. Such curiosities and fanciful items should be reincorporated into our view of the Gothic world.

Willem van Ruysbroek, a Franciscan monk in the service of Louis IX, was sent to the Mongol court in 1253. His amazing account mentions a group of Christians living at Karakorum, including a Parisian goldsmith named Guillaume Boucher.

Laon Cathedral (Notre-Dame). West facade (detail): gargoyle in the form of a rhinoceros. c. 1212–1215.

Boucher had been captured by the Mongol hordes that advanced as far as Belgrade in 1242; not only did he continue practicing his craft, he staged the encounter of Gothic "monsters" with Chinese "monsters."[60] Van Ruysbroek

Villard de Honnecourt's notebook: foliate head of a bearded man and foliage designs. c. 1220–1230. Bibliothèque Nationale, Paris (Ms. Fr. 19093, fol. 5).

notably described a "magic" fountain of silver set on a base of four lions, with intertwined serpents (i.e. dragons) spewing strong liquors while an angel blew a trumpet. The fountain presents a striking analogy with certain devices shown in Villard de Honnecourt's sketchbook, such as a "musical" bookstand, and a dragon enclosed in the letter S. Such objects derive from the venerable technology of automatons acquired from Byzantium and Arab treatises. Items produced by Parisian goldsmiths obviously contributed to the prestige enjoyed by French art in the Far East, demonstrating that the world was not as isolated as it once had been; as of the fourteenth century, exotic elements (based on fanciful notions) began appearing in Western art.

England was highly active in this sphere, becoming the repository of apocalyptic and visionary subjects whose importance was waning in France. After the Romanesque period, French artists were never able to rival the phantasmagorical imagery of Canterbury or Winchester. But echoes could still be found in works like Richard de Fournival's *Bestiaire d'Amour* (circa 1250, above right) and Gossouin de Metz's *Image du Monde* (1248). They provided a medium for illustrating rare and fantastic animals that sprang from folklore or from travelers' accounts, ultimately leaving a lasting mark on illustration and decoration.[61]

It is sometimes surprising to come upon a clownish illustration in the margins of a sacred text or commentary, but it should be remembered that Franciscan and Dominican preachers were in the habit of concluding their sermons with *exempla*, that is to say amusing anecdotes, puns, and occasionally risqué jokes.[62] The twin registers of the earnest and the acrobatic—serious stories with light-hearted accompaniment—appear to have been de rigueur, and can even be observed in the Bayeux Tapestry. Romanesque sculpture took wonderful advantage of this by

Richard de Fournival's *Bestiare d'Amour* (written c. 1250; a copy dated 1400–1435.) Bibliothèque Nationale, Paris (Ms. Fr. 15213, fol. 30).

Right:
Le Roman de la Rose, by Guillaume de Lorris and Jean de Meung. Manuscript c. 1330–1340. Bibliothèque Nationale, Paris (Ms. Fr. 25526, fol. 111v).

the monstrously cruel became monstrously comic. Newly liberated humor could use all the resources of exoticism and decoration in an authentic and precise mode of expression. At Rouen Cathedral, the quatrefoils along the base wall of the Calendar Portal were decorated around 1270–1280 with little hagiographic scenes whereas twenty years later, on the "Portail des Libraires," similar medallions were endowed with droll and fantastic creatures descended from the exotic and extravagant fauna of yore, though now tamed by humor. In this world of extraordinary contrasts, the elegant quatrefoil became, as later at Lyon, the receptacle for either elegant "Parisian-style" images or bizarre monstrosities.

The moment has probably come when, in conclusion, the disparate nature of the two parts of the *Roman de la Rose* must be mentioned. First there is the courtly quest, gently symbolic and floral, in the four thousand lines by Guillaume de Lorris (circa 1225–1240), the numerous manuscripts of which are illuminated in the pure Parisian style using abstract decorative grounds and fine figures. Then there is the broad encyclopedic and critical discourse of eighteen thousand lines, penned by Jean Clopinel (called Jean de Meung) around 1270, that accords with the satirical vein reflected in marginalia and accessory decoration (below). This single book incorporates the two contrasting aspects of a constantly see-sawing mentality.

allowing the imagination and the grotesque to inhabit evangelical scenes. After a period of calm and order during the first half of the thirteenth century, the need to joke and clown appeared again with increasing force in sculpture and manuscript illumination, culminating in the work of Jean Pucelle.

A *Chansonnier de Paris* (circa 1300, Montpellier, Bibliothèque de la Faculté de Médecine, Ms. 196) offers a fine example of the amusing device of incorporating small bizarre animals into a decorative pattern. Robert de Boiron's *Histoire du Graal* (circa 1280, Bibliothèque Nationale, Fr. 95) presents little pantomimes and countless caprices on the borders, which are no longer just animated scrolls and strange terminals, but an entire subversive and humorous poetry related to an upside-down world (Chrétien de Troyes wrote in *Cligès,* circa 1170, "Thus go things upside-down"). The burlesque could even be found in psalters, in the *Heures de Mahaut d'Artois* (circa 1300, Cambrai, Bibliothèque Municipale, Ms. 87).

Thus, though long in gestation, it was during the second half of the thirteenth century that a significant shift occurred:

9. Castles and Towns

Philip Augustus's capture of Château-Gaillard in 1204 after a famous siege marked the end of an era, insofar as the future of an entire province would never again depend on a single fortress. Yet at no other period had it been so easy to perceive the relationship between a castle and its site, which it incarnated and magnified. A position on a spur overlooking the meander of a river not only provided defenders with unimpeded views in all directions, it also encouraged a structured mass to rise up with almost natural dignity. Rulers and engineers knew that a castle had to mark the landscape, as did the superb fortress at Najac, overlooking the Aveyron River (right). After the Duchy of Toulouse became part of the royal domain, Alphonse de Poitiers refurbished Najac in 1253, and today's ruins betray features highly typical of that period—two walls, a large military tower or keep, and a square residential tower. This powerful structure could shelter the entire peasant population in a crisis, yet was also designed to be a spectacular demonstration of the long-range visual impact of an intrepid stone edifice on the horizon.

Among the castles built in the Ile-de-France region in the thirteenth century were several large examples erected by

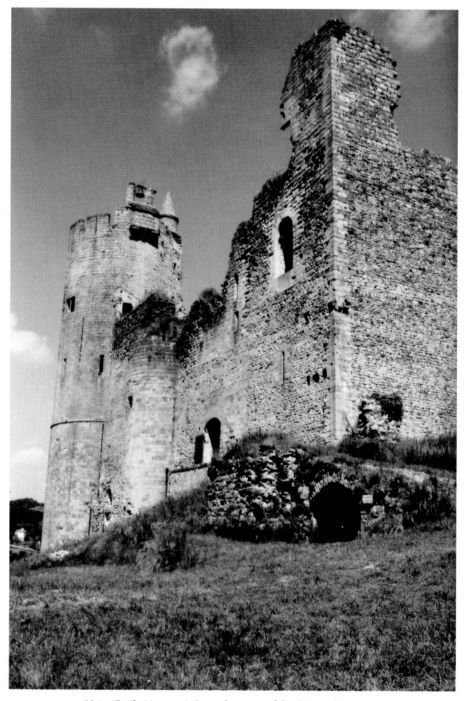

Najac Castle (Aveyron). Second quarter of the thirteenth century.

knights who were not of high rank but who, having proved their valor at the battle of Bouvines, received royal favors.[63] Seignorial residences of the old nobility were thus challenged by those of upstarts,

a phenomenon that would recur several times in the architectural history of the area, for a castle was more than ever a grand title of nobility.

This is well illustrated by the story of

Coucy, where Enguerrand III built a colossal fortress to assert his power and demonstrate the validity of his claims. The castle is well-known despite its demolition in 1917, because it interested Androuet Du Cerceau who made a detailed plan of it, and because Viollet-le-Duc also studied it closely and drew an elegant section of the large keep. An immense wall ringed the hill, punctuated by round towers. In the middle was the castle chapel, where an entire town could camp if necessary. The enormous, three-storey tower (thirty-two meters in diameter, fifty-four meters high) was topped by a lantern overlooking the domain, and included a large hall, a gallery, and so on. The lord of Coucy undertook all this building to demonstrate that he was more powerful than the king himself—a keep became a piece on the political chessboard. It was costly and cumbersome, but eloquent.

The final years of the twelfth century saw the construction of the keep in the Temple, that enormous Parisian fortress— a veritable fortified town—which belonged to the increasingly influential Knights Templar. The Temple was also a financial powerhouse, which in the end led to the order's downfall. Nothing of the keep survives today, but there are accurate depictions of a high, square tower, flanked by round turrets, containing four vaulted rooms around a central pillar, with an avant-corps which led from one floor to the next. Examples such as the Temple in fact represent a sort of return to the residential Romanesque keep.

Saint Louis's long stay in the Holy Land spurred his interest in defensive fortifications at places like Sidon, Jaffa, and Caesarea. The building capacities of European lords in these lands of stone and brick architecture were impressive. Equally striking was their concern to build Gothic halls within the fortifications, the ribbed vaults of which reminded them of their own country, as seen at Krak and Athlit (Pilgrim Castle). That period ended

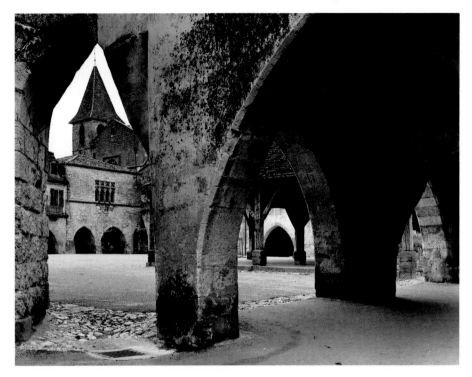
Monpazier (Dordogne), founded in 1284 by Edward I of England, view of the marketplace.

in 1291 with the fall of Saint John Acre, the last stronghold in the Holy Land. But European institutions survived, including fortifications that today are ruins reflecting a distinctly "French" style: Saint-Hilarion Castle and the Famagusta fortress on Cyprus, which the Lusignan family ultimately inherited; Clermont (or *Shlemutsi,* circa 1220–1223) in the Peloponnesus where the Villehardouins carved themselves a principality after Constantinople was taken; and Mistra, another Villehardouin castle built of fine stone for William, prince of Morea (1248–1278).

TOWNS

Thirteenth-century town development will be touched upon briefly here, in the light of the century's need for regularity and (relative) order. But it represents a complex sphere involving several fields— topography, economics, sociology, and, to a certain extent, art.

Starting in the twelfth century, the spurt of new towns and royal foundations was linked to the adoption of regular plans that accompanied the lord's authorization, charter, or contract. The original layout can still be detected in the current configuration of towns seen in aerial photographs, as demonstrated in Auvergne, for example.[64]

Taking larger cities as an example (the exact size of which can often be estimated by the number of religious foundations), it appears that the arrival of the mendicant orders led to major changes. Their occupation of the land, or more precisely their nearly symmetrical implantation at both ends of a town, lent a certain equilibrium to urban centers in France, as in Italy.[65]

The creation of towns from scratch was indicative of a new situation characterized by new initiatives as the art of town planning was mastered. The annexation of the south by the Capets provided a town-building opportunity—Alphonse of Poi-

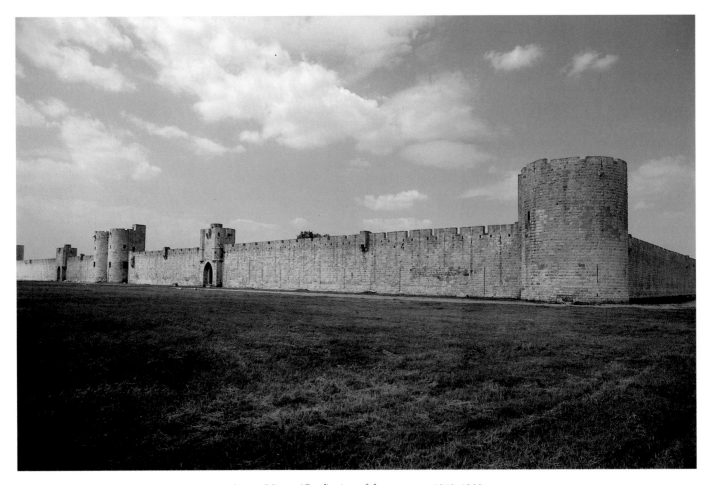

Aigues-Mortes (Gard), view of the ramparts. 1240–1300.

tiers, Louis IX's brother, was allegedly responsible for founding forty-five towns, from Villeneuve-sur-Lot to Sainte-Foy-la-Grande. These initiatives are particularly interesting because for the first time urban development entailed a studied handling of space. Of very modest dimensions, such towns were little more than large farm complexes. There was competition between villages chartered by the king of France and those charged by the English king; yet they were not strongholds, but rather a group of residential and commercial buildings built around a large, arcaded market square. These communities have been correctly described as developed rural centers, and often have a great deal of character due to the geometric regularity of the core town, for example at Grenade-sur-Garonne and Monpazier (founded by King Edward I of England in 1284, p. 275).

The most interesting urban development during the century of Saint Louis therefore took place in the south of France. Villefrance-de-Rouergue, the seat of the counts of Toulouse and a major trade center, owed its fate and privileges to Alphonse of Poitiers. The town's checkerboard plan gives it a unity and rigor easily seen in an aerial photograph or in the mind's eye, map in hand.

Any overview of the period requires discussion of two typical sites, Carcassonne (restored in the nineteenth century, right) and Aigues-Mortes (restored in the twentieth century, above). Aigues-Mortes was begun in 1240 as a launching port for the Crusades, and is a good example of medieval town planning (as fate would have it, the French monarchy's maritime policy was a failure in the long run). It was planned as a rectangle with six gates, in a clever checkerboard pattern designed to create windbreaks. It also had an extremely well appointed control tower, the Constance tower, and constituted an ensemble of impressive bearing.

As to Carcassonne, Viollet-le-Duc's model reconstruction created a fine theatrical effect with the fortress overlooking the Aude River on a long-inhabited site. Carcassonne became a French royal city in 1226, following the conquest of the county of Toulouse and the capitulation of Count Raymond VII, and was endowed with fifty-two towers, six barbicans, a castle to the west, the Narbonne gate to the east, and two skillfully devised protective walls.

Engineers working for Louis IX of France and Philip the Bold of Burgundy were active everywhere. It was a time when the urban landscape was also being shaped by large bridges such as those in Avignon (Saint-Bénezet bridge, which has lost two-thirds of its piers), Orthez, and Cahors (the well-constructed Valentré bridge, 1308).

Every French town has its profile, or visual character, just as it has an escutcheon or coat of arms. In many cases, this profile or character was defined in the thirteenth century. The construction of the great cathedrals was spurred by what might be called "municipal" aspirations, for each city wanted to have *its* church. And cities have been permanently marked by that effort. It might be useful here to raise the issue of cathedral spires, those "pyramidal" projections toward the sky that were both visual beacon and homage. Saint-Sernin in Toulouse was one of the southern basilicas with the most relics—it was completed in the twelfth century, but the high bell tower over the crossing, which so efficiently concludes the ensemble, was only finished in the thirteenth century. Likewise at Caen, in Normandy, the original Romanesque building was endowed not only with a vast Gothic chancel but also with stone spires, which were mounted on the twelfth-century towers. At the crossing, a bell tower fully one hundred and twenty meters high was erected, but it collapsed in 1566 and was never replaced.

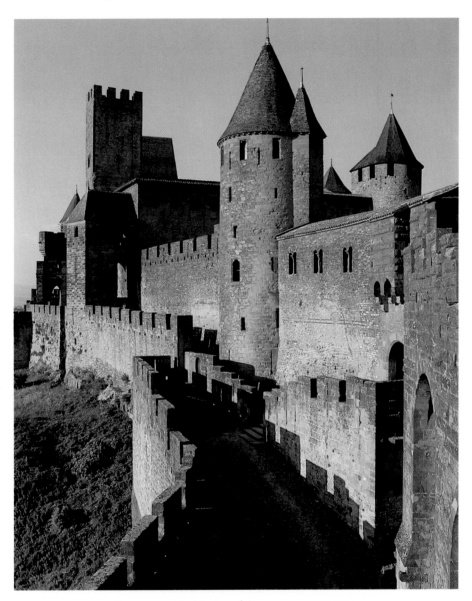

Carcassonne (Aude), view of the ramparts. 1250–1300, restored by Viollet-le-Duc starting in 1844.

The spires apparently planned for the towers of Notre-Dame in Paris, Amiens, and Bourges were never built. Of Chartres' two twelfth-century towers, only the right-hand one is topped by a Romanesque spire (restored in 1896); the left spire was not built until the sixteenth century by Jean de Beauce, perhaps because spires, long considered optional, were felt to be essential to the overall profile at a certain point. The same thing occurred in Rouen, where construction dragged on forever—the central spire collapsed in the sixteenth century, so was rebuilt from 1523 to 1544, the current one being a cast-iron replacement done by Alavoine in the nineteenth century. The facade of Strasbourg Cathedral, begun in 1277, was erected very slowly but, with the eventual completion of a dazzling, single spire, the city finally acquired its emblematic image.

III ARISTOCRATIC GOTHIC

1. TROUBLED TIMES

"Days of pain and temptation."

"In the history of French art, the fourteenth century was a moment of special importance: it was the moment when it was decided that the art of the Middle Ages would die, without having reached its culmination, that instead of becoming progressive it would become decadent," wrote Ernest Renan in 1865.[1] Renan's global judgment covered, in his view, not only poetry and literature but all the arts. This idea of a more or less accelerated decline of the grand art of the thirteenth century has become a commonplace that accords easily with the countless series of misfortunes, rivalries, and civil struggles of the period. Yet it has the drawback of allowing historians to dispense with the need for close study of artistic production, which turns out to hold more surprises than is generally supposed and which stunningly enriched "the French manner." Renan's nineteenth-century view, then, has been modified by the past fifty years of scholarship.

Following the reigns of Louis IX (died in 1270) and his grandson Philip IV the Fair (1285–1314), a disconcerting series of *rois maudits* ("cursed kings") led to the unexpected accession of the first Valois, Philip VI, in 1328, and to the most disastrous of Anglo-French crises. The dynastic rivalry commenced in 1337 when Edward III of England, son of Philip the Fair's daughter, laid claim to the French throne, and was rejected on the grounds that a woman could neither inherit nor transmit the right to inherit the crown.

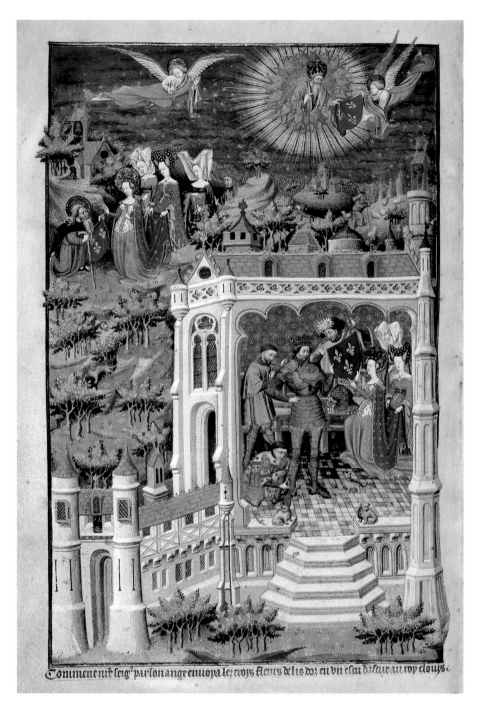

Master of Bedford and assistant, *The Bedford Hours:* the legend of Clovis and the origin of the *fleurs-de-lys.* c. 1429. British Library, London (Add. Ms. 18850, fol. 288v).

The resulting conflict lasted one hundred years, with the English occupying a good part of France from Calais to the Poitiers region, as well as Aquitaine. French royal patronage, directives, and influence nevertheless remained strong until the lamentable defeat at Crécy (1346) and, worse, the battle of Maupertuis (near Poitiers) in 1356, when the Black Prince, Edward III's eldest son,

captured the king of France, John II the Good. Prior to his death in 1364, John had created an entirely new situation by instituting the system of appanage—or land grants to members of the royal family—by giving the duchy of Burgundy to his son, Philip the Bold. The political disintegration was so serious that the king of Navarre, Charles the Bad, refused to recognize the French king's authority. In 1358 the provost of merchants of Paris, Etienne Marcel, took advantage of the confusion and the king's absence to defy the dauphin Charles (Marcel perhaps envisaged the establishment of a free municipal government with the backing of a foreign coalition). It took the extraordinary skill of the dauphin, the future Charles V, to put the house back in order.

In the mid–fourteenth century, France had to grapple with the ills that plagued all of the West—epidemics and princely rivalries. The bubonic plague arrived from the south in 1348 and its terrible aftermath lasted for a good fifty years. Horrible and inexplicable, the plague was truly a calamity from heaven. According to all evidence, it ultimately killed nearly half the population, provoking a general upheaval so obvious that, as Georges Duby put it, "in reality it marked the end of an historical epoch, the one that out of habit we continue to call the Middle Ages." Yet although echoes of these misfortunes are apparent in literature, and although an obsession with death characterizes contemporary poetry, it should be recognized that, contrary to facile assumptions, an atmosphere of fright and dereliction is not evident in painting or the visual arts. There was merely a predictable and mild intensification of piety toward Saints Roch and Sebastian, whose statues were found in churches in greater numbers. Obsession with the macabre did not appear until later, in the following century. What *was* observed at the time was a denial of calamity; lucky survivors exhibited the well-known phenomenon of frenzied indulgence in luxury, in elegance, and pleasure.

Nothing better illustrates this situation than the work of poets and musicians who marked that period, such as Guillaume de Machaut (circa 1300–1377). In addition to his famous *Notre-Dame Mass* and numerous motets, he composed songs like:

Musique est une science
Qui veut qu'on rie et chante et danse
Cure n'a de merencolie
[Music is a science
 Inviting laughter, song, and dance
 Caring little for melancholy]

Eustache Deschamps (1346–1407), a remarkable poet of disenchantment, was amazingly inventive and gave the old denunciation of the human world a harsher tone:

Temps de doleur et de temptacion
Age de pleur, d'envie et de tourment
Age en tristesse qui abrège la vie.
[Days of pain and temptation
 Age of tears, envy, and torment
 Ageing sadness that shortens life]

Both Machaut and Deschamps, of course, were associated with the nobility. Machaut's patron was John of Luxembourg, who died at the battle of Crécy in 1346, then his daughter Bonne, and finally Jean, duke of Berry. Deschamps was one of Charles V's high-ranking officials; as a witness of the disorder that followed, he could be both sardonic and dismayed.

These contradictions hold the key to the situation. For they provide a test of the solidity of the accomplishments of the previous ages, of artistic vitality in protected zones or peaceful moments, and of the impact of such powerful events on cultural development. The author of the *Chronicles of Saint-Denis* supplied an interesting explanation for the unfortunate outcome of the battle of Crécy: the nobility was behaving poorly, and the Lord wanted to punish its members for the immoral habits they had adopted. Short dress (too short for the liking of moralists and the church) had won out over the long dress that Philip the Fair felt obliged to wear as an example to others. The chronicle is worth

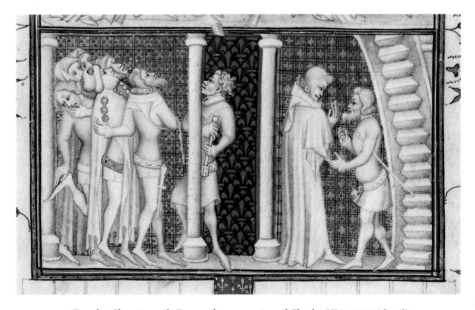

Grandes Chroniques de France: the coronation of Charles VI in 1380 (detail).
Bibliothèque Nationale, Paris (Ms. Fr. 2813, fol. 3v), added c. 1381 to the Charles V *Chroniques.*

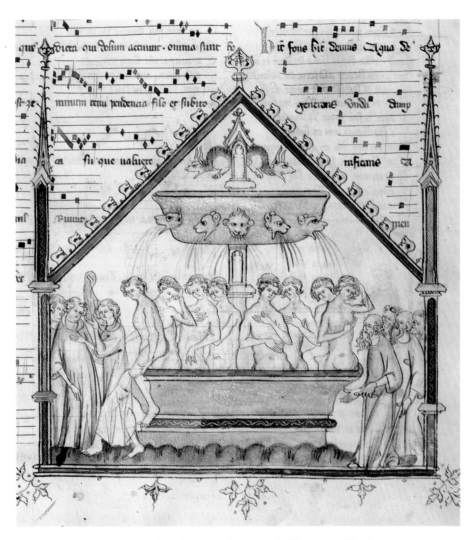

Gervais du Bus, *Le Roman de Fauvel*: the Fountain of Youth.
c. 1320. Bibliothèque Nationale, Paris (Ms. Fr. 146, fol. 42).

As to French women (not mentioned by our commentator), like their English counterparts they wore plunging necklines and tight tunics, and above all delighted in complicated and fantastic headdresses, of which the horned hennins were just one example; head finery was so tall and architectural that the moderate queen of Charles V, Jeanne of Bourbon (died 1377), was unable to curb it. The headdress would continue to become bigger and more elaborate in the festivities of Isabeau of Bavaria, as recorded in miniatures and tapestries.

Moral turpitude—exemplified by dress—became a common theme of preachers and poets following plagues and political disasters. An incredible romance by Gervais du Bus, the *Roman de Fauvel* (between 1320 and 1350, these pages), brutally and ferociously denounced the nobility. There was nothing fundamentally new in that, except that this time it concerned two high officials of Philip the Fair for whom "the garden of sweet France" was ravaged by a series of vices summed up in the fantastic name and appearance of Fauvel, a monster whose name spelled "*Flatterie, Avarice, Vilenie, Vanité, Envie, et Lâcheté* [cowardice]." A society that feared neither God nor man was laughable—the "fools" and "idiots" whose vulgar jokes were found amusing were seen to be wisest. The *Roman de Fauvel* also included songs and striking illustrations, such as the justly famous *charivari* or "hullabaloo" (Bibliothèque Nationale, Fr. 146).

But down-to-earth irony was only one aspect of the social game. A taste for ostentation became general, as proven by the extraordinary spread of escutcheons. There was a marked infatuation for heraldry and coats of arms, with all social categories and classes imitating the aristocratic fashion. This important visual phenomenon will be discussed below, given its obvious consequences for painting and sculpture.

quoting: "Great also was the impropriety of clothes worn throughout the kingdom, for some had robes so short they came only to the buttocks and when they bent to serve a lord, their breeches showed to those behind them. And in like manner these were so tight that they needed help to dress and to undress, it was like flaying them when they undressed. And others had flounced robes like women; and also wore breeches with a leg of one fabric and the other of another; and their cornets and sleeves came close to the ground and they seemed more like entertainers than other people. And for that, it is no wonder that God wanted to correct the abuses of the French through his scourge, the king of England . . ."

The jerkin or short doublet originally worn under a coat of mail thus became a popular civilian fashion when embellished with padded shoulders, gold embroidery, and a large belt for purse and dagger. Tight, particolored leggings represented the height of fashion. They ended in a sole or slipper that was pointed at the toe and could even be elegantly attached to the knees by a little chain.

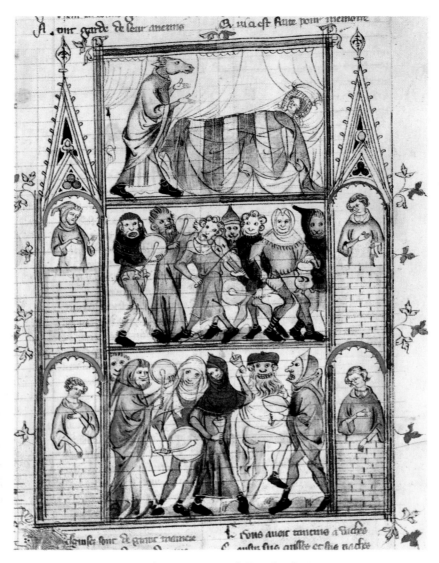

Gervais du Bus *Le Roman de Fauvel:* a charivari.
c. 1320. Bibliothèque Nationale, Paris (Ms. Fr. 146, fol. 34).

By one of those lucky reversals that the history of France would undergo on several occasions, the relatively brief but extremely active reign of Charles V (1364–1380) would lend new weight to royal authority. Charles reorganized what he could and, most notably in terms of the present discussion, instigated a "cultural" policy of great scope, spurring artwork that consciously aimed at renewal and elevation. This key period was of enormous importance for Paris, yet still could not compare with what had occurred in the previous century. It was followed, moreover, by one of the strangest periods in the entire history of the French monarchy, the reign of Charles VI (1380–1422). Charles, only twelve when his father died, suffered the regency of his uncles and then, once in power himself, went mad in 1392 at the age of twenty-four. This produced colossal anarchy, abetted by the English presence to the east, the ambitions of the dukes of Burgundy to the west, and the inconsistencies and deceptions of irresponsible and destabilizing policies at home.

The period was epitomized by the absurd defeat at Agincourt (1415) and the Treaty of Troyes (1420) that named Henry V of England (1387–1422) the legitimate heir to the French throne. A fine conclusion to the selection of Philip VI of Valois over the English line and their claim based on female descent a hundred years earlier!

COURT ART

The status of artistic activity, meanwhile, had changed completely. It would be inaccurate to imagine the reign of Philip the Fair as being comparable in mores and culture to the Regency that followed the reign of Louis XIV four hundred years later. There was no slacking off. To the contrary, the period was characterized by an administrative monarch with a powerful chancellery that was able to oblige Pope Clement V to leave Rome for Avignon. This administrative monarchy assumed fiscal controls that led to the ruin

of the Knights Templar beginning in 1307. Everything pointed to a concern to pursue established practices—the "royal tomb policy" and commissioning of psalters were officially confided to the monarch. Artists became civil, rather than ecclesiastical, servants. One need merely consider a figure like Enguerrand de Marigny (circa 1260–1315), who charged hefty fees for his skills as financial counselor to the king, highlighting a feature that explains the entire period. The collegiate church of Ecouis, founded by Marigny, was designed for his own tomb (no longer extant) decorated by a remarkable set of statues.[2] Social ascension and power would henceforth be marked by artistic signs.

Better yet, fate would have it that there were many interesting widows among the nobility. Mahaut, countess of Artois (died 1329), granddaughter of Louis IX's brother, lost her husband in 1303. The court she held at Conflans became famous for its art patronage. Her accounts, which have survived, provide a mine of information on that milieu. Jeanne d'Evreux (died 1374), wife of Charles IV (at whose death the direct Capet line came to an end in 1328), donated a silver-gilt Virgin to Saint-Denis in 1339, one of the century's most admirable works (right). Jean Pucelle worked for Jeanne, and she arranged for her own tomb at Maubuisson. Several great ladies thus played a role in artistic life, to which should be added Isabeau of Bavaria (died 1435), the wife of Charles VI, even though her court was known more for its social manners (she was famous for the wonderful bird cages that she took on all her travels).

The term "court art," sometimes applied—prematurely, in this author's opinion—to art produced during the days of Louis IX, is perfectly appropriate to describe key developments of the fourteenth century. Fashion, crafts, and painting (all increasingly important elements of elegance and glamour) were henceforth associated with ranking nobles, who were

all collectors and, as their rank demanded, founders of private chapels. Accounts and inventories henceforth included the names of artists; when a work remained anonymous, it at least bore the name of the noble who commissioned it, like the *Boucicaut Hours* after the marshal who, around 1400, played a role in the defense of Constantinople (Musée Jacquemart-André, Paris, Ms. 2, below right).

A new element of the tale thereby made its appearance—the inventory. Royal and noble collections that included objects, cameos, gems, precious metalwork, assem-

Saint Agnes. Stone. c. 1310.
Former collegiate church of Notre-Dame, Ecouis (Eure).

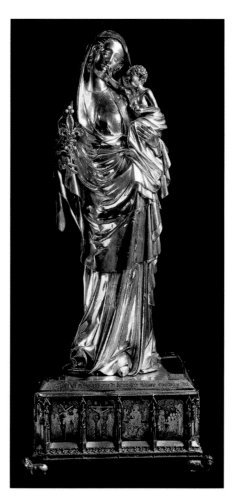

Virgin and Child. Gift from Jeanne d'Evreux to the Abbey of Saint-Denis.
Silver gilt, enamel, pearls and gems.
Height: 69 cm. 1339. Musée du Louvre, Paris.

Virgin and Child (detail). Stone. Fourteenth century.
Notre-Dame, former collegiate church, Ecouis (Eure).

Formal equilibrium gave way to refinements sometimes taken to an extreme. But instead of harping on symptoms of decay and extravagance, as cultural historians of the "autumn of the Middle Ages" tend to do, it would be better to observe how artistic activity was sustained within previously defined genres and models.

These comments indicate the manner in which this period will be handled here, taking it up to the years 1415–1420. Miniatures and stained glass will be examined first, including a brief section on other religious and secular artifacts (a sphere in which technical virtuosity and originality accorded with the "precious" taste). Then architecture and statuary will be discussed, followed by tapestries and precious metalwork (a great luxury item) in a section devoted to aristocratic pleasures. The reign of Charles V, with its considerable cultural and artistic implications, must and will be handled separately.

blies of antique items, etc., required regular assessment. In 1379, Charles V organized a commission to draw up an overall inventory of the crown jewels, which numbered nearly four thousand objects, going from plate to reliquaries and books. This magnificent "treasure" was progressively sold off, however, as indicated by four subsequent inventories up to 1422, when Charles VI's wastefulness had reduced it to almost nothing.

John II the Good enhanced the glory of the crown by commissioning works from Jean de Montmartre (*Bible Moralisée,* circa 1350, Bibliothèque Nationale, Fr. 167), the illuminator Jean Le Noir and the master of the *Bible of Jean de Sy.* Charles V was patron to Jean de Bondol. Artists mentioned in documents were henceforth in the employ of nobles. By acceding, for example, to the title of "personal valet," artists became a new type of social animal. The secularization of production, the emancipation of artisans, and the establishment of a new market and competition in the fourteenth century rapidly created a situation that would have a major impact on the future. The defining features of the Middle Ages were disappearing.

This apparently diverse period exhibited a sort of unity in the striking "aristocra-tization" of production and commissioning processes. And, since noble families were increasingly allied to one another from one country to another (the idea of nation not yet having emerged), increasing numbers of artists from northern lands and even from Italy arrived in France. Speaking generally, the hegemony of "French Gothic" had come to an end—exchanges with Flemish and Italian regions took a new turn, operating in both directions, spurred by two political events of major cultural consequence: the shift of the papacy to Avignon at the start of the century and the creation of the Flemish-Burgundian axis at the close of it. There was a growing variety of artistic trends flowing to and from various artistic centers, themselves established and maintained as a function of circumstance. But it would be a mistake to think that this entailed a dilution of professional skills. Art diversified into a network of mutual support and influence. Paris retained a dominant though no longer hegemonic position, and by the end of the century it was a center of Western cosmopolitanism, thanks to exchanges and competition with other brilliant centers of "aristocratic" art like Prague, Siena, and Milan.

Only in this sense is it valid to speak of a dissolution of the "Gothic synthesis."

Boucicaut Master (Jacques Coene?),
The Boucicaut Hours: Saint Denis.
c. 1410–1412. 27.4 × 19 cm. Musée
Jacquemart-André, Paris (Ms. 2, fol. 31v).

3. COURT ART: MINIATURES AND CURIOS

In 1309, Philip the Fair engaged an Italian team to carry out decoration work at Poitiers. No other details are known. But Mahaut countess of Artois, owned Italian panels that were described as "works from Rome." Throughout the century, even prior to the arrival of Sienese painter Simone Martini at Avignon in 1340, Italian compositions had circulated in France; they are assumed to have been in the style of Duccio or Giotto, to judge by the Tuscan manner echoed in the work of Jean Pucelle and, more surprisingly, in stained-glass windows. Contrary to Gothic composition, the Italian manner created a cube-like space around the figures, which was perceived as an interesting novelty. At Aix there is a fragment of a little, now-dispersed triptych by a student of Martini, sent to the convent of Sainte-Claire by Robert of Anjou, king of Naples. The Annunciation is set in this cube-like interior while the Nativity is set in a broad landscape, which was unusual in France at the time. Thus began a process of osmosis evident in many other examples.

The construction of the new papal palace in Avignon was the work of French architects, whereas the decoration was done by Italian teams headed, when the moment came, by Matteo Giovannetti. It is possible that French painters were immediately able to profit from the large decorative frescoes executed during the

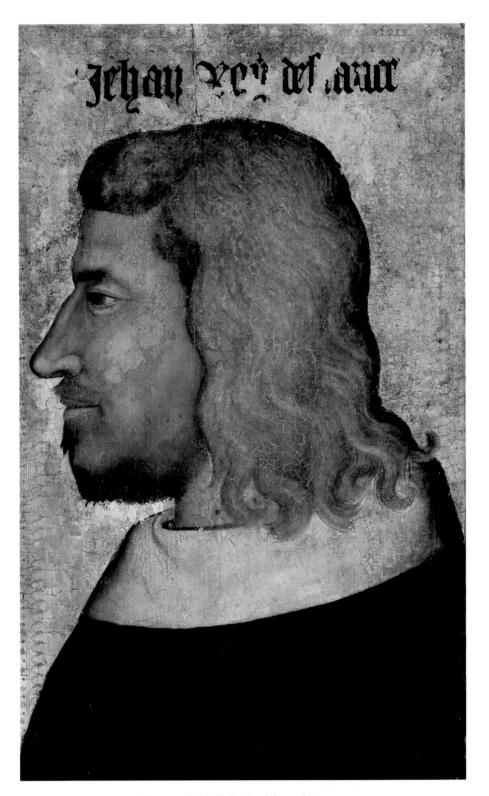

Portrait of John II the Good, king of France.
Anonymous. Panel. 60 × 44.5 cm. c. 1350. Musée du Louvre, Paris.

Anonymous Neopolitan [or Sienese?] artist, *The Nativity*. Panel. 67 × 47 cm. 1335–1340. Musée Granet, Aix-en-Provence.

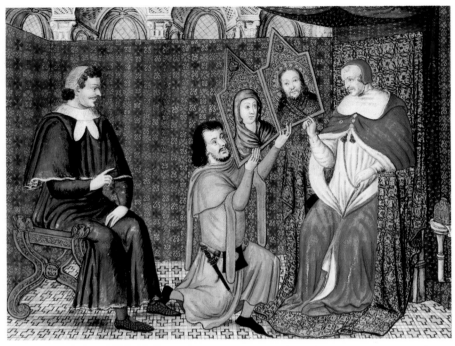

John the Good offers a diptych to Pope Clement VI on the occasion of his visit to Avignon in 1342 [?]. Seventeenth-century copy of a painting probably executed in Avignon c. 1342–1343 [by Matteo Giovannetti?]. Drawing embellished with color. Bibliothèque Nationale, Paris, Gaignières Collection (Est. Oa 11, fol. 85–88).

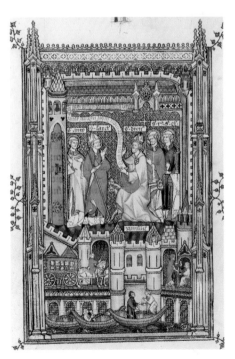

Parisian workshop, *La vie de Saint Denis*: Saint Denis instructs Saint Saintin and Saint Anthony to write his biography. c. 1317. Bibliothèque Nationale, Paris (Ms. Fr. 2091, fol. 125).

papacy of Clement VI (1340–1352). The Avignon connection was crucial, and it would be a mistake to overlook it. One specific point may illustrate this: the papal halls included veritable portrait galleries, a painterly "genre" likely to interest the French. In a now-lost painting (known from a copy by Gaignières, above), John the Good can be seen giving a devotional diptych to Clement VI[3]—this double portrait panel must have been the work of an Italian painter working in Avignon (Giovannetti?). Such factors should be taken into account when considering the problem raised by the portrait of John the Good in the Louvre (far left), probably by a French artist who was certainly familiar with the work of the Italians at the papal court. Since John is not wearing a crown, the painting must be anterior to his ascendance in 1350; the fine draftsmanship, delicate modeling of the nose, and medallion-style profile all constitute new departures for painting in France.

With Master Honoré, credited with producing the *Breviary of Philip the Fair* (Bibliothèque Nationale, Lat. 1023, p. 268), a supple and coherent style was established in Parisian miniatures by the late thirteenth century. Early in the following century, major historical and hagiographic subjects were reworked and illustrated. Thus the *Life of Saint Denis* (1317, Bibliothèque Nationale, Fr. 2090–2092) was a three-volume work by Yves, a monk at the Abbey of Saint-Denis (left). Since most of the story takes place in Paris, the volumes constitute a sort of novel accompanied by miniatures showing everyday scenes of the capital, within a somewhat heavy architectural framework. Less lively and delicate than Master Honoré, the painter boldly adopted the anecdotal path that everyone would soon follow.

The "Wit of Jean Pucelle"

Jean Pucelle, the most refined and witty painter of the fourteenth century, was identified in the late nineteenth century by Leopold Delisle, thanks to the *Belleville Breviary* (far right) that listed Pucelle as head of the workshop (between 1323 and 1326, Bibliothèque Nationale, Lat. 10483–10484). The same name appears with those of two collaborators in a short note in a 1327 Bible by an English copyist called Billyng (Bibliothèque Nationale, Lat. 11935, right). Finally, Pucelle is credited with the "prayer book" of Jeanne d'Evreux (p. 288), painted in grisaille and described as being "illuminated in black and white, for the use of Preachers," in an inventory for the duke of Berry (between 1325 and 1328, The Cloisters, New York, Acc. 54, 1–2).

These three works suffice to demonstrate the new direction taken by manuscript illumination in Paris, and of the debt that all miniaturists owed to Jean Pucelle, the uncontested master of Parisian elegance and "wit." Three stylistic features were of particular importance. First of all, the supple and plastic modeling of figures; whether colored or grisaille, they look like statues wrapped in light and shadow rather than flat silhouettes set against the background. There is no doubt that this new design stemmed from an accurate knowledge of the masters whose fame had spread across the West, namely Giotto and Duccio.

The second feature was an Italian-style intuition of volume and space, which the somewhat casual freedom of French miniatures allowed them to assimilate, as demonstrated by the tiny tabernacle of the Annunciation on one of the pages of the *Hours of Jeanne d'Evreux*. The same approach can be seen in the illumination

Jean Pucelle, *The Robert de Billyng Bible*: Genesis. 1327. Bibliothèque Nationale, Paris (Ms. Lat. 11935, fol. 5).

Right: Jean Pucelle, *The Belleville Breviary*: Saul attempts to stab David. c. 1323–1326. Bibliothèque Nationale, Paris (Ms. Lat. 10483, fol. 24v).

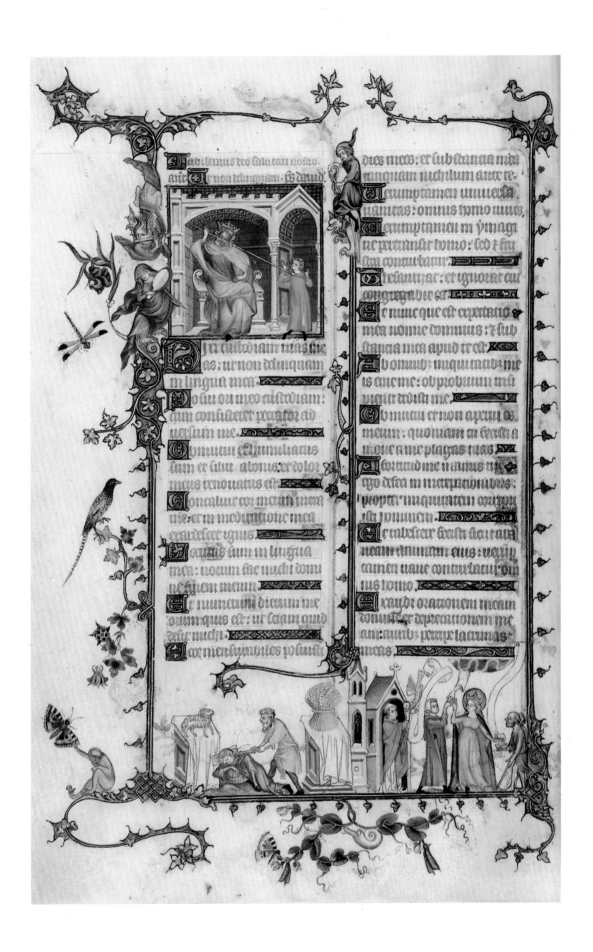

Jean Pucelle, *The Hours of Jeanne d'Evreux.* Above: the Betrayal of Christ and the Annunciation.
Right: miracle of the breviary brought to Saint Louis in prison; page decorated with monsters and humorous figures.
1325–1328. 9 × 6 cm. The Cloisters, Metropolitan Museum of Art, New York (Acc. 54.1.2, fols. 15v–16r and 154v–155r).

of the *Miracles de Notre-Dame*, (circa 1330, Bibliothèque Nationale, Nv. Acq. Fr. 24541) that is readily ascribed to Pucelle (opposite, top left). It generates emotive possibilities, a sense of mimicry and hence a range of expressive or animated movements and gestures—surprise, devotion, fear, etc.—that had been rarely attained up to that point. Despite the format and the framing, images became far more convincing, whether it was a question of Saul threatening to kill David or a portrait of Saint Louis. This was the aspect conserved by Pucelle's disciples, such as the brilliant colorist and lively draftsman Jean Le Noir, who illuminated the *Hours of Jeanne de Navarre* (circa 1336–1340, Bibliothèque Nationale, Nv. Acq. Lat. 3145, opposite, top right). The impact of monochrome scenes continued throughout the century, beginning with a *Bible Moralisée* illuminated for John the Good (circa 1350, Bibliothèque Nationale, Fr. 167, p. 292).

The third feature was humor. A dragonfly or damselfly ("damsel"—maiden—is *pucelle* in French) was probably Jean Pucelle's cryptic signature, and every element on the page was for him an occasion for ironic whimsy. The text was still copied with the same care, but in the decoration, for which Pucelle was responsible, the relationship between the initial letter (which theoretically constituted the main image) and auxiliary embellishments was reversed, so that marginal creatures grew from

Left:
Jean Pucelle and workshop, *Miracles de Notre-Dame*. 1330–1335. Bibliothèque Nationale, Paris (Ms. Nv. Acq. Fr. 24541, fol. 70v).

Right: Jean Le Noir, *Hours of Jeanne de Navarre*: the Annunciation. In the initial: Jeanne of Navarre before the Virgin and Child.

At the bottom of page: playing blind man's buff. 1336–1340. Bibliothèque Nationale, Paris (Ms. Nv. Acq. Lat. 3145, fol. 39).

Master of the Jean de Sy Bible (Boqueteaux Master), *Oeuvres de Guillaume de Machaut*: Nature introduces *Sens* (Insight), Rhetoric, and Music to the author. c. 1375. Bibliothèque Nationale, Paris (Ms. Fr. 1584, fol. E).

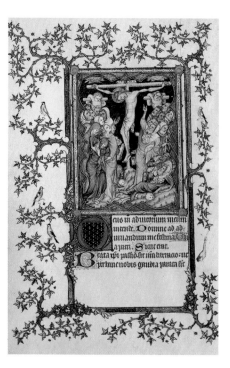

garlands, buds and flourishes with unceasing and mocking wit. The limited, neutral repertoire of headings and indentations suddenly blossomed in every sense. The page became a theater where figures and animals were given walk-on parts of every type, indulging once again in humor and giving a poetic feel to the whole. In the *Hours of Jeanne d'Evreux,* framing figures even take the form of atlantes (or supports) for the evangelical scenes; elsewhere, they frolic and play with charming verve, be they hunters, peasants doing a round-dance, or farfetched animals (p. 294).

By the time Pucelle died in 1334, he had pointed Parisian painting in a new direction. Artists obviously indebted to him included the painter of the *Jean de Sy Bible* (now considered to be the Master of Boqueteaux) who, twenty years later, worked with other Pucelle-influenced artists in the employ of the poet Guillaume de Machaut. It should also be pointed out that Pucelle may have had a decisive effect on a major masterpiece of grisaille technique, namely the chapel hanging or altar decoration, painted on silk around 1375, known as the *Parement of Narbonne* (Musée du Louvre).

The most interesting heir to Pucelle was Jean Le Noir, whose career continued into the 1370s. He produced the lively and highly colorful *Hours of Jeanne de Navarre* (p. 289), as well as those of Yolande of

Jean Le Noir,
Petites Heures du Duc de Berry.

Far left: the Betrayal of Christ.
In the initial: Christ on the Mount of Olives; lower part of page: Judas accepts payment for betraying Christ.

Left: the Crucifixion. c. 1388. 21.5 × 14.5 cm.
Bibliothèque Nationale, Paris
(Ms. Lat. 18014, fols. 76 and 89v).

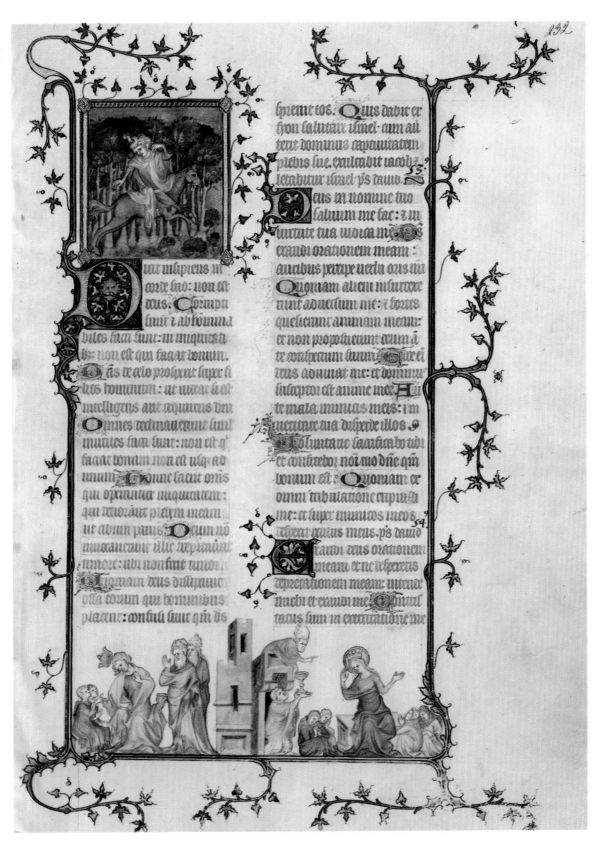

Jean Le Noir, *Breviary of Charles V*: the death of Absalom.
1364–1370. Bibliothèque Nationale, Paris (Ms. Lat. 1052, fol. 232).

Parisian workshop of Jean de Montmartre, *Bible Moralisée* of John the Good: the story of Samson and Delilah. c. 1349–1352. Bibliothèque Nationale, Paris (Ms. Fr. 167, fol. 59).

Flanders (circa 1350 but unfortunately altered, British Library, London, Ms. Yates Thomson 27), and later works like the *Breviary of Charles V* (Bibliothèque Nationale, Lat. 1052, p. 291). He also started the *Petites Heures du Duc de Berry* (1372–1373, Bibliothèque Nationale, Lat. 18104, p. 290), though with somewhat less success than his earlier work. Le Noir's long career had the effect of sustaining Pucelle's tradition in more or less official form until the major innovations of the 1380s.

John the Good's *Bible Moralisée* includes a host of over five thousand little illustrations arranged according to a principle of alternation between square framed historical scenes and polyfoil-framed moral scenes. This arrangement was strictly followed by the dozen or so artists who worked on the vast undertaking. There are no droll touches in the margins, but there is a Pucelle-like tendency toward monochrome figures highlighted with gold.

With Guillaume de Machaut, the author became advisor not only to the scribe, but also to the illuminator. This lent rare quality and efficiency to the manuscript of his *Remède de Fortune* (circa 1350, Bibliothèque Nationale, Fr. 1586, top right) which constitutes a minor masterpiece through its depiction of "fashionable" dress and its concern to be stimulating yet genteel.[4] Something even newer appeared twenty years later with the the Master of the Boqueteaux's illustration of Machaut's *Dit du Lion* and two demi-grisaille frontispieces to volumes of poetry. This anonymous artist brought landscape to miniatures (circa 1375, Bibliothèque Nationale, Fr. 1584, p. 290), with a host of delightful details in an almost colorless space, perhaps comparable to tapestries fashionable at the time. The same artist contributed a highly poetic frontispiece to the 1378 *Songe du Verger* produced for Charles V (British Library, Ms. Royal 19 C IV, above), showing a symbolic garden arranged vertically, featuring characters

Master of Le Remède de Fortune, *Oeuvres de Guillaume de Machaut*: courtly scene. c. 1350. Bibliothèque Nationale, Paris (Ms. Fr. 1586, fol. 28v).

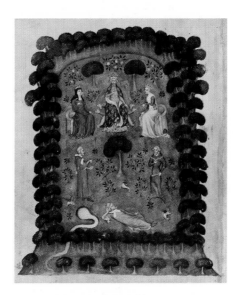

Master of the Jean de Sy Bible (Boqueteaux Master), *Le Songe du Verger*: debate between the cleric and the knight. British Library, London (Ms. Royal 19 C IV, fol. 1v).

from the text set among tiny trees making up a *boqueteau*, or small wood.

Hence a new phenomenon was emerging. Books of Hours appeared in the fourteenth century and reached their height of popularity in the fifteenth and early sixteenth centuries.[5] An instrument of piety for lay people, somewhat like the aids used by monks, they became the enduring, archetypal family book from which the moneyed classes learned to read. In paintings, they can be seen in the hands of

saints, of the Madonna, and in particular of the Virgin of the Annunciation, who was supposedly reading the passage concerning herself while awaiting the angel. The spread of these illustrated books, accompanied by a calendar setting out the order of feast days and commentaries on the miniatures, provides a treasure-house of information on the bizarre fragmentation of devotional prayers. But they were above all an aristocratic privilege, a sign of "chic" according to Eustache Deschamps, writing around 1380:[6]

> *Heures me faut de Nostre Dame*
> *Si come il appartient a fame*
> *Venue de noble paraige...*
> [Our Lady's Hours do I need
> As should belong to any lady
> of noble birth]

"JESTING"

Long before Gringore and Rabelais immortalized them, *jongleurs*, or entertainers, were key figures of medieval life, whether invited to noble castles to recount the charming *Flamenca* (circa 1270) in the *Langue d'oc* dialect, or hired to perform at a burgher's wedding, or simply working the streets as strolling minstrels, jesters, and tellers of bawdy tales. If the whimsical aspect of Romanesque sculpture and the playful borders of Gothic miniatures are carefully studied, they inevitably reveal small comic scenes, acrobatics, clowning, and grimaces that are closely related to the world of *jongleur* buffoonery. Although it might be going too far to assert that their repertoire was essentially "of the people," it is not too risky to assume that it met with great success among the crowds who thronged public squares and fairs. Every epoch has its way of having fun.

Fanciful margins go back a long way; on an early eleventh-century manuscript of the *Annales* of Saint-Germain-des-Prés, decorated with blind arcades in the manner of the Gospel canons (Bibliothèque Nationale, Lat. 12117), two monkey-like

Jean Pucelle, *The Belleville Breviary*:
margin decoration (detail). c. 1323–1326.
Bibliothèque Nationale, Paris (Ms. Lat.10483 fol. 24v).

was the end of the sublime, it was nature as tease. This already ancient tradition, of course, nourished Pucelle's unparalleled refinement.

Manuscript illumination was also nourished, in Paris, by street scenes, farces and celebrations, thereby possessing a more precise comic source which Jean Pucelle exploited marvelously; a work like the *Roman d'Alexandre* by Jean de Grise (circa 1340, Bodleian Library, Oxford) draws on images from the carnival world. A book of hours perhaps produced in Avignon (circa 1360, Bibliothèque Nationale, Lat. 10527, right), to the contrary, plays with strange frenzy on the twists and turns of floral stems that blossom into weird beings with outlandishly long necks and legs. The fun here lay in an anarchic exaggeration of the old decoration.

Thus a thoroughly secular freedom of tone constantly informed sacred imagery. It was the role of the illuminators, aware of the originality of their task, to exploit the vivid liberty of the "jesting" mode. Sometimes there was a strange shift from one register to another; indeed, when the secular element, losing its sense of distance, tended to overwhelm the sacred, the Middle Ages had come to an end. To appreciate the slow evolution of this interesting process, one need only look at "minor sculpture" in churches.

creatures armed with bows face one another on right and left. This unexpected little scene mimics the face-to-face warriors planted like acroteria (decorative sculpture) on the pediments of Carolingian canons, like that of Ebbo, archbishop of Reims. Three centuries later, the mood was one of parody. There were countless variations on the monkey–priest, the monkey–clown, or monkey–warrior astride strange mounts, running, playing, dancing in the blank spaces of a page.[7] This was by no means a French specialty, for it was a general trait of miniatures, and English workshops were tirelessly inventive in this sphere. In France, centers in Picardy, Tours, and above all Paris in the thirteenth

and fourteenth centuries exploited such images in refined and witty ways.[8]

This marginal "jesting" enabled Romanesque monsters to make a comeback, though now devoid of any seriousness. Only mockery and whimsy remained, whether aimed at depictions of master and students, mitered owls or burlesque church rites. Joking knew no limits. Satiric poetry and the animal fables of the *Roman de Renart* revealed the ferocious side of monastic humor, echoed in the now well-established register of miniatures showing humanity playing out its comedy through marginal metamorphoses as, say, an archer–snail threatens a hare astride a lion. It was the world turned upside down, it

Strasbourg Cathedral (Notre-Dame).
Detail of the west facade. 1276–1318.

Sculptors working on cathedral sites rectified the exuberant fantasy of the Romanesque age, as can be seen at Notre-Dame in Paris: Romanesque indiscipline was gone, but nothing else had vanished. In minor places—the understated surfaces of interior consoles, corner pieces, misericords, vault bosses or, on the outside, cornices and crochets on gables or arch moldings—little monsters and whimsical figurines continued to proliferate, like some grotesque but nevertheless indigenous population. The British workshops' predilection for eccentric forms, which became highly pronounced in the fourteenth century, periodically provided renewed intensity and charm, notably in the north and west of France. Two or three of the countless, diverse architectural examples will suffice as illustration here: donkeys and demons perched on gables in a relief on the north portal of Saint-Urbain in Troyes (thirteenth century), caryatids on consoles at Semur-en-Auxois (late thirteenth century), two-headed figures in the chapter room at Bayeux (early fifteenth century).

"Misericords" in the choir (brackets on the underside of hinged seats in a choir stall, allowing occupants to rest while standing during long services) were the site of strange, ridiculous, popular imagery that owed its comic nature to the dense, squat form of the bracket itself. Hundreds of fourteenth-century examples are known, especially in northern France, and they enjoyed even greater success in the following century.

Religious and Secular Curios

There survives an infinite number of items in ivory, generally dating from the mid–fourteenth century and generally in the form of statuettes, diptychs, or even triptychs (which looked like miniature retables). In the latter category, the Musée Pincé in Angers boasts a Virgin and Child in bas-relief between two panels, each with a candle-bearing angel; a tabernacle

Heures et Récueil de Prières d'Avignon. c. 1360.
Bibliothèque Nationale, Paris. (Ms. Lat. 10527, fol. 27).

Mirror case: the game of chess. Ivory.
First half of the fourteenth century.
Diameter: 12 cm. Musée du Louvre, Paris.

Right: *Virgin and Child*,
known as *Our Lady of Bethlehem*. Alabaster.
Height: 180 cm. c. 1375.
Narbonne Cathedral (Saint-Just),
Notre-Dame-de-Bethléem Chapel.

topped by a gable acts as a vaulted ceiling (p. 297). Sometimes, scenes clearly inspired from cathedral portals were copied and recomposed with a rare finesse of execution under polyfoil arches, like the triptych of the Death of the Virgin (Martin Le Roy Collection). This piece was extensively imitated, suggesting the existence of a major workshop. As to diptychs, they were generally composed of scenes arranged in horizontal bands or under arcades, depicting the childhood of Christ or stories of saints, notably Peter and Paul (circa 1340, Musée de Cluny, Paris); the delicately modeled figures in half-relief can be easily related to the standard iconography of the day.

The production of highly detailed, carefully carved ivory scenes for the backs of mirrors, chests, and writing tables, was one of the glories of fourteenth-century Parisian art. Suppliers to high-ranking clients enjoyed a certain notoriety—Jehan Cyme, the ivoryworker who procured combs for Mahaut, countess of Artois, also manufactured chess pieces for Orléans and Burgundy. The 1394 accounts of Isabeau of Bavaria, the wife of Charles VI, mention a "Jehan Aubert, ivory imager, for the sale of one ivory *absconce* [small candle holder] bought from him to hold a candle when the Queen says her Hours." Practical items, such as those making up part of a vanity set, were usually sculpted in shallower relief than were devotional diptychs. Their accumulation was a typical sign of luxury and fashion, the decorative motifs all being borrowed from courtly poetry (trysts and round-dances), romances (*Tristan and Iseult*, *Percival*) or allegories from the *Roman de la Rose*. The repertoire included flirtatious games such as "hot cockles" (p. 110) and even elegantly amorous confrontations across a chessboard (left). Round medallions often had small monsters on the corners to form a square. Quality varied greatly, but the strongest period is generally considered to be mid-century, when semi-industrial workshops produced ivories

of exquisite delicacy. There was competition from the Rhineland, England and, a little later, Italy, but around 1350 the market was dominated by pretty, gay, and well-made Parisian ivory.

Hundreds of small statues of the Virgin survive, whether of polychrome stone, silver, or alabaster. A given model can be traced from workshop to workshop, from brilliant original to banal copy, distinctions being made on the basis of the precise nature of the pose, the fluted folds of the gown, and the serious or banal tilt of the head. Several examples stand out from the crowd. A Virgin and Child, formerly polychromed, now missing the infant, offers a profile of rare elegance (circa 1340, Lisors). It is to be compared with a silver-gilt Virgin owned by Jeanne d'Evreux, offered to Saint-Denis in 1339, whose size (69 cm) allows for a broad overall effect and fine drapery—the exquisite refinement of the Virgin is underscored by the way the veil falls around her head. Furthermore, the lily in the right hand is made of crystal and gold with translucent green enamel, and the base is decorated with high-quality enameling. It is an exceptional work, displaying all the merits of a delicate and ultimately fragile style (Musée du Louvre).

In 1341, a canon offered a somewhat original stone Virgin to Saint-Etienne Cathedral in Sens—the seated Virgin's throne is decorated with cabochons and deeply carved reliefs, she wears a bulky cloak, and conveys unexpectedly hieratic nobility, perhaps explained by the dorsal cavity that probably made this piece a reliquary. A good example of a precious artifact from southern France is the large alabaster Virgin called Our Lady of Bethlehem (circa 1375, Saint-Just Cathedral, Narbonne, left). She wears a magnificent clasp on her chest, and delicately holds the folds of her robe with an elegant gesture. The clasps and the draping recall the manner of the Master of Rieux Chapel, credited with a fine statue

Virgin and Child flanked by two angels. Ivory triptych. 33 × 25 cm. c. 1320–1340. Musée Pincé, Angers.

of Bishop Tissandier (1333–1334, p.118) and an exquisite Saint Louis of Toulouse (Musée des Augustins, Toulouse).

NEW LIGHT ON STAINED-GLASS WINDOWS

Unlike painting and sculpture, whose basic materials did not change, stained glass was directly linked to the glassmaking industry and therefore more amenable to technical innovation. One such innovation occurred around 1315–1320, with the introduction of silver yellow to the glassmakers' hues. Simultaneously, the development of thinner glass in larger sections allowed for a more open composition, less limited by leadwork. Jean Lafond has pinpointed the first use of silver yellow to a small Norman window dated 1313 (Saint-Ouen, Rouen), where it was employed to depict carnations. In general, it was Normandy—that great national storehouse of stained glass—that witnessed the increasingly free use of this coloring agent, a derivative of sulfide of silver. It could be used not only to tint transparent

glass yellow but, when mixed with another color and fired, would produce a third color (transforming blue to green, for example). This gave artists new freedom. Stained glass became lighter just at a time when exquisite refinement was so appreciated.

The artists' emancipation was linked not only to a sudden enrichment of their palette, but also to the possibility of varying backgrounds, decorative borders, and fabric-like effects. They did not forsake the dignity inherent in the medium of stained glass, however, for two new types of imagery preserved monumental impact all the while permitting formal virtuosity: large human figures and imaginary architectural settings. This brilliant transformation can best be seen in the stained glass at Saint-Ouen in Rouen, most of it miraculously preserved (p. 298). The legendary incident of Lucian's Dream, for instance, is set against swirling purple foliage, and the sleeper's blanket is striped with gold embroidery; an extensive use of grisaille, with black touches blended into the glass with the help of a fitchew brush, creates almost imperceptible shading.

The new, clearer light provided by these windows can be appreciated in the chancel of Saint-Ouen, with its twenty-four figures from the Old Testament in the clerestory. The names of Habakuk and Malachi are etched in large, colored letters. On the south side are the twelve apostles (still rendered in the tradition of the apostolic college at Sainte-Chapelle) and twelve bishops of Rouen (which raises the notion of the personalized portrait in glass). All this constitutes a thoroughgoing exercise in the characterization of the human figure. On the right-hand side is a richly ornamented window depicting Saint Nicasius, created by a subtle master who—to judge by certain effects of rolling landscape—had some familiarity with Sienese painting. The same artist must have worked on the stained glass in Rouen Cathedral as well (Pentecost Window, circa 1340).

Saint-Ouen Church, Rouen. North ambulatory, Saint-Etienne Chapel,
stained-glass window dedicated to Saint Stephen (bay 17):
the Apparition of Gamaliel to Father Lucian. 1325–1339.

The outstanding group of windows in Saint-Ouen incorporates all the innovations of stained glass, such as Sienese influence, subtle coloring, and softer hues (the blues are less deep).[9] It was probably a royal production, if it is true that the donor was Charles IV (died 1328), whose wife was Jeanne d'Evreux. A series of six lancet windows in the ambulatory dedicated to Saint Michael deploy an enchanting collection of surprising small "worldly" figures worthy of Jean Pucelle.

At Evreux, a window showing Canon Raoul de Ferrières (died 1330) kneeling before the Virgin is a perfect example of the use of larger figures. The canon, holding a symbolic window, occupies an entire lancet, facing a crowned Madonna whose marked contrapposto fills another lancet. It is easy to perceive the large pieces of glass set into the lead work; truly "flamboyant" (or late Gothic) tracery caps each part of the diptych. The Parisian feel of this work should hardly be surprising, for this was the home of Queen Jeanne d'Evreux. The entire cathedral is like a small conservatory of fourteenth-century stained glass. These windows influenced others, such those at the priory of Saint-Hymer-en-Auge (circa 1325), notable for their horizontal, "landscape" format.

Destruction, modification, and massive restoration make it impossible to reconstruct accurately the state of stained-glass decoration in the provinces during the fourteenth century. Apart from known vestiges in Vendôme, Tours, Limoges, Clermont-Ferrand, and Bordeaux, it is worth mentioning major pieces such as the rare fourteenth-century Tree of Jesse in Carcassonne (circa 1320). In the cathedrals, fourteenth-century elements were often added to earlier windows, such as the medallion of Saint John on Patmos at Beauvais, in a chapel dedicated to the evangelist in 1349. Given the gaps in the material, however, it is hard to escape the conclusion that the century's turmoil finally put a brake on great French production.

3. ARCHITECTURE AND STATUARY

Once the great southern fortress cities of Carcassonne and Aigues-Mortes were completed by Philip the Fair, programmed construction in the south came to an end. The colossal transformation of Avignon was the century's most impressive achievement, prior to the projects launched by Charles V. The pope who agreed to move the papacy to Avignon, Clement V, was originally from Aquitaine and was no sooner installed in Avignon than he decided to erect a major fortress near Bazas back in his native region. The archaic—or at least highly traditional—nature of the castle is surprising. It is rectangular (52 × 43 meters), with corner towers (28 meters high), an entrance fort flanked by two more towers, and a lined moat (15 meters across). There were two interesting novelties, however—the arrow-slits had a small central crossbar (making them easier to use) and there were large windows, which suggest a less rigorous lifestyle, if indeed they date from that period. There was no keep. At Roquetaillade in the same part of the country, a somewhat smaller copy of the papal palace, but this time with a keep,

Villandraut (Gironde), view of the south side of the castle. Fourteenth century.

was built by the pope's nephew (p. 300).

The Avignon popes who succeeded Benedict XII (1334–1342), notably Clement VI (1342–1352), sat in one of the most skillful complexes built during the entire Middle Ages. The tall Trouillas tower, whose rampart walk loomed fifty-two meters above the ground, acted as a keep for the palace—it was topped by modern crenellation on stone corbels.

Roquetaillade (Gironde), view of the new castle and keep. c. 1310.

Saint-Servan (Ille-et-Vilaine), the Solidor tower.
Fourteenth century.

M. Marcel,
Perspective View of Tonquedec Castle
(Côte-d'Armor). Ink sketch for a
restoration project.
c. 1892. Bibliothèque du Patrimoine,
Paris (plan 10.072).

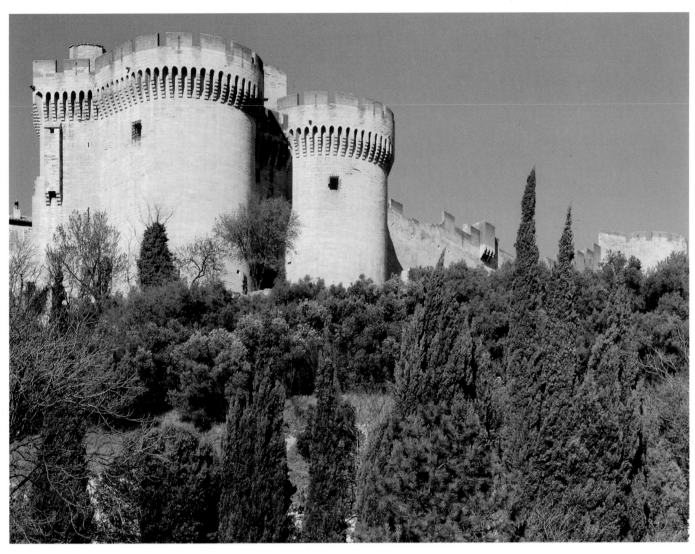

Villeneuve-lès-Avignon (Gard), view of the fortified gate of Saint-André Fort. c. 1363–1368.

Jean de Louvres, who built the New Palace for Clement VI, extended the system of machicolation, or projecting ramparts (p. 302). The palace interiors, meanwhile, are justly famous—the imposing papal chapel (50 × 15 × 19 meters) was admired by all visitors, including those familiar with the Sistine Chapel. The painted decoration also marked the epoch.

Avignon's city wall, erected at the beginning of 1355, was over three miles long and today represents a wonderful relic, with its dozens of projecting towers and rectangular ramparts along the curtain wall. The defensive system was carefully designed. At the main entrance, Saint-Lazare Gate, there was a barbican (outer defensive work) with towers. On the west bank of the river, a citadel called Saint-André Fort was built on the Villeneuve hill (above), with curtain walls and a gatehouse to protect the bridge linking the empire's riverbank to that of the kingdom.

The only comparable construction in terms of scope and engineering skills were those that Charles V undertook to systematically reinforce the defenses of Paris. This was a direct outcome of civil conflict and English wars, which little by little led grand and minor noblemen throughout the land to reorganize their defenses, for fear of siege and roving bands called *grandes compagnies*. Since it was also thought necessary to strengthen the fortifications around cities, the king set an example with a new

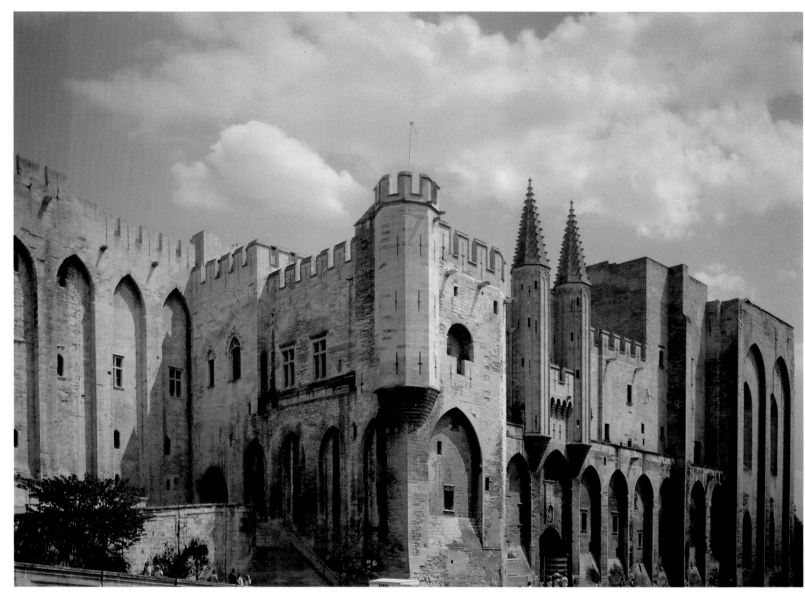

Palace of the Popes, Avignon (Vaucluse). View of Clement VI's New Palace,
built by Jean de Louvres. Second half of the fourteenth century.

wall around Paris. This was a sensible wartime move, because the French–English conflict was entering a phase of sieges conducted both with and without artillery.

The provinces were less directly threatened, but there were initiatives worthy of interest. Gaston Phébus, count of Foix, consolidated his possession of the Béarn region by renovating the castle at Pau (circa 1370). The work was entrusted to an engineer named Sicard de Lordat. The hill was wrapped in protective defenses, the old walls being raised and endowed with a projecting, crenellated parapet, still a novelty at the time. To protect the Armagnac flank, Gaston's engineer built a fortress at Montaner, a square mass (13 meters to a side) looming above a polygonal wall that could serve as barracks, refuge, or strategic support.

Brittany was another active province, where numerous building projects perpetuated the standard forms, namely round tower (Cesson, near Saint-Brieux) and octagonal plan (Largoët-en-Elven, circa 1380). Other, more original, designs ultimately took the form of a triangle with

round towers, like the Solidor Tower at Saint-Servan (p. 300). All these fortifications were associated with the troubled years at the end of the century, and work continued into the fifteenth century at places like Tonquedec (after 1407, p. 300). Defense procedures were similar everywhere, so that Brittany's collection constitutes a representative family.

The house of Bourbon serves to illustrate the evolution of construction priorities. Louis II, duke of Bourbon (1337–1410) had a large number of fortresses and strongholds restored, such as the castle at Moulins, whose layout is known thanks to Guillaume Revel's *Armorial*. Because it included numerous bays and galleries, it has been described as a demonstration of "the transition from the concept of castle based on efficiency to the concept of château offering a rather pleasant lifestyle."[10] A similar shift occurred at Bourbon-l'Archambault (cradle of the dynasty), Hérisson, etc. The problem confronting grand aristocrats concerned the need for "double modernization": political circumstances called for military modernization, whereas new lifestyles called for civil modernization.

THE CHARM OF MACHICOLATION

Low defense systems such as arrow-slits were progressively abandoned during the fourteenth century in favor of devices on the higher part of the wall, where machicolation transformed the rampart walk into a projecting parapet. These long, upper projections presupposed stonework employing brackets and corbels, offering possibilities for fine visual effects. This perhaps gave birth to "picturesque" architecture, starting with the work of Charles V's architect, Raymond du Temple. A line of machicolation set on corbels was "the most visible sign distinguishing work of the period."[11] It henceforth characterized a good number of keeps, ramparts, and castle walls, with slight and sometimes elegant variations in brackets in the form of

The Limbourg brothers, *Très Riches Heures du Duc de Berry*:
castle with the Temptation of Christ. c. 1412–1416.
29 × 21 cm. Musée Condé, Chantilly (Ms. 65, fol. 161v).

tiny arcading, double corbeling, etc. The castle, or fortified residence, thus projected a lacy profile against the sky, somewhat like churches with their now-standard pinnacles and decorative arcading. This led to a stress on upper elements (seen at the Louvre, in Saumur, in Mehun-sur-Yèvre) as a sign of the aristocratic rather than the military nature of a resi-

dence. This original development is all the easier to appreciate for having been depicted in many paintings.

THE INVASION OF STATUARY

Huge churches with their extensive arrays of sculpture were no longer modifiable. It was only during the seventeenth and eighteenth centuries that the portals would be

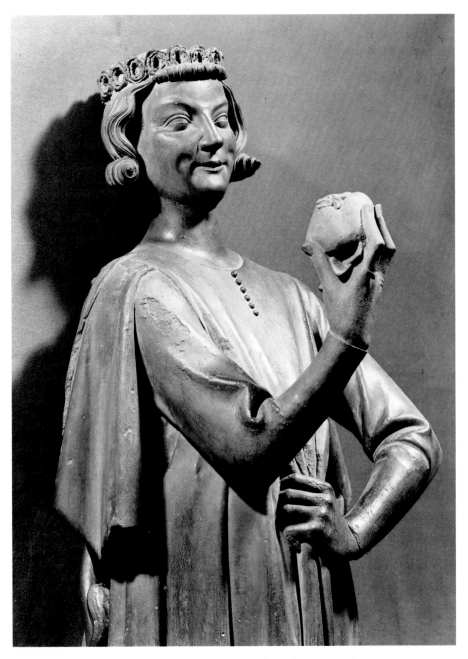

Churches whose main structure was complete were subject to a phenomenon

The Tempter (detail). Stone statue from the west portal, Strasbourg Cathedral (Notre-Dame). 1280–1290. Height: 170 cm. Musée de l'Oeuvre Notre-Dame, Strasbourg.

A Wise Virgin. Stone statue from the west portal, Strasbourg Cathedral (Notre-Dame). 1280–1290. Musée de l'Oeuvre Notre-Dame, Strasbourg.

enlarged. A certain number of cathedrals remained unfinished, however, and work progressed sporadically, as at Saint-Urbain in Troyes. Programmed sculpture had to be completed, whether it involved groups like those at Rampillon and, once again, Saint-Urbain (the cells of the arch moldings), or multiple registers of reliefs, as on the south transept of Saint-Etienne in Auxerre. The case of Strasbourg Cathedral serves to illustrate a contrast that henceforth marked two approaches to sculpture: one was "French" in style, as seen on the south transept, espe-

typical of a dynastic age—the addition of a series of chapels all along the nave, between external supports. "Now, every chapel requires a patron saint, and every saint an image."[12] This explains the hundreds and hundreds of statues of the Virgin with Child produced during the fourteenth century, along with the complementary phenomenon of the introduction and spread of statue–portraits of donors within the church. Furthermore, the chancel screens being completed in Paris, Bourges, and elsewhere provided ongoing work for small teams of sculptors in cathedrals.

Insofar as new work was confined to secondary features, the Gothic structure obviously remained present, yet a sense of ensemble was subsumed to the impression of added embellishments. The key development was an increasingly marked taste for fragmentation, for forms that divided into minor elements as though by natural proliferation—apses sprouted vegetation of stone.

It is worth dwelling on the process of accumulation long practiced by churches. Begun during the thirteenth century, it intensified as a concern to valorize pious offerings, led to a dense clutter of carvings, statues, and reliefs (though not yet of paintings). A rather typical example of this tendency to multiply religious furnishings is represented by Saint-Thibault-en-Auxois in Burgundy at the beginning of the century: in addition to a portal with "historical" figures, the church boasted a carved retable, a Virgin with Bird, and a fairly grandiose tomb comprising a funeral cortege (that is to say, an early version of what would later become the motif of "mourners"). All this came from the normal and familiar repertoire, but it was accompanied by a phenomenon that would significantly alter the atmosphere of the sanctuary—the introduction of contemporary portraits via statuary.

Saint-Denis and Fontevrault were not the only mausoleum–churches; others were established at Dominican monaster-

Jean de Liège, sculptures for the reliquaries containing the viscera of Charles IV the Fair and Jeanne d'Evreux, queen of France, from the Cistercian abbey at Maubuisson. Marble. 1372. Musée du Louvre, Paris.

ies in Paris, Royaumont, and Longpont. Vestiges of monuments have sometimes found their way into museums, where a sense of their original decorative ambitions and impact has obviously been lost. Yet an idea can be gleaned from the drawings commissioned by Roger de Gaignières at the end of the seventeenth century. At Longpont, for example, there was a series

of slabs on arcades, including that of Jean de Montmirail, depicted as a knight and as a monk, who departed first from society before departing this world. Major Anjou family tombs at Saint-Jean-d'Aix-en-Provence merit mention; although nothing of them remains, drawings by Millin give an idea of their originality. Their use of a double image of the "quick" and dead is

comparable—once again—with the monumental tombs in Naples in the days of Robert of Anjou, establishing yet another link in the history of royal tombs.

The group of twelve apostles in Sainte-Chapelle, known as the Apostolic College, inspired an amazing line of descendents. The theme initially required an array of twelve statues on which artists could exercise their talent; then local saints might be added, as at Saint-Nazaire in Carcassonne, in Ecouis, and in Rieux. Often enough, the donor would also be included. Statuary now truly entered the sanctuary proper. An amazing cycle in alabaster was produced for the tomb of Philippe de Cabassol in the Carthusian church of Bonpas (1372–1377), but the group has been dispersed (elements now in Avignon, Marseille, and elsewhere).

The increase in sculpted portraits placed in churches was a rather remarkable phenomenon. Tombs, especially those at Saint-Denis, only offered generic images, that is to say stereotyped portraits of royalty according to a simple, noble model that hardly differentiated between Louis IX and his grandson Philip the Fair. Beauty itself was still stereotypical, so there was no urgency to identify people by explicit facial features. But a "portrait" supposes the intention of depicting an individual. It is far from clear that this intention was already present in a votive offering in the form of an equestrian statue placed by Philip the Fair in Notre-Dame-de-Paris after his 1328 victory at Cassel.[13] The question might be raised, however, concerning the grand ladies like Mahaut of Artois and Jeanne d'Evreux who prepared their funeral effigies in their own lifetimes, following well-established princely tradition.

Yet the intent to leave an image for posterity becomes quite clear when considering a fragment of the Paris rood screen (Musée du Louvre) in which the donor, canon Pierre de Fayel (died in 1344) was placed opposite the sculptor Jean Ravy—there is nothing generic about

Charles VI Watched Over by Saint James the Less. Alabaster group from the tomb of Cardinal Jean de La Grange in Saint-Martial Church, Avignon. Late fourteenth–early fifteenth centuries. Musée Calvet, Avignon.

the canon's heavily marked face. Donor and artist accorded themselves immortality within the sanctuary.

No less remarkable is the effigy of Jean Tissandier, bishop of Rieux (p. 118). He holds a large and accurate, if unfinished, model of the funerary chapel he had built at the Franciscan monastery in Toulouse. The statue, originally placed in the chapel, dates from circa 1333–1334 (Musée des Augustins). The young face possesses an individuality accentuated by the admirable pose.

Princely donors had themselves portrayed on portals (like the duke of Burgundy at Champmol), appropriating the place sometimes allocated to the founding Merovingian dynasty in the

twelfth century. But it is still difficult to appreciate fully the coup-like initiative of Cardinal de La Grange in 1375: the north tower of Amiens Cathedral is buttressed by a pier decorated with statues on hierarchical levels depicting the Virgin, King Charles and the royal children, and three of his "officers" including Bureau de La Rivière and the cardinal himself. It is hard to imagine a more spectacular move, since no explicit act of devotion justified such immortalization. The sculptor of this impressive ensemble remains unidentified (the attribution to Beauneveu being rejected); the features of the figures display remarkable modeling—the king and his key counselors are associated with a holy image which suddenly loses all its mystery and simply participates in the glorification of the high and mighty.

As bishop of Amiens, Cardinal de La Grange already had major resources at his disposal. He marshalled even more once he actively supported the schismatic church at Avignon. He commissioned his own tomb at Saint-Martial in Avignon, so it was certainly planned prior to his death in 1402, and is the finest example of extravagant funerary sculpture in the fourteenth century and perhaps throughout the entire era, with the exception of the Neapolitan models. The tomb sculpture (broken up during the Revolution) was arrayed across six levels, topped by a canopy, and included all major statuary motifs such as crowned Virgin, Apostolic College, and so on. The extant pieces, of uneven quality, do not permit the identification of known sculptors from Avignon (like Jacques Morel) or Burgundy, but one fragment demonstrates the degree of precision achieved around 1400 in the art of sculpted portraiture: a kneeling King Charles VI prays under the protective gaze of Saint James the Less (above). Not only are the crumpled folds of the garments executed in an interesting and confident way, but the little face of the mad king is not easily forgotten.

4. CHARLES V AND "ROYAL ART"

The fifteen years of Charles's reign were characterized by the determination to "rebuild" swiftly and powerfully, following the difficult periods the monarchy had experienced. The scepter prepared for the king's coronation in 1365 (reworked in 1380, originally at Saint-Denis, now at the Musée du Louvre) was already described in the context of the imperial dignity it evoked by alluding to the Carolingian dynasty. Above a knob with three representational medallions (one showing Saint James) is an enormous fleur-de-lys on which Charlemagne is enthroned in grand style. In the same spirit, if in the specific context of more recent events, a new copy of the *Grandes Chroniques de France* (pp. 319, 323) was prepared for the king, adapting the traditional text and illustrations in order to the stress the legitimacy of the house of Valois (Bibliothèque Nationale, Fr. 2813).[14]

Charles's library in the Louvre has remained justly famous. A great reader and enthusiastic humanist, the king inherited a booklover's thrill in fine editions from his father John II the Good, although with less passion and imagination than his brothers the dukes of Orléans and Berry. In addition to the *Grandes Chroniques*, the king commissioned illuminated manuscripts as diverse as a collection of ancient Roman anecdotes by Valerius Maximus (Bibliothèque Nationale, Fr. 9749) and a great liturgical treatise by Durand de

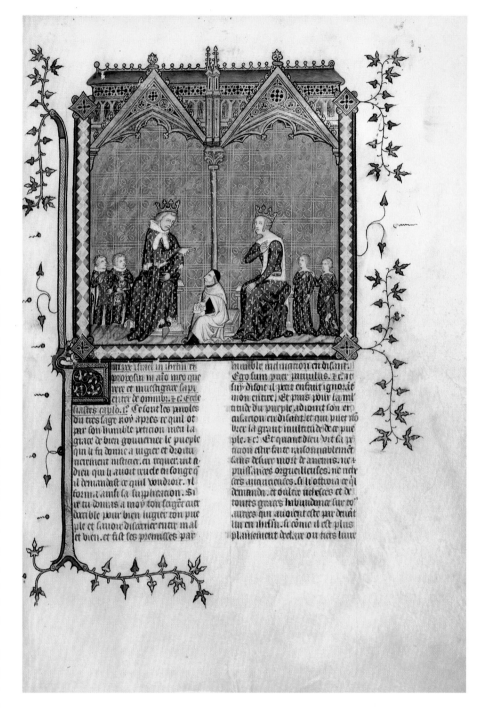

Durand de Mende's *Rational des Divins Offices*: Charles V and Jeanne of Bourbon flanked by their children; at their feet is the translator, Jean Golein. Bibliothèque Nationale, Paris (Ms. Fr. 437, fol. 1).

Mende, the *Rational des Divins Offices* (above). The *Rational* (Bibliothèque Nationale, Fr. 437) includes a painting of Charles and his family. A French translation of Livy's *History of Rome* by Pierre Bersuire (1354–1359) was recopied for Charles with an illustration by the Master of the Boqueteaux (p. 308), who strangely condensed the

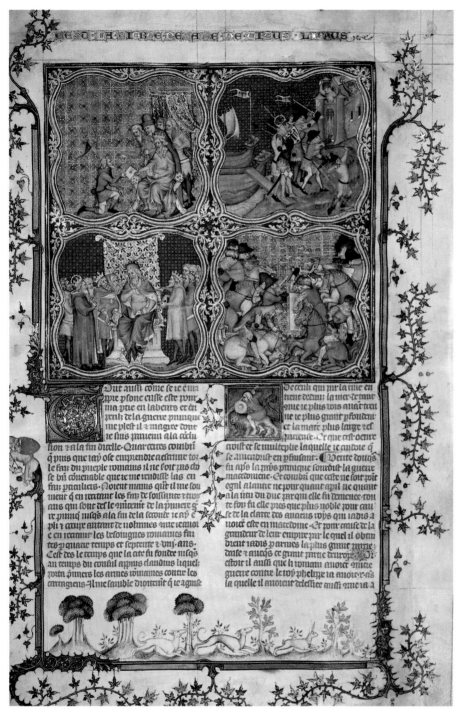

Livy's *History of Rome*: the Romans wage war against Philip V of Macedonia. c. 1370. Bibliothèque de Sainte-Geneviève (Ms. 777, fol. 316).

ancient tales into little scenes framed by quatrefoils (circa 1370, Bibliothèque de Sainte-Geneviève, Paris, Ms. 777). At the king's request, Nicolas Oresme translated Aristotle, and his copy of the *Ethics* (above, right) also features large plates with didactic images in quatrefoils (circa 1375, Brussels, Bibliothèque Royale, Ms. 9505–6). The dedication of a *Bible Historiale* offered to the king by one of his coun-

selors, Jean Vaudetar (1372, Meermanno-Westreenianum Rijksmuseum, The Hague, Ms. 10 B 23), indicates that the illumination, which opens with a portrait of king and counselor, was the work of "Jean de Bruges *pictor regis*," that is to say Jean de Bondol. The court artist had a thoroughly Flemish sense of modeling which was adapted here to Parisian taste via the fine yet lively letters, full of charm.

As has already been stressed, the reign of Charles V (1364–1380) was marked by many construction projects in Paris, including the Louvre. But it was also marked by a unified policy, which the king himself oversaw, as recounted by his special chronicler, Christine de Pisan. Charles had himself depicted everywhere; three centuries before Louis XIV, art was being developed and exploited as a tool of government. This policy greatly stimulated free-standing statuary strong on details of physiognomy and clothing, such as the two large statues ultimately representing the effigies of King Charles and Queen Jeanne of Bourbon (p. 311). The original placement of these statues, which has sparked much debate (the Quinze-Vingts Hospital, demolished in 1781, according to Alexandre Lenoir; the Celestine Convent, according to François de Guilhermy), may have simply been the east entrance of the old Louvre (demolished around 1660).[15] The king is wearing a long surcoat and the queen a simple dress as though protesting against the extravagance of reigning fashion. The grand, calm, and frank style of this pair, conveying rather singular insight, is justly famous (prior to 1380, Musée du Louvre).

It is known that there were royal statues on the portal of the Celestine monastery (circa 1370); as mentioned above, a certain audacity was still required to "have oneself depicted on the door jamb of a church," that is to say the place reserved two centuries earlier for the kings of Judah or the apostles.[16] Following this innovation, images of individuals were

Aristotle's *Ethics*: Nicolas Oresme presents his translation of the *Ethics* to Charles V; the royal family; Nicolas Oresme gives a commentary on Aristotle in the presence of the king; a teacher and his pupils. Bibliothèque Royale, Brussels (Ms. 9505–06, fol. 2v).

Right: book cover of the Sainte-Chapelle *Apocalypse*: Saint John is seated at his desk, surrounded by the symbols of the Evangelists. Gold niello. 1379. Bibliothèque Nationale, Paris (Ms. Lat. 8851).

placed in churches for reasons other than eternal repose. Thus it was prior to 1375 that the "fine pier" in Amiens, described above, honored members of the Royal Council in unforgettable fashion by placing them just below the royal family, itself a notch below the Virgin and two saints.

The cultural policy of any good monarch entailed the planning of an appropriate tomb. In his testament, Charles V (1374) asked for three distinct tombs—his body was to be buried at Saint-Denis, his heart at Rouen Cathedral, and his viscera at the Cistercian abbey in Maubuisson. These two latter monuments have disappeared, except for the effigy from the Maubuisson tomb. But the Saint-Denis tomb, executed during the king's lifetime by André Beauneveu ("image-carver to the King"), was saved by

Alexandre Lenoir in 1793; only fragments remain of the carved black marble slab and canopy.

As Danielle Gaborit-Chopin has clearly demonstrated, French royalty continued to accumulate precious items, curiosities, plate, and bizarre or amusing objects throughout the fourteenth century. These were transferred from one to another by gift or by bequest, beginning with Jeanne of Burgundy (died in 1348), wife of Philip VI, with her gold ewers and saltcellars "with two mantled monkeys." Her grandchildren, Charles V foremost among them, all had a passion for rare and exotic knickknacks. In the rivalry between connoisseurs, it was the king who seemed to have gone the farthest by collecting nearly four thousand objects for his "cabinet of curiosities," thereby

inaugurating a practice that would culminate in the vast heterogeneous collections of the seventeenth century. Everything found its place, in addition to modern items—artifacts that were antique (or believed to be so), objects of dynastic tradition, cut gems, etc. This important stage in the development of taste can be illustrated by the binding of an Ottonian evangelistary that, as part of the royal collection, received in 1379 a rather singular complement (as indicated by the inscription): on a gold cover with a niello ground of fleurs-de-lys, John the Evangelist is flanked by the four traditional evangelical medallions, over which is an angel bearing an inscription (Bibliothèque Nationale, Lat. 8851). This "pastiche" has provoked debate, and was thought to have been a forgery. Rather,

The Limbourg brothers, *Très Riches Heures du Duc de Berry*:
the month of December with Vincennes castle in the background (detail).
c. 1412–1416. Musée Condé, Chantilly (Ms. 65, fol. 12v).

Right: Charles V and Jeanne of Bourbon. Stone.
1365–1380. Height: 195 and 194 cm. Musée du Louvre, Paris.

bank, including the Louvre castle built by Philip Augustus, which thereby ceased to be the western-most fortress. At Saint-Antoine gate to the east, there arose an enormous fortification, to be known as the Bastille; built from 1370 to 1382, it had a polygonal plan with eight severe, round towers. Crowned by an unbroken rampart, this austere fort was never very popular.

In contrast, the Louvre began to look like a princely residence. The royal palace on the Ile de la Cité—where it had been too easy for Etienne Marcel to reach and massacre the dauphin's counselors—was abandoned. The transformation of the Louvre typified fourteenth-century concerns: buildings were made higher and endowed with rectangular openings; walls were given projecting ramparts with pinnacles and figures dancing against the sky. In short, an apparently lively and refined residence was stacked on top of the superb walls of the old fortress. The one brilliantly new and modern addition was the monumental staircase—a remarkable event in the history of construction. The "grand new winding stair" at the royal castle was begun in 1364. The broad spiral that rose around the newel, or central post, was surprising for its size and wealth of decoration—namely, magnificent statues appropriate to the majesty of royal lodgings. This grandiose structure was demolished in 1624, when a final extension was added to the Louvre. Recent excavations (1984), completing those made by Berty (published in 1866), suggest that the design was square rather than polygonal.[17] A similar staircase was built a century later by members of the Orléans branch of the royal family at Blois (1457, demolished). At about the same time, in the mid–fourteenth century, a vast interior stairway was built at the papal palace in Avignon, with a rising series of straight flights—an Italian design that had little broader impact in France at the time.

like the other board of the same binding, "redone" with thirteenth-century figures, it is proof of a somewhat sophisticated virtuosity in the days of Charles V.

The inventory made after Charles's death lists one hundred eighty pieces of tapestry, about which almost nothing is known. Arras tapestries had been highly fashionable for at least fifty years, but the sources for these largely secular motifs can only inferred through orders placed by Louis of Anjou, brother of Charles, not by the ones executed for the king himself.

Royal Buildings

Civil disturbances, the existence of uncontrolled bands roving the country, and general insecurity sparked energetic measures to protect Paris. In ten years, the capital underwent one of the greatest transformations in its history. First a protective wall was raised around a large part of the right

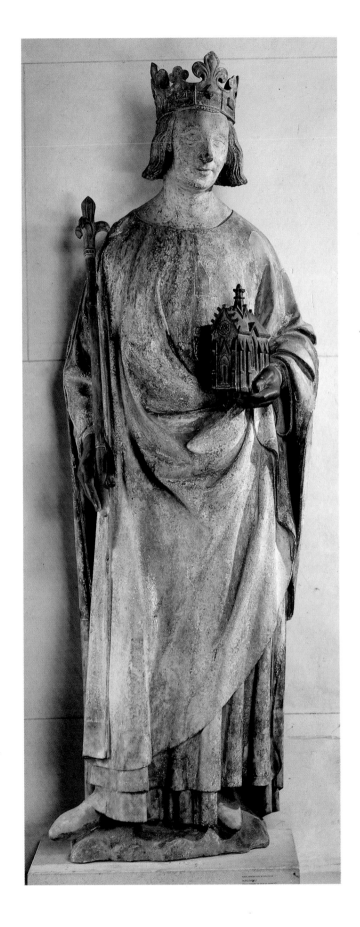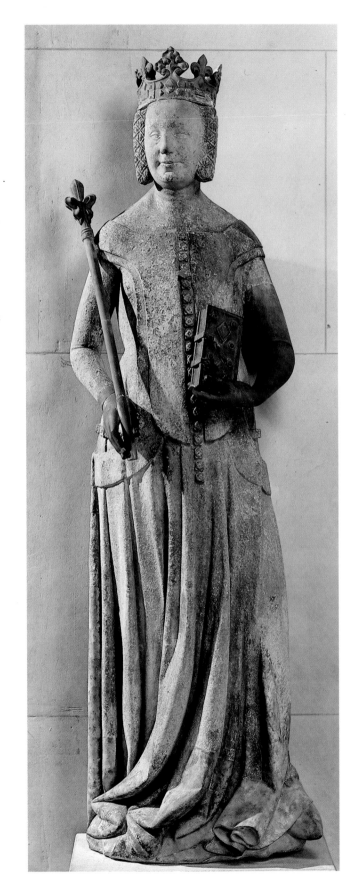

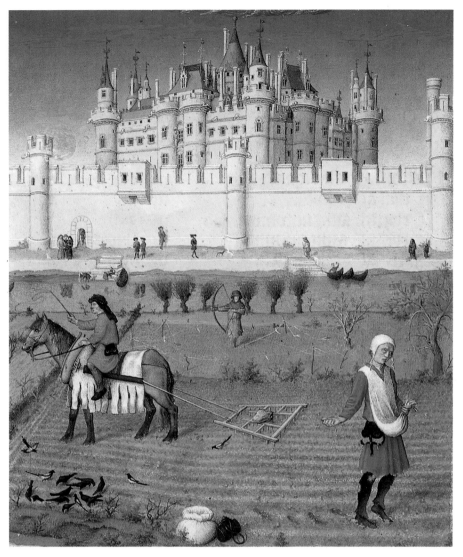

The Limbourg brothers, *Très Riches Heures du Duc de Berry*:
the month of October with the Louvre in the background (detail).
c. 1412–1416. Musée Condé, Chantilly (Ms. 65, fol. 10v).

The building of the new Louvre was of capital importance. The king set an example of the way old castles should be handled and how new ones should be designed: the lower portion should remain rough and powerful but the upper floors should feature open galleries, fancy crenellation, and a forest of gables and chimneys, yielding a rarified, aristocratic, fairy-tale residence. Such castles would be wonderfully depicted in the *Très Riches Heures du Duc de Berry* (Musée Condé, Chantilly, Ms. 65, above and pp. 303, 310). To conform to this poetic and aristocratic notion, for instance, the round towers at Saumur were endowed at mid-height with octagonal, more plastic, features. The duke of Berry's castle at Mehun-sur-Yèvre, near Bourges, was erected on thirteenth-century foundations by Guy de Dammartin, who had worked on the Louvre. It has not always been clearly perceived that the idea behind the new design was to maintain the fortress quality at ground level while erecting a luxurious residence on the upper floors. This was in no way a contradiction; rather, it reflected a sharp sense of the

contradictions of a princely existence.

Charles V was responsible for another major initiative, namely a type of castle built outside the city walls. At Vincennes, where there was already a hunting pavilion, Charles transformed the site into a royal ensemble that prefigured the one erected three centuries later at Versailles, when Louis XIII's modest château was enlarged according to a well-defined program. Charles's intentions for Vincennes, however, are far less clear. An enormous rectangular wall (335 × 175 meters) guarded by nine 40-meter-high towers, enclosed a little manor and chapel built by Saint Louis; the unusual, imposing keep was, in a way, anachronistic, being closer to Romanesque fortifications than to modern castles. It was begun under Philip the Fair, continued by John the Good, and completed by Charles V around 1370. Similar in its massiveness to the keep in the Temple, the edifice was fifty meters high and of square design, with a round tower at each corner. There were two special features: it had a sloping revetment wall at the base, surrounded by an extremely wide moat, and access to the king's floor was by a drawbridge lowered from the entrance fort.

This strange complex, once thought to be deliberately "old-fashioned" and related to the fortifications in the Holy Land, obviously fulfilled requirements of a military nature; however, if a comment by Christine de Pisan is correct, the famous square towers along the wall—defensive at the bottom but endowed with elegant windows topped with machicolated ramparts—housed royal friends and favorites. Vincennes would therefore have been a precursor of Louis XIV's château at Marly, where eight pavilions framed the king's lodgings. François Gébelin has noted the influence of the strange Vincennes keep on the Maubergeon Tower in Poitiers, built by Guy de Dammartin from 1384 to 1386.[18] This square structure in turn influenced other castles in the duke of Berry's fiefs (at Anjony, for example).

5. ARISTOCRATIC OSTENTATION: THE THREE PLEASURES

Gaston Phébus, count of Foix, opened his *Livre de la Chasse* ("Book of Hunting") with the following comment dated 1 May 1397: "All my time I am distracted by three things especially, one is arms, another is love, and the other is hunting . . ."[19] Phébus did not brag too much about his successes in the first two spheres, but certainly did in the third, thereby producing one of the finest books of the period around 1400, to be discussed below. But it is worth immediately pointing out the extent to which the aristocratic lifestyle had become depictable and even, to be more precise, was molded by depictions. A little treatise on morals titled *Le Songe du Verger* ("The Orchard Dream," 1378, British Library, London, Ms. Royal 19 C IV), reveals that "Knights of our times have painted foot and cavalry battles in their halls in order that by this vision they take pleasure in imaginative battles." The allusion is to frescoes, not tapestries, of which no trace remains. But there are countless scenes of combat in miniatures and sculpture, a medium for the courtly allegories that constituted a secular revival of the old representation of moral combat between vice and virtue.

In terms of amorous scenes, the number of models available to aristocratic courts grew throughout the century, or at least the works displaying such scenes became more and more numerous, in the form of ivory plaques mounted on little chests or the backs of mirrors. They always illustrate the same genteel situations of

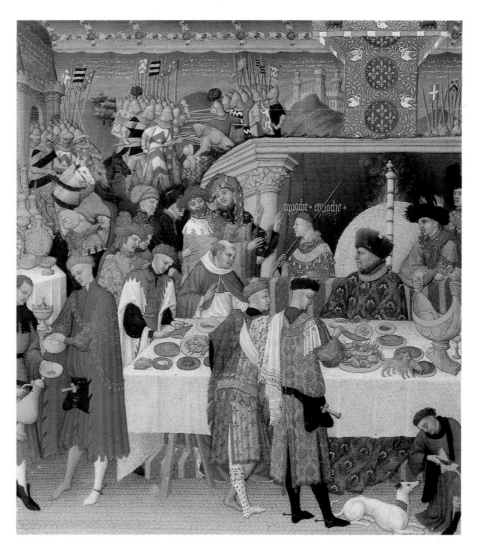

The Limbourg brothers, *Très Riches Heures du Duc de Berry*: the month of January, the duke of Berry dining (detail). c. 1412–1416. Musée Condé, Chantilly (Ms. 65, fol. 1v).

embracing or crowning the loved one, playing chess, doing a round dance or other amusements. Sometimes, as on a regal casket from that period (1320–1340), famous couples were depicted—Lancelot and Guinevere, Tristan and Iseult—at exciting moments of their story, such as a joust in front of the damsels' stands (p. 314). The visual organization of these objects was similar to that employed on religious artifacts. In household decoration—tapestries or frescoes—love scenes

were regularly evoked (the hunting and dancing scenes discovered at Sorgues, dating from 1380–1390, and now at Avignon, are perhaps not the best example).

Goldsmiths were privileged suppliers to royalty and nobility. They were responsible for jewelry and precious objects, supervising the use of such objects during ceremonies. In Paris, they worked for the king, and in other cities for noble administrators, fashioning and overseeing official stamps. Philip VI accorded them

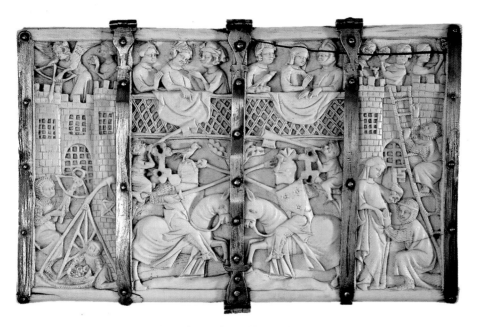

Casket carved with fictional and allegorical scenes. Ivory. Paris.
Second quarter of the fourteenth century. Height: 8 cm. British Museum, London (MLA 56–6–23).

Right: table centerpiece. Silver gilt and translucent enamel over relief carving.
Paris, mid–fourteenth century. Height: 31 cm. The Cleveland Museum of Art (Acc. 24.859).

ist carefully recorded the extraordinary diversity of dress—everyone at court wore gowns covered in heraldic symbols (a most significant detail since throughout the century there was a tendency to identify people and institutions by their coats of arms). In the *Roman de Godefroy de Bouillon* (1337, Bibliothèque Nationale, Fr. 22495), the battle between Europeans and Saracens becomes a heraldic clash of leopards and eagles against crescent moons, thanks to images on shields and armor (p. 316). The French nobility's tendency to favor visual emblems and, more precisely, the use of heraldry needs to be stressed. Nor should it be forgotten that this represents an aristocratic version of a more widespread practice. "In the minds of people living on the continent, an Englishman was always a figure dressed in red and white. The same phenomenon worked for France—a Frenchman was somebody dressed in white and blue."[20]

A GOLDEN AGE OF HERALDRY

Thanks to a taste for adornment and ostentation, heraldry—an already ancient noble practice—underwent extraordinary expansion and lent a strongly emblematic coloring to every social event. This occurred at a time when armorial bearings were progressively disappearing from the battlefield itself, due to changes in equipment (the discarding of small arm shields called bucklers, for instance) and the increasing importance of foot soldiers. Everywhere else, however—at tournaments, parades, and celebrations—the heraldic shield and crested helmet were more present than ever.

Heraldry, or the system of identifying lineage, probably sprang from the need to distinguish various combatants during battle,[21] as can be seen on the Bayeux Tapestry. An enameled plaque (circa 1160) showing Geoffrey Plantagenet's escutcheon "azure with six lioncels or" is apparently the oldest object attesting to the existence of a coat of arms. In the next

privileges and even granted letters of semi-nobility. A certain Jean Le Braillier, valet to John the Good, was the king's supplier of silver plate. Similarly, John's son, Louis of Anjou, king of Naples, had his own goldsmith, named Henry, who produced elaborate tableware and a nef (or boat-shaped container) to hold cutlery, goblets, etc. Inventories from 1369 and subsequent years reveal that Louis possessed an incredible total of three thousand objects. All have disappeared, many during Louis's own lifetime in order to finance his reconquest of Naples. Two medallions from a mirror are all that remain (Musée du Louvre). The famous miniature of a heavily laden table from the *Très Riches Heures du Duc de Berry* (p. 313) also presents a valid picture for the duke's two brothers, Louis of Anjou and King Charles. Table, interior decoration, dress, and everything else is colored with royal magnificence.

There were many other rare, amusing, or exotic items made of precious metal.

For example, an extremely complicated table centerpiece in silver gilt with enamel decoration (circa 1330–1350, Cleveland Museum) boasts little mechanisms embellished with the grotesques and animals that had been fashionable in both Eastern and Western courts since the thirteenth century (right). This was a typically princely gift—Louis of Anjou reportedly owned thirty-eight of them. Automatons of all sorts, usually imported, were very popular—chronicles and romances are full of references to them. Around 1380, Froissart wrote a symbolic poem, *L'Horloge Amoureuse* ("The Amorous Clock") based on an analogy between the mechanisms of a soul in love and the new instrument for measuring time, images of which were beginning to appear in miniatures. It was a century that adored objects.

It also adored emblems. On a now-lost miniature (known from a copy produced for Gaignières), Louis of Bourbon is seen rendering homage to Charles V. The copy-

Le Roman de Godefroy de Bouillon: battle between Europeans and Saracens.
Paris, 1337. Bibliothèque Nationale, Paris (Ms. Fr. 22495, fol. 154v).

fifty years, from 1180 to 1230, the practice would extend to the entire nobility, thanks notably to tournaments—originally veritable battles between two groups—the fashion for which spread in the twelfth century among feudal vassals who displayed the arms of their liege lord on their shields. Then the fashion spread to women, clerics, tradesmen, and civil and religious institutions. Every aspect of social life was colored by the practice as it swept throughout all of Europe.

Seignorial heraldry reached its fullest development during the days of Saint Louis, dominating subsequent generations. Rules governing symbolism, plus the need to resolve conflicts and abuses, led to the drawing up of repertoires, or armorials (already numerous in France and England after 1270, and in the Holy Roman Empire after 1310), accompanied by the rise of specialists in "blazonry" who tended to standardize usage.

Blazons presented appropriate symbols primarily to denote genealogical lineage, marriages, and bastardy, yet they also displayed the eloquence of admirably selected signs and stylized figures that would soon be found on everything, from furniture to manuscripts and stained glass. These lively, brilliant compositions gave a new, sharpened sense of color and form to public life in the fourteenth century.

The basic repertoire comprised seven colors—or (gold), argent (silver), gules (red), purpure (purple), azure (blue), vert (green), and sable (black). The French monarchy set the example—the old escutcheon had an overall fleur-de-lys pattern, whereas the modern one, which emerged in the fourteenth century, has three fleurs-de-lys, conforming to the legend of three flowers given to Clovis by an angel (recounted in Guillaume de Digulleville's *Roman de la Fleur de Lys*, 1338), which particularly suited the Valois branch of the family.

In principle, only the eldest son had the right to bear the "full" arms. His brothers had to add a "brisure" or cadency mark that indicated a secondary line. The cadency mark would vary depending on the arms— a "bend" (diagonal band) might be "engrailed" (given a curvy edge). The brother of Philip the Fair, Charles of Valois, bore the arms of "France with border gules" while Charles's son, the future Philip VI, "France with border gules engrailed."

Instead of engrailing, the cadency mark might be a "label," or horizontal strip with a number of downward pendants. Hence Saint Louis's brother Alphonse, count of Poitiers and Toulouse, bore an escutcheon "party of France and Castile" (represented by small castles, the heraldic heritage of their mother, Blanche of Castile, noted earlier on stained-glass windows). The king's younger brother, Charles of Anjou (1227–1285), who became king of Naples in 1266, wore these arms with label gules (which became the blazon of the Guelph faction in Italy).

According to Michel Pastoureau, "everything, absolutely everything, from the thirteenth to the eighteenth century, was blazoned." The repertoires established in the fourteenth century were extended and deployed through incessant invention, which fully revealed heraldry's twin aspects of combination and stylization. This extension also embraced entire classes, professional groups and towns as well as individuals and families. The use of escutcheons eventually colored every aspect of social life, giving events the flavor of a continuous spectacle, turning both tailors and decorators into set designers. Artists were henceforth omnipresent

Bellenville Armorial. c. 1364–1386. Bibliothèque Nationale, Paris (Ms. Fr. 5230, fol. 70v).

and, in this new physiognomy of the social body, talented painters like the Limbourg brothers (and, in the next century, the painters to King René of Anjou) would produce riots of colorful emblems.

Starting in the mid–thirteenth century, heraldic vocabulary became a somewhat fixed, esoteric language in both France and England. The first half of the fourteenth century, just prior to the long conflict between the French and English knights, was a period of maturity and growth. Further additions included personal marks or mottoes, which came back into fashion with a wealth of inventiveness and whimsy. Placing a device—symbol and motto—on clothing tended to turn a garment into a "cryptic" image, a fashion imported from England by Louis II of Bourbon on his return from captivity in 1366. It became one of the great games of English, French, and Italian aristocracies whose symbols—like the bear and swan of Jean of Berry, the white rose of York, or the sword of Burgundy—can be seen in countless miniatures.

The French fleur-de-lys, for that matter, first appeared on the seal of Henry I (1035), which showed the king holding a lily in his right hand, perhaps an adaptation of an Eastern motif. It became the symbol of the Capet monarchy in the twelfth century, and would henceforth figure on scepter, crown, counter-seal, mantle, and shield.

THE THREE DUKES

All the traits, talents, foibles, privileges, and passions of the aristocracy were intensified to an extreme degree by princes awarded appanages, or land grants, following a decision of John the Good that was reiterated by Charles V in favor of his three brothers: Louis of Anjou (who died in 1384 leaving an adventurous heir, Louis II, whose revealing portrait at the Bibliothèque Nationale bears the inscription "King of Naples and Sicily") Jean, duke of Berry (who died in 1416, after

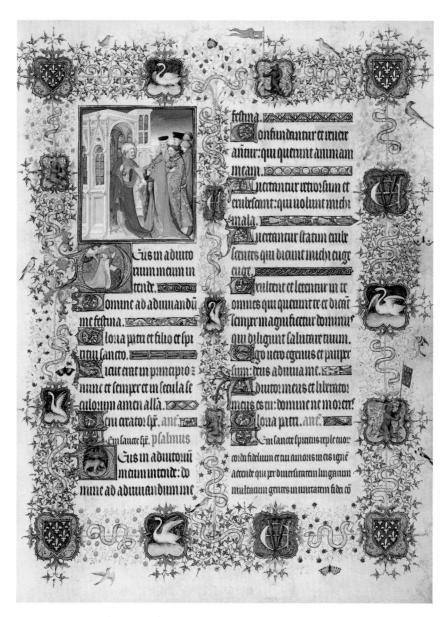

Grandes Heures du Duc de Berry: Jean, duke of Berry received by
Saint Peter at the gates of Paradise. Finished in 1409. 40 × 30 cm.
Bibliothèque Nationale, Paris (Ms. Lat. 919, fol. 96).

becoming an immortal art patron), and Philip the Bold (who forged the great duchy of Burgundy and was succeeded in 1404 by the dreaded John the Fearless). To their number should be added Louis, duke of Orléans, the young brother of the future Charles VI. Everyone agrees that it is impossible to decide which of these princes was the most chimerical, the most madly ambitious, the most tied to ostentation. And one might wonder if the purely aristocratic mentality which, in the absence of any ideal of commonweal, produced appalling policies during the reign of Charles VI, is not also behind the extraordinary artistic development of the late fourteenth century, bringing medieval art to such a fine conclusion.

The "uncles" used to get together in Paris, their celebrations and expenditures contributing to the climate of luxury and the production of fashionable items. But Paris had become cosmopolitan, for each duke, according to the location and orientation of his duchy, maintained active relationships with foreign centers. The most interesting foreigners were drawn toward the capital. With Louis II of Anjou, who held Provence and intended to reestablish his rights over Naples, a diagonal axis was

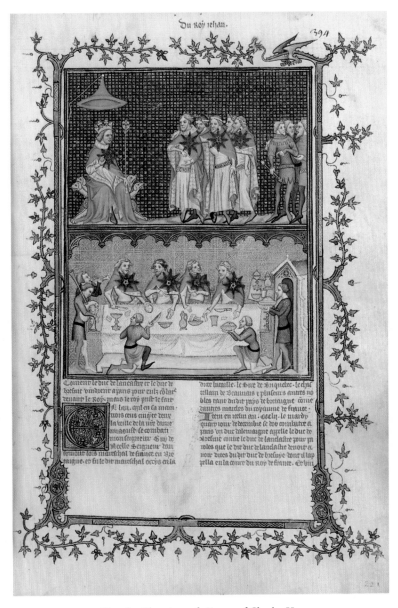

Grandes Chroniques de France of Charles V:
the institution of the Order of the Star, and banquet.
c. 1375–1379. Bibliothèque Nationale, Paris (Ms. Fr. 2813, fol. 394).

drawn from the Loire to the Tyrrhenian Sea. As of 1385, Philip the Bold summoned the Dutch sculptor Claus Sluter to erect a dynastic mausoleum at Champmol; never had so many artists from northern lands been engaged in the service of French princes. The duke of Berry, moving between luxurious residences around Paris and Mehun, turned everything he touched into a priceless treasure

through his indefatigable art patronage.

Inventories reveal that tapestries constituted one of the costliest items in noble residences. Woven at Arras or Tournai, tapestries were the object of highly active trade during an epoch that sought more refined and more secular interior decoration. There were countless "Saracenic tapestries worked with gold in Arras fashion" and "Charlemagne tapestries" that

are, alas, as impossible to illustrate today as the lost frescoes. By exceptional good luck, the name of Nicolas Bataille is known. Bataille was in the service of Louis I of Anjou and undertook to produce the extraordinary Apocalypse cycle starting in 1374, on cartoons prepared by Jean de Bondol (pp. 320, 321 and 322). Donated to Angers Cathedral in 1490, the cycle comprises six large tableaus

(totaling 720 square meters) with alternating red and blue grounds, each of which includes a figure of a prophet standing in a tabernacle. A recent technical examination has resulted in the definitive attribution of the first two tableaus to Jean de Bondol.[22] The exceptionally confident and harmonious composition was based on a manuscript that the duke borrowed from his brother the king. It is easy to see that, whatever misfortunes plagued the times, the subject of doomsday was treated with fantasy and imagination rather than dread. The role played here by Louis of Anjou is arguably as critical as the one played by his brother in Burgundy in summoning Sluter to Dijon, or by the duke of Berry's commissioning the Limbourg brothers to execute the fabulous *Très Riches Heures* around 1405. But one should not forget that the castles of all of them were magnificently endowed with tapestries decorating the walls.

The duke of Berry was well informed about things Italian; in 1408, he was told of a marquetry specialist in Siena and, "since you know that we take delight in strange things,"[23] had the man sent to him immediately. Everything happened according to the whim of these princes. Unfortunately, it will never be possible to marshal enough knowledge and imagination to reconstruct their bizarre collection of marvels. How wonderful it would be to have some idea of the portrait gallery, destroyed by fire in 1411, that the duke installed in his castle in Bicêtre.

He enjoyed a fame and influence in the realm of art, connoisseurship, and curiosity that was somewhat equivalent to Louis IX's prestige in the political and religious spheres a century earlier. But by that very token the duke of Berry lacked the authority and gravity of a statesman. He was an art patron and unparalleled aesthete, but nothing more. He constantly raised taxes and squeezed his subjects to acquire the funds needed for his fine undertakings, and his destiny was played out on the

Angers Apocalypse: The Four Horsemen. Tapestry commissioned by Louis I, duke of Anjou and designed by Jean de Bondol between 1374 and 1381. 153 × 247 cm (approx.). Musée du Château d'Angers, Angers.

pleasant stage of his art collection, amid the Limbourg brothers' gems and masterpieces. This was a purely aristocratic triumph, of course, yet as fate would have it the duke had the time to prepare a retreat for the young dauphin who, though deprived of land and throne by his mother, Queen Isabeau, would become king as Charles VII. Once again, Berry displayed good instincts.

NEW ORDERS OF CHIVALRY

The notion of chivalry assumed its full import in the twelfth and thirteenth centuries—dubbing elevated a knight by conferring on him honor, rights, and duties. The institution never involved more than a fraction of the nobility, but it was the source of a stereotyped figure of a man completely equipped with coat of mail, helmet, and shield. This image, used on carved reliefs, frescoes, and miniatures, was suitable for representing militant energy, and hence was abundantly exploited in Romanesque art and thirteenth century imagery to symbolize Virtue overcoming Vice.

But the institution declined during the fourteenth century; around 1300, France numbered some five to ten thousand knights, yet by 1460 there were no more than a thousand. The reason for this diminution was a change in the way armies were recruited, and the ravages of military campaigns.[24] But knighthood continued to embody the idea of a mark of honor, valid above all in the entourage of kings—there were numerous dubbings during a coronation or on the occasion of a processional entry into a town. What had been a commitment became a favor, a reward, and an opportunity for fine display. But for most of society, the institution no longer played a key role. It was something else—an element of show and prestige, of course, yet also an obscure principle of association by affinity, of services spontaneously offered. That, at least, is what is suggested by the original and amazingly widespread phe-

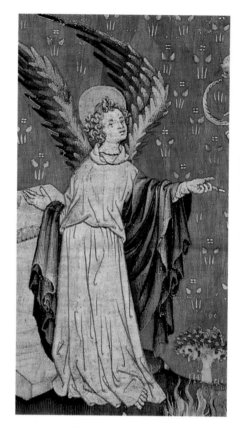

Angers Apocalypse: Harvest of the Damned (detail). Tapestry designed by Jean de Bondol between 1374 and 1381. 153 × 247 cm (approx.). Musée du Château d'Angers, Angers.

nomenon of new orders of chivalry that sprouted precisely at the fourteenth century and then flowered for another century. An instinctive compensation for the inadequacies of the institution itself was sought on the levels of imagination and pageantry.

The new associations sometimes appeared to be a parody of religious orders, with vows, ceremonies, obligations, solemn gatherings, special apparel and decorations that transformed them into somewhat mysterious "clubs." This artificial institution replaced the traditional *ordo militum.* What is of interest here is chivalry's role in the explosion of emblems, costumes, show and display. New orders became an international fashion, as evidenced by Edward III of

England's founding of the Order of the Garter in 1346, echoed by John the Good's Order of the Knights of the Star in 1350. It would be hard to draw up a complete list of the "orders," for some of them were ephemeral, like the Order of the Hood of Mail or Porcupine, which was founded by Louis of Orléans in the early fifteenth century and which provided Louis XII with his emblem at the end of that century.

A particularly interesting example in terms of artistic repercussions, however, was the order founded by the house of Anjou in Naples. Pentecost 1353 was the anniversary of the coronation of Louis of Tarentum (nephew of Robert of Anjou), and the date of the first meeting of the first chapter of the "Order of the Holy Ghost of Virtuous Desire," also known as the "Order of the Knot" after its emblem (which symbolized the unity of this lay confraternity). Two years earlier, John the Good had founded the "Order of the Noble House" (or Order of the Star) which served as a model for the statutes, rites, and intensely romantic and religious language of the Neapolitan order, whose aim was "to attain virtuous desire and seek adventure." The order is known thanks to a superb manuscript (Bibliothèque Nationale, Fr. 4274) dating from around 1355 which may be the work of Cristoforo Orimina, a southern miniaturist familiar with French art. The paintings depict offerings, galleys, tombs, and battles with delightful sharpness.[25]

People were stirred by fiction and delight in ceremony. Chivalry was a simultaneously serious and naive fantasy in which a certain blurring of the secular and the sacred created a climate most flattering to princes, who could set themselves up, as Philip the Good and King René would later do, as "grand masters" of an impeccably "emblematized" order. The next epoch would capitalize on this climate, culminating in France's national Order of Saint-Michel.

6. The "International" Style

In 1378, Holy Roman Emperor Charles IV, originally of Luxembourg, uncle of Charles V, paid a visit to the French king, an occasion commemorated by a famous miniature (right) in the *Chroniques de France* (Bibliothèque Nationale, Fr. 2813). Prague, where the emperor held court, was not far away, and was developing an imaginative, lavish art as witnessed by manuscripts of great charm. Meanwhile, Louis, duke of Orléans and brother of the French king, had married Valentina Visconti, and painters from northern Italy were streaming to Paris. One of the court's official accountants, Jean Le Bègue, kept a notebook on the illuminators that particularly interested him, thus bequeathing to posterity information on encounters in Paris circa 1398 between Jacques Coene from Flanders and a Milanese gentlemen who apprised him of the work of Giovannino de' Grassi, well known to Christine de Pisan.[26] Such encounters made Paris the center of luxury fashion fueled by princely demand, spurred by competition between European courts, giving rise to what is

Grandes Chroniques de France of Charles V:
banquet in honor of Holy Roman Emperor Charles IV, king of Bohemia and his son, Wenceslas, king of the Romans, given by Charles V, king of France, in the palace's grand hall in 1378. c. 1375–1379. Bibliothèque Nationale, Paris (Ms. Fr. 2813, fol. 473v).

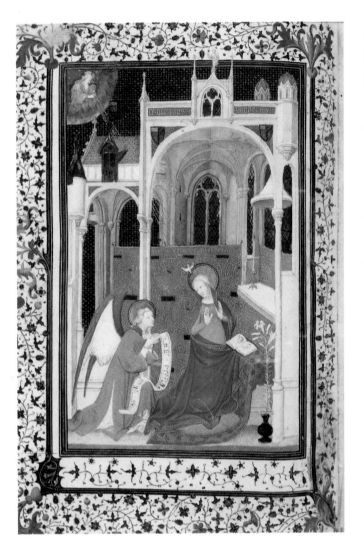

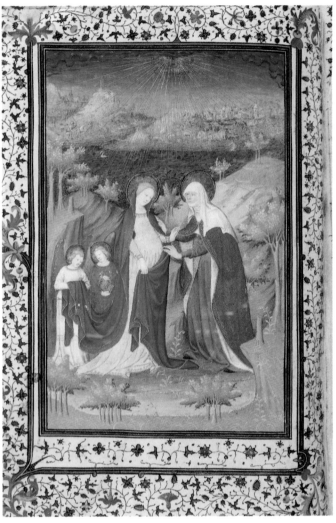

Boucicaut Master (Jacques Coene?), *The Boucicaut Hours:* the Annunciation and the Visitation.
27.4 × 19 cm. c. 1410–1412. Musée Jacquemart-André, Paris (Ms. 2, fols. 53v and 65v).

conveniently known as "International Gothic." The ensuing professional repercussions must, of course, be interpreted with care: in 1301, a group of twenty-five painters and five sculptors submitted its statutes to the provost of Paris for approval. This was probably a defensive move to protect their market yet was also, it would seem, an attempt to maintain the quality of production.

The arrival in Paris of Flemings like the aforementioned Jacques Coene is noteworthy. It is tempting to identify

Coene as the author of one of the indisputable masterpieces of the "school of Paris"—the marvelous *Boucicaut Hours* (circa 1410–1412, Musée Jacquemart-André, Paris, Ms. 2, above and p. 283). In 1399, the three Limbourg brothers—Paul, Herman, and Jean—left their native Guelders to come to Paris, summoned by their uncle Jean Malouel, who was recruiting on behalf of Philip the Bold. But on Philip's death in 1404, the team found lasting employment with the duke of Berry, whose patronage of fine manu-

scripts assumed almost extravagant proportions. It is conceivable that without the calamities of 1415 and the English occupation of Paris, the capital would not have gone into decline, and the likes of Jan Van Eyck would have made the trip. In the meantime, however, the duchy of Burgundy expanded northward, and its capital shifted from Dijon to Lille, so that "Eyckism" ultimately had only an indirect influence on the art of miniatures in France.

An unusually large bible offered to Charles V by Jean de Vaudetar in March

1372 (Meermanno-Westreenianum, Rijks-smuseum, The Hague), displays the same taste for sober yet robust narrative noted in the Bible of Jean de Sy, produced fifteen years earlier for John the Good. The novelty of the *Bible Historiale* resides in the dedication pages, the importance of which have often been stressed: first a proud inscription names the artist—*Johannes de Bruges, Pictor Regis* (otherwise known as Jean de Bondol, designer of the Apocalypse tapestry cycle at Angers). On the facing page, in a double portrait, the painter offers his work to the king against a ground of fleurs-de-lys that underscores the volume, plastic quality, and fullness of the two figures. Flemish skills had obviously been enhanced by some Italian expertise.

Painters of the day would go from one patron to another. A work called the *Grandes Heures du Duc de Berry*, completed in 1409 (Bibliothèque Nationale, Lat. 919, p. 318) included, according to a 1413 inventory, "large stories [i.e. miniatures] in the hand of Jacquemart de Hesdin." It is thought that a parchment showing the Bearing of the Cross, now separate, may have been included. This dense and dynamic composition, with its soft colors and broad deployment in space, represents a brilliant adaptation of Simone Martini's Sienese model.

The rather stirring moment had arrived, therefore, when the art of the miniature acquired the concentrated quality and full forms that nudged it toward the realm of painting proper. A step in the evolution was marked by the *Très Belles Heures de Notre-Dame* (Bibliothèque Nationale, Nv. Acq. Lat. 3093), a manuscript painted in several stages and mentioned in duke of Berry's 1413 inventory (p. 327). The hand of the Master of the Parement of Narbonne can be detected in a major part of these large pages, which would date them circa 1380. The conventional scenes are more concentrated and unified through a mastery of color, without

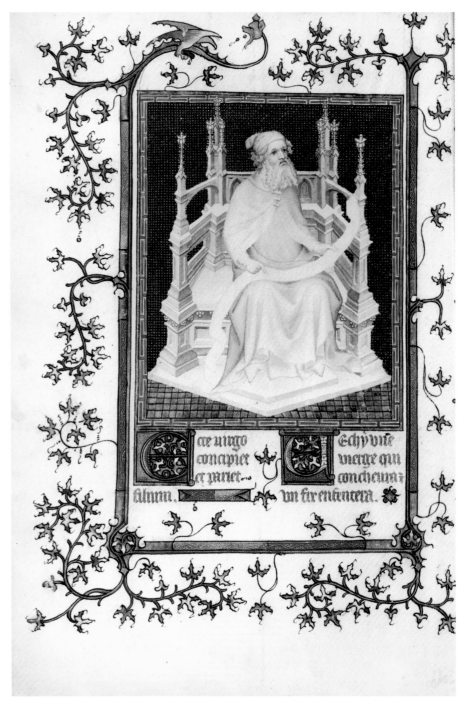

André Beauneveu, *Psalter of the Duke of Berry*: Isaiah. c. 1385.
Bibliothèque Nationale, Paris (Ms. Fr. 13091, fol. 11v).

losing any of the traditional Parisian elegance.

The painter of the *Parement of Narbonne* (1375, p. 326) was a powerful artist, working in India ink on silk. Neither the exact origin of the black-and-white altar decoration nor the reasons for placing it in the southern cathedral of Narbonne are known, since the Lenten ornament was probably designed for some royal chapel. The overall organization recalls large,

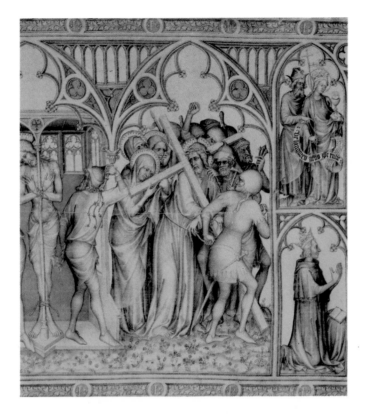

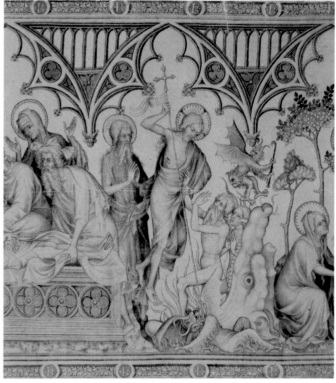

Master of the Paremont of Narbonne, *The Parement of Narbonne* (details):
Christ Bearing the Cross; the Harrowing of Hell; the Church and the prophet Isaiah; Queen Jeanne of Bourbon.
Black ink on white silk. c. 1375. Musée du Louvre, Paris.

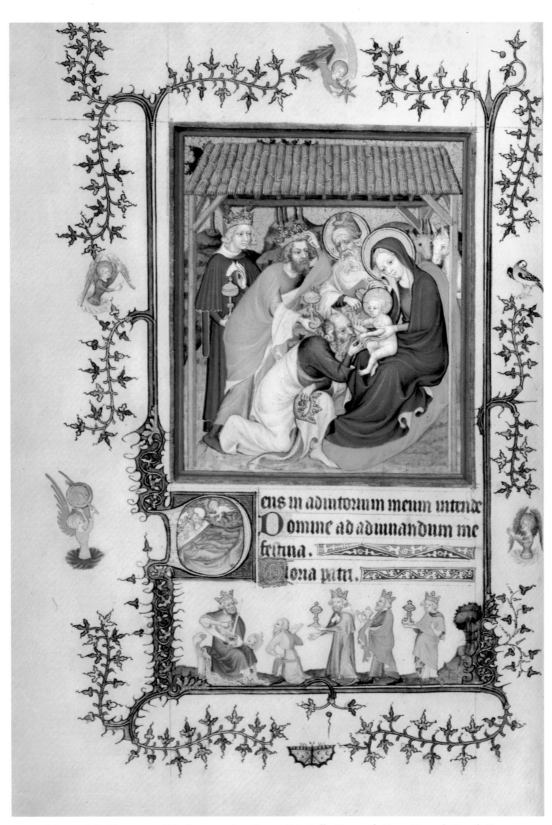

Master of the Paremont of Narbonne and assistants, *Très Belles Heures de Notre-Dame du Duc de Berry*:
the Adoration of the Magi; in the initial: an angel appears to the sleeping Magi; bottom of page: the Magi before
Herod. c. 1380. 27.9 × 19.9 cm. Bibliothèque Nationale, Paris (Ms. Nv. Acq. Lat. 3093, fol. 50).

Claus Sluter, *The Well of Moses* (detail): Moses and David. Stone,
traces of polychromy. 1395–1405. Chartreuse de Champmol, Dijon.

Aristotle's *Politics and Economics*: working the fields in a "good democracy."
Paris, c. 1375–1376. Bibliothèque Royale, Brussels (Ms. 11201–2, fol. 241).

compositions in the Sienese style—the scenes are condensed, but the figures possess modeling and breadth, and their faces are marked with an expressiveness devoid of all monotony. It would be nice, some day, if scholars could accurately account for this masterpiece.

Many works from the years around 1400 display the same charming manner yet retain an ambiguous status. An *Adoration of the Magi*, one panel of a Burgundian diptych (circa 1390, Bargello, Florence) typifies the various trends of the day with its terse style and subtle use of rare colors. Far more calm and confident is the *Presentation in the Temple* produced for the altar at Champmol by Melchior Broederlam (circa 1400, Dijon), whose superb Flemish technique was here placed at the service of both Sienese exquisiteness and Parisian elegance.

By commissioning André Beauneveu to paint the initial images of his *Psalter* (circa 1385, Bibliothèque Nationale, Fr. 13091, p. 325), the duke of Berry obtained a series of figures remarkable for their modeling and finish, including the spatial handling of thrones. This represented a way of associating the two crafts of painting and sculpture in one delicate image.

Meanwhile, in Burgundy, a vigorous style was emerging that would keep the two arts separate for a long time. Claus Sluter's work in Champmol on a *Well of Moses* (or, more accurately, the base of a crucifix, in conformity with the Carthusian rule) lasted from 1395 to 1405 (left). All sorts of incidents altered this major piece (only a fragment remains of the highly moving Christ), but the figures of the prophets with their flowing robes represented a new era in sculpture. The vogue for statuary described above entailed a style quite removed from these strong, virile figures, which should be linked instead to the development of Rhenish sculpture.

Flemish [?] painter working in Paris, *Livre de la Chasse de Gaston Phébus*: deer hunt.
c. 1405–1410. Bibliothèque Nationale, Paris (Ms. Fr. 616, fol. 85v).

In the mid–fourteenth century, the Parler dynasty of sculptors mastered a "polished" style (*der schöne Stil*) comparable to that of Parisian sculptors of beautiful madonnas, yet buttressed by a broader energy marked by the experience of nature and a certain awareness of the specific historical role of their art.

LANDSCAPE

An interest in landscape was one of the pictorial novelties to emerge in Parisian miniatures in the days of Charles V. Various farm tasks are condensed into a single scene in a manuscript of Aristotle's *Politics*, translated by Nicolas Oresme (circa 1376, p. 329), and in the *Très Belles*

Heures du Duc de Berry by Jacquemart de Hesdin (both in the Bibliothèque Royale, Brussels, Ms. 11201–2 and Ms. 11060–61). In the calendar of a Book of Hours (formerly Chester Beatty Collection), each month occupies a full page with farming scenes framed by highly realistic foliage; it has been suggested that this was the work

of a potentially Italian precursor of the Limbourg brothers,[27] or of one of their followers. These compositions have been linked to the the vogue for large landscape frescoes that certainly existed in France. A remarkable example of landscape fresco, circa 1407, survives in the Aquila Tower of the Bishop's Palace in Trento, Italy. The tall frescoes have a vertical space dotted with intense little scenes showing work in the fields and aristocratic leisures, providing a wealth of detail. The artist was obviously aware of trends in Prague, that is to say one of the major centers of the "International Gothic" style. Another late fourteenth-century center was Verona, which was in constant contact with France and specialized in anthologies of plant illustrations (known as *Tacuina Sanitatis*).[28]

The "landscape vogue" as an aspect of courtly art can also be detected in the bucolic decoration of the Wardrobe Room in Avignon's papal palace (1340), and in the many hunting or flirtatious scenes in fourteenth-century tapestries, especially Flemish (few examples survive, but there are numerous references in texts). This trend, which reached its "climax" around 1400, stretched from England to Venice and from Paris to Prague and Catalonia. Paris and its satellites played a key role, and the dominant place accorded to miniatures, so light and charming in nature, should not disguise the fact that, as with Parisian art under Louis IX, the phenomenon was global, encompassing tapestries, frescoes, carved panels, jewelry, etc. The ancient penchant for eulogizing rustic life—as opposed to urban vices—also reappeared in poetry, notably that of Christine de Pisan. As during all "chic" periods of glittery urban stimulation, a pretty peasant scene offered an escape from pomp and affectation (or rather, was exploited as an additional pleasure, a fresh source of costumes and games).

A crucial complement to the sentimental attraction for the countryside and rus-

French painter working in Avignon, *Livre de la Chasse de Gaston Phébus: wild boar hunt*. Late fourteenth century. (Ms. Fr. 619, fol. 83v).

tic life was the enthusiasm for hunting found in all aristocratic societies but most especially in France. Riding through fields and forests was an almost daily sport for the highly privileged. All sorts of hunting anthologies had existed since classical times, extended or updated for noblemen like Frederick II of Hohenstaufen or Don Juan Manuel of Castile.

But the day of precise and complete illustrations had truly dawned. The *Livre du Roi Modus et de la Reine Ratio* ("King Measure and Queen Reason") by a certain Henri de Ferrières (circa 1375, Bibliothèque Nationale, Fr. 12399) represents a somewhat unsubtle allegory linking a section on the pleasures of hunting to a sinister sequel titled "Dream of Pestilence." The first part, with its thirty or so miniatures, presents a series of genre scenes that are rather lively and amusing.

The masterpiece of the genre, however, is the *Livre de la Chasse* ("Book of Hunting") commissioned by Gaston Phébus, which exists in some forty manuscript versions. The most complete of these (Bibliothèque Nationale Fr. 616, p. 330; Fr. 619, above; and The Hermitage, Saint Petersburg) contain remarkable paintings of forests and fields, images of trapping, stalking, and chasing, along with descriptions of animals, dogs, and remedies for wounds. In short, it was an illustrated manual of great authority, and would be superseded only much later, in 1561, by Jacques Du Fouilloux's *Vénerie,* a printed text accompanied by woodcuts.

Christine de Pisan, France's first "woman of letters," carefully supervised the copying and illustrating of her writings. She dedicated them all to great nobles in turn, employing Franco-Flemish illuminators who painted frontispieces

showing her presenting volumes to the likes of Philip the Bold, Louis of Orléans and Charles VI. A convinced champion of women's rights, Christine de Pisan pointed out in *La Cité des Dames* (1405) that she employed the services of a female painter named Anastasia who, though probably just a decorator, could rival the best artisans "in the city of Paris, where the best in the world are found." Among the most remarkable of these Parisian artists is the painter known only as the Master of the Epître d'Othéa, whose robust style has been compared to the work of artists in Milan and Prague. On one of these miniatures, Minerva is seen giving blazoned shields and weapons to Hector and his companions, who are depicted as contemporary knights (Bibliothèque Nationale, Fr. 606, p. 332.)[29]

Not all of the duke of Berry's extraordinary collection of manuscripts has survived. The inventories, however detailed, provide

Master of the Cité des Dames, *Oeuvres de Christine de Pisan*:
Christine de Pisan presents *La Cité des Dames*
to Isabeau of Bavaria, queen of France. c. 1410–1412.
British Library, London (Ms. Harley 4431, fol. 3).

Master of the Epître d'Othéa, Christine de Pisan's *L'Epître d'Othéa à Hector:* Minerva gives arms and shield to Hector.
c. 1404–1408, Bibliothèque Nationale, Paris (Ms. Fr. 606, fol. 8v).

only imperfect information for identifying certain books like the *Petites Heures*. There is no doubt, however, concerning books like the *Belles Heures* or *Heures d'Ailly* (The Cloisters, New York, p. 333); the *Grandes Heures* on which Jacquemart de Hesdin worked (1409, Bibliothèque Nationale, p. 318); the aforementioned *Psalter* illuminated by Beauneveu and, *Très Belles Heures de Notre Dame* executed by several hands; and of course the *Très Riches Heures*, the most magnificent of all masterpieces with its famous calendar depicting settings of great castles. Manuscript painting never again attained such inventiveness and efficient elegance.

The list of manuscripts produced for Berry forms the principal constellation of painting around 1400. The admittedly limited framework of a page could mislead some scholars at a time when only painting done on panels, slow to arrive in France, was thought to be of interest. But that misconception has now been put aside. It is obvious that, starting with Jean Pucelle, Charles V's painters, and Machaut's

illustrators, there emerged an approach favorable to initiatives and exercises in modeling, depth, and composition. Obviously, the scale of the works was still reduced. But the artist's pleasure came precisely from composing on a square of parchment such complex and stimulating spectacles as a delightful allegory in a flowering orchard, or a scene of the Louvre during the harvest.

The heritage of these great workshops can be schematically reduced to three groups, each headed by an anonymous master yet typified by a work of great style: the above-mentioned *Boucicaut Hours* (p. 324) produced for the great soldier who would die a prisoner in England, containing forty-five large paintings notable for their brilliant palette and spatial depth; the *Rohan Hours* (circa 1418, Bibliothèque Nationale, Lat. 9471, p. 334), by an artist endowed with great dramatic temperament and highly advanced learning; and the abundantly illustrated *Duke of Bedford Breviary* (circa 1430, Bibliothèque Nationale, Lat. 17294, p. 335), begun for

John, duke of Bedford, Henry V's brother and regent during the English occupation of Paris. Each of these great artists produced works that corresponded to the end of the great Parisian school, which sank into mediocrity after 1430 (the English left Paris only in 1426).

Strangely, the duke of Berry's library contained nothing but Books of Hours, demonstrating that for nearly fifty years the genre had been favored by a distinguished company able to associate piety with snobbery.

But the two were not always easy to separate. By great good luck, the *Très Riches Heures* contains a complete depiction of a propitiatory procession (fol. 71v and fol. 72). It is supposed to represent one in A.D 590 led by Pope Gregory, who had obtained an end to the plague thanks to the intercession of the archangel Michael. The broad development of the image accompanying the text evokes several registers of significance: the fantastic image of Rome (related to Italian art), the liturgy against the plague that Western Europe had just experienced, and the parading of relics by monks, priests, and cardinals. All of this suggests that, formalism or not, the manifestations of religious life had lost none of their intensity.

If the iconographic repertoire is studied from the standpoint of insight into religious behavior, it becomes clear that piety was now directed above all toward saints, whose legends proliferated in increasingly varied and touching illustrations.

Colorful saints became accessible to all, and were often appropriated by guilds: Saint Julian became the patron saint of strolling minstrels in Paris, whereas Saint Julian the Hospitaller was featured on the stained-glass window donated to Rouen Cathedral by fishmongers. Saints were the objects of endless tales whose very charm lay in their incredibility, surpassing even the wonders recounted in the *Golden Legend* (late thirteenth century).

The Limbourg brothers, *Belles Heures du Duc de Berry:*
the Martyrdom of Saint Ursula. c. 1410.
The Cloisters, Metropolitan Museum of Art, New York (Acc. 54.1.1., fol. 178v).

There was a strange lapse in grand Christian imagery. The Resurrection and Ascension of Christ, for instance, were very rarely depicted. Religious feeling was drawn more toward scenes of Christ's nativity, childhood, and epiphany, which allowed for a swarm of little details and familiar invention. As to the life of the Virgin, it provided anecdotal opportunities that were ardently and often beautifully exploited—

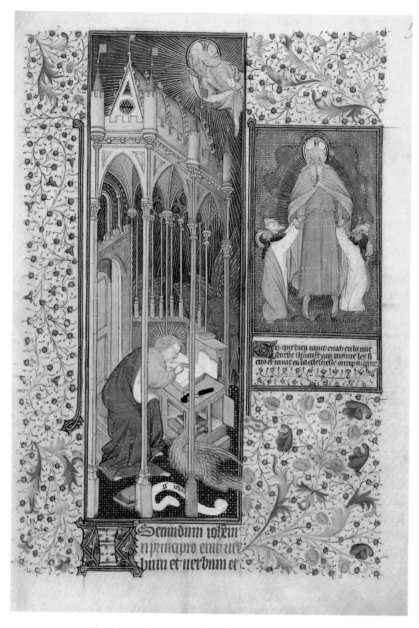

The Rohan Hours: Saint John the Evangelist. c. 1418.
29 × 20.8 cm. Bibliothèque Nationale, Paris (Ms. Lat. 9471, fol. 19).

Right: The Bedford Master and his workshop, *Breviary of the Duke of Bedford*
known as the *Salisbury Breviary*: scenes from the life of Saint Edward the Martyr, king
of England. Between 1424 and 1435.
Bibliothèque Nationale, Paris (Ms. Lat. 17294 fol. 432v).

the Annunciation was transposed from a mystic chapel to a well-furnished contemporary domestic interior, the Flight into Egypt was set in a verdant European landscape with a red-nosed Joseph (often an object of jest). These fanciful images irritated the great Jean de Gerson (1363– 1429), chancellor of the University of Paris and severe critic of his times. In a famous sermon, he claimed that there were too many feast days and too many new, fanciful, and sometimes grotesque objects of devotion. He warned against an excessive number of images and paintings in churches (*Sermon on the Reform of the Church*, 1410). This excess was born of a malaise, a sort of collective, melancholic reverie. Gerson's was a striking and significant diagnosis—the feverish imagination of the day was affecting piousness as well as aristocratic dress and customs.

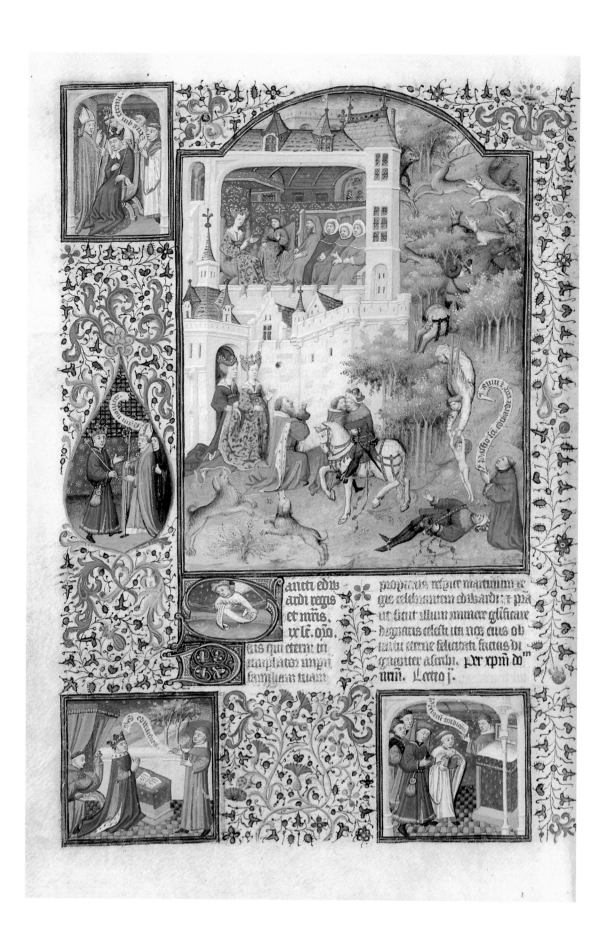

NOTES

PART I: ORIGINS [PP. 10–89]

PREHISTORY [PP. 11–27]

1. É. Lartet and H. Christy, "Sur des figures d'animaux gravées ou sculptées et autres produits d'art et d'industrie rapportable aux temps primordiaux de la période humaine," *Revue archéologique,* 1884.
2. J. Céard, "La querelle des géants et la jeunesse du monde," *The Journal of Medieval and Renaissance Studies,* VIII, 1 (1879), and A. Schnapper, "Persistance des géants," *Annales E.S.C.,* 1, 1986, pp. 177–200.
3. D. Vialou, "L'art des grottes en Ariège magdalénienne," supplement to *Gallia,* XXVI, 1986.
4. R. Lantier, *Les Origines de l'art français,* Paris: Le Prat, 1947.
5. G. Childe, *Man Makes Himself,* London: Watts, 1936.
6. A. Mussat, *La Cathédrale du Mans,* Paris: Berger-Levrault, 1981.
7. R. de Lasteyrie, *L'Architecture religieuse en France à l'époque romane,* Paris: Picard, 1911 (second edition revised by M. Aubert, 1929).
8. A. Varagnac, *L'Art gaulois,* La-Pierre-qui-Vire, Zodiac, 1964, p. 25.
9. S. de Girardin (attributed to), *Promenade et itinéraire des jardins d'Ermenonville,* Paris: Mérigot Père, 1811

CELTS AND GALLO-ROMANS [PP. 28–49]

10. P.-M. Duval, *Les Celtes,* Paris: Gallimard, 1977.
11. Thoroughly catalogued thanks to the work begun by E. Espérandieu and continued by R. Lantier and P.-M. Duval, *Recueil genéral des bas-reliefs de Gaule romaine,* vols. I–XVI, Paris: P.U.F., 1907–1981.
12. P.-M. Duval, "L'originalité de l'architecture gallo-romaine," *Travaux sur la Gaule,* Paris: De Boccard, 1989.
13. *Ibid.*
14. P.-M. Duval, *La Vie quotidienne en Gaule pendant la paix romaine,* Paris: Hachette, 1976.

15. L. Demaison, *Congrès archéologique de France,* Session LXXXVIII, Reims, 1911, Paris: Picard, 1911, pp. 13–14.
16. J. Hubert, *L'Art préroman,* Nogent-le-Roi: Arts et Métiers, 1974.
17. P. Mesplé, *De l'art des Gaules à l'art français*, exhibition catalogue, Musée des Augustins, Toulouse, 1956.
18. P. -M. Duval, *Paris antique, des origines au IIIe siècle,* Paris: Hermann, 1961.
19. J. Adhémar, *Influences antiques dans l'art du Moyen Age français,* London: Warburg Institute, 1937, plus many other specialized studies focusing on cities like Orléans, Auxerre, Bourges, etc.
20. J. Le Goff, "Les Paysans et le monde rural dans la littérature du haut Moyen Age (Ve–VIe siècles)," *Settimane di studio . . . sull'Alto Medioevo,* XIII, Spoleto, 1966, reprinted in *Pour un autre Moyen Age,* Paris: Gallimard, 1977, pp. 131 ff.
21. J. Lestocquoy, "Le paysage urbain en Gaule du Ve au IXe siècle," *Annales E.S.C.,* VIII, 1953, pp. 159–172.
22. R. Agache, "La somme pré-romaine et romaine," *Mémoires de la Société des antiquaires de Picardie,* XXIV, Amiens, 1978.
23. P.-A. Février, *Le Développement urbain en Provence de l'époque romaine à la fin du XIVe siècle,* Paris: De Boccard, 1964.

MEROVINGIANS (500–750) [PP. 50–65]

24. W.F. Volbach, "Les arts somptuaires," in Hubert, Porcher, and Volbach, *L'Europe des invasions,* Paris: Gallimard, 1967, p. 218.
25. Gregory of Tours, *The History of the Franks,* trans. Lewis Thorpe, London: Penguin, 1974.
26. C. Heitz, *La France pré-romane,* Paris: Errance, 1987.
27. J. Hubert, "La topographie religieuse d'Arles au VIe siècle," *Cahiers archéologiques,* vol. II, 1947.
28. E. Delehaye, *Sanctus. Essai sur le culte des saints dans l'Antiquité,* Brussels: Société des

bollandistes, coll. Subsida Hagiographica, 1979, p. 94.
29. This passage is a summary of a remarkable article by J. Hubert, "Introibo ad altare," *Revue de l'art,* no. 24, 1974, pp. 9 ff.
30. T. Sauvel, "Les miracles de Saint Martin: Recherches sur les peintures murales de Tours aux Ve et VIe siècles," *Bulletin monumental,* CXIV, 1956, pp. 153–179.
31. M. Vieillard-Troïekouroff, *Les Monuments religieux d'après les œuvres de Grégoire de Tours,* Paris: Champion, 1976.
32. M. Vieillard-Troïekouroff, D. Fossard, E. Chatel, C. Lamy-Lassalle, "Les plus anciennes églises suburbaines de Paris (IVe–Xe siècles)," *Mémoires de la Société de l'histoire de Paris et d'Ile-de-France,* 11, 1960, pp. 18–282.
33. "La Daurade"—and the magnificent cloister that the Benedictines added to it circa 1100—was described in the seventh century, and demolished due to its decrepitude by Maurist Benedictines in 1761.
34. J. Hubert, "Les cathédrales doubles de la Gaule," *Geneva,* XI, 1963, Mélanges Louis Blondel, pp. 105 ff. with lists.
35. On the episcopal group in Lyon see also J.-F. Reynaud, *Lyon (Rhône) aux premiers temps chrétiens: basiliques et nécropoles,* Paris: Imprimerie Nationale, 1986, and J.-F. Raynaud, R. Collardelle *et. al.,* "Les édifices funéraires et les nécropoles dans les Alpes et la vallée du Rhône. Origines et premiers développements," *XIe Congrès international d'archéologie chrétienne,* Lyon, 1986.
36. M. Fleury and A. France-Lanord, "Les bijoux mérovingiens d'Arnégonde," *Art de France,* I, 1961, pp. 7–17.
37. A. Erlande-Brandebourg, *Le Roi est mort. Études sur les funérailles, les sépultures et les tombeaux des rois de France jusqu'à la fin du XIIIe siècle,* Geneva: Droz / Paris: A.M.G., 1975.
38. *Recueil général des monuments sculptés en France pendant le haut Moyen Age, IVe– Xe siècles,* Paris: Bibliothèque Nationale, 1978.

39. D. Fossard, "Décors Mérovingiens des sarcophages de plâtre," *Art de France,* III, 1963.
40. H. Focillon, *The Art of the West,* trans. Donald King, London: Phaidon, 1969, p. 18.
41. É. Mâle, *L'Art Religieux du XIII^e siècle en France,* Paris: Armand Colin, 1986, p. 329. See also J. Vanuxem, "The Theories of Mabillon and Montfaucon on French Sculpture of the Twelfth Century," *Journal of the Warburg and Courtauld Institutes,* XX, 1957, pp. 45–58.
42. Mâle, *Ibid.*

CAROLINGIANS (750–850) [PP. 66–79]

43. B. de Montesquiou-Fezensac, "Ivoires narratifs de l'époque carolingienne,"*Mémoires de la Société nationale d'antiquaires de France, Recueil du cent cinquantenaire (1804–1954),* Paris, 1955.
44. A. Grabaer, *Martyrium. Recherches sur le culte des reliques et l'art chrétien antique,* Paris: Maisonneuve, 1946, p. 203.
45. Hubert, *L'Art préroman,* note 16, pp. 53

ff. See also C. Heitz, *L'Architecture religieuse carolingienne,* Paris: Picard. 1980, pp. 167–182.
46. A similar design must have already existed at Clermont cathedral.
47. H. Swarzenski, *Monuments of Romanesque Art,* London: Faber and Faber, 1954.
48. E. Panofsky, *Tomb Sculpture,* New York: Harry N. Abrams, 1964, p. 48.
49. P. E. Schrammh, *Der König von Frankreich,* Weimar: Böhlau, 1960, pp. 137 ff.

A TROUBLED CENTURY (850–987) [PP. 80–987]

50. J. Henriet, "Saint-Philibert de Tournus. Critique d'authenticité. Étude archéologique du chevet (1009–1019)," *Bulletin monumental,* CXLVIII (1990), pp. 229–316.
51. A Châtelain, "Les châteaux forts de l'an mil à onze cent cinquante," *Le Château en France,* Paris: Berger-Levrault / CNMHS, 1986.

52. J. and M.-C. Hubert, "Piété chrétienne ou paganisme: Les statues-reliquaires de l'Europe carolingienne," *Settimane di Studio . . . sull'Alto Medioevo,* 28, Spoleto: 1980, pp. 235–268.
53. J. Porcher, *L'Enluminaire française,* Paris: A.M.G., 1959, p. 12.
54. D. Gaborit-Chopin, *La Décoration des manuscrits à Saint-Martial de Limoges et en Limousin du IX^e au XII^e siècle,* Paris/Geneva: Droz, 1974.
55. T. Sauvel, "Les Manuscrits Limousins. Essai sur le liens qui les unissent à la sculpture monumentale, aux émaux et aux vitraux," *Bulletin monumental,* CVIII (1950), pp. 117 ff.
56. See the proceedings of *Millénaire monastique du Mont-Saint-Michel,* Paris: 1967.
57. R. Krautheimer, *Rome, Profile of a City, 312–1308,* Princeton: Princeton University Press, 1980, p. 144.

PART II: THE MIDDLE AGES [PP. 92–335]

THE WEST AT WORK [PP. 93–138]

1. H. Focillon, *The Art of the West,* trans. Donald King, London: Phaidon Press, 1969, p. 169.
2. É. Gilson, *La Philosophie au Moyen Âge,* Lausanne and Paris: Payot 1947, new ed. 1986.
3. J. Le Goff, *La Civilisation de l'Occident médiéval,* Paris: Artaud, 1964, new ed. 1972.
4. G. Duby, *Les Trois Ordres ou l'imaginaire du féodalisme,* Paris: Gallimard, 1978.
5. M.-D. Chenu, *La Théologie au XII^e siècle,* Paris: Vrin, 1957, new ed. 1976.
6. V. Mortet and P. Deschamps, *Recueil de textes relatifs à l'histoire de l'architecture et de la condition des architectes en France au Moyen Âge, XII^e–XIII^e siècles,* vol. II, Paris: A. et J. Picard, 1929, no. XLIV, p. 110.

7. The observations of R. Branner on Reims ("Historical Aspects of the Reconstruction of Reims Cathedral," *Speculum,* 36 [1961], pp. 23–551) and those of S. Murray on Beauvais ("The Choir of the St. Pierre Cathedral of Beauvais," *The Art Bulletin,* Dec. 1980, pp. 533–551) and those of A. Chedeville on Chartres (*Chartres et ses campagnes aux XII^e et XIII^e siècles,* Paris, 1973) are clearly explained in A. Mussat, "Les cathédrales dans leurs cités," *Revue de l'art,* no. 55 (1982), pp. 9–22. On the financing and organization of the construction, see J. Gimple, *Les Batisseurs de cathédrales,* Paris: Seuil, 1980.
8. M.-M. Gauthier, *Catalogue international de l'œuvre de Limoges, I, Époque romane,* Paris: CNRS, 1987.
9. M. Schapiro, "On the Aesthetic Attitude in Romanesque Art," *Art and Thought,* 1947, reprinted in *Romanesque Art,* New York,

Braziller, 1977, pp. 1 ff.
10. Helgaud de Fleury, *Vie de Robert le Pieux,* edited by R.H. Bautier and G. Labory, Paris: CNRS, Sources d'histoire médiévale, 1965.
11. E. Lefèvre-Pontalis, "Répertoire des architectes, maçons, sculpteurs, charpentiers et ouvriers français au XI^e siècle," *Bulletin monumental,* LXIX (1911), pp. 423–468.
12. R. Branner, "The Labyrinth of Reims Cathedral," *Journal of the Society of Architectural Historians,* XXI (1962), pp. 18–25.
13. V. Mortet and P. Deschamps, text by Nicolas de Biard, op. cit. note 5, no. CCXC.
14. N. Pevsner, " The Term 'Architect' in the Middle Ages," *Speculum,* 17 (1942), p. 549, and J. Harvey, *The Medieval Architect,* London: Wayland, 1972.
15. J. Bony, "Architecture gothique: accident ou nécessité," *Revue de l'art,* no. 58/59 (1983), pp. 9–20.

THE ROMANESQUE PERIOD
[PP. 138–205]

1. E. Pognon, *L'An Mille: Mémoires du passé pour servir au temps présent. Œuvres de Luitprand, Raoul Glaber, Adémar de Chabannes, Adalbéron, et Helgaud,* collected, translated and introduced by E. Pognon, Paris: Gallimard, 1947, p. 89.

2. L. Grodecki, "Guillaume de Volpino et l'expansion clunisienne," *Le Moyen Age retrouvé,* Paris: Flammarion, 1986, pp. 199–210.

3. M. Deyres, "Le Donjon de Langeais," *Bulletin monumental,* CXXVIII (1970), pp. 179–193.

4. A. Châtelain, "Les châteaux forts de l'an mil à onze cent cinquante," *Le Château en France,* Paris: Berger-Levrault / CNMHS, 1986.

5. C. Nordenfalk, "Miniature ottonienne et ateliers capétiens," *Art de France,* vol. IV (1963), pp. 44 ff.

6. E. Vergnolle, "Un carnet de modèles de l'an mil originaire de Saint-Benoît-sur-Loire," *Arte medievale,* no. 2, pp. 23 ff.

7. R. Folz, *Le Souvenir et la légende de Charlemagne dans l'Empire germanique médiéval,* Geneva: Slatkine, 1973.

8. M. Durliat, "La Catalogne et le 'premier art roman,'" *Bulletin monumental,* CXXXXVII (1989), pp. 209–238.

9. E. Vergnolle, *Saint-Benoit-sur-Loire et la sculpture du XIe siècle,* Paris: A. et J. Picard, 1985.

10. C.K. Hersey, "The Church of St. Martin at Tours (903–1150)," *Art Bulletin,* XXVII (1943), pp. 1–39, and F. Lesueur, "Saint-Martin de Tours et les origines de l'art roman," *Bulletin monumental,* CVII (1949), pp. 7–84.

11. C. Lelong, *La Basilique de Saint-Martin de Tours,* Chambray-lès-Tours: CLD, 1986.

12. J. Henriet, "Saint-Philibert de Tournus. Critique d'authenticité, Étude archéologique du chevet (1009–1019)," *Bulletin monumental,* CXXXXVIII (1990), pp. 229–316.

13. See, for example, the Zodiaque series, La Pierre-qui-Vire, France.

14. G. Duby, *Leçon inaugurale au Collège de France,* Paris: Collège de France, 1970.

15. A.K. Porter, *Romanesque Sculpture of Pilgrimage Roads,* 10 vols., Boston: Marshall Jones, 1923.

16. J. Riley-Smith, *The First Crusade and the Idea of Crusading,* London: Athlone Press, 1985.

17. See Porter. For a recent discussion of the issue, see M. Durliat, *La Sculpture romane de la route de Saint-Jacques, de Conques à Compostelle,* Mont-de-Marsan: CEHAG, 1990.

18. E. Lambert, "La cathédrale de Saint-Jacques-de-Compostelle et l'école des grandes églises romanes des routes de pèlerinage," *Le Pèlerinage de Compostelle,* Toulouse: Privat, 1959, p. 157.

19. G.B. Ladner, *The Idea of Reform,* Cambridge: Cambridge University Press, 1959, and C. Waddell, "The Reform of the Liturgy, *Renaissance and Renewal in the Twelfth Century* (Genson and Constable, eds.) Oxford: Oxford University Press, 1982.

20. J. Wöllasch, *Mönchtum des Mittelalters zwischen Kirche und Welt,* Munich: W. Fink, 1973, pp. 155 ff.

21. P. Diemer, "What does *Prudentia* advise? On the Subject of the Cluny Choir Capitals," *Gesta,* XXVII/1–2, 1988, pp. 149–173.

22. J. Weststein, *La Fresque romane: Études comparatives, II, La Route de Saint-Jacques, de Tours à Léon,* Geneva: Droz / Paris: AMG, 1978.

23. M.T. Camus, "A Propos de trois découvertes récentes: Images de l'Apocalypse à Saint-Hilaire-le-Grand de Poitiers," *Cahiers de Civilisation Médiévale,* 1989, II, pp. 125–134.

24. J. Taralon and H. Toubert, "Les fresques romanes de Vendôme," *Revue de l'art,* no. 53, 1981, pp. 9 ff.

25. L. Pressouyre, "Lecture d'une inscription du XIIe siècle à Saint-Antonin-Noble-Val (Tarn-et-Garonne)," *Bulletin de la Société nationale des antiquaires de France,* 1986, pp. 256 ff.

26. K. J. Conant, *Cluny, les églises et la maison du chef d'ordre,* Mâcon: Protat, 1968.

27. F. Salet, "Cluny III," *Bulletin monumental,* CXXVI (1968), pp. 285 ff.

28. W. Cahn, "Le Tympan de Neuilly-en-Donjon," *Cahiers de civilisation médiévale,* 1965, pp. 351–364.

29. M. Schapiro, *The Sculpture of Moissac,* London: Thames & Hudson, 1985.

30. J.-C. Bonne, *L'Art roman de face et de profil, le tympan de Conques,* Paris: Le Sycomore, 1985.

31. R. Crozet, *L'art roman en Saintonge,* Paris: A. et J. Picard, 1971.

32. After Vöge (1894), the most recent example is R. Hammann, *Die Abteikirrch von Saint-Gilles und ihre künstlerische Nachfolge,* Berlin: Akademie Verlag, 1955.

33. J. Baltrusaitis, *La Stylistique ornementale dans la sculpture romane,* Paris: Leroux, 1931, revised and augmented edition published as *Formations, déformations, la stylistique ornementale dans la sculpture romane,* Paris: Flammarion, 1986.

34. C. O. Nordström, "Text and Myth in Some Beatus Miniatures," *Cahiers archéologiques,* XXV, 1976, pp. 19–20.

35. A. Grabar, "Peinture murale," in Grabar and Nordenfalk, *La Peinture romane du onzième au treizième siècle,* Geneva: Skira, 1958.

36. W. Koehler, "Byzantine Art in the West," *Dumbarton Oaks Papers,* I (1941), pp. 61–87.

37. J. Thirion, "Ganagobie et ses mosaïques," *Revue de l'art,* no. 49, 1980, pp. 50–69.

38. X. Barral i Altet, *Les Mosaïques de pavement en France et en Italie,* Rome: École Française de Rome, 1987.

39. M.–M. Gauthier, *Catalogue des émaux méridionaux,* I, *Époque romane,* Paris: CNRS, 1987, Cat. 208, pp. 109–113.

40. *Ibid.*

41. L. Grodecki, *Le Vitrail français,* Paris: Editions des Deux Mondes, 1958, p. 105.

42. M. de Boüard, *La Motte. Archéologie du village médiéval,* Louvain, 1967.

43. V. Mortet and P. Deschamps, *Recueil de textes relatifs à l'histoire de l'architecture au Moyen Age, XIIe–XIIIe siècles,* vol. II, no. XXIX, Paris: A. et J. Picard, 1929.

44. J. Mesqui and N. Faucherre, "Le château de Châtillon-Coligny, " *Bulletin monumental,* CXXXXVI, 1988, 2, pp. 72 ff.

45. D.D. Rower, "The Secular Inspiration of the 'Chanson de Roland,'" *Speculum,* 37, 1962.

46. M. Roques, *Le Graal de Chrétien et la Demoiselle au Graal,* Geneva: Droz, 1955.

47. V. Mortet, *Recueil de textes relatifs à l'histoire de l'architecture et à la ccondition des architectes en France au Moyen Age, XIe–XIIe siècles,* vol. I, no. CXLIII, Paris: A. et J. Picard, 1911, p. 166.

48. English translation by G. Coulton, *Life in the Middle Ages,* 1935, quoted and adapted by Meyer Schapiro in *Romanesque Art,* London: Chatto & Windus, 1977, p. 6.

49. Mortet, p. 366.

50. J. Bousquet, "Le rôle des cisterciens dans la décadence romane. Exemples et réflexions," *Les Cahiers de Saint-Michel-de-Cuxa*, July 1984.

51. English translation taken from Schapiro, *Romanesque Art*, p. 7.

52. H. J. Zakin, *French Cistercian Grisaille Glass*, New York: Garland, 1979.

THE GOTHIC ERA [PP. 206–277]

1. For a fuller discussion of this point, see J. Henriet, "Saint-Germer-de-Fly," *Bulletin monumental*, CXXXXIV (1986), pp. 93–142. Henriet supplies a precise date for the start of this little-known edifice from the 1130s.

2. J. Bony, *French Gothic Architecture of the 12th and 13th Centuries*, Berkeley: University of California Press, 1983.

3. D. Kimpel, "Le développement de la taille en série dans l'architecture médiévale et son rôle dans l'histoire économique," *Bulletin monumental*, CXXXV, 1977, pp. 195–222.

4. M. Wolfe and R. Mark, "The Collapse of the Beauvais Vaults in 1284," *Speculum*, 51, 1976, pp. 462–476.

5. R. Mark, *Experiments in Gothic Structure*, Cambridge, Mass.: MIT Press, 1982.

6. S. Murray, *Building Troyes Cathedral, the Late Gothic Campaigns*, Indianapolis: Indiana University Press, 1982.

7. K.J. Conant, "The After Life of Vitruvius in the Middle Ages," *Journal of the Society of Architectural Historians*, 27, 1968, pp. 33–38.

8. L.R. Shelvy, "The Geometrical Knowledge of Mediaevel Master Masons," *Speculum*, 47, 1972, 4, pp. 395–421.

9. P. Bénard, "Recherche sur la patrie et les travaux de Villard de Honnecourt," *Travaux de la Société académique de Saint-Quentin*, 1864–1866, pp. 260–280.

10. R. Recht, "Sur le dessin d'architecture gothique," *Études d'art médiéval offertes à Louis Grodecki*, Paris: Ophrys, 1981, pp. 233–250.

11. J.-P. Paquet, "Les tracés directeurs des plans de quelques édifices du domaine royal au Moyen Age," *Monuments historiques*, 1963, pp. 59–84.

12. A. Scheller, *A Survey of Mediaeval Model Books*, Haarlem: De Erven Bohn, 1963.

13. R. Granner, "Villard de Honnecourt, Reims and the Origin of Architectural Drawing," *Gazette des Beaux-Arts*, 6th Series, LXI, 1963, pp. 129–146.

14. J.F. Finó, *Forteresses de la France médiévale*, Paris: A. et J. Picard, 1977.

15. Translated from the Latin by Erwin Panofsky, *Abbot Suger*, Princeton: Princeton University Press, 1979, p. 63.

16. As pointed out by P. Kidson's correction of Erwin Panofsky in "Panofsky, Suger and St. Denis," *Journal of the Warburg and Courtauld Institutes*, vol. 50, 1987, pp. 1–17.

17. Translated from the Latin by Panofsky, *Abbot Suger*, p. 75.

18. L. Grodecki, *Les Vitraux de Saint-Denis, Corpus Vitrearum Medii Aevi*, Paris: CNRS/AMG, 1976.

19. P. Blum has plausibly suggested a Coronation of the Virgin. See his "Lateral Portals of the West Facade at the Abbey Church of Saint-Denis: Archeological and Iconographical Considerations," *Abbot Suger and St. Denis: A Symposium*, New York: Metropolitan Museum, 1986, pp. 199–228.

20. S. M. Crosby, *L'Abbaye Royale de Saint-Denis*, Paris: Hartmann, 1953, and C. A. Bruzelius, *The 13th-Century Church at Saint-Denis*, New Haven: Yale University Press, 1985.

21. Henriet, pp. 93 ff, note 1.

22. H. Schaefer, "The Origins of the Two Towers Facade in Romanesque Architecture," *Art Bulletin*, XXVII 1945, pp. 85–108.

23. P. Kurman, *La Façade de la cathédrale de Reims*, Paris: Payot, 1987.

24. S. Pressouyre, *Images d'un cloître disparu*, Paris: Joël Cuenot, 1976.

25. L. Pressouyre, "La colonne dite 'aux trois chevaliers' de Châlons-sur-Marne," *Bulletin de la Société nationale des antiquaires de France*, 1960, pp. 76 ff.

26. F. Salet, "Notre-Dame de Paris, état présent de la recherche," *La Sauvegarde de l'Art Français*, vol. 2, Paris: A. et J. Picard, 1982.

27. C. A. Bruzelius, "The Construction of Notre-Dame in Paris," *Art Bulletin*, LXIX, 4, 1987, pp. 540–569.

28. *La France de Philippe Auguste*, symposium conducted by R.H. Bautier, Paris, CNRS, 1982.

29. W. Sauerländer, "Art antique et sculpture autour de 1200," *Art de France*, I, 1961, pp. 47 ff.

30. *Ibid.*

31. Grodecki, *Le Moyen Age retrouvé*, pp. 545–563.

32. See the collective volume on *Crusader Art in the Twelfth Century*, Oxford: British Archaeological Report, 1982.

33. Grodecki, *Le Moyen Age retrouvé*, pp. 385–543, note 29.

34. E. Mâle, *L'Art religieux du XIIIe siécle en France*, Paris: Armand Colin, 1986.

35. J. Bony, *French Gothic Architecture of the 12th and 13th Centuries*, Berkeley: California Studies in the History of Art, 20, 1983.

36. R. Branner, *La cathédrale de Bourges et sa place dans l'architecture gothique*, Paris/Bourges: Tardy, 1962.

37. J. Bony, "The Resistance to Chartres in Early Thirteenth-Century Architecture," *Journal of the British Archaeological Association*, XX–XXI, 1957–1958, pp. 35–52.

38. H.B. Titus Jr., "The Auxerre Cathedral Chevet and Burgundian Gothic Architecture," *Journal of the Society of Architectural Historians*, XLVII, 1988, 1.

39. R. Wortmann, "Der Westbau des Strassburger Münsters und Meister Erwin," *Bonner Jahrbuch*, LXIX, 1969, pp. 290 ff.

40. P. Frankl, *Gothic Literary Sources and Interpretations through Eight Centuries*, Princeton: Princeton University Press, 1960, pp. 827–828.

41. *Dictionnaire raisonné de l'architecture française*, Paris: Bance, 1858–1868, vol. VIII, p. 140.

42. W. Sauerländer, "Les statues royales du transept de Reims," *Revue de l'art*, 27, 1975, pp. 9–30.

43. P. Verdier, *Le Couronnement de la Vierge. Les Origines et les premiers développements d'un thème iconographique.* Montreal: Institut d'Études Médiévales / Paris: Vrin, 1980.

44. W. Sauerländer, "Les statues royales du transept de Reims," *Revue de l'art*, 27, 1975, pp. 9–30.

45. L. Pressouyre, "Pour une reconstruction du jubé de Chartres," *Bulletin monumental*, CXXV, 1967, pp. 419 ff.

46. C. Gnudi, "Le jubé de Bourges et l'apogée de 'classicisme' dans la sculpture de l'Île-de-France," *Revue de l'art*, 3, 1969, pp. 18 ff.

47. E. Kantorowicz, *L'Empereur Frédéric II*, Paris: Gallimard, 1987, p. 514.

48. Jean de Joinville, *Histoire de Saint Louis*, Société de l'Histoire de France, 1868.

49. I.K. Little, "Saint Louis' Involvement with the Friars," *Church History,* XXXIII, 1964.

50. R. Branner, *Saint Louis and the Court Style in Gothic Architecture*, London: Zwemmer, 1965.

51. Bruzelius, pp. 540–569, note·18.

52. Proceedings of the symposium, "Septième centenaire de la mort de Saint Louis" (1970), Paris: Les Belles Lettres, 1976.

53. A. Chastel, *Le Cardinal Louis d'Aragon*, Paris: Fayard, 1986.

54. L. Grodecki, *Sainte-Chapelle,* Paris: CNMH, n.d [1962].

55. M. Aubert, L. Grodecki, et. al., *Les Vitraux de Notre-Dame et de la Sainte-Chapelle de Paris, Corpus Vitrearum Medii Aevi, France,* I, Paris: CNRS/CNMH, 1959.

56. R. Branner, "Le Maître de la cathédrale de Beauvais," *Art de France*, II, 1962.

57. Translated from the Italian by C.H. Sisson, *The Divine Comedy,* "Purgatory," Canto XI, 80–81, London: Pan, 1980.

58. R. Branner, *Manuscript Paintings in Paris during the Reign of St. Louis*, Berkeley: University of California Press, 1977.

59. Special dossier assembled by M. M. Gauthier published in *Revue de l'art*, 63, 1984, pp. 57–82.

60. L. Olschiski, *Guillaume Boucher, a French Artist at the Court of the Schans*, Baltimore: Johns Hopkins Press, 1946.

61. C. V. Langlois, *La Connaissance de la nature et du monde au Moyen Age,* Paris: Hachette, 1911.

62. L.M.C. Randall, "*Exempla* as a Source of Gothic Marginal Illumination," *The Art Bulletin*, 1957, pp. 97–107.

63. A. Châtelain, *Château forts et féodalité en Île-de-France*, Nonette: Editions Créer, 1982.

64. G. Fournier, *Châteaux, villages et villes d'Auvergne au XVᵉ siécle d'après l'Amorial de Guillaume Revel,* Paris: AMG, 1973.

65. J. Le Goff, "Ordres mendiants et urbanisation dans la France médiévale," *Annales E.S.C.*, 1970, p. 939.

ARISTOCRATIC GOTHIC [PP. 278–335]

1. Le Clerc, *Histoire littéraire de la France*, Paris: Firmin-Didot, 1865.

2. J. Favier, *Un conseiller de Philippe le Bel, Enguerrand de Marigny*, Paris: PUF, 1970.

3. Charles Sterling, in *La Peinture française médiévale à Paris, 1300–1500*, argues that the diptych was in fact offered to the king by the pope (pp. 140 ff).

4. F. Avril, "Les manuscrits enluminés de Guillaume de Machaut," *Colloque Guillaume de Machaut* (Reims, 1978), Paris: Klincksieck, 1982, pp. 117–132.

5. P. Perdrizet, *Le Calendrier parisien à la fin du Moyen Age d'après les bréviaires et les livres d'heures*, Strasbourg: Assoc. Publ. Univ. Strasbourg, 1933.

6. E. Deschamps, *Oeuvres complètes*, De Queux de Saint-Hilaire (Société des anciens textes français), 11 vols., 1878–1903, vol. IX, p. 46.

7. H.W. Janson, *Apes and Apelore in the Middle Ages and the Renaissance*, London: Warburg Institute, 1952, p. 179.

8. L. M. C. Randall, *Images in the Margins of Gothic Manuscripts,* Berkeley: University of California Press, 1966.

9. J. Lafond, F. Perrot, P. Popesco, *Les Vitraux du chœur de Saint-Ouen de Rouen, Corpus Vitrearum Medii Aevi*, Paris: CNRS, 1970.

10. Y. Bruand, "L'amélioration de la défense et les transformations des châteaux du Bourbonnais pendant la guerre de Cent Ans," *Compte rendu de l'Académie des inscriptions et belles-lettres,* October 1972, pp. 518 ff.

11. F. Gébelin, *Les Châteaux de France*, Paris: PUF, 1962.

12. L. Lefrançois-Pillion and J. Lafond, *L'Art en France au XIVᵉ siècle*, Paris, 1954.

13. F. Baron, "Le cavalier royal de Notre-Dame-de-Paris," *Bulletin monumental*, CXXVI, 1968, pp. 141–154.

14. A. Dawson-Hedeman, "Valois Legitimacy: Editorial Changes in Charles V's *Grandes Chroniques de France*," *The Art Bulletin,* LXVI, 1984, pp. 97 ff.

15. J. R. Gaborit, "Les statues de Charles V et de Jeanne de Bourbon," *Revue du Louvre*, 1981, pp. 237–245.

16. A. Erlande-Brandebourg, *L'Art gothique*, Paris: Citadelles, 1983.

17. M. Whiteley, *L'Escalier dans l'architecture de la Renaissance*, Paris: Picard, 1985.

18. Gébelin, op. cit. note 11.

19. P. Tucoo-Chala, *Gaston Phébus, un grand prince d'Occident du XIVᵉ siècle*, Pau: Marrimpouey, 1976.

20. M. Pastoureau, "L'État et son image emblématique," *Figures et couleurs, Études sur la symbolique et la sensibilité médiévales,* Paris: Le Léopard d'Or, 1986, p. 65.

21. M. Pastoureau, *Traité d'héraldique,* Paris: A. et J. Picard, 1993.

22. F. Salet (preface), *La Tenture de l'Apocalypse d'Angers*, Nantes: Cahiers de l'Inventaire, no. 4, 1987.

23. G. Previtali, *Storia dell'Arte*, 38–48, 1940.

24. P. Contamine, "Points de vue sur la chevalerie en France à la fin du Moyen Age," *Francia*, 1978, pp. 255–285.

25. E. Léonard, *Les Angevins de Naples,* Paris: PUF, 1954, p. 368 and F. Bologna, *I Pittori della Corte Angioina di Napoli, 1266–1414*, Rome: U. Bozzi, 1969.

26. A *Bible Moralisée* (Bibliothèque Nationale, Fr. 9561) with a wealth of Italian details, is certainly Neapolitan in origin; brought to Avignon, it is another link in the exchanges between the south of France and the Anjou kingdom, strongly marked by the noble art of Giotto.

27. O. Pächt, "Early Italian Nature Studies and the Early Calendar Landscape," *Journal of the Warburg and Courtauld Institute,* XIII, 1950, pp. 36 ff.

28. E. Castelnuovo, *I Mesi de Trento, Gli Affreschi di Torre Aquila e il gotico Internazionale*, Trento: Teni, 1986.

29. P. M. de Winter, "Christine de Pisan, ses enlumineurs et ses mécènes, les ducs de Bourgogne," *L'Aquitaine (Actes du 104ᵉ Congrès national des sociétés savantes,* Bordeaux, 1979), Paris, 1982, pp. 335 ff.

INTRODUCTION TO THE HISTORY OF FRENCH ART
EXTRACTS*

INTRODUCTION

I can only hope that the work of setting things in perspective succeeds in guiding my compatriots to a more serious, less abstract, less moralizing, ungenerous, and conventional perception of artworks. The French need to understand that this wonderful heritage is theirs. It is not so much "ideas" that are important, but rather "forms"; indeed, it is these forms that make us instant contemporaries of a Cistercian monk or a marquis. It is the most diverse, the most spirited and most *livable* of countries in the world.

The second volume of Michelet's *Histoire de France* contains a strange sentence that merits consideration: "The Middle Ages left us such a poignant memory of itself that all the joy and grandeur of modern times will not suffice to console us" (Vol. II, p. 195). Michelet was referring to the presence at the heart of French thought of an exalted moment of civilization glorifying a (supposedly) Christian order and (widespread) fervor.

One of the tasks of all historical research on France—and, I feel, especially on its art—is to shed light on this attachment to a period that defined and, in a sense, shaped the country's artistic landscape, marked by incontrovertibly sublime masterpieces.

One of the finest texts to attempt an all-embracing definition of French art was Henri Focillon's introduction to an exhibition of French masterpieces in 1937. His idealized definition made somewhat exaggerated claims that "filigree metalwork from cemeteries in the Aisne region" and Merovingian jewels prefigured what occurred generations later in the Romanesque art of architectural sculpture, that the complexities of manuscript miniatures paved the way for the subtleties of painting two or three centuries later, that a shared force was at work. Focillon's assertion of continuity should not be rejected, yet must be questioned. The long-sought equilibrium—often obtained only to be subsequently lost—between the taste of architects and the delights of decoration is what has made "us," wrote Focillon, skillfully exploiting the immediate access to works from the past enjoyed by all those who were born and raised in France. In the optimism of Focillon's triumphant humanism, the diversity and contradictions of a thousand years of history were all accorded a place.

A LAND, A LANDSCAPE

France has to be seen from high above to be properly pictured. This piece of the planet is placed, as though by design, on the western edge of Europe, capping the continent. France's four clear boundaries—the English Channel, the Rhine, the Pyrenees, and the Alps—function as so many barriers and bridges.

France's relatively recent nickname of "the Hexagon" expresses the concrete condition of the country's abstract nature, which suits a well-contained historical entity. This six-sided view stems from aerial photographs—taken by airplane or satellite—that convey the extreme diversity of an (apparently) coherent whole. In the nineteenth century, Michelet felt obliged to undertake a tour of France province by province, an admirable and still valid approach; these days, however, one is able to see the country instantly in its entirety, criss-crossed by long rivers running from the mountains to the seas. It does not take long to realize that France, a composite land, is above all a compound entity.

One of the questions which must be considered is the following: to what extent can one refer to "French" art when there was neither nation, nor state, nor any unity whatsover—just an unstable group of territories? The response entails uncovering and reconstituting fundamental affinities based on shared experiences, on relationships of proximity or dependence (what I will call linkage), on conformity to glamorous prototypes, on the flux of models. The slowly emerging whole revealed the existence of a shared artistic and cultural ensemble. The same process occurred with the French language.

*From *Introduction à l'histoire de l'art français,* by André Chastel, Paris: Flammarion, 1993.

The constitution of a "French space" with its own means of communication, shared myths and beliefs did not directly derive from political factors (which played a conditioning but not determining role, as demonstrated by the extreme example of the "Plantagenet kingdom"), nor from economic factors (the economic network, insofar as it can be assessed at any given period, simultaneously promoted contact and isolation among the provinces). The same thing applied to religion—pilgrimage routes ran diagonally across the land, well-trod by orders that nevertheless retained their own strong regional attachments.

It required the endless silence of millennia for the final retreat of glaciers to carve the pleasant valleys and plains of what would become Gaul. South of the Massif Central, long navigable rivers flowed from east to west, while the Seine and its tributaries irrigated the north. North–south travel was facilitated by the rivers flowing down the Massif Central, which were rich in fish and, occasionally, minerals along the riverbanks. Information circulating among nomad tribes from the tundras must have made the mild region to the west sound like an Eldorado, with abundant game in large forests in the central and eastern part of the land, and herds of horses roaming remarkable landscapes. At any rate, it was from the tundra that invaders came to the cultivated plains at the time of the Neolithic revolution.

First there were the Celts. Toward the middle of the Bronze Age (1500 B.C.), metal objects and burial mounds indicate the passage of Celtic tribes across central France. Necropolises eventually yielded vestiges easy to group into series; prior to modern excavations, the plowing of fields and digging of foundations sufficed to bring such vestiges to the surface.

Favorable natural conditions spurred the emergence of a large, essentially agrarian population within the space of a few millennia. The following statistics may surprise, but prehistoric archaeology has inventoried too many vestiges in France for there to be any doubt about the extraordinary figure of three to four million human beings during the Chalcolithic (or Copper) Age, a figure that had doubled by the Christian era. Thus, the end of the Chalcolithic marked the beginning of demographic growth, and inhabitants in the area became so numerous that the countless invaders of the pre–Middle Ages wound up being absorbed even as they conquered. This immediately raises an issue that will be briefly discussed in a rapid consideration of origins: this density of population was without a doubt valid for the fertile lands to the south and along the edges of northern forests, but in a more northerly climate Europe was perhaps populated primarily in advantageous zones that soon became "lands" in the sense used by Vidal de La Blache. Specific sites began to be defined, coveted, inhabited—a sort of purely geographical continuity must be behind certain modes of activity, representing the point of departure of the idea of "native soil" (see *Histoire de la Population Française,* edited by J. Dupâquier, 4 vols., 1987–1988).

It has occasionally been noted that each stage of prehistory marked by new tools—iron, copper, and bronze alongside wood (the latter being a major raw material in the area)—corresponded to new means of transportation (river travel, harnessed vehicles, etc.).

The top figure of twenty million inhabitants at the peak of the Middle Ages was reached again in the sixteenth century. However suggestive these statistics may be, they should not be misconstrued. During long centuries, "France" was a continually emerging concept, not a concrete nation and much less a formal state. The upshot is that the notion of French art was practically meaningless in the centuries preceding the Middle Ages. It is up to historians to justify use of the notion when discussing periods preceding the moment—as yet undetermined—when the concept of France no longer posed a problem. That is one of the tasks attempted here.

But, all anachronism aside, it is necessary to stress the power—or if you prefer, the inevitability—of continuity. From the time Neolithic settlements in what would become France were endowed with a decorative repertoire, none of the motifs observed (spirals, loops, waves) would ever totally disappear from the decoration seen on weapons and tools. Certain motifs persisted on the most banal of artifacts, by simple transmission that does not seem to depend on ethnic factors.

THE FRENCH LANGUAGE AS A CONCEPT OF UNITY

"French contains barely two hundred words of Gaulish origin." The provincial Latin of the Late Empire (which had lost Rome's tonic accent and free syntax) prevailed by the seventh and eighth centuries, perhaps as a result of the universal scope of the language of Rome. In 843, "Romance," a language distinct from German and Latin, appeared. But it should not be concluded that all Gallo-Roman prac-

tices and usage had been swept away. Utensils such as casks persisted, as did garments like trousers (surviving tools and techniques that involved construction or woodworking will be briefly discussed). All of these things, however, were given new names.

The vernacular long remained Germanic in the north and Latinate in the south (as can still be perceived today). But just as the slow development of regional languages led to dialects in Picardy, Champagne, Touraine, and Berry, so there emerged methods of building and decorating that ultimately constituted in the eleventh and twelfth centuries (and more convincingly in the thirteenth) a corpus that can only be called French. Sanctuaries marked and defined sites. The skyward thrust of Mont-Saint-Michel crowned and sharpened an isle threatened by the sands. At Rocamadour, the pinning of a church to a cliff overlooking the valley provoked amazement in both tourists and pilgrims. Such churches constituted a map of "wonders," whether nestled in dry hills as at Conques, or rising vertically above a vast plain like Notre-Dame at Chartres, or adding unexpected, irresistible power to an arid plateau, like Notre-Dame at Laon.

People became aware very early of the place of castles in the landscape. A certain continuity can be traced from the duke of Berry's "months," or illustrated calendar, that associated lordly manors with farming activities (circa 1415) to the tapestry of the Maisons Royales, also called "months," that linked Louis XIV's pastimes to the physiognomy of both nature and buildings.

There were also "portraits" of castles in the residences themselves or in annexes—for example, at the Château du Moulin (circa 1500), and underneath a large fresco of Saint Christopher in the seignorial chapel of the church at Lassay, and at Dissay on the edge of a mural by David.

Not only did the phenomemon of castles define the landscape from north to south, but it also served as a focal point for legends, heroic or otherwise, as place-names so often indicate, generating countless allusions in epic poetry and literature.

While castles were associated with domination of rural spaces, they were also (and, for us, above all) associated with the French landscape via choice of site, architectural profile, surrounding means of access, and auxiliary buildings that extended the castle's dominion. The history of art in France can not and should not be reduced to a series of models divorced from the natural space in which noble residences were erected, a misconception that this book will attempt to avoid.

As J. P. Babelon has pointed out in his excellent publications, ordinary vocabulary may sometimes be misleading. For the sake of convenience, however, the generic term "castle" will be used to refer to all "aristocratic" products of vernacular architecture, but only by redefining the aptness of the term at each stage.

The profiles of castles, whether ruins or modern restorations, follow the ridges of certain valleys like a dotted line of stone.

In other valleys they confront one another, reflecting old feudal rivalries. Centuries of conflict and turmoil—or false civility—can be read in this topographic staging of history.

The castle—*castellum*—that became the heart of a "castellany" toward the ninth century, was sometimes heir to a Gallo-Roman villa, as Viollet-le-Duc, who was interested in fortifications, surmised. But this association conflates two distinct dimensions or functions of a stronghold: its relationship to a rural domain (an agricultural operation that translated into the submission of peasants to a lord) versus its role as *fortericia* (a tower or fortified site designed to provide protection from raids and pillaging).

It indicated social superiority and the subjection of "laborers" on the one hand, and constituted a defensive stronghold on the other. The Romantics were only too quick to see that the cluster of turrets, towers, and weather vanes added an indescribable touch of gaiety, liveliness, and pride to noble residences. Fortified, yes, but with a delightful or even slightly mad silhouette. This architecture was typically "French," or at least embodied the "French wit" (*l'esprit français*) of the day.

Castles reflected the same proliferation of spires and gables seen in churches. The reasons for the choice of these architectural forms are far from clear. On the other hand, castles' specific location, their stance against the sky, their value as visual reference point on the horizon—in short, their remarkable role in constructing the French landscape—are instantly obvious. Archaeological research has contributed a great deal here, for in the past fifty years it has yielded discoveries of considerable interest for the sociology of feudalism via the implantation of fortified hillocks, or mottes. The archaeological map of western France has turned up a surprising swarm of castles

in the Poitou and Saintonge regions, but no study of a castle has completely analyzed its site and examined the environment that spurred construction and its consequences.

To simplify a great deal, while looking to the cardinal points around France, it could be said that links with the Rhineland and Germany were crucial during the Carolingian age, links with Spain dominated from the reconquest to the eleventh and twelfth centuries, and with Plantagenet England from the twelfth century and throughout the birth of the Gothic era. "The year 1200," meanwhile, served as a convenient point of convergence of antique and Byzantine models thanks to increasingly active relationships with Italy and Byzantium (the capture and sack of Constantinople by Crusaders dates from 1204).

Links with Spain were nevertheless constant, and worthy of attention right from the Carolingian period—the Franks created a Christian border zone on the other side of the Pyrenees, and the Crusader spirit that inflamed the Galician kingdoms was fueled by the pilgrimage to Compostela, like some Western version of the "sacred way."

The typical back-and-forth motion of exchanges occurred in all directions: southern France exported pilgrimage-style churches to Compostela and in turn welcomed mozarabic features like polyfoil arches and polychrome stone. It goes without saying that the same was true of Lombard Italy, the Ottonian Rhineland, and ultimately England.

Exchange and influence are sometimes invoked too hastily. The Crusades were not designed to discover models in the East, but to impose those of Western Christiantiy on the new kingdoms that were to be founded. And that is what happened with churches in Cyprus and with the Crusaders' huge fortresses. Obviously, by working as always with a local labor force, shared technical resources were employed and local decorative motifs appeared.

France was a filter. It sifted, and received. The country was porous on all sides. Its workers, sure of themselves, borrowed from left and right as if everything belonged naturally to them. In art, there is never any point in drawing up invoices, figuring out who owes what to whom. The point is to move forward, tools in hand. This attitude was a constant feature of the composite, richly contrasting land that became France. If this attitude is overlooked—if the importance of these appropriations is not grasped, if a definition of French art is attempted independently of this action of filtering and assimilating—only an impoverished and disappointing notion of that activity will result, quickly exhausting itself in a celebration of refinement and clarity.

The interest of French art would seem to lie in two things: its capacity for self-interested filtering and assimilation, and the power of its vernacular forms (which is less contradictory than previously thought).

The term "influence"—widely used in both art and literary histories—is disastrous. It implies straightforward borrowing, which occurred, of course, in every century. But the important, specific thing was the technique of appropriation which no civilization pioneered or practiced as thoroughly as France. The steady, powerful development of this technique resulted from mutual solidarity, even though relations varied in intensity and the direction of exchange shifted. But this operating principle has continued to function from the tenth or eleventh century to the present, slowly and laboriously at first, then in a natural and serene way once a certain confidence reigned (in the twelfth century, say).

THRONE AND ALTAR

The emergence of a king of Francia just prior to the year 1000 had largely symbolic value, of course—the country was far from united and its three or four major regions were organized (so to speak) in terms of feudal groupings. Two organizing principles, monarchy and feudalism, would develop simultaneously within and against one another, provoking moments of grave tension and fissures, exemplified by Plantagenet pretensions to the west, and the claims of Lorraine and later Burgundy to the east. This twin aspect of things is an essential element of the argument developed here. As France began to constitute itself, it was profoundly provincial; the monarchic principle initially served to resist the hegemony of Holy Roman Emperors (tenth and eleventh centuries), then to limit and ultimately eliminate centrifugal forces, and finally to rein in feudal lords and weave a network of administrative constraints that would blossom after the Revolution in 1789. The development of "French" art can only be grasped if a sense of this tricky balance is constantly kept in mind. To be concrete, the regions that fell under Plantagenet control after Eleanor of Aquitaine's marriage to Henry II of England absolutely

must be integrated into this development, while never forgetting that this highly original and ambitious dynasty straddled France and southern England.

Two centuries of ambivalence.

The development of large "figured" portals that constitute an entire program in "pictures," starting around 1130, coincides so exactly with the affirmation of the Capet dynasty (Louis VI, Louis VII, Philip Augustus) that it is hard not to perceive allusions to royal power.

The statue–columns at Saint-Denis and Chartres clearly represent the ancestors of Christ. By describing them as kings and queens of the three "races of kings"—Merovingian, Carolingian, Capetian—Maurist scholars of the eighteenth century unwittingly encouraged an association among the people that led to massive destruction of these statues during the revolutionary events of 1792 and 1793. But it is also clear that by celebrating the major biblical representatives of royal power, these figures helped endow the kings of France with unmatched dignity—they were an illustration of the monarchic institution (see A. Katzenellenbogen, *The Sculptural Programs of Chartres Cathedral: Christ, Mary, Ecclesia*, Baltimore, 1959).

In the so-called "traditional" society that typified France for centuries, everything was genealogical. Whether invented or not, ancestral tradition weighed heavily on the nobility, governing its symbolism and defining its duties. The way the theory of "the three social orders" was constituted, with manifold consequences for French society, has been admirably explained (see G. Duby, *Les Trois Ordres ou l'imaginaire du féodalisme*, Paris: Gallimard, 1978). The figure of a knight dressed for battle is one of those found just about everywhere, starting in the tenth century with characters (English, at that) from the Bayeux tapestry.

The knight in shining armor lent his image to that of Virtue in Romanesque depictions of the psychic struggle between Vice and Virtue, becoming the hero of famous chronicles. But when the knight dismounted, where did he go? Without helmet or coat of mail, where could he be placed? The answer raises the issue of castles.

It would obviously be contradictory to examine feudal buildings of the Middle Ages and aristocratic residences of the Ancien Régime from the sole standpoint of architectural techniques, without taking into account the needs of the social class for whom they were designed.

In return, it is equally surprising to see the mores of chivalry described with no consideration of the cramped and austere residences in which they were nurtured—how could home be reconciled with fort or, later, comfort with prestige? These were the constant concerns of castle architecture. And if the residence was of necessity austere, in what ways was it made more pleasant—paintings, ironwork, tapestries? Or did people build simpler and more comfortable houses at some distance from the "official" family castle?

All these questions must be kept in mind when examining the vast sphere of castles and châteaux in France. And it is above all crucial to abandon completely the modern image of a castle as a luxury residence, for now they have generally been renovated for the benefit of rich owners (except in the very rare cases when the family seat has not changed hands).

It may not be appreciated how heavy a burden a vast, traditional residence could represent for a family. (Nor should it be forgotten here that marriage to another family, an inheritance, or political events could cause castles to change hands).

This brings us to a capital point, which will be illustrated more fully at the appropriate moment. Castles were centers of culture during the Romanesque and Gothic periods. In the fourteenth century there was an intense "aristocraticizing" of artistic patronage by grand noblemen. But with the social changes of the fifteenth century, there was a shift in money and power that led to the emergence of a new class, typified by royal financiers and secretaries, which for the sake of convenience could be called the upper bourgeoisie.

While the *noblesse de sang* (old hereditary nobility) was conducting wars in Italy on behalf of the monarchs, holding on to their old castles but not modernizing them, the new social class—highly cultivated, clever, ambitious, keeping close to members of the royal family—little by little constituted the *noblesse de robe* (new administrative nobility) that was the true harbinger of what is generally called the Renaissance.

Architecture presupposes reliance on a design, but it was rare for that design to be specifically elaborated for a a given building; usually, it sufficed to mention an existing model to be followed. The historical development of construction was a series of "chain reactions," so to speak, which was common to all periods. To cite just a few examples among many, when the bishop of Rodez contracted the construction of an episcopal castle in Moyrazès (Aveyron) in 1341, he stipulated that the hall should be identical to the one in Muret, and that the chimneys and *latrina in volta* be similar to those in episcopal residences in Palavas and Rodez. These precise instructions covered overall design and

highly visible details like portals, the color of walls, and iron fittings. In certain instances, it clearly involved conforming to a more or less recent fashion—for a house in Caylus, the windows were to be done "in the French manner" (a twinned opening with slender column in the middle that pleasantly ornamented the facade). The latter term recurs constantly in cost estimates made up to the eighteenth century (E. Douais, *L'Art à Toulouse, matériaux pour servir à son histoire du XV^e au XVIII^e siècle*, Toulouse, 1904, cited by Aurel Bongin, 41st Regional Convention, Tarn-et-Garonne Archaeological Society, 1986).

Similar examples could be found in all regions and all periods, at all social levels. Thus new trends were slowly woven into building activity through a process of "linkage" in which specific innovations were inserted into conventional designs.

A certain importance is justifiably attached to the sketchbook left by Villard de Honnecourt—the determination to emphasize the human figure and submit it to a system of proportion makes it one of the strongest extant examples of the "geometric" spirit in art. Lack of documentation makes it hard to assert that this attitude thrived in the French provinces, but it can perhaps be glimpsed in the popular "leaf figures" on vault bosses, for instance, or the droll masks that presuppose a rigorous format within which the imagination can go to work.

Villard's sketchbook includes several pages of precise comments on stone-cutting. One of the sketches (fol. 39r) examines the work of carving a smooth and even archivolt stone. The same problem and a simular solution can be found in a book that Mathurin Jousse wrote for journeyman masons—*Le Secret d'architecture* (1642). This represents an example of "linkage across time" (See "La stéréotomie médiévale," *Bulletin monumental*, 145: 4, 1987, pp. 387 ff.).

ELDEST DAUGHTER OF THE CHURCH

The Merovingian period equals episcopal implantation.
The Carolingian period equals the Benedictines' arrival on the scene.
The eleventh century equals the nearly total domination by Cluny.
The twelfth century equals the diversification of religious orders,
the thirteenth the strong assertion of the episcopacy, and the seventeenth, the renaissance of monastic orders.

Saint Bernard's anti-artistic reform has often been stressed, given its radical nature and religious depth. But the fact that its impact was ultimately rather limited should not blind us to the persistence—even outside Cistercian circles—of a certain wariness or even open hostility to the exuberant art of the Middle Ages as well as of the period that followed. Clerics vehemently criticized wasteful allocations unrelated to piety; Gerson, in 1400, warned about absurd cults and the abusive use of religious imagery; humanists concerned about spiritual rigor disapproved of extravagant expenditures.

Guillaume Budé unhesitatingly condemned the pointless lavishness of the archbishop of Rouen's Château de Gaillon with its "Nero-like" splendors; the Huguenots, taking their cue from Calvin, denounced ecclesiastical art far more loudly than secular art, leading to dreadful "iconoclast" rampages; the Jansenist movement inherited a little something from all these attitudes, and its contempt for the worldliness inherent in architectural and artistic pomp sparked certain scruples and anxieties in religious minds; Voltaire wrote the poem "Le Mondain" in response to vague accusations leveled against the frivolity and license of Regency art. It would be naive to think that the vast deployment of artistic activity in each generation was accepted and approved by all. Not only was art's role in the church suspect, but its close ties to political motives and princely ostentation regularly prompted reservations and suspicion.

In the fourteenth and fifteenth centuries, "to attain notoriety, the cause of a saint had to have the approval, if not the support, of those in power." The case of Charles of Blois, killed at the battle of Auray in 1364, is a perfect example. As pretender to the duchy of Brittany, Charles—known, and sometimes criticized, for his piousness and attachment to the mendicant orders—was the object of canonization procedures as early as 1371 thanks to events like the children's pilgrimage backed by his cousins from the house of Anjou. It might be noted that Charles himself had obtained the canonization of Yves, also from Britanny, by the pope in Avignon, and that wooden statues of Charles were soon in circulation (see A. Vauchez, *La Sainteté en Occident aux derniers siècles du Moyen Age*, Rome, 1981, 2nd ed.1988, p. 269 ff.).

The benevolence of saints was a fundamental feature of medieval life and attitudes. As has been well demonstrated, it was increasingly accepted that the boons formerly obtained by visiting a tomb could be acquired by petitioning from a distance, that is to say by venerating an image rather than a physical relic. During Yves's canonization procedure of 1371, it was reported that at the instigation of Charles of Blois, effigies of the saint painted *ad modium Lombardiae* (in the Lombard fashion) had circulated among the mendicants. Private, indeed domestic, veneration went hand in hand with a recourse to an "international" model of representation. (see A. Vauchez, p. 528, and A. Dupont, *Mélanges*, ed. F. Braudel, Second series, Paris, 1973, pp. 183-226).

One of the most original contributions of the monarchy to religious practice was the institution of holy chapels in royal castles, designed to house prestigious relics, based on the model of the Sainte-Chapelle reliquary–church in Paris. These chapels, reserved for princes of the blood, fell into two groups. The first group was located around Paris—Le Gué de Maulny (1329, transferred to Le Mans in 1369), Le Vivier-en-Brie (1352), and Vincennes (1379), each with a chapter of canons responsible for maintaining the relics and conducting services. The other group was associated with the Bourbon branch of the dynasty: Bourbon-l'Archambault (1515), Riom and Bourges (built by Jean of Berry, in 1382 and 1405 respectively), Chambéry (built in 1408 by Amadeo VIII of Savoy), Aigueperse (1475) and Champigny-sur-Veude (1498).

Sainte-Chapelle, built by Louis IX, played the same role in the selective spread of the two-storey chapel that Charlemagne's octagon in Aix-la-Chapelle (Aachen) had played in the Rhineland two centuries earlier, the two series being linked insofar as Louis's chapel could not ignore Carolingian precedents. As already stated above, these prestigious monuments were designed to glorify the role of the Capet dynasty.

"Saint-Chapelle in Paris was built by King Saint Louis in an admirable architecture such as we no longer see. I once heard it said to master Jacques Audrouet, called Le Cerceau, one of the greatest architects ever to be found in France, that of all the buildings in the modern style, there was none more bold than that one" (Etienne Pasquier, *Recherches de la France*, 1667, p. 362).

Legends that sprang up around churches bear witness to an immense and pathetic need for appeasement and consolation through miracles. At Saint-Denis, in order to sustain hope for succor from current plights, the hideous skin of a healed leper served as a relic, the centerpiece of a celebration held on 24 February since the eleventh century. This was the date of a consecration conducted by Christ himself—the anointing of the basilica by the spontaneous healing of the leper's condition, a miracle which remained in the collective memory of the populace up until the Revolution (A. Lombard-Jourdan, *Bulletin monumental*, 143, 1985, p. 237).

As soon as a major construction project was undertaken, Providence signaled its favor through some unexpected revelation or development: lime kilns during the building of the first basilica at Saint-Denis in 475 and, during later construction in 1135, the discovery of "a new quarry, a veritable gift from God, supplying highly sturdy stones of a quality and quantity never before seen in the area," according to Suger.

The finest known texts—apart from Ruskin on Venice—are observations made by Viollet-le-Duc and A. Choisy on stone-cutting.

Examples abound to prove that people were very attentive to the issue of construction materials—any succesful research in this direction was naturally credited to the Lord.

Master builders and workers constantly demonstrated a precise, active, almost sentimental interest in the quality of stone.

ACCESS TO ARTWORKS

On the fringes, alongside, or sometimes in association with major ecclesiastical and royal projects, there was a precocious appreciation of what might be called art for delectation, that is to say a more restricted, less public, more intimate application of art's technical resources.

One thinks first, naturally, of manuscript paintings (miniatures), of items and ornaments in precious metals. Then one imagines the closed worlds of monasteries and noble courts, which governed both production and appreciation. One concludes that these luxurious

productions were reserved for those in power, a tradition maintained down through the ages to the wonderfully decorated interiors of the eighteenth and nineteenth centuries.

This initial interpretation, apparently based on common sense, arouses and inflames our awareness of the terrible inequality reigning in French society, in all the ways so often described and discussed. In the end, however, this does not constitute the best approach to the phenomenon of French art. The sharp sense of exclusive ownership of "works of art" is a modern attitude linked to a collector's mentality (which, true enough, has venerable roots), and to the development of the art market (which was not born yesterday, either, but which has exaggeratedly shaped today's cultural awareness). It should be pointed out that seven, eight, or more centuries ago things were not the same. The "artistic property" of powerful bishops and princes was commonly placed on show—it is even possible that such art was produced for spectacles in which the populace took part. Furthermore, the extensive industry which, in the pre-medieval period as well as in those that followed, churned out reliquaries, candelabra, enameled caskets, and painted and gilded statues was, obviously, oriented toward filling church "treasures," but those treasures themselves were designed to be placed on ritual, periodic show. Their display was part of their "use value," to employ a modern concept.

Works of a secular nature—statues and precious objects that accumulated in wealthy residences—entail concerns that were apparently more egotistical and possessive than those of pious donors, but were perhaps less different than is generally thought. There was a need for, or love of, ostentation during the "non-bourgeois" periods of Western civilization that spurred anyone who had managed to get ahead or receive a social promotion to display his property. Circumstances varied and analysis is difficult. But, as in other countries, the French nobility exposed the signs of its station with conviction, be those signs precious objects, tapestries, jewelry, or works of art. There was no marriage, celebration, or festive occasion on which these items were not displayed for privileged guests—and, often enough, for all—to see.

The vast majority of glassmakers, stonecutters, sculptors, painters, miniaturists, and so on, remained anonymous. They did not belong to the category of people whose names were worthy of note, which means that their names were not recorded in chronicles. The fact that major projects were executed by successive teams, often over several generations, also explains the absence of specific attribution.

The case of manuscripts, whether illuminated or not, is rather mysterious, and no one can say to what extent they were designed to be circulated; in any event, they belonged to monastic libraries or to seignorial chapels (where Books of Hours swiftly came to be considered part of the family estate to be handed down to descendents). It would be wonderful to know how masterpieces like the *Psalter of Saint Louis*, Jean Pucelle's *Belleville Hours*, or the *Très Riches Heures du Duc de Berry* were handled, when and by whom they were seen, prior to being carefully inventoried. The fact that they have survived to the present day proves at least that they were not simply shoved into some chest but were generally known and shown—displayed is perhaps the word—to worthy visitors.

A good indication of the attitude of "art patrons" was, of course, the general practice of donating retables and statues to church chapels, not only during the Middle Ages but right into modern times. Devotional ostentation went hand in hand with a demonstration of the donor's taste. Countless major works of art came before the eye of the general public—and not merely the faithful—thanks to the widespread practice of pious offerings.

Painting should be studied first of all as an artistic activity, rather than as a series of painted panels and canvases. Modern bias, influenced by museum practices, frustrates an appreciation of a French art that for centuries applied form and color to murals, to transparent stained-glass images, to manuscript illumination, to the marvels of enameling, to virtuoso tapestries and magnificent altar decorations. Mutual influence among all these activities certainly did not pass via easel painting.

Entire periods from which easel painting appears absent, such as the early sixteenth century, were great moments of stained glass, and it would be unwise to demote such inventive artists as Berain and Audran (Watteau's mentor) to the role of decorators.

The composition at which the French excel is not necessarily that of the traditional painting.

Fouquet's miniature landscapes would not have the same meaning if executed on a large panel; moreover, when he painted the large-format Nouans *Pietà*, he refrained from adding landscape.

Everyone likes painting. Few cultivated people in France would admit to being indifferent to painting. It is absolutely impossible to present the history of French painting from the unique standpoint of easel painting. Yet it is customary to do just that, by identifying the famous portrait of John the Good (Louvre), painted around 1349, as the French school's natural point of departure. This painting is obviously important for its rigorous draftsmanship and its acute profile which transposes the art of medallions into a simple image with a distinct visual power. The example did not go unnoticed. It is the only vestige of an art of portraiture that swiftly grew among princely circles, as inspired by the Saint-Martial Chapel in the papal palace in Avignon (1345). Painting was nevertheless practiced in several media—fresco, stained glass, miniature, and tapestry cartoons, as well as on devotional panels and retables.

The relationship between Gothic architecture and stained glass is one of the most revealing aspects of the "autonomous" play of forms in medieval art. Windows simultanously acted as "opening" (to let light in) and as "closure," creating a sort of dialectical relationship between a structure that lightened the wall and the glass that "enclosed" the interior space by coloring it. Large windows could give more light, but denser, more highly saturated colors sustained a somewhat subdued atmosphere where reds—which block more light—play a powerful role.

The brutal destruction of stained glass during the age of canons, and its often chancy restoration in the nineteenth century, have usually altered the dramatic relationship essential to Gothic "interiors." Ultimately, however, good luck—given the fragility of the object in question—and the vigilance of certain authorities have enabled France to offer for delectation such striking ensembles as those at Le Mans, Bourges, Beauvais, and Auch.

RUPTURES AND CONTINUITY

Archaeological research has produced evidence of continuity everywhere it was least expected, as well as early models that pre-date well-known phenomena by two or three centuries or more, suggesting not only (surreptitious) precedents but perhaps also affiliations. It has been discovered, for example, that prior to the development of Romanesque painting in Burgundy in the twelfth century, the crypt of Saint-Germain in Auxerre had already been decorated during the Carolingian epoch.

Archaeology and art history can come to the aid of historians who, in the absence of reliable documents, perceive a sort of black hole, or dark phase, easily interpreted as a moment of misery and desolation. Furthermore, the rare chronicles that exist, such as the one by Cluniac monk Raoul Glaber (died 1050), are constructed around fantastic or legendary concepts, giving the impression of a pitiful, naively cruel world in which feudal power was exercised by a thousand local tyrants and the Church's network of monasteries.

This situation sometimes requires that the official version be examined from the underside, using other sources of documentation to construct an inter-linking political and economic picture. This yields a world still full of bitterness and conflict, but one of surprising developments in the arts of construction and decoration, in art itself, which merely needs to be examined to produce a less banal image.

What happend at Saint-Benôit-sur-Loire, at Saint-Germain-des-Prés, at Saint-Bénigne-de-Dijon, presupposes not only organizational skills and determination on the part of dynamic individuals, but also technical competence and an able workforce—things not usually found in a ravaged society.

Nineteenth-century archaeological pioneer Jules Quicherat thought that no existing building in France pre-dated the tenth century. Excavation of foundations and closer analysis of structures has led to the identification of a number of churches attested to by the great sixth-century chronicler, Gregory of Tours.

Everything was thought to have disappeared through natural ruin, human destruction, the effect of time. But the striking determination and persistence of scholarship has caused this idea to become superseded. The "dark ages" were in fact due to the opacity of intervening centuries. Previous historians were nevertheless right insofar as practically no edifice crossed the centuries intact—but this was due above all to the law of "alteration."

The early eleventh-century rotunda at Saint-Bénigne should have sufficed to convey a different idea of things around the year 1000—

a multi-leveled cupola, a double ambulatory in imitation of the Holy Sepulcher of Jerusalem. But all that is left is a crypt. The history of art in France provides a remarkable illustration of the twin disasters of alterations and vandalism.

I would like to try to show that more than any other country, France—subject to many upheavals, accidents, risky undertakings—established a robust continuity, even if the French themselves were barely aware of or appreciated it, thanks to strong local roots, customs and practices, as well as to artisanal capacities (often more instinctive than reasoned, that is to say finding their justification in free execution rather than in higher motives). This continuity, if the art of construction is taken as a unifying thread, began with practices assimilated by the Gallo-Romans and, through every imaginable vagary, continued into the early Middle Ages, finding its fullest expression in the prodigious output of the twelfth and thirteenth centuries. Artisanal methods, henceforth fully confident, found new occasions to manifest themselves through the vernacular architecture that triumphed in the Renaissance, then in ambitious classical buildings, continuing down to the present through the age-old traditions of *compagnons* (journeymen artisans).

It is important to dismiss the constant temptation to assume that Carolingian art, for instance, contains interesting harbingers of medieval art that became more specific around the year 1000 only to reach a certain fruition in A.D. 1100. This Darwinian-style evolution has the drawback of establishing a linear development, after the fact, from events that obviously counted in and of themselves, thereby ignoring chance encounters en route.

Advances in research naturally lead to more complicated systems of classification. A typical example is the identification of a new stage—the A.D. 1200 phase—between the Romanesque and Gothic eras. This caesura accounts for a distinctly "antique" feel to the art of Nicolas of Verdun and to the sculpture on Reims Cathedral, typifying a trend that would not survive past the year 1220.

It would seem that between the reign of the great, dominating styles, an intermediate phase should be introduced, representing a highly active, inventive and confident period in which other possibilities arose; although subsequently abandoned or absorbed into a new trend, these possibilities were revealing of cultural ferment and capacities. Hence the idea of a "1200 style" emerged around 1960 to account for a movement away from Romanesque severity without moving toward Gothic fluidity. Similarly, superb examples of fifteenth-century painting and stained glass are no longer shoe-horned into an indefinitely expandable "Middle Ages." Nor do they have to be discussed in terms of a "pre-Renaissance" or "proto-Renaissance." An intermediate definition is far more suitable.

The same evolutionary curve seems to have occurred at least twice in France. Seen from on high, the Middle Ages as a whole reveal a period of intense, decentralized activity (Romanesque) followed by a phase of relative concentration establishing new relationships in Western Europe based on new contingencies (Gothic), and finally a superficial and refined movement, labeled "aristocratic," in which Gothic art underwent an elegant dissolution. This curve does not resemble the pre-established three-phase pattern that has sometimes been attributed to medieval development (experimental, classic, mannerist stages). Rather, the picture is more flexible and adapted to the French realm, and it is remarkable that the same curve is found in accounts (as objective as possible) of the art during the so-called classic age following the Renaissance. A period of effervescence, characterized by a wealth of local and original experiments that could be described as a "heroic" period, was followed by the extraordinary ordering and centralizing associated with the "Age of Louis XIV," which achieved a surprising consensus throughout Europe, whether ally or enemy. Finally, the fertile, aristocratic appropriation of the wellsprings of artistic life sparked one of the most exquisite and delicate periods in French culture—rococo and the reign of Louis XV.

It is probably the convenience of historical distance that permits this correlation between two evolutionary curves which, despite their differences, jointly seem to establish a sort of French law. There is no indication that those artists active in the seventeenth and eighteenth centuries were aware of repeating a prior pattern, although the eighteenth century increasingly indulged in references to the Middle Ages, to the skill of Gothic architects, and to ancient aristocratic settings. There must have been a certain awareness, or vague presence, of a past disdained for its art but constantly evoked as a source of monarchic and religious authority.

Whether this schematic evolution across the centuries is accepted or not, it would seem that France's incredible ignorance concerning its own artistic past has placed it, until recently, in a rather strange situation. Recognized in Western eyes and then in those of every

modern civilization for visual vestiges dotted across its territory, France apparently remains unaware of the defining role played by age-old artistic production. Foreigners perceive, appreciate and interpret France via works on French soil or scattered in museums throughout the world. France seen from the exterior is largely—though obviously not exclusively—a land of art. But it is precisely this aspect of its identity that French culture has had the most difficulty assuming throughout the ages, and the one with which it is least familiar today.

It almost seems as though the French mind has generally consigned to its subconscious what admiring—or wary—gazes from abroad tend to see as most essential to it.

If this analysis is valid, then the study of French art is equivalent to an analysis of the national subconscious. And there is to be no hesitation about underscoring, where appropriate, its dismaying irrelevance as well as its pleasant aspects and its insight.

What we call the Middle Ages concerns a period of local and regional crystallization of forms within a broad international movement. The term influences is not useful here. Some places were characterized by great inertia, obstinate foot-dragging; elsewhere, thanks to circumstances easy to describe (noble courts, church networks, trade routes), there was an earnest welcoming, seeking, and seizing of new models, which were manipulated and absorbed with a mixture of rage and fervor. Then, at a certain moment and at a certain place that historians must try to pinpoint or circumscribe, there burst forth the determination to bring experiments to a successful conclusion; at a certain point, intellectual maturation and manual confidence combined to devise a system that claimed to embrace everything. The manifestation of a grand style, with its sovereign simplicity, subjugated onlookers and, progressively, neighbors and foreigners, until it sparked a movement of resistance or rejection.

Does this constitute an accurate profile of the period, a valid account of artistic events constituting French art? Is it legitimate to claim that the process occurred in the West two, three, or four times? I can see no better way of presenting things than by going straight to the heart of the French problem.

CODA

To put it in a harsh and straighforward way that may shock some people, I love the French less than France, and France less than French art, all the while taking as much trouble as anyone, I feel, to show how it was through their idea of France that the French undertook and accomplished so many extraordinary things in their art. One can and should challenge countless details in a work of this scope. Given the many hasty and peremptory judgments included here, irritation and doubt are understandable. But the key points of the overall argument cannot be rejected much longer—the concept of *sollertia* (aptitude) originating from the dawn of time, combined with an artisanal culture (not to be confused with "folk" culture) that has been formed, transformed, consolidated then lost, generation after generation. Then there is the idea of "selective assimilation," which alone can account for the alternatively receptive and dominating aspect of French art in the midst of other European art (whose entire history, it hardly needs pointing out, should be reconsidered). To which could be added the periodic appearance of a light, exquisite, pleasant style, exhibiting contentment and radiant delight which, in its successive manifestations, has deeply etched its presence and confirmed itself as France's unique and hallowed artistic gift to the world. All of this is associated, of course, with an unparalleled sense of formal arrangement, without which there would never have emerged, on this inexhaustible soil, multitudinous examples of magnificent, highly moving architecture.

BIBLIOGRAPHY

HISTORICAL SOURCES

(THE MIDDLE AGES)

ADÉMAR DE CHABANNES. *Chronique.* Edited by J. Chavanon. Paris: A. et J. Picard, 1897. See below, *L'An Mille.*

ANDRÉ DE FLEURY, *Vita Gauzlini abbatis Floriacensis monasterii. Vie de Gauzlin, abbé de Fleury.* Translated and annotated by R.-H. Bautier and G. Labory. Paris: Institut de recherche et d'histoire des textes–C.N.R.S., 1969.

L'An Mille. Mémoires du Passé pour servir au Temps présent. Oeuvres de Luitprand, Raoul Glaber, Adémar de Chabannes, Adalberon, Helgaud. Selected, translated and introduced by E. Pognon. Paris: Gallimard, 1947.

BERNARD OF CLAIRVAUX. *Apologia ad Guilelmi Sancti Theodorici abbat.* Edited by J. Migne. Patrologia Latina, vol. CLXXXII.

DURANDUS, Gulielmus, Bishop of Mende, the Elder (Durand de Mende, Guillaume). *Rationale Divinorum officiorum* (1286). Lyon, 1551. Translated into the French by C. Barthelemey. Paris: 1854. English editions: *The Symbolism of Churches and Church Ornaments.* A translation of the first book of the 'Rationale Divinorum Officiorum.' Annoted with an introduction by J.M. Neale and B. Webb. Leeds: 1843; *The Sacred Vestments.* An English rendering of the third book of the 'Rationale Divinorum Officiorum.' Translated with notes by T.H. Passmore. London, 1899.

Grandes Chroniques de France. 10 vols. Edited by J. Viard. Paris: Société d'histoire de l'art français, 1920–1953.

GREGORY OF TOURS (Saint). *Historia Francorum.* Translated from the Latin with an introduction by Lewis Thorpe under the title *The History of the Franks.* Harmondsworth: Penguin Books, 1977.

Guide du Pèlerin de Saint-Jacques de Compostelle. Edited and translated by J. Vielliard. Mâcon: Protat, 1938. New ed. 1990.

GUILLAUME DE SAINT-PATHUS. *Vie et miracles de Saint Louis.* Edited by H.-F. Delaborde. Paris, 1899.

HELGAUD DE FLEURY. *Epitoma Vitæ Regis Rotberti Pii, Vie de Robert le Pieux.* Translated with notes by R.-H. Bautier and G. Labory. Paris: Institut de recherche et d'histoire des textes-C.N.R.S., 1963. See above, *L'An Mille.*

JOINVILLE, J. de. *La Vie de Saint Louis.* Translated with an introduction by M.R.B. Shaw under the title *The Life of Saint Louis.* Harmondsworth: Penguin Books, 1963.

Liber miraculorum sanctæ Fidis, (Miracles de sainte Foy). Edited by A. Bouillet. Paris: A. et J. Picard, 1897.

Miraculi Sancti Benedicti, (Les Miracles de saint Benoît), écrits par Adrevald, Aimoin, André de Fleury, Raoul Tortaire et Hugues de Sainte-Marie, moines de Fleury. Edited by E. de Certain. Paris: Société de l'Histoire de France, 1858.

RAOUL GLABER. *Les Cinq Livres de ses Histoires. 900–1044.* Edited by M. Prou. Paris: A. et J. Picard, 1886. See also above, *L'An Mille.*

ROBERT DE TORIGNI. *Chronique.* Edited by L. Delisle. Rouen, 1872–1873.

SUGER, *Œuvres complètes.* Edited by A. Lecoy de la Marche. Paris: Renouard, 1867; Société de l'Histoire de France, 1939. New ed. Hildesheim and New York, 1979.

SUGER, *Abbot Suger on the Abbey Church of Saint Denis and its Art Treasures.* Edited, translated from the Latin, and annotated by Erwin Panofsky. Princeton: Princeton University Press, 1946. 2nd edition (revised) by Gerda Panofsky-Soergel. Princeton: Princeton University Press, 1979.

SULPICIUS SEVERUS (Sulpice Sévère), *Vita Sancti Martini.* Edited by J. Fontaine. Paris: Le Cerf, coll. Sources chrétiennes, 1968. Translated from French with an introduction by Paul Monceau under the title *Saint Martin of Tours.* Edited by Mary Caroline Watt. London: Sands & Co., 1928.

16TH–19TH CENTURIES

BELLEFOREST, F. de. *Cosmographie universelle.* Paris, 1575.

BOUCHER DE CREVECŒUR DE PERTHES, J. de. *Antiquités celtiques et antédiluviennes.* Paris, 1847.

CAYLUS, comte de. *Antiquités égyptiennes, grecques, romaines et gauloises.* Paris, 1774.

Dessins de la collection Roger de Gaignières, Paris, Bibliothèque nationale, cabinet des Estampes, Oa 11 and 12. See also below, *Inventaire des Dessins . . .* and J. Adhépar, G. Dordor, A. Dufour, *Les Tombeaux de la collection Gaignières.*

FÉLIBIEN, dom M. *Histoire de l'abbaye royale de Saint-Denys en France.* Paris: F. Léonard, 1706. New ed. Paris: Editions du Palais-Royal, 1973.

MILLIN, A.-L. *Antiquités nationales ou Recueil des monuments pour servir à l'Histoire générale et particulière de la France*, 5 vols. Paris, 1790–1798.

MONTFAUCON, B. de. *Dessins, notes et gravures pour les monuments de la Monarchie françoise, XVII^e siècle,* 2 vols. Bibliothèque Nationale, Ms. Fr. 15634 and 15635.

MONTFAUCON, B. de. *Monuments de la Monarchie françoise,* 5 vols. Paris: J.-M. Gandouin and P.-F. Giffart, 1729–1733.

ARCHIVES AND INVENTORIES

Archives de la commission des Monuments historiques, ministère de la Culture. *Plans et Dessins, Basse-Normandie; Languedoc-Roussillon; Picardie.* Paris: A. et J. Picard, 1980, 1982, 1985.

Corpus des Inscriptions de la France médiévale. R. Favreau and J. Michaud. General editor, E.-R. Labande. 14 vols. Poitiers: Centre d'études supérieures de civilisation médiévale, 1974–1989.

Corpus Vitrearum Medii Ævi
Les Vitraux de la cathédrale Notre-Dame de Strasbourg. V. Beyer, C. Wild-Block, F. Zschokke, with C. Lautier. Paris: C.N.R.S., 1986.
Les Vitraux de Notre-Dame et de la Sainte-Chapelle. M. Aubert, L. Grodecki, J. Lafond, J. Verrier. Paris: C.N.M.H.–C.N.R.S., 1959.
Les Vitraux de Saint-Denis. Étude sur le vitrail au XII^e siècle. Histoire et restitution. L. Grodecki, Paris, C.N.R.S.–A.M.G., 1976.
Les Vitraux du Chœur de Saint-Ouen de Rouen. J. Lafond, F. Perrot, P. Popesco. Paris: C.N.M.H.–C.N.R.S., 1970.

Inventaires des Dessins exécutés pour Roger de Gaignières et conservés au département des Estampes et des Manuscrits de la Bibliothèque nationale. 2 vols. H. Bouchot. Paris: Plon, 1891.

Inventaire général des richesses d'art de la France. Paris, Monuments civils. 4 vols. *Monuments religieux.* 3 vols. Paris: Plon, 1883–1913.

Inventaire général des richesses d'art de la France.
Inventaires topographiques (par canton ou groupes de cantons). Paris: Direction du Patrimoine, Ministère de la Culture–Imprimerie nationale Éditions, 17 vols. published to date, 1967.
Cahiers de l'Inventaire. Paris: Direction du Patrimoine. 26 fascicules published to date, 1983.
Principes d'analyse scientifique. Méthode et vocabulaire. Imprimerie nationale Éditions–Ministère de la Culture: *La Tapisserie,* 1971; *L'Architecture,* 1972; *La Sculpture,* 1978.
Recensement des vitraux anciens de la France. Paris: C.N.R.S.–Ministère de la Culture: *Paris, Région parisienne, Picardie, Nord-Pas-de-Calais,* 1978; *Centre et Pays de Loire,* 1981; *Bourgogne, Franche-Comté, Rhône-Alpes,* 1986; *Champagne-Ardenne,* 1992.
Répertoire des Inventaires, (critical bibliography of publications on national heritage). Paris: Imprimerie nationale Éditions–Ministère de la Culture, 1970–1991.

Inventaire des mégalithes de la France. Supplement to *Gallia Préhistoire.* Paris, C.N.R.S., 8 fascicules published to date, 1963–1986.

Recueil des bas-reliefs, statues et bustes de la Gaule romaine. E. Espérandieu, continued by R. Lantier and P.-M. Duval. Paris: P.U.F., vols. I–XVI, 1907–1981.

Recueil de textes relatifs à l'histoire de l'architecture et à la condition des architectes en France au Moyen Âge. Vol. 1, *XI^e–XII^e siècles,* by V. Mortet. Vol. 2, *XII^e–XIII^e siècles,* by V. Mortet and P. Deschamps. Paris: A. et J. Picard, 1911 and 1929. New ed. College Art Association of America, 1972.

Recueil général des monuments sculptés en France pendant le haut Moyen Âge (IVe–Xe siècles), 4 vols. Vol. 2, *Paris et son département,* edited by D. Fossard, M. Vieillard-Troïekouroff, E. Chastel. Vol. 2, *Isère, Haute-Savoie,* edited by E. Chastel. Vol. 3, *Val d'Oise et Yvelines,* edited by J. Sirat, M. Vieillard-Troïekouroff. Vol. 4, *Haute-Garonne,* edited by C. Derou, M. Durliat, M. Scelles. Paris: Comité des travaux historiques et scientifiques–Bibliothèque Nationale–C.T.H.S., 1978, 1981, 1984, 1987.

Topographie chrétienne des cités de la Gaule des origines au milieu du VIIIe siècle. 7 vols. N. Gauthier and J.-C. Picard. Paris: De Boccard, 1985–1989.

JOURNALS AND PERIODICALS
Dates given are those
of the first year of publication

Actes du Congrès national des Sociétés savantes. 1913.

Antiquités Nationales. Saint-Germain-en-Laye: Musée des Antiquités nationales, 1969.

Archéologie médiévale. Paris: C.N.R.S., 1971.

Art Bulletin. New York (originally Providence): College Art Association of America. 1919.

Art de France. Paris, 1961–1964.

Arte medievale. Rome, 1983.

Bulletin archéologique du Comité des travaux historiques et scientifiques. Paris: Bibliothèque Nationale, 1883.

Bulletin de la Société de l'histoire de l'art français. Paris, 1927.

Bulletin de la Société nationale des antiquités de France. Paris, 1857.

Bulletin du Centre international d'études romanes. Tournus, 1971.

Bulletin monumental. Paris: Société française d'archéologie, 1834.

Cahiers archéologiques. Paris, 1962.

Cahiers de civilisation médiévale. Poitiers, 1958.

Cahiers de Saint-Michel de Cuxa. 1970.

Congrès archéologique de France. Paris: Société française d'archéologie, 1834.

Fondation Eugène Piot. Monuments et Mémoires. Paris: Académie des inscriptions et belles-lettres, 1894.

Gallia, Paris. C.N.R.S., 1943. Supplement to *Gallia,* 1946.

Gallia Préhistoire. Paris: C.N.R.S., 1963. Supplement to *Gallia Préhistoire,* 1967.

Gesta. New York: International Center of Medieval Art, The Cloisters, 1964.

Les Monuments historiques de la France. Paris, 1936. Then *Monuments historiques.* Paris, 1977.

Revue archéologique. 1844.

Revue de l'art. Paris, 1968.

Revue du Louvre et des Musées de France. Paris, 1960.

Sauvegarde de l'art français. Paris, 1979.

Settimane di studio del Centro italiano di Studi sull'alto medioevo. Spoleto, 1954.

GENERAL STUDIES

ADHÉMAR, J. *Influences antiques dans l'art du Moyen Âge français.* London: Warburg Institute, 1937.

ADHÉMAR, J., G. DORDOR, A. DUFOUR, et. al. *Les Tombeaux de la collection Gaignières. Dessins d'archéologie du XVIIe siècle.* 3 vols. Paris: P.U.F., 1974–1977.

AGACHE, R. *Détection aérienne de vestiges protohistoriques, gallo-romains et médiévaux dans le bassin de la Somme et ses abords.* Amiens: Société de préhistoire du Nord, 1971.

Artistes, artisans et production artistique au Moyen Âge. Proceedings of the international colloquium at Rennes, 1983. Edited by X. Barral i Altet. Paris: A. et J. Picard, 1986–1989.

AUBERT, M. with the marquise de MAILLÉ. *L'Architecture cistercienne en France.* 2 vols. Paris: Van Oest, 1947.

AUBERT M. and M. BEAULIEU. *Musée du Louvre. Description raisonnée des sculptures du Moyen Âge et de la Renaissance.* Paris: Musées nationaux, 1950.

BABELON, J.-P., editor. *Le Château en France.* Paris: Berger-Levrault, C.N.M.H., nd. [1986].

BARRAL i ALTET, X. *Les Mosaïques de pavement en France et en Italie.* Rome: École française de Rome; Paris: De Boccard, 1987.

BAULIEU, M. and V. BEYER. *Dictionnaire des sculpteurs français du Moyen Âge.* Paris: A. et J. Picard, 1992. Bibliothèque de la Société française d'archéologie.

Bibliographie de l'histoire médiévale en France (1965–1990). Paris: Société des historiens médiévistes de l'enseignement supérieur, publications de la Sorbonne, 1992.

BOUÄRD, M. de. *Manuel d'archéologie médiévale.* Paris: S.E.D.E.S., 1975.

BREDERO, A. *Cluny et Cîteaux au XIIe siècle. L'histoire d'une controverse monastique.* APA–Holland University Press, 1985.

CHATELAIN, A. *Châteaux forts et féodalité en Île-de-France du XIe au XIIIe siècles.* Nonette: Créer, 1983.

CHOISY, A. *Histoire de l'architecture.* 2 vols. Paris, 1899. New ed. Geneva: Slatkine, 1982.

CONANT, K.J. *Carolingian and Romanesque Architecture, 900–1200.* Harmondsworth, Penguin Books, 1959; The Pelican History of Art, 1960.

CONANT, K.J. "The Afterlife of Vitruvius in the Middle Ages." *Journal of the Society of Architectural Historians,* 27, (1968), pp. 33–38.

DEBIDOUR, V.-H. *Le Bestiaire sculpté du Moyen Âge en France.* Paris: Arthaud, 1961.

Dictionnaire des églises de France, Belgique, Luxembourg, Suisse. 5 vols. Paris: Laffont, 1966–1971.

DUBY, G., editor. *Histoire de la France urbaine.* Paris: Seuil, 1980.

DUBY, G., X. BARRAL i ALTET, and S. GUILLOT DE SUDUIROT. *Histoire d'un art, la sculpture. Le Moyen Âge.* Geneva: Skira, 1989. Translated from the French by Michael Hero under the title *Sculpture: the Great Art of the Middle Ages from the Fifth to the Fifteenth Centuries.* New York: Skira–Rizzoli, 1990.

DUBY, G. *L'Europe au Moyen Âge. Art roman. Art gothique.* Paris: A.M.G., 1979; Paris: Flammarion, coll. Champs, 1984.

DUBY, G. *Le Temps des cathédrales, l'art et la société. 960–1420.* Paris: Gallimard, 1976.

DUBY, G. *Les Trois Ordres ou l'imaginaire du féodalisme.* Paris: Gallimard, 1978. Translated from the French by A. Goldhammer under the title *Three Orders: Feudal Society Imagined.* Chicago: University of Chicago Press, 1981.

DUBY, G. and A. WALLON, editors. *Histoire de la France rurale.* 4 vols. Paris: Seuil, 1975–1977.

DUBY, G., editor. *Revelations of the Medieval World.* Translated by Arthur Goldhammer. Cambridge, Mass.: Harvard University Press, Belknap Press, 1988.

DUNLOP, I. *The Cathedral's Crusade: The Rise of the Gothic Style in France.* London: Hamilton, 1982.

ERLANDE-BRANDENBURG, A. *La Cathédrale.* Paris: Fayard, 1991.

ERLANDE-BRANDENBURG, A. *Le roi est mort. Études sur les funérailles, les sépultures et les tombeaux des rois de France jusqu'à la fin du XIIIe siècle.* Bibliothèque de la Société française d'archéologie, 7. Geneva: Droz. Paris: A.M.G., 1975.

FÉVRIER, P.A. *Le Développement urbain en Provence de l'époque romaine à la fin du XIVe siècle.* Bibliothèque des Écoles françaises d'Athènes et de Rome. Paris: De Boccard, 1964.

FINÓ, J.-F. *Forteresses de la France médiévale. Construction, attaque, défense.* Paris: A. et J. Picard. 3rd ed. 1977.

FLEURY, M, A. ERLANDE-BRANDENBURG, and J.-P.BABELON. *Paris monumental.* Paris: Flammarion, 1974.

FOCILLON, H. *Art d'Occident. Le Moyen Âge roman et gothique.* Paris: Armand Colin, 1938. New ed. 1988. Translated from the French by Donald King under the title *The Art of the West.* London: Phaidon Press, 1969.

FOLZ, R. *Le Souvenir et la légende de Charlemagne dans l'Empire germanique médiéval.* Paris: Publications de l'université de Dijon, 1950, pp. 87 ff. New ed. Geneva: Slatkine, 1973.

GABORIT-CHOPIN, D. *La Décoration des manuscrits à Saint-Martial de Limoges et en Limousin du IXe au XIIe siècle.* Paris: Société de l'École des Chartes, Mémoires et Documents–Geneva: Droz, 1974.

GAUTHIER, M.-M. *Émaux du Moyen Âge occidental.* Fribourg: Office du Livre, 1972.

GAUTHIER, M.-M. *Les Routes de la foi. Reliques et reliquaires de Jérusalem à Compostelle.* Fribourg: Office du Livre. Paris: Bibliothèque des Arts, 1983.

GEBELIN, F. *Les Châteaux de France.* Paris: P.U.F., 1962.

GELDERT, E. *A Manual of Church Decoration and Symbolism.* Oxford and London, 1899.

GIMPEL, J. *Les Bâtisseurs de cathédrales.* Paris: Seuil, 1980.

GRABAR, A. *Les Voies de la création en iconographie chrétienne. Antiquité et Moyen Âge.* Paris: Flammarion, coll. Idées et Recherches, 1979.

GRODECKI, L. *Le Moyen Âge retrouvé, I, De l'an mil à l'an 1200.* Paris: Flammarion, 1986. *Le Moyen Âge retrouvé, II, De Saint Louis à Viollet-le-Duc.* Paris: Flammarion, 1990.

GRODECKI, L. *Le Vitrail français.* Paris: Éditions des Deux Mondes, 1958.

HAMEL, C. de. *A History of Illuminated Manuscripts.* Oxford: Phaidon Press, 1986.

HARVEY, J. *The Medieval Architect.* London: Wayland, 1972.

HEDEMAN, A.D. *The Royal Image: Illustration of the Grandes Chroniques de France, 1274–1422.* Berkeley: University of California Press, 1991.

HUBERT, J. *Arts et vie sociale de la fin du monde antique au Moyen Âge.* Geneva: Droz, 1977.

HUBERT, J. *Nouveau recueil d'études d'archéologie et d'histoire sur la fin du monde antique et le Moyen Âge.* Geneva: Droz, 1985.

JANSON, H.W. *Apes and Apelore in the Middle Ages and the Renaissance.* London: The Warburg Institute, 1952.

La Céramique médiévale en Méditerranée occidentale, Xe–XVe siècles. Proceedings of the international colloquium of the C.N.R.S., Valbonne, 1980.

LANGLOIS, C.-V. *La Connaissance de la nature et du monde au Moyen Âge.* Paris: Hachette, 1911.

LE BRAS, G., editor. *Les Ordres religieux. La vie et l'art.* 2 vols. Paris: Flammarion, 1979–1980.

LELONG, C. *La Basilique Saint-Martin de Tours.* Chambray-lès-Tours: CLD, 1986.

LE GOFF, J., "Ordres mendiants et urbanisation dans la France médiévale." *Annales E.S.C.,* 1970, pp. 939 ff.

LE GOFF, J. *La Civilisation de l'Occident médiéval.* Paris: Arthaud, 1964. New ed. 1972.

LE GOFF, J. *Les Intellectuels au Moyen Âge.* Paris: Seuil, 1957. 2nd ed. 1985.

Les Manuscrits à peintures en France du VIIe au XIIe siècle. Exhibition catalogue. by J. Porcher. Bibliothèque Nationale, Paris, 1954.

Les Manuscrits à peintures en France du XIIIe au XVIe siècle. Exhibition catalogue by J. Porcher. Bibliothèque Nationale, Paris, 1955.

MÂLE, É., *L'Art religieux de la fin du Moyen Âge en France.* Paris: Armand Colin, 1908. 5th ed. 1949. Translated from the French and published under the title *Religious Art in France, the late Middle Ages.* Princeton: Princeton University Press, 1986.

MÂLE, É., *L'Art religieux du XIIe siècle en France.* Paris: Armand Colin, 1922. 7th ed. 1966. Translated from the French by Marthiel Mathews and published under the title *Religious Art in France, the Twelfth Century.* Princeton: Princeton University Press, 1978.

MÂLE, É., *L'art religieux du XIIIe siècle en France.* Paris: Armand Colin, 1988. Rev. ed. by G. Chazal, 1986. Translated from the 3rd edition by Dora Nussey under the title *The Gothic Image: Religious Art in France of the Thirteenh Century.* London: Collins, 1961. New ed. *Religious Art in France, the Thirteenth Century.* Princeton: Princeton University Press, 1984.

MESURET, R. *Les Peintures du Sud-Ouest de la France du XIe au XVIe siècle.* Paris: A. et J. Picard, 1967.

Mines, carrières et métallurgie de la France médiévale. Proceedings of a colloquium, 1980. Edited by P. Benoit, and P. Braunstein. Paris: C.N.R.S., 1984.

MONTESQUIOU-FEZENSAC, B. and D. GABORIT-CHOPIN. *Le Trésor de Saint-Denis.* 3 vols. Paris: A. et J. Picard, 1973–1977.

MUSSAT, A. "Les cathédrales dans leurs cités." *Revue de l'art,* 55 (1982), pp. 9–22.

NATANSON, J. *Gothic Ivories of the Thirteenth and Fourteenth Centuries.* London, 1951.

PANOFSKY, E. and F. SAXL. *Classical Mythology in Medieval Art.* New York: Metropolitan Museum Studies, 1933.

PANOFSKY, E. *Tomb Sculpture.* New York: Harry N. Abrams, 1964. New ed. 1992.

PASTOUREAU, M. *Figures et couleurs, études sur la symbolique et la sensibilité médiévales.* Paris: Le Léopard d'or, 1986.

PASTOUREAU, M. *Les Armoiries.* Turhout: Brepols, 1976.

PASTOUREAU, M. *Traité d'héraldique.* Paris: A. et J. Picard, 1979. 2nd ed. 1993.

PÄTCHT, O. *Book Illumination in the Middle Ages.* London and Oxford: Oxford University Press, 1986.

PEVSNER, N. "The Term 'Architect' in the Middle Ages." *Speculum,* 17 (1942), pp. 549 ff.

PLANHOL, X. de. *Géographie historique de la France.* Paris: Fayard, 1988.

PORCHER, J. *L'Enluminure française.* Paris: A.M.G., 1959.

RUDOLPH, C. *Artistic Change at Saint-Denis: Abbot Suger's Program and the Early Twelfth-century Controversy over Art.* Princeton: Princeton University Press, 1990.

RUDOLPH, C. *The 'things of greater importance,' Bernard of Clairvaux's Apologia and the Medieval Attitude toward Art.* London, 1990.

RÉAU, L. *Histoire du vandalisme. Les monuments détruits de l'art français.* 2 vols. Paris: Hachette, 1959.

ROWER, D.D. "The Secular Inspiration of the 'Chanson de Roland.'" *Speculum,* 37, 1962.

Saint Bernard et le monde cistercien. Exhibition catalogue, edited by L. Pressouyre and T.N. Kinder. Conciergerie, Paris, 1990–1991. Paris: C.N.M.H.S., 1990.

SHELBY, L.R. "The Geometrical Knowledge of Mediaeval Master Masons." *Speculum,* 47 (1972), 4, pp. 395–421.

SOUTHERN, R.W. *Art and the Church in the West.* Harmondsworth: Penguin Books, 1970.

SOUTHERN, R.W. *Medieval Humanism and Other Studies.* Oxford: Blackwell, 1970.

TARALON, J., editor. *Jumièges, Congrès scientifique du XIIIe centenaire.* Rouen, 1955.

Trésors des abbayes normandes. Exhibition catalogue. Rouen, 1979.

Trésors des églises de France. Exhibition catalogue by J. Taralon. Paris: Musée des Arts décoratifs–C.N.M.H., 1965.

VERDIER, P. *Le Couronnement de la Vierge. Les origines et les premiers développements d'un thème iconographique.* Montreal: Institut d'études médiévales. Paris: Vrin, 1980.

VIEILLARD-TROIEKOUROFF. "La cathédrale de Clermont-Ferrand du Ve au XIIe siècle." *Cahiers archéologiques,* XI, 1960, pp. 199–247.

VIOLLET-LE-DUC, E. *Dictionnaire raisonné de l'architecture française du XIe au XVIe siècle.* 10 vols. Paris: Danse, 1858–1868.

Vitraux de France. Exhibition catalogue by L.Grodecki. Musée des Arts décoratifs, Paris, 1953.

WEBSTER, J.C. *The Labors of the Months in Antique and Medieval Art to the End of the Twelfth Century.* Princeton: Princeton University Press, 1938.

WOODCOCK, T. and J.M. ROBINSON. *Oxford Guide to Heraldry.* London and Oxford: Oxford University Press, 1990.

ZARNECKI, G. *Art of the Medieval World: Architecture, Sculpture, Painting, the Sacred Arts.* New York, 1975.

ORIGINS

PREHISTORY

Archéologie de la France. Exhibition catalogue. Grand Palais, Paris. Paris: Réunion des Musées Nationaux, 1989.

BARRIÈRE, C. *L'Art pariétal de Rouffignac.* Paris: A. et J. Picard, 1982.

BREUIL, H. (abbé). *400 siècles d'art pariétal.* Paris: F. Windels, 1952. New ed. 1974.

BREUIL, H. (abbé) and R. LANTIER. *Les Hommes de la pierre ancienne.* Paris: Payot, 1959. New ed. 1979.

CÉARD, J. "La querelle des géants et la jeunesse du monde." *The Journal of Medieval and Renaissance Studies,* VIII, I (1879).

CHILDE, G. *Man Makes Himself.* London: Watts, 1936.

DÉCHELETTE, J. *Manuel d'archéologie préhistorique, celtique et gallo-romaine.* 4 vols. Paris: A. et J. Picard, 1908–1914. New ed. 1987–1989.

DEYTS, S. "Les bois sculptés des sources de la Seine." Supplement to *Gallia,* 42, 1983.

JACOBSTHAL, P. *Early Celtic Art.* Oxford, 1944. New ed. 1969.

JOFFROY, R. and A. THÉNOT. *Initiation à l'Archéologie de la France.* Vol. 1, *Préhistoire et protohistoire.* Paris: Tallandier, coll. Approches, 1983. New ed. 1990.

LANTIER, R. and F. BRAUDEL. *Les Hommes de la pierre ancienne.* Paris: Payot, 1953.

LARTET, É. and H. CHRISTY. "Sur des figures d'animaux gravées ou sculptées et autres produits d'art et d'industrie rapportables aux temps primordiaux de la période humaine." *Revue archéologique,* 1884.

LEROI-GOURHAN, A. and M. BRÉZILLON. *Fouilles de Pincevent: essai d'analyse ethnographique d'un habitat magdalénien.* Paris: C.N.R.S., 1972.

LEROI-GOURHAN, A. *Préhistoire de l'art occidental.* Paris: Mazenod, 1965. New ed. 1975. Translated from the French by Norbert Guterman under the title *The Art of Prehistoric Man in Western Europe.* London: Thames and Hudson, 1968.

MEGAW, R. and V. *Celtic Art: from its Beginnings to the Book of Kells.* London: Thames and Hudson, 1989.

MOHEN, J.-P. *Le Monde des mégalithes.* Paris: Casterman, 1989.

MOHEN, J.-P. *Métallurgie préhistorique. Introduction à la paléométallurgie.* Paris: Masson, 1990.

MOHEN, J.-P. *Musée des antiquités nationales, Saint-Germain-en-Laye.* Paris: Réunion des Musées Nationaux, 1989.

SANDARS, N.K. *Prehistotic Art in Europe.* Harmondsworth: Penguin Books, The Pelican History of Art, 1968.

SCHNAPPER, A. "Persistance des géants." *Annales E.S.C.,* 1986, 1, pp. 177–200.

AGACHE, R. "La Somme pré-romaine et romaine." *Mémoires de la Société des antiquaires de Picardie*, XXIV, Amiens, 1978.

À l'aube de la France, la Gaule de Constantin à Childéric. Exhibition catalogue. Musée du Luxembourg, Paris, 1981.

BABELON, E. "Le tombeau du roi Childéric et les origines de l'orfèvrerie cloisonnée." *Mémoires de la Société nationale des antiquaires de France*, 76 (1924).

BECK, F. and F. BARRATE, editors. *Orfèvrerie galloromaine. Le Trésor de Rethel.* Paris: A. et J. Picard, 1988.

BENOIT, F. "Sarcophages paléochrétiens d'Arles et de Marseille." Supplement to *Gallia,* V, 1954.

BOUBE, J. "Les sarcophages paléochrétiens de Martres-Tolosanne." *Cahiers archéologiques*, IX (1957), pp. 33–72.

BOUCHER, S. *Recherches sur les bronzes figurés de Gaule pré-romaine et romaine.* Paris: De Boccard, Bibliothèque des Écoles françaises d'Athènes et de Rome, 1976.

BOUCHER, S. *Vienne, musée d'Archéologie et de Peinture Les bronzes antiques,* Paris: Réunion des Musées Nationaux, Inventaire des collections publiques françaises, 17, 1972.

BOUTEMY, A. "Un grand enlumineur du Xᵉ siècle, l'abbé Odbert de Saint-Bertin." *Annales de la Fédération archéologique et historique de la Belgique*, 32nd session, 1947, pp. 247 ff.

BRUNAUX, J.-L. *The Celtic Gauls: Gods, Rites, and Sanctuaries.* London: Seaby Ltd., 1988.

Childéric–Clovis, rois des Francs, De Tournai à Paris, naissance d'une Nation. Exhibition catalogue. Tournai, 1983.

COSTA, D. *Nantes, musée Th. Dobrée, art mérovingien;* Paris: Réunion des Musées Nationaux, Inventaire des collections publiques françaises, 10, 1964.

DÉCHELETTE, J. *Les Vases céramiques ornés de la Gaule romaine.* Paris: A. et J. Picard, 1904.

DELEHAYE, E. *Sanctus. Essai sur le culte des saints dans l'Antiquité.* Brussels: Société des Bollandistes, coll. Subsidia hagiographica, 1927. New ed. 1979.

De l'art des Gaules à l'art français. Exhibition catalogue. Preface by M. Labrousse, catalogue text by P. Mesplé. Musée des Augustins, Toulouse, 1956.

DEYTS, S. *Dijon, Musée archéologique; sculptures gallo-romaine, mythologiques et religieuses.* Paris: Réunion des Musées Nationaux, Inventaire des collections publiques françaises, 20, 1976.

DUBY, G. *Adolescence de la chrétienté occidentale, 980–1140.* Geneva: Skira, coll. Art, Idées, Histoire, 1968.

DURLIAT, M. *Des Barbares à l'An Mil.* Paris: Citadelles-Mazenod, coll. L'art et les grandes civilisations, 1985.

DUVAL, P.-M. "L'originalité de l'architecture gallo-romaine." *VIIIᵉ Congrès international d'archéologie classique.* Paris: De Boccard, 1965. Also published in *Travaux sur la Gaule*, 1989.

DUVAL, P.-M. *La Vie quotidienne en Gaule pendant la paix romaine.* Paris: Hachette, 1953. New ed. 1976.

DUVAL, P.-M. *Paris antique, des origines au IIIᵉ siècle.* Paris: Hermann, 1961.

DUVAL, P.-M. *Travaux sur la Gaule (1946–1986).* Paris: De Boccard, coll. École française de Rome, 1989.

EYGUN, F. "Le baptistère Saint-Jean de Poitiers" *Gallia*, 22 (1964), pp. 137–171.

FLEURY, M., FRANCE-LANORD A. "Les bijoux mérovingiens d'Arnégonde." *Art de France*, I (1961), pp. 7–17.

FOCILLON, H. *L'An Mil.* Paris: Armand Colin, coll. Henri Focillon, II, 1952 (published posthumously).

FOSSARD, D. "Décors mérovingiens des sarcophages de plâtre." *Art de France*, III (1963).

GABORIT-CHOPIN, D. "L'orfèvrerie cloisonnée à l'époque carolingienne." *Cahiers archéologiques*, XXIV (1980–1981), pp. 5–26.

Gallo-Romains en Île-de-France. Exhibition catalogue. Sceaux: Association des conservateurs des musées d'Île-de-France, 1984.

GAUTHIER, N. and J.-C. PICARD, editors. *Topographie chrétienne des cités de la Gaule.* 8 vols. published to date. Paris: De Boccard, 1986–1992.

GEARY, P.J. *Before France and Germany: The Creation and Transformation of the Merovingian World.* Oxford and London: Oxford University Press, 1988.

GRABAR, A. *Martyrium. Recherches sur le culte des reliques et l'art chrétien antique.* Paris: Maisonneuve, 1946.

GRABAR, A. and C. NORDENFALK. "Les mosaïques de Germigny-des-Prés." *Cahiers archéologiques*, VII (1954), pp. 171–184.

GRABAR, A. and C. NORDENFALK. *Les Grands Siècles de la peinture. Le haut Moyen Âge.* Geneva: Skira, 1957.

GRENIER, A. *Manuel d'archéologie gallo-romaine.* 6 vols. Paris: A. et J. Picard, 1934–1960. New ed. 1985.

HEITZ, C. *L'Architecture religieuse carolingienne. Les formes et leurs fonctions.* Paris: A. et J. Picard, 1980. New edition in preparation.

HEITZ, C. *La France pré-romane.* Paris: Errance, 1987.

HUBERT, J. and M.-C. HUBERT. "Piété chrétienne ou paganisme: les statues-reliquaires de l'Europe carolingienne" *Settimane di studio . . . sull'alto medioevo*, 28, Spoleto, 1980, pp. 235– 268.

HUBERT, J. *L'Architecture religieuse du haut Moyen Âge en France. Plans, notices et bibliographie.* Paris: Bibliothèque nationale (Bibliothèque de l'École pratique des Hautes Études), 1952.

HUBERT, J. *L'Art préroman.* Paris: Van Oest, 1938. New ed. Nogent-le-Roi: Arts et Métiers, 1974.

HUBERT, J., J. PORCHER, and W.F. VOLBACH. *L'Europe des invasions.* Paris: Gallimard, coll. Univers des formes, 1967.

JOFFROY, R. and A. THENOT. *Initiation à l'archéologie de la France, II, Gallo-Romain et Mérovingien.* Paris: Tallandier, coll. Approches, 1983. New ed. 1990.

JOFFROY, R. *Vix et ses trésors.* Paris: Tallandier, 1979.

JOUVEN, G. "Fouilles des cryptes de l'abbatiale de Saint-Pierre de Flavigny." *Monuments historiques de la France*, 1960, pp. 9–28.

LANTIER, R. *Les Origines de l'art français.* Paris: Le Prat, 1947.

LE GOFF, J., "Les paysans et le monde rural dans la littérature du haut Moyen Âge (Vᵉ–VIᵉ siècles)" *Settimane di studio del Centro italiano di Studi sull'alto medioevo*, XIII, "L'agricoltura e il mondo rurale nell'alto medioevo." Spoleto, 1966, pp. 723–741. Republished in *Pour un autre Moyen Âge.* Paris: Gallimard, coll. Tel, 1977.

LEBOUTEUX, P. "L'église Saint-Philibert-de-Grandlieu." *Bulletin archéologique des Travaux historiques et scientifiques*, vols. I–II (1966–1967), pp. 49–107.

LESTOCQUOY, J. "De l'unité à la pluralité: le paysage urbain en Gaule du Vᵉ au IXᵉ siècle." *Annales E.S.C.*, VIII (1953), pp. 159–172.

LOUIS, R. *Les Églises d'Auxerre, des origines au XIᵉ siècle.* Paris: Clavreuil, 1952.

LOUIS, R. and H. MOREAU. "Les cryptes de Saint-Germain d'Auxerre. État de la question." *Bulletin de la Société des fouilles archéologiques et des monuments historiques de l'Yonne*, 3 (1986), pp. 25–32.

Lutèce Paris, de César à Clovis. Exhibition catalogue. Musée Carnavalet and Musée National des Thermes et de l'Hôtel de Cluny, Paris, 1984–1985.

MAILLÉ, marquise de. *Les Cryptes de Jouarre.* Paris: A. et J. Picard, 1971.

MÂLE, É. *La Fin du paganisme en Gaule et les plus anciennes basiliques chrétiennes.* Paris: Flammarion, 1950.

MCKITTERICK, R., editor. *Carolingian Culture, Emulation, and Innovation.* Cambridge: Cambridge University Press, 1994.

Millénaire monastique du Mont-Saint-Michel. Commemorative publication. Paris: Lethielleux, 1967.

MONTESQUIOU-FEZENSAC, B. de. "Ivoires narratifs de l'époque carolingienne." *Mémoires de la Société nationale des antiquaires de France*, 150th anniversary issue (1804–1954), Paris, 1955.

MORIN-JEAN. *La Verrerie en Gaule sous l'Empire romain.* Paris: Renouard-Laurens, Société de propagation des livres d'art, 1922–1923. New ed. L. Laget, 1977.

MÜTHERICH, F. "Die Buchmalerei am Hofe Karls des Grossen." *Karl der Grosse*, III, Düsseldorf: L. Schwann, 1965.

Le Nord de la France de Théodose à Charles Martel. Trésors des musées du nord de la France. Exhibition catalogue. Lille: Éditions de l'Association des conservateurs de la région Nord-Pas-de-Calais, 1983.

Paris mérovingien. Exhibition catalogue: Musée Carnavalet, Paris, 1981–1982.

PÉRIN, P., L. RENOU, and P. VELAY. *Collections mérovingiennes et du haut Moyen Âge du musée Carnavalet.* Musée Carnavalet, Paris, 1985.

PRINZ, Fr. *Frühes Mönchtum im Frankenreich (IV.VIII Jh.).* Munich, 1965. New ed. Darmstadt: Wissenschaftliche Buchgesellschaft, 1988.

REYNAUD, J.-F. et. al. "Les édifices funéraires et les nécropoles dans les Alpes et la vallée du Rhône. Origines et premiers développements." *Actes*

du XI^e *Congrès international d'archéologie chré-*
tienne, Lyon, Vienne, Grenoble, Genève et
Aoste, 1986. Paris: De Boccard, coll. École
française de Rome, 1989, vol. 3, pp. 1475–1514.

REYNAUD J.-F. Lyon *(Rhône) aux premiers temps*
chrétiens: basiliques et nécropoles. Paris:
Imprimerie nationale, coll. Guides archéologi-
ques de la France, 1986.

RICHÉ, P. *Gerbert d'Aurillac. le pape de l'An Mil:*
Paris: Fayard, 1982. New ed. 1987.

ROUVIER-JEANLIN, M. *Les Figurines gallo-romaines*
en terre cuite au musée des Antiquités nationales.
Paris: C.N.R.S., 1972.

SALIN, E. *La Civilisation mérovingienne d'après les*
sépultures, les textes et le laboratoire. 4 vols. Paris:
A. et J. Picard, 1949–1969. New ed. 1973–1988.

SAUVEL, T. "Les miracles de saint Martin:
recherches sur les peintures murales de Tours
aux V^e et VI^e siècles." *Bulletin monumental,*
CXIV (1956), pp. 153–179.

TARALON, J. "La Majesté d'or du trésor de Sainte-
Foy de Conques" *Revue de l'art,* 40/41 (1977–
1978).

THÉVENOT, E. *Divinités et sanctuaires de la Gaule.*
Paris: Fayard, 1968.

Trésors des princes celtes. Exhibition catalogue:
Grand Palais, Paris. Paris: Réunion des Musées
Nationaux, 1987.

VARAGNAC, A. *L'Art gaulois.* La-Pierre-qui-Vire:
Zodiaque, 1956. 2nd ed. 1964.

VIEILLARD-TROÏEKOUROFF, M., D. FOSSARD, E. CHA-
TEL, and C. LAMY-LASSALLE. "Les plus anciennes
églises suburbaines de Paris (IV^e–X^e siècles)."
*Mémoires de la Société de l'histoire de Paris et de
l'Île-de-France,* 11, (1960), pp. 18–282.

VIEILLARD-TROIEKOUROFF, M. *Les Monuments*
religieux d'après les œuvres de Grégoire de
Tours. Paris: Champion, 1976.

ROMANESQUE ART

ALEXANDER, J.J.G. *Norman Illumination at Mont*
St Michel, 966–1100. Oxford: Clarendon Press,
1970.

L'Art roman à Saint-Martial de Limoges. Les Man-
uscrits à peinture. Historique de l'abbaye—La
basilique. Exhibition catalogue. Musée munici-
pal, Limoges, 1950.

AUBERT, M. *L'Église de Conques.* Paris: Laurens,
1954.

AVRIL, F., X. BARRAL I ALTET, and D. GABORIT-
CHOPIN. *Les Royaumes d'Occident.* Paris: Galli-
mard, coll. Univers des formes, 1982.

AVRIL, F., X. BARRAL I ALTET, and D. GABORIT-
CHOPIN. *Le Temps des croisades,* Paris, Galli-
mard, coll. Univers des Formes, 1982.

BALTRUSAITIS, J. *La Stylistique ornementale dans la*
sculpture romane. Paris: Leroux, 1931. Revised
and enlarged edition *Formations, déformations,*
la stylistique ornementale dans la sculpture
romane. Paris: Flammarion, 1986.

BARRAL I ALTET, X. "Les débuts de la mosaïque de
pavement romane dans le sud de la France et en
Catalogne." *Cahiers de Saint-Michel-de-Cuxa,*
III, 1972, pp. 117–131.

BARRAL I ALTET, X., editor. *Le paysage de la France*
autour de l'an mil. Paris: A. et J. Picard, 1987.

BAYLÉ, M. *La Trinité de Caen. Sa place dans l'his-*
toire de l'architecture et du décor roman.
Geneva: Bibliothèque de la Société française
d'archéologie. Paris: Droz-Paris, A.M.G., 1979.

BAYLÉ, M., *Les Origines et les premiers développe-*
ments de la sculpture romane en Normandie. Caen,
1992 (Art de Basse-Normandie, no. 100 bis).

BEAULIEU, M. and V. BEYER. *Dictionnaire des sculp-*
teurs du Moyen-Âge. Paris: A. et J. Picard, 1992.

BONY, J. "La technique normande du mur épais."
Bulletin monumental, LXXXXVII (1939),
pp. 153–188.

BORG, A. *Architectural Sculpture in Romanesque*
Provence. Oxford: Clarendon Press, 1972.

BOUÄRD, M. de. "La motte féodale." *Archéologie*
du village médiéval. Colloquium proceedings.
Louvain: Centre belge d'histoire rurale, 1967.

BOUSQUET, J. "Le rôle des cisterciens dans la déca-
dence romane. Exemples et réflexions." *Les*
Cahiers de Saint-Michel de Cuxa, July 1984.

CABANOT, J. "Le décor sculpté de la basilique de
Saint-Sernin de Toulouse." *Bulletin monumen-*
tal, (1974), pp. 99–145.

CABANOT, J. *Les Débuts de la sculpture romane*
dans le sud-ouest de la France. Paris: A. et J. Pi-
card, 1987.

CAHN, W. "Le tympan de Neuilly-en-Donjon.
Cahiers de civilisation médiévale, 1965, pp. 351–
364.

CAHN, W. *Romanesque Bible Illumination,* Ithaca,
New York: Cornell University Press, 1982.

CAHN, W. *Romanesque Wooden Doors of Au-*
vergne. New York: New York University Press,
1974.

CAMUS, M.-T. À propos de trois découvertes
récentes. Images de l'Apocalypse à Saint-
Hilaire-le-Grand de Poitiers." *Cahiers de civili-*
sation médiévale, 2, 1989, pp. 125–134.

CAMUS, M.-T. *La Sculpture romane du Poitou. Les*
grands chantiers du XI^e siècle. Paris: A. et J. Pi-
card, 1992.

CHÂTELAIN, A. "Les châteaux forts de l'an mil à
onze cent cinquante." *Le Château en France,*
Paris: Berger-Levrault-C.N.M.H.S., 1986.

CHENU, M.-D. *La Théologie au XII^e siècle.* Paris:
Vrin, 1955. 3rd ed. 1976.

CONANT, K.J. *Cluny, les églises et la maison du chef*
d'ordre. Mâcon: Protat, 1968.

CROZET, R. *L'Art roman en Berry.* Paris: H. Lau-
rens, 1932.

CROZET, R. *L'Art roman en Poitou.* Paris: H. Lau-
rens, 1948.

CROZET, R. *L'Art roman en Saintonge.* Paris: A. et
J. Picard, 1971.

DEMUS, O., HIRMER M. *La Peinture murale*
romane. Paris: Flammarion, 1976.

DESCHAMPS, P. "Notes sur la sculpture romane
en Languedoc et dans le nord de l'Espagne."
Bulletin monumental, CLXXXI (1923),
pp. 305– 351.

DESCHAMPS, P. and M. THIBOUT. *La Peinture*
murale en France. Le haut Moyen Âge et
l'époque romane. Paris: Ars et Historia, 1951.

DESHOULIERES. *Éléments datés de l'art roman en*
France. Paris: Éditions d'art et d'histoire, 1936.

DEYRES, M. "Le donjon de Langeais." *Bulletin*
monumental, CXXVIII (1970), pp. 179–193.

DIEMER, P. "What does Prudentia Advise? On the
Subject of the Cluny Choir Capitals." *Gesta,*
XXVII/1–2 (1988), pp. 149–173.

DURLIAT, M. "L'architecture du XI^e siècle à Saint-
Michel de Cuxa." *Études d'art médiéval offertes*
à Louis Grodecki. Paris: Ophrys, 1981, pp. 49-57.

DURLIAT, M. "La Catalogne et le 'premier art
roman'." *Bulletin monumental,* CXXXXVII
(1989), pp. 209–238.

DURLIAT, M. "La cathédrale du Puy." *Congrès*
archéologique de France, Vézelay, 1975,
pp. 55– 163.

DURLIAT, M. *L'Art roman.* Paris: Citadelles-
Mazenod, 1982.

DURLIAT, M. *La Sculpture romane de la route de*
Saint-Jacques: de Conques à Compostelle. Mont-
de-Marsan: C.E.H.A.G., 1990.

DURLIAT, M. *La Sculpture romane en Roussillon.*
5 vols. Perpignan: La Tramontane, 1948–1954.

ECKSTEIN, H. *Die romanische Architektur. Der Stil*
und seine Formen. Cologne: DuMont Schau-
berg, 1975.

FOCILLON, H. *L'Art des sculpteurs romans.* Paris:
E. Leroux, 1931. New ed. Paris: P.U.F., 1964.

FORSYTH, I.H. *The Throne of Wisdom: Wood*
Sculptures of the Madonna in Romanesque
France. Princeton: Princeton University Press,
1972.

La France romane (par régions). Coll. La Nuit des
temps. La Pierre-qui-Vire: Zodiaque, 40 vols.

GAILLARD, G. *Études d'art roman.* Paris: P.U.F.,
1972.

GAUTHIER, M.-M. *Catalogue international de*
l'œuvre de Limoges. I, Époque romane. Paris:
C.N.R.S., 1987.

GRABAR, A. and C. NORDENFALK. *La Peinture*
romane du onzième au treizième siècle. Geneva:
Skira, 1958.

GRIVOT, D. and G. ZARNECKI. *Gislebertus, sculp-*
teur d'Autun. Clairvaux-les-Lacs: Trianon, 1960.

GRODECKI, L. "Les débuts de la sculpture romane
en Normandie." *Bulletin monumental,* CVIII
(1950), pp. 7–67.

GRODECKI, L. *Au seuil de l'art roman. L'architec-*
ture ottonienne. Paris: Armand Colin, 1958.

GRODECKI, L. *Le Vitrail roman.* Fribourg: Office
du Livre, 1977. New ed. 1983.

GRODECKI, L., F. MÜTTERICH, J. TARALON, and
F. WORMALD. *Le siècle de l'an mil.* Paris: Galli-
mard, coll. Univers des Formes, 1973.

HAMMANN, R. *Die Abteikirche von Saint-Gilles*
und ihre künstlerische Nachfolge. Berlin:
Akademie Verlag, 1955.

HÉLIOT, P. "Les dates de constructions de
Bernay, Cerisy-la-Forêt et Lessay." *Bulletin de*
la Société des antiquaires de France, 1959, II,
pp. 188–204.

HÉLIOT, P. "Les portails polylobés de l'Aquitaine
et des régions limitrophes." *Bulletin monumen-*
tal, 1946, pp. 63–89.

HENRIET, J. "Saint-Philibert de Tournus. Critique
d'authenticité. Étude archéologique du
chevet (1009–1019)." *Bulletin monumental,*
CXXXXVIII (1990), pp. 229–316.

HENRIET, J. "Saint-Philibert de Tournus. L'œuvre
du second maître: le galilée et la nef." *Bulletin*
monumental, CL (1992), pp. 101–164.

HUYGENS, R.B.C. "Le moine Idung et ses deux ouvrages: 'Argumentum super quatuor questionibus' et 'Dialogus duorum monachorum.'" *Studi medievali*, XIII (1972), p. 291.

KATZENELLENBOGEN, A. *The Sculptural Programs of Chartres Cathedral: Christ, Mary, Ecclesia.* Baltimore: Johns Hopkins University Press, 1959.

KAUTZCH, R. *Der romanische Kirchenbau im Elsass.* Fribourg-en-Brisgau: Urban Verlag, 1944.

KOEHLER, W. "Byzantine Art in the West." *Dumbarton Oaks Papers*, I (1941), pp. 61–87.

KUBACH, H.E. *L'Architecture romane.* Paris: Gallimard-Electa, 1992.

KUPSER, M. *The Politics of Narrative Romanesque Wall Painting in Central France.* New Haven and London: Yale University Press, 1933.

LADNER, G.B. *The Idea of Reform.* Cambridge, 1959.

LAMBERT, E. "La cathédrale de Saint-Jacques de Compostelle et l'école des grandes églises romanes des routes de pèlerinage." *Le Pèlerinage de Compostelle.* Toulouse: Privat, 1959, chap. VII, pp. 157 ff.

LASSALLE, V. "L'influence antique dans l'art roman provençal." *Revue archéologique Narbonnaise*, suppl. 2. Paris: De Boccard, 1983.

LASTEYRIE, R. de. *L'Architecture religieuse en France à l'époque romane.* Paris: A. et J. Picard, 1911. 2nd edition revised by M. Aubert, 1929.

LEFÈVRE-PONTALIS, E. "Répertoire des architectes, maçons, sculpteurs, charpentiers et ouvriers français aux XIe et XIIe siècles." *Bulletin monumental*, LIXC (1911), pp. 423–468.

LESUEUR, F. "Saint-Martin de Tours et les origines de l'art roman." *Bulletin monumental*, CVII (1949), pp. 7–84.

Les Siècles romans en Basse-Normandie. Exhibition catalogue. Inspection des musées contrôlés du Calvados, 1984–1986 (1985).

LYMAN, W. *French Romanesque Sculpture: An Annotated Bibliography.* Boston: GK Hall & Co., 1987.

MALLET, J. *L'Art roman de l'ancien Anjou.* Paris: A. et J. Picard, 1985.

MESPLÉ, P. *Toulouse, musée des Augustins, Sculptures romanes.* Paris: Réunion des Musées Nationaux, Inventaire des collections publiques françaises, 1960.

MESQUI, J. and N. FAUCHERRE. "Le château de Châtillon-Coligny." *Bulletin monumental*, CXXXXVI (1988), 2, pp. 73 ff.

NORDENFALK, C. "Miniature ottonienne et ateliers capétiens." *Art de France*, vol. IV (1963), pp. 44 ff.

NORDSTRÖM, C.O. "Text and Myth in some Beatus miniatures." *Cahiers archéologiques*, XXV (1976), pp. 19–20.

PORTER, A. K., *Romanesque Sculpture of Pilgrimage Roads.* 10 vols. Boston: Marshall Jones, 1923.

Pressouyre, L. "Lecture d'une inscription du XIIe siècle à Saint-Antonin-Noble-Val (Tarn-et-Garonne)." *Bulletin de la Société nationale des antiquaires de France*, 1986, pp. 256 ff.

RILEY-SMITH J. *The First Crusade and the Idea of Crusading.* London: The Athlone Press, 1985.

SALET, F. "Cluny III." *Bulletin monumental*, CXXVI (1968), pp. 285 ff.

SAULNIER, L. and N. STRATFORD. *La Sculpture oubliée de Vézelay.* Bibliothèque de la Société française d'archéologie. Geneva: Droz. Paris: A.M.G., 1984.

SAUVEL, T. "Les manuscrits limousins. Essai sur les liens qui les unissent à la sculpture monumentale, aux émaux et aux vitraux." *Bulletin monumental*, CVIII (1950), pp. 117 ff.

SCHAEFER, H. "The Origins of the two Towers Façade in Romanesque Architecture." *Art Bulletin*, XXVII (1945), pp. 85–108.

SCHLINK, W. *Saint-Bénigne in Dijon. Untersuchungen zur Abteikirche Wilhelms von Volpiano (962–1031).* Berlin: Gebr. Mann, 1978.

SCHAPIRO, M. "On the Aesthetic Attitude in Romanesque Art." *Art and Thought,* 1947. Reprinted in *Romanesque Art.* New York: Braziller, 1977, pp. 1 sq.

SCHAPIRO, M. "The Sculpture of Moissac." *The Art Bulletin*, 1931, pp. 248–251. New ed. London: Thames and Hudson, 1985.

SOLMS, E. de. *Bestiaire roman.* La Pierre-qui-Vire: Zodiaque, 1977.

STODDARD, W.S. *The Façade of Saint-Gilles-du-Gard: Its Influence on French Sculpture.* Middletown, Conn., 1973.

STRATFORD, N "Le portail roman de Neuilly-en-Donjon." *Congrès archéologique de France. Bourbonnais*, 1988, pp. 311–338.

SWARZENSKI, H. *Monuments of Romanesque Art.* London: Faber and Faber, 1954.

SWIECHOVSKI, Z. *Sculpture romane d'Auvergne.* Clermond-Ferrand: Éditions de Bussac, 1973.

TARALON, J. and H. TOUBERT. "Les fresques romanes de Vendôme." *Revue de l'art*, 53 (1981), pp. 9 ff.

THIRION, J. "Ganagobie et ses mosaïques." *Revue de l'art*, 49 (1980), pp. 50–69.

VALLERY-RADOT, J. "Notes sur les chapelles hautes dédiées à saint Michel." *Bulletin monumental*, CLXXXVII (1929), pp. 453–478.

VALLERY-RADOT, J. *Églises romanes. Filiations et échanges d'influence.* Brionne: Montfort, 1979.

VANUXEM, J. "The Theories of Mabillon and Montfaucon on French Sculpture of the Twelfth Century." *Journal of the Warburg and Courtauld Institutes*, XX (1957), pp. 45–58.

VERGNOLLE, E. "Fortune et infortunes du chapiteau corinthien dans le monde roman." *Revue de l'art*, 90 (1990–1991), pp. 21–34.

VERGNOLLE, E. "Un carnet de modèles de l'an mil originaire de Saint-Benoît-sur-Loire (Paris Bibl. Nat., Paris and Vatican Library, Rome)," *Arte medievale*, 2, 1984, pp. 23 ff.

VERGNOLLE, E. *Saint-Benoît-sur-Loire et la sculpture du XIe siècle.* Paris: A. et J. Picard, 1985.

WADDELL, C. "The Reform of the Liturgy." *Renaissance and Renewal in the Twelfth Century.* R.L. Benson and G. Constable, editors. Oxford and London: Oxford University Press, 1982.

WETTSTEIN, J. *La Fresque romane. Études comparatives, I, Italie–France–Espagne.* Bibliothèque de la Société française d'archéologie, 2. Geneva: Droz. Paris: A.M.G., 1971.

WETTSTEIN, J. *La Fresque romane. Études comparatives, II, La route de Saint-Jacques, de Tours à León.* Bibliothèque de la Société française d'archéologie, 9. Geneva: Droz. Paris: A.M.G., 1978.

WÖLLASCH, J. *Mönchtum des Mittelalters zwischen Kirche und Welt.* Munich. W. Fink, 1973, pp. 155 ff.

ZALUSKA, Y. *L'Enluminure et le scriptorium de Cîteaux au XIIe siècle.* Brecht-Cîteaux-Lille 3, 1990.

GOTHIC ART

Abbot Suger and Saint-Denis: A Symposium. P.L. Gerson, editor. New York: The Metropolitan Museum, 1986.

AUBERT, M., L. GRODECKI, J. LAFOND, and J. VERRIER. *Les Vitraux de Notre-Dame et de la Sainte-Chapelle de Paris, Corpus Vitrearum Medii Ævi, France, I.* Paris: C.N.R.S.–C.N.M.H., 1959.

AVRIL, F. "Un chef-d'œuvre de l'enluminure sous le règne de Jean le Bon: la *Bible moralisée*, manuscrit 167 de la Bibliothèque nationale." Fondation Eugène Piot. *Monuments et Mémoires.* Académie des inscriptions et belles-lettres, 1973, pp. 91–125.

AVRIL, F. "Les manuscrits enluminés de Guillaume de Machaut." *Colloque Guillaume de Machaut* (Reims, 1978). Paris, 1982, pp. 117–132.

BALTRUSAITIS, J. Réveil et prodiges. *Le gothique fantastique.* Paris: Armand Colin, 1960. New ed. Paris: Flammarion, 1988.

BARON, F. "Le cavalier royal de Notre-Dame de Paris." *Bulletin Monumental*, CXXVI (1968), pp. 141–154.

Les Bâtisseurs de cathédrales gothiques. Exhibition catalogue under the direction of R. Recht. Ancienne Douane, Strasbourg, 1989.

BAUDOIN, J. *La Sculpture flamboyante en Champagne-Lorraine.* Nonette: Créer, coll. La sculpture flamboyante, n.d. [1990].

BAUDOIN, J. *La Sculpture flamboyante en Normandie et Île-de-France.* Nonette: Créer, coll. La sculpture flamboyante, 1991.

BAUDOIN, J. *Les Grands Imagiers d'Occident: la sculpture flamboyante.* Nonette: Créer, 1983.

BECHMANN, R. *Villard de Honnecourt. La pensée technique au XIIIe siècle et sa communication.* Paris: A. et J. Picard, 1991.

BÉNARD, P. "Recherche sur la patrie et les travaux de Villard de Honnecourt." *Travaux de la Société académique de Saint-Quentin*, 1864–1866, pp. 260–280.

BIDEAULT, M. and C. LAUTIER. "Saint-Nicaise de Reims. Chronologie et nouvelles remarques sur l'architecture." *Bulletin monumental*, CXXXV (1977), pp. 195–330.

BIDEAULT, M. and C. LAUTIER. *Île-de-France gothique, I, Les Églises de la vallée de l'Oise et du Beauvaisis.* Paris: A. et J. Picard, coll. Les Monuments de la France gothique, 1983.

BLOMME, Y. *Poitou gothique.* Paris: A. et J. Picard, coll. Les Monuments de la France gothique, 1993.

BLUM, P. "The Lateral Portals of the West Façade at the Abbey Church of Saint-Denis: Archeological and Iconographical Considerations." *Abbot Suger and Saint-Denis, a Symposium.* New York: The Metropolitan Museum of Art, 1986, pp. 199–227.

BOLOGNA, F. *I pittori della corte angioina di Napoli, 1266–1414.* Rome: U. Bozzi, 1969.

BONY, J. "Architecture gothique: accident ou nécessité." *Revue de l'art,* 58/59 (1983), pp. 9–20.

BONY, J. *French Gothic Architecture of the Twelfth and Thirteenth Centuries.* Berkeley, Los Angeles: California Studies in the History of Art, 20, 1983.

BONY, J. "The Resistance to Chartres in Early Thirteenth-Century Architecture." *Journal of the British Archeological Association,* XX–XXI (1957–1958), pp. 35–52.

BRANNER, R. "Historical Aspects of the Reconstruction of Reims Cathedral." *Speculum,* 36 (1961), pp. 23–37.

BRANNER, R. "The Labyrinth of Reims Cathedral." *Journal of the Society of Architectural Historians,* XXI (1962), pp. 18–25.

BRANNER, R. "Paris and the origins of Rayonnant Gothic Architecture down to 1240." *Art Bulletin,* XXXXIV (1962), pp. 39–51.

BRANNER, R. "Le Maître de la cathédrale de Beauvais." *Art de France,* II (1962).

BRANNER, R. *La Cathédrale de Bourges et sa place dans l'architecture gothique.* Paris–Bourges: Tardy, 1962.

BRANNER, R. "Villard de Honnecourt, Reims and the Origin of Architectural Drawing." *Gazette des Beaux-Arts,* 6th s., LXI (1963), pp. 129–146.

BRANNER, R. "Gothic Architecture 1160–1180 and its Romanesque Sources." *Studies in Western Art, Acts of the 20th International Congress of the History of Art,* New York, 1961. Princeton, 1963.

BRANNER, R. *Saint Louis and the Court Style in Gothic Architecture.* London: Zwemmer, Stud. Archit. 7, 1965.

BRANNER, R. *Manuscript Paintings in Paris during the Reign of Saint Louis.* Berkeley and Los Angeles: University of California Press, 1977.

BRUAND, Y. "L'amélioration de la défense et les transformations des châteaux du Bourbonnais pendant la guerre de Cent Ans." *C. R. Académie des inscriptions et belles-lettres.* October 1972, pp. 518 ff.

BRUZELIUS, C.A. "Cistercian High Gothic: The Abbey Church of Longpont and the Architecture of Cistercians in the Early 13th Century." *Analecta Cistercensia,* XXXV (1979), pp. 3–204.

BRUZELIUS, C.A "The Construction of Notre-Dame in Paris." *Art Bulletin,* LXIX (1987), 4, pp. 540–569.

BRUZELIUS, C.A. *The 13th-Century Church at Saint-Denis.* New Haven and London: Yale University Press, 1985.

BURNAND, M.-C. *La Lorraine gothique.* Paris: A. et J. Picard, coll. Les Monuments de la France gothique, 1989.

CASTELNUOVO, E. *I Mesi di Trento. Gli affreschi di Torre Aquila e il gotico internazionale.* Trente: Teni, 1986.

CHASTEL, A. *Le Cardinal Louis d'Aragon:* Paris: Fayard, 1986.

CHÂTELET, A. and R. RECHT. *Le Monde gothique. L'humanisation du sacré, 1350–1500.* Paris: Gallimard, coll. Univers des Formes, 1989.

CHEDEVILLE, A. *Chartres et ses campagnes aux XIIe et XIIIe siècles.* Paris: Klincksieck, 1973.

COLOMBIER, P. du. *Les Chantiers des cathédrales: ouvriers, architectes, sculpteurs.* Paris: A. et J. Picard, 1953. 2nd ed. 1973.

CONTAMINE, P. "Points de vue sur la chevalerie en France à la fin du Moyen Âge." *Francia,* 1978, pp. 255–285.

COURTILLÉ, A. *Auvergne et Bourbonnais gothiques, I, Les débuts.* Nonette: Créer, n.d. [1990].

CROSBY, S.M "Abbot Suger's Saint-Denis. The New Gothic." *Studies in Western Art,* 1961, I, pp. 85–91.

CROSBY, S.M. *Royal Abbey of Saint Denis: From its Beginnings to the Death of Suger.* New Haven: Yale University Press, 1987.

Crusader Art in the Twelfth Century. Oxford: British Archeological Report, 1982.

DAVIS, M.T. "The Choir of the Cathedral of Clermont-Ferrand: the Beginning of Construction and the Work of Jean Deschamps." *Journal of the Society of Architectural Historians,* 40 (1981), pp. 181–202.

DAWSON-HEDEMAN, A. "Valois Legitimacy: Editorial Changes in Charles V's Grandes Chroniques de France." *The Art Bulletin,* LXVI (1984), pp. 97 ff.

"Le décor des églises en France méridionale. XIIIe siècle–mi-XIVe siècle." Various authors. *Cahiers de Fanjeaux,* 28, Toulouse: Privat, 1993.

DESCHAMPS, E. *Œuvres complètes.* De Queux de Saint-Hilaire, ed. Société des anciens textes français, 11 vols., 1878–1903, vol. IX, p. 46.

DEUCHLER, F. *Der Ingeborgpsalter.* Berlin: de Gruyter, 1967.

DUBY, G. *L'Europe des cathédrales, 1140–1280.* Geneva: Skira, 1966. 2nd ed. Skira–Flammarion, 1984.

DUBY, G. *Fondement d'un nouvel humanisme, 1280–1440.* Geneva: Skira, 1966. 2nd ed. Paris and Geneva: Skira–Flammarion, 1984.

ERLANDE-BRANDENBURG, A. "Jean de Thoiry, sculpteur de Charles V." *Journal des Savants,* July–September 1972, pp. 210–227.

ERLANDE-BRANDENBURG, A. "La façade de la cathédrale d'Amiens." *Bulletin monumental,* CXXXV (1977), pp. 253–293.

ERLANDE-BRANDENBURG, A. *L'Art gothique.* Paris: Citadelles, 1983.

ERLANDE-BRANDENBURG, A. *La Sculpture de Notre-Dame au musée de Cluny.* Paris: Réunion des Musées Nationaux, 1977.

ERLANDE-BRANDENBURG, A. *Le Monde gothique. La conquête de l'Europe, 1260–1380.* Paris: Gallimard, coll. Univers des Formes, 1988.

ERLANDE-BRANDENBURG, A. *Notre-Dame de Paris.* Paris: Nathan–C.N.M.H.S., 1991.

L'Europe gothique, XIIe–XIVe siècles. Exhibition catalogue. *12e exposition du Conseil de l'Europe,* Musée du Louvre, Paris, 1968. Paris: Réunion des Musées Nationaux, 1968.

Les Fastes du gothique, le siècle de Charles V. Exhibition catalogue. Galeries nationales du Grand Palais, Paris, 1981. Paris: Réunion des Musées Nationaux, 1981.

FAVIER, J. *Un conseiller de Philippe le Bel, Enguerrand de Marigny.* Paris: P.U.F., 1970.

FOURNIER, G. *Châteaux, villages et villes d'Auvergne au XVe siècle d'après l'Armorial de Guillaume Revel.* Bibliothèque de la Société française d'archéologie. Geneva: Droz. Paris: A.M.G., 1973.

La France de Philippe-Auguste, le temps des mutations. Edited by R.H. Bautier. International Colloquia of the C.N.R.S., 1980. Paris: C.N.R.S., 1982.

La France de Saint Louis. Septième centenaire de la mort de Saint Louis. Exhibition catalogue. Salle des Gens d'armes du Palais, Paris 1970–1971. Paris: Les Presses artistiques, 1970.

FRANKL, P. *The Gothic Literary Sources and Interpretations through Eight Centuries.* Princeton: Princeton University Press, 1960.

FREIGANG, C. "Jean Deschamps et le Midi." *Bulletin monumental,* III (1991), pp. 265–298.

GABORIT, J.R. "Les statues de Charles V et de Jeanne de Bourbon." *Revue du Louvre,* 1981, pp. 237–245.

GARDELLE, J. *Aquitaine gothique.* Paris: A. et J. Picard, coll. Les Monuments de la France gothique, 1992.

GAUTHIER, M.-M, editor. "De la couleur dans l'édifice médiéval: carreaux et carrelages gothiques." *Revue de l'art,* 63 (1984), pp. 57–82.

GISCARD D'ESTAING, F., M. FLEURY, and A. ERLANDE-BRANDENBURG. *Notre-Dame de Paris. Les rois retrouvés:* Paris: Joël Cuenot, 1977.

GNUDI, C. "Le jubé de Bourges et l'apogée du 'classicisme' dans la sculpture de l'Île-de-France." *Revue de l'art,* 3 (1969), pp. 18 ff.

GRODECKI, L. "Les vitraux de la cathédrale du Mans." *Congrès archéologique de France,* CXIX (1961), pp. 59–99.

GRODECKI, L. *Sainte-Chapelle.* Paris. C.N.M.H., n.d. [1962].

GRODECKI, L. "Le psautier de la reine Ingeburg et ses problèmes." *Revue de l'art,* 5 (1969). Reprinted in *Le Moyen Âge retrouvé,* I. Paris: Flammarion, 1986, pp. 545–563.

GRODECKI, L. *Les Vitraux de Saint-Denis, Corpus Vitrearum Medii Ævi.* Paris: C.N.R.S.–A.M.G., 1976.

GRODECKI, L. "Le style 1200." *Encyclopaedia Universalis,* suppl. II, 1980, pp. 1337–1340. Reprinted in *Le Moyen Âge retrouvé,* I. Paris: Flammarion, 1986, pp. 385–398.

GRODECKI, L. and C. BRISAC. *Le Vitrail gothique au XIIIe siècle.* Fribourg: Office du Livre, 1984.

GRODECKI, L. (with A. Prache and R. Recht). *Architecture gothique.* Milan: Electa, 1978. French ed. Paris: Gallimard-Electa, 1992. Translated from the French and published under the title *Gothic Architecture.* London: Faber and Faber, 1986.

HACKER-SÜCK, I. "La Sainte-Chapelle de Paris et les chapelles palatines du Moyen Âge en France." *Cahiers archéologiques*, XIII (1962), pp. 217–257.

HASKINS, C.H. *The Renaissance of the Twelfth Century*. Cambridge, 1927.

HENRIET, J. "La cathédrale Saint-Étienne de Sens. Le parti du premier maître et les campagnes du XII^e siècle." *Bulletin monumental*, CXXXX (1982), pp. 81–168.

HENRIET, J. "Saint-Germer-de-Fly." *Bulletin monumental*, CXXXXIII (1986), pp. 93–142.

HUIZINGA, J. *Herfsttij der Middeleeuwen*. Haarlem: 1919. Translated from the Dutch by F. Hopman under the title *The Waning of the Middle Ages*. Harmondsworth: Penguin Books, 1990.

KIDSON, P. "Panofsky, Suger and St. Denis." *Journal of the Warburg and Courtauld Institutes*, vol. 50 (1987), pp. 1–17.

KIMPEL, D. "Le développement de la taille en série dans l'architecture médiévale et son rôle dans l'histoire économique." *Bulletin monumental*, CXXXV (1977), pp. 195–222.

KIMPEL, D. and R. SUCKALE. *L'Architecture gothique en France, 1130–1270*. Paris: Flammarion, 1990.

KOECHLIN, R. *Ivoires gothiques français*. 3 vols. Paris: A. et J. Picard, 1924. New ed. 1968.

KURMANN, P. *La Cathédrale Saint-Étienne de Meaux, étude architecturale*. Bibliothèque de la Société française d'archéologie. Geneva: Droz. Paris: Champion, 1970.

KURMANN, P. *La Façade de la cathédrale de Reims*. Paris and Lausanne: Payot, 1987.

LASTEYRIE, R. de. *L'Architecture religieuse en France à l'époque gothique*. 2 vols. Paris: A. et J. Picard, 1926-1927.

LEFRANÇOIS-PILLION, L. and J. LAFOND. *L'Art en France au XIV^e siècle*. Paris, 1954.

LENIAUD, J.-M. and F. PERROT. *La Sainte-Chapelle*. Paris: C.N.M.H.S., 1992.

LÉONARD, E. *Les Angevins de Naples*. Paris: P.U.F., 1954, pp. 368 ff.

La Librairie de Charles V. Exhibition catalogue, by F. Avril and J. Lafaurie. Paris: Bibliothèque nationale, 1968.

LITTLE, I.K. "Saint Louis' Involvement with the Friars." *Church History*, XXXIII (1964).

MARK, R. *Experiments in Gothic Structure*. Cambridge, Mass. and London: M.I.T. Press, 1982.

MEISS, M. *French Painting in the Time of Jean de Berry*. 5 vols. London and New York: Phaidon Press, 1967–1976.

MESQUI, J. *Île-de-France gothique, II, Les demeures seigneuriales*. Paris: A. et J. Picard, coll. Les Monuments de la France gothique, 1989.

MURRAY, S. "Looking for Robert de Luzarches: the Early Work at Amiens Cathedral. *Gesta*, XXIX, 1 (1990), pp. 111–131.

MURRAY, S. "The Choir of the St. Pierre Cathedral of Beauvais." *The Art Bulletin*, December 1980, pp. 533–551.

MURRAY, S. *Building Troyes Cathedral, the Late Gothic Campaigns*. Indianapolis: Indiana University Press, 1982.

MUSSAT, A. "Les cathédrales dans leurs cités." *Revue de l'art*, 55 (1982), pp. 9–22.

MUSSAT, A., R. Barrié, C. Brisac, et. al. *La Cathédrale du Mans*. Paris: Berger-Levrault, 1981.

"La Naissance et l'essor du gothique méridional au XIII^e siècle." Various authors. *Cahiers de Fanjeaux*, 9, Toulouse, Privat, 1974.

OLSCHSKI, L. *Guillaume Boucher, a French Artist at the Court of the Schans*. Baltimore: John Hopkins University Press, 1946.

PÄCHT, O. "Early Italian Nature Studies and the Early Calendar Landscape." *Journal of the Warburg and Courtauld Institutes*, XIII (1950), pp. 36 ff.

PAQUET, J.-P., "Les tracés directeurs des plans de quelques édifices du domaine royal au Moyen Âge." *Monuments historiques*, 1963, pp. 59–84.

PERDRIZET, P. *Le Calendrier parisien à la fin du Moyen Âge d'après les bréviaires et les livres d'heures*. Strasbourg: Assoc. Publ. Univ. Strasbourg, 1933.

PRACHE, A. *Saint-Remi de Reims. L'œuvre de Pierre Celle et sa place dans l'architecture gothique*. Bibliothèque de la Société française d'archéologie. Geneva: Droz. Paris: Champion, 1978.

PRESSOUYRE, L. "La colonne dite 'aux trois chevaliers' de Châlons-sur-Marne." *Bulletin de la Société nationale des antiquaires de France*, 1960, pp. 76 ff.

PRESSOUYRE, L. "Pour une reconstruction du jubé de Chartres." *Bulletin monumental*, CXXV (1967), pp. 419 ff.

PRESSOUYRE, S. *Images d'un cloître disparu*. Paris: Joël Cuenot, 1976.

RANDALL, L.M.C. "Exempla as a Source of Gothic Marginal Illumination." *The Art Bulletin*, 1957, pp. 97–107.

RANDALL, L.M.C. *Images in the Margins of Gothic Manuscripts*. Berkeley and Los Angeles: University of California Press, 1966.

RAVAUX, J.P. "Les campagnes de construction de la cathédrale de Reims au XIII^e siècle." *Bulletin monumental*, CXXXVII (1979), pp. 7 ff.

RECHT, R. "Sur le dessin d'architecture gothique." *Études d'art médiéval offertes à Louis Grodecki*. Paris: Ophrys, 1981.

ROBIN, F. *La Cour d'Anjou-Provence. La création artistique sous le roi René*. Paris: A. et J. Picard, 1985.

ROQUES, M. *Le Graal de Chrétien et la Demoiselle au Graal*. Geneva: Droz, 1955.

SALET, F. "Le premier colloque international de la Société française d'archéologie, Reims, 1965. Chronologie de la cathédrale." *Bulletin monumental*, CXXV (1967), pp. 347–394.

SALET, F. "Notre-Dame de Paris, état présent de la recherche." *La Sauvegarde de l'art français*, vol. 2. Paris: A. et J. Picard, 1982.

SAUERLÄNDER, W. "Art antique et sculpture autour de 1200." *Art de France*, I (1961), pp. 47 ff.

SAUERLÄNDER, W. "Les statues royales du transept de Reims." *Revue de l'art*, 27 (1975), pp. 9-30.

SAUERLÄNDER, W. *La Sculpture gothique en France. 1140–1270*. Paris: Flammarion, 1972.

SAUERLÄNDER, W. *Le Siècle des cathédrales (1140–1270)*. Paris: Gallimard, coll. Univers des Formes, 1989.

SCHELLER, A. *A Survey of Mediaeval Model Books*. Haarlem: De Erven Bohn, 1963.

Senlis. Un moment de la structure gothique. Exhibition catalogue by D. Brouillet. *Sauvegarde de Senlis*, 45–46, 1977.

Septième Centenaire de la mort de Saint Louis. Proceedings of the conference at Royaumont-Paris, 1970, under the direction of L. Carolus-Barré. Paris: C.N.R.S., 1976.

SEYMOUR, C. *Notre-Dame de Noyon in the Twelfth Century. A Study in the Early Development of Gothic Architecture*. New Haven: Yale University Press. 1939.

STERLING, C. *La Peinture française médiévale à Paris, 1300–1500*. 2 vols. Paris: Bibliothèque des Arts, 1987–1990.

STODDARD, W.S. *The West Portals of Saint-Denis and Chartres. Sculpture in the Île-de-France from 1140 to 1190. Theory of Origins*. Cambridge, Mass.: Harvard University Press, 1952.

La Tenture de l'Apocalypse d'Angers. Cahiers de l'Inventaire, 4. Preface by F. Salet. Nantes. 2nd ed. 1987.

TITUS, H.B., Jr. "The Auxerre Cathedral Chevet and Burgundian Gothic Architecture." *Journal of the Society of Architectural Historians*, XLVII (1988), 1.

TUCOO-CHALA P. *Gaston Phébus, un grand prince d'Occident du XIV^e siècle* Pau: Marrimpouey, 1976.

VERDIER, P. "La grande croix de l'abbé Suger à Saint-Denis." *Cahiers de civilisation médiévale*, XIII (1970), pp. 1–31.

VERMAND, D. *La Cathédrale Notre-Dame de Senlis au XII^e siècle. Étude historique et monumentale*. Société d'histoire et d'archéologie de Senlis, 1987.

Villard de Honnecourt. Carnet. Edited by A. Erlande-Brandenburg, R. Pernoud, J. Gimpel, R. Bechmann. Paris: Stock, n.d. [1986].

WARNKE, M. *Hofkünstler zur Vorgeschichte der modernen Künstlers*. Cologne: DuMont Schauberg, 1985.

WHITELEY, M. *L'Escalier dans l'architecture de la Renaissance*. Paris: Picard, coll. De architectura, 1985.

WINTER, P.-M. de. "Christine de Pisan, ses enlumineurs et ses mécènes les ducs de Bourgogne." *L'Aquitaine*: Études archéologiques. Proceedings: *Actes du 104^e Congrès national des sociétés savantes*. Bordeaux, 1979. Paris, 1982, pp. 335 ff.

WOLFE, M. and R. MARK. "The Collapse of the Beauvais Vaults in 1284." *Speculum*, 51 (1976), pp. 462–476.

WORTMANN, R. "Der Westbau des Strassburger Münsters und Meister Erwin." *Bonner Jahrbuch*, LXIX (1969), pp. 290 ff.

The Year 1200. A Centennial Exhibition at the Metropolitan Museum of Art. Vol. 1: Exhibition catalogue. K. Hoffman, New York, 1970. Vol. 2: *The Year 1200. A Background Survey*. Fl. Deuchler (dir.). New York: Graphic Society Ltd., 1970. Vol. 3: *The Year 1200. A Symposium*. New York: Metropolitan Museum of Art, 1975.

ZAKIN, H.J. *French Cistercian Grisaille Glass*. New York: Garland, 1979.

INDEX

References to illustrations are printed in italics.

INDEX OF PROPER NAMES

Abadie, Paul 156, 168, 170
Abbo of Fleury 138, 143
Abraham, Pol 209
Ademar of Chabannes 98
Alavoine, Jean-Antoine 277
Alcuin 76
Alexander III, Pope 227
Alpais, master enameler 270
Alphonse, count of Poitiers and
 Toulouse 274, 275, 316
Anastasia 332
Agilbert 62,
Angilbert 71
Anjou see Louis of Anjou,
 René of Anjou, Charles of Anjou
Ansquitilius, Abbot 176
Anthony, Saint 285
Antonius Pius, Emperor 233
Ariosto 198
Aristotle 226, 308, 329, 330
Arnegunde (Arégonde) 57, 59
Arthur, King 198
Aubert, bishop of Avranches 88
Aubert, Jehan 296
Augustine, Saint 191

Baltrusaitis, Jurgis 186
Bataille, Nicolas 319
Beatrice of Provence 266
Beatus Liebana, monk 93, 140
Beauneveu, André 306, 309, 325,
 329, 332
Bedford, Master of 278, 333, 334
Bégon, Abbot 158
Belleforest, François de 18
Benedict XII, Pope 299
Benedict of Nursia 62, 143, 144
Benoît de Sainte Maure 89, 198,
 199, 218
Benveniste, Emile 126
Bernard d'Angers 87
Bernard of Clairvaux, Saint 153,
 164, 198, 200, 202-203, 203,
 204-205
Bernard de Sédirac 151
Bernard de Soissons 243
Béroul 199
Berry, duke of see Jean de Berry
Bersuire, Pierre 307
Berty, Adolphe 310
Billyng, Robert de 286, 286
Blanche of Castile 259, 265
Blondel, Nicolas François 206
Boileau, Etienne 268

Boiron, Robert de 273
Bondol, Jean de 283, 308, 319-320,
 321-322, 325
Bony, Jean 131, 217
Boucher, Guillaume 272
Boucher de Crèvecœur de Perthes
 11-12, 15
Boucicaut, Marshal 282, 324, 332
Boucicaut Master (Jacques
 Coene?) 283, 324
Boqueteaux Master 293, 307
Bourbon see Jeanne of Bourbon;
 Louis II, duke of Bourbon
Burgundy, dukes of, see Philip the
 Bold; John the Fearless
Branner, Robert 238
Broederlam, Melchior 329
Brunehilda 60
Bruno, Saint 153
Bureau de la Rivière 306

Cabassol, Philippe de 306
Caesar 37-8, 45
Caylus, comte de 26
Ceraunis 54
Charlemagne, Charles I 53, 66-67,
 71, 74, 76, 143, 246, 307, 319
Charles II the Bald 53, 58, 66, 67,
 69, 77, 80, 82, 84, 194, 264
Charles III the Fat 82
Charles IV the Fair (king of France)
 282, 298, 305
Charles V the Wise 66, 279-280,
 279, 281-283, 291, 293, 299,
 301, 303, 307, 307-310, 309-310,
 312, 314, 317, 319, 323, 323-324,
 330, 332
Charles VI 279, 281, 282, 283, 306,
 306, 318
Charles VII 322
Charles IV, Emperor, king of
 Bohemia 66, 323
Charles of Anjou, king of Naples
 129, 260, 266, 316
Charles the Bad, king of Navarre
 279
Charles Martel 67, 113
Chastelon, Jean 269
Childe, Gordon 19
Childebert 56, 65, 231
Childéric I 50, 50, 59
Chilpéric I 57
Chlodomer 65
Chlotar 65, 160

Choisy, Auguste 209
Chrétien de Troyes 199, 218, 273
Christine de Pisan 308, 312, 323,
 332, 332
Christy, Henry 12
Clement, Saint 140, 142
Clement V, Pope 282
Clement VI, Pope 96, 285, 285,
 299, 301, 302
Clotilda, Queen 51, 65
Clovis, King 50, 51, 56, 65, 78, 98,
 278, 316
Coene, Jacques (Boucicaut
 Master?) 283, 323, 324, 324
Constance of Arles 264
Constantine 164
Coucy, lord of 275
Curthose, Duke Robert of
 Normandy 161
Cuvier, Georges 14
Cyme, Jehan 296

Dagobert 54, 57-58, 65, 72, 86,
 215, 264
Dammartin, Guy de 312
Dante 268
Delisle, Léopold 286
Denis, Saint 52, 97, 194, 218, 230,
 244, 250, 252, 285
Deschamps, Eustache 279, 293
Deschamps, Jean 132, 248
Diodorus 37
Dionysius the Areopagite 52, 216
Drogo, Bishop of Metz 67, 68,
 76, 77
Duby, Georges 150, 279
Duccio 284, 286
Du Fouilloux, Jacques 331
Durand de Mende, Guillaume 122,
 164, 307, 307

Ebbo, archbishop of Reims 77,
 77, 294
Edward I of England 275, 276
Edward III of England 278, 322
Einhard 76
Eiffel, Gustave 244
Eleanor of Aquitaine 89, 161-162,
 265, 266
Éloi, Saint 57-58, 65, 72, 215
Enguerrand III 275
Étienne of Sancerre 197
Eudes, king of France 82
Eudes Clément, Abbot 218, 261

Fayel, Pierre de 306
Félibien, André 210
Ferrières, Henri de 331
Ferrières, Raoul de 298
Focillon, Henri 93, 138, 147, 149
Fossier, Robert 61
Fournival, Richard de 272, 273
Frederick Barbarossa 143
Frederick II of Hohenstaufen 66,
 200, 202, 268, 331
Froissart, Jean 314
Fulrad 72

Gaborit-Chopin, Danielle 309
Gaignières, Roger de 142, 142
Garsia, Stephanus 140
Gaston Phébus, count of Foix 302,
 313, 331
Gauthier, Marie-Madeleine 119
Gauzlin, Abbot 89, 112, 142-143
Gauzon 98
Gébelin, François 312
Genevieve, Saint 52, 56, 269
Geoffroy V the Fair, Plantagenet
 192-193, 193, 197, 314
Girard II, Bishop 170
Girart de Roussillon 143
Gerson, Jean de 334
Gervais Du Bus 280, 280-281
Gervase of Canterbury 213
Gildas, Saint 46
Gilduin, Bernard 46
Giotto di Bondone 54, 284, 286
Giovannetti, Matteo 284-285, 285
Giovannino de' Grassi 323
Girard, Bishop 156
Girardin, marquis de 26
Giraud de Cardaillac 168
Girbertus 128
Gislebertus 172, 173
Glaber, Raoul 138, 151
Godefroid de Huy 194, 216
Godefroy de Bouillon 314, 316
Godescalc 74, 76, 150
Gossouin de Metz 272
Gratian, monk 157, 268, 268
Gregory the Great, Pope 54, 333
Gregory VII, Pope 153
Gregory of Tours, Saint 48, 51, 54,
 56-57, 65
Gregory of Vendôme, Abbot 160
Grise, Jean de 294
Grodecki, Louis 119, 139, 194
Grosseteste, Robert 109

Gui de Bazoches 112
Guilhermy, François de 308
Guillaume, called Dirty-Beard 98
Guillaume de Digulleville 316
Guillaume de Lorris 273
Guillaume de Machaut 279, 290, 290, 293, 332
Guillaume de Saint-Pathus 94, 95, 260, 267
Guinamundus, monk 158
Guy de Meijos 269

Harding, Stephen 161
Hardouin-Mansart, Jules 265
Helgaud 126
Henri I, count of Champagne 197
Henry I, king of France 317
Henry II, king of England 161-162, 198, 265-266
Henry V, king of England 281
Henry of Blois 191
Herodotus 28
Hilary of Poitiers, Saint 48
Hildebert de Lavardin 163
Hincmar, Archbishop 78
Honorius of Autun 157
Horace 123
Hugh Capet, king of France 80, 139
Hugh, Saint, abbot of Cluny 170-171, 176, 190
Hugo, Victor 110, 119
Hugues, Count 98
Hugues of Saint-Victor 109

Isabeau of Bavaria 280, 282, 296

Jacquemart de Hesdin 325, 330, 332
James, Saint (the Greater) 123
James, Saint (the Less) 123, 306
Jaucourt, Louis 14
Jean Clément 244
Jean de Beauce 222, 277
Jean de Bruges see Bondol, Jean de
Jean de Chelles 262, 264
Jean de la Grange, Cardinal 306, 306
Jean de Meung or Jean Clopinel 273
Jean de Monmartre 292
Jean de Montmirail 305
Jean de Sy 283, 290, 290, 293, 325
Jean, duke of Berry 279, 286, 303, 312, 313, 317, 319, 320, 318, 322, 325, 325, 327, 329, 332-333
Jean Le Bègue 323
Jeanne d'Evreux 119, 282, 286, 288, 297-298, 305, 306
Jeanne of Navarre 288, 289, 290
Jeanne of Bourbon 280, 307, 308, 310
Jeanne of Burgundy 309
Jerome, Saint 108

Job 202
Johannes Scotus Erigena 72
John II the Good, king of France 279, 283, 284-285, 285, 288, 292, 293, 307, 312, 314, 317, 322, 325
John, Saint 123, 309
John the Baptist, Saint 263
John the Evangelist, Saint 263, 309, 334
John the Fearless, duke de Burgundy 318
John of Luxembourg 279
Joinville, Jean de 260
Jovin 44
Julian, Emperor 45
Julian the Hospitaller, Saint 102, 333
Justinian, Emperor 163

Krautheimer, Richard 89

Lallemand, Jean-Baptiste 171
La Bruyère, Jean de 206
Lacerta, Hugo 119, 194
Lafond, Jean 297
Lambert, Elie 152
Lartet, Edouard 12
Launebolde, Duke 51
Le Braillier, Jean 314
Lechler, L. 212
Lenoir, Alexandre 308-309
Le Noir, Jean 283, 288, 289, 290, 291
Leo III, Pope 66, 230
Leroi-Gourhan, André 15, 18
Libergier, Hugues 128, 223
Limbourg, Paul, Herman, and Jean 303, 310, 312-313, 317, 320, 322, 324, 333
Livy 37, 308
Lomello, count of 143
Lothair, King 78, 80
Louis I the Pious 67, 80
Louis IV 78
Louis V 78
Louis VI 72
Louis VII 54, 98, 151, 214-215, 231
Louis VIII 264-265
Louis IX or Saint Louis 96, 99, 102, 122, 132, 151, 228, 247, 259-260, 265, 266, 267, 268, 269, 275-278, 282, 306, 312, 316, 320, 331
Louis X 267
Louis XII 322
Louis XIII 312
Louis XIV 265, 282, 312
Louis I of Anjou 310, 314, 319, 320
Louis II of Anjou 318
Louis II, the German 80
Louis, duke of Orléans 322-323
Louis II, duke of Bourbon 303, 314, 317
Louis of Aragon, Cardinal 262

Louis of Tarentum 322
Louvres, Jean de 301
Lucian, Saint 102
Luzarches, Robert de 243, 262

Mabillon, Jean 225
Mahaut, countess of Artois 273, 282, 284, 296, 306
Mâle, Émile 227, 236, 244, 255, 269
Malouel, Jean 324
Mamerot, Sébastien 98
Manuel, Don Juan 331
Marcel, Etienne 279, 310
Marguerite of Provence, 265
Marie de France 199
Marigny, Enguerrand de 282
Martial, Saint 88
Martin, Saint, bishop of Tours 48, 52-54, 97
Martini, Simone 284, 325
Master Erwin 249
Master Honoré 268, 268, 285
Master Nicolas 213
Master of Saint-Chéron 253
Master of Saint-Gilles 58
Master of the l'Épître d'Othea 332, 332
Master of the Parement of Narbonne 325, 326-327
Master of the Rieux Chapel 297
Maximilian, Saint 102
Mayeul, Abbot 83
Mérimée, Prosper 160
Merovech 50, 65
Méryon, Charles 110
Michael, Saint, the Archangel 88, 140, 142, 159, 160, 298, 333
Michelet, Jules 95
Millin, Aubin-Louis 305
Monmouth, Geoffrey of 198
Montaner, Abbot Gregory of 140
Montfaucon, Bernard de 65, 78, 224, 236
Montmartre, Jean de 292
Montmorency, connétable de 40
Morard, Abbot 149
Morel, Jacques 306

Namatius, Bishop 54
Napoleon I 50
Nicolas of Verdun 194, 233
Norbert, Saint 153

Odbert, Abbot 142
Oderisi da Gubbio 268
Odilo de Mercœur, Abbot 83, 96, 99, 170
Odolric, Abbot 146
Odolricus, monk 140
Odon, Saint, abbot of Cluny 78, 83
Ogier the Dane 225
Olybrius, Governor 226
Orderic Vital 161
Oresme, Nicolas 308, 309, 330

Orimina, Cristoforo 322
Otto I the Great, Emperor 80
Otto III, Emperor 138, 80
Ovid 163

Panofsky, Erwin 129, 212
Pantaleon, Saint 246
Parler, master sculptors 330
Pasquier, Etienne 206
Pastoureau, Michel 316
Paul Aurelian, Saint 46
Paul, Saint 52, 123, 296
Paul the Silentiairy 44
Paulin of Périgueux 54
Pepin the Short, king of the Franks 67, 72
Perotinus 212
Perpetuus, Bishop 54
Peter, Saint 123, 180, 296
Philip I 163
Philip II Augustus 56, 196-198, 198, 231, 248, 264, 274, 310
Philip III the Good 322
Philip IV the Fair 265, 268, 268, 278-280, 284, 299, 306, 312, 316
Philip V of Macedonia 30, 308
Philip VI of Valois 162, 278, 281, 316
Philip Dagobert 265
Philip the Bold, duke of Burgundy 277, 279, 306, 318-319, 324, 332
Philostratus 37
Pierre d'Agincourt 129, 213
Pierre de Corbie 129
Pierre de Montreuil 128, 218-219, 260-262, 264, 267
Peter the Venerable, Abbot 173, 202
Pirenne, Henri 138
Pisano, Giovanni 252
Pisano, Nicola 252
Pliny 14
Pons de Melgueil, Abbot 202
Proust, Marcel 119
Pucelle, Jean 267, 273, 282, 284, 286, 286, 288, 288-289, 290, 294, 294, 298, 332
Pugin, Augustin Welby N. 121
Pulci, Luigi 198

Quicherat, Jules 214

Raban Maur 269
Rabelais, François 206
Radegonde, Saint (Radegund) 160
Ramnulphe, Bishop 156
Ravy, Jean 306
Raymond-Beranger IV, count of Provence 266
Raymond du Temple 303
Regnault de Cormont 243
Remi, Saint 51, 52, 65, 78
Renan, Ernest 278

René of Anjou, 317, 322
Revel, Guillaume 303
RichardI the Lionheart, king
 of England 197-198, 249, *265*
Richard de Verdun 268
Riley Smith, J. 151
Robert II the Pious 80, 112, 126,
 139, 142, 150, 264
Robert d'Anjou 266, 284,
 305, 322
Robert d'Arbrissel 154, 162
Robert de Billyng *see* Billyng,
 Robert de
Robert de Molsme 153
Robert de Torigny 112
Robert of Clermont 265
Robert the Strong 80
Roch, Saint 279
Rollo 84
Roriczer, M. 212
Rousseau, Jean-Jacques 26
Ruskin, John 119

Saint Louis *see* Louis IX
Sancho III the Great, king
 of Navarre 150
Schapiro, Meyer 188

Sebastian, Saint 279
Serenus, Bishop 54
Sicard de Lordat 302
Simon, Abbot 65
Sluter, Claus 319-320, *328, 329*
Sorbon, Robert de 260
Stephen II, Pope 72
Stephen, Saint 185
Stephen of Muret, Saint *119,* 194
Strabo 37
Suger, Abbot 58, 73, 102, 126,
 204-205, 214-218, *218,* 224,
 255, 261
Sully, Maurice de, bishop
 227, 231
Sy, Jean de *see* Jean de Sy
Sylvester II, Pope (Gerbert
 of Auvergne) 96, 138

Taurin, Saint *104,* 269
Theodechilde 62
Theodoric 57, 65, 67
Theutobochus, king of the
 Teutons 14
Thevet, André 14
Thibaud V of Blois 197
Thibaut III of Champagne 269

Thibaut IV of Champagne 269
Thomas Aquinas, Saint 97, 260
Thomas Becket *104*
Thomas de Cormont 243, 262
Tiberius, Emperor 38
Tissandier, Jean *118,* 306
Tolstoy, Leo 203
Trencavel, Raymond Roger 260
Trutbert, Pierre 192
Turoldus 198
Tutankhamen 20

Ultrogoth, Queen 65
Urban II, Pope 96, *96,* 151,
 153, 156
Urban IV, Pope 260, 263

Valerius Maximus 307
Van Eyck, Jan 324
Vaudetar, Jean de 308, 324
Vegetius 197
Venantius Fortunatus 40, 47, 51,
 54, 65
Verrier, Jean 119
Villard de Honnecourt 129,
 209-212, *211,* 234, *272*
Vincent de Beauvais 227, 244, 260

Viollet-le-Duc, Eugène 110,
 115, 121, 128, 163, 206, 209,
 213, 214, 228, 244, 252, 275,
 277, *277*
Virgil 163
Visconti, Valentina 323
Vitruvius 210

Wace, Robert 198
Willem van Ruysbroek 272
William IX, duke of Aquitaine
 161
William Longsword 89
William of Champeaux 153
William of Orange 146
William of Passavant, Bishop
 199
William of Sens 213
William of Volpiano 138, 149,
 164
William the Conqueror 161,
 196

Yolande of Flanders 290
Yves, monk 285

INDEX OF PLACES

Aachen (Germany) 66, 67
Aigues-Mortes (Gard) 276,
 276, 299
Aix-en-Provence (Bouches-du-
 Rhône) 284; baptistery 64;
 Saint-Jean 305
Albi (Tarn), Sainte-Cécile 249, *249*
Ambronay (Ain), abbey *78*
Amfreville-sous-les-Monts (Eure)
 29, *31*
Amiens (Somme), Notre-Dame
 207, 208, 218, 222, 224, 234,
 234, 237, *243,* 243, 250, 254, 256,
 262, 264, 306
Angers (Maine-et-Loire) 266, 295;
 Saint-Serge 170; castle 213
Angoulême (Charente), Saint-Pierre
 156, 170, 222
Anjony (Cantal), castle 312
Anzy-le-Duc (Saône-et-Loire), la
 Trinité 172
Arcy-sur-Cure (Yonne) 15
Apt (Vaucluse) *39*
Arles (Bouches-du-Rhône),
 Saint-Trophime *123,* 165,
 183, 183, 224; les Alyscamps
 44, *47*
Arras (Pas-de-Calais) 319
Arzon (Morbihan) 21
Aulnay-de-Saintonge (Charente-
 Maritime), Saint-Pierre *121,*
 181, *182*

Aurignac (Haute-Garonne) 16
Autun (Saône-et-Loire), Saint-
 Lazare *122, 130,* 151, 171,
 173-175, 181, 184, 185;
 Saint-Maur monastery 60;
 Saint-Martin 56, 57; Janus
 temple 42
Auxerre (Yonne), Saint-Germain
 53, *70,* 71, 76, 139, 242;
 Saint-Étienne 304
Avanton (Vienne) *28*
Avaricum *see* Bourges
Avignon (Vaucluse) 283, 284,
 285, 299, 301, 306; Saint-
 Martial, 306, *306;* Notre-Dame-
 des-Doms 165; Papal palace
 284, *302,* 331; New Palace
 301, 310; Saint-Bénezet bridge
 277
Avranches (Manche), Saint-André
 (destroyed) 146
Avrillé (Vendée), dolmen 26
Azincourt (Pas-de-Calais) 281

Bamberg (Germany), cathedral 249
Barcelona (Spain), Santa Catalina
 249
Bayeux (Calvados), Tapestry *162,*
 198, 272, 314; Notre-Dame 146,
 161, 295
Beaulieu (Corrèze), Saint-Pierre
 181

Beauvais (Oise), Saint-Pierre 208,
 209, 243, 264, 298; church of
 Basse-Œuvre 70; Saint-Étienne
 219
Belgrade 272
Bernay (Eure), Notre-Dame
 146, 149
Berzé-la-Ville (Saône-et-Loire),
 priory 190
Bibracte (near Autun, Saône et
 Loire), oppidum 29
Bicêtre (Val-de-Marne), castle 320
Blois (Loir-et-Cher), castle 310
Bonpas (Vaucluse) 306
Bordeaux (Gironde), Sainte-Croix
 182, 298; Saint-André 208
Bourbon-l'Archambault (Allier),
 castle 303
Bourges (Cher) [Avaricum 29, 38];
 Saint-Étienne 225, 236, 238,
 239, 246, 247, 250, 258, 277,
 305
Boves (Somme), castle 198
Brassempouy (Landes), La Grotte
 du Pape *12*
Brinay-sur-Cher (Cher),
 Saint-Aignan *188,* 270
Brioude (Haute-Loire),
 Saint-Julien 57
Buissonnet (Oise) *11*
Byzantium 70, 71; *see also*
 Constantinople

Caen (Calvados), Saint-Etienne
 146, 167, 220; Trinité Church
 149
Cahors (Lot), pont Valentré 277
Cambrai (Nord), former Notre-
 Dame Cathedral (destroyed)
 206, 213
Carcassonne (Aude), Saint-Nazaire
 116, 248, 276, 277, *277,* 299,
 306
Carennac (Lot) 187; Saint-Pierre
 priory 127, 128
Carnac (Morbihan), 21, *24*
Cassel (Nord) 306
Casteil (Pyrénées-Orientales), abbey
 of Saint-Martin-du-Canigou
 143, *143*
Cellefrouin (Charente) 20
Centula *see* Saint-Riquier
Cesson (Côte d'Armor), tower 302
Chaise-Dieux, La (Haute-Loire),
 abbey 158
Châlons-sur-Marne (Marne) 260;
 Notre-Dame-en-Vaux 226
Champmol (Côte-d'Or), chartreuse
 306, 319, 329
Charenton-sur-Cher (Cher) *61*
Charité-sur-Loire, La (Nièvre),
 Notre-Dame-de-la-Charité 143
Charlieu (Loire), Saint-Fortunat
 172, 184, 190
Charroux (Vienne), abbey 144

Chars (Val d'Oise), Saint-Sulpice 228

Chartres (Eure-et-Loire) 70, Notre-Dame 54, 65, 94, 112, 114, *114, 115,* 121, *123,* 152, 184, 195, 207, 208, *208,* 209, 218, 222, 223, 224, *224,* 225, *225,* 226, *226,* 227, 228, 230, 233, 236, 237, *236, 237,* 238, 242, 243, 244, *244,* 246, 247, 250, 252, 253, 254, *254,* 255, 256, 258, *258,* 260, 277; Saint-Pierre 233, 247

Château-Chalon (Jura) 225

Château Gaillard, Les Andelys (Eure) 197, *197,* 274

Château-Gontier (Mayenne), Saint-Jean-Baptiste 160

Châteaudun (Eure-et-Loir), keep 196, 197

Châtillon-Coligny (Loiret), castle 197

Chauvigny (Vienne), Saint-Pierre *100, 126*

Chiaravalle (Italy) 200

Chinon (Indre-et-Loire), castle 198

Cîteaux (Côte-d'Or) 153, 161, 194, 200

Clairvaux (Aube), abbey 153, 200

Clermont (Shlemutsi, Greece) 275

Clermont-Ferrand (Puy-de-Dôme) 82, 96, 151; Notre-Dame 152, 212, 248, 298; Notre-Dame-du-Port 167; Saint-Etienne (destroyed) 54

Cluny (Saône-et-Loire), abbey 83, *96,* 98, 130, 138-139, 143, 146, 150, 152, 154, 156, *156,* 165, 170-171, 176, 190, 200, 202, 205

Cologne (Germany), Saint-Pierre 71, 237, 243

Commarque (Dordogne), castle 22

Compiègne (Oise), Hôtel-Dieu (hospital) 261

Compostela *see* Santiago de Compostela

Conflans (Yvelines) 282

Conques (Aveyron), Sainte-Foy 53, *53,* 87, *144,* 145, 150, 158, 165, 181, *187*

Constantinople 262, 275, 282; Saint Sophia 215; Holy Apostles 168; *see also* Byzantium

Coucy (Aisne), castle 213, *213,* 274

Coutances (Manche), Notre-Dame *117,* 146, 238, 242

Crécy (Somme) 278, 279

Cuperly (Marne) *30*

Die (Drôme), chapel of Saint-Nicolas 192, *192*

Dijon (Côte-d'Or), Saint-Bénigne 138, *139,* 146, 149, *150, 151,* 164, 225; Notre-Dame 242

Doué-la-Fontaine (Maine-et-Loire), tower (destroyed) 196

Dourdan (Essonne), castle 198

Dreux (Eure-et-Loire), castle 213

Ecouis (Eure), collegiate church 282, *282-283,* 306

Ensérune (Hérault) 29

Entremont (Bouches-du-Rhône) *34, 35, 36*

Étampes (Essonne), Notre-Dame-du-Fort 225

Etschmiadzin (Armenia), cathedral 73

Euffigneix (Haute-Marne) 35, *49*

Évreux (Eure), Saint-Taurin 269, 298

Eymoutiers (Haute-Vienne), Saint-Étienne 270

Eyzies, Les (Dordogne) *14, 18*

Famagousta (Cyprus) 275

Fécamp (Seine-Maritime), Trinité Church 266, 267

Fenioux (Charente-Martime) 22

Fenouillet (Haute-Garonne) 29

Flavigny-sur-Ozerain (Côte-d'Or), Saint-Pierre 71, 139

Fleury-sur-Loire *see* Saint-Benoit-sur-Loire

Fontaines Salées 15

Fontenay (Côte-d'Or) 165, *165,* 200, *205*

Fontevrault (Maine-et-Loire), abbey *161,* 162, 194, *265, 266,* 305

Fossanova (Italy) 200

Fréjus (Var), baptistery 64

Fulda (Germany) 71

Gavrinis (Morbihan) 21

Genabum *see* Orléans

Germigny-des-Prés (Loiret), villa of Theodulf 73, *73*

Gisors (Eure), keep 197

Glanum *see* Saint-Rémy-de-Provence

Gorge-Meillet (Marne) 29, *32*

Gourdon (Saône-sur-Loire) 58

Grand-Pressigny (Indre-et-Loire) *22*

Grandlieu (Loire-Atlantique), Saint-Philibert 53, 71, 82

Grandmont (Haute-Vienne), abbey (destroyed) 194

Grenade-sur-Garonne (Haute-Garonne) 276

Grézin (Puy-de-Dôme) *54*

Hallstatt (Austria) 28

Hérisson (Allier), castle 303

Hildesheim (Germany), doors 72

Issoire (Puy-de-Dôme) 167

Isturiz (Basses-Pyrénées) *12*

Javols (Lozère) 38

Jouarre (Seine-et-Marne), Notre-Dame 62, *63*

Jumièges (Seine-Maritime), abbey 62, 146, *148,* 167

Karakorum (Inde) 272

Klosterneuburg (Austria) 194, 233

La Bouvandeau (Marne) 29

La Graufesenque (Aveyron) 39, *39*

Lagat-Jar (Finistère) *23*

Langeais (Indre-et-Loire), tower 139, 196

Langres (Haute-Marne), Saint-Mammès 171

Laon (Aisne), Notre-Dame 152, 157, 164, 206, *206,* 207, 213, 220, 221, *222,* 223, 227, 233, 236, 247, 255, 258, 272

Largoët-en-Elven (Morbihan), tower 302

La-Roche-aux-Fées (Ille-et-Vilaine) *24-25,* 26

La Sauve-Majeure (Gironde), abbey 151

Lascaux *see* Montignac-sur-Vezère

Laval (Mayenne), Trinité Church 170

Le Mans (Sarthe) [Vindinum 29]; Saint-Julien 21, 65, 70, 192, *195,* 225, 227, 238, *238,* 247

Le Puy (Haute-Loire), Notre-Dame 47, 151

Les Eyzies-de-Tayac *see* Eyzies

Lespugue (Haute-Garonne) *16,* 18

Lessay (Manche), Trinité Church 206

Lezoux (Puy-de-Dôme) 44

Limbourg am Lahn (Germany) 249

Limoges (Haute-Vienne), enamel *104-105,* 119, 142, 158, 191, *192,* 193, 194, 270, *270;* Saint-Étienne 87, 212, 248, 298; Saint-Martial 151, 152, 154

Loches (Indre-et-Loire), keep *85,* 86, 196

Longpont (Aisne), abbey 237

Longpont-sur-Orge (Essonne), Notre-Dame 255, 305

Lourcine, Cordeliers monastery 266

Lutetia, amphitheater 40; *see also* Paris

Lyon (Rhône) 70; Saint-Jean 256

Madeleine, La (Dordogne) 16, *19*

Mailly-le-Camp (Aube) *37*

Mainneville (Eure), Saint-Pierre *259, 266*

Marburg (Germany), Sainte-Élisabeth 249

Marignac (Charente-Maritime), Saint-Sulpice *186*

Marseille (Bouches-du-Rhône) 305; Saint-Victor 56

Mas d'Azaïs (Aveyron) *26*

Mas d'Azil (Ariège) *20*

Maubuisson, *see* Saint-Ouen-l'Aumône

Maupertuis (Vienne) 278

Meaux (Seine-et-Marne), Saint-Faron 225

Mehun-sur-Yèvre (Cher), castle 303, 312, 319

Metz (Moselle) 70

Mistra (Greece), castle of Villehardouin 275

Moissac (Tarn-et-Garonne), Saint-Pierre 140, 176-181, *177, 178, 179, 180,* 181, 184, *185*

Monpazier (Dordogne) *275, 276*

Montaner (Pyrénées-Atlantiques), castle 302

Montbazon (Indre-et-Loire), keep 86, 139, 196

Mont-Saint-Michel (Manche) 89, 195, 248, 248

Monte Gargano (Italy) 88, 150

Montignac-sur-Vézère (Dordogne), Lascaux caves 16, *17,* 18

Montreuil-Bellay (Maine-et-Loire), castle 197

Montségur (Ariège) 260

Morienval (Oise), Notre-Dame 206

Moulins (Allier), castle 303

Moutiers-Saint-Jean (Côte-d'Or), abbey 65

Mozac (ou Mozat, Puy-de-Dôme), Saint-Pierre 184, *184*

Mussy-sur-Seine (Aube), Saint-Jean-Baptiste 264

Najac (Aveyron), castle 213, *274, 274*

Nantes (Loire-Atlantique), Saint-Pierre 40

Naples (Italy), Castelnuovo 213; San Lorenzo 266

Narbonne (Aude), Notre-Dame-de-Lamourguier 248, *248;* Saint-Just *296,* 297

Nesle-la-Reposte (Marne) 225

Neuchâtel (La Tène, Switzerland) 28

Neuilly-en-Donjon (Allier), Sainte-Madeleine 172

Neuvy-en-Sullias (Loiret) *34,* 37

Neuvy-Saint-Sépulcre (Indre), Saint-Étienne, rotunda 164, *164*

Nevers (Nièvre), Saint-Étienne 152

Nîmes (Gard), Maison Carrée 41, *42*

Niort (Deux-Sèvres), keep 197

Nogent-le-Rotrou (Eure-et-Loir) 139

Noyon (Oise), Notre-Dame 206, 213, 220, *220,* 221, *221,* 236

Orange (Vaucluse), amphitheater 40, *40*

Orbais (Marne), Saint-Pierre 237, 246

Orcival (Puy-de-Dôme) 167

Orléans (Loiret) [Genabum 29]; 48, 139; Saint-Aignan 270

Padua (Italy), Sainte-Justine 168

Paray-le-Monial (Saône-et-Loire), priory *168-169,* 171, 190

Paris 227, 238, 305; la Bastille 310; Celestine convent and monastery 308 ; Dominican monasteries 305; Notre-Dame 66, 128, *133, 207,* 208-209, 213, 217, 224, *226,* 227, *228-231,* 231, 236, 250, 252-255, 256, *256, 257,* 264, 267, 270, 277, 294, 306; royal palace on Ile de la Cité 310; Louvre 98, *198,* 231, 265-266, *271,* 303, 308, 310, 312, *311-312;* Palais-Royal 231; Quinze-Vingts hospital 260; Saint-Denis 56, 57, 65; Sainte-Chapelle 121, 123, *124-125,* 206, 231, 258, 261-263, *261-263,* 264, 266-267, 269, 297 ; Sainte-Croix 56; Saint-Germain-des-Prés 56, 65, 81, 129, 149, 210, 225, 262, 266; Holy Apostles basilica (destroyed) 56; Saint-Vincent 56; *see also* Lutetia

Pau (Pyrénées-Atlantiques), castle 302

Pérignac (Charente-Maritime), Saint-Pierre 182

Périgueux (Dordogne), Saint-Front 158, 168, *170;* Saint-Étienne-de-la-Cité 169

Peu-Richard (Charente-Maritime) 20

Pincevent (Seine-et-Marne) *14,* 15

Poissy (Yvelines) 265; priory Saint-Louis *266*

Poitiers (Vienne), Saint-Jean baptistery 64, *64;* Notre-Dame-la-Grande 156, *158,* 165, 222; Sainte-Radegonde 160; Saint-Hilaire 56; Maubergeon tower 312

Pontoise (Val-d'Oise), Hôtel-Dieu 261

Pouan (Aube), treasure *58, 59*

Provins (Seine-et-Marne), Saint-Ayoul 225; Caesar's tower 196, *196*

Rampillon (Seine-et-Marne), Saint-Éliphe 304

Ravenna (Italy) 54, 70, 183; Sant' Apollinaire Nuovo 57

Reims (Marne) 44, 48, 66, 70, 72; Notre-Dame *112,* 113, *127,* 128, 131, *137,* 208, 211, 224, 227, 233, *233,* 234, *235,* 237, 242, *242,* 243, *245, 246,* 250, *250,* 251, 252, *252,* 253, *253,* 254, *255,* 256, 264; Saint-Nicaise 56, 223, 297; Saint-Pierre 233; Saint-Remi 78, 149, 152, 160, 195, 255

Rémoulins (Gard), Pont du Gard 42, *43*

Rethel (Ardennes) 48

Rieux (Haute-Garonne) 306

Ripoll (Spain), abbey 143

Roc-de-Sers (Charente) *11*

Rodez (Aveyron) [Segodunum 29]; Notre-Dame 248

Rome (Italy) 72, 163

Roque d'Anthéron, La (Aveyron), abbey of Sylvanès *200-201*

Roquepertuse (Bouches-du-Rhône) 35, *35*

Roquetaillade (Gironde), castle 299, *300*

Rouen (Seine-Maritime) 277, 333; Notre-Dame 146, *210, 212,* 273, 309; Saint-Ouen 297, 298

Rouffignac (Dordogne) 19

Royaumont (Val-d'Oise), abbey 261, 265, 305

Saint-Antonin-Noble-Val (Tarn-et-Garonne) 163

Saint-Aubin-sur-Mer (Seine-Maritime) 44

Saint-Avit-Senieur (Dordogne) 169

Saint-Benoît-sur-Loire (Loiret) 58, 140, 143, *144,* 149, *149,* 152, 192, *192*

Saint-Bertin *see* Saint-Omer

Saint-Bertrand-de-Comminges (Haute-Garonne) 46

Saint-Denis (Seine-Saint-Denis), abbey 53, *55, 56,* 59, 72, *72,* 73, 78, *81-82,* 86, *134-135,* 160, 171, 184, 192, 194, 204, 207, 213, 214, *214, 215, 216, 217,* 218, 219, 215-216, 218, 219, 222-224, 226-227, 230, 232, 237, 248-249, 252, 261, 264-266, 282, 297, 305-306, 309

Saint-Gall (Switzerland) 71

Saint-Germain-en-Laye (Yvelines), Musée des Antiquités Nationales, castle 28

Saint-Germer-de-Fly (Oise), Saint-Germer 213, 220, 263, *264*

Saint-Gilles-du-Gard (Gard), abbey 46, 165, 183, 224

Saint-Guilhem-le-Désert (Hérault), abbey 146, *146*

Saint-Hilarion (Cyprus), castle 275

Saint-Hymer-en-Auge (Calvados), priory 298

Saint John Acre (Israel) 275

Saint-Loup-de-Naud (Seine-et-Marne), priory 225

Saint-Malo (Ille-et-Vilaine), Saint-Vincent 170

Saint-Martin-aux-Bois (Oise), abbey 264

Saint-Martin-du-Canigou *see* Casteil

Saint-Maurice at Agaune (Switzerland) 83

Saint-Michel-de-Cuxa (Pyrénées-Orientales), abbey *82,* 83, *83,* 143

Saint-Nazaire (Loire-Atlantique) 24

Saint-Nectaire, (Puy-de-Dôme) 167, *167*

Saint-Omer (Pas-de-Calais) 194, 216

Saint-Ouen-l'Aumône (Val-d'Oise), Maubuisson 282, *305,* 309

Saint-Paul-Trois-Châteaux (Drôme), Notre-Dame 165, 192

Saint-Pierre-le-Moutier (Nièvre), Saint-Pierre 149

Saint-Pierre-sur-Dives (Calvados), abbey 272

Saint-Quantin-de-Rançanne (Charente-Maritime), church 182

Saint-Quentin (Aisne), Saint-Quentin-et-Notre-Dame 211, 264

Saint-Rémy-de-Provence (Bouches-du-Rhône) 40, *40,* 48

Saint-Riquier (Somme), Centula abbey 71, *71,* 81

Saint-Saturnin (Puy-de-Dôme), church 167

Saint-Savin-sur-Gartempe (Vienne) *138,* 140, 159, *159,* 188, 189, 195

Saint-Servan (Ille-et-Vilaine), Solidor tower *300,* 303

Saint-Sever-sur-Adour (Landes), abbey 140

Saint-Sulpice-de-Favières (Essonne), church 264

Saint-Thibault-en-Auxois (Côte-d'Or), Saint-Blaise 255, 264, 305

Saint-Wandrille (Seine-Maritime), abbey 89

Sainte-Foy-la-Grande (Gironde) 276

Saintes (Charente-Maritime), Sainte-Marie-des-Dames *157,* 182; Saint-Eutrope *154-155,* 156, 165

Santiago de Compostela (Spain) 83, 147, 150, 151, 152

Sanxay (Vienne), amphitheater 40

Saumur (Maine-et-Loire), castle 303, 312

Sées (Orne), Notre-Dame 263

Semur-en-Auxois (Côte d'Or), Notre-Dame 295

Semur-en-Brionnais (Saône-et-Loire), Saint-Hilaire 171

Senanque 204

Senlis (Oise), Notre-Dame 57, 139, 218, 219, 223, 225, 227, *227,* 233, 236, 255, 258

Sens (Yonne), Saint-Étienne 57, 208, 218, 220, 227, *232,* 233, 234, 236, 258, 297

Serre-Grand (Aveyron) 27

Shlemutsi (Greece) *see* Clermont

Silvacane (Bouches-du-Rhone), abbey *204*

Soissons (Aisne) 103, 271; Saint-Gervais-Saint-Protais 218, 220, 221, 237, 247; Saint-Médard 53, 71

Sorgues (Vaucluse) 313

Souillac (Lot), Sainte-Marie 181, *181,* 184

Souvigny (Allier) 190, *191*

Strasbourg (Bas-Rhin), Notre-Dame 136, 237, *248,* 249, 258, 277, *294,* 304, *304*

Tavant (Indre-et-Loire) 189

Toledo (Spain) 238

Tonquedec (Côte-d'Armor), castle *300,* 303

Toulouse (Haute-Garonne) 260; Franciscan monastery *118,* 306; Dominican church 249; Notre-Dame de la Daurade 54, 56, 120; Saint-Étienne 224, 249; Saint-Sernin 46, 131, 152, 167, 270, *270*

Tournai (Belgium), Notre-Dame 221; tomb of Childeric I 50

Tournus (Saône-et-Loire), Saint-Philibert 146, *147,* 165, *166*

Tours (Indre-et-Loire) 54, 298; Saint-Gatien 261; Saint-Julien 140, 160; Saint-Martin 53, 57, 144, 151, 152, 160, 238

Trémolat (Dordogne), Notre-Dame 169

Trento (Italy), Bishop's Palace 331

Trouillas (Pyrénées Orientales), tower 299

Troyes (Aube) 281; Saint-Pierre-Saint-Paul 208, 209, 218, 249; Saint-Urbain 304

Tursac (Dordogne) *see* Madeleine, La

Vaison (Vaucluse), amphitheater 40

Vaucelles (Nord), church (destroyed) 211

Venasque (Vaucluse), baptistery 64

Vendôme (Loir-et-Cher), Trinité Church 194, 195, 298

Venice (Italy), San Marco 168

Verdun (Meuse) 71

Vermenton (Yonne), Notre-Dame 225

Verona (Italy) 72

Versailles (Yvelines) 312
Vertault (Côte-d'Or) *45*
Vézelay (Yonne), basilica of
Sainte-Madeleine 15, 54,
101, 131, 143, *153,* 153,
156, *172,* 173, 181, *184,* 185,
224

Vicq (Indre), Saint-Martin 189,
189
Vienne (Isère) 70
Vignory (Haute-Marne), Saint-
Etienne 149, *150*
Villandraut (Gironde), castle
299

Villefranche-de-Rouergue
(Aveyron) 276
Villeneuve-sur-Lot (Lot-et-
Garonne) 276
Villeneuve d'Aveyron (Aveyron),
Saint-Julien 144
Villeneuve-lès-Avignon (Gard),

Saint-André fort 301, *301*
Vincennes (Val-de-Marne), castle
312
Vix (Côte-d'Or) 28, 29, *37*

Wimpfen am Neckar (Germany),
Saint Peter 249

INDEX OF MANUSCRIPTS

AVRANCHES, Bibliothèque
Municipale
Saint Clement, *Recognitiones*
140, *142*
BOULOGNE, Bibliothèque
Municipale
Psalter 142
BRUSSELS, Bibliothèque Royale
Aristotle, *Ethics* 308, *309*
Aristotle, *Politics and Economics*
329, *330*
Histoire de Charles Martel et de ses
successeurs 113
Très Belles Heures du Duc de Berry
330
CAMBRAI, Bibliothèque Municipale
Heures de Mahaut d'Artois 273
Saint Augustine, *Works* 191
CHANTILLY, Musée Condé
The Otto III Gospels 80
Très Riches Heures du Duc de Berry
312, *312, 313,* 320, 332, *333*
CLERMONT-FERRAND, Bibliothèque
Municipale
Clermont-Ferrand Bible 190, *191*
DIJON, Bibliothèque Municipale
Letters of Saint Jerome 108
Moralia in Job 108, *202*
Stephen Harding Bible 161
DOUAI, Bibliothèque Municipale
Saint Bernard, *œuvres 203*
ÉPERNAY, Bibliothèque Municipale
The Ebbo Gospels 77
HAGUE, THE, Meermanno-
Westreenianum Rijksmuseum
Bible Historiale 308, *324*
LONDON, British Library
Bedford Hours, The 278
Bible Moralisée 269
Moutier-Grandval Bible 76, *76*
œuvres de Christine de Pisan 332
Psalter of Henry of Blois 191
Songe du Verger 293, *293,* 313
MONTPELLIER, Musée Atger

Le Chansonnier de Paris 111, *273*
MOULINS, Bibliothèque Municipale
Souvigny Bible 190, *191*
NEW YORK
The Cloisters
Belles Heures du Duc de Berry or
Heures d'Ailly 332, *333*
Hours of Jeanne d'Évreux 286,
288, 290
Prayer Book of Jeanne d'Évreux 286
Pierpont Morgan Library
Mont-Saint-Michel Sacramentary
142, *142*
ORLÉANS, Bibliothèque Municipale
Homilies on Ezekiel 142
OXFORD, Bodleian Library
Bible Moralisée 269
Roman d'Alexandre 294
PARIS
Bibliothèque de l'Arsenal
Paris Psalter 268, *269*
Bibliothèque Nationale
Annales of Saint-Germain-des-Prés
293
Apocalypse of the Sainte-Chapelle
309
Beatus of Liebana, *Commentary on*
the Apocalypse 93, 140, *187*
Bellenville Armorial 317
Belleville Breviary 286, *287,* 294
Benoît de Sainte Maure, *Roman de*
Troie 89, 198, *199,* 218
Bible de Saint-Martial 88, *88*
Bible Moralisée 268, *269*
Bible Moralisée (of John the Good)
283, 288, *292,* 293
Boiron, Robert de, *Histoire du*
Graal 273
Breviary of Charles V 291, *293*
Breviary of Philip the Fair 268,
268, 285
Charles the Bald Bible, also known
as the *Vivian Bible* 75, *77*
Charles the Bald Psalter 66, 67, *69*

Christine de Pisan, *Épître d'Othea à*
Hector 332, *332*
Cluny Lectionary 190, *190*
Drogo Sacramentary 67, *68, 76,* 77
Duke of Bedford Breviary, also
known as the *Salisbury Breviary*
332-333, *334*
Durand de Mende, Guillaume,
Rational des divins offices
307, *307*
Fournival, Richard de, *Bestiaire*
d'amour 272, *273*
Gaignières Evangelistary 142, *142*
Gervais Du Bus, *Le Roman de*
Fauvel 280, *280,* 281
Godescalc Evangelistary 74, 76
Grandes Chroniques de France
de Charles V 279, 307, *319,* 323,
323
Grandes Heures du Duc de Berry
318, 325, *332*
Guillaume de Saint-Pathus, *Vie*
et Miracles de Saint Louis 94,
95, 267
Heures de Jeanne de Navarre 288,
289, 290
Heures de Rohan 332, *334*
Heures et recueil de prières
d'Avignon 294, *295*
Images du Monde 90, *109,* 272
Jean de Sy Bible 290, *290, 293,* 325
Joinville, Jean de, *Vie de Saint Louis*
267, *267*
La Noble Chevalerie de Judas
Maccabée 269, *269*
Le Roman de la Rose 273, *273*
Livre de la Chasse de Gaston Phébus
331, 331
Livre du Roi Modus et de la Reine
Ratio 331
Mamerot, Sébastien, *Passages faits*
outremer 98
Manuscript of musical tropes and
prose *89*

Martyrology 269, *269*
Miracles de Notre-Dame 288, *289*
œuvres de Guillaume de Machaut
290, *290, 293*
Petites Heures du Duc de Berry
290, 332
Psalter of the Duke of Berry 325,
329
Recueil historique et liturgique
de l'abbaye de Cluny 96
Remède de Fortune 293
Robert de Billyng Bible 286, *286*
Roman de Godefroi de Bouillon
314, 316
Saint Louis Psalter 99, 267
Saint-Martial Lectionary 86, 88
Second Bible of Saint Martial
of Limoges 160, *161*
Très Belles Heures de Notre-Dame
du Duc de Berry 325, *327,* 332
Valerius Maximus, *Roman*
Anecdotes 307
Vie de Saint Denis 51, 285, 285
Villard de Honnecourt, Notebook
129, *129,* 210-212, *211, 272, 272*
Bibliothèque de Sainte-Geneviève
Livy, *History of Rome* 307-308, *308*
Musée Jacquemart-André
The Boucicaut Hours 282, *283, 324,*
324, 332
POITIERS, Bibliothèque Municipale
Vie de Sainte Radegonde 160, *160*
TOURS, Bibliothèque Municipale
Decretals of Gratian 268
Vie de Saint Martin 97
UTRECHT, Bibliothèque
Universitaire
Hautvilliers Psalter, known as the
Utrecht Psalter 77, *183*
VALENCIENNES, Bibliothèque
Municipale
Apocalypse of Saint John 87
Saint-Amand Bible 191
The Gospels 86

PICTURE CREDITS

Photographic archives /© Spadem 1993, Paris: 101, 131, 232. Artephot, Paris/Babey: 105. Norbert Aujoulat/Centre national de la Préhistoire, Périgueux: 17, 18. Jean Bernard, Aix-en-Provence: 116, 117, 208, 210, 214, 215, 216/217, 220, 221, 224, 225, 227, 236b, 237, 238/239, 240, 241, 244, 247, 248, 258, 296b. Bibliothèque municipale, Avranches: 142tl. Bibliothèque municipale/Laboratoire Blow up, Dijon: 108r. Bibliothèque municipale/I.H.R.T.- C.N.R.S., Moulins: 191l, 191r. Bibliothèque municipale, Tours: 97, 268tl. Bibliothèque nationale, Paris: 33, 50, 51b, 52, 56, 57t, 66, 68, 69, 71, 74, 75, 76l, 81, 86l, 88, 89, 90, 93, 94, 95, 96, 98, 99, 109, 129, 139, 140/141, 142tr, 160b, 171, 190, 199, 211, 236t, 267, 268hr, 268b, 269, 272b, 273, 279, 280, 281, 285tr, 285b, 286, 287, 289t, 290, 291, 292, 293t, 294t, 295, 307, 309r, 316, 317, 318, 319, 323, 325, 327, 330, 331, 332b, 334, 335. Bibliothèque Royale Albert Ier, Brussels: 113, 309l, 329. British Library, London: 76r, 278, 293b, 332t. British Museum, London: 314. Bulloz, Paris: 34. Jean-Loup Charmet, Paris: 308. Laurent Chastel, Paris: 193l. Cleveland Museum of Art: 315. C.N.M.H.S., Paris © Spadem 1993/B. Acloque: 124; /F. Delebecque: 300b; /Jean Feuillie: 144t, 170, 204, 218, 219, 222, 264; /Lonchampt-Delehaye: 243, 277; /Caroline Rose: 301; /Martin Sabon: 233. G. Dagli Orti, Paris: 11, 12, 13, 14d, 23, 24, 25, 29tr, 29b, 34t, 35, 37, 38r, 39br, 43, 44/45, 45, 48, 49, 51t, 58, 59, 61b, 64, 65, 67, 70, 73, 77, 78, 80, 84/85, 86r, 87, 100, 108l, 111, 112, 121, 125, 126, 127, 130, 137, 138, 152, 153, 154/155, 157, 158, 159, 160t, 162, 163, 172, 173, 174, 175, 176/177, 178tl, 178r, 179, 182, 188, 189, 193r, 202, 209, 223, 235, 242, 245, 246r, 250, 251, 252, 253, 255, 260/261, 262, 305, 328. Bernard Delgado, Arles: 46. Jean Dieuzaide, Toulouse: 53, 120, 200/201, 270b, 275. Studio Dumont, Sin Le Noble: 203. Explorer, Vanves/Jean-Luc Bohin: 283t; /Loïc Jahan: 40, 145; /F. Jalain; 196; /Alain Parinet: 300tr; Ph. Roy: 299, 300tl; /N. Thibaut: 274; /Henri Veiller: 213; /Paul Wysocki: 41. Flammarion: 181l, 254, 285tl. Franceschi: 156l. Giraudon, Vanves: 123l, 180, 303, 310, 312, 313. Jean-Luc Godard/Commission du Vieux Paris: 55. Gris Banal, Montpellier: 82, 83. Hirmer Fotoarchiv, Munich: 181r. I.H.R.T./C.N.R.S, Orléans: 191m. Images et Son, Dijon: 147, 165, 166, 168, 169, 205. Inventaire général, Nantes © Spadem 1993/P. Giraud-F. Lasa: 320/321, 322. Inventaire général, Rouen © Spadem 1993/Thierry Leroy: 298. Jean-Frédéric Ittel, Paris: 123r, 133, 226, 272t, 294b. Hubert Josse, Paris: 60/61, 79. Lauros-Giraudon, Vanves: 136, 151t, 156r, 246l, 282l, 304. Jean Lechartier, Évreux: 259. Lescuyer: 164. Erich Lessing/Magnum, Paris: 36, 57b, 62/63, 92, 122, 146, 148, 161, 197, 198, 228, 229, 230, 257, 265, 266, 276, 302. Metropolitan Museum of Art, New York: 156b, 192b, 288, 289b, 333. Musée des Beaux-Arts, Angers: 297. Musée Calvet, Avignon/Guerrand: 306. Musée de l'Homme, Paris: 10; /Delaplanche: 14l; /J. Oster: 16. Musée Jacquemart-André, Paris: 283b, 324. Musée Rolin, Autun: 39bl. Jacques Nestgen, Montrouge: 178br. Pierpont Morgan Library, New York: 142b. Rapho, Paris/Francis Debaisieux: 185tlr; /Dominique Repérant: 249l; /Sarramon: 249r. Réunion des musées nationaux, Paris: 8, 15, 19, 20, 21, 22, 26, 27, 28, 29tl, 30, 31, 32, 38l, 39t, 44, 54, 72, 102l, 104, 106, 107, 110, 118, 119, 134, 135, 263, 270t, 271, 282r, 284, 296t. Caroline Rose, Paris: 207, 231, 256, 311, 326. Top, Paris/J. Ph. Charbonnier: 42; /Rosine Mazin: 114, 115, 149; /M.-J. Jarry and J.-F. Tripelon: 183; /J.-N. Reichel: 192tl. Victoria and Albert Museum, London: 103. F. Walch, Paris: 206, 234. Yan/Zodiaque, Toulouse: 132, 143, 185blr, 187. Zodiaque, La Pierre-qui-Vire: 102r, 128, 144b, 150, 151b, 167, 184, 186, 192tr, 194, 195.

The publisher would like to thank the following people who provided assistance: Angela Armstrong, Claude Bourgeois, Marie-Pierre Charbit, Laurent Chastel, Christophe Cornubert, Constance Didier, Raphaël Douin, Marie-Madeleine Gauthier, Brigitte Haslouin, Maryse Hubert, Dominique Thiébaut, and, for the English edition, Christine Schultz-Touge.